W9-CBT-440

NIXON

AND

KISSINGER

ALSO BY ROBERT DALLEK

An Unfinished Life: John F. Kennedy, 1917–1963

Flawed Giant: Lyndon B. Johnson and His Times, 1961–1973

Hail to the Chief: The Making and Unmaking of American Presidents

Lone Star Rising: Lyndon Johnson and His Times, 1908–1960

Ronald Reagan: The Politics of Symbolism

The American Style of Foreign Policy: Cultural Politics and Foreign Affairs

Franklin D. Roosevelt and American Foreign Policy, 1932–1945

Democrat and Diplomat: The Life of William E. Dodd

NIXON

— AND —

KISSINGER

PARTNERS IN POWER

ROBERT DALLEK

HarperCollins*Publishers*

HarperCollins books may be purchased for educational, business, or sales promotional use. For information, please write: Special Markets Department, HarperCollins Publishers, 10 East 53rd Street, New York, NY 10022.

FIRST EDITION

Designed by Joy O'Meara

Library of Congress Cataloging-in-Publication Data is available upon request.

ISBN-10: 0-06-0722304
ISBN: 978-0-06-0722302

07 08 09 10 11 NMSG/RRD 10 9 8 7 6 5 4 3 2 1

To our grandchildren:
Hannah Claire Bender and Ethan Jack Bender

CONTENTS

PART FOUR – THE WORST OF TIMES

PREFACE

Human history becomes more and more a race between education and catastrophe.

—H. G. WELLS

This book is about the exercise of power by two of the most important practitioners of the art in the twentieth century: President Richard Nixon and Henry Kissinger, whose unprecedented influence as a national security adviser and secretary of state made him a kind of co-president, especially during the administration's turmoil over Watergate.

We know almost all of what they did during their five and a half years in the White House; their major initiatives were and remain landmarks in the history of American foreign policy. Why and how they acted, however, is incomplete and imperfectly understood—partly hidden behind the facade the two men consciously and unconsciously erected to disguise their intentions.

The Nixon and Kissinger personae do not lend themselves to easy understanding. But neither man is less understandable than Franklin Roosevelt, John Kennedy, Lyndon Johnson, and Ronald Reagan, other political leaders I have studied. This is not to suggest that all these men are alike or lack distinctive traits. Each one had his unique qualities that

made him a challenge to explain. And while practice in political biography never makes perfect, it has encouraged me to believe that none of these men are so complicated that we cannot describe the private men behind the public images. I hope my recounting of the Nixon and Kissinger life stories will cast fresh light on who they were and why and how they collaborated in their use and abuse of power.

A vast array of previously untapped records has served my reconstruction of their histories. The recent opening of the bulk of these materials—millions of pages of national security files, 2,800 hours out of 3,700 hours of Nixon tapes, and 20,000 pages of Kissinger telephone transcripts that were made by aides listening in on the conversations—makes another reexamination of the men and their leadership particularly timely and instructive.

The Nixon-Kissinger partnership presents the historical biographer with a striking irony. The two men presided over a government that was unequaled in its secrecy. But the availability of the richest presidential records in history makes their White House more transparent than any before or since. The materials provide an unprecedented opportunity to probe Nixon's and Kissinger's policymaking. Specifically, mining administration records has allowed me to reconstruct the interactions between Nixon and Kissinger and others in the government—the collaborations and rivalries, the backstabbing, intrigues, and foul language, or "expletive deleted" in contemporary White House transcripts—to an unparalleled extent.

The great events of Nixon's presidency—ending the Vietnam War, opening a new era in Sino-American relations, building détente with the Soviet Union, managing daunting Middle East problems, favoring Pakistan in the Indo-Pakistan War, seeking the overthrow of Salvadore Allende Gossen's government in Chile, using foreign affairs to counter growing cries for impeachment of the president over Watergate, and hiding Nixon's erratic behavior in response to the crisis—can also be more fully re-created than ever before. It gives us a chance to see what Bismarck famously advised against, viewing the making of sausages and laws—in this case the development and implementation of foreign policy.

The archival riches provide the most authoritative answers to a number of enduring questions. Foremost, the four additional years of fighting in Vietnam cry out for explanation. Could the war have been ended

sooner? And could the Saigon regime have been saved from itself and a Communist takeover by Hanoi? In light of the end results in Vietnam, Kissinger's selection for the Nobel Peace Prize in 1973 is another point of controversy.

The opening to China is a largely celebrated event, usually cited as the most important achievement of Nixon's and Kissinger's foreign policy. But how it occurred and which man deserves the principal credit for realizing it still provokes debate. Questions about its usefulness in balancing the Communist superpower in Peking against the one in Moscow also remain.

Arguments about the wisdom and value of détente with the Soviet Union continue to be worthy of consideration as well. Were the SALT and trade agreements as essential to international stability and peace as Nixon and Kissinger believed? Neoconservative critics of détente complain that the rapprochement was nothing more than a Soviet ploy in the Cold War and did more to undermine than benefit U.S. national security. The available records and the passage of time allow for more rounded judgments on this controversy.

Meanwhile arguments about the Middle East today are especially pressing. Was the administration too slow to deal with the region's problems? Could we have averted the Yom Kippur War? The decision to increase America's defense condition (Defcon) in response to a Soviet threat to send paratroops into the Sinai to prevent the demise of Egypt's surrounded Third Army is a troubling fact, especially in light of what new records show about how it was done. And the postwar peacemaking against the backdrop of recent strife between Israel and its Arab neighbors is a subject with a seemingly timeless quality.

As for the 1971 Indo-Pakistan war and the administration's famous tilt toward Pakistan, revelations from Nixon-Kissinger conversations make clear how truly controversial their decisions were in response to that crisis. Was the war a realistic extension of great power politics, as Nixon and Kissinger believed? Was world peace as much in jeopardy as they thought?

Administration efforts first to block Allende's accession to power and then to bring him down are now well known. Additional details about the extent of that concern and the Nixon-Kissinger response to it are part of this book's new history. More important is the need to revisit asser-

tions about Allende's threat to U.S. national security in the hemisphere. Inevitably, questions arise about the Nixon administration's part, if any, in the deaths of Chilean Chief of Staff Rene Schneider in 1970 and Allende in 1973. And what role, if any, did we play in the Pinochet coup and his subsequent hold on power?

Nixon's use of foreign affairs to overcome impeachment threats in 1973–1974 are a disturbing part of the administration's history. Its impact on foreign policy deserves particular consideration, as does the more extensive use of international relations to serve domestic political goals throughout Nixon's presidency. Nixon's competence to lead the country during his impeachment crisis also requires the closest possible scrutiny. It raises the question of whether Kissinger and other cabinet members should have considered invoking the Twenty-fifth Amendment to ensure that foreign adversaries did not take advantage of a weakened administration, as Kissinger feared.

At variance with the German philosopher Georg Hegel's view that "nations and governments have never learned anything from history," I am convinced that the many questions raised in this book have relevance for current national and international problems. Arguments about the wisdom of the war in Iraq and how to end U.S. involvement there, relations with China and Russia, what to do about enduring Mideast tensions between Israelis and Arabs, and the advantages and disadvantages of an imperial presidency can, I believe, be usefully considered in the context of a fresh look at Nixon and Kissinger and the power they wielded for good and ill.

RD
Washington, D.C.

BRETHREN OF A KIND

~ Chapter 1 ~

NIXON

A man's philosophy is his autobiography. You may read it in the story of his conflict with life.

—Walter Lippmann, *The New Republic*, July 17, 1915

In the nearly twenty years following his resignation from the presidency in 1974, Richard Nixon struggled to reestablish himself as a well-regarded public figure. He tried to counter negative views of himself by writing seven books, mostly about international relations, which could sustain and increase his reputation as a world statesman. Yet as late as 1992, he complained to Monica Crowley, a young postpresidential aide: " 'We have taken . . . shit ever since—insulted by the media as the disgraced former president.' "

Above all, he craved public attention from his successors in the White House. The reluctance of Gerald Ford, Ronald Reagan, and George H. W. Bush to invite him back to the Oval Office for advice, particularly on foreign policy, incensed him. When Bush sent him national security form letters, "he erupted in fury. 'I will not give them [the Bush advisers] any advice unless they are willing to thank me publicly,' " he told Crowley. " 'I'm tired of being taken for granted. . . . No more going in the back door of the White House—middle of the night—under the cloak-of-darkness crap. Either they want me or they don't.' "

At the 1992 Republican Convention, after Bush publicly praised Nixon's contribution to America's Cold War victory, Nixon exclaimed, " 'It took guts for him to say that. . . . It's the first time that anyone has referred to me at a convention. Reagan never did. It was gutsy.' " After Bill Clinton invited him to the White House to discuss Russia, Nixon declared it the best meeting " 'I have had since I was president.' " He was gratified that Clinton addressed him as " 'Mr. President.' " But when he saw his advice to Clinton being "diluted," it "inspired rage, disappointment and frustration."

Nixon's postpresidential resentments were of a piece with longstanding sensitivity to personal slights. His biography is in significant part the story of an introspective man whose inner demons both lifted him up and brought him down. It is the history of an exceptional man whose unhappy childhood and lifelong personal tensions propelled him toward success and failure.

It may be that Winston Churchill was right when he said that behind every extraordinary man is an unhappy childhood. But because there are so many unhappy children and so few exceptional men, it invites speculation on what else went into Nixon's rise to fame as a congressman, senator, vice president, and president. Surely, not the least of Nixon's motives in his drive for public visibility was an insatiable appetite for distinction—a need, perhaps, to make up for psychic wounds that produced an unrelenting determination to elevate himself to the front rank of America's competitors for status, wealth, and influence. Like Lincoln, in the words of law partner William Herndon, Nixon's ambition was a little engine that knew no rest.

Like most political memoirists who romanticize the realities of their upbringing, Nixon painted a portrait of an "idyllic" childhood in Yorba Linda, California, a rural town of two hundred about thirty miles northeast of Los Angeles, and Whittier, a small city of about five thousand east of Long Beach. He remembered "the rich scent of orange blossoms in the spring . . . glimpses of the Pacific Ocean to the west [and] the San Bernardino Mountains to the north," and the allure of "far-off places" stimulated by train whistles in the night that made him want to become a railroad engineer. "Life in Yorba Linda was hard but happy." His father worked at odd jobs, but a vegetable garden, fruit trees, and a cow provided the family with plenty to eat.

When Richard was nine, the family moved to Whittier, where his mother's Milhous family lived. He described growing up there in three words: "family, church and school." There was an extended family with scores of people, including his grandmother, Almira Burdg Milhous, who inspired him on his thirteenth birthday in 1926 with a gift of a framed Lincoln portrait and a Longfellow poem, "Psalm of Life": "Lives of great men oft remind us/We can make our lives sublime/And departing, leave behind us/Footprints on the sands of time." Nixon cherished the picture and inscription, which he kept hung over his bed while in high school and college.

Richard remembered his parents as models of honest decency who endowed him with attributes every youngster might wish to have. "My father," Nixon wrote, "was a scrappy, belligerent fighter with a quick, wide-ranging raw intellect. He left me a respect for learning and hard work, and the will to keep fighting no matter what the odds. My mother loved me completely and selflessly, and her special legacy was a quiet, inner peace, and the determination never to despair."

But in fact, Nixon's childhood was much more tumultuous and troubling than he let on. Frank Nixon, his father, was a boisterous, unpleasant man who needed to dominate everyone—"a 'punishing and often brutal' father." Edward Nixon, the youngest of the Nixon children described his "mother as the judge and my father as the executioner." Frank's social skills left a lot to be desired; he offended most people with displays of temper and argumentativeness. As a trolley car conductor, farmer, gas station owner, and small grocer, he never made a particularly good living. Nixon biographers have painted unsympathetic portraits of Frank as a difficult, abrasive character with few redeeming qualities. Though Nixon would never openly acknowledge it, he saw his father as a harsh, unlikable man whose weaknesses eclipsed his strengths.

Frank was a standing example of what Richard hoped not to be—a largely inconsequential figure in a universe that valued material success and social standing. Richard was driven to do better than his father, but he also struggled with painful inner doubts about his worthiness. Despite his striving, Richard initially doubted that he had the wherewithal to surpass his father. Frank was not someone who either by example or direct messages to his sons communicated much faith in their worth. At the same time, however, Richard was his father's son: his later readiness

to run roughshod over opponents and his mean-spiritedness in political combat said as much about Frank as it did about Richard.

Richard felt much more kindly toward his mother, Hannah. But for all the descriptions of her as a "saint," to which her son always subscribed, she was a remote person whom Richard saw as "intensely private in her feelings and emotions." She was not the sort, in biographer Tom Wicker's words, to offer "a close embrace, a kiss, a rollicking bounce on a mother's lap."

And Hannah was repeatedly absent during Richard's early years. In 1913, nine months after Richard's birth in Yorba Linda, she was hospitalized for mastoid surgery, followed by a period of recovery at her parents' Whittier home. Richard's maternal grandmother Almira cared for him and an older brother, but he felt his mother's absence nevertheless. In subsequent years, when her demanding husband and their hard life in a bungalow house, where she and Frank lived with four small boys, overwhelmed her, she repeatedly returned home to Whittier for sometimes brief and sometimes lengthy stays. Hannah's burdens, including two sickly sons, one of whom, Arthur, died at age seven in 1925, while the other, Harold, died in 1930 at age twenty-one, were reasons for her to give Richard less than full attention during his childhood and adolescence.

Although Richard sympathized with his mother's need to attend principally to his afflicted brothers, his understanding could not fill the void he felt from her occasional physical, and more important, emotional absences. " 'My Dear Master,' " he wrote Hannah at the age of ten, in what biographer Roger Morris calls "the pitiable cry and fantasy of a lonely boy," who disguised his unhappiness in a dog story. " 'I wish you would come home right now. Your good dog Richard.' " Hannah remembered that "as a youngster, Richard seemed to need me more than my other sons did. As a schoolboy, he used to like to have me sit with him when he studied. . . . It wasn't that Richard needed my help with his work. . . . Rather it was that he just liked to have me around."

As a boy and young man, Nixon impressed most classmates and teachers as a well-adjusted, socially engaged activist. At Whittier College, he was a class leader: a strong student with a record of campus activism as an actor, member of the debate and football teams. Those who got closer to him, however, recall "a solitary, shy, painfully uncertain boy amid all

the apparent energy and versatility . . . Many saw him as strained and tightly strung." A classmate recalled that "Dick was a very tense person." Another schoolmate said, "He never had any close friends in college. He was a loner." His Whittier debate coach thought "there was something mean in him, mean in the way he put his questions, argued his points." Ola Florence Welch, Richard's college girlfriend, with whom he had a stormy on-and-off again relationship, believed he suffered from "an underlying unease and awkwardness, a deeper unfulfilled need. 'He seemed lonely and so solemn at school. He didn't know how to mix. He was smart and sort of set apart. I think he was unsure of himself, deep down.' "

During his three years at Duke Law School between 1934 and 1937, he was nicknamed "gloomy Gus." This was less because he was so glum as because he was a workaholic who strictly limited his participation in the social life of the campus. One classmate considered him "something of an oddball" and "slightly paranoid." He was a compulsive student who spent most of his time in the law library "hunched over his books." Only at Duke football games, to which he came and went by himself, did he give public vent to his emotions, yelling himself hoarse in support of the team.

When Tom Wicker first encountered the forty-four-year-old Nixon in the U.S. Senate lobby in 1957, five years after he had been elected vice president, he was "walking along rather slowly, shoulders slumped, hands jammed in his trouser pockets, head down and his eyes apparently fixed . . . on the ornate Capitol floor. What I could see of his face seemed darker than could be accounted for by the trademark five o'clock shadow; it was preoccupied, brooding, gloomy, whether angry or merely disconsolate I was unable to tell." Wicker believed that he "had glimpsed a profoundly unhappy man," and "found it hard to fathom why" a vice president, who might someday become president, "should appear so desolate and so alone."

To Adlai Stevenson, one of Nixon's principal 1950s political opponents, the man's character registered clearly on his politics: "Nixonland—a land of slander and scare, of sly innuendo, of a poison pen, the anonymous phone call, and hustling, pushing, shoving—the land of smash and grab and anything to win." For Garry Wills, Nixon was "a brooding Irish puritan. And a lonely man." Not the qualities one would

normally expect in a president, but then "Lincoln was even more melancholy, and downright neurotic," Wills believes. "I'm an introvert in an extrovert profession," Nixon said of himself.

Like Nixon, who obviously puzzled over his success in a profession seemingly little suited to his temperament, his biographers will always wonder about Nixon's career choice and how someone with limited affinity for small talk and so little personal charm could have run so often and so successfully for high office. In an age when personality had replaced character as the ostensible measuring rod for political advance, Nixon seems to have defied the odds.

His considerable intelligence, knowledge of American history, and ability to measure the current state of the nation were certainly attributes that served his career. But so did his work ethic and tireless efforts during the forty-two years he campaigned for everything from high school student body president to chief executive of the United States. Circumstance may have schooled him in the need to work hard: At the age of fifteen, he was responsible for buying and setting out vegetables at his parents' grocery. He would begin work at 4 A.M., driving twelve miles to a Los Angeles market, where he could purchase the best and cheapest produce.

More was in play here than the need to ensure the success of the family store. Richard saw hard work as the means to make something of himself—to get beyond his parents' cloistered world and break the chains that bound them to a life of relative drudgery in a small town. More than that, work seemed the best way to raise his self-esteem—to give him a sense of accomplishment and importance, to make him feel worthwhile, valued, and admired, even loved.

Involvement in productive activities became a mainstay of his life, but not just schoolwork, which as a teenager occupied his afternoons, nights, and weekends. In high school, he also devoted himself to acting, debate, football, and school governance. He attended to all these commitments as if his existence depended on it. In college, the pace became even more frenetic. "I won my share of scholarships, and of speaking and debating prizes in school," he said later about his four years at Whittier, "not because I was smarter but because I worked longer and harder than some of my gifted colleagues." In addition to the constant attention to his classes, which earned him second place in a class of eighty-five Whit-

tier graduates, he played football and basketball, ran track, joined the debate team, acted in theater productions, participated in campus politics, and helped organize and lead a men's society, the Orthogonians.

In law school at Duke, he displayed a "single-minded, often fierce diligence" he believed required to keep pace with his forty-three classmates, many of whom came from more prestigious institutions than Whittier. During his first year, when he confided to a third-year student his concern that he could not compete effectively against his better prepared colleagues, the older student, who observed him at the library seven days and five nights a week, advised him not "to worry. You have what it takes to learn the law—an iron butt."

Although intelligence and high energy were essential elements in Nixon's rise to political power, they were not enough to explain his extraordinary success. A visceral feel for what voters wanted to hear—expressions of shared values—also brilliantly served his political ambition.

Between 1946 and 1972, when he ran for high office seven times, the issues were no longer principally about the economic security of the middle- and workingclass voters he had to win over; years after the Depression, amid a booming economy, fears of economic problems and job loss were diminished concerns. Instead, public debate focused on the Communist threat. Below the surface was a concern with what the historian Richard Hofstadter called status politics. As in the progressive era at the start of the twentieth century, when politics revolved less around ensuring national prosperity than restoring "morality" to civic life, politics after 1945 centered on "status anxieties" and "status resentments . . . issues of religion, morals, personal style, and culture." It was not the politics of who got what but of insistence on deference—the anger of ordinary citizens toward elites, the most privileged members of society who impressed less sophisticated, conventional-thinking folks as disrespectful of their standards. As Hofstadter stated it, these Americans "believe that their prestige in the community, even indeed their self-esteem, depends on having their values honored in public."

Dick Nixon's early life is a textbook example of status strivings. When he was a young man growing up in the 1920s and 1930s in Southern California, a developing region removed from the country's power centers in the Northeast and Middle West, the recent migrants to the area were ambitious not only for economic success but also for recognition

as valued members of American society. The status concerns of Nixon's contemporaries in Yorba Linda and Whittier reinforced the intense desire for personal recognition of a boy from an unexceptional lower-middle-class family whose ownership of a grocery and a gas station gave it limited status in the community. A cousin remembered how Dick's work at the store embarrassed him: "He didn't want anybody to see him go get vegetables, so he got up real early and then got back real quick," she said. "And he didn't like to wait on people in the store."

In college, Richard gave clear expression to his status concerns when he took a central part in creating and advancing the Orthogonians. Although he quickly established himself as someone of importance on campus by being elected president of his freshman class, the unwillingness of the Franklins, the leading campus men's society, to offer him membership incensed him. When another new student responded to the same slight by proposing the organization of a competing society, Dick was so eager to help that the group made him its first president. The Orthogonians distinguished themselves from the Franklins, who were notable for their elitism, by emphasizing the square shooting unpretentious qualities of student athletes, its principal members. "They were the haves and we were the have-nots," Nixon said later of the two groups. But others remember that the Orthogonians quickly took on the pretensions of the Franklins, asserting political influence, setting social standards, and excluding most of the college's athletes and everyone else from its ranks.

Nixon later rationalized the snobbery of arrivistes by making a distinction between inherited and earned exclusivity. Reflecting on the status strivings of young people, he said, "What starts the process really are laughs and slights and snubs when you are a kid. Sometimes it's because you're poor or Irish or Jewish or Catholic or ugly or simply that you are skinny. But if you are reasonably intelligent and if your anger is deep enough and strong enough, you learn that you can change those attitudes by excellence, personal gut performance, while those who have everything are sitting on their fat butts." During a 1968 interview, asked if he had a special affinity for Theodore Roosevelt, Nixon replied: " 'I guess I'm like him in one way only: I like to be in the arena. I have seen those who have nothing to do—I could be one of them if I wanted—the people just lying around at Palm Beach. Nothing could be more pitiful.' His voice," Garry Wills said, "had contempt in it, not pity."

A winning campaign for student body president at the end of his junior year, in the spring of 1933, was his first schooling in the use of status politics. Although a Quaker, whose strict religious upbringing forbade dancing, Richard made a fuller campus social life, including monthly dance parties, his platform. The proposal appealed to a student majority which, unlike members of the elite campus societies, lacked a sense of belonging or involvement in the college. Although he raised other issues during the campaign, "the promise of dance parties on campus," Roger Morris wrote, "inexpensive and open to all students, continued to be his main appeal.... The dance issue also pitted the less affluent, non-organization students who lived at home against the wealthier dormitory residents." After he won, his student opponent said, "He knew what issue to use to get support . . . He's a real smart politician."

When Richard began at Duke Law School in September 1934, it was with a sense of exhilaration that he was entering a larger world in which he could achieve big things. But his law degree in 1937 did not immediately satisfy his yearning for greater distinction. Although he would hold third place in his graduating class, he could not land a job at either of the two prestigious New York law firms to which he applied. The rejections, especially alongside of the fact that one classmate with lower grades received a position at another desirable New York firm, left him feeling "bitterly defeated." He returned to Whittier, where he spent weeks in "a petulant, stubborn pout." Invitations from a local firm to discuss a position went unanswered for over a month. When he finally accepted an appointment with Wingert and Bewley, he wrote Duke's law school dean, "I've convinced myself that it is right." Nixon felt humiliated by having to take a job in a local Whittier law firm rather than in a more prestigious one in a major metropolis. But the "defeat," as Nixon saw it, strengthened his determination to make something more of himself than a small-town lawyer.

During his first two years at Wingert and Bewley, where he became a partner in 1939, Nixon's strivings began to find an outlet in local politics, especially a campaign to win a Republican nomination for an assembly seat, which collapsed when the incumbent decided to run again. In October 1941, sixteen months after he had married Patricia Ryan, a secondary-school teacher of commercial subjects, he accepted a job at the Office of Price Administration in Washington, D.C. The Nixons

saw the job as a way to escape Whittier for a more interesting life in the capital. They also hoped Dick might contribute something to America's nonbelligerent war effort against Hitler. Pat, whose ambitions, as with so many other middle-class women at that time, were entirely invested in her husband's career, was more than happy to move anyplace that might broaden Dick's opportunities.

In August 1942, with the United States now in the fighting after Pearl Harbor, Richard joined the Navy. He became a lieutenant commander and served in the southwest Pacific in the Combat Air Transport Command arranging supply shipments from island to island and the removal of wounded troops. After returning to the States in July 1944 and completing his Navy service over the next fourteen months in Washington, Philadelphia, New York, and Baltimore overseeing Navy contract terminations, Dick accepted an invitation from a college classmate and local Republican leader, who saw him as a representative figure in California's Twelfth Congressional District and a combative fellow willing to do political battle, to run for the area's House seat. Nixon's intelligence, competitive drive, skills as a debater, and commitment to conservative shibboleths convinced the district's Republican committee that he would make a strong candidate against Jerry Voorhis, a five-term New Deal Democrat.

Nixon's campaign was a combination of old-fashioned sleazy politics and high-minded rhetoric appealing to the ideals of a wide array of voters. In an era when political leaders like Franklin Roosevelt and Winston Churchill inspired young men to reach for high office, Nixon could imagine himself doing great things for his country and even the world. Yet the give and take of local politics for a House seat did not encourage Nixon's idealistic side.

The premium was on winning by fair means and foul. And the need to outspend an entrenched opponent came first. Nixon's backers spent more than three times what Voorhis did. The thousands of dollars poured into the campaign came in significant part from big oil, which was eager to beat a liberal who had joined President Harry Truman in opposing a tidelands bill permitting offshore drilling. Former president Herbert Hoover saw Voorhis as emblematic of the Democratic party's big-government philosophy. He put his not inconsiderable support behind someone who promised to become an opponent of everything

Voorhis stood for. The twelfth district's newspapers gave Nixon another big advantage. He held a monopoly on editorial support for his candidacy. Local businesses backed him with billboard ads all over the district; Voorhis had none.

Nixon also gained an edge over Voorhis by besting him in a series of five debates and spending more time in the district wooing voters. Voorhis did not match Nixon's fastidiousness about seeing constituents; he assumed that his ten years of service to the district made renewed contacts with voters superfluous.

Yet neither the money nor the backing of old-line conservative Republicans, nor Nixon's forensic skills and hard work, however considerable, were enough to ensure him the decisive 57 percent majority he won in November 1946. His appeal rested primarily on a message of shared principles with the district's voters, who were increasingly concerned about the Communist threat to America's way of life. Communism's antagonism to all organized religions, commitment to state planning, and suppression of freedoms, especially to enjoy the fruits of a free enterprise system in which twelfth-district voters were prospering, made any candidate even vaguely identified with such an outlook more than suspect.

Nixon's campaign was much less about what he would do in Congress than an effective assault on Voorhis's reliability as an anti-Communist defender of American institutions and traditions. As Nixon told his campaign manager after being nominated, "We definitely should not come out on issues too early. . . . We thereby avoid giving Voorhis anything to shoot at."

Instead, the objective was to reflect the country's and district's growing fear of communism. At a time when the Soviets were asserting their dominance over Eastern Europe and a civil war in China threatened a Communist takeover of a former ally, a handful of New Dealers remained sympathetic to Moscow, despite its transparent abuse of democratic freedoms. "Radical" labor unions antagonized millions of middle-class citizens by disrupting the economy with work stoppages, and Americans were drawn to candidates promising to defeat the Communist threat at home and abroad.

Jerry Voorhis was a perfect target for an aspiring challenger like Nixon. A privileged American from a wealthy family who had earned a Yale degree, been a youthful member of the Socialist party, and supported

every major New Deal program since his election in 1936, including its close alliance with the American Federation of Labor and the Congress of Industrial Organizations, Voorhis was an exemplar of what Republicans trying to unseat Democrats were aiming at in the 1946 elections. Nixon attacked Voorhis in their first debate as the candidate of the CIO's political action committee, which the *Los Angeles Times* speculated was under Communist influence. Although Voorhis denied Nixon's charges of his ties to the CIO-PAC, the smear stuck. It persuaded Nixon that false accusations against political opponents for weakness in response to communism or insufficient commitment to "American values" was an irresistible means to defeat them.

Nixon's speeches during the campaign echoed the theme of standing up for America against the ideas that Jerry Voorhis supported. "The Republican party must again take a stand for freedom," Nixon declared in a Lincoln day address. The Democrats have "led us far on the road to socialism and communism." In August, he "welcome[d] the opposition of the PAC, with its communist principles and its huge [labor union] slush fund." At their first debate in September, Nixon supporters handed out a two-page "fact sheet" stating that Voorhis "votes straight down the line for the SOCIALIZATION OF OUR COUNTRY." A few days later, Nixon warned a rally against those in office "who would destroy our constitutional principles through the socialization of American free institutions. These are people who front for un-American elements, wittingly or otherwise." Nixon predicted that his opponents would "deprive the people of liberty." He intended to "return the government to the people."

Pro-Nixon newspapers denounced Voorhis as casting "pro-Russian votes" and votes against "measures the communists vigorously oppose." One newspaper ad for Nixon described Voorhis as "a former registered Socialist" with a "voting record in Congress more Socialistic and Communistic than Democratic." During the last month of the campaign, Nixon repeatedly warned against "extreme left-wingers . . . boring from within, striving . . . to bring about the socialization of America's basic institutions." He saw radicals in government set upon giving "the American people a communist form of government."

The day before the election, newspapers urged a "vote against New Deal communism. Vote Republican. Vote American!" The campaign

generated exceptional enthusiasm from Nixon's backers who felt themselves part of a crusade to save America. As one of Nixon's businessmen supporters put it, "Roosevelt's era was fading. All of the various government agencies that had been created were having their problems and the government . . . was flailing in the air." The historian David Greenberg concludes that Nixon won "because he had aligned himself with the people and Voorhis with the federal bureaucracy."

Because Nixon later had a reputation as "tricky Dick," a man constantly reinventing himself to serve the political moment, biographers have wondered what, at any given time, did he really believe? "Nixon watchers have long debated whether the candidate's man-of-the-people self-portrait was genuine or a cynical contrivance," Greenberg says of the 1946 campaign. "To his critics, who didn't emerge as an identifiable bloc until some years later, Nixon's presentation was thoroughly phony, a guise assumed by a lackey of oilmen and fat cats. His defenders have argued otherwise, seeking to show that his advocates were not plutocrats but 'small-business men' or 'entrepreneurs.' "

It is conceivable, and indeed likely, that Nixon, with his eagerness to win and genuine idealism infused in him by his moralistic Quaker mother, was both an opportunist exaggerating Voorhis's affinity for radicalism and an honest reflector of the district's ethics. As has been the case with so many other American politicians throughout the country's history, candidates for low and high offices have rationalized cutting corners with self-assurances that opponents genuinely posed a threat to the national well-being and that political hyperbole and insincerity are commonplace devices for winning office.

For the ambitious Richard Nixon, his performance in the 1946 campaign was not all that different from what other successful political candidates challenging incumbents for House seats did that year. Nixon knew that his campaign rhetoric was hyperbolic and that he was encouraging current irrational fears about the Communist threat in the United States. "Of course I knew Jerry Voorhis was not a communist," Nixon said later, "[but] I had to win." At the same time, however, he had genuine concerns about the danger to American institutions from Communist subversion. And so he justified his campaign as an expression of democracy—a reflection of what he and a majority of Southern California voters believed were essential for the country's future.

Nevertheless, his eagerness to win a House seat was more at the center of his overstatements than any genuine fear that Voorhis's return to the House would seriously jeopardize the national well-being. He comforted himself with the rationalization that becoming a profile in political courage could come later.

As a congressman between 1947 and 1950, he seized several opportunities to act boldly on behalf of larger national purposes. The first of these came in 1947 when he was chosen to serve on a House Select Committee on Foreign Aid. Although Republican leaders in the twelfth district warned him against "an unworkable" and inflationary foreign aid policy, Nixon felt compelled to rise above such partisanship to back the Truman administration's Marshall Plan for reconstructing Western Europe. A visit to the Balkans to assess Communist dangers convinced him that the United States had no choice but to supply the economic wherewithal to combat Moscow's political assault on the West. It was the beginning of his schooling in matters he believed essential to the country's national security.

At the same time, a House proposal to rein in labor union excesses seemed like an opportunity not only to serve the country's domestic well-being but also to give him instant visibility as a potential political star. "I was elected to smash the labor bosses and my one principle is to accept no dictation from the CIO-PAC," Nixon declared melodramatically upon entering Congress. He promptly took a prominent place among supporters of the controversial anti-Union Taft-Hartley legislation that became law over Truman's veto.

But it was his role in the Alger Hiss case that brought him national fame on a grand scale. A former high state department official under suspicion as a Soviet agent, Hiss and his alleged record of wrongdoing impressed Nixon as a chance to educate the public about the Communist danger in the United States. The case also struck him as an irresistible chance to assert himself against someone who seemed like a perfect stand-in for all those self-important people who he believed looked down on him, and to advance his political career by making headlines in a high-profile spy case.

In his 1962 book, *Six Crises*, Nixon explained that going after Hiss meant "opposing the President of the United States and the majority of press corps opinion, which is so important to the career of anyone in

elective office." His "stand, which was based on my own opinion and judgment, placed me more or less in the corner of a former Communist functionary [Whitaker Chambers, who was Hiss's principal accuser] and against one of the brightest, most respected young men following a public career. Yet I could not go against my own conscience and my conscience told me that, in this case, the rather unsavory-looking Chambers was telling the truth and the honest-looking Hiss was lying."

In insisting on the need for an investigation of Hiss, Nixon saw the stakes for the House Un-American Activities Committee (HUAC), on which he was serving, and more important, the nation, as terribly high. The principal object of such an investigation was, as Nixon remembered Woodrow Wilson's view, "to inform the public on great national and international issues. . . . More important by far than the fate of the Committee," Nixon concluded, "was the national interest."

Aside from assumptions about serving the country, Nixon took satisfaction from the thought of bringing down Hiss and vindicating Chambers. Hiss, with his degrees from Johns Hopkins and Harvard and credentials as a lawyer associated with Justices Oliver Wendell Holmes and Felix Frankfurter, two of the country's most distinguished jurists, was everything Nixon envied and longed to be, but could only attain vicariously by eclipsing Hiss.

Nixon's personal antagonism to Hiss expressed itself in a memo to a journalist describing Hiss as "rather insolent toward me . . . and from that time my suspicion concerning him continued to grow." Nixon later described Hiss as "too suave, too smooth, and too self-confident to be an entirely trustworthy witness." Robert Stripling, HUAC's chief investigator, believed that Nixon's eagerness to expose Hiss as a spy was "a personal thing." Stripling concluded that after Hiss said to Nixon, "I graduated from Harvard, I heard your school was Whittier," Nixon was determined to get him.

Political ambition, of course, was also at work. In promoting the Hiss investigation in the summer of 1948, Nixon may have felt some trepidation at taking on the President of the United States, who had called HUAC's probe of Hiss a "red herring," but he also knew that it was a relatively easy way to generate substantial personal publicity. If he could show up the president by proving Hiss a liar, or better yet, a secret Soviet agent, it would make him an overnight political star. And even if

he couldn't make any charges stick against Hiss, it would still give Richard Nixon a degree of national visibility that would be the envy of more senior congressmen.

The more Nixon became identified with the case, however, the more he saw it as essential to demonstrate Hiss's guilt—as a liar and a perjurer, if not a spy. During the investigation, when Nixon believed he had nailed Hiss, he told the press that he had "conclusive proof of the greatest treason conspiracy in the nation's history . . . proof that cannot be denied [and] puncturing the myth of the 'red herring' President Truman had created." When the reliability of this "proof" came under temporary suspicion and it appeared that Chambers would be discredited and Hiss exonerated, Nixon exploded: "Oh, my God, this is the end of my political career! My whole career is ruined." But of course it wasn't, and with Hiss's conviction as a perjurer, Nixon gained everything he hoped for—personal notoriety and the humiliation of someone considered his better.

Nixon's success in the Hiss case made him a viable candidate for a U.S. Senate seat from California in 1950. (Hiss was convicted in January 1950 of lying about stealing state department documents and contacts with Chambers. The statute of limitations had expired on espionage charges.) After the Republicans lost control of the House in the Truman victory over New York Governor Tom Dewey in 1948, Nixon bristled at the thought of being " 'a comer with no place to go.' " He didn't want to be part of "a vocal but ineffective minority." Like John F. Kennedy, who found membership in the House too narrow a venue for his ambitions, Nixon was eager for greater political influence. When it appeared that Sheridan Downey, the incumbent Democrat, would not run because of health problems and that the Democrats would make Congresswoman Helen Gahagan Douglas the nominee, Nixon entered the Senate race.

Douglas impressed him as more beatable than Downey or almost any other Democrat who might run that year. A beautiful former stage and movie actress and wife of movie star Melvyn Douglas, Mrs. Douglas was, like Voorhis, a down-the-line liberal Democrat with ties to Eleanor Roosevelt and Hollywood celebrities known for their leftist politics. She was also the offspring of an elite New York family and a privileged woman who had attended private East Coast schools and gained enough public notoriety to make her a three-term member of Congress. Her

superior social standing made her all the more appealing to Nixon as an opponent he would take special pleasure in defeating.

But what made her vulnerable in a 1950 statewide race was her seeming casualness about the Communist threat. She had voted against funding HUAC, declared on the floor of the House in 1946, "Mr. Speaker, I think we all know that communism is no real threat to the democratic institutions of this country," and in 1947, opposed the Truman Doctrine aiding Greece and Turkey as likely to prop up undemocratic regimes and undermine the United Nations by substituting American power for collective security. Although she deplored the Soviet system as "the cruelest, most barbaric autocracy in world history" and saw no place for communism in America, she had opened herself to charges of being insufficiently concerned about the Soviet menace and, perhaps worse, of being more sympathetic to Moscow's brand of politics and governance than she let on.

Douglas failed to realize how much worldwide Communist gains had frightened the great majority of Americans. Soviet control of Eastern Europe, a Communist coup in Czechoslovakia, a Soviet blockade of West Berlin, the vulnerability of an economically unstable Western Europe to Communist subversion, allegations about spy rings in Canada and the United States, Moscow's detonation of an atomic bomb, Communist control of China, Wisconsin Senator Joseph McCarthy's assertions about subversives in the State Department, and a North Korean attack on the South convinced millions of Americans that the United States was locked in a life-and-death struggle with radicals at home and abroad intent on destroying the American way of life.

Douglas was also unprepared for how ruthless Nixon might be in attacking her ideas, party, and loyalty to American political and economic traditions. He declared the election a contest between "freedom and state socialism." He characterized the Democrats as "a group of ruthless, cynical seekers-after-power" who had committed themselves "to policies and principles which are completely foreign to" the country and their party.

The assault on Douglas was, if anything, even more overstated. Nixon identified her with New York Representative Vito Marcantonio, "an admitted friend of the Communist Party," labeled her an appeaser of hostile forces, issued over five hundred thousand copies of a "pink sheet," detailing her shared votes in the House with Marcantonio, "the notorious

Communist party-liner," and labeled her "the pink lady," who was "pink down to her underwear," a pejorative image that sunk her campaign. The challenge, Nixon declared throughout the election, was preserving American institutions against alien ideas and influences. Hundreds of billboards across the state described Nixon as "On Guard for America."

Although House Speaker Sam Rayburn warned Douglas about Nixon, describing him as a man with "the most devious face of all those who have served in Congress in all the years I've been here," she later acknowledged that she had "failed to take his attacks seriously enough." She dismissed the pink sheet as "ridiculous, absolutely absurd." And when she responded to Nixon's charges, it was an ineffective attempt to identify him with Hitler and Stalin, who, she asserted, had also gained power by using "the Big Lie."

Nixon won by a landslide, 59 percent to 40 percent, the largest victory margin in any 1950 U.S. Senate race. His success had almost nothing to do with interest politics or the economic well-being of Californians. In fact, there was hardly a mention of how occupants of the state would personally gain from Nixon's election. To be sure, big oil and agribusiness as well as wealthy banking, realty, brokerage, construction, and chemical executives saw Nixon as more likely to serve their interests than Douglas and the Democrats. But the great majority of voters never showed any sustained concern with how the election would affect their jobs or the state's economic future. Everywhere Nixon spoke in the state, he told a campaign manager, he was asked about communism and Hiss. "There's no use trying to talk about anything else," Nixon said, "because it's all the people want to hear about."

Nixon's appeal rested on his ability to reflect voter fears and principles. He described himself as determined to "resist the socialization of free American institutions . . . [to] take a clear, aggressive stand against communist infiltration . . . [and to] place national security above partisanship in foreign policy." Mrs. Douglas and the Democrats could call their program a "Fair Deal or social welfare," Nixon said. "It's still the same old socialist baloney any way you slice it."

Nixon repeatedly said, "I have been advised not to talk about communism, but I'm going to tell the people of California the truth." No one in Nixon's campaign was urging him to mute the Red threat. But saying so, suggested that he was fearless in taking on forces that might person-

ally punish him. He described the great issue in the campaign as "whether the American system of government can be maintained." He explained that American Communists had been "given a virtual blueprint for revolution" that included plans, as reported in the press, "to contaminate food supplies, wreck trains, seize arsenals and cities . . . sabotage defense plants, and deprive major industrial cities of lights, power, and gas." His campaign ads announced, "If you want to work for Uncle Sam instead of slave for Uncle Joe, vote for Dick Nixon. Don't be left, be right, with Nixon. Don't vote the Red ticket, vote the Red, White, and Blue ticket. Be an American, vote for Nixon."

Nixon would later acknowledge that his campaign was regrettable. "I'm sorry about that episode," he told a publisher in 1957, "I was a very young man." But his later regrets for what one biographer described as "the most notorious, controversial campaign in American political history" was no doubt tied to hopes of portraying himself as more moderate in a coming presidential contest. Although the 1950 election would permanently fix him in the minds of millions of Americans as "Tricky Dick," the campaign would also school him in the importance of foreign relations and stimulate an interest in finding realistic responses to national security threats. Nixon entirely agreed when President John F. Kennedy rhetorically asked him in 1961, "It really is true that foreign affairs is the only important issue for a President to handle, isn't it? I mean, who gives a shit if the minimum wage is $1.15 or $1.25, in comparison to something like" the failed invasion of Cuba at the Bay of Pigs? Kennedy added.

Less than two years after entering the Senate, in 1953, Nixon became Dwight Eisenhower's vice presidential running mate. Eager to appease the conservative wing of the Republican party, which had hoped to make Senator Robert Taft of Ohio the nominee, Ike gave the nod to the party's poster boy for anticommunism at home and abroad. Nixon's preconvention support of Eisenhower over Taft and Governor Earl Warren, his fellow Californian, demonstrated Nixon's consistent talent for sensing the country's political direction, which saw Eisenhower's military credentials as highly appealing in the intensifying Cold War.

Nixon began the campaign by reiterating his conservative credentials. After a leading party conservative refused to second Nixon's nomination because of the party's treatment of Taft, Nixon used his vice-

presidential acceptance speech to strongly praise Taft. The warmth of his language touched off a demonstration for "Mr. Republican" that embarrassed Eisenhower's supporters. When the Taft demonstration subsided, Nixon underscored his conservative credentials by predicting that the party's success in the coming election would depend on convincing voters that the Republicans would be more effective than the Democrats in "destroying the forces of communism at home and abroad." It was a restatement of the "Americanism" issue that had carried Nixon so far so quickly in national politics.

Nixon intended to make his defense of American institutions against Communist dangers the centerpiece of his vice-presidential campaign. Eisenhower shared Nixon's conviction that this was not only essential for national security but also good electoral politics. As president, Ike declared, he would "get out of the governmental offices . . . people who have been weak enough to embrace communism."

But allegations beginning in mid-September 1952 that wealthy supporters had set up a secret fund to allow Nixon's family to live lavishly beyond his senator's salary distracted the public from his anti-Communist appeal. Columnist Drew Pearson's assertion that Nixon's aides threatened to attack him as a Communist if he publicized the fund story helped make the charges against Nixon an irresistible issue. The press reported that the inches of newspaper columns discussing Nixon's fund "now exceeded those for both Eisenhower and [Adlai] Stevenson [the Democratic candidate] throughout the country."

Believing that the accusations could jeopardize Eisenhower's candidacy, Ike's aides pressured Nixon to leave the ticket or at the very least defend himself before a national television audience. Eisenhower himself urged Nixon to "tell them [the public] everything there is tell, everything you can remember since the day you entered public life. Tell them about any money you have ever received." Because the charges of corruption were unmerited (the fund consisted of only $18,000 that had been reported as legitimate campaign contributions) and because Nixon had no intention of stepping down and giving up his long-term political ambitions, he agreed to offer a public defense of himself. Angered and frustrated by what he saw as an unwarranted attack on his integrity, Nixon initially responded that the charges against him were Communist-inspired. After deciding that he would have to meet the

accusations head-on, he privately criticized Eisenhower for refusing to take a stand in his defense. "After the television program," he told Ike, "if you think I should stay on or get off, I think you should say so either way. There comes a time in matters like these when you have to shit or get off the pot!"

On September 23, from the El Capitan Theatre near the corner of Hollywood and Vine in Los Angeles, Nixon spoke to sixty million Americans, the largest TV audience to that point in the nation's history. The setting for the speech was an invented den with an armchair and a desk against a backdrop of "a bookcase with wooden prop books with painted titles, one of them captioned *Roosevelt Letters*." A journalist reported, "The spectacle was stage managed by Hollywood soap opera experts."

Nixon's speech was a masterpiece of political showmanship that appealed to millions of Americans. The address was especially effective in reaching out to voters who had never seen or heard Nixon before. A youthful-looking thirty-nine-year-old with dark hair and plain features, distinguished by what cartoonists portrayed as a "ski-slope" nose, Nixon seemed like an ordinary American. Speaking from an outline, his speech came across as an unrehearsed spontaneous explanation. His apparent openness and sincerity seemed to belie complaints that he was an untrustworthy, even ruthless politician dubbed "Tricky Dick."

He began his talk by acknowledging that his "honesty and integrity" were in question. The charges were "a smear" that he would refute by telling "the truth." There was no "secret fund," the $18,000 was strictly for "political expenses that I did not think should be charged to the taxpayers of the United States." Moreover, "no contributor to any of my campaigns has ever received any consideration that he would not have received as an ordinary constituent." Nor had he ever had his wife on his office payroll as other elected officials had. The fund was for expenses essential to exposing the Truman administration's communism and corruption.

Mindful that it was insufficient to explain the fund's legitimacy, Nixon provided "a complete financial history; everything I've earned; everything I've spent; everything I owe." Recounting his family's modest circumstances, he provided a detailed accounting of his and Pat's assets and debts. "Every dime we have is honestly ours," he assured his audience. "Pat doesn't have a mink coat," he added. "But she does have a respectable cloth coat. And I always tell her that she'd look good in any-

thing." To demonstrate his qualities as a loving family man, he described how a man in Texas sent his two little girls a cocker spaniel. Tricia, the six-year-old, had named him Checkers. "And you know the kids love the dog and I just want to say this right now, that regardless of what they say about it, we're gonna keep it."

Nixon was determined to use the speech not only to defend himself but also to gain an edge in the campaign. He drew comparisons between Adlai Stevenson's privileged social position as the inheritor of a family fortune and his emergence from "modest means." Quoting Lincoln, "God must have loved the common people—he made so many of them," Nixon suggested that Honest Abe would have been on his side.

Nixon's performance stirred strong viewer emotions. To those who were already Nixon antagonists, the speech was at a minimum "tasteless" and "histrionic." *New Yorker* columnist Richard Rovere complained that Nixon's language formed a striking contradiction with his Quaker faith: "It would be hard to think of anything more wildly at variance with the spirit of the Society of Friends," Rovere wrote, "than his appeal for the pity and sympathy of his countrymen . . . on the ground that his wife didn't own a mink coat." To most Nixon critics, the speech was "a sort of comic and demeaning public striptease that cast Nixon forever as a vulgar political trickster who would disclose the most intimate private details and stoop even to exploiting his wife and his children's dog to grub votes."

Most of the response, however, was decidedly positive. Of the approximately four million written and telephoned messages, favorable reactions outran negative ones by a seventy-five to one margin. The reaction was less to the substantive issue of personal corruption or to the campaign issues of communism and Korea than to the man himself. A scholar who studied the messages concluded that Nixon "had succeeded in projecting an image of himself to which they [writers and callers] could respond. . . . As a man who shared their own feelings, thought as they thought, and valued what they valued . . . a reflection of themselves, and in their responses they seemed to say 'We trust him; we believe in him because he is one of us.'"

Nixon's defense of his financial history and his appeal to American egalitarianism put him back in Eisenhower's good graces and secured his place on the ticket. But his humiliation at having to defend his integrity

intensified the "partisan zeal and harshness" that were the hallmarks of his past political campaigns. In speech after speech, he described Adlai Stevenson and the Democrats as "spineless" dupes taken in by Communist trickery. "Nothing would please the Kremlin more" than a Stevenson presidency, Nixon declared. The Democratic candidate held "a Ph.D. degree from [Secretary of State Dean] Acheson's College of Cowardly Communist Containment." In appealing to the cranky, frightened, paranoid side of the American character, Nixon provoked counterattacks that intensified his own feelings of persecution and made him all the more inclined to see opponents as agents of sinister forces out to destroy him.

Nixon's eight years as vice president were in part a continuation of his unrestrained rhetoric about political foes. During the 1954 midterm elections, with congressional control at stake, he pummeled the Democrats for losing China, causing the Korean War, and jeopardizing Indochina. He also claimed that Eisenhower's election in 1952 saved the country from a Democratic "blueprint for socializing America." Everything from medicine to housing and atomic energy was supposed to come under state control. Nixon's "ill-will campaign," Stevenson said, was "McCarthyism in a white collar," associating Nixon with Wisconsin Senator Joseph McCarthy's reckless indifference to the truth in pursuit of political advantage.

The most memorable moments in Nixon's vice presidential term came in the spring of 1958 when he visited Latin America, and in the summer of 1959 when he debated Soviet Premier Nikita Khrushchev in an American model kitchen at an exhibition in Moscow. The climax of the eighteen-day tour of South America occurred in Caracas, Venezuela, where Nixon was mobbed, spat on, stoned, and almost killed. He portrayed the attacks as a "firsthand demonstration of the ruthlessness, fanaticism and determination of the enemy we face in the world struggle." After this, Nixon believed, no one could describe Latin American Communists as "merely 'harmless radicals.'" They were not nationalists with justifiable grievances against their respective governments but tools of the "international Communist conspiracy."

The Caracas confrontation had substantial political benefits: millions of Americans rallied behind their vice president and boosted his chances of becoming Eisenhower's White House successor. (Lyndon Johnson, the Democratic Senate majority leader, who had described Nixon to a

reporter as nothing but "chicken shit," led a crowd of dignitaries welcoming Nixon back to Washington. "In politics," Johnson now told the journalist, "overnight, chicken shit can turn to chicken salad.")

Nixon's political stock, however, took a sharp tumble in November 1958 when big Democratic gains in the House and the Senate defeated his high-profile campaign to restore Republican control of Congress. The upturn in his approval ratings after the Caracas episode seemed only temporary.

But his confrontation with Khrushchev gave renewed luster to his public standing. A fierce argument with Khrushchev—the "kitchen debate"—over the virtues of their respective economic and political systems, including finger-poking exchanges before TV cameras, once again showed Nixon as a devoted spokesman for American values. A televised address to the Russian people, in which Nixon extolled the superiority of the American way of life, "was designed to make everyone wish he or she had been born in the U.S.A." Quoting statistics about home, auto, TV, and radio ownership in the United States, Nixon implicitly emphasized the superior standard of living produced by a free-enterprise system. But more important than the material benefits of capitalism, he said, were the freedoms Americans enjoyed—of speech, religion, press, and movement within and outside the United States.

At the height of the Cold War competition with Soviet communism, a contest millions of Americans feared might end in disaster, Nixon gave the country fresh hope that it would come out on top, and, not incidentally, renewed the conviction that Richard Nixon might be the best public official to secure the victory.

Nixon viewed his vice presidency as preparing him for a presidential campaign and the presidency. It was a difficult challenge. Vice presidents traditionally played a distinctly minor role in both domestic and foreign affairs. There's nothing to be said about the vice presidency, Woodrow Wilson declared, and after you've said that, there's nothing more to say. Eisenhower echoed the point during the 1960 campaign when he answered a query about Nixon's involvement in a major administration decision by asking for a week to come up with an example.

Nixon understood that he would not be able to rely on past campaign strategies to win the White House. Eight years of Republican rule foreclosed renewed attacks against Democrats for failing national secu-

rity tests. Moreover, a Democratic opponent might effectively match appeals to national standards that Nixon had used so successfully in the past. Consequently, he aimed to establish himself as a statesman with unmatched foreign policy credentials in a time of continuing overseas dangers. He used the vice presidency to school himself in the major challenges the United States seemed certain to face in Europe, Asia, Latin America, and the Middle East. He took six high-visibility trips abroad, traveling nearly 160,000 miles to fifty-eight countries and four U.S. possessions.

But more than a strategy for the 1960 campaign shaped Nixon's focus on foreign affairs during his vice presidency. He believed himself temperamentally best suited to making foreign policy. Becoming a successful executive legislator, as Lyndon Johnson would prove to be as president, was nothing Nixon relished. He did not find the give and take with congressmen and senators very appealing. Instead, he preferred to fix his attention on foreign affairs, where "he could engage his *intelligence* more than his *personality*" and enjoy greater freedom to assert leadership.

BETWEEN 1960 AND 1964, however, Nixon seemed to lose his political magic: whether because his personal failings as a slash-and-burn politician had alienated some voters or because he was out of sync with the current public mood, he suffered the first major electoral defeats in his career and had to temporarily sit on his ambition for the White House.

Since unrelenting effort had been a mainstay of his earlier victories, Nixon planned to work harder in the 1960 presidential contest than ever before. But a jam-packed schedule, including a pledge to campaign in all fifty states, proved to be a serious mistake. Instead of appearing relaxed and vibrant, his Herculean exertions made him seem exhausted and unprepared to bring fresh energy to the presidency. One adviser accurately warned him that it would be a fatal error to project less than a "relaxed, confident, fresh and unwearied" image, which was exactly what his Democratic opponent, the youthful Massachusetts Senator John F. Kennedy, was doing.

Because nonstop campaigning combined with a two-week hospital stay for an infected knee left him thin and pale, Nixon came across as scrawny, listless, and far less presidential than Kennedy, during an initial television debate. ("My, God!" Chicago's Mayor Richard Daley quipped.

"They've embalmed him before he even died.") Nixon's exhaustion registered on aides during a motorcade through Iowa, where he was sick with flu and small crowds at crossroads in farm communities frustrated him. Losing self-control on the drive between towns, Nixon, like an enraged child, began kicking the driver's seat in front of him until the car stopped and his fellow passengers could calm him down.

Nixon hoped to use the Eisenhower foreign policy record to make his case for the presidency. But the "missile gap," allegedly favoring the Soviet Union, and the rise of a hostile pro-Communist government in Cuba made it difficult for Nixon to take the high ground in arguing his superior credentials as a foreign policy leader. Nixon found it hard to play the anti-Communist card that had served him so well in past campaigns. Instead, he emphasized his superior executive experience to Kennedy's and his greater knowledge of the crucial foreign policy challenges that would face the nation over the next four years.

But Nixon's rhetoric lacked the sort of bite that had previously made him successful. The columnist Joseph Alsop, who had been a Nixon admirer, called his speeches "a steady diet of pap and soothing syrup," more like a TV commercial than a statement of how he would actually lead the country. Imitating Nixon's earlier use of anticommunism, Kennedy emphasized not only Moscow's apparent advantage in missile technology but the Eisenhower-Nixon failure to support the Hungarian revolution or prevent expanded Communist influence in Tibet, Laos, Guinea, Ghana, and Cuba.

Unlike the campaigns against Voorhis, Douglas, and Stevenson, in which Nixon could present himself as an aspiring middle American battling elitists, he could not draw a similar contrast to Kennedy. True, Nixon had known poverty as a youngster, and Kennedy, the son of one of America's richest men, was more privileged than any other opponent Nixon had ever faced. But as a senator, Kennedy stood lower in the political pecking order than Vice President Nixon, and as a Catholic representing an underrepresented minority, Kennedy was more the man on the make than Nixon. Moreover, Nixon's identification with the Republican party and Kennedy's with the Democrats allowed JFK to declare the election a contest "between the comfortable and the concerned."

Nixon's defeat by a scant 118,000 popular votes and a controversy

over whether Illinois and Texas were lost because of ballot-box stuffing gave Nixon hope that he could win the White House after a second Kennedy term, which Nixon believed JFK would get. So he returned to California, where he could run for governor in 1962 and position himself for a possible race in 1968, when he would still be only fifty-five years old. Yet he knew that the odds of defeating incumbent Governor Edmund G. (Pat) Brown were not especially good. It would not be like 1950, when he could win a Senate seat with little discussion of California's issues, which Nixon freely acknowledged in private he had little acquaintance with or interest in mastering. Moreover, having presided over the state's growing prosperity, Brown enjoyed the backing of a solid majority, who shared his outlook and party politics.

Nevertheless, Nixon decided to run. The appeal of another campaign with a chance to vindicate his loss in 1960 and position himself for another presidential bid was too attractive to ignore. His whole life had been given over to politics and he could not sit on the sidelines for seven years before running again.

He might have improved his chances of a political comeback by running for a congressional office. But winning a House or Senate seat would have been a retreat into the past, a repeat of what he had done before. The governorship of the country's second-largest state would mean breaking new ground—a chance to perform executive duties as a prelude to being president.

But more like 1960 than in any of his earlier campaigns, it was difficult to find the traction to make him a winner. Right-wing Republicans led by John Birch Society members co-opted anticommunism in the campaign; nor could Nixon outdo Brown as someone more in tune with voter concerns than the affable, homey governor. In addition, Nixon could not shake the public conviction that his chief interest in the governorship was as a stepping-stone to the presidency. When the Cuban Missile Crisis focused attention on Kennedy's success in October, it partly rubbed off on Brown and other Democrats and ensured that Nixon lost by close to three hundred thousand votes out of six million.

Angered and frustrated by another defeat and smarting over what he saw as the hostility of a liberal press to his candidacy, Nixon used a post-election press conference to lambaste his tormentors. "As I leave you," he said, "I want you to know—just think how much you're going

to be missing. You won't have Nixon to kick around any more, because, gentlemen, this is my last press conference."

But of course it wasn't. Like Lyndon Johnson, who would sink into a depression after being compelled to give up the presidency in 1968, Nixon's life was bound up with politics. As he acknowledged in his memoirs, "there was no other life for me but politics and public service. Even when my legal work [which he performed with a New York firm between 1963 and 1968] was at its most interesting I never found it truly fulfilling. I told some friends at this time that if all I had was my legal work, I would be mentally dead in two years and physically dead in four."

During his time in New York, he consulted Dr. Arnold Hutschnecker, who, according to the *New York Times*, "for many years served as Richard Nixon's psychotherapist." Hutschnecker could at times be indiscreet about his relationship with Nixon. During the sixties, Hutschnecker boasted to an analyst in training that he was treating the former vice president who, Hutschnecker related, complained that he was nobody, that he felt empty. When he looked in the mirror each morning, it was as if there were nobody there. The analyst who related the discussion with Hutschnecker to me explained that Nixon's unquenchable ambition was a product of his drive for a sense of self or to create a persona. It was Hutschnecker's opinion that Nixon "didn't have a serious psychiatric diagnosis," although he had "a good portion of neurotic symptoms," including "anxiety and sleeplessness."

WITHIN HOURS of his setback in California, Nixon was already planning another presidential campaign. Though he would later claim that it was fate alone that brought him back into the political arena, his biographer Stephen Ambrose said that "from the beginning of 1963 to the spring of 1968, his actions could not have been better calculated to put him in sight of the [presidential] nomination." His 1962 press conference, with criticism of Kennedy's handling of the Cuban crisis and an attack on the press, his two principal political enemies, Democrats and liberal journalists, was a tip-off that he was running again. Nixon "had known no other life since 1946, and wanted no other, short of occupying the ultimate seat of power itself," Ambrose added. Nixon also knew that "his fate rested to a large degree on chance, accident, and luck . . . but . . . the point was to be ready to seize opportunities."

And so he spent the next five years cultivating Republican leaders in every part of the country. After eight years as vice president and five more maintaining party contacts, he knew every important GOP leader in America. Circumstances and political calculation now came together to propel him toward another nomination. To gain the prize, Nixon stood aside in 1964 while Barry Goldwater, an ultraconservative, led the party into a disastrous defeat against a majority left-center coalition backing LBJ. Nixon shrewdly anticipated that strong support for Goldwater would allow him to become the party's unifier after so great a failure. "This he would accomplish," a journalist predicted in the summer of 1964, "by persuasion, by conferences, by speech-making, by traveling and by writing, without seeking interim public office as he did, regrettably, two years ago in California." A big Republican victory in the 1966 congressional elections, for which Nixon, who campaigned tirelessly, received considerable credit also reestablished him at the head of the party.

But preparing to win the nomination was only step one. If he was to be elected, he needed to design a political strategy that could bring a majority of voters to his side. As with the nomination, he knew that this would partly depend on unpredictable and uncontrollable circumstances. But even if these were in his favor, he would still need a compelling appeal.

The vehicle for selling himself to the country was his mastery of foreign affairs. As the Johnson administration expanded the war in Vietnam, first with a sustained bombing campaign beginning in March 1965 and then with the introduction of combat troops in July, Nixon foresaw that overseas events would eclipse LBJ's Great Society as the central issue in the next campaign. The commitment of over five hundred thousand troops by 1968 in what was rapidly becoming the greatest foreign policy disaster in the country's history vindicated Nixon's judgment about what would count most in the coming election.

His use of world politics was a satisfying marriage of personal interest and political expediency. Between 1963 and 1968, Nixon traveled abroad constantly, ostensibly for corporations, which paid his way, but chiefly to promote his public image as a world statesman. Six trips to Europe, four to Asia, two to the Middle East, and one to Africa, where he met most of the world's important government officials and political

leaders, expanded his understanding of international problems. But it also allowed him to command considerable press attention and make headlines in the United States.

Nixon did not formally decide to run until the beginning of 1968. True, he had been working toward this for five years, but the prospect of another possible defeat was painful for him to contemplate and made him hesitant about entering another campaign. In December 1967, he had to convince himself that running was a good idea. In a revealing note, he declared he "did not want to be President in order to *be* someone. . . . 'I don't give a damn,' " he said defensively. But politics was the only way he had ever been "someone," and though the risks of permanently losing that identity were considerable, he could not give up a last chance to reach his life's goal. "I have decided to go," he told his family in January 1968. "I have decided to run again."

~ *Chapter 2* ~

KISSINGER

*Deep down one could never be certain that what one
found so disturbing in Nixon might not also be a reflec-
tion of some suppressed flaw within oneself.*

—HENRY KISSINGER, *Years of Renewal*

*He is a European and he has a view of the world that a
born American could not have.*

—RALPH BLUMENFELD, *Henry Kissinger: The Private and Public Story*

Like Nixon's, Kissinger's reach for influence and deference took root
in a tumultuous childhood. Kissinger himself would not subscribe
to such an assertion. "It is fashionable now to explain everything psy-
choanalytically," he told an interviewer in 1971, "but let me tell you,
the political persecutions of my childhood are not what control my life."
And yet so much of what one learns about the man—his intense concern
with converting people to his viewpoint or making "people understand
him . . . his eagerness to be regarded as, and accepted as, an American,"
speaks forcefully about his inner life. One later associate said that Henry
"is not always sure he'll be accepted. He doesn't really believe anybody
likes him."

Such observations about Kissinger hardly represent the sum total of his psychology. But they provide clues to his compulsions to be the best and win universal acclaim, which are evident in everything he did. It is not unreasonable to suggest that for Kissinger, like Nixon, politics was a form of vocational therapy. There is nothing unique about this; most politicians are drawn to public life by the personal satisfaction of fame and adulation: some of the greatest men and women in history have struggled with inner demons that motivated their ambitions. Personal aspirations, however, can make for problems when they are incompatible with ethical public standards; it is usually the latter that suffer. The careers of both Nixon and Kissinger reflect the extent to which great accomplishments and public wrongdoing can spring from inner lives.

KISSINGER OR HEINZ, as he was called in his youth, grew up in a solidly middle-class Bavarian Orthodox Jewish family in the city of Furth. Louis Kissinger, his father, was a schoolmaster in state schools, which gave him high standing in German society. Paula Stern, Heinz's mother, came from a well-to-do family that had gained prominence as cattle traders. As the Kissingers and Sterns knew, however, Bavarian Jews were subjected to periodic bouts of repression and abuse. Their hometown had sprung up in the fourteenth century when Nuremberg officials had barred Jews from living in that city.

As a boy in the 1920s and early 1930s, Heinz, who was born in May 1923, was not spared the sting of rejection by his countrymen. Smarting from the pain of defeat in World War I, they celebrated Germany's Teutonic roots at the expense of the country's most vulnerable minority. Anti-Semitism barred Heinz from entrance to the *Gymnasium*, the public high school, which he was well qualified to attend. He was also denied the right to join his city's soccer team or even attend their matches. He had to satisfy his passion for the sport by playing on Jewish club teams. He bolstered his self-esteem by an intuitive understanding that he enjoyed a superior intellect to most of the "Aryans" persecuting Jews.

The rise to power of Hitler and the Nazis in 1933 made life especially difficult for Germany's Jewish minority, including the Kissingers, who cherished their national identity. Louis Kissinger was driven from his cherished job in the city of Furth's state school; it was a humiliation he never forgot. Yet Heinz later denied that his life in Furth left "any last-

ing impressions. I can't remember any interesting or amusing moments. That part of my childhood is *not* a key to anything. I was not consciously unhappy. I was not so acutely aware of what was going on. For children, these things are not that serious."

But one longtime acquaintance of Kissinger's told a biographer: "Imagine the horror of life in Nazi Germany, imagine seeing a father whom one has loved and revered, being made to give up a job, being humiliated. And all this, when one is young and defenseless, and so impressionable." And, the friend might have added, Heinz was no longer a child but a teenager with all those volatile feelings about his place in the world—who am I, what do others think of me, will I be able to make anything of myself?

In August 1938, when Heinz was fifteen, the Kissingers, anticipating additional Nazi abuse of Jews, fled Germany for America, where they had relatives in New York. The parting was traumatic. The family could take only a single trunk of possessions with them. Louis had to leave behind his precious books—a part of himself. As they boarded a ship for London, Heinz, refusing to acknowledge his loss of German identity, defiantly told a German customs inspector, "I'll be back someday."

In America, where his family settled in the Washington Heights district, on the Upper West Side of Manhattan, an area that became known as the "Fourth Reich," Heinz developed a dual identity. On one hand, his objective was to embrace the habits of his new country. He quickly learned the rules of American baseball, for example, by attending games at Yankee Stadium and rooting for the country's most storied major league team. He also attended closely to his studies at George Washington High School and then at New York's City College, where he laid plans to enter America's celebrated business world as an accountant. "For a refugee, it was the easiest profession to get into," he said later, and the easiest way to assimilate, he might have added. At the same time, he made a break from the orthodoxy of his parents by becoming a member of a Jewish Reform youth group. Despite their shared German backgrounds, the young immigrants devoted themselves to speaking English and educating themselves about America.

Unlike many of his friends, however, Heinz also clung to his German roots. Most of his contemporaries signaled their Americanization by losing the distinctive Bavarian accents that revealed their parents' origins;

but not Heinz. It was part of his German identity, which he wished to maintain. It also liberated him from feeling too dependent on the approval of native-born Americans, many of whom looked down on recent unassimilated immigrants.

Yet whatever Heinz's impulse to maintain his German identity, circumstances compelled his fuller integration into American life. In 1943, at the height of American involvement in the Second World War, and before Kissinger turned twenty, the U.S. Army drafted him and assigned him to Camp Croft in Spartanburg, South Carolina, for basic training. It was "the greening of a greenhorn," two biographers wrote. He left the cloistered German-Jewish community in New York and became part of a larger America he had not known before. Heinz now became Henry. He was summarily made a naturalized U.S. citizen and a private first class in a "melting pot platoon" that turned "cosmopolitan aliens into acculturated American citizens." He served with middle-class young men from the South and the Midwest. "I found that I liked these people very much," Kissinger said. "The significant thing about the army is that it made me feel like an American." It "made the melting pot melt faster," another immigrant recruit said.

Ironically, Kissinger's army service also strengthened his German identity. An IQ test demonstrating his exceptional intelligence persuaded commanders to assign him to a program at Lafayette College in Pennsylvania, where he could be trained as an engineer, a skill the military expected to call upon in the future. In April 1944, however, as U.S. forces prepared the invasion of Europe and the need for combat troops eclipsed all other priorities, Kissinger was reassigned to the Eighty-fourth Infantry Division in Camp Claiborne, Louisiana. But his German origins and intelligence continued to set him apart from the general population of American-born troops. In addition to field maneuvers, forced marches, and target practice, the twenty-one-year-old Kissinger, despite his age and limited higher education, was directed to serve as his company's education officer, lecturing the men on Nazi Germany and the reasons for U.S. participation in the war.

During his time in Camp Claiborne, Kissinger met Fritz Kraemer, another German émigré, who would deepen Henry's impulses to see himself as a transplanted German. The two men had strikingly different backgrounds: the thirty-five-year-old Kraemer had grown up in a

Wiesbaden Protestant family who enjoyed inherited wealth, had earned a Ph.D. at the University of Frankfurt in law and another in politics at the University of Rome, and was a caricature of an authoritarian Prussian aristocrat replete with a monocle and swagger stick. The two men, however, had more in common than their different religious and class backgrounds might suggest. They shared an affinity for the German language, which they comfortably spoke together, German history and philosophy, which they saw as antagonistic to Nazism, and the need to restore Germany to its great cultural roots.

Their initial encounter occurred on a Camp Claiborne rifle range, where Kraemer lectured Kissinger's company from the back of a Jeep on the reasons the United States had to defeat Hitler. Impressed with Kraemer's forceful talk and authoritative manner, Kissinger sent him a flattering note, which partly revealed Henry's intellectual self-confidence and eagerness to find a larger role for himself than being just another foot soldier: "I heard you speak yesterday. This is how it should be done. Can I help you somehow?" Kraemer, who undoubtedly enjoyed the thought of having an acolyte, responded by seeking out Henry, discussing past and current events with him, and recommending that this young man, whom Kraemer saw as having "a sixth sense of musicality—historical musicality—" become the German translator for the division's general.

It was the beginning of a long-term friendship in which Kraemer tutored Kissinger about Europe's greatest modern thinkers. "He would squeeze me for my ideas the way one would squeeze a sponge," Kraemer said later. "He hankered for knowledge, for truth. He wanted to know everything."

Kraemer was also an example to Henry of someone who shaped his own destiny. Unlike Kissinger's fellow Jews, who had been forced to leave Germany, Kraemer's moral revulsion for Hitler and the Nazis had made him decide to flee. It was a demonstration to Kissinger that individuals could rise above historical circumstances to shape their own destinies: that the advent of a viciously anti-Semitic regime in Germany would not permanently divorce him from his homeland or consign him to obscurity in a foreign country.

As important, Kraemer helped arrange jobs for Henry that strengthened his self-confidence and added to feelings that he was not just a naturalized American but a German and, more broadly, a European with

a keen feel for international affairs. Entering Europe in November 1944, five months after the D-Day invasion, Kissinger served first as General Alexander Bolling's translator, and then, as the war was ending, as the administrator of Krefeld, a city of two hundred thousand on the Rhine River in Westphalia, where he helped to reestablish civic order.

His success brought a promotion to sergeant in the Counter-Intelligence Corps assigned to find and arrest Nazis, and Gestapo or secret police officials in particular, as part of the Allies' de-Nazification program. His effectiveness in performing his duties led to his command of a counterintelligence unit responsible for the larger Bergstrasse district in the state of Hesse. Stationed in Bensheim, to the south of Frankfurt, Kissinger described himself to the local citizenry as Mr. Henry rather than Mr. Kissinger lest he stir opposition to himself as a displaced German Jew intent on revenge. As the local commander, Kissinger "became about as German as he could be," speaking German, living in a confiscated villa, cohabiting with the widow of a young German nobleman killed in the war, and attending local sporting events.

In May 1946, Kissinger received an honorable discharge from the Army but stayed on in Germany for almost a year as an instructor in the European Command Intelligence School in Bavaria near his native Furth. He taught majors and colonels about "the structure of the Nazi state," explaining how to detect Nazis, implement de-Nazification, and promote democracy. Though still without a college degree and only an ex-sergeant, he made a strong impression as a lecturer who effectively educated his student-officers. "He was short on the podium," one member of his class recalls, "but easy to listen to. He had a well-modulated voice and a very good style. He kept his voice down. It was very soothing." Though a sumptuous salary of $10,000 made it attractive for him to continue teaching at the school, his interest in an academic career drew him back to the States to complete his education and become a university teacher of history, politics, and international relations.

He hoped that university training would expand and deepen what his wartime experience had already taught him about human behavior. A brief test of courage in the winter of 1944–1945 and his postwar encounters with concentration camp survivors showed him that no one ever knows just how he would react in perilous moments, and that making moral judgments about people faced with threats to their survival is

presumptuous. With his division forced to retreat from a Belgian town during the Battle of the Bulge, Kissinger volunteered to be part of a rearguard action that could have meant his death or capture. He never thought of himself as "brave," he said later, but rather as someone responding to immediate pressures in the midst of combat.

The survivors of Nazi extermination camps were, Kissinger wrote to the relative of a former inmate, people who were "possessed of extraordinary powers, both psychic and of will, to even want to survive. The intellectuals, the idealists, the men of high morals had no chance. . . . Having once made up one's mind to survive, it was a necessity to follow through with a singleness of purpose, inconceivable to you sheltered people in the States. Such singleness of purpose broached no stopping in front of accepted sets of values, it had to disregard ordinary standards of morality. One could only survive through lies, tricks and by somehow acquiring food to feed one's belly. The weak, the old had no chance." Although it was an odd conflating of survival with ambition, it was a lesson Kissinger found useful in much of his later work as a policy maker. When faced by "ruthless adversaries," he viewed refined rules of the game as a deterrent to success.

Kissinger learned at least four other lessons from camp survivors. Impulses to dwell on past horrors would produce sorrow and self-pity, which were forms of "weakness" that were "synonymous with death." Second, those most likely to lead successful future lives would be people who "applied themselves to the peace with the same singleness of purpose and sometimes the same disregard of accepted standards as they had learned in the camp[s]." Third, the victims of Hitler's persecution became sensibly suspicious of human nature and human behavior. Like them, Kissinger distrusted the good intentions of others, always assuming that given half a chance a competitor would take advantage of any show of weakness. Last, Henry shared with some survivors doubts about the value of religious faith. He stopped attending Sabbath services and seemed to be asking, "How could a benevolent God have allowed such horrors against his worshippers?" People, he believed, did better to rely on themselves than on some unknowable superior authority.

In September 1947, Kissinger, following Kraemer's advice to attend an elite college, won admission to Harvard as a sophomore on the G.I. Bill of Rights and a New York state scholarship. Although most of his class-

mates, who were also veterans in their twenties, studied hard and enjoyed the variety of extracurricular activities Harvard offered, the twenty-four-year-old Henry was all business. He showed no interest in the university's athletic competitions, social clubs, student parties, or the campus Hillel. Aside from occasional visits to New York to see Ann Fleischer, his old girlfriend from Washington Heights and a member of the Reform Jewish group he socialized with in high school, Henry worked twelve-, fourteen-, and sixteen-hour days at his studies.

His two roommates in Claverly Hall, the oldest, most run-down dormitory on campus, were also Jewish veterans. Despite the university's conviction that putting Jews together would be more comfortable for them and their gentile classmates, Henry kept his roommates at a distance, revealing little about his personal life. They never discussed religion; he never told them he had a younger brother; and they barely knew he had a girlfriend in New York. He preferred "a discussion that was not personal but dealt rather with political, historical or other academic questions," one of them remembered. And when he said anything that could be interpreted as a statement of personal identity, it was at odds with what one would have expected from a victim of Hitler's persecution. He objected strongly to a state of Israel, saying it would antagonize the Arabs and jeopardize America's Middle East interests. "I thought it was a strange view for someone who'd been a refugee from Nazi Germany," one roommate recalled. "I got the impression that Kissinger suffered less anti-Semitism in his youth than I did as a kid in New Jersey," another dormitory resident remarked.

Another classmate remembered Kissinger as "secretive, very serious" and without charm. "He sat in that overstuffed chair—the kind Harvard rooms were full of—studying from morning till night and biting his nails to the quick, till there was blood." Yet another contemporary described him as "Thin, bony," bespectacled, and poorly dressed in "the same clothes all the time for two years." Henry impressed this student as someone "already playing the part of the German scholar."

Henry's intelligence and diligence put him in the top rank of his class. Unlike most of his classmates, who had junior faculty or graduate teaching assistants assigned to tutor them, Henry's academic standing gave him access to a senior professor and a chance to make an impression on a faculty member who could help him enter a graduate pro-

gram leading to some kind of public service job. Initially majoring in philosophy and government with an interest in practical uses for the knowledge he was now acquiring, Henry chose William Y. Elliott as his mentor. Recognized as the most powerful member of the Government department along with Carl Friedrich, the fifty-two-year-old Elliott was in some respects a model of what Henry aspired to be. "I am interested in the practical politics of international relations, and you are interested in philosophy and scholarship," Kissinger told Friedrich, signaling a decision to become a Government major intent on the useful application of his learning.

Elliott was a larger-than-life figure—both physically and temperamentally—who staged cockfights in the basement of his residence and enjoyed being called "Wild Bill." A native of Tennessee, Elliott had won distinction as an all-American football player at Vanderbilt. He was a memorable character, with the attributes of a Southern politician who would have been as comfortable in Washington's corridors of power as in the halls of academe. He wore his service in the Office of War Mobilization during World War II as a badge of honor, and encouraged Kissinger and other students to see dual careers in government and the academy as noble ambitions.

Henry had to prove himself to Elliott, who greeted him coolly at their first meeting. "Oh God, another tutee," he exclaimed after making Kissinger stand awkwardly in front of his desk for a bit while he attended to some business. Elliott instructed him to read twenty-five books on Immanuel Kant and write a paper comparing his critiques of pure and practical reason. Henry surprised the professor by reading all the books and completing a paper in three months that dazzled Elliott. "I want you to meet this fellow Henry Kissinger, who is a combination of Kant and Spinoza," Elliott told another tutee. "If we put together his profundity with your elegance of style, we'll really have something." Elliott wrote to the Phi Beta Kappa selection committee: "I have not had any students in the past five years, even among the summa cum laude group, who have had the depth and philosophical insight shown by Mr. Kissinger." But Elliott also noted Henry's limits: "His mind lacks grace and is Teutonic in its systematic thoroughness."

It was the beginning of a relationship that served their mutual purposes. Henry became a reliable assistant who helped Elliott grade papers,

research professional journal articles, and prepare papers to be presented at scholarly meetings. And Elliott supported scholarship applications that freed Henry from having to work off-campus to pay his way through school. As important, Elliott became Kissinger's senior thesis adviser and directed his work on what was an essential prelude to graduate study.

As with everything else, the thesis set Henry apart from all the many brilliant Harvard undergraduates then and before who had written senior papers. A 377-page treatise on "The Meaning of History: Reflections on Spengler, Toynbee and Kant," the thesis was the longest ever written by an undergraduate. So long, in fact, that Friedrich refused to read more than 150 pages and the Government department introduced a rule limiting such papers to 40,000 words. Marred by turgid prose and convoluted arguments, the thesis nevertheless helped make Henry summa cum laude in his 1950 graduating class and a member of Phi Beta Kappa.

Despite its flaws, the paper was an impressive achievement for a man in his twenties, asking questions not just about the meaning of history but also about man's existence. It was, in historian Stephen Graubard's view, "a kind of personal statement," an existential assertion of the individual's responsibility for his fate despite unmanageable historical crosscurrents. "Is man doomed to struggle without certainty and live without assurance?" Kissinger asked. "In a sense that is so. Man cannot achieve a guarantee for his conduct. No technical solutions to the dilemmas of life are at hand. That is the fatedness of existence. But it also poses a challenge, an evocation of the sense of responsibility to give one's own meaning to one's life. . . . The experience of freedom enables us to rise beyond the suffering of the past and the frustrations of history."

In brief, Henry had no intention of letting the horrors of his past and the world's recent history make him cynical about leading a life of constructive activity. His grandiosity, which was evident in so outsized a thesis—both as a topic and a finished product—would be a valuable aid in advancing him toward personal success in a postwar America alive with opportunity for so bright and ambitious a young man.

What had partly allowed him to write so substantial a paper in his senior year was comfortable domestic conditions resulting from his marriage in February 1949 to Ann Fleischer. The "fat, dumpyish, pale, and sickish" Kissinger, as one colleague described him, was no doubt grateful that an attractive woman with "a Lana Turner figure," as some described

Ann, agreed to marry him. Temperamentally they seemed like a good fit. Both were essentially lapsed German Jews with a shared sense of traditional values. Ann was a perfect hausfrau: she worked as a bookkeeper to help put Henry through school while simultaneously providing him with a well-ordered household. Although she would type his manuscripts in her spare time, she had few academic interests and contributed little, if anything, to Henry's scholarship. And though they would have two children—a daughter born in 1959 and a son in 1961—they grew apart during a fifteen-year marriage.

As his career progressed and he became more focused on his professional life, he excluded Ann from even a token part in his intellectual pursuits. A study he had built over a garage attached to their house in Belmont Hill, a Cambridge suburb, became a sanctuary from which she was excluded. A Harvard associate recalls a social hour with Henry in his study having a drink when Henry ordered Ann, who had joined them, "to get out—he didn't want her there." Later in the 1950s, when they lived in New York and he was working on a book, he instructed her not to speak to him unless invited to. She might "interrupt his train of thought." In response, "she dutifully slid trays of snacks inside the door of his study as he wrote." Henry, who later described himself as "miserable in a marriage for most of my life," agreed to a separation in 1962 and a divorce in 1964. He referred to his marriage as a form of emotional "blackmail," suggesting that he had entered into and remained in the marriage less out of love than a sense of obligation.

As he completed his bachelor's degree in 1950, Henry struggled with vocational questions. His undergraduate performance at Harvard had demonstrated his capacity for advanced study. But becoming an academic seemed a little too tame or uninteresting. Like Elliott, he wanted a part in shaping public policy, particularly international relations. He thought about studying abroad as a prelude to earning a graduate degree and possibly "entering government service."

Elliott convinced him, however, to enter the Government Ph.D. program at Harvard and to become the executive director of a University Summer International Seminar. It was a measure of how well Elliott thought of him that he was willing to make Henry such an offer even before he had proved himself in his graduate studies. The program would not only help pay Henry's way through graduate school but also allow

him to interact with young—under forty—promising academics, public servants, and journalists from Europe, Asia, Africa, Latin America, and the Middle East. The idea appealed to the Ford and Rockefeller Foundations and the CIA, all of which provided generous financial support, as a way to counter anti-American Communist and left-wing propaganda by showing future leaders who had never visited the United States the virtues of American society.

Henry made the most of the opportunity. He consulted widely with campus notables about whom to invite, paid some of the university's leading lights and other prominent Americans to lecture and lead seminar discussions, and established ties with participants that would serve both U.S. and his long-term personal interests. During its seventeen-year history, 1952–1969, nearly seven hundred distinguished foreigners spent six summer weeks in Cambridge educating themselves about American culture and politics. Henry became acquainted with French President Valéry Giscard d'Estaing, Belgian's Prime Minister Leo Tindemans, Japanese Premier Yasuhiro Nakasone, Turkish Premier Bülent Ecevit, Israel Knesset member and cabinet official Yigal Allon, Bruno DeChamps, political editor at the *Frankfurter Allgemeine,* and a host of American notables, including Eleanor Roosevelt, *New York Times* columnist James Reston, conservative journalist William F. Buckley, Jr., Automobile Workers Union president Walter Reuther, General James Gavin, sociologist David Riesman, and historian Arthur Schlesinger, Jr.

The seminar gave Henry a part in promoting America's international image. But it also gave him an opportunity to establish relationships that might serve him in the future. Some at Harvard believed that Kissinger was primarily intent on advancing himself. "Henry collected a repertoire of people," one colleague said. "I don't think it was altruism." A seminar assistant, however, did not see Kissinger as primarily self-serving: "He is obviously a man with a great deal of foresight and calculation. But I'd be surprised if anybody could lay out his life to that degree." No doubt, Henry hoped that interacting with so many emerging stars abroad would be to his future advantage. But the seminar also presented him with an intrinsic challenge that was irresistible for a graduate student intent on making his mark in the larger world. How could he persuade thoughtful foreigners from so many different backgrounds that America was worthy of their admiration? He believed that the realities of American life, and

in particular the workshop in democratic debate they would find in the seminar and the country more generally, would exert a positive influence on them.

If the seminar made most participants feel better about the United States and well disposed toward Henry, not all of them were won over. One young English woman, a journalist intent on being a correspondent in the United States for a London newspaper, was impervious to Kissinger's instruction. Sensing her hostility, Henry asked her in front of a graduate student and seminar assistant, "Why don't you like me?" She replied: "Because you're a fascist." Henry was dumbfounded: "A fascist? Why, I participated in the invasion of Belgium," he exclaimed. "Really," she shot back, "with which army?"

However useful the battle for "hearts and minds" was, as some described the contest with communism in the 1950s and 1960s, it impressed Kissinger as secondary to forging an effective national security strategy. Henry's ambition may have included the cultivation of important people at home and abroad, but he was more concerned with writing a doctoral thesis, and ultimately a book, that could help ensure America's defense against Communist advance. Although his choice of a dissertation topic—"A World Restored: Metternich, Castlereagh and the Problems of Peace, 1812–1822"—hardly seemed calculated to address current dangers, in fact it aimed at just that. Kissinger, Stephen Graubard says, had no interest in filling a void in the academic literature about Metternich or Castlereagh. Instead, he was responding to contemporary threats to the peace. "In theory," Graubard explained, "Kissinger was writing about problems that confronted European statesmen early in the nineteenth century; in fact, he was probing the nature of the international system of the mid-twentieth century."

Kissinger saw parallels between Metternich's time and his own. In 1812, a struggle between Napoleon's France intent upon revolutionary change in Europe and Austrian-British interest in preserving the status quo, paralleled the contest between Soviet determination to protect its security by exporting communism and Western commitments to preserving democratic states. Kissinger saw a fundamental lesson in the European peace fashioned by Metternich: revolutionary states like Napoleonic France and Soviet Russia could not be accommodated by moralistic appeals or idealistic crusades. Only a reliance on balance-of-power

diplomacy could defend the interests of nations hoping to preserve an existing world order. In time, however, Kissinger would accept the proposition that once revolutionary states gained enough of "a stake in the legitimacy of the international order," they could be persuaded to give up destabilizing attacks on the system.

Nevertheless, Kissinger never changed his mind about the primacy of order over justice or abstract moral good. What if a revolutionary state were in pursuit of a just cause and a status quo nation were serving unjust goals? a colleague asked Kissinger. "If I had to choose between justice and disorder, on the one hand," Kissinger replied, "and injustice and order, on the other, I would always choose the latter." It was an article of faith that would later lead him into a number of questionable and, in the eyes of some critics, indefensible actions. Despite a dearth of primary research, the dissertation was accepted as a fine piece of analysis, which earned Henry his Ph.D. in 1954 and a contract with Houghton Mifflin, which published his book in 1957.

Among several lessons that Kissinger learned from his study of Metternich and Castlereagh was one that resonated personally and became a standard by which he intended to proceed should he ever attain significant influence over American foreign policy. A nation's destiny was not strictly shaped by "external circumstance—geography, national character, resources, and the like," but the goals and choices statesmen set and made. "Those statesmen who have achieved final greatness did not do so through resignation," Kissinger wrote in *A World Restored*, but by having "the strength to contemplate chaos, there to find material for fresh creation." The successful statesman worked to "bridge the gap between a people's experience and his vision, between a nation's tradition and its future."

The originality of Kissinger's thesis was not enough in the mid-fifties to land him an immediate tenure-track appointment in Harvard's Government department. Harvard being Harvard, it reserved permanent positions for scholars with achievements that put them in the front rank of their specialties. Though the department saw fit to make Henry an "instructor," it was seen as premature to make any longer-term decision about his ties to the university. Besides, he was not all that popular with either junior or senior faculty members, a number of whom thought him "pompous." Dean of faculty McGeorge Bundy described him as

someone with "a certain Germanic cast of temperament which makes him not always an easy colleague." Some of his fellow graduate students, mindful of his tendency to court authority figures and treat lesser lights with disdain, called him "Henry Ass-Kissinger." But his intellectual fire power made him irresistible to have around in some role. "He was, in fact, almost as brilliant as he thought he was, so that made up for it," one fellow graduate student said.

In 1955, his brilliance and feel for what mattered most in current foreign policy debates began to make Kissinger a prominent figure in discussions about how best to ensure U.S. national security. The year after receiving his doctorate, he published an article in *Foreign Affairs*, the leading journal on U.S. foreign relations, about nuclear weapons and defense policy. He took issue with the Eisenhower administration's public avowals of "massive retaliation" as the best way to deter and, if need be, fight a war with the Soviet Union. Since Moscow was building a nuclear arsenal that could compete with America's, massive retaliation seemed unlikely to inhibit the Soviets from promoting communism in the Third World or encouraging insurgencies in what Kissinger called the "Gray Areas." The United States needed to adopt an alternative strategy of preparing to fight limited wars to ensure against Communist expansion.

Kissinger's article led to an offer from the Council on Foreign Relations in New York to direct a study group on how to integrate nuclear weapons into U.S. foreign policy. The council itself was an elitist "men's club" consisting exclusively of American citizens, most of whom lived in New York or Washington, D.C. Study group members were some of the nation's most prominent establishment figures, including State Department and Pentagon experts as well as David Rockefeller, a mainstay of the banking and business world. The invitation included a commitment to pay Henry to write a book on the ways in which the United States should rely on nuclear weapons to defend its security. Turning down teaching positions at the University of Chicago and the University of Pennsylvania and taking a leave from his Harvard instructorship, Henry seized the opportunity to discuss and write about a matter of unquestionable importance to the national well-being.

The challenge facing Kissinger and his colleagues was to figure out how the United States could fight a successful limited conflict (the Korean War seemed like a model of how not to do it) and the possible role

of nuclear weapons in any such military action. Would it be possible to fight a limited war without escalation into an all-out conflict? And would such a conflict exclude the use of nuclear weapons? Or would American military planners have to accept the likelihood that a limited war could include the use of tactical nuclear bombs?

Kissinger tried to answer these questions in a book, *Nuclear Weapons and Foreign Policy*, published in 1957. The volume was a dense treatise of over four hundred pages. "I don't know if Mr. Kissinger is a great writer," one reviewer said, "but anyone finishing his book is a great reader." Nevertheless, the book became an overnight best-seller. "I am sure that it is the most unread best-seller since [Arnold] Toynbee['s]" *History of the World*, Kissinger joked. But a seventy-thousand-copy sale, Book-of-the-Month-Club selection, and fourteen weeks on the *New York Times* best-seller list suggested that Kissinger was fulfilling some public need.

A concern that the United States was falling behind the Soviet Union in military strength made Kissinger's discussion of American defense policy especially timely. His book provided a refutation to Soviet boasts of increasing economic and technical superiority to the United States, or at least encouragement to the hope that the country could effectively meet a Soviet military challenge. In October 1957, Moscow's successful launching of a *Sputnik* rocket orbiting the earth gave its claims resonance and produced an outcry in the United States for a huge expansion of military spending. A government committee appointed by the Eisenhower administration to study the problem of U.S. defense declared it inadequate to meet the Soviet danger, cited a missile gap favoring Moscow, warned of America's possible defeat in a nuclear conflict, and even suggested launching a preventive war before Russia became too powerful.

Kissinger's book spoke to American fears of defeat. He counseled against illusions that American goodwill could avert war. Nor could the country rely on Eisenhower's massive retaliation policy as a long-term effective deterrent to the Soviet Union. Fears of a nuclear holocaust from an all-out conflict were making massive retaliation a questionable strategy. "A deterrent which one is afraid to implement when it is challenged ceases to be a deterrent," he wrote. The strategy of massive retaliation was more a prescription for paralysis than for meeting Moscow's likely efforts to subvert developing countries, bring them into the Soviet orbit, and demoralize America and its allies.

Kissinger's analysis challenged the conventional wisdom. Americans needed to think not in terms of all-out war provoked by Soviet aggression, but of more limited or local conflicts in peripheral areas. As important, defense planners needed to focus on limited wars in which the United States considered the possible use of tactical or battlefield nuclear weapons. Kissinger did not argue that every limited war would require the use of such powerful arms, but he urged planning for that possibility through "the graduated employment of force."

Critics of Kissinger's strategy saw no assurance that a limited nuclear conflict would remain limited. "If the limitations are really to stand up under the immense pressures of even a 'little' war," Paul Nitze, a prominent defense intellectual, argued in a critical review of the book, "it would seem something more is required than a Rube Goldberg chart of arbitrary limitations." Kissinger himself had serious doubts about keeping such a war within bounds. But his conviction that the United States desperately needed a coherent doctrine for meeting the dangers of the nuclear age persuaded him that a limited war strategy, including the use of tactical nuclear arms, should take primacy over unanswered questions about how it would all work.

Kissinger's ascent as a national security adviser actually preceded publication of his 1957 book. In 1955, he met Nelson Rockefeller, John D.'s son, who was serving as a special assistant to President Eisenhower for international affairs. During a June arms control conference at the Quantico Marine Base in Virginia, Henry "tremendously impressed" Nelson by his "broad," "conceptual" approach to national security issues. Specifically, Kissinger's contributions to an "Open Skies" inspection plan that might rein in the Soviet-American nuclear arms race persuaded Rockefeller to make him a paid consultant.

In 1956, after differences with Secretary of State John Foster Dulles had made Rockefeller decide to stop working as a special presidential assistant, he organized a Rockefeller Brothers Fund study of "American Prospects." He asked Kissinger to become the project's director. Part of Rockefeller's preparation for a gubernatorial bid in 1958 and a presidential campaign in 1960, the project excited Henry's hopes of becoming a White House adviser. At the same time he worked on the council book, Kissinger arranged meetings between Rockefeller and prominent national security policy academics, who were then asked to write papers. Henry

managed a staff of over one hundred, coordinated the study's several advisory groups, and wrote an opening chapter, "International Security: The Military Aspects," of *Prospects for America*. His chapter anticipated the general themes of his *Nuclear Weapons* book.

Between 1955 and 1957, the Rockefeller and council projects compelled Henry to work up to sixteen-hour days. Although still in his early thirties with a great appetite for work, the schedule exhausted him and touched off occasional outbursts at staff subordinates, academic colleagues, and Rockefeller aides guarding their boss from Henry's insistent demands for attention and approval. He was sensitive to any slight, however small. Academic consultants communicating with someone other than him in a Rockefeller advisory group provoked complaints of neglect.

"He was enormously sensitive, often had hurt feelings," Oscar Ruebhausen, a Rockefeller attorney, said later. "He suffered a great deal by taking things personally, simple things. Like whether a car met him at the airport . . . whether it was a Cadillac or not. He would weep on one's shoulders at some little slight . . . It was candor and Byzantine, Machiavellian scheming at the same time." Biographer Walter Isaacson says, "Kissinger was notoriously short-tempered with subordinates. His impatience could be withering: he would throw around words like idiots and morons."

Eventually, Kissinger learned to couch his complaints in what Ruebhausen called "self-deprecating humor," which "spared him the consequences of an enormous ego." Ruebhausen recounted the "Picasso story" to Ralph Blumenfeld, a Kissinger biographer: Kissinger "complained bitterly" to Rockefeller about having three speechwriters review an address he had drafted: "You tell Nelson," Henry said, "that if he had a Picasso, he wouldn't call in three housepainters to touch it up."

Kissinger's temper tantrums can be attributed to an inflated ego. His academic success at Harvard coupled with his ability to impress himself on so many influential people made him feel exceptional and deserving of special regard. But no one with genuine self-confidence would need to be as demanding as Kissinger was. His outbursts were childish pleas to be seen and heard as the favored son, the best among the brightest. It says something about Kissinger's talents as a foreign policy adviser that Rockefeller and the power brokers at the Council on Foreign Relations would

put up with his petulance. Of course, it was chiefly subordinates who bore the brunt of Kissinger's unpleasantness, and many of them took their leave after being exposed to Henry's dark side. He was never as abrasive with those who sat in judgment on him. Nevertheless, they were aware of how difficult he could be, but they granted him the sort of leeway people reserve for the temperamental artist demanding special consideration because of his special gifts.

Kissinger's ambition and insecurity made him eager to reduce the sort of commitments he had in New York during 1955–1957; he wanted to return to Harvard as a tenured professor. Working at the council and for Rockefeller offered no long-term security of the kind he could enjoy as an academic.

Yet despite the advantages of a permanent professorship that would free him to write, consult, and help shape thinking about national defense, Kissinger had a fiercely ambivalent relationship with the university. Offered a lectureship in Harvard's Government department beginning in September 1957 with an implicit promise of a tenure review in two years, Henry accepted with some reluctance. He saw the department as less than uniformly friendly to him and the conditions of his renewed appointment as less than perfect. He would need to become associate director of a new Center for International Affairs under Robert Bowie, a former Harvard law professor and chairman of the Eisenhower-Dulles State Department Policy Planning Council, but someone Kissinger did not hold in high regard. He would also be required to tutor undergraduates, some of whom wrote papers that needed considerable editing, and from whom Kissinger believed he would learn nothing; and he would have to spend time preparing lectures for an introductory course on "Principles of International Politics" and seminar meetings for a class on "Administrative and Policy Problems of the United States in the Field of Diplomacy."

The unwelcome obligations of the lectureship did not deter Kissinger from seeking a tenured Harvard professorship. Although he would achieve his goal in 1959, the two years preceding his promotion made him doubt whether the prize was worth it. His intellectual and personal differences with Bowie were a form of academic combat. They disagreed about the utility of massive retaliation and the wisdom of building a multilateral force (MLF) made up of nuclear-armed units from NATO.

The differences between them, however, were more personal than theoretical: Bowie did not feel that Kissinger, who in 1957 was preoccupied with publishing his *Nuclear Weapons* book and completing the Rockefeller project, was meeting his obligations to the center. Bowie and others saw him as "always . . . running, always late, and constantly harassed." Bowie also complained that Henry was a self-promoter who took personal advantage of center grants and gave precedence to his own writings over editing obligations on center publications. Kissinger reciprocated the animus, describing Bowie as a "malicious maniac," who had engaged him in "an insane rassle [sic]." They developed a mutual paranoia: Each of them feared that the phone system and secretaries they shared allowed for eavesdropping. By the spring of 1958, less than a year after becoming center colleagues, they were not speaking to each other.

Kissinger's teaching obligations proved to be as onerous as he'd feared. He saw his weekly meetings with tutees as a distraction from more satisfying intellectual activities. He struggled to keep up with preparations for the discussions of assigned readings tutorials required and found it impossible to see tutees on schedule, often holding abbreviated sessions with them. "The obligation to read badly written and badly conceived student essays, and to correct them for stylistic shortcomings, for faults in logic, reasoning and fact was never entirely satisfying," Graubard writes with some understatement.

Initially, Kissinger's lecture courses were also more of a burden than a source of gratification. In the 1950s, he never made a mark as a particularly interesting lecturer. But in time, he remedied this by giving his lectures a dramatic flair. "Instead of a planned program Kissinger would frequently start off with almost a press conference, especially if something unusual had just happened like the [May 1960] U-2 incident," a student recalled. The format allowed for questions and answers in which Kissinger encouraged an intellectual give and take that created a sense of student participation. The lectures were most successful when they became a form of personal performance, with Henry dropping names of famous people he knew and putting his considerable wit on display. "Kissinger is quite a sight as he struts back and forth across the lecture platform alternately praising Metternich, castigating Kennedy, and tossing laurel wreaths to Kissinger for Kissinger's solutions to the evils that

beset our mismanaged foreign policy," the student guide to course offer-
ings announced in 1963.

Although he was focused on winning tenure in 1957–1958, Kis-
singer was also attentive to Nelson Rockefeller's political fortunes. When
Rockefeller won the New York governorship in November 1958, it made
him a leading contender for the 1960 Republican presidential nomina-
tion. With the party suffering an "unprecedented and decisive" beating
in the 1958 congressional elections, Nixon, who had been the party's
most visible campaigner, was, in his own words, "tarred with the brush
of partisan defeat at a time when . . . Rockefeller [was] basking in the
glory of victory."

As a prelude to a presidential run in 1960, Rockefeller, in line with
Kissinger's thinking, publicly advocated increased defense spending to
counter the alleged Soviet-American missile gap. But Rockefeller was
too idealistic or too reluctant to do the necessary dirty work to win the
nomination. In 1960, he refused to enter the early primaries, mistakenly
assuming that he could sway the Republican convention with the force
of his ideas—a comprehensive program promising a better America and
a safer world.

Rockefeller was too much of an equivocator and too hesitant to prac-
tice what Kissinger later called "the politics of manipulation . . . the es-
sence of modern American Presidential politics." In 1960, Eisenhower
feared that if Nelson ever openly declared his candidacy, he "would be
called 'off again, on again, gone again, Finnegan.' " Because, Kissinger
said, Rockefeller would not "devote himself monomaniacally to the
nominating process," he was "pursuing a mirage." Although "Rockefeller
considered Nixon an opportunist without the vision and idealism needed
to shape the destiny of the nation," he could not bring himself to do the
required "demeaning" work to become the Republican nominee.

Nixon's victory over Rockefeller in the 1960 Republican nomination
fight and Kennedy's defeat of Nixon in November barred Kissinger from
a major foreign policy position in the new administration. But it did not
preclude an advisory role of some kind. Between 1955 and 1960 he had
published a dozen articles in *Daedalus, Foreign Affairs, The New Repub-
lic,* and *The Reporter* criticizing accepted wisdoms about U.S. national
security policy. At the beginning of 1961, moreover, he published the
Necessity for Choice: Prospects of American Foreign Policy with Harper &

Brothers, a major trade press, which reiterated his principal objections to the Eisenhower administration's foreign and defense policies.

The articles and book established Kissinger as one of the country's most thoughtful foreign policy critics. Indeed, his book echoed the catalog of complaints the Kennedy campaign had been making about the Eisenhower record. "America has reached a turning point in its relations with the rest of the world," Kissinger wrote. "The patterns of action of a secure past no longer work. . . . The issues which have gone unresolved for a decade no longer permit delay. At every turn America confronts directly and urgently the necessity for choice." The tepid criticism or all-too uniform thinking about foreign affairs in the fifties, Kissinger added, was no longer acceptable. "In the field of national security," he warned, "we have rigidly pursued patterns which may have been adequate when they were developed but which have become dangerously dated in the interval. . . . Fifteen years after the advent of the nuclear age we still cling to the [outdated] strategy of World War II."

Kissinger acknowledged that he had no comprehensive solution to current problems and that his own earlier conclusions about limited war needed reassessing. "It is unfortunately easier to think of problems than of remedies," he said. "But equally, a difficulty must be recognized before it can be dealt with." He was clear, however, on the need for the "intellectual" to play a role in helping policy makers shape fresh approaches to international affairs, but not necessarily as appointed officials or even advisers to the highest elected members of the government; rather, as innovative analysts searching out more considered ways of answering foreign policy dilemmas.

Although he did not wish to appear too self-serving in describing the influence of academic analysts, Kissinger's articles and book were an invitation to the new Kennedy administration to involve him in their foreign and defense policy deliberations. Kennedy's selection of Harvard Dean McGeorge Bundy as National Security Adviser and historian Arthur Schlesinger, Jr., as special assistant to the president gave Kissinger contacts at the highest levels.

During the 1960 campaign, Schlesinger had quoted Kissinger, "who hardly qualifies as a bleeding heart," to JFK: " 'We need someone who will take a big jump [on foreign policy]—not just improve on existing trends but produce a new frame of mind, a new national atmosphere.

If Kennedy debates Nixon on who best can manage the status quo, he is lost. The issue is not one technical program or another. The issue is a new epoch.' " In February 1961, a month into his term, Kennedy invited Kissinger into the Oval Office, where he said he had read his new book "(or at least a long review of it in the *New Yorker*)," Kissinger believed, and "asked me to join the White House staff."

Bundy was apparently not receptive to the proposal: according to Kissinger, Bundy did not share "the President's sense of urgency to add to the White House staff another professor of comparable academic competence. . . . He tended to treat me with the combination of politeness and subconscious condescension that upper-class Bostonians reserve for people of, by New England standards, exotic backgrounds and excessively intense personal style." Kissinger's solutions to foreign policy issues "did not commend themselves" to the Kennedy team: "Neither in his views on the need for conventional forces nor in his opinions on Summit meetings or arms control negotiations did Kissinger sound notes that the Kennedy White House wanted to hear."

Although Bundy did agree to make Kissinger a part-time consultant, Henry never greatly influenced the new administration's decisions. His occasional interactions with Kennedy did not work well: Kennedy thought him "pompous and long-winded," a national security staffer recalled. Kissinger also understood that there was no special chemistry between them: "With little understanding then of how the Presidency worked, I consumed my energies in offering unwanted advice and, in our infrequent contact, inflicting on President Kennedy learned disquisitions about which he could have done nothing in the unlikely event that they aroused his interest." In time, Kissinger saw his academic pronouncements to the president as pointless: "A President's schedule is so hectic that he has little time for abstract reflection," Kissinger concluded.

But Kissinger's differences with the administration were also substantive. He had a brief moment of influence in the summer of 1961 when Kennedy and Khrushchev traded threats over Berlin. Khrushchev's determination to halt the exodus of talent from Eastern Europe to the West took form in warnings that he would sign a treaty with East Germany that freed it to close off Western presence in Berlin. Kennedy's public pronouncements left no doubt that the United States would defend its transit to and from the city. But where some U.S. militants led by former

Secretary of State Dean Acheson warned that negotiations with Moscow or anything less than a military response to a Soviet attack on American treaty rights would be a disaster, JFK wanted suggestions for a more flexible response. Kissinger believed that diplomacy was not without value in the Berlin crisis, and he joined Schlesinger and State Department counselor Abram Chayes in preparing a paper that met Kennedy's request for proposals bringing Berlin planning "back into balance."

In August, however, when Moscow resolved its Berlin and East German problem by erecting a Wall between the Eastern and Western zones, Kissinger disputed Kennedy's evenhanded response, which included promises to defend Berlin from a Communist takeover with a willingness to talk, "if talk will help." Kissinger believed that a tough reaction, including threats of military force, was essential to compel a Soviet reversal and preserve West European expectations that the United States would not abandon them to Russian control. By contrast, Kennedy understood that the Wall would now defuse tensions between Moscow and Washington, with Khrushchev retreating from insistence on an East German treaty.

At the start of 1962, during a trip to Israel, Pakistan, and India for the United States Information Agency, Kissinger's public statements inflamed East-West tensions and embarrassed the administration. "If you don't keep your mouth shut," Bundy cabled him, "I'm going to hit the recall button." After Kissinger returned to the States in February, Bundy, who had told reporters that Kissinger was not a government spokesman, refused to renew his appointment as a consultant.

Although "he left in a huff," Kissinger's failure to influence Kennedy's foreign policy did not deter him from additional public pronouncements on international affairs. Between 1962 and 1965, he published numerous articles in the United States, Germany, and France on U.S. relations with Europe, and a book, *The Troubled Partnership: A Reappraisal of the Atlantic Alliance* (1965). These writings argued for improved relations between the United States and its NATO allies that would ensure a unified front against the Soviet threat to Western Europe. Though his criticism of Kennedy's European policy was less sharp than it had been of Eisenhower's, Kissinger did not think that the new administration had gone far enough in charting a fresh approach to ongoing defense and political problems.

His criticisms partly reflected his continuing ties to Nelson Rockefeller, who hoped to run against Kennedy in 1964. Kissinger regularly briefed Rockefeller and wrote speeches for him on foreign and defense policy. With conservative Arizona Senator Barry Goldwater, Rockefeller's leading competitor for the nomination, making the Soviet threat a centerpiece of his campaign, Kissinger became a significant member of the New York governor's staff responsible for foreign policy. Because Kissinger's language remained too academic, Rockefeller aides made his prose more accessible to a popular audience. "My God," Henry exclaimed to one of them half in jest, "you keep trying to make me more comprehensible!"

Rockefeller brought Kissinger with him to the Republican convention in San Francisco, where he helped temper the party platform's foreign policy plank. The victory of Goldwater extremists, who verbally abused Rockefeller during an appearance at the convention, coupled with reckless Goldwater statements about foreign affairs, persuaded Kissinger to vote for Lyndon Johnson in November.

Ironically, Kissinger's return to government service came not through Rockefeller or because of his expertise on nuclear weapons or Europe but through the crisis in Vietnam. In October 1965, after Johnson had begun a sustained bombing campaign in March and dispatched one hundred thousand combat troops in July, Henry Cabot Lodge, the U.S. ambassador in Saigon, asked Kissinger to assess how long it would take to pacify the country.

After spending two weeks in Vietnam, Kissinger believed that "We had involved ourselves in a war which we knew neither how to win nor how to conclude. . . . We were engaged in a bombing campaign powerful enough to mobilize world opinion against us but too halfhearted and gradual to be decisive. . . . No one could really explain to me how even on the most favorable assumptions about the war in Vietnam the war was going to end." He doubted that we could help build a nation whose people had "little sense of nationhood." Nevertheless, he told Lodge that "You are engaged in a noble enterprise on which the future of free peoples everywhere depends." He described Vietnam as "the hinge of our national effort where success and failure will determine our world role for decades to come." In December, he joined 189 other American academics in signing a letter to the *New York Times* saying domestic op-

position "could prolong the war by causing the Communists to underestimate American resolve."

A press report in October, at the conclusion of Kissinger's trip, jeopardized a continuing part in the Johnson administration as an adviser. Speaking off-the-record to reporters at the Saigon embassy before he left the country, Kissinger revealed his pessimism about the capacity of the South Vietnamese government to defeat the Communists. When the *Los Angeles Times* published his remarks, Kissinger became persona non grata at the Johnson White House. But his emphatic, though insincere, denial of the published remarks, Johnson's readiness to see the press as distorting Kissinger's views, and support from Secretary of State Dean Rusk, who saw Kissinger as a trustworthy supporter of the administration, preserved Henry's credentials as a consultant.

In 1966, Kissinger made two additional visits to Vietnam that deepened his pessimism about America's war effort. He came away convinced that a U.S. military victory was out of reach. Nevertheless, he thought a negotiated settlement could preserve South Vietnam. He urged the U.S. government to put all its military, political, and economic efforts toward "creating a situation favorable to negotiations with the NLF–VC." And he could "imagine no more vital assignment in today's world," he told Lodge. "If we fail there, I foresee decades of mounting crisis. If we succeed, it will mark a historic turning point in the postwar era. Just as the Cuban-Berlin confrontation may have convinced the Soviets of the futility of seeking political breakdowns by military means, so Vietnam can put an end to Chinese expansionism by the use of threat of force."

In a popular magazine article, Kissinger asserted that withdrawal from Vietnam "would be disastrous, and negotiations are inevitable." If the United States left without securing South Vietnam's autonomy, it would "lessen the credibility of American pledges in other fields. . . . In short, we are no longer fighting in Vietnam only for the Vietnamese. We are also fighting for ourselves and for international stability."

It would not be the last time Kissinger overestimated the importance of a U.S. commitment abroad. What he overlooked was the extent to which international opinion would have seen a pullback from a failing action as an act of courageous realism that made America a more sensible ally and an adversary that would make better future use of its power.

In 1967, Kissinger became a secret go-between in unsuccessful U.S.–

North Vietnamese negotiations code named Pennsylvania. Despite his inability to get a positive result from these talks, he made a powerful impression on Secretary of Defense Robert McNamara, who described Kissinger as "a very shrewd negotiator . . . the best I've seen in seven years." Johnson was less sure of Kissinger's skills: During a telephone conversation with Henry, in which he repeatedly called him "Professor Schlesinger," whom LBJ saw as representative of liberal academic war opponents, Johnson agreed to let Kissinger travel to Paris for a last try at advancing the talks. "I'm going to give it one more try," Johnson said, "and if it doesn't work, I'm going to come up to Cambridge and cut your balls off."

The failure of the discussions did not end Kissinger's involvement in the administration's ongoing efforts to find a basis for negotiations with Hanoi. Although he would not have the sort of direct part he played in the 1967 Pennsylvania discussions, Kissinger would have access in 1968 to inside information about a new Johnson peace initiative. His knowledge would establish a special connection with Nixon that would help propel him into an eight-year public career as a defense and foreign policy official at the highest levels.

1968

Politicians are the same all over. They promise to build a bridge even where there is no river.

—Nikita Khrushchev, 1963

That man is unfit to be president.

—Kissinger on Nixon, 1968

When Nixon decided to run again for president in January 1968, he knew that however well known he might be and however clever his campaign strategy, circumstances would be the final arbiter of who won the election. And at the start of the year, they seemed to both favor and impede him. Despite Lyndon Johnson's landslide victory over Goldwater in 1964 and his extraordinary legislative record of success in 1965–1966, the three years leading up to 1968 had sharply reduced Johnson's popularity.

The principal culprit, as Johnson himself described it, was that "bitch of a war in Vietnam," a seemingly endless struggle that had cost the United States more than twenty-five thousand lives and over 100 billion dollars. By 1968, millions of Americans saw the conflict as a mis-

taken intrusion into a civil war that had less to do with U.S. security than Vietnamese national self-determination. The resilience and determination of the Communist Viet Cong and North Vietnamese forces, which became all too transparent during the Tet Offensive at the end of January 1968, made the conflict seem like an unwinnable stalemate that undermined the support that most Americans normally gave their government in wartime. The erosion of popular support was reminiscent of the U.S. military setback in the Korean War and the downturn in Harry Truman's domestic political standing.

Ironically, Johnson's passage of the War on Poverty and the Great Society laws were also playing havoc with his political fortunes. Governor Ronald Reagan of California ridiculed Johnson's programs by saying, "We fought a war on poverty and poverty won." Reagan was only half right: Johnson's reforms reduced the number of Americans living in poverty by over 12 million people—from roughly 22 percent to about 13 percent of the population. Yet at the same time, the poverty war gave big social engineering programs a bad name. Most of those leaving the poverty rolls did so not as taxpayers using newly developed skills in decent jobs but as welfare recipients under Aid to Families with Dependent Children (AFDC). Only a modest number of the impoverished received a hand up rather than a handout, as the war against want had promised.

Inner-city riots between 1965 and 1968 had also eroded Johnson's political standing. His sponsorship of the 1964 Civil Rights bill, the 1965 Voting Rights Act, and a program of affirmative action described in a 1965 speech at Howard University had made Johnson a hero among antisegregationists. But his reforms also made him vulnerable to charges that he had opened the way to black violence by indulging minorities and encouraging their sense of victimization. In 1966, 90 percent of the country opposed additional civil rights legislation, while 88 percent favored self-improvement over more government help to disadvantaged citizens.

Nixon believed that Johnson would be a formidable opponent in spite of his troubles. The power of incumbency, coupled with his affinity for the rough-and-tumble politics Nixon himself had used so freely, made Johnson a serious contender for another term. Nevertheless, Nixon hoped that rumors of Johnson's retirement would prove false. In 1966, when the Republicans made strong congressional gains, Nixon

had led the way with attacks on Johnson's domestic and foreign policies. As Johnson's political fortunes declined further in 1967 and early 1968 (in December 1967, *U.S. News & World Report* predicted that Johnson would win only twelve states), Nixon became all the more convinced that he could take LBJ's measure in a fall campaign. Johnson, however, surprised Nixon and most political pundits by taking himself out of the race in a March 31 speech in which he also announced a reduction in the bombing of North Vietnam as a possible prelude to peace talks.

Johnson's withdrawal reminded Nixon of how uncertain a presidential race could be. The Democrats might now nominate Minnesota Senator Eugene McCarthy, New York Senator Robert Kennedy, or Vice President Hubert Humphrey—any one of whom could be more difficult to defeat if Johnson managed to end the fighting in Vietnam.

It was also conceivable that a peace agreement might bring Johnson back into the race as a more popular candidate. In fact, in August, even without a settlement in the war, Johnson secretly tried to arrange a draft for himself at the Democratic convention. "What will throw a new wrinkle into history," former Texas Governor John Connally said in 1990, "is that I could make a very strong case that, notwithstanding his statement of withdrawal, he [Johnson] very much hoped he would be drafted by the convention in 1968." LBJ sent White House aide Marvin Watson to Chicago to "assess the possibility of the convention drafting LBJ." Connally himself "was asked to go to meet with the governors of the southern delegations . . . to see if they would support President Johnson in a draft movement." But to no avail. Vietnam had permanently ended Johnson's political career.

During the first half of 1968, however, concerns about winning the Republican nomination were a higher Nixon priority than mapping out plans for the fall campaign. Nixon's principal challengers were Rockefeller, Michigan Governor George Romney, Illinois Senator Charles Percy, and California Governor Ronald Reagan. Nixon saw Rockefeller and Reagan as his least serious opponents: A divorce and remarriage in the early sixties and continuing refusal to make an open fight for the nomination convinced Nixon that Rockefeller was not a serious contender. Likewise, despite his national recognition as a Hollywood celebrity, popularity as a governor, and appeal to party conservatives, Reagan's inexperience (he had been governor for only two years) made it premature for him to be taken seriously as a Nixon competitor.

Percy and Romney were another matter. Both were moderate Republicans who could make a case against Nixon as unelectable. "My biggest problem is 'Nixon can't win,' " he told supporters. But Republican county chairmen disagreed: They favored Nixon over Romney by 4–1 and by 10–1 over Reagan. In May 1967, *Newsweek* expected Percy to be a front-runner at next year's convention. But like Reagan, he had won his first major election in 1966 and lacked the party support Nixon enjoyed. As Garry Wills said, in spite of his attractive image—fresh, handsome, moderate—Percy "had no clout; could not even count on his own [Illinois] delegation at the convention. He was pretty, and resonant, and politically nubile—and, by the time he reached [the] Miami [convention], all alone."

Romney was apparently a better bet. A moderate from a big industrial state with a reputation for religiosity and personal integrity, he initially seemed like a formidable challenger. In the summer of 1963, the Kennedys saw him as a serious threat to the president's reelection. "People buy that God and country stuff," Bobby Kennedy said when hearing that Romney "was awaiting a message from God on whether to run."

But Nixon accurately sized him up as a political lightweight who would not do well in a national campaign. In September 1967, Romney destroyed his candidacy with a verbal gaffe that made him a memorable also-ran. Asked by reporters why he was so inconsistent on Vietnam—a hawk turned dove—he famously declared, "Well, you know when I came back from Vietnam, I just had the greatest brainwashing that anybody can get when you go over to Vietnam. Not only by the generals but also by the diplomatic corps over there, and they do a very thorough job." After reading some history about Vietnam, he had "changed his mind. . . . I no longer believe that it was necessary for us to get involved in South Vietnam to stop Communist aggression." Instead of bringing antiwar supporters to his side, Romney's remarks marked him out as lacking the good judgment expected of a president.

When Romney dropped out of the nomination fight in February 1968 after polls demonstrated the hopelessness of his candidacy, Rockefeller immediately declared himself open to a draft. But he still refused to enter any primaries or campaign for the nomination. Then in April, he changed his mind and announced his active candidacy. In June, he spent $5 million on ads in the country's forty-one leading newspapers, citing

polls showing that he, not Nixon, was the one who could defeat Mc-Carthy or Humphrey. Though Rockefeller kept up a drumbeat of anti-Nixon self-promotion before the convention in August, it was a foregone conclusion that Nixon would win the nomination on the first ballot.

But Nixon's relatively easy victory guaranteed nothing about the outcome in November. The likelihood in the spring that Bobby Kennedy would become his Democratic opponent sent a shiver of fear through the Nixon campaign. On hearing of Bobby's entrance into the race, a shaken Nixon privately declared, "Something bad is going to come of this." As a war opponent who had broken with Johnson, Kennedy would not bear responsibility for the stalemate in Vietnam that Humphrey, Johnson's second in command, would have to take. Where Hubert would "have to admit the mess" in Washington, Bobby would be insulated from such attacks: "We can't hold his feet to the fires of the past," Nixon said.

In June, after a decisive victory in the California primary against McCarthy, Kennedy looked like the sure nominee. But Bobby's assassination by Sirhan B. Sirhan, a crazed Palestinian blaming Kennedy for his people's troubles, made Humphrey the likely winner at the Chicago convention in August. Nixon was as horrified as everyone else by Bobby's death, but it seemed to improve his chances of winning the White House. Humphrey, who had not won a single primary and had to defend Johnson's war policies at the convention, began the campaign with not only personal political negatives but also the burden of a divided party associated with civil strife. A tumultuous Democratic convention, highlighted by ugly street violence between antiwar, counterculture activists and the Chicago police, whose excesses matched and at times exceeded those of the protesters, made Nixon's familiar face and voice an attractive alternative to more upheaval. "See America while it lasts," a French travel agent advertised. Nixon began the fall campaign with a twelve-point lead over Humphrey; 43 percent to 31 percent.

Yet Nixon took nothing for granted. He worried that former Alabama Governor George Wallace, who had entered the race in February as the candidate of the American Independent party, might take enough votes away from him in the South and among conservatives to give Humphrey the presidency, especially if Johnson engineered a last-minute truce or peace agreement that relieved Humphrey of having to defend an unpopular war. Polls showed Wallace commanding as much as 20 percent

of the popular vote. Yet Wallace's candidacy also gave Nixon more of a claim on the broad political center, positioning him between Humphrey on the left and Wallace, an out-and-out segregationist and reckless war hawk like Goldwater, on the right.

Nixon's strategy, then, was to woo conservative Republicans and try to ensure against a sudden outbreak of peace on the eve of the voting that would shift centrist votes to Humphrey. By making Maryland Governor Spiro T. Agnew, a law-and-order Republican, his running mate, Nixon hoped to blunt some of Wallace's appeal. But Agnew turned out to be as much of an embarrassment as an asset: he described Polish-Americans as "Polacks" and a Japanese-American reporter as a "fat Jap." Nixon quickly relegated Agnew to a limited role in the campaign, keeping him at arm's length and never mentioning him during public appearances. Though Agnew unquestionably appealed to Wallace voters, Nixon's assertion that conservatives would be casting a wasted ballot if they backed Wallace probably did more to reduce his vote count than Agnew's presence on the ticket. In November, Wallace won only 13.5 percent of the popular tally and 46 votes in the Electoral College.

Knowing that as a fifty-five-year-old one-time loser this would be his last chance to win the presidency, Nixon urged "his staff to treat the campaign as if it were an all-out war." The 1968 election was one of the hardest fought and most emotional since 1860, with more skullduggery than in any previous twentieth-century presidential campaign.

Nixon was particularly on edge about his old enemy, the liberal press, as he described journalists covering his campaign. He tried to freeze out reporters from major newspapers like the *New York Times, Washington Post*, and *Los Angeles Times*. He avoided talking to them, substituting interviews with local papers and TV stations.

When Don Oberdorfer, the *Post* correspondent covering the campaign, asked for an interview about Nixon's views on a Nuclear Nonproliferation Treaty (NPT) Johnson had negotiated with the Soviets, Nixon's aides put him off. Oberdorfer, joined by colleagues from the *New York Times* and *Los Angeles Times*, pressed for an interview, which the campaign took more than a week to arrange at a TV studio in North Carolina at the conclusion of a live Nixon broadcast. After a brief conversation about the treaty, Oberdorfer asked Nixon if they could put a system in place for future meetings. "If looks could kill, I would have

been dead," Oberdorfer recalled. "Go ask Humphrey," Nixon shouted at him and stormed out of the studio.

Nixon and Johnson, who were schooled in the business of cutting political corners, collaborated to do in Humphrey. Sensing that Johnson was less than happy with Humphrey's candidacy and the likelihood that he would break with administration policy on Vietnam if he became president, Nixon made a shrewd appeal to Johnson that enlisted his hidden support. Nixon's TV campaign ads on Vietnam cleverly courted antiwar sentiment. In a series of sixty-second spots, Fred Panzer, Johnson's White House pollster, told the president that Nixon was using "war footage in the best antiwar new wave style. Punctuating the visual shock was Nixon's calm voice promising to end the war and correct the mistakes of the old set of leaders who were responsible." At the same time, however, Nixon tried to appease Johnson by telling a group of reporters that "the President and Vice President of the United States should have the respect of all citizens and he would do nothing to destroy that respect. He said anyone speaking on public policy in this country must be aware that he is being heard in Hanoi and that voices heard in Hanoi are of major importance to our country."

Nixon followed this up with a more direct appeal to Johnson through the Reverend Billy Graham. Graham carried a message to LBJ saying that Nixon would "1. . . . never embarrass" Johnson "after the election. I respect him as a man and as the President. He is the hardest working and most dedicated President in 140 years. 2. I want a working relationship with him. . . . And will seek his advice continually. 3. Want you (President Johnson) to go on special assignments after the election, perhaps to foreign countries. 4. I must point out some of the weaknesses and failures of the administration. But will never reflect on Mr. Johnson personally. 5. When Vietnam is settled he (Nixon) will give you (President Johnson) a major share of credit—because you . . . deserve it. 6. [I] will do everything to make you a place in history because you deserve it."

In a memo about their conversation, Graham told Nixon that Johnson "was not only appreciative but I sensed that he was touched by this gesture on Mr. Nixon's part." Johnson responded to each of Nixon's points: "The substance of his answers was warm appreciation. He said, 'I intend to loyally support Mr. Humphrey but if Nixon becomes the President-elect, I will do all in my power to cooperate with him.' " In a

follow-up phone conversation with Johnson about the meeting, Graham told Nixon "that the President was deeply appreciative of [your] generous gesture."

Nixon's initiative and Humphrey's growing public opposition to Johnson's Vietnam policies translated into LBJ's indirect help to Nixon in the campaign. At the end of September, after polls showed Humphrey trailing Nixon by between eight and fifteen points, Humphrey began promising an unconditional halt to bombing North Vietnam "as an acceptable risk for peace."

Publicly, Johnson said nothing that revealed his unhappiness with Hubert's announcement. But privately, he was furious and refused to aid Humphrey's campaign. When Hubert had given Johnson advance notice of what he was going to say, Johnson "tartly" dismissed Humphrey's assurances that he would neither embarrass him nor jeopardize peace negotiations. Later, when Larry O'Brien, Humphrey's campaign manager, passed along information from a journalist about a $500,000 contribution to Nixon's campaign from Greece's military rulers, Johnson would not ask CIA Director Richard Helms to verify the report or, should it be true, consider secretly leaking it to the press (a common Johnson political maneuver to outflank opponents). In October, after polling data from eighteen states indicated that Humphrey was behind in thirteen of them, Humphrey campaign adviser James Rowe, an old LBJ friend, asked Johnson to make speeches for Hubert in New Jersey and some crucial border states. Johnson refused. "You know that Nixon is following my policies more closely than Humphrey," he told Rowe.

Humphrey tried to see Johnson about their differences. But Johnson put him off. Although he agreed to meet with Hubert in the Oval Office, he used Humphrey's late arrival from a local campaign rally as an excuse to cancel the meeting. Humphrey now reciprocated Johnson's anger: "That bastard Johnson . . ." he told a campaign aide, "I saw him sitting in his office. Jim Jones [an LBJ aide] was standing across the doorway, and I said to him: 'You tell the President he can cram it up his ass.' I know Johnson heard me."

It was clear to Nixon throughout the campaign that Vietnam was the central issue and that he needed to generate hope that he would end the war. As a hard-line cold warrior who had supported Johnson on the fighting and criticized him for failing to defeat the Communists (Vietnam "is

the cork in the bottle of Chinese expansion in Asia," was a standard Nixon line), he now saw fit to promise an end to U.S. involvement through a negotiated settlement that preserved South Vietnam's autonomy. Following Nixon's lead, the Republican convention endorsed a Vietnam platform "plank" that was, Tom Wicker says, "just dovish enough to make Humphrey look like the hard-liner" and Nixon the sensible peacemaker.

The Democratic convention, which met two weeks after the Republican assembly, struggled to find a formula for a Vietnam plank that would appease Johnson and help Humphrey. But Johnson rejected any wording that seemed even slightly at variance with administration policy, and the result was a plank that endorsed Johnson's hard-line approach to peace negotiations. Johnson defense secretary Clark Clifford believed that the president's victory "was a disaster for Humphrey. At a moment when he should have been pulling the party back together to prepare for the battle against Nixon," Clifford said later, "Humphrey had been bludgeoned into a position that had further split the party and given more evidence of his own weakness."

But Humphrey's Vietnam bind did not guarantee Nixon a pass on the issue. After pledging in New Hampshire in March that he would "end the war and win the peace in the Pacific," reporters kept pressing him to explain how he would achieve these ends. Although he never spoke of "a secret plan to end the war," he did keep his counsel on just how he would ensure peace and security. He spoke vaguely of mobilizing "our economic and political and diplomatic leadership," and emphasized the need for pressure on Moscow to use its "leverage" on North Vietnam as a "key to peace." He also invoked Eisenhower's successful 1952 campaign promise to go to Korea to break the stalemate in that war.

He refused, however, to provide any details on how he would end the conflict, saying that if he revealed what he intended, it "would fatally weaken his bargaining position if he became President." Ambrose said, "Hidden in all the verbiage was a clear-cut change in Nixon's thinking about Vietnam. No longer was he calling for victory. No longer was he calling for escalation. Never before had he suggested cutting a deal with the Russians. For the first time he was using the words 'honorable peace,' not 'victorious peace.' " And yet, as subsequent events would show, Nixon spent the next four years battling to ensure that neither the United States nor South Vietnam suffered defeat.

After Johnson announced the cutback in bombing on March 31 and preliminary peace talks began in Paris, Nixon took refuge in the argument that for him to keep speaking out on Vietnam would subject Johnson's representatives to "partisan interference. . . . The pursuit of peace is too important for politics as usual," Nixon declared. But because Nixon had a reputation for deceit, he had trouble persuading independent voters eager for an end to the fighting that he in fact had a prompt solution to the Vietnam problem.

And of course he didn't. And so at the end of September, after Humphrey had publicly stated a more flexible position than Johnson's on ending the war by promising to make peace in January, Nixon worried that the administration might come up with an October surprise that decisively wrested the peace issue from him and assured Humphrey's election. Fueling Nixon's concern were October polls showing that two-thirds of voters preferred a candidate who promised to begin withdrawing U.S. troops from Vietnam in January 1969. The polls also showed that Humphrey's September peace speech was having an impact: Where he trailed Nixon by fifteen percentage points on September 29, he had closed the gap to two points by November 2. In the closing weeks of the campaign, Nixon wanted inside information on Johnson's peace campaign if he was to blunt or head off an initiative that might tip the balance to Humphrey.

Nixon found a willing collaborator in Henry Kissinger. His involvement in the abortive Pennsylvania negotiations in 1967 had been at the highest levels: On October 18, for example, he had met at the White House with the president, secretaries of state and defense, Dean Rusk and Robert McNamara, National Security Adviser Walt Rostow, Joint Chiefs of Staff Chairman General Maxwell Taylor, Supreme Court Justice Abe Fortas, a close LBJ friend and adviser, and future Defense Secretary Clark Clifford. Kissinger did not have the same access through the first half of 1968 because he was part of Rockefeller's on-again, off-again bid for the Republican nomination; as a result, he had no part in the preliminary Paris peace talks following Johnson's March 31 speech. Rockefeller's statements in May and July on Vietnam, which criticized the Johnson administration's negotiating strategy, were drafted by Kissinger.

Kissinger's Rockefeller connection did not automatically bar him from the Johnson circle. Johnson was in fact warmly disposed toward Rockefeller, who he hoped might succeed him in the White House. At

the end of April, during a White House dinner, Johnson urged Rock-efeller to run: "He was very friendly about '68, and very supportive of me for '68," Rockefeller said afterward. In June, when Johnson gave him a briefing on Vietnam, "Rockefeller vowed to toe [the Johnson] line on Vietnam, expressly assuring the President: 'Believe me, I'd like to get the nomination, but I'm not going to do it at the expense of this country.' "

Kissinger's ties to Rockefeller were no deterrent to continuing contacts with Johnson administration officials. David Davidson, a former Harvard student and aide to Averell Harriman, who was LBJ's chief negotiator in Paris, kept Henry posted on developments in the talks. Kissinger passed along what he knew to Richard Allen, a thirty-two-year-old staff member at Stanford's Hoover Institution who had become Nixon's principal foreign policy aide. To shield their phone conversations from eavesdroppers, Kissinger and Allen spoke in German.

During the Republican convention in August, Kissinger collaborated with Allen on the Vietnam platform plank. And in early September, after Nixon's nomination, Allen asked Kissinger to join a Nixon foreign policy advisory board. Because this would have meant openly identifying himself with Nixon, Kissinger suggested instead that he work "behind the scenes." Joining the Nixon campaign would have precluded an appointment in a Humphrey administration, which Kissinger saw as a distinct possibility. In 1973, Humphrey said that he would have appointed Henry National Security Adviser if he had become president. Working openly for Nixon would also have made Kissinger appear to be a hypocrite. He privately made scathing comments about Nixon to several people during the 1968 campaign, saying that he was "unfit to be president" and that a Nixon presidency would be "a disaster" for the country.

In his eagerness for a White House appointment, Kissinger was cozying up to both Democrats and Republicans. It reflected not only his ambition but also his genuine ambivalence about the candidates. "I cannot deny that I said most of the bad things about Nixon attributed to me at the time of the nomination," he later acknowledged. "But in the end I was reluctantly for Nixon, and I voted for him." Henry told someone in the Humphrey campaign, "Six days a week I'm for Hubert, but on the seventh day, I think they're both awful."

Nonetheless, he was confident that regardless of who won the election, he would be invited to take a significant job in either the state or

defense department. His confidence rested less on his ties to both political camps than on his understanding that his analysis of contemporary foreign and security problems had registered forcefully on political leaders in both parties. At a moment when the U.S. foreign policy establishment was reeling from its evident defeat in Vietnam, Kissinger published a 1968 essay, "Central Issues of American Foreign Policy," that provided a compelling intellectual framework for thinking about current international difficulties.

The essay was not a policy blueprint for Vietnam, Europe, Latin America, or any other region of the world but a broad discussion of global structural problems that a new administration would need to consider before making specific decisions on challenges abroad. Kissinger's essay dispelled some of the gloom that had descended over the country about its international relations. "The central task of American foreign policy," Kissinger wrote, "is to analyze anew the current international environment and to develop some concepts which will enable us to contribute to the emergence of a stable order. . . . It is part of American folklore that, while other nations have interests, we have responsibilities; while other nations are concerned with equilibrium, we are concerned with the legal requirements of peace. . . . A mature conception of our interest in the world . . . would deal with two fundamental questions: What is it in our interest to prevent? What should we seek to accomplish?"

Kissinger's answers were too abstract for the sort of verbal briefings he had unsuccessfully put before JFK. But as written analyses that Washington policy makers could digest at their leisure, they resonated effectively. The essay, coupled with his earlier writings, strengthened his appeal as America's chief practitioner of realpolitik.

He asserted that the United States principally needed "to think in terms of power and equilibrium" instead of legalities and principles. "The task of defining positive goals is more difficult," he said, "but even more important. . . . Our pragmatic, ad hoc tendency [in the two postwar decades] was an advantage in a world clamoring for technical solutions." But the situation was now "more complex." It was essential for the United States "to generate coalitions of shared purposes." Local powers would have to take responsibility for regional issues, with America more concerned about "the over-all framework of order than with the management of every regional enterprise." Kissinger doubted that "such

a leap of imagination is possible for the modern bureaucratic state," which "widens the range of technical choices while limiting the capacity to make them."

A major challenge of a new administration, then, would be to shift control of foreign policy from the bureaucracy to the chief executive and his principal deputies armed with a broad conception of how to bring order to world affairs. Nothing was better calculated to appeal to Richard Nixon, who was intent on doing just that, should he become president.

For all his expectations of becoming a leading foreign policy official in the next administration, Kissinger believed that he needed to demonstrate a more concrete value to the Humphrey and Nixon campaigns than the power of his ideas. Consequently, in September, before going to a conference in England, he traveled to Paris, where he discussed the Vietnam peace talks with several members of the American delegation. No one in the delegation saw him as anything but helpful, and in December 1968, when Johnson asked Rusk for his impressions of Kissinger, Rusk replied: "Theoretical more than practical. Kissinger handled himself in an honest fashion on the Paris talks." Walt Rostow then chimed in: "Henry is a man of integrity and decency." But he "doesn't understand [the] emergency [in] Asia."

None of the Johnson or Humphrey advisers apparently knew that Kissinger had also been talking to Nixon's advisers about what he had learned in Paris. According to Nixon foreign policy historian William Bundy, John Mitchell, Nixon's campaign manager and future attorney general, had enlisted Kissinger as a secret consultant before he went to Paris. On September 26, after he had returned from Europe, Kissinger called Mitchell and, according to Nixon, reported "that something big was afoot regarding Vietnam. He advised that if I had anything to say about Vietnam during the following week, I should avoid any new ideas or proposals. Kissinger was completely circumspect in the advice he gave us during the campaign," Nixon asserted. "If he was privy to the details of the negotiations, he did not reveal them to us. He considered it proper and responsible, however, to warn me against making any statements that might be undercut by negotiations I was not aware of."

During the next five weeks, Kissinger had at least two more conversations with Mitchell in which he warned that a bombing halt might come as soon as mid-October or in the closing days of the month. Nixon

described Kissinger as saying that the bombing pause would "be tied in with a big flurry of diplomatic activity in Paris which will have no meaning but will be made to look important." Kissinger predicted that Johnson "will take some action before the election." Nixon received similar information from Bryce Harlow, a former Eisenhower White House staff member and a Nixon campaign adviser. He claimed to have "a double agent working in the White House" who informed him "about every meeting they held. I knew who attended the meeting. I knew what their next move was going to be. I kept Nixon informed."

Kissinger and Harlow accurately predicted an important Johnson action before the November 6 election: On October 31, after Hanoi had promised to reciprocate a bombing halt by giving Saigon a place at the peace table, Johnson announced a complete stop to the air war over North Vietnam. The Nixon campaign saw Johnson's announcement as a last-minute attempt to swing the election to Humphrey. "The word is out that we are making an effort to throw the election to Humphrey," Florida Democratic Senator George Smathers told Johnson. ". . . Nixon had been told of it." But Johnson was less interested in whether Humphrey or Nixon succeeded him than in improving his historical reputation by making peace. Nixon's resistance to a rapid end to the fighting pushed Johnson back into Humphrey's camp.

Was Kissinger guilty of any wrongdoing in passing along his predictions to Mitchell and Nixon? There was no legal breach in what he did; but in his eagerness to win a government appointment did he commit an ethical lapse? William Bundy, Johnson's assistant secretary of state for East Asian and Pacific Affairs, has provided the most thoughtful response to these questions.

"There is of course nothing wrong in offering advice and judgment to a candidate in the hope of preferment," Bundy wrote. "Such action is open to harsh criticism only if it involves the use of inside government information. Yet that is where the charge collapses. . . . There simply was no useful inside information" about a new departure in the peace talks that Kissinger could have obtained during his Paris visit. Kissinger's advice rested not on special knowledge of decision making at the White House but on an astute analyst's insight into what was happening. "Almost any experienced Hanoi watcher might have come to the same conclusion" as Kissinger did, Bundy believes. He "does not rule out the possibility that

he [Kissinger] said or hinted that his advice was based on contacts with the Paris delegation. This sort of self-promotion," Bundy says, "while unattractive, is at worst a minor and not uncommon practice, quite different from getting and reporting real secrets."

How did Nixon use the information provided by Kissinger and Harlow? And more important, did Nixon's response to Johnson's peace campaign break any laws and bend accepted political practices? Convinced that Johnson's bombing halt was politically motivated, Nixon had no hesitation in exerting pressure on the South Vietnamese government of Nguyen Van Thieu to reject Washington demands to begin participating in the Paris talks on November 2, three days before the U.S. elections. Everyone involved in the negotiations believed that progress in the talks partly depended on Saigon's presence in Paris, and most everyone inside the Nixon and Humphrey campaigns, as well as outside political observers, thought that surging hopes of peace could affect the outcome of an increasingly close presidential election.

From early in his campaign, Nixon had seen a peace settlement or even substantial movement in that direction as crucial to Humphrey's chances in November. Consequently, in July 1968, Nixon had begun discouraging Saigon from accepting a possible invitation to join the ongoing Paris discussions. During that month, he and Mitchell met in Nixon's New York apartment with South Vietnam's ambassador to the United States, Bui Diem, and Anna Chennault, a co-chair of Republican Women for Nixon and the widow of General Claire Chennault of China's World War II Flying Tigers. Nixon asked Chennault to be "his channel to Mr. Thieu via Bui Diem." She agreed and periodically reported to Mitchell that Thieu had no intention of attending a peace conference before Nixon, hopefully, became president.

On October 31, after Johnson announced the bombing halt, Mitchell phoned Chennault to say, "Anna. I'm speaking on behalf of Mr. Nixon. It's very important that our Vietnamese friends understand our Republican position and I hope you have made that very clear to them." Despite Chennault's assurances that Thieu would not agree to send a South Vietnamese delegation to the talks in early November, Mitchell said, "They really have decided not to go to Paris?" Chennault answered: "I don't think they'll go. Thieu has told me over and over again that going to Paris would be walking into a smoke screen that has nothing to do with reality."

When Thieu continued to resist U.S. embassy pleas that he join the Paris talks, and Johnson heard that someone "very close to Nixon" believed he was encouraging "Saigon to be difficult," Johnson blamed Nixon for Thieu's uncooperativeness. At a White House meeting with diplomatic and military advisers on October 29, Johnson said, "It would rock the world if it were said [that] he [Thieu] was conniving with the Republicans. Can you imagine what people would say if it were to be known that Hanoi has met all these conditions and then Nixon's conniving with them [the South Vietnamese] kept us from getting [a peace agreement]?"

Because he believed that Thieu might still be persuaded to join the peace talks and because he wanted to learn precisely what the Nixon camp was telling Saigon, Johnson instructed the FBI to wiretap Chennault and keep her under surveillance. He also ordered U.S. intelligence agencies to intercept cables between the South Vietnamese embassy in Washington and Saigon. Since the White House believed that violations of national security laws might be involved, it saw the bugging and surveillance as legal. But there were other risks: National Security Adviser Walt Rostow warned Johnson that the taps posed "real difficulties. She lives at Water Gate—a huge apartment. She is constantly seeing Republicans—the risk of discovery is high." It was a warning that surely could have been useful to Nixon and John Mitchell in the future.

The intercepts and wiretaps, including taps on "the telephone connection in vice-presidential candidate [Spiro] Agnew's chartered campaign plane," confirmed that the Nixon campaign was discouraging Thieu from a part in the Paris talks. As Johnson described it later to Cartha DeLoach, the deputy director of the FBI, Chennault told the South Vietnamese ambassador on November 2, " 'I have just heard from my boss in Albuquerque [Agnew, who was campaigning in New Mexico that day] who says his boss [Nixon] says we're going to win. And you tell your boss [Thieu] to hold on a while longer.' "

With only four days left in the campaign, Humphrey, who learned about Nixon's activities from Johnson, wrestled with questions about whether to leak the information to the press or openly accuse Nixon of undermining the peace talks. Johnson was furious at Nixon. Aides recalled that Johnson described Nixon as guilty of "treason": American boys were losing their lives in the service of Nixon's political ambitions,

Johnson said. The fact that Nixon frustrated Johnson's hopes of getting a settlement before he left office also incensed Johnson, who wanted the historical record to show that he had made peace as well as war in Vietnam. Because they knew that they would have to disclose how they obtained their information if they revealed it and because they feared it might provoke a constitutional crisis and make it nearly impossible for a Nixon administration to govern, Johnson and Humphrey decided against revealing Nixon's secret intrusion into the Paris discussions.

Nixon knew that Johnson was "mad as all get-out" over what he was doing to impede the talks. After Illinois Republican Senator Everett Dirksen told Harlow that Johnson had called in a rage, Harlow urged Nixon to speak to Johnson. "Someone has told him that you're dumping all over the South Vietnamese to keep them from doing something about peace. . . . If you don't let him know quickly that it's not so, then he's going to dump" on you. Nixon denied any involvement, but Harlow never believed him. Stopping the peace talks "was too tempting a target. I wouldn't be a bit surprised if there were some shenanigans going on," Harlow said later.

On November 3, Nixon called Johnson and categorically denied that he was doing anything to disrupt the peace negotiations. Nixon's call strengthened Johnson's decision not to publicize the allegations, and according to a later story in the *Sunday Times* of London, "Nixon and his friends collapsed in laughter" after he and Johnson hung up. "It was partly in sheer relief that their victory had not been taken from them at the eleventh hour." William Bundy says that Nixon's "barefaced lie was his only tenable line of defense." In 1997, Chennault revealed that Nixon and Mitchell knew everything: "I was constantly in touch with Mitchell and Nixon," she said.

Did Nixon's pressure on Thieu have an impact on the 1968 election? The popular vote favored Nixon by only .7 percent, 43.4 percent to Humphrey's 42.7 percent; 13.5 percent of the votes went to Wallace. The Electoral College was a different story: Nixon had a decisive edge of 301 to 191. If Wallace had not been in the race, it seems almost certain that a majority of his votes would have gone to Nixon.

It is doubtful that successful peace talks or the likelihood of an early peace settlement would have changed the outcome. Humphrey was too clearly identified with Johnson's unpopular administration. And though

some voters might have concluded that Humphrey would steer the country on a new course, the majority saw Humphrey as likely to continue much of what Johnson had been doing in domestic affairs, where many Americans now felt he had overreached himself. And even if Humphrey ended the war, he would remain tainted with his earlier support of Johnson's actions in Vietnam.

The country wanted a clean break with the immediate past. The assassinations of Martin Luther King and Robert Kennedy, inner-city riots, militants demanding black power, campus upheavals, and the turmoil in the streets at the Democratic convention in Chicago exasperated the country and turned it against Johnson, Humphrey, and the Democrats, whom it identified with all the difficulties. Nixon, however familiar a face, presented a chance for something of a fresh start. Moreover, in a less overt way, he had used the appeal to values that had been so instrumental in ensuring his political success in the 1940s and 1950s—his 1968 campaign promised to reflect the concerns of "the Silent Majority, Middle America, the white, comfortable, patriotic, hawkish 'forgotten Americans.' "

Yet Nixon received less than a mandate. The Democrats held on to both houses of Congress: despite losing five seats, they continued to have a 16-vote Senate majority; in the House, where they lost only four seats, the Democrats emerged with a 51-seat edge. The voters preferred Nixon over Humphrey in the White House, but, apparently remembering Nixon's controversial history, they were also eager to give Congress a check on his powers.

Nixon's pressure on Thieu's government to reach a settlement probably made no difference. Even if Nixon had not been discouraging Thieu from joining the Paris talks, Thieu was unlikely to have sent a delegation. He didn't need Nixon to tell him that participation in the discussions would improve Humphrey's chances of winning, and Thieu clearly preferred a more hard-line Republican administration to one that was almost certainly going to make unpalatable concessions to the Communists in a peace settlement. And even if Thieu had decided to go to Paris, which the presence of the National Liberation Front (NLF) made more than unlikely, he and the Communists would have entered into protracted negotiations that could have lasted by fits and starts for years.

Still, even if Nixon's worries about a last-minute peace surprise were

overdrawn, his secret undermining of the peace talks does him no credit. "From a moral and political standpoint," William Bundy asserts, "Nixon's actions must be judged harshly. Certainly if the full extent of those actions had become known then—or indeed at any point during his presidency—his moral authority would have been greatly damaged and the antiwar movement substantially strengthened."

But it was not only Nixon's moral authority that could have been called into question; his actions were a contravention of the 1799 Logan Act prohibiting a private citizen from conducting diplomatic negotiations with foreign officials. Johnson and Humphrey were correct in believing that if revelations about Nixon's messages to Thieu did not deny Nixon the presidency, a constitutional crisis could have followed his election. A Democratic Congress would probably have investigated the Nixon pressure on Thieu through the Agnew–Mitchell–Chennault–Bui Diem connection, which could have led to a court contest over access to FBI wiretaps and CIA intercepts and ended in impeachment proceedings. Humphrey's decision not to go public with the information was, in the journalist Theodore White's judgment, an uncommon act of political decency.

The greatest actual consequence of Nixon's request to Thieu was the obligation Nixon incurred to him. It would become a significant impediment to Nixon's freedom to influence Thieu's conduct of the war and reduce Vietnam's dependence on the United States for its security and autonomy. "That a new American President started with a heavy and recognized debt to the leader he had above all to influence," Bundy asserts, "was surely a great handicap brought on by Nixon for domestic political reasons."

NIXON'S VICTORY INCREASED the possibility that Henry Kissinger would achieve his ambition of serving in a high government position as a foreign policy adviser. Although he believed that the information he had passed along to John Mitchell might result in an offer to join a Nixon administration, he was uncertain that someone as remote from Nixon as himself would be asked to take an important post. (They had met only once in 1967 at a Christmas party in New York given by Claire Booth Luce, the widow of *Time* publisher Henry Luce, and that meeting had taken all of five minutes and consisted of unmemorable small talk.) After

the journalist Joseph Kraft told Kissinger that if Nixon won the presidency he was thinking of making Henry national security adviser, Kissinger begged Kraft not to publish the story. Kissinger feared that such a rumor might destroy his chances of joining a Humphrey administration and worried that it would provoke a hostile reaction from Harvard colleagues and Rockefeller associates describing him as an unprincipled opportunist.

Intrigued but unconvinced by Kraft's titillating information, Kissinger's principal hope for a high-level appointment rested on his association with Rockefeller. On November 22, sixteen days after Nixon's election, when Rockefeller discussed the possibility of serving in Nixon's cabinet, Kissinger urged him to become secretary of defense, a job that would allow him to serve the nation and implicitly make Kissinger a principal deputy.

At the same time, on the off-chance that Nixon might appoint him to a high-level job independent of Rockefeller, Kissinger reminded Nixon of his usefulness by sending word to the president-elect through conservative journalist William Buckley that defense secretary Clark Clifford might be arranging a coup against Thieu to ensure a South Vietnamese government willing to participate in the Paris talks. If Thieu were assassinated, as Diem had been in November 1963, Kissinger advised Nixon, "word will go out to the nations of the world that it may be dangerous to be America's enemy, but to be America's friend is fatal."

Kissinger could not have been totally surprised then when Nixon asked to see him on November 25 at his transition headquarters on the thirty-ninth floor of New York's Pierre Hotel on Fifth Avenue. Nixon's uneasiness surprised Kissinger, who "did not know then that Nixon was painfully shy. Meeting new people filled him with vague dread, especially if they were in a position to rebuff or contradict him. . . . Nixon entered the room . . . with a show of jauntiness that failed to hide" his "extraordinary nervousness. . . . His manner was almost diffident; his movements were slightly vague, and unrelated to what he was saying, as if two different impulses were behind speech and gesture."

Nixon spoke about his "task of setting up his new government," and of establishing a foreign policy apparatus that would serve his aims. He had no confidence in the state department or foreign service officers who had treated him with disdain as vice president. "He was

determined to run foreign policy from the White House. . . . He felt it imperative to exclude the CIA from the formulation of policy; it was staffed by Ivy League liberals who behind the facade of analytical objectivity were usually pushing their own preferences. They had always opposed him politically."

Now that he had power, Nixon was all but saying, he would not let a bunch of uncooperative bureaucrats deprive him of his rightful control of foreign affairs and a record of presidential greatness which he thirsted after. Asked his opinion on Nixon's views of the foreign policy bureaucracy, Kissinger assured him that "a President who knew his own mind would always be able to dominate foreign policy." He shared Nixon's view on the "need for a more formal decision-making process . . . A more systematic structure seemed to me necessary." Invited to describe his vision of a Nixon foreign policy, Kissinger emphasized the need "to free our foreign policy from its violent historical fluctuations between euphoria and panic." The task was to identify "basic principles of national interest that transcended any particular Administration."

The conversation ended inconclusively or with at least no discernible offer to serve in the administration. "Nixon's fear of rebuffs caused him to make proposals in such elliptical ways that it was often difficult to tell what he was driving at, whether in fact he was suggesting anything specific at all," Kissinger wrote later. As best he understood the conversation, Nixon was asking "whether in principle I was prepared to join his Administration in some planning capacity." Nixon suggested that Kissinger prepare a memorandum on "the most effective structure of government."

The following day, John Mitchell's office called to schedule an appointment for November 27 to discuss "my position in the new Administration." Kissinger was unclear on what position was being offered, if any, or whether they were to have "another exploratory talk." When they met, Mitchell asked, "What have you decided about the National Security job?" "I did not know I had been offered it," Kissinger replied. "Oh, Jesus Christ," Mitchell exclaimed, "he has screwed it up again." After a five-minute conversation with the president-elect, Mitchell escorted Kissinger in to see Nixon, who made clear that he wanted Henry to become his security adviser and to help him run foreign policy from the White House.

After consulting Rockefeller, some friends, and Harvard colleagues, Kissinger accepted the offer. At a press conference on December 2, Nixon "announced a program substantially at variance with what he had told me privately." He described Kissinger's role as principally devoted to planning; as security adviser, he "would not come between the President and the Secretary of State." Nixon also declared that the unnamed secretary was going to have a "strong" influence on the making of foreign policy.

In recounting the story of his appointment, Kissinger seemed to have misread Nixon's behavior. His oblique references to a Kissinger appointment had much less to do with any characteristic shyness or an aversion to being rebuffed or contradicted than with Nixon's ambivalence about Kissinger as someone he could trust to accept his control over foreign affairs. The "two different impulses behind speech and gesture" Kissinger saw was a desire on one hand "to co-opt a Harvard intellectual," especially one identified with Rockefeller and the liberal wing of the Republican party, and, on the other, a fear that Kissinger might eclipse him intellectually and become the administration's substantive foreign policy leader. Nixon's decision to appoint Kissinger had less to do with any political intrigue over the Paris peace talks than with his impressive credentials as a foreign policy analyst.

Circumstance and shared interest in great foreign policy issues was the ostensible bond bringing Nixon and Kissinger together. But the connection rested on larger commonalities. True, their backgrounds and experience could not have been more different: the small-town Southern California Quaker who gained prominence through political combat and the German-Jewish émigré whose innate brilliance elevated him to the front rank of American academics. But they were as much alike as they were different: both self-serving characters with grandiose dreams of recasting world affairs.

Their coming together also represented a union of two outsiders who distrusted establishment liberals: Nixon, their great antagonist, and Kissinger, the academic, who was held at arm's length by the Kennedy-Johnson administrations. In addition, harsh life experiences had made both men cynical about people's motives and encouraged convictions that outdoing opponents required a relaxed view of scruples. Ironically, their cynicism would also make them rivals who could not satisfy their aspirations without each other.

After Nixon had offered Kissinger the security adviser's post and he had asked for a week to consult with Harvard colleagues, Nixon "rather touchingly . . . suggested the names of some professors who had known him at Duke University and would be able to give me a more balanced picture of his moral standards than I was likely to obtain at Harvard." Nixon may have used the word "moral," but he was referring to his intellect and powers of analysis. He wanted Kissinger to understand that he was as thoughtful about foreign affairs as Kissinger was and had no intention of ceding control of policy making to a subordinate, however considerable his talents as an academic. In short, Nixon was saying, I am no intellectual slouch who can be led around by a Harvard professor.

Nixon was determined to be his own secretary of state, with the support of national security advisers. He had first revealed this intention during the campaign when he had relied on the thirty-two-year-old Richard Allen to oversee foreign policy research. A meeting with Johnson and his foreign policy advisers on November 11 for a pre-presidential briefing without Allen demonstrated Nixon's intention to control all major foreign policy decisions.

An additional indirect statement of Nixon's plans came after the November 25 meeting with Kissinger, when H. R. (Bob) Haldeman asked Kissinger into his office, where he described his job as Nixon's chief of staff. He would be preventing "end-runs" around the president—all memoranda reaching Nixon would go through him or an appropriate White House staff member. The message to Kissinger was clear enough—if you join this administration, there won't be any grandstanding on your part; you will work through me and consistently stand in the president's shadow. Nixon and Haldeman did not know Kissinger well enough to understand that his drive for influence was a match for theirs. The professor would give them some lessons in bureaucratic in-fighting that even as experienced a politician as Richard Nixon would find painfully instructive.

Yet nothing demonstrated Nixon's preoccupation with controlling foreign policy more than his appointment of a secretary of state. His selection of Kissinger before choosing his chief diplomatic officer underscored his intention to largely ignore anyone who took the job. Moreover, he didn't believe that foreign ministers counted for much anywhere.

In 1971, when Nixon confronted the prospect of a foreign ministers meeting to discuss Soviet relations, he called it a "goddamn façade . . . In dealing with the Soviets . . . they can't do a goddamn thing," he told Kissinger. Henry, who enjoyed Nixon's preference for his advice over that of the secretary of state, confirmed Nixon's assumption: In no modern government, he told him, France, Britain, or Germany, did a foreign secretary actually conduct foreign policy; they were little more than administrators of large bureaucracies.

Nixon chose William P. Rogers, a New York attorney who had been Eisenhower's attorney general and a Nixon friend and ally in the 1950s. But their long-standing relationship had almost nothing to do with Rogers's appointment; by 1968, they were no longer close. Rather, Nixon chose Rogers mainly because he had so little background in foreign affairs. Nixon told Kissinger that he "considered Rogers's unfamiliarity with the subject an asset because it guaranteed that policy direction would remain in the White House." After Nixon asked Kissinger to meet Rogers and to report his reactions, he appointed him without ever hearing Kissinger's impressions. (In addition, though Kissinger was one of only two men Nixon asked for suggestions on what to include in his inaugural speech, he discarded most of what Kissinger proposed.) Nixon was showing Kissinger that his advice would have only limited influence in shaping what he did.

Nixon rationalized Rogers's appointment by emphasizing his likely loyalty, discretion, and tough-mindedness. Nixon described him as one of the "most cold-eyed, self-centered, and ambitious men" he had ever known. "As a negotiator he would give the Soviets fits. And 'the little boys in the State Department' had better be careful because Rogers would brook no nonsense," Nixon told Kissinger. Kissinger marveled at the irony of a president's attraction to a secretary of state notable for his "ignorance of foreign policy." (It was not the first time a president had selected an unworldly political ally for the job: William Jennings Bryan, Wilson's first secretary of state, was transparently uninformed about international affairs. Although this seemed to matter less in 1913 than in 1969, Wilson's problems in Latin America and the challenges presented by World War I gave the lie to this assumption.)

Nixon saw a reliable secretary of defense as another priority in ensuring his control over foreign affairs. He did not want someone who

would have as much visibility and influence as the Kennedy-Johnson secretaries, Robert McNamara and Clark Clifford. Instead, he preferred a party wheelhorse who would be more an administrator and liaison with Congress, which, under Democratic control, seemed likely to be troublesome in setting a timetable for leaving Vietnam, endorsing treaties, and supporting defense budgets.

Nixon settled on Melvin Laird, a sixteen-year Wisconsin House Republican with credentials as an expert on defense appropriations. Nixon also liked the fact that he had a reputation for deviousness. "Of course Laird is devious," Eisenhower told Nixon, "but for anyone who has to run the Pentagon and get along with Congress, that is a valuable asset."

With the formalities of choosing cabinet and subcabinet officials out of the way, Nixon instructed Kissinger to plan a new bureaucratic structure that would assure his control of foreign policy. His eight years as vice president had taught him to despise the state department's professionals, who he believed had "manipulated and subverted" Eisenhower in the service of "their special interests." Nixon instructed Henry to begin his service as national security adviser by reforming the National Security Council. He wanted the changes to be more than cosmetic; they should " 'give the people of this country the foreign policy they want,' a system that took power from the bureaucrats and placed it where it belonged, in the White House."

There was more at work here than Nixon's or Kissinger's egotistic assumptions about their superiority as foreign policy makers or a compulsion to create an "Imperial Presidency." The miserable failure in Vietnam had cost the United States not only thousands of lives and billions of dollars but also the freedom to focus on larger Cold War tensions with Moscow and Peking and Middle East dangers, where the 1967 Arab-Israeli war had turned the Middle East into an area of East-West confrontation.

Kissinger shared Nixon's belief that the primary enemy of a wise, more successful diplomacy was a turgid, self-serving bureaucracy. His study of past and contemporary history convinced him that a successful foreign policy began at home, where a statesman needed to free himself from the accepted wisdoms of cautious bureaucrats frightened by innovative thinking. "It seemed to me no accident that most great statesman

had been locked in permanent struggle with the experts in their foreign offices," Kissinger asserted.

Kissinger, with the help of a brilliant group of aides he recruited to serve on the National Security Council, devised a plan that shifted control over policy making from state department and Pentagon committees to a new Review Group at the NSC: it allowed Kissinger to set the agenda for White House foreign policy discussions. Although Rogers ultimately joined Laird in opposing a restructuring that was condemned by their bureaucracies as inimical to their respective departments, Nixon, after some hesitation (he abhorred confrontations with dissenting colleagues), ordered implementation of the Kissinger plan. He and Henry saw it as a vital first step in extricating the United States from Vietnam and creating an international balance that reduced the chances of a Soviet-American conflict and opened the way to a more stable world order.

Yet no bureaucratic arrangement or even the most carefully thought out plan could guard against the vicissitudes of world politics. Reading the eight-page outline of the new NSC system that Kissinger urged Nixon to put in place, with a "Review Group, Ad Hoc Under Secretary's Committee, Inter-Agency Regional Groups, Ad Hoc Working Groups, and Outside Consultants," analysts can marvel at how this shuffling of deck chairs was supposed to change the course of American foreign relations. True, the "system" indisputably aimed at enlarged presidential control over foreign policy. But, as Roger Morris wrote later, "It was the man who ruled, and not the mechanism. As Kissinger's power and fame widened, the system became less and less used."

Yet it wasn't simply the Nixon-Kissinger affinity for personal control that diminished the importance of their organizational arrangements. True, their reasoned consideration of how to manage international conflicts sharply reduced the influence of other government agencies responsible for national security during their five-and-a-half years together in the White House. But unforeseen and uncontrollable domestic and international crosscurrents pushed them in unanticipated directions. They would have done well to recall Abraham Lincoln's famous comment on his direction of affairs during the Civil War: "I claim not to have controlled events, but confess plainly that events have controlled me."

This is not to suggest that circumstances can excuse the many controversial actions that have generated criticism and, in some instances, condemnation of Nixon and Kissinger. Their decisions and behavior left indisputable marks on America and the world and historians will judge what they did. At the same time, commentators will want to see the men and their actions in context. Their collaboration is part of a history that tells us as much about the opportunities and limits of national and international conditions as about the men themselves.

THE LIMITS
OF POWER

THE NIXON-KISSINGER WHITE HOUSE

The President can be just as big a man as he chooses to be.

—Woodrow Wilson

By 1969, Richard Nixon had been a public figure for over twenty years. But his prominence as a congressman, senator, vice president, and now president had not made him understandable to contemporary commentators on American politics. His evolving public persona from fierce anti-Communist and unprincipled opportunist—"tricky Dick"—to national unifier and international peacemaker left critics asking: "Which is the real Nixon?" Was he the consummate "political man," as many people believed, "the born trimmer, the zigzagger, and flipflopper"—a "chameleon on plaid," as Herbert Hoover described Franklin Roosevelt? Or was he a politician whose opportunism aimed to serve not only himself but also the national well-being, as he understood it?

The inner workings of the Nixon presidency, which is now largely accessible from the abundant available written and audio records, show a secretive, devious, thoughtful, energetic, erratic, and painfully insecure man who struggled against inner demons and sometimes uncontrollable circumstances to reach for greatness. In 1970, two university psychologists analyzing presidential rhetoric starting with Theodore Roosevelt

concluded that Nixon outranked all his twentieth-century predecessors, including the overtly grandiose Lyndon B. Johnson, in eagerness for unsurpassed achievements.

Nixon is a study in contradictions. Millions of Americans, however, saw him as a one-dimensional man: His admirers considered him a self-controlled paragon of conservative values and a wise defender of the national interest: "calm and implacably ordered." His detractors viewed him as an unprincipled scoundrel who abused the country's democratic institutions. "Behind the façade of the Administration," one of them said, "there is a façade." To one degree or other, Nixon was everything his supporters and critics believed him to be—an idealist struggling to advance international harmony and a defender of national traditions as well as an arbitrary—sometimes ruthless—wielder of power at home and abroad.

Nixon speechwriter William Safire said, "He wanted to be seen as upright and true, long-suffering and pious, cool in crisis, beset by Lilliputians and despised by aristocrats . . . a man of the people who never forgets the folks." Safire also described Nixon "as a layer cake. The icing, the public face or crust is conservative, stern, dignified, proper." Beneath this was "a progressive politician" and "a pugnacious man" who despised "snobs" without a genuine work ethic. He was also a "loner," a "hater, the impugner of motives," and a "realist" with a commitment to power politics which derived from his understanding of what had been necessary to overcome the Axis threat during World War II.

The placid, positive image Nixon wished to project was at odds with the hidden realities of an anxious man sometimes making tortured decisions on intractable problems. His fear that political enemies would see through his veneer of self-assurance was a breeding ground for anger at critics. He could not bear to read negative comments about himself and his administration. Scanning daily media stories for anything unflattering, Nixon responded by ordering aides to deny White House access to offending journalists.

At the same time, however, he publicly described his administration as receptive to all viewpoints, depicting himself as a great defender of traditional freedoms of speech and press. And this was not simply rhetoric; he genuinely believed that his administration showed as much regard for American liberties and popular sentiment as any in the country's history.

As president, he worked tirelessly to align himself with public opinion, especially on Vietnam, as a prelude to running for a second term in 1972 and establishing himself as a great democratic chief. Yet when a syndicated columnist predicted that "popular opinion would roll over him as it did LBJ" unless he quit Vietnam, Nixon ordered Ehrlichman and Kissinger to "Tell him that RN is less affected by press criticism and opinion than any Pres in recent memory."

Kissinger, who saw and spoke with Nixon more often than anyone during his presidency, describes him as "a loner," a recluse who "would hole up in his hideaway office, slump in a chair, and write notes on a yellow legal pad. For hours or even days, he would shield himself from outsiders, allowing only a small circle of aides to join him in his rambling ruminations." Occasionally, when he had displeased the president, Kissinger found himself cut off as well. "Isolation had become almost a spiritual necessity to this withdrawn . . . tormented man who insisted so on his loneliness and created so much of his own torment. It was hard to avoid the impression," Kissinger added, "that Nixon, who thrived on crisis, also craved disasters."

Nixon was "a very odd man, an unpleasant man. He didn't enjoy people. What I never understood is why he went into politics," Kissinger said. Ultimately, Kissinger concluded that it was a form of vocational therapy: It gave Nixon the chance "to make himself over entirely," but it was a "goal beyond human capacity," and Nixon paid "a fearful price for this presumption."

So tormented a man not surprisingly surrounded himself with other imperfect people. Kissinger complained to British Ambassador John Freeman in 1970 that the men around Nixon were a collection of rogues: "I have never met such a gang of self-seeking bastards in my life . . ." Kissinger said. "I used to find the Kennedy group unattractively narcissistic, but they were idealists. These people are real heels."

Kissinger might have recognized himself in some of Nixon's inner struggles and the self-promoters populating his administration. Like the president, Kissinger was a man of great "intensity and stamina," as Nixon described him. It was the "intensity" of someone who was making up, or compensating, for a troubled past. Ehrlichman saw him as a nervous, impetuous neurotic, with nails bitten close to the quick. "He cared desperately what people wrote and said about him," Ehrlichman said. He

"erected a protective façade that was part self-deprecating humor and part intellectual showboating, but behind it he was devastated by press attacks on his professional competence." Bill Rogers, Kissinger's principal rival for control of foreign policy, saw him as "Machiavellian, deceitful, egotistical, arrogant, and insulting."

While Henry enjoyed intellectual give and take with thoughtful people arguing matters of substance, he couldn't bear to be one-upped, pushed aside, or made to play second fiddle. His petulance, temper tantrums, and need to dominate others and make them recognize his superiority bespoke inner doubts about identity and competence akin to Nixon's. He also shared Nixon's impulse to see ill-intentioned rivals everywhere, competitors motivated to make gains at his expense. More simply put, their sour view of people gave them license to be mean, or so they believed. "Kissinger and Nixon both had degrees of paranoia," Lawrence Eagleburger said. "It led them to worry about each other, but it also led them to make common cause on perceived mutual enemies."

Nixon and Kissinger were also decidedly different. Nixon's tensions with others made him reluctant to interact with people. "It would be goddamn easy to run this office if you didn't have to deal with people," Nixon told his press secretary. He recoiled from confronting antagonists or even friendly dissenters from his outlook, often taking refuge in solitude.

By contrast, Kissinger enjoyed the challenge of charming opponents by "taking on [their] coloration." Flattery was a principal tool in winning over adversaries, including Nixon, with whom he developed a keen rivalry. "It has been an inspiration to see your fortitude in adversity and your willingness to walk alone," Henry wrote him in 1972. "For this—as well as for the unfailing human kindness and consideration—I shall always be grateful."

One Kissinger associate described Henry as "irrepressibly gregarious," mesmerizing the press with his articulateness and self-deprecating wit. Journalists loved the story about the woman who, after an international crisis Kissinger helped end, told him, " 'Thank you for saving the world from a nuclear war.' 'You're welcome,' " Henry was reported as replying.

Shared personality traits made Nixon and Kissinger effective collaborators. Their combative natures made them distrustful of others, whom

they suspected of envy and ambition to outdo them. They focused a lot of their antagonism on bureaucrats, whom they saw as unimaginative protectors of their control over cumbersome government agencies.

Their similarities also made them combative rivals. Nixon distrusted Henry, doubting his sincerity about professions of admiration for him. Kissinger's eagerness for the spotlight and self-serving ambition put Nixon on edge about Henry's loyalty. He accurately suspected that Kissinger saw himself as a superior intellect manipulating a malleable president. He didn't like Henry's associations with the Georgetown elite and imagined him sitting around at dinner parties regaling his friends with unflattering tales about the bumbling president. Nixon called him my "Jew boy" behind his back and occasionally to his face, as a way to humiliate him and keep him in his place.

Kissinger reciprocated the nastiness by privately referring to Nixon as "that madman," "our drunken friend," and "the meatball mind." The journalist Marvin Kalb recalls numerous instances in which Henry would end a conversation with unflattering throwaway lines about Nixon: "Marvin, you see him as President of the United States. I see him as a madman." Or, he would ask rhetorically, "What can you expect of that madman, that maniac?" Henry would lament his fate: "I can't explain to you how difficult it is to work here. I am surrounded by maniacs in a madhouse." Henry never said such remarks were off the record. He was as indiscreet with other journalists. He simply assumed that none of them were going to publish his negative comments. It was a way to create feelings of intimacy with reporters, who found Henry's candor refreshing. Most important from Kissinger's perspective, it inclined the journalists to treat him sympathetically in published stories about his performance as national security adviser and secretary of state.

At the start of the Nixon term, none of the tensions between the president and Kissinger had surfaced. All was excitement and there were expectations of doing great things. In the ten weeks between the election in November and Nixon's inauguration on January 20, he was almost giddy. No one, at this time, would have accepted his description of himself as an introvert in an extrovert's business—a man who hated small talk and preferred to be alone. At his inaugural, dressed in formal attire, the fifty-six-year-old president-elect's radiance formed a contrast with the cold and overcast of a gloomy winter's day. "The expression on his face

was unforgettable," one aide recorded. "This was the time! He had arrived, he was in full command, someone said he felt he saw rays coming from his eyes." He made the rounds of the evening's six inaugural balls, giving witty speeches, exuding enthusiasm, and "relishing it all."

The day after his inauguration, during a meeting with former campaign workers, he came across as warm and sentimental, saying that he had moved Woodrow Wilson's desk from the vice president's office, where he had used it for eight years, to his own. The desk had been President McKinley's; it had his signature embedded in the wood, where he had signed the Spanish-American War peace treaty. Theodore Roosevelt had put the desk in the White House basement after McKinley's assassination, fearing it might bring him bad luck. When Mrs. Wilson rediscovered it in storage at the start of Wilson's second term, she had it moved back to the Oval Office. After Calvin Coolidge succeeded Harding on his death, Coolidge sent the Wilson desk to the VP's office, saying it had only one drawer and wasn't worth a "hoot."

At meetings with members of his staff and the cabinet, Nixon displayed an uncharacteristic affinity for banter; he declared his eagerness for "nice little chats" with every member of each gathering; joked that he wanted to be sure that he didn't forget the name of his commerce secretary, Maurice Stans, as he had a few weeks before on nationwide television; and facetiously announced his attraction to Harry Truman's suggestion that the cabinet include secretaries for columnists and semantics.

After eleven days in office, he was like an excited child enamored of a new toy; his pleasure at presidential ceremonials was transparent. During a white-tie diplomatic reception, he followed the color guard "playing processional" down the stairs from the second floor into the "cross hall," where he was announced. Preceded by the color guard playing "Hail to the Chief," the president marched "like a little kid or a wooden soldier, arms stiff, trying not to look as tickled as he obviously was," through the East Room into the Green Room, where he received guests. "P really ate it up," an aide recorded, "as at all ceremonies. He loves being P."

At the same time, the substantive business of governing never left his mind, as he made clear in his Inaugural Address on January 20. His speech was an appeal for a new era of peace at home and abroad. After so many years of domestic and foreign conflict, he declared the need for an end to "raucous discord . . . We are caught in war, wanting peace,"

he said. "We are torn by division, wanting unity . . . To lower our voices would be a simple thing. In these difficult years, America has suffered from a fever of words; from inflated rhetoric that promises more than it can deliver; from angry rhetoric that fans discontents into hatred; from bombastic rhetoric that postures instead of persuading. We cannot learn from one another until we stop shouting at one another."

His hope was to transfer the country's wealth "from [the] destruction of war abroad to the urgent needs of our people at home . . . After a period of confrontation, we are entering an era of negotiation," he predicted. He promised to devote his administration "to the cause of peace among nations." He intended to curb the excesses of Johnson's Great Society while ending the Vietnam War and improving relations with Communist adversaries.

His plea for renewed national comity could not instantly dissolve the divisions and anger provoked by Vietnam or long-standing impressions of him as an unscrupulous politician. The parade route from the Capitol to the White House along Pennsylvania Avenue was alive with protestors chanting "Ho, Ho, Ho Chi Minh, the NLF [Viet Cong] is going to win." Between Thirteenth and Fourteenth Streets, demonstrators hurled beer cans, bottles, and stones at the president's limousine. It was the first time in the Republic's 180-year history that such overt hostility had marred an inauguration.

In a White House summary of the day's events reported by newspapers on January 21, the first of what would become a regular digest of press stories Nixon read each morning, the *Washington Star* complained that police and other security forces guarding the president's route made no arrests of the "hoodlums" shouting obscenities and making obscene gestures. "Why not?" Nixon wrote in the margin, seeing a missed opportunity to evoke public sympathy and score political points against war opponents. A characteristic impulse to punish adversaries and seize a political advantage trumped public rhetoric about restoring civic peace and showing greater tolerance for opposing opinions.

But no one outside Nixon's inner circle saw the president's comment. The news summaries, on which Nixon made a habit of scribbling comments and orders for subordinates, became something of an open secret. Though their distribution was strictly limited, word leaked out that this was how Nixon kept track of press and television reporting on his administration.

The *Washington Post's* Don Oberdorfer recalls that in April 1971, when he was alone in a White House assistant's office for a few minutes, waiting to begin an interview, he took a copy of a daily news brief that was on the aide's desk. After setting the digest alongside of the actual press stories, Oberdorfer published a front-page article pointing out the distortions in the summaries. Pat Buchanan, the aide responsible for the digest, complained angrily to Oberdorfer, but it made Buchanan and the White House more fastidious about the summaries.

As with every president, Nixon began his term by reinventing the wheel. Though he had observed the operations of the office during his eight-year vice presidency, "Life in the White House," one of his aides said, "was like entering an entirely new world." Nixon did not want to make the Oval Office in the West Wing the principal center of his daily activities. He believed it fine for ceremonial and official meetings, and decorated it with paintings and prints that would appeal to Americans interested in the arts. (But not modern art, preferring period pieces like a color print titled *The President's House,* that was published in London in 1839 and given as a gift to Kennedy in 1962.) A Gilbert Stuart portrait of George Washington, a 1775 English wall clock, a pair of 1760 Dutch Delft vases converted into lamps, a collection of Edward Marshall Boehm porcelain birds, four 1846 silver sweetmeat dishes, and an 1820 French marble top pier table also adorned the room.

Yet however attractive and comfortable the Oval Office was, Nixon didn't want to work there. Nor did he like the small room down the hall, where Johnson used to confer with a single visitor and have drinks provided by a steward operating from a nearby cubbyhole. Nixon preferred an easily accessible "hideaway" office next door in the Old Executive Office Building (OEOB), "where he would not be interrupted by the constant activity in and around the West Wing," and could work alone or hold "private meetings with staff members." The handful of aides who had access to him in that office remember him always dressed in a jacket and tie sitting at his desk or in a brown easy chair with his feet on an ottoman reading or writing on a yellow-lined pad.

Nixon also turned his bedroom into another workplace, asking for two dictaphones, one to record "current matters and another for memoranda for the file which he will not want transcribed at this time." He

also requested a larger table at which he could sit more comfortably when he worked at night.

As was characteristic of every political office he held, he saw a fixed work schedule as essential to an effective presidency. In order to assure himself of sufficient time for "long-range, broad-scope thinking," he told an aide, he intended to focus his attention on only truly important matters and leave less compelling issues to subordinates. Avoidance of time wasting was crucial. He prided himself on saving two hours a day by not scheduling business or social breakfasts or lunches. On most days, he devoted only five minutes to eating breakfast and another five minutes to lunch. He reserved 40 to 45 minutes after lunch to read and prepare himself for the afternoon and evening schedules. He also rejected staff suggestions that he have people in for cocktails between five and six-thirty in the afternoon, preferring to use the time strictly for business meetings. "Whoever is President," he believed, should give up the luxury of socializing "in the interest of doing his job better."

To Nixon, self-indulgence was a forbidden comfort. He considered it negligent for a president to take his distance from "the burdens of the Presidency." He was "most frustrated" when he spent time enjoying himself away from work. His conscience bothered him, he said, that he was not doing "what I really ought to be doing." He remembered James K. Polk's admonition that "no one who really does the job of the Presidency adequately has any time for leisure—and this was 100 years ago."

He thought that Polk had gone a bit too far, however, and conceded that occasionally a president serves himself and the country well by taking a little "time off to recharge his batteries." His idea of exercise was "jogging in place for three or four hundred fast steps in the morning." As for recreation, an hour's walk on the beach at a California western White House, or bowling, or swimming, or boating was a sufficient restorative. He found these brief periods of activity "enormously refreshing" and not so time consuming as to make him "feel guilty about having left the job."

The same was true of periodic naps he secretly took to help him through long workdays. He never wanted to be seen as "taking time off . . . for relaxation or rest." The staff had "to provide evidence of constant . . . activity." He also enjoyed listening to classical music, but only late at night before going to bed. His principal recreation was reading

history and philosophy, especially because it gave him "good ideas" he could "use in speeches and meetings," and "a sense of perspective," which he could never get from "the instant news analysis in the newspapers and on TV." Occasionally, when he felt overwhelmed by work and too keyed up to sleep, he would have two or three drinks, which would do more than relax him. He had a low tolerance for alcohol, which would often result in slurred speech and tirades about perceived and real enemies.

A devoted staff made Nixon's exaggerated expectations of a non-stop work week more realizable. He surrounded himself with loyalists who shared his commitment to long days in the service of altering America and the world and winning Richard Nixon a second term.

H. R. (Bob) Haldeman, his chief of staff, a forty-two-year-old former Los Angeles advertising executive, who had worked as an advance man in the 1960 campaign, was Nixon's gatekeeper and man Friday, protecting him from the excessive demands that crowd a president's life and from himself, often deciding which presidential orders to implement and which to ignore. It was no small assignment. Haldeman spent hours each day taking notes, "then diffusing or distributing the President's momentary passions, threats, and tantrums into cool gusts of formal action memos over his own name. Nixon was angry many days and repetitive most days, saying the same things, usually about firing bureaucrats and cutting off reporters." Haldeman assured that most of Nixon's "ramblings and foul language" never reached a wider White House circle.

Haldeman was Nixon's indispensable man. Known as "the German," the austere Haldeman, identifiable by his crew cut and rough treatment of subordinates, set up "a Berlin Wall" around the president that kept everyone but a select few away from Nixon. The indefatigable Haldeman was available to Nixon 24/7 during the 1,561 days he served at the White House. Amazingly, the two men had no social ties beyond the exchanges that occurred in the course of doing business. Despite a ten-year association and day-to-day contacts in the White House, for example, Nixon knew nothing about Haldeman's four children.

John Ehrlichman, a former Seattle attorney, who had worked in every Nixon campaign since 1960, was domestic counselor. The forty-three-year-old Ehrlichman had been a Haldeman classmate at UCLA and had a successful law practice in Seattle, when he agreed to serve at the White House. As the aide in charge of domestic affairs, matters of

secondary interest to Nixon, Erlichman was less important than Haldeman. But "the burly," usually unsmiling Ehrlichman joined Haldeman in throwing up a barrier between the president and unwanted visitors whom Nixon saw as distractions from the compelling national security issues that generally filled his days.

John Mitchell, the third member of Nixon's inner circle, who had been a partner in the New York law firm Nixon had joined in 1962 and the 1968 campaign manager, became attorney general. Although he had no legal experience beyond practice as a bond attorney, his success in arranging Nixon's election and reputation as a tough law-and-order advocate brought him to the head of Nixon's justice department.

Haldeman, Ehrlichman, and Mitchell, none of whom had ever run for anything, shared an uncritical devotion to Nixon, whom they saw as a masterful politician and wise leader certain to serve the national well-being against Communist dangers abroad and liberal, big government advocates at home. Part of their attraction to the president was his willingness to do whatever seemed necessary to defeat opponents of what they saw as good for the country.

Because of his primary interest in foreign policy, no aide was more important to Nixon than Henry Kissinger. Like Kennedy, Nixon saw himself as, above all, a foreign policy president. He believed that since World War II and the onset of the Cold War, every president—FDR, Truman, Eisenhower, and Kennedy—had been compelled principally to devote their administrations to foreign affairs and the defense of the nation's security. Nixon contemptuously described domestic affairs as "building outhouses in Peoria."

His limited concern with domestic issues registered in his first cabinet meeting on January 22. He didn't wish to have regularly scheduled discussions with his full cabinet, which he considered an "unmanageable body with which to do business." More important, such meetings seemed certain to focus on domestic matters that bored him. Nor did he wish to sit around listening to cabinet members, several of whom were ex-governors likely to pronounce at length on the doings of their departments. At this initial meeting, according to Haldeman, the governors had "trouble adjusting to their new status as members of the cabinet instead of chief executive officers." They "distinguished themselves by their compulsion to talk, whether or not they had anything to say."

Nixon masked his true feelings about cabinet meetings by declaring that he wanted a "working cabinet" and set up subcabinet groups such as an Urban Affairs Council that would meet without him. Likewise, Nixon decided against giving a State of the Union address. Since Johnson had already fulfilled this constitutional requirement before the change of administrations in January, Nixon was not compelled to do it. And if he did, he thought it would have to focus on "legislative specifics," providing "an all-inclusive Nixon prescription for the nation's ills." Such a speech would "not reflect the real priorities of the new Administration."

To give foreign affairs the centrality Nixon wanted, Kissinger set up shop in the basement of the West Wing, from which he could have easy access to the president. From the beginning of Nixon's tenure, Henry became one of the few who could see him repeatedly almost every day, with numerous phone conversations filling the gaps between visits. In Nixon's Weekly Abstract or log of daily visitors for the first hundred days, when patterns were set, Kissinger had 198 individual or group meetings with the president. By contrast, in the same period, Rogers and Laird attended only thirty total meetings.

On the administration's third day in office, Henry began implementing Nixon's plan to ensure White House dominance of foreign policy. After William Bundy, assistant secretary of state for Asian affairs, told CIA director Richard Helms that he would organize a Saturday briefing on Vietnam, Henry emphatically told Helms, "This is not a State Department show and Bundy is not in charge." Henry promised to get the word to state. Later in the week, when the state department's Middle East division sent the president a policy paper which did not simultaneously come to Kissinger, he warned that if he didn't get a copy, a meeting with Nixon would be canceled.

Unlike Nixon, Kissinger surrounded himself with staff members notable not for their loyalty to Nixon or even Henry, but for their apparent intelligence and capacity to do their jobs. The principal figures in the opening months of Kissinger's tenure were Lawrence Eagleburger, a Foreign Service officer, Alexander Haig, a career military man, Morton Halperin, a Harvard academic, and Helmut Sonnenfeldt, a state department area and intelligence expert.

The thirty-eight-year-old Eagleburger, after a brief stint in the Army as a first lieutenant during the Korean War, became a professional dip-

lomat, serving in Honduras and Yugoslavia, where he developed a command of Spanish and Serbo-Croatian. His evident intelligence recommended him to superiors, who brought him into the state department to serve as a special assistant to the undersecretary in 1967–1968. An earlier two-year stint as a European expert at the National Security Council made him an attractive choice to return to the NSC as Kissinger's civilian deputy.

The forty-four-year-old Al Haig was an Army colonel who had come up through the ranks. A West Point graduate in the class of 1947 with an undistinguished academic record (he was 214 in a class of 310 cadets), he had won promotion to colonel through his service in Vietnam, where he had won seven medals, including a Silver Star, a Bronze Star for valor, and a Purple Heart. A by-the-book soldier with no special intellectual talents, language skills, area expertise, or even hobbies, he had advanced himself by the force of his drive and devotion to duties. Kissinger found him through former defense secretary Robert McNamara, Haig's onetime boss at the Pentagon, and Fritz Kraemer, who also knew Haig there. He was the deputy commandant at the U.S. Military Academy when Kissinger brought him back to Washington as his military aide.

Halperin was a Kissinger junior colleague at Harvard. He was someone "with an eight-cylinder mind and darting eyes that were always working." He was an expert on bureaucratic structures and "had put his theories into practice when he helped draft the new NSC structure for Kissinger, and played the game daily as he shuttled between Kissinger's office in the White House basement and the NSC staff offices in the Executive Office Building." Kissinger found a certain comfort in having another academic around who "was nimble both as a thinker and as an aficionado of faculty politics.

Hal Sonnenfeldt also appealed to Henry's academic side. The forty-two-year old Sonnenfeldt, like Kissinger, was a German-born émigré, with exceptional brain power. Though he had not gone beyond bachelor's and master's degrees at Johns Hopkins, his command of German and French, reading skills in Russian, and knowledge of European affairs generally and the U.S.S.R. and Eastern Europe in particular made him a valuable addition to the NSC. Henry brought him to the White House from the state department, where he had served as a director for intelligence and research on Russia and the East European Communist bloc.

The staff quickly learned that working for Kissinger was a difficult and at times even painful experience. Henry made it clear that he wanted them to be faceless subordinates whom the president and the press neither saw nor heard. "Access to the monarch is power," Haig said, "and no one understood such matters better than Kissinger." Any breach of this rule or any other failure to meet Kissinger's instant demands during fourteen- to sixteen-hour days, seven days a week, could produce explosions of anger—tantrums more appropriate to a child than someone forty-five years old with exceptional academic credentials and analytic powers. When in a stormy mood, as Haig describes it, Kissinger would pronounce a nautical homily: " 'When the ship sails onto the rocks, the captain is relieved!' His tone left no doubt that Eagleburger and I were the co-captains; Henry was the admiral."

Ten of the twenty-eight staff members Kissinger brought on board in January would be gone by September, including Eagleburger and Halperin, driven away by Kissinger's excessive demands on their lives. Eagleburger was a man of less than robust constitution who collapsed from nervous exhaustion and had to be hospitalized after three months on the job. As Haig described it, "On one occasion, after many hours of uninterrupted work, Kissinger asked Eagleburger to get him a certain document. Larry stood up, turned deathly pale, swayed, and then crashed to the floor unconscious. Kissinger stepped over his prostrate body and shouted, 'Where is the paper?' " When Kissinger realized that Eagleburger might have had a heart attack or stroke, he became as concerned about him as the rest of the staff. Fortunately, Eagleburger was only in a state of nervous exhaustion and after a period of recovery, he left the NSC for a state department job in Europe.

Haig soldiered on for four years, despite what he described as Kissinger's "fits of temper." They could be brought on not only by staff missteps but also "a scrap of gossip in which he was unfairly demeaned or a casual snub by a stranger." These could result in "hours, and sometimes days, of brooding and resentment." Haig's attributes, which quickly made him an essential part of Kissinger's NSC, included a talent for organizing the council's day-to-day work and a capacity to bear Henry's abuse stoically. "Only someone schooled in taking shit could put up with it," another staff member said. "Why have I been inflicted with such incompetents!" Henry would shout, while throwing memos on the floor and stomping on them.

Understanding that comic relief could break the mood of fear he cast over the staff, Kissinger cultivated a talent for making fun of himself. After moving to a larger office, he "complained that, when angry, it took him so long to stomp across the room and fling open the door that he sometimes forgot what had enraged him." Haig also used humor as a release from the abuse Kissinger inflicted on subordinates. After a Kissinger tirade against Haig before other staffers, Haig would imitate Henry behind his back and then march around the office like an unfeeling, mechanical robot impervious to anything but his master's commands. The sense of excitement at working with someone so intelligent and committed to large designs allowed many on the staff to follow Haig's lead in staying with Kissinger, despite his many abusive manners toward subordinates.

THE STRENGTHS AND FOIBLES of Nixon and Kissinger are biographical details that make them endlessly intriguing. How their personal traits shaped their performance in office is just as compelling. Their ambitions, hunger for power and control, suspicions, and personal rivalries both advanced and retarded their efforts to end the war in Vietnam and alter Soviet-American relations, dealings with China, conditions in the Middle East, and developments in Latin America. Variations in circumstance as well as region and country also influenced the outcome of their policies. But the impact of their personalities on their administration was of no small importance, as their making of foreign policy would forcefully demonstrate.

– Chapter 5 –

HOPE AND ILLUSION

Forces now are converging that make possible, for the first time, the hope that many of man's deepest aspirations can at last be realized.

—RICHARD NIXON, INAUGURAL ADDRESS, JANUARY 20, 1969

The pledges of each new Administration are leaves on a turbulent sea. No President-elect or his advisers can possibly know upon what shores they may finally be washed by that storm of deadlines, ambiguous information, complex choices, and manifold pressures which descends upon all leaders of a great nation.

—HENRY KISSINGER, *White House Years*

Major challenges faced Nixon and Kissinger at the start of their first term—Vietnam, Soviet relations, the Middle East, and China. They believed that if Nixon were going to win reelection and make a mark on history, these were the crucial foreign policy problems they would have to solve or at least make less threatening to America's national security.

Vietnam and advances in Soviet-American relations came first. In the "short range," Nixon recorded in January 1969 about China, "—no change. Long range—we do not want 800,000,000 people living in angry isolation. We want contact." He intended to restart secret diplomatic meetings with the Chinese in Warsaw, and told Kissinger to give private " 'encouragement to the attitude that this administration is exploring possibilities of rapprochement with the Chinese.' " It was a striking departure from Nixon's harsh attacks on "Red China" prior to 1969. As president, however, he no longer saw any domestic political value in bashing Democrats as soft on the Chinese Communists. He was focused instead on how unproductive continuing Sino-American tensions could be in the reach for greater international stability and peace. It was an initial demonstration of what Nixon and Kissinger sensibly thought of as foreign policy realism.

As for the Middle East, it "is a powder keg" he intended to make "every effort to defuse," beginning with Soviet-American talks, but not ruling out four-power negotiations, including Britain and France, and possible initiatives through the UN. Nixon and Kissinger told American Jewish leaders that it would make "many moves" to solve the region's problems, but the means to a sensible solution were unclear. As events would demonstrate, it was a gross understatement.

Achieving an "honorable" end to the Vietnam War was America's most compelling need. The emphasis was on "honorable." Kissinger believed that the United States could settle for nothing less. "What is involved now," he wrote in a January 1969 *Foreign Affairs* article, "is confidence in American promises . . . Unilateral withdrawal or a settlement which, even unintentionally, amounts to it could therefore lead to the erosion of restraints and to an even more dangerous international situation." Though Kissinger and Nixon believed this, they were also mindful that Johnson's inability to end the war had forced him from the presidency and seemed likely to cast a pall over his historical reputation. They were determined to withdraw from Vietnam to spare the United States from further losses and ensure against their political defeat.

Although Nixon had implied during the presidential campaign that he had a plan for ending the war, it was nothing more than an election ploy. Once he was elected, however, he began trying to find a formula to end the conflict. A month before he took office, he told Hanoi that

he was prepared for "serious talks," but would accept only "an honorable settlement," meaning an autonomous South Vietnam, which vindicated U.S. sacrifices.

Hanoi's initial reply to the president-elect discouraged hopes of an early settlement: The North Vietnamese insisted on the withdrawal of U.S. troops without saying anything about their departure from South Vietnam. They also insisted on an end to Thieu's rule in Saigon. Because Hanoi was so unforthcoming, Nixon initially refused to discuss troop withdrawals in the Paris negotiations. In February, after he had used his first press conference to announce U.S. insistence on mutual withdrawal of forces and a POW exchange, and Hanoi had rejected these conditions, the Paris talks seemed hopelessly stalled.

But the stalemate did not particularly worry Nixon. He believed it would take at least a year to get a settlement and that the public needed to hear this as a counter to press demands that Washington be more flexible in the negotiations. Though there was little truth to it, Nixon and Kissinger agreed that they should tell the public, "We know where we are going, [a] plan exists, some progress has been made."

In time, Nixon believed that he would be able to intimidate Hanoi. A report from Paris that the North Vietnamese saw Nixon as under less domestic pressure than Johnson to reach a quick settlement pleased Nixon. He told Haldeman that he was relying on what he called "the Madman theory." He believed that the North Vietnamese would see him as ready to "do anything to stop the war. We'll just slip the word to them that, 'for God's sake, you know Nixon is obsessed about Communism. We can't restrain him when he is angry—and he has his hand on the nuclear button'—and Ho Chi Minh himself will be in Paris in two days begging for peace." Nixon's assessment was no more realistic than Johnson's belief in 1965 that Ho couldn't say no to a billion-dollar development program Johnson proposed in a speech at Johns Hopkins University.

Nixon, like Johnson, misread the resolve of Ho and his colleagues in Hanoi. Decades of struggle to oust the French and unify all of Vietnam under Communist control insulated the North Vietnamese from favors and threats. The seventy-nine-year-old Ho was the symbol not only of Vietnam's struggle for self-determination but also of Communist rebellion against colonialism. Although he would die in September 1969, Ho's acolytes would not betray his resolve to maintain the struggle

against Western intruders in their domestic affairs. Nixon was aware of the French and American failures in Vietnam. Instead of chalking it up to Vietnamese effectiveness, he laid the blame on Western irresolution. He would avoid the mistakes that the French and Johnson had made—they weren't tough enough. He assumed that he could scare the Communists into believing that he would exert enough force to compel an acceptable end to the war for the United States. And if need be, he would apply sufficient power to compel a settlement.

To give credibility to his "Madman theory," Nixon believed it essential to increase the military pressure on the Communists in South Vietnam at once, but without provoking a break in negotiations. He told Kissinger to encourage press reports that the administration " 'at the highest levels' is considering an air strike on North Vietnam, designed to show the war will take a very tough new direction if the Paris talks collapse."

Kissinger pressed Laird and the Joint Chiefs to come up with something that could signal our determination to pressure the enemy during the initial negotiations in Paris. But they also needed to guard against provoking domestic repercussions in the U.S. Offensive operations in Laos and Cambodia were all considered as well as renewed air attacks on North Vietnam, but no one thought any of this would make a strong impression on Hanoi.

Although Nixon said later that they considered and summarily rejected "knockout blows"—destroying North Vietnam's dikes or using tactical nuclear weapons—there is no documentary evidence that such extreme action was ever discussed. Nixon and Kissinger knew that any substantial escalation of the conflict would touch off an explosion of domestic opposition that would undermine the administration's ability to govern and its prospects for a second term. The truth is that Nixon and Kissinger had no good alternative for ending the war except the application of more force. It was no different from what LBJ had tried before accepting in 1968 that a combination of Hanoi's resilience and American public opposition made military escalation an unproductive alternative.

On February 22, 1969, the Communists began an offensive in South Vietnam's central region from sanctuaries in Cambodia. Nixon was determined to identify something—anything—that could be seen by the Communists as an effective response to the renewed aggression.

He agreed to a Kissinger proposal for B-52 air attacks on the South Vietnamese side of the Cambodian border and to a contingency plan for a B-52 strike against "the central committee of the communist party in South Vietnam (COSVN)—the controlling headquarters of the North Vietnamese," which was supposedly located in what was described as the "fish hook" area of Cambodia northeast of Tay Ninh in South Vietnam.

Increased U.S. casualties and the belief that Hanoi was testing his resolve to maintain the U.S. commitment to Saigon convinced Nixon that he must retaliate with secret air strikes. He and Kissinger believed that "absolute secrecy" was essential to the success of any attack inside Cambodia—not only to ensure destroying the target but also out of a concern not to undermine peace talks by putting Hanoi "in a public position of seeming to negotiate under pressure." The unspoken reason for secrecy was White House fear of stirring antiwar protests that gave the lie to Nixon's campaign promises to end the war and domestic strife.

Reluctance to alienate the Phnom Penh government and fears of peace marches at home persuaded Nixon to hold back from an immediate assault on Cambodia. The country had long been a Communist supply route: the Chinese sent matériel through the port at Sihanoukville on the southwest coast in the Gulf of Thailand; and Hanoi supported their troops and the Viet Cong via the Ho Chi Minh Trail running south through Laos and eastern Cambodia. But hopes of convincing Prince Norodom Sihanouk to side with the U.S. and South Vietnamese had given the country immunity from attack, and Nixon was reluctant to abandon this strategy. In February 1969, moreover, Laird and Rogers warned that if U.S. air raids on Cambodia became public knowledge—the Cambodians or the North Vietnamese might reveal them—it would touch off fresh antiwar demonstrations in the United States and deepen Hanoi's conviction that U.S. domestic opposition would force a settlement on its terms.

With little reason to think that an air assault would produce a prompt end to the conflict, Nixon decided to make an attack on Cambodia a contingency rather than an immediate reality. Besides, Nixon and Kissinger had some hope that the CIA might be able to use "bribery" to curtail Sihanouk's collaboration with Hanoi. "K[issinger] asked if H[elms] could get him a formal reply as to whether anything can be done—bribery, etc.—re Cambodian assistance to the North Vietnam-

ese," the summary of a February Kissinger telephone conversation with Helms reads. Helms promised him a prompt answer.

The CIA considered offering bribes to Cambodian officials to halt the flow of arms through its country to Vietnam, but concluded that it could not match the profits accruing to the officials from the arms traffic. Nor would these officials be willing to take the political risks involved in working with the United States.

Nixon and Kissinger resorted to other means to gain Sihanouk's cooperation. They viewed him as a "vain and flighty" but masterful politician who had miraculously managed to preserve his country's independence. Appealing to his well-honed survival instincts, U.S. representatives convinced Sihanouk that he could benefit from the reopening of a U.S. diplomatic mission in Phnom Penh and from turning a blind eye to air attacks on North Vietnamese forces in eastern Cambodia, from which his countrymen had been expelled.

Before expanding military action, however, Nixon and Kissinger wanted to try convincing Moscow to pressure Hanoi into a settlement. In December, before Nixon took office, Kissinger had a conversation with an unamed Soviet diplomat in which he explained that Moscow's interest in strategic arms talks would be reciprocated if it cooperated on Vietnam and the Middle East. Arms control without political agreements would not significantly reduce tensions, the Soviets were also told.

At a meeting with Nixon on February 17, Ambassador Anatoly Dobrynin assured the president that the Soviet government shared his interest in starting a new era of negotiations rather than confrontation. Nixon expressed the view that Vietnam would be a good place to start and asked the Soviets "to get the Paris talks off dead-center . . . Progress in one area is bound to have an influence on progress in all other areas," he said.

Dobrynin's receptivity to negotiations with the United States suggested to Nixon and Kissinger that they might be able to link arms control talks to peace arrangements for Vietnam. But it was wishful thinking. As with hopes that the "Mad Man theory" could push Ho into a peace agreement, the Nixon-Kissinger assumption about prospects for what Kissinger called "linkage" was no more realistic.

Malcolm Toon, the state department's director of Soviet Affairs, told Kissinger that Moscow understood Nixon's eagerness to link progress on political problems to advances on arms control, but that they were reluc-

tant to make the connection. Dobrynin dismissed administration expectations in a conversation with Averell Harriman, saying Moscow "would not be bribed or intimidated." His comment spoke volumes about Soviet understanding of what limited influence they held over their Middle East allies and North Vietnam.

Toon's cautionary note went unheeded. It was part of the Nixon-Kissinger effort to isolate the state department from direct involvement in negotiations with the Soviets. Before the meeting with Dobrynin, Nixon had asked Haldeman to inform Rogers that he would not be invited. When Rogers objected, Nixon, against Kissinger's advice, agreed to have Toon present at the conversation. After Toon and Kissinger had left the meeting, Nixon told Dobrynin that in the future he wanted him to discuss sensitive issues with Kissinger before there was any contact with Rogers or the state department.

Dobrynin was happy to agree. An astute diplomat with a substantial knowledge of American politics and personalities honed during four years as head of the American division of the Soviet Foreign Office and seven years in Washington, Dobrynin understood from the first that Nixon intended to make Kissinger his principal negotiator. Let us address each other by our first names, Anatoly told Henry at their initial meeting in February 1969. Kissinger described him as "subtle and disciplined, warm in his demeanor while wary in his conduct, Dobrynin moved through the upper echelons of Washington with consummate skill." Henry saw him as an ambassador who, unlike the many ciphers Moscow had representing it abroad, could make a valuable contribution to reduced tensions in Soviet-American relations.

The relationship with Dobrynin "formally established" what Kissinger called "the Channel." Nixon and Kissinger feared a loss of control over policy making if they included Rogers and the state department in discussions with the Soviets, but their concerns seem overblown and less than a full explanation of their motives. They not only considered Rogers and state's bureaucracy an impediment to fresh diplomatic initiatives, they also saw the arrangement as a way to guard against sharing accolades for administration successes. Yet by cutting themselves off from the expertise someone like Toon brought to the analysis of Soviet-American relations, they overinvested in hopes of a major Soviet part in forcing an end to the Vietnam conflict.

Nixon and Kissinger certainly had identified the greatest challenges facing the United States when they gave priority to ending the war, reducing tensions with Moscow, establishing official relations with China, and promoting Middle East peace talks. But their shared belief that they were able to address these problems without significant help from the state and defense departments or the CIA was a serious mistake. Their assumption that press leaks from the departments would undermine and even destroy their initiatives is unconvincing. True, these agencies could waste time and energy in bureaucratic turf wars and were notorious for less than imaginative thinking. But treating other U.S. government officials as if they were enemies who could not be trusted created resentments and forestalled internal discussions with experienced diplomats and national security authorities that might have produced a greater realism about international challenges. Their failure to consult members of the Senate and House committees on foreign affairs was as pronounced.

Because their rationalization for barring others in the administration and Congress from a central role in policy making is so questionable, it suggests that Nixon and Kissinger had a hidden agenda that they themselves did not fully glimpse. Both men were painfully unsure of themselves. They put up bold fronts that masked inner uncertainties and made them all too prone to guard against self-doubts by insisting on the greatest possible control. It was as if they couldn't bear criticism or open themselves to advice that might conflict with their views. Nixon needed constant reassurance that he was performing effectively. After the meeting with Dobrynin, for example, Nixon repeatedly asked and received Kissinger's assurances that he had struck all the right notes in the conversation.

Walter Isaacson got it just right when he wrote that the Nixon-Kissinger style of governance was more the result of "their personalities than because it suited the security interests of the nation. They both had a penchant for secrecy, a distaste for sharing credit with others, and a romantic view of themselves as loners . . . Neither believed he had much to learn from professional diplomats or congressmen. Nor did either have any faith that public input and the messiness of public debate might lead to wiser decisions." Roger Morris says that "the brutal truth was that, at heart, neither man had a steadfast faith in the democratic process, least of all as applied to the conduct of foreign policy."

Kissinger himself acknowledged that "less elevated motives of vanity and quest for power [may have] played a role" in what he and Nixon did. "It is unlikely that they were entirely absent," he conceded. But neither he nor Nixon seemed to have enough self-awareness to accept the extent to which such impulses governed their behavior and reduced their receptivity to outside judgments that might have made them more successful in managing foreign affairs.

BECAUSE NEITHER VIETNAM, Soviet-American relations, China, nor Middle East problems offered any prospect of a quick advance in international relations, Nixon decided to make a late-February trip to Europe, where he could demonstrate his interest in and relative mastery of foreign policy. He wished to impress himself on everyone at home and abroad as the leader of the free world, he told Haldeman. The eight-day trip between February 23 and March 2, with stops in Brussels, London, Bonn, Berlin, Rome, and Paris, was a whirlwind of ceremonies largely devoid of substance. As Nixon acknowledged to reporters at the start of the trip, the discussions would not produce "any spectacular news" about the successful negotiation of existing problems. "He was under no illusions that grand tours or . . . a 'new spirit' would resolve basic differences between adversaries, or even allies," he told congressional leaders. Nevertheless, he expected the trip to underscore his standing as an American statesman intent on advancing international harmony.

The most telling moments of the trip came in France when Nixon met with President Charles de Gaulle, the West's most prominent political figure. De Gaulle was ending a thirty-year public career dating from the French defeat early in World War II. Nixon remembered a lunch with him on an outdoor patio at the Elysée Palace in 1962, at which de Gaulle gave an "eloquent toast," remarking on Nixon's "difficult defeats" and predicting that "at some time in the future I would be serving my nation in a very high capacity." It was a flattering comparison to the arc of de Gaulle's own career.

During the February meeting in de Gaulle's Elysée Palace office, de Gaulle declared himself "entirely at the President's disposal to discuss anything he wished." It was an expression of his self-confidence that he could instruct the Americans on all the major issues of the moment. "He exuded authority," Kissinger recalls. When he came to Washington four

weeks later for Eisenhower's funeral, he was the most impressive head of government in attendance.

Nixon asked his advice on the Soviet Union. De Gaulle forcefully encouraged Nixon's inclinations to work out differences with them. "There was Russia and there was Communism and . . . they were not always the same thing," de Gaulle said. While he did not think "the danger of communism was over . . . it can no longer conquer the world. It is too late for that."

De Gaulle saw the possibility for a "rapprochement," by which he meant not "full confidence and trust" in the West but an arrangement that would assure against any Western attack. He was also confident that the Soviets had no intention of marching west. They knew this would lead to a war that they could not win. A policy of détente toward Moscow "was a matter of good sense. . . . In a world of détente, liberty would be the gainer" in Eastern Europe and possibly Russia as well. Nixon embraced de Gaulle's advice on Soviet Russia as sensible realism.

What would de Gaulle suggest about equally perplexing problems in the Middle East? The 1967 war, in which Israel had occupied the West Bank of the Jordan River, the Sinai, and Syria's Golan Heights, had left a legacy of rage that provoked intermittent violence. While the United States and some European countries supplied Israel with weapons to meet the attacks, the Soviets equipped Egypt and Syria, making the Middle East, in Nixon's words, "an international powder keg" that could provoke a crisis between the United States and the U.S.S.R.

De Gaulle had limited sympathy for Israel. He described France as friendly to the Israelis before their attack in the recent war. He believed that a prompt settlement was essential to international stability, which should include a return of occupied territories, recognition of Israel's existence, freedom of navigation in the Gulf of Aqaba and the Suez Canal, and a return of Palestinian refugees to their homes "insofar as this could be done." Without a settlement, he expected the Israelis to "become more and more imperialistic." They would "go to the Nile, to Beirut and to Damascus." But then they "would face colossal difficulties . . . There would be assassinations and concentration camps, the [oil] pipe lines would be blown up."

Nixon assured de Gaulle that unlike other presidents, he would not be influenced by the Jewish vote in the United States. He intended to

make decisions about the Middle East based on strict considerations of national security.

Nixon described himself to de Gaulle as "somewhat pessimistic on the Middle East." He was fearful that even with a settlement "Radical Forces" could scuttle any agreement. In addition to the likely intransigence of the Arabs and Israelis, he knew that, despite his talk of indifference to internal political pressures, American domestic politics would have a significant impact on decisions about the Middle East. In a mid-February meeting with six pro-Israeli congressmen, Nixon had assured them that the administration would not urge a settlement that jeopardized Israel's basic interests. Before his meeting with the congressmen, Kissinger had told Nixon, "Your response will be important in setting the tone of our relationship with the [American-Jewish] community on Mid-East policy. They can make it very difficult for us to pursue a sensible policy."

Not surprisingly, a brief discussion about China did not come up until the following day, when de Gaulle urged improved relations and Nixon described China as a long-range problem which could not be resolved in the short term.

Vietnam, by contrast, which was an urgent, immediate dilemma, was left for consideration at a final third-day meeting. Nixon may have assumed that de Gaulle's advice would not be very helpful or that he would urge ending U.S. involvement in the fighting without offering constructive suggestions on how to do it.

Nevertheless, Nixon asked for de Gaulle's counsel. Although he did not view the Algerian war as "a parallel situation," de Gaulle replied, it was "a similar one." Unlike Algeria, however, where France had a million settlers and had been for 130 years, the United States had a limited involvement with Vietnam. And though a settlement would produce "attacks at home and needles from the outside," it was better to conclude U.S. involvement than to continue a struggle that was bound to end badly. Ending the war would free the United States to advance toward normal relations with Moscow. Moreover, "the U.S. could make such a settlement because its power and wealth were so great that it could do this with dignity. It would be better to let go than to try and stay."

It was not what Nixon wanted to hear. He told de Gaulle that if the United States did not end the war "in a responsible way," it would erode America's credibility. De Gaulle was too polite or too doubtful that it

would help to tell him that continuing the war was causing greater injury to America's international standing than finding a rapid exit.

De Gaulle was more direct with Kissinger. At the end of a formal dinner, de Gaulle privately asked Henry: "Why don't you get out of Vietnam?" Kissinger replied: "Because a sudden withdrawal might give us a credibility problem. 'Where?' the general wanted to know. I mentioned the Middle East. 'How very odd,' the general said from a foot above me. 'It is precisely in the Middle East that I thought your enemies had the credibility problem.'" As Nixon and Kissinger would learn in time, de Gaulle had it right: a quick exit from Vietnam would have helped, not undermined America's credibility.

It is surprising that neither Nixon nor Kissinger said anything about the Domino theory—namely, that a Communist victory in South Vietnam would topple other Southeast Asian states. But by 1969, this was an argument that had little continuing credence in the United States. What Nixon and Kissinger understood was that an ongoing U.S. presence in Vietnam would have to be tied more directly to American national security; hence, the credibility argument. A loss of U.S. credibility with its allies and adversaries would undermine the country's ability to battle communism in the Cold War.

It was an argument that left de Gaulle and others abroad unconvinced, but many Americans were reluctant to summarily reject it. It is surprising that neither the president nor Kissinger saw fit to inquire how other governments would view America's prompt end to the war. One can only assume that they thought the answer would not have been to their liking, and so they plunged ahead on a Vietnam strategy that they saw protecting U.S. credibility by preserving Saigon's autonomy. And, not incidentally, giving them an assertion that made domestic critics seem all too casual about national defense.

The European trip gave Nixon what he wanted: a positive public reaction describing him as "a man of stature and wisdom. We could not have asked for more," Pat Buchanan told him. Kissinger privately echoed the praise: "It is an understatement to say that the trip was an overwhelming success, both in reinforcing a positive public image of yourself and the United States."

Such hyperbole made Nixon feel good, but it did nothing to foster his understanding of how difficult it would be to reach his foreign policy

goals. True, there were domestic political benefits from the trip, which Nixon was happy to exploit. But the more important measure of whether the trip had changed international relations was rationalized. "We should have 'no illusions' that a trip of this nature can solve basic disagreements between nations," Nixon told congressional leaders. "However, on this trip we 'did set a climate which can settle the close ones' and help us toward settlement of the more difficult disagreements."

Kissinger was less happy with the trip's impact on his control of foreign policy. To be sure, Nixon asked de Gaulle to ignore the usual diplomatic channels whenever he wished to reach him, and instead communicate through Kissinger. But Rogers's presence on the trip pushed Henry off center stage. Protocol dictated that Rogers be more often at Nixon's side than the national security adviser. Kissinger complained to Haldeman that his diminished status would weaken his ability to deal with foreign officials. "Henry swings from very tense to very funny," Haldeman recorded during the trip.

AFTER THEY RETURNED FROM EUROPE, Kissinger criticized Rogers for telling Dobrynin that the administration was ready to enter into four-party political discussions on Vietnam with the North and South Vietnamese and the Viet Cong. Kissinger described this to Nixon as a serious error that would undermine the administration's negotiating maneuverability in Paris and relations with Saigon.

Kissinger fought Rogers's initiative by telling Dobrynin that we remained in favor of bilateral discussions with Hanoi about withdrawal, with political matters left to Saigon and the NLF. In a telephone conversation with Nixon, Henry predicted that Rogers's proposal would injure relations with Thieu, and warned against the state department turning "itself loose again."

A scant month into the administration, Kissinger told Haldeman that he couldn't work with Rogers and was considering resigning. Haldeman counseled against any such talk, and the president appeased Henry by acknowledging Rogers's mistake. But Nixon did not think that Rogers realized "the tremendous significance of tying political with military matters," and recommended that they educate him.

Kissinger was less forgiving: He complained to Haldeman that "Rogers' self-interest is so paramount that he can't adequately serve the

President." (Rogers, whose affinity for intrigue and self-promotion was no match for Kissinger's, might have lodged just this complaint against Henry.) Kissinger's solution was to urge the president to appoint Rogers Chief Justice when Earl Warren resigned at the close of the Court's term in June.

DURING THE FIRST TWO WEEKS of March, Nixon had bigger worries than making peace between his secretary of state and national security adviser. During his European trip in February, the North Vietnamese offensive, which more than doubled the number of American troops killed in a week to 453, outraged Nixon. As the journalist Seymour Hersh argued, the attacks were probably in retaliation for stepped-up American ground operations between November 1968 and February 1969. The state department, as a Nixon-Kissinger telephone conversation released in 2004 makes clear, put this argument before Nixon, but he rejected it. "State Department people never see these things with any realism," Nixon said. He chose to interpret the attacks as a personal slap in the face: He saw Hanoi saying that the new president had no leverage to negotiate an honorable settlement and that the only U.S. recourse was to withdraw its forces and leave Vietnam's fate to the Vietnamese—North and South.

Nixon now spent close to a month agonizing over how to respond. He and Kissinger continued to believe it desperately important to hide any air attacks on Cambodia lest they touch off an explosion of domestic opposition. Consequently, at a news conference on March 14, he coolly declared his intention to proceed with private talks in Paris that could lead to a settlement. "My response" to the Communist offensive, he added, "has been measured, deliberate, and some think, too cautious. But it will continue to be that way, because I am thinking of those peace talks every time I think of a military option in Vietnam."

His only public indication of a heightened resolve to fight the war to a satisfactory conclusion was a response to a reporter's question about troop levels: "There is no prospect for a reduction of American forces in the foreseeable future," he said. For those who hoped to see a prompt end to American involvement, it was a troubling signal that Nixon had no clear idea of how to bring peace.

In fact, Nixon knew he couldn't sustain the war effort at current

levels without destroying his presidency, as Johnson had. And so plans were already being made to withdraw troops from Vietnam. But Nixon felt "very strongly," Kissinger told Laird, that this "has to be kept to a small circle—there can be no leaks beforehand."

As for bombing Cambodia, Nixon privately seethed and ran an erratic course. "All his instincts were to respond violently to Hanoi's cynical maneuver," Kissinger recalled. On the way to Brussels, his first European stop, Nixon excitedly instructed Kissinger to direct the Pentagon to implement plans to bomb the Cambodian sanctuaries. Haig and an Air Force colonel were ordered to fly at once to the Brussels airport for a secret conference with Kissinger and Haldeman on *Air Force One*. A concern for "total secrecy" about the plan was reflected in instructions to the colonel that the Strategic Air Command be kept in the dark and that B-52 pilots be misled into believing that they were bombing targets in South Vietnam.

It would entail an astonishing act of duplicity. The colonel later told Seymour Hersh that if the operation "leaked to the press and led to antiwar and anti-Nixon protests . . . he would be . . . saddled with the blame." Since it would take time for the colonel to devise a means to hide the operation from Air Force chiefs and since Rogers opposed the whole idea and Laird favored doing it openly, Nixon delayed a final decision.

For two weeks after he returned from Europe, Nixon struggled over whether to proceed. But he was eager to hit hard at the Communists. "There is not going to be any de-escalation," he told Kissinger in a phone conversation on March 8. "We are just going to keep giving word to [Joint Chiefs Chairman General Earl] Wheeler to knock hell out of them." He also told Kissinger that he didn't like being in the position of saying "No, yes, no, yes, or maybe."

But Henry added to Nixon's hesitation by warning that if private talks they favored outside the established venue began in Paris, an attack on Cambodia would jeopardize them. Nixon insisted, however, that he would not allow the Communists to kick us without a response. "We cannot tolerate one more of these [assaults in South Vietnam] without hitting back," he said. ". . . However, if they don't hit us, we are screwed," meaning he badly wanted a rationale for bombing. He was avid to show the Communists that they were dealing with a president who was ready to beat them into submission.

A Viet Cong attack on Saigon on March 15 settled the issue. Still, Nixon was unsure about an effective course of action. Despite ordering an attack on North Vietnam's Cambodian base, Nixon manifested continuing doubts in repeated telephone calls to Kissinger. "State is to be notified only after the point of no return," he shouted into the receiver at 3:35 on the afternoon of the fifteenth. "The order is not appealable." Calling back nine minutes later, he excitedly declared that orders were to go out to all officials prohibiting any comment on the Communist attack. "No comment, no warnings, no complaints, no protests . . . I mean it, not one thing to be said to anyone publicly or privately without my prior approval." One minute later, he called again: "Everything that will fly is to get over to North Vietnam . . . There is to be no appeal from that either. He will let them [the Communists and the doubters in his administration] know who is boss around here."

Hyperbole was Nixon's response to doubts and indecision: "The 'order is not appealable' was a favorite Nixon phrase," Kissinger said, "which to those who knew him grew to mean considerable uncertainty."

The air raid became a moment for self-congratulation. Code-named Menu, with a March 18 attack dubbed Breakfast ("as meaningless as it was tasteless," Kissinger said), the bombing three miles inside of Cambodia was hailed at the White House as a great success. It apparently hit ammunition and fuel depots, which allegedly produced seventy-three secondary explosions. Kissinger told General Wheeler, "Psychologically, the impact must have been something."

Although they had no evidence that the North Vietnamese headquarters, which had been the principal target of the raid, had been destroyed, Nixon and Kissinger took satisfaction from Communist and Cambodian silence. Instead of loud protests, which they feared and had planned a public response to, neither Hanoi nor Phnom Penh said anything. The North Vietnamese apparently kept quiet out of a reluctance to acknowledge their presence in Cambodia and the possibility that it might become an excuse for a U.S. ground assault, which could deprive Hanoi of a useful sanctuary.

Nixon and Kissinger also believed that the air attack advanced the Paris peace talks. Two days after the attack, Hanoi's acceptance of bilateral private talks in Paris seemed connected to the raid. "Now we know how badly they need" the negotiations, Henry told the president, imply-

ing that because of the bombing, the North Vietnamese felt compelled to come to the peace table.

Nixon agreed. He told Kissinger that North Vietnamese complaints to Moscow about the air action was a response to the attack. Henry replied: "If Hanoi weren't in trouble, they would never have agreed so fast" to private talks. "If our domestic critics would leave us alone for six months, we could get something accomplished," he added.

It was all wishful thinking. "Domestic critics" in the Congress, the press, and a growing body of public opinion made it impossible for the White House to enjoy an extended period in which war protests would be suspended. Over the next month, the Paris talks also demonstrated that Hanoi was unyielding in its resistance to U.S. peace plans.

For the moment, however, Hanoi's willingness to engage in secret talks after the air attacks encouraged Nixon to assume that his tough action was having the desired effect. He was ready to keep hitting them. "There will be no de-escalation except as an outgrowth of mutual troop withdrawal," Nixon declared after a March 28 NSC meeting. Hence, on March 31, when the Communists staged another rocket attack on Saigon, Nixon told Kissinger, "We should let them have it again—crack the hell out of them . . . Our major problem is for them not to have a sign that we are caving in." Henry wanted to hit a different area in Cambodia.

Despite a nonresponse to the March 31 attack and ongoing North Vietnamese insistence on unilateral U.S. withdrawal, Nixon and Kissinger continued to talk as if they were prepared to break Hanoi's will through expanded military actions. On April 3, Kissinger told Dobrynin that "the President was determined to end the war one way or the other." He wanted Dobrynin to understand that he "did not speak idly." He also raised the possibility that an ongoing conflict in Vietnam could provoke a Soviet-American conflict. On the fifteenth, he warned Dobrynin that U.S. actions in Vietnam might complicate Soviet-American relations and impede strategic arms and Middle East peace talks.

The Nixon-Kissinger threats were empty talk. They had no intention of forcing a showdown with Moscow over Vietnam; nor did they feel free to buck American public sentiment by openly escalating the war against Hanoi. A Kissinger plan, which had been discussed during LBJ's presidency, to mine North Vietnam's Haiphong harbor unless there were

results in Paris was more posturing. The threat was also a way to pressure Rogers and Laird, to whom Nixon sent a tough memo emphasizing their need to support White House policy.

Nevertheless, Nixon and Kissinger continued to see military action as essential to an honorable peace in Southeast Asia. In April, they unleashed additional air attacks on Cambodia code-named Lunch. In raids on April 23 and April 24, they increased the number of B-52s hitting Cambodia from forty-eight to ninety. The attacks caused "150 secondary explosions and 44 secondary fires." The chiefs told Henry that "this is the most successful thing of this kind they have ever done." The hyperbole about the raids and the continuing lack of a public Cambodian or North Vietnamese response encouraged Nixon to authorize additional attacks over the next five weeks—callously titled by someone at the Pentagon, Snack, Dinner, Dessert, and Supper.

Reports from General Abrams and Ambassador Bunker that "Menu has been one of the most telling operations in the entire war" encouraged White House hopes that the air campaign would make Hanoi more flexible in the Paris discussions. It was a false assumption. Whatever one may say about the legality and morality of such secret raids—and much critical comment would be made when they were revealed in 1973—they did not produce a significant change in North Vietnam's determination to fight.

Although the administration would consistently hide attacks on Cambodia by listing them as raids on South Vietnam and though neither Hanoi nor Phnom Penh made them public, they became news nevertheless. On May 9, 1969, William Beecher, the *New York Times* Pentagon correspondent, ran a front-page story describing the B-52 raids on Communist supply dumps in Cambodia.

Nixon and Kissinger were outraged and refused to comment on the report. Henry called Laird, who he believed had leaked the Cambodian story: "You son of a bitch," Kissinger shouted at him on the telephone. "I know you leaked that story, and you're going to have to explain it to the president." Laird, who had not given the story to Beecher but had confirmed the bombing, hung up on Kissinger.

Nixon and Kissinger had no categorical objections to leaks per se: they saw them as inevitable and were happy to use them to promote their own agendas, including impressions that they would act decisively

in Vietnam. Moreover, within a month of becoming president, Nixon had told Henry, "I believe in controlling the news—but not in the sense of curbing anything—but in what you put out. Just find what you want to say and say it."

Nixon's response to a negative newspaper account belied his words: "What is this cock-sucking story," he exploded. "Find out who leaked it, and fire him!" From the start of his presidency, Nixon had obsessed about using the media to create positive images of himself and the administration. He wanted aides to orchestrate letters to newspaper editors and calls to TV stations. He felt that letters attacking various columnists who "unfairly" criticized him would be especially useful. When the television comedians, the Smothers Brothers, poked fun at him for thinking he could solve national problems, he wanted administration supporters to flood the producers with complaining letters and calls.

Henry initially announced his intention to avoid dealings with the press. But he quickly learned how much Nixon would rely on him to explain administration policies and purposes. Within days of becoming national security adviser, he began talking to leading members of the Washington press corps. Nixon repeatedly used him to plant stories with a few key columnists about the president's effectiveness in making foreign policy and winning public approval. Henry was happy to satisfy Nixon's requests, and at the same time, establish good relations with journalists who could help create a positive public image of himself. His staff, however, was warned against press contacts, especially those that led to unauthorized leaks or took the limelight away from their boss.

In April, after press stories appeared about Soviet missile deployments based on "highly classified information," plans to withdraw troops from Vietnam, and negotiations for arms sales to Jordan, Nixon and Kissinger tried to find the sources of these leaks. They were particularly angered by what they saw as pressure on the administration to act prematurely in pulling out of Vietnam and by stories that might demoralize the South Vietnamese.

On April 18, Henry "expressed dismay" to Rogers about a leak "and said so help him if he finds out who that man is." In a conversation with FBI Director J. Edgar Hoover, Henry promised to "destroy whoever did this if we can find him, no matter where he is." Henry also described one story to Joe Alsop as "totally untrue." Reports that they were plan-

ning to withdraw "200,000 troops is absurd." On April 25, Nixon discussed means of reining in leaks with Attorney General John Mitchell and Hoover. Hoover said that wiretaps were "the only really effective means of uncovering leakers." Every president since Franklin Roosevelt had used them to defend the country against the unauthorized release of sensitive information. Ten days later, Kissinger conferred with Hoover at FBI headquarters as a follow up to a Nixon decision to have Henry "supply Hoover with the names of individuals who had access to the leaked materials and whom he had any cause to suspect." Kissinger named Al Haig as his go-between to Hoover.

When Nixon and Kissinger told Hoover that the May 9 and earlier leaks "were more than just damaging; they were potentially dangerous to national security," Hoover began tapping the phones of three national security officials identified by Henry—Daniel Davidson, Morton Halperin, and Hal Sonnenfeldt—and one defense department officer, Colonel Robert Pursley, a Laird assistant. Within days, two other NSC staff members came under scrutiny as well: Richard Moose and Richard Sneider. FBI agents also began listening to the phone conversations of four journalists—Beecher and Hendrick Smith of the *Times*, an English correspondent based in Washington, Henry Brandon of the *Sunday Times of London*, and CBS newsman Marvin Kalb.

"From early 1969 to early 1971," Nixon said seven years later, seventeen individuals were wiretapped by the FBI. The group included four newsmen and thirteen White House, state, and defense department aides. An eighteenth tap was put on the syndicated columnist Joseph Kraft. He came under suspicion because he "had very good sources in the White House and NSC staffs and at the State and Defense Departments," and also had "direct contact with the North Vietnamese," with whom he spoke when he traveled to Paris.

The irony is that the taps on Kraft may have been aimed as much at Kissinger as at Kraft. Nixon came to believe, with good reason, that Henry was a prime source of Kraft's inside information. Nixon said later that he could not remember why he authorized all these taps and acknowledged that "unfortunately none of these wiretaps turned up any proof linking anyone in the government to a specific national security leak." In a 1973 taped conversation with White House counsel John Dean, Nixon was more graphic about the pointlessness of the

taps: "They never helped us," he said. "Just gobs and gobs of material. Gossip and bullshitting."

Partisan politics may have partly motivated the tapping. Hoover advised Nixon, Kissinger, and Haig that many of the leaks were coming from Democrats eager to undermine a Republican administration. During their April 25 conversation at Camp David, Hoover, according to Haldeman, talked about "all the bad guys" who had "infiltrated into everywhere, especially State. Hoover full of hair-raising reports about all this." After receiving "a very sensitive report" from Hoover, Haig told Kissinger, "I suspect that many of these individuals [civil service Democrats] are the sources of our leaks to the press and some of the problems we have experienced in enforcing and implementing Presidential policy."

Although Nixon justified the taps as legal and essential to the national interest and in line with what earlier presidents had done—"the average number of warrantless wiretaps per year during my presidency was less than in any administration since FDR's"—they had less to do with national security or even politics than Nixon acknowledged.

The principal motives for the taps were the Nixon-Kissinger compulsion to exercise as much control over foreign policy as possible, and Nixon's long-standing animus toward the press. ("The press is the enemy," Nixon never tired of telling his aides and supporters.) Specifically, by the spring of 1969, he and Henry were frustrated at the limits of their control over international affairs. Neither the Soviets nor the North Vietnamese were responding to the administration's pressure for productive peace talks; the Middle East and Latin America presented insurmountable barriers to gains.

If they couldn't master developments overseas, Nixon and Kissinger hoped at least to control foreign policy making at home. In brief, if they couldn't bend other governments to their will, they became all the more insistent on forcing their bureaucracies and the American press to follow their lead. It was hardly a reason to wiretap fellow citizens, but foreign policy making by Nixon and Kissinger was never as rational as they pretended it was or hoped it might be.

Vietnam was the prime case in point. During the first four months of the administration, a tone of confident optimism ran through all the private and public discussion about bringing the war to a satisfactory

conclusion. When Nixon met with *Time* magazine executives and CEOs of major corporations on March 11, he brimmed with enthusiasm: America's military commanders and diplomats in Vietnam were "an especially fine team . . . the best yet," while "Thieu was the best leader the South Vietnamese people have had to date." Things were "going far better in Vietnam than most Americans realize. Press stories do not convey our current military advantages. If we are losing the war, we are losing it in the U.S., not in Vietnam. . . . Militarily, there is light at the end of the tunnel," though "a long-term U.S. military presence will be necessary." Thieu was ready to accept a fifty-thousand U.S. troop reduction in 1969. The *Time* representatives and businessmen who had recently visited Vietnam shared Nixon's positive outlook.

Nixon's optimism partly rested on a report from Laird describing what he had found during an early March visit to Vietnam: the success of the pacification program, bringing expanded Saigon control over rural areas, and the likely increased effectiveness of a South Vietnamese military receiving the best possible equipment and training from U.S. advisers. It was what the administration, led by Laird, now agreed to describe as Vietnamization—Saigon's assumption of growing responsibility for the war.

U.S. public opinion and American missionaries in Vietnam encouraged Nixon's attraction to the idea. A Louis Harris survey reported in the *Washington Post* and *Philadelphia Inquirer* showed a 49 to 34 percent approval for a fifty-thousand troop recall from Vietnam. The Reverend Billy Graham told the president that American missionaries, who had been in Southeast Asia for five to twenty years and had spoken with "hundreds of Vietnamese officials" urged "a full enlistment of our Vietnamese allies in their own defense." Vietnamization needed to replace the Americanization of the war. In fact, it was the only way Nixon saw to escape from the war. Would it work? Nobody could be sure, but it was the most sensible means the White House saw for ending what was no longer a politically viable war—no matter which party or individual held the presidency.

But Nixon believed that Vietnamization could not be rushed. Hanoi and the American public would have to be convinced that this was a workable plan. After eight years of trying to mold the South Vietnamese military into an effective fighting force at a cost of billions of dollars and over thirty-five thousand American lives, there was justifiable skepticism.

Vietnamization partly rested on a cynical calculation that the policy might turn out to be nothing more than a fig leaf for American and South Vietnamese defeat. As Nixon had told Richard Whalen, a speech writer, during the 1968 election campaign, "I've been saying, 'an honorable end to the war,' but what the hell does that really mean?" Nixon understood that the war couldn't be won, but he also believed he couldn't say this. It was essential, not only for the administration's political survival but also for reasons of national morale, to maintain the fiction that America had fought a successful war and that Saigon would now stand on its own.

Consequently, in mid-April, when *Newsweek* published an article describing divisions between the state and defense departments over Vietnam, Nixon told national security advisers that "criticism has reached a dangerous point where the President seems to have lost control of his team and everyone seems to be going off in different directions." He believed it essential to have "a consistent line with no deviation whatever." At the beginning of May, when Kissinger gave a background briefing to the press, he assured reporters that the president was "following a carefully thought-out strategy" on Vietnam. The Paris peace talks were proceeding "approximately as we had expected them to go." The message, in short, was: The administration is in control of events, knows where it is heading, and expects to reach a satisfactory settlement in due course.

Nixon's design for Vietnam was self-evident. Like Johnson before him, he wanted to ensure that the war ended with guarantees of South Vietnam's autonomy. To achieve this, Hanoi would have to agree to mutual troop withdrawals, and Vietnamization would have to be the result not of American determination to withdraw from Vietnam but of Saigon's genuine ability to defend itself. Vietnamization would be "accomplished as an act of strength rather than weakness," Nixon advised Rogers as he prepared to visit Saigon in mid-May. Rogers needed to take this line with the South Vietnamese, U.S. embassy and military officials, and the press. "In Saigon the tendency is to fight the war to victory," Nixon told Henry during a phone conversation on May 12. "But you and I know it won't happen—it is impossible. Even General Abrams agreed." Kissinger was to hide Nixon's candor.

Nixon and Kissinger faced three insurmountable problems in trying to leave behind an autonomous South Vietnam: Hanoi had no intention of ending the war with less than Communist control of the country,

North and South; the South Vietnamese were incapable of effectively defending themselves; and a majority of Americans were unwilling to fight an open-ended war—the cost in blood and treasure was exceeding the price the country was disposed to pay for South Vietnam's freedom from Communist control.

Leonard Garment, a Nixon White House counsel, advised the president in mid-May that the word which best described the national mood on Vietnam was "impatience." The country wished "to turn away from excessive world involvement and back to the solution of social problems at home." Garment also warned against asking for patience. "Words alone have a way of causing even greater impatience," he told Nixon. It was a "Helpful, good analysis," Nixon wrote Kissinger, signaling that he understood how essential it was to end America's military involvement in Vietnam.

Nixon's sensitivity to public impatience with losses in the war registered forcefully in a White House announcement on May 13 describing plans to reform the military draft. He intended to end conscription and replace it with an all-volunteer armed force. Because a draft would still be essential for the immediate future, however, Nixon said he would continue the present call-up procedures but wished to alter them to minimize the disruption to young men's lives. He asked that the period of prime vulnerability to the draft be reduced from seven years to one year between the ages of nineteen and twenty. The objective, as Nixon freely acknowledged, was not only to make the system fairer and less uncertain for young men but also to quiet public unhappiness with military conscription.

The nation's growing impatience with the war dictated that Nixon promise more than changes in the draft. On May 14, six days after the NLF announced a ten-point plan for ending the conflict, Nixon outlined U.S. conditions for a settlement in a nationally televised speech. Although Kissinger assured reporters and senators that the president's speech had been in the works for quite a while, Hanoi's initiative, coupled with congressional and public pressure for some explanation of how the administration intended to end the fighting, moved Nixon to speak out at once.

Nixon and Kissinger focused the speech on how to get the Paris negotiations "off dead center. This is not a take it or leave it proposal," Nixon

said to Henry. "This is an honest attempt—a starting point." Kissinger didn't want the speech "to sound as if you can't hardly bear the sound of the war anymore. Because we have to keep the other option [of increased force] open." Nixon agreed: He wanted the Communists to understand that if they continued their military actions, we would "bang them and bang them hard." In speaking to senators, Nixon warned Henry against "playing it too dovish." He wanted him to leave the impression that force remained a serious option. At the same time, however, it seemed unwise to agitate the country's antiwar advocates with belligerent language. Veiled threats were unnecessary, Kissinger said. "The other side will get the point anyhow."

The Communists' ten points and Nixon's speech, which featured an eight-point agenda, gave little hope for a quick settlement. True, Nixon agreed to a more flexible troop withdrawal arrangement: U.S. forces could be withdrawn at the same time as North Vietnamese forces instead of after them, as Johnson had proposed. But beyond this, the two sides remained deadlocked over a U.S. refusal to withdraw without North Vietnamese concessions or to abandon the Thieu-Ky government.

Despite declaring that the "time has come for new initiatives," Nixon's rhetoric was familiar. There would have to be an "honorable settlement," not "a disguised defeat," which would threaten Saigon's self-determination and "our long-term hopes for peace in the world. A great nation cannot renege on its pledges," Nixon declared. He predicted that "the time was approaching when the South Vietnamese forces would be able to take over some of the fighting fronts now being manned by Americans." He ended with a "blunt" warning: "Our allies are not going to be let down."

Some in the United States saw Nixon's speech as a "bitter disappointment." They accurately described the eight-point plan as nothing more than warmed-over Johnson proposals. The response from Hanoi offered no hope that Nixon had found a path to peace. "The plan of the Nixon administration," a North Vietnamese spokesman declared, "is not to end the war but to replace the war of aggression fought by US troops with a war of aggression fought by the puppet army of the United States."

Despite Hanoi's response, Nixon and Kissinger believed that they had taken a significant step forward. Nixon was convinced that if the speech had no impact, it was the fault of the press. He lamented the fact

that he had not appointed a high-level PR operator who worked at promoting Nixon's image "all day, every day."

Kissinger also deluded himself about the value of the speech. After a press briefing, he told Nixon that reporters "thought it was a very meaty speech." Nixon wanted reassurance: "Did you think it was worthwhile?" he asked Henry. "Tremendous success," Kissinger replied. He believed there was now a serious prospect for a mutual withdrawal. Either Kissinger was fooling himself or uncritically telling Nixon what he wanted to hear, probably the latter.

Hindsight demonstrates how unimportant the speech was. But the president and Kissinger were reluctant to confront harsh realities—that the United States was being forced into an unconditional withdrawal and Communist control of South Vietnam. If Kissinger was falsely encouraging Nixon's hope of making an honorable peace, he was undermining the national well-being and Nixon's grasp of international realities. It would have been better to confront hard truths: North Vietnam believed that Saigon would not be able to defend itself after the Americans left; and that American public opinion would force Nixon to wind down the war. Hanoi was confident that rumors about U.S. troop withdrawals would prove correct and that Nixon's implicit threats of military escalation were essentially a political ploy to wrest concessions from it in Paris. Ho Chi Minh assumed that he could outlast the Americans and Thieu's regime.

In the second half of May, Hanoi responded to Nixon's peace initiative with stepped-up attacks on South Vietnam. In response, the president agreed to further Cambodian air raids. He also instructed everyone to take a hard line on Vietnam. A White House press aide told a Soviet contact that public opinion wasn't going to pressure the president into a withdrawal from Vietnam. The White House leaked a story that increased attacks would delay troop withdrawals for at least several months.

The administration's tough talk was partly meant to appease Thieu, who publicly called for a Summit meeting with the president to discourage U.S. troop reductions. Thieu asked Nixon to meet him at Midway Island. He was eager to be seen as an ally rather than a supplicant. When they met on June 8 and Thieu saw that Nixon had a larger chair than his, he searched the U.S. commandant's house for a chair of equal size and personally carried it into the meeting room.

Despite the tough talk on Vietnam and Thieu's pressure, Nixon told

him that he would announce a 25,000-troop reduction in July. A story in the *Washington Post* on June 3 made it clear that Nixon had no choice: "Vietnam 'may be one of those things that destroys everyone who touches it,'" the *Post* quoted someone at the White House, "and although the president 'knows how desperately people want to get out, wanting isn't enough.'"

At a June 3 cabinet meeting, Rogers, who had just returned from Saigon, encouraged hopes that the South Vietnamese could take over a major share of the fighting; Vietnamization could work. Nixon also took hope from a Kissinger report on June 4 that the North Vietnamese were showing some give in Paris.

On June 7, Nixon met with his national security team in Honolulu. Kissinger records that the American military "approached the subject [of a withdrawal] with a heavy heart." It seemed certain to "make victory impossible and even an honorable outcome problematical." The withdrawal rested on a combination of hope and illusion—the hope that Vietnamization would actually work and the illusion that after eight years of advising and training Saigon's forces to fight the insurgency, they could finally stand on their own.

However reluctant both Nixon and Thieu were to have Vietnam assume full responsibility for the war, neither felt he had a choice. Five months into his term, Nixon understood that his political credibility and freedom to achieve other things in foreign and domestic affairs depended on acceding to public pressure to end U.S. involvement in the fighting. In March, Senator J. William Fulbright, Democratic Chairman of the Senate Foreign Relations Committee and an outspoken critic of the war, had predicted that Nixon's "honeymoon" on the war would not last long, and warned the president against allowing the conflict to turn into "Nixon's War." Fifty-two percent of the public thought the war was a mistake. By early June, Fulbright declared that the administration had only another month before the country would lose confidence in Nixon's willingness to change U.S. policy in Vietnam. "I knew that time was running out for us because the public wasn't going to support the war any longer," Laird said.

Thieu also understood that he had no way to hold off a shift in U.S. policy and so publicly described a phased withdrawal of U.S. troops as his idea. In return for Thieu's cooperation, Nixon, according to Thieu,

promised to compel Hanoi's withdrawal from the South, provide continuing military support during the next three and a half years, and economic help during a Nixon second term. There is no hint of how Nixon expected to accomplish any of this, especially North Vietnam's departure.

Kissinger recalls that at the conclusion of the meeting, "Nixon was jubilant." He saw "the announcement as a political triumph." Thieu's acceptance and the likelihood that Nixon had at least temporarily quieted antiwar activists elated him. "Henry," Nixon noted on a daily news summary, "virtually all the press are crying in their beer because their dire predictions of RN-Thieu troubles did not surface."

Nevertheless, Nixon had doubts about his freedom to withdraw most U.S. troops without a South Vietnamese collapse. When *Newsweek* expressed skepticism about the results of the Midway meeting, Nixon told Ehrlichman to "cut *Newsweek* out of any backgrounder." He instructed aides to say nothing about future troop withdrawals, for fear it would encourage the belief that the United States was now ready to quit the fighting without Communist concessions. Nixon also urged Kissinger to warn Dobrynin that if nothing happened in Paris, we were going to consult our self-interest. It was largely posturing that made Nixon feel better about what he saw as a likely losing strategy.

On June 19, after Nixon learned that former defense secretary Clark Clifford was publishing an article implying that the "war is lost" and that the United States would do well to unilaterally withdraw 100,000 troops by the end of 1969 and the rest of its combat forces by the end of the following year, he publicly took issue with Clifford's analysis. During a press conference, Nixon stated his intention to beat Clifford's timetable. Not because we were fighting a lost cause, but rather because Vietnamization was working.

Nixon's promise to withdraw sooner than Clifford suggested badly shook Kissinger. He thought it foretold South Vietnam's collapse in the near future and would be interpreted by Thieu and others in Southeast Asia as a "unilateral withdrawal." Henry worried that Nixon had secretly decided to pull out, but Haldeman told him it was more a case of Nixon hitting back at Clifford.

Haldeman was right. Nixon "couldn't sleep" and "stayed [up] late last night calling people about [the] press conference," Haldeman noted

in his diary. Kissinger echoed his contemporary concern in his memoirs, saying that efforts to put a positive spin on the president's remarks were useless; Nixon had destroyed any likelihood that Hanoi could be pressured into a mutual withdrawal.

From the perspective of 1969, it is understandable that Kissinger thought Nixon's remarks undermined chances for a favorable settlement. But it is difficult to explain why he held to this view ten years later. A wish to still believe that they had alternatives—that they might have saved South Vietnam from its fate—seems like another example of wishful thinking. For someone who prided himself on his unblinking realism, it is hard to understand why Kissinger believed that training South Vietnamese troops or expanded U.S. military action would bring any better results than Johnson had achieved in the previous four years.

At the time, Kissinger hid his skepticism about the wisdom of troop withdrawals from Nixon and the public. Kissinger did not wish to discourage hopes that a satisfactory peace settlement remained possible; nor was he willing to tell Nixon that his pronouncement was a blunder. Instead, he gave Nixon continuing public and private support.

When *Washington Post* journalist Chalmers Roberts asked Henry whether the president wasn't "serving up to Hanoi . . . a unilateral withdrawal," he replied, "It depends on how you read the statements." Defending Nixon before the press was part of his job. But giving the president solace in private was another matter. He told Nixon that "It was a very effective press conference," and praised his handling of Clifford's article. The reassurance pleased Nixon. He believed that "The press conference had solid impact from the standpoint of style," whatever style may have meant. He was sure that "If in 1970 we are at the [reduced troop] level Clifford suggests, we have had it." It was an acknowledgment that unilateral withdrawal would mean defeat for Saigon.

Kissinger understood that Nixon could never accommodate himself to those who took issue with him. Opposition opinion made him angry and brought out the worst in him—impulses to repress critics. In the middle of June, in response to criticism by administration insiders, he told Haldeman and Ehrlichman, " 'White House staffers privately' were raising questions about some of my activities . . . I want the whole staff in the strongest possible terms to be informed that unless they can say something positive about my operations and that of the White

House staff they should say nothing." He also wanted a list of friendly and unfriendly journalists attending his news conferences. He intended to follow the FDR-Eisenhower practice of calling on sympathetic press people, however few they might be. He received the list before the end of the day.

His response to antiwar students and organizations was more draconian. Some of this opposition was committed to violence, and investigative agencies were justifiably acting to preserve law and order. But Nixon had few qualms about using executive powers to go after legitimate dissenters as well as rule breakers. In March, after 549 San Francisco State students receiving federal financial assistance were arrested at an antiwar rally, Nixon wanted to know what action the department of health, education and welfare was taking to punish the "rioters." He was apocalyptic about the dangers to the country from campus dissidents, who had disrupted and, in some instances, shut down universities in 1968. In a March 22, statement on student disorders, he declared that "this is the way civilizations begin to die . . . As Yeats foresaw: 'Things fall apart; the center cannot hold.' "

When the economist Dr. Arthur Burns, a White House adviser on domestic affairs, told Nixon that student protestors led by Students for a Democratic Society (SDS) were intent on "destruction of the university (and other institutions) rather than reform," the president wanted an investigation to determine "the exact nature of this new, rather frightening, movement." When intelligence agencies told Nixon that there was no "specific information or 'ironclad proof' that Red China or Cuba is funding campus disorders," Nixon ordered Ehrlichman to have Tom Huston, the White House coordinator of domestic intelligence, "keep after this; give Huston (or someone of his toughness and brains) the job of developing hard evidence on this." In response to a Huston report that the Internal Revenue Service (IRS) would be looking at the activities of "left-wing" tax-exempt groups, Nixon told Burns: "Good—but I want *action*—have Huston follow up *hard* on this."

Why was Nixon so determined to strike out against the antiwar movement? No doubt, as the historian William Gibbons says, he feared its effects "both on the conduct of the war and effort to negotiate an end to the fighting." But he knew that the Johnson administration had also tried unsuccessfully to establish a connection between antiwar groups

and Communists, and that in 1967 and again in 1968 the CIA reported "no convincing evidence of control, manipulation, sponsorship, significant financial support of student dissidents by any international communist authority." On June 30, 1969, the CIA told Huston that there was still no evidence of "foreign communist support to revolutionary protest movements in the United States." Yet Nixon, like Johnson, could not let go of the idea that international communism was behind the opposition to the war and his administration. In fact, the most effective way to have combated domestic antiwar efforts was not through using the IRS against dissidents or people the White House put on an "Enemies List," but by promptly ending U.S. involvement in the war.

But a quick withdrawal from Vietnam was too much a confession of defeat. And even though Nixon could have laid the disaster at Johnson's doorstep, he didn't see this as a viable solution to the problem. It was less because his political scruples would not allow him to assign blame to LBJ than because he and Kissinger genuinely feared the international consequences of such an action. As subsequent events would demonstrate, they falsely believed that abandoning Saigon to its fate would have terrible consequences for U.S. foreign policy all over the globe, especially in its ongoing struggle against communism. It was a mistaken assumption, and the consequences for the United States and the Vietnamese, North and South, in blood and treasure were disastrous. (Over twenty thousand U.S. troops would lose their lives during Nixon's presidency.) It was a lesson in the heavy price nations pay when their leaders are held fast by unrealizable hopes that morph into illusions.

THE POLITICS OF FOREIGN POLICY

Politics is war without bloodshed while war is politics with bloodshed.

—Mao Zedong, 1938

War is a very rough game, but I think that politics is worse.

—British Field Marshal Lord Montgomery, 1956

However confident Nixon and Kissinger were about their fitness to make foreign policy, they also understood that competence in a democracy is only one part of the equation. Congress, the press, and public opinion, especially on any issue that worried Americans, were essential elements of a successful response to overseas threats and challenges. This is not to say that Nixon and Kissinger intended simply to reflect domestic sentiment, but they were mindful of the need to enlist its backing by all possible means, including stealth or misleading information, for any major foreign policy initiative.

Arms control policies are one case in point. As president, Nixon understood the dangers the nuclear arms race posed to world peace and the limitations it imposed on an America eager to fund domestic reforms.

If he were going to fulfill his inaugural promise that his administration would be remembered as beginning "an era of negotiation," he wished to go beyond the Kennedy-Johnson record on arms limitations. Specifically, he hoped to exceed Kennedy's 1963 limited nuclear test ban treaty, and bring Johnson's incomplete 1968 discussions with the Soviets at Glassboro, New Jersey, to some better result. In January and February 1969, Nixon declared himself eager for strategic arms limitation talks (SALT) tied to progress on international political problems, and urged the Senate to approve a nuclear nonproliferation treaty (NPT) signed by Johnson.

Nixon's commitment to an NPT carried no political or economic costs. His internal directive supporting ratification emphasized that adherence to the treaty neither created new commitments abroad nor broadened existing ones. Nor would the treaty cause any international difficulties for the United States, since Nixon had no intention to pressure other countries to follow America's lead. Moreover, as a number of senators who would approve the treaty believed, it included an escape clause which made the agreement "relatively meaningless."

By contrast, arms control policies required difficult choices and were certain to provoke sharp divisions in the United States and abroad. Through the mid-sixties, the United States had a decided advantage over the Soviet Union in nuclear weapons, but a concerted Soviet effort to reduce the gap after its embarrassing retreat in the Cuban missile crisis created new challenges for the West. Moscow's construction of an antiballistic missile system named Galosh designed to defend Soviet cities and missile sites joined with rapid Soviet production of Intercontinental Ballistic Missiles (ICBMs), especially the SS-9, a missile capable of delivering larger bombs than anything in the U.S. arsenal, raised questions about how best to defend the United States and its allies. The Johnson administration had responded to the Soviet buildup by increasing production of submarine-launched ballistic missiles (SLBMs), proposing to build an antiballistic missile system (ABM), Sentinel, to protect American cities, and developing MIRVs, multiple independently targeted reentry vehicles, missiles capable of carrying several bombs aimed at separate targets.

At a National Security Council meeting on February 19, Nixon and Kissinger acknowledged that the United States had lost its dominant position in the arms race and that it would be "hard to recapture a 5 to 1

superiority." The best they foresaw was a "stable deterrence." This would require maintaining the U.S. advantage in SLBMs and countering the Soviet ICBMs by building an ABM system that protected not cities but U.S. missile sites. The NSC agreed that ABM could be a stabilizing force and could advance strategic arms limitation talks (SALT).

Gerard Smith, the head of the Arms Control and Disarmament Agency (ACDA) and the man slated to be Nixon's chief negotiator at subsequent SALT talks, disagreed. "I am against ABM," Smith said. "We don't know what effect it will have," he conceded, "but I don't think it will be decisive one way or another."

Nixon was not persuaded. "The intellectual community is getting hysterical about ABM," he told the NSC, "partly because we don't have facts" about its workability. They also feared its costs and impact on Moscow, which would probably feel threatened by it. But Nixon and Kissinger saw the threat as useful in negotiations. Nixon told ABM opponents that it wouldn't provoke a new round in the arms race by frightening the Soviets. Because the Soviets already had such a system, Nixon believed that the United States would be at a disadvantage in arms talks without a comparable bargaining chip.

Nixon viewed the domestic battle over ABM as a test of his capacity to control foreign policy and dominate the Congress. Because an ABM vote would be the first significant congressional vote on defense measures in his administration, Nixon "wanted the signal to go out that we had not lost our national sense of purpose and resolve." More important, he wanted to show that he and not Congress would be making the big foreign policy decisions.

The contest, which mainly became a fight for Senate votes, turned into something of a holy war. Opponents saw ABM as likely to open a new round in an expensive and dangerous arms race. "There's a sort of religious opposition to ABM," Kissinger told a defense department official in March, "which isn't going to be moved no matter what we do." Kissinger feared that the struggle would become "a symbol of a basic schism" in the country. Kissinger told Nixon that his opponents "were hoping to turn this thing into a Bay of Pigs or Vietnam War syndrome." Henry told an academic friend, "We have less trouble with Dobrynin [on ABM] than with the *New York Times*."

Because it was impossible to demonstrate that ABM was vital for na-

tional security, Nixon saw the battle for congressional approval as more a test of his political strength and prospects for reelection than of the country's future safety against attack. Senator Edward Kennedy's opposition to ABM was seen as a first confrontation in a likely contest with Nixon for the presidency in 1972.

Nixon was determined to fight for ABM as if his political life depended on it, and he wanted everyone in the administration to do the same. When NBC and CBS gave what he saw as anti-ABM reports, Nixon instructed the White House press office to "raise hell" with the networks. "Every time one of these [ABM] opponents opens his mouth, calls should flood the station."

As the Senate came closer to a vote in August, Nixon intensified his efforts to bend the Senate to his will. He publicly attacked anti-ABM advocates as isolationists, which provoked angry replies. "The dominant new mood in Congress is one of sober questioning, and Nixon's intemperate remarks hit the wrong note," *Time* reported.

Because his aides predicted fifty to fifty-three Senate votes for ABM, he refused to publicly express any interest in a compromise. "We will win the fight on safeguard," he told a news conference on June 19. When CIA Director Richard Helms was quoted in the press as implicitly doubtful about ABM, Nixon told Kissinger, "He has fifteen minutes to decide which side he is on." Anti-ABM leaks to the *New York Times* from the Foreign Intelligence Advisory Board (FIAB) and the state department put Nixon "on the war path." He wanted every member of the board to reveal their press contacts, and demanded that five departmental officers be removed or transferred and pushed "into the woodwork."

Yet all Nixon's efforts to exert control couldn't prevent news reports in July of ineffective leadership. "Rough lead article in *Newsweek*," Haldeman noted in his diary, "—really cracks P for lack of leadership and direction . . . Clearly we need to reverse the PR trend." With United Press International (UPI) reporting that the Senate vote on ABM stood at forty-eight to forty-eight, Nixon felt as if the fate of his administration rested on winning this fight, regardless of what it meant for the country's security and negotiations with Moscow. Leaks from Pentagon officials reporting that ABM tests had failed and that the missile seemed unlikely to work impressed Nixon as nothing more than the work of political opponents. "Here we go again," he told Kissinger about these leaks.

In response, Nixon and Kissinger pressured the intelligence community to frighten senators into believing that Moscow's SS-9 missile posed a serious threat that could be countered with ABMs. Neither assertion was based on more than speculation. "P and K agreed [that] Senators are getting scared after hearing intelligence briefings," a summary of a telephone conversation between them on July 18 reads. "Opponents have shifted line on SS-9. P said he thinks intelligence community is shaping up—K agreed, saying we have them scared."

Nixon won the narrowest possible victory—a fifty-fifty tie vote was broken by Agnew. In a memo to Haldeman, Ehrlichman, and Kissinger, Nixon said nothing about the consequences for national security. It was all about the president's masterful political leadership. He wanted them to get "out the true story as to presidential influence and the 'Nixon style' in dealing with the Congress." Never mind that administration opponents might be correct about ABM. The emphasis needed to be on Nixon's courageous fight and effectiveness.

Nixon's attitude toward launching strategic arms limitation talks with the Soviets exhibited similar concerns about personal credit and domestic politics. He saw more political than national security value in a SALT agreement. Its importance would be in "the public's recognition that a U.S.-Soviet accord had been achieved and the political clout that would provide him with Congress and the press." When the newspaper columnist Joseph Kraft advised the president to "abandon the illusion that meaningful agreements . . . could be worked out with the Soviets," Nixon described Kraft's observations as "very significant." Any SALT initiative, Nixon told the NSC, would be "more for U.S. public opinion than for showing good faith to the Soviets." In short, Nixon saw little hope of a significant arms control agreement with Moscow; U.S. public opinion was the principal object of his initial public diplomacy toward the Soviets.

Nixon was especially worried that Gerard Smith would impede his reach for political gains. He had made Smith the administration's point man in arms discussions because Smith enjoyed widespread recognition as a nonpartisan public servant. But Nixon didn't trust him. His views on negotiating did not coincide with the president's or Kissinger's. "You can tell Smith that I don't have confidence in him," Nixon told Rogers on the eve of arms talks. He was more explicit with Kissinger: "I've got

to get credit, I told [Rogers], for anything that happens in arms control, and I said it can't be Smith that's going to get credit. I said he's a small player and I don't trust him."

To keep Smith from achieving anything of consequence in the arms talks, Nixon gave him innocuous instructions in March on how to proceed at an eighteen-nation disarmament conference in Geneva. Smith was to aim for "a world of enduring peace and justice." Nixon offered no advice on how Smith might achieve such lofty goals. Nixon asked Paul Nitze, another member of the delegation in Geneva, to inform the White House about anything Smith was doing that contradicted presidential directives. Nitze refused, but Nixon's request demonstrated just how divided the administration was in working toward a Soviet-American agreement on nuclear weapons.

During the spring and summer, Nixon and Kissinger tried to build a positive public image of their efforts to begin arms control discussions with Moscow. The Soviet Union would not settle for an agreement "that codifies her strategic inferiority," Kissinger said in a background briefing for the press. The president knew this, Kissinger explained, and would be consulting with Moscow about when and where talks would begin.

Nixon and Kissinger had some small hope of using SALT to advance the country's national security. But they struggled to chart out a wise course of negotiations. A central question was whether MIRV development would intimidate the Soviets into concessions or touch off a new and more dangerous phase of the arms race. A debate raged in the administration over whether or not the Soviet SS-9 could be equipped with independently targeted missiles or MIRVed. And if so, would this give Moscow a greater first-strike capability that would diminish America's capacity to retaliate? The Soviets, Nixon told a congressional delegation, "have shown no interest in a moratorium on MIRV . . . It would be disastrous for the United States to be in an inferior position . . . while the other side is making a great leap forward."

The CIA went back and forth on Soviet capacity to MIRV SS-9s, and Nixon and Kissinger bluntly told the FIAB that the intelligence community was mixing fact and opinion. "There are too many people, instead of giving us intelligence, giving us their opinion," Nixon told Kissinger. Nixon also complained that between 1965 and 1969 intelligence estimates were 50 percent too low on Soviet missile strength. De-

spite these warnings, as many as forty Senators urged a moratorium on MIRV testing. The British also weighed in with a recommendation for "a MIRV ban. They argued—as did MIRV-ban supporters at home—" Henry told Nixon, "that unless these weapons are stopped we will have done nothing to prevent a new phase in arms competition." Subsequent events would prove them right.

Settling on a specific agenda for the talks was impossible. Administration experts couldn't agree on how to verify arms reductions and limitations without inflaming Soviet suspicions of American spying. And even if Moscow had been willing to accept some kind of verification apparatus, Nixon had little confidence in the judgment of America's arms control experts: "Technical people think with their hearts not their heads," he said. More important, Moscow and Washington were far apart on what might constitute a "limited agreement." In September, Nixon sent word to Soviet Foreign Minister Andrei Gromyko that "we have found this to be a highly complex matter," but we're committed "to the principle of sufficiency" for both sides, whatever that might mean.

Nixon's message to Moscow was unproductive. Georgi Arbatov, a leading Soviet expert on America, told Hal Sonnenfeldt during a conference in The Hague that Moscow saw "our talk of negotiations" as "a sham." A report from the defense department's intelligence agency in October advised that the Soviets were expanding their nuclear forces at a rapid pace and the deployment of all their weapons systems was continuing "unabated." In response, Nixon put U.S. forces on higher alert. He wanted actions that would "be discernable to the Soviets," but neither threatening nor evident to the public.

Moscow was as uncertain as Washington on how to proceed. But the administration's heightened defense posture apparently persuaded the Soviets to begin discussions. In October, four months after William Rogers had issued a public invitation for talks, the Soviets finally agreed to meet in Helsinki on November 17. But they were as vague about the negotiations as the Americans. "It would be dangerous if the talks were only a series of platitudes," Nixon told Dobrynin. Although they agreed that their respective countries' futures and world peace depended on their improved relations, neither side could say what "long-term goals" should be discussed.

Poor prospects for the negotiations frustrated Nixon, but so did the

impression in the press that Rogers and the state department were getting more credit for starting the talks than he was. The department, Haig told Kissinger, was pursuing a "freewheeling, undisciplined and frequently disloyal" strategy on SALT that was endangering America's security.

Nixon also worried that Kissinger was upstaging him. In October, at a luncheon of Harvard alumni in Washington, Robert Osgood, a Kissinger deputy, belittled Rogers by saying that the president gets advice from the secretary of state, "whoever he is," and added: "Everybody knows that Henry is the intellectual center of this administration."

To boost himself, Nixon believed it "absolutely essential that we have a man in the White House who is able to handle foreign policy press questions with sufficient skill so that the White House Press Corps does not turn to the State Department for their answers. We've got to talk about this and figure out a way to handle it, because it is very much on the President's mind," Haldeman told Kissinger. Nixon wanted Henry to give press backgrounders at least once if not twice a week. Nixon instructed Kissinger to constantly emphasize "the fact that the President is in charge where matters like Vietnam and Salt are concerned." Henry promptly gave written assurances that he was telling the press that past and future policies were "the results of your personal leadership."

Every president before Nixon worried that no one in the administration should be more powerful than he was. Because vice presidents—almost always ambitious politicians—were the greatest threat to presidential power, they were invariably kept in the background. Nixon's concern then was not unprecedented. But it was excessive and reveals his self-doubt and lifelong fear of being eclipsed or having to stand in someone's shadow. He was incapable of believing that his office and actions as president would ensure his standing at the head of the country, his administration, and his party.

Since none of Nixon's dealings with Vietnam, the Soviet Union, or any other country so far had established him as an effective foreign policy leader, Nixon decided on another overseas trip like his February visit to Europe that had generated so much good publicity. Only this time he would travel around the world beginning in the Pacific and Asia and returning through Europe. Stops in Guam, the Philippines, Indonesia, Thailand, Vietnam, India, Pakistan, Romania, and England during a ten-day tour would allow him to encourage hopes for a settlement of

the Vietnam War, a new era of peace in Asia, and a shift toward greater freedom for Eastern Europe.

Coincidentally, the fulfillment of John Kennedy's vision of landing a man on the moon before the end of the decade gave Nixon a spectacular start for his global excursion. On July 20, he said he had placed "the most historic telephone call ever made from the White House" to U.S. astronauts Neil Armstrong and Colonel Edwin (Buzz) Aldrin, congratulating them on their successful landing on the moon's Sea of Tranquility. Although the *New York Times* took Nixon to task for "sharing the stage with the astronauts," wasting their time in idle conversation, and failing to give credit to Kennedy and Lyndon Johnson, who were the real architects of the Apollo 11 mission, the president was not deterred from launching his journey by flying on to the U.S.S. *Hornet* in the Pacific to welcome the astronauts back to earth.

Nixon's grandiosity and reach for political gains registered in his assertion to them that "this is the greatest week in the history of the world since the Creation." He used the occasion to plug his coming journey: "As I am going to find on this trip around the world . . . as a result of what you have done, the world has never been closer together before." The successful moon walk made Nixon an advocate of additional space exploration, including a plan for a manned landing on Mars.

Nixon's overriding concern with his image shaped his round-the-world trip. After greeting the astronauts on the *Hornet*, he flew to Guam, where he held a background briefing for reporters at an officers' club. Others, including Kissinger, he said, would provide future press meetings during the trip. But he chose to hold an initial off-the-record news conference to underscore the trip's importance and impress himself on the press, the public, and the world as a visionary leader intent on changing U.S. dealings with Asia.

With the instincts of a seasoned politician who understood the importance of timing and clarity of message, Nixon provided an announcement which was guaranteed to make headlines and launch his presidential trip on a high note. Because he wanted exclusive credit for it, he purposely kept his intentions to himself; neither Kissinger nor the state department knew what he would say. Though he encouraged everyone to believe that his comments to the newsmen were spontaneous, it is difficult to believe that so carefully crafted a statement was anything less than the product of a preconceived plan.

He began by emphasizing that he had visited Asia repeatedly during the previous sixteen years and knew all the leaders he would be meeting except for President Yahya Khan of Pakistan. Conferring with them, however briefly, would give him the chance to assess their current thinking on problems of mutual interest to their countries and the United States.

The principal topic for discussion with all his Asian counterparts would be "What will be its [America's] role in Asia and in the Pacific after the end of the war in Vietnam?" They were all wondering whether U.S. frustrations with Vietnam would lead us, like the British, French, and Dutch, to "withdraw from the Pacific," Nixon said.

It was time for the United States to develop a long-range policy. To assure against another Asian war, his administration intended to continue playing "a significant role" in the region. It was in Asia, after all, that America's last three wars had begun, and it was in Asia, where Chinese, North Korean, and North Vietnamese belligerence made future wars a serious danger. In our future role, Nixon declared, we need to be mindful of Asian nationalism, of interest in U.S. help that does not compromise another country's independence. "We must avoid that kind of policy that will make countries in Asia so dependent upon us that we are dragged into conflicts such as the one that we have in Vietnam." There would be "no more Vietnams"; we would help combat future Communist insurgencies but we "would not fight the war for them."

The press immediately dubbed Nixon's pronouncement "the Guam Doctrine." But he was not content to have the policy associated with the island on which he had stated it. He directed Kissinger and others on his staff to identify it as "the Nixon Doctrine." He was determined to ensure that he got all possible credit for the new policy. He wanted someone "to plant [a] story with the *Washington Star* that State dragged its feet on [the] trip—wants to rap State," Haldeman recorded in his diary. Getting his achievement across to the American people was a constant concern. He told Haldeman, Ehrlichman, and Kissinger "how important it is to follow up . . . in a positive way" on what he was doing. The party line was to be: "The trip was RN's idea" and established a new Asian policy.

There was little, however, to say about the meetings with Asian heads of state. The visit to the Philippines, as the news accounts described it, was notable for the emphasis on U.S. determination "to shift primary re-

sponsibility for Asian security to the Asians." The press coverage incensed Nixon, who called the description of his reception as "friendly, but restrained" and "less enthusiastic" than that given Johnson in 1966 "a deliberate job!" The visits to Djakarta, Indonesia, and Bangkok, Thailand, were noteworthy only for heavy rains that drenched them to the skin, terrible heat that again left them "dripping wet," and delicious food.

A quick four-and-a-half hour visit to Saigon to discuss the war with Thieu and visit some U.S. troops accomplished nothing of importance. Pronouncements on U.S. determination to preserve South Vietnam's autonomy and put additional military pressure on Hanoi if it did not show greater flexibility in the Paris talks and Vietnamese assurances that they planned to defend themselves in the future were all reprises of what the two sides had been telling each other since Nixon took office.

A meeting with American troops left Nixon emotionally overwrought. On the plane back to Bangkok from Saigon, he "gave quite an emotional charge to me," Haldeman recorded, "never to let the hippie college types in to see him again." Like the other stops, Nixon's visits to India and Pakistan provided an opportunity for expressions of mutual regard but little else.

Nixon's private expression of feelings about the troops and protestors was an example of what Haldeman called letting off steam. Nixon wasn't the only president to ventilate irritation behind the scenes. Truman, Eisenhower, Kennedy, and Johnson also made their unhappiness with people and events frustrating them known to their staffs. But Nixon's explosions of anger had a disconnected quality that reflected deeper, smoldering resentments and hatreds reignited by current events. His suspicions and antagonism toward the press and fears that others would get undeserved credit for what he did were incessant concerns that Haldeman's diary describes as "numbing complaints" inflicted on long-suffering aides. Nixon wasted considerable time fretting about these matters; it was presidential energy that could have been spent in more rational, constructive ways.

Other than the Nixon Doctrine, the significant news from the trip was Nixon's visit to President Nicolae Ceauşescu of Romania. The stop in Bucharest was meant to shore up Romanian independence from Moscow. The objective, Kissinger told Nixon, was not "to get Romania to break away from its association with Moscow, but to demonstrate that nowadays one can call oneself Communist, live at Moscow's doorstep

and yet pursue one's own interests even at Moscow's discomfiture." The president's visit would "make the Soviets more conscious of the costs they would incur in their relationship with us should they move to discipline or crush their weak neighbor," as had been the case in Czechoslovakia in 1968. The visit was also aimed at suggesting to other East European countries under Soviet control that they could expand economic and cultural exchanges with the United States.

Nixon took special pleasure in the outpouring of enthusiasm from Romanian spectators who lined the routes of his motorcades during his two-day visit. "P elated and really cranked up," Haldeman recorded. After returning from a state dinner at 11:30 P.M. to the villa in which the Romanians housed him, Nixon, in pajamas, "walked and talked and smoked a cigar for over an hour" in a huge garden while he enthused to Kissinger and Haldeman about Ceauşescu and the Romanian people. Nixon called him "shrewd and bright" and gutsy to take on Moscow with the Nixon visit. Henry described him as "a shrewd, ambitious, power-conscious operator on the international stage who has succeeded in making his country a crossroads." But typical of Nixon, he doubted that the U.S. press would get out the proper story and that the American people would gain an understanding of his "historic visit" to Romania, which he thought would improve communications with the Communist world.

NIXON HOPED THAT ROMANIA would now become a more reliable intermediary for Sino-American exchanges. Nixon had told de Gaulle in March that there was an interest in better long-term relations with China, but he didn't anticipate a quick change. His comment was partly a response to Peking's decision in February to cancel secret Warsaw talks after a defecting Chinese diplomat had been granted political asylum in the U.S. embassy in Holland. A military clash in March between Soviet and Chinese border troops, however, stimulated U.S. interest in contacts with Peking that might make the Soviets more helpful in the Paris talks and more forthcoming in SALT negotiations.

In June, Nixon endorsed a proposal by Senator Mike Mansfield to visit Peking to signal an interest in better relations. At the same time, Nixon approved a relaxation of economic controls limiting trade with China. "I basically agree with attempts to play off the Chinese Communists against the Soviets in an effort to extract concessions from or

influence actions by the Soviets," Kissinger told Nixon. But both of them saw any effort of this kind as "replete with complexities," especially in dealings with Taiwan and throughout Asia.

They also worried that improved relations with China might impede Soviet-American cooperation. On balance, though, they thought it would spur Moscow to be more conciliatory. It could give them greater "leverage against the Soviet Union." For Nixon, it was a triumph of realistic foreign policy thinking over his earlier knee-jerk anticommunism, which had been so useful in advancing his political career. His reputation for toughness now gave him an advantage over domestic conservatives who could hardly accuse him of being soft on communism.

The visit to Bucharest gave Nixon the chance to secretly tell Peking through Ceaușescu that the United States was ready to consider normalizing relations. He had no desire to isolate China and did not consider its Communist system a bar to diplomatic ties. Only its external actions—support for Communist efforts to overturn Saigon's government—stood in the way of a change in U.S. policy. He assured Peking that the U.S. believed it "wrong for the Soviets to arrange a cabal against China in Asia." His aim in going to Romania, he told a group of GOP senators, one of whom leaked it to the press, " 'was partly to dispel' the possibility of a U.S.-Russian agreement against China." He also informed Peking about the change in Washington's trade policies.

In September, Nixon further signaled his interest in better relations by informing the Chinese that he was reducing the presence of U.S. warships in the Taiwan Strait; the U.S. ambassador to Poland was to tell his Chinese counterpart that the United States was ready for "serious talks." Nixon then instructed all American diplomats to answer "Soviet probing of our position on Communist China" by saying that "we deplore the idea of a Soviet strike against Chinese nuclear facilities or any other major Soviet military action."

Since Nixon and Kissinger were unclear on what "serious talks" might mean and since they remained uncertain that more contacts with Peking would have a useful impact on Moscow, they muted their efforts to begin substantive discussions with the Chinese. "The President agrees completely with your recommendation against advising Ambassador Dobrynin of our talks with the Chinese," Kissinger wrote Rogers in December. "He has asked that under no circumstances should we inform

Dobrynin of the talks or their content." As Kissinger stated in a meeting of a review group on Sino-Soviet differences, the United States wanted to lean toward Peking in its conflict with Moscow, but needed to act with the greatest possible care lest it exacerbate the Sino-Soviet conflict or tensions between the U.S. and the U.S.S.R.

SIX MONTHS into his presidency, the war in Vietnam continued to overshadow SALT, Nixon's Asia doctrine, and dealings with China and Russia. The mounting loss of American lives, frustrated hopes for a quick settlement, undiminished divisions in the United States, and White House fears that three more years of fighting would destroy Nixon's presidency made the conflict Nixon's number-one priority.

But no one in the administration had a clear idea of how to end the fighting. Kissinger was "deeply discouraged" about the Paris negotiations, advising Nixon that "we must play a harder line . . . for the present." Kissinger urged some kind of military escalation to force the Communists into a settlement. But he had no idea what form it should take. A reluctance to risk increased U.S. casualties, which would agitate greater antiwar sentiment, discouraged Nixon from resorting to any immediate escalation.

Nixon believed that demonstrations of eagerness for peace would have to precede any increase in U.S. military action. On July 11, after Thieu announced what Nixon described as "a comprehensive, statesman-like and eminently fair proposal for a political settlement in South Vietnam," he publicly restated "the sincere desire of our two Governments to negotiate an honorable and rapid settlement of the war."

At the same time, Nixon and Kissinger tried to convince war opponents that nothing could do more to persuade "the enemy that he should negotiate in good faith than to see the American people united behind a generous and reasonable peace offer." Henry privately urged Vermont Senator George Aiken, who had famously suggested that the U.S. declare victory and leave Vietnam, to appeal to Hanoi for a "contribution" to peace that matched America's. Our biggest problem, Kissinger told Aiken, was to dissuade Hanoi from thinking that "if they just sit tight, American public opinion will force us into unconditional surrender." It "would be a great national service" if Senate doves would help convince the North Vietnamese otherwise.

To persuade Americans and Hanoi that he was genuinely committed to reaching a settlement, Nixon sent Ho Chi Minh a letter "to reaffirm in all solemnity my desire to work for a just peace . . . The time has come to move forward at the conference table toward an early resolution of this tragic war."

Jean Sainteny, a French diplomat who had served in Hanoi and was the husband of a former Kissinger student, delivered the letter to Ho with the message that unless there was a breakthrough in discussions by November 1 Nixon would feel compelled to resort "to measures of great consequence and force." Sainteny agreed to act as a go-between. But he was highly skeptical that Nixon's threat would be any more effective than all the use of military power in the previous four and a half years.

Simultaneous with his overture to Ho, Nixon suggested that Henry ask Nelson Rockefeller to organize a group of twenty-eight prominent Americans to argue against antiwar advocates urging "new initiatives to end, and not simply de-Americanize, the war." He also wanted the CIA to counter reports by Richard Dudman, a *St. Louis Post-Dispatch* journalist Nixon described as "a violent leftist," that Thieu was losing political support in South Vietnam, which was "a semi-police state." Nixon asked conservatives Bill Buckley and Leo Cherne to organize an attack on the Student Mobilization Committee to End the War in Vietnam, which Nixon said was advocating surrender to the Communists.

In mid-July, Nixon and Kissinger saw a ray of hope when the North Vietnamese in Paris seemed to signal their readiness "to probe in detail the substance of our position on a number of issues." Kissinger interpreted this as "a substantial shift in tactics for Hanoi." Though "the tone of the session in Paris was the best we have ever had," Ambassador Henry Cabot Lodge reported, a state department analyst cautioned that while this might suggest "a desire to encourage private talks," it did "not necessarily portend any substantial Communist concessions in the immediate future." Henry shared these doubts, but "still half believed that rapid progress would be made if we could convince them of our sincerity." He urged Nixon to sign on to "another overture both for the record and because of the lack of real movement in the Paris negotiations."

Opinion polls showing a continuing erosion of support for the war made Nixon receptive to expanded peace efforts. Only about a third of the country continued to see the war as vital to U.S. national security,

with more than 50 percent declaring it a mistake. A Harris survey in July 1969 showed that 71 percent of Americans wanted the president to withdraw 100,000 troops from Vietnam by the end of the year. As for Nixon's handling of the war, only 38 percent gave him positive marks, while 53 percent saw "at best little difference between the Nixon and Johnson approaches to the war." Johnson's war was turning into Nixon's war: It was clear to Nixon that if he did not end U.S. involvement in the conflict over the next three years, he would be presiding over a ruined administration with as little prospect of being reelected as LBJ had in 1968.

Because Hanoi refused to receive Sainteny and because Nixon felt under growing pressure to achieve a breakthrough, he sent Kissinger on a secret mission to meet with North Vietnam's representatives in Paris. On August 4, as Nixon flew home, Kissinger stopped in Paris on the pretext that he would brief French officials about the president's trip. Tony Lake, a Foreign Service officer who had replaced Eagleburger and had become one of Kissinger's favored assistants, accompanied him. General Vernon Walters, the U.S. military attaché in Paris, a skilled linguist, became Kissinger's translator in the talks. Kissinger subsequently made him his back channel to the North Vietnamese delegation in Paris. Walters was told to hide his role in the negotiations from embassy officials, U.S. representatives to the talks, and his superiors at the Pentagon.

Henry met with Ho's spokesmen at Sainteny's apartment on the Rue de Rivoli. Since the press did not shadow his every move at this time and since he had no record of secret diplomacy, he arrived at Sainteny's residence unobserved.

Kissinger was excited and nervous in this new role as negotiator. It was one thing to frame policies but a different challenge to execute them. Intelligence and wit were valuable and even essential skills in the academy, but whether they would translate into assets when trying to convince adversaries to give up something their countrymen had been dying for was another matter. Henry need not have worried about his capacity to represent the United States. While the stakes had not been life and death in the academic clashes at Harvard or in the administration's bureaucratic battles at which he had excelled, they were a useful prelude to the verbal jousting he now faced with the North Vietnamese.

Moreover, Kissinger had thought carefully about what would serve him as a negotiator. When a journalist later asked him what personal

qualities he considered essential to diplomatic exchanges, Henry replied: "Knowledge of what I am trying to do. Knowledge of the subject. Knowledge of the history and psychology of the people I am dealing with. And some human rapport . . . To have some human relations with the people I am negotiating with. This takes some rough edges off. They won't make concessions they wouldn't otherwise make."

Despite his preparations, Kissinger was understandably on edge as he arrived a half hour early at Sainteny's apartment. Xuan Thuy and Mai Van Bo, Hanoi's representatives, were experienced functionaries who for months had shown themselves impervious to American demands for mutual troop withdrawals and free elections. When they arrived at the appointed time, they impressed Henry with their "dignity and quiet self-assurance . . . In meeting with the representative of the strongest power on earth, they were subtle, disciplined, and infinitely patient." Xuan Thuy was "tiny, with a Buddha face and a sharp mind, perpetually smiling even when saying the most outrageous things." He was "always courteous," showing no "undue eagerness" or impatience during the three-and-a-half-hour exchange of views.

Although Kissinger would later describe the meeting as a repetition of "stock formulas" by the North Vietnamese, he portrayed the conversation at the time in the best possible light. Eager for reasons of national advance and personal ego to believe progress was being made, he interpreted the comments of the North Vietnamese as suggestive of some give in the negotiations. "Xuan Thuy did not hit back hard at my statements about the necessity for us to take actions of gravest consequence if there is no major progress by November 1," Henry stated in a summary of the meeting. "Thuy appeared to be hinting at some linkage between the withdrawals of our forces and theirs. While he was vague on specifics, the message was nonetheless clear and perhaps significant."

Kissinger wasn't the only one to see progress in the talks: At a meeting of the delegations a few days later, the North Vietnamese seemed "to indicate some movement following your discussions in Paris," Haig told Kissinger on August 11. In retrospect, Kissinger could see that the North Vietnamese agreed to nothing more than a willingness to hold additional secret discussions at unspecified future dates. Xuan Thuy had "no authority to negotiate. His job was psychological warfare," Kissinger later concluded.

At the time, however, Henry could not acknowledge that threatening Hanoi with greater violence had no impact. Like Johnson before them, he and Nixon wanted to believe that Hanoi could not stand up to U.S. power. Nixon hoped that a July lull in the fighting "may indicate that the enemy is hurting and wants to bring an end to the conflict."

Kissinger told French Foreign Minister Maurice Schumann, "In the conduct of long-range American policy throughout the world, it was important that we not be confounded by a fifth-rate agricultural power . . . It was unthinkable for a major power like the United States to allow itself to be destroyed politically by North Vietnam." As Kissinger told Thuy, if they prolonged the conflict and turned it into "Mr. Nixon's War," it would work against them. "If it is Mr. Nixon's War," Henry declared, "he cannot afford not to win it." In short, America's world position was at stake and the prospect of domestic instability resulting from two administrations in a row defeated by the war was impermissible.

Hopes that Hanoi would bend in response to the U.S. peace offensive and threats of increased military action were shattered on August 11 when the Communists launched ground attacks against more than one hundred South Vietnamese targets. On August 22, Kissinger reported to the president that Communist attacks were continuing across South Vietnam and that Hanoi was repeating its standard line in Paris.

If the White House needed any more evidence that the North Vietnamese were not ready for peace on anything but their terms, it came in a letter from Ho on August 30. His reply to Nixon was unyielding: "Our Vietnamese people . . . are determined to fight to the end." He demanded that the United States withdraw its forces without any reciprocal steps by Hanoi, abandon Thieu, and leave the Vietnamese to decide their own fate "without foreign influence."

Nixon now found himself in the same trap that Johnson had struggled to escape. Bombing pauses, peace feelers, and proposals for ending the war seemed to make no impression on Hanoi. Like Johnson, the only alternative Nixon now saw to giving up on the war was more bombing and killing. If you kill enough, they will eventually give in, most U.S. military commanders believed.

At the end of August, Nixon agreed to additional air raids on Communist sanctuaries in Cambodia. He also announced that he would wait until he returned to Washington in September from an extended stay

at the San Clemente, California, White House to consider additional unilateral troop withdrawals. "The decision," Kissinger says, "was greeted with outrage by the Congress and the media." The *Christian Science Monitor* said that Nixon was "testing U.S. public patience with the withdrawal delay." Senator Kennedy "accused the administration of making only 'token' withdrawals of U.S. troops and heeding advice that leads 'to war, and war and more war.' " Nixon wanted Kissinger and Haldeman to "get out speeches and articles to answer this . . . Give me a battle plan," he instructed.

The administration now faced a growing and possibly insurmountable quandary on Vietnam. Henry persuaded Nixon to set up a Special Study Group to provide "systematic analysis," which Kissinger believed had been lacking and now might point them in more reliable directions. His recommendation was meant to hold out hope that social science might come to the rescue. It was the conceit of an academic who had no better clue than anyone else about how to turn a failing effort in South Vietnam into a victory.

Although Nixon approved Henry's suggestion, it did nothing to relieve his immediate frustrations about Vietnam. When the press reported Pentagon leaks about plans to reduce September draft calls as a way to head off campus antiwar protests in the fall, Nixon complained to Henry, "Now we lose the surprise impact!" Similarly, a White House announcement that it would honor a temporary truce in response to Ho's death on September 3, 1969, backfired when Thieu unilaterally announced his refusal to go along. It signaled the deterioration in relations with Saigon, CBS reported. "Who put this out?" Nixon asked Kissinger. "Knock it down. Deny it to Thieu." According to the president's news summaries, the peaceniks were seen and heard everywhere and "the voice of the hawk is barely heard in the land." It was an acknowledgment that organized efforts to sell the war to the public were achieving nothing.

Because Kissinger now sensed that the administration was moving toward a political disaster in its management of the war, he sent Nixon a five-page memo describing his concerns about Vietnam. He warned the president that pressure on him to end the war quickly was increasing and that Vietnamization was an insufficient answer to the problem. Indeed, as the process went forward, it would likely increase demands for a full withdrawal. It "will become like salted peanuts to the American public:

The more U.S. troops come home, the more will be demanded." Nixon would then face a new round of public polarization on the war. Like Johnson, "you will be caught between the Hawks and the Doves." The division in the country would confirm Hanoi "in its course of waiting us out." Though we had been hurting Hanoi militarily, the Communists would rely on a "low-cost strategy of 'protracted warfare' aimed at producing a psychological, rather than military, defeat for the United States."

Was there a way out of their Vietnam dilemma? Henry put four possibilities before Nixon—maintain the current strategy, which Kissinger's memo had implicitly urged Nixon to abandon; accelerate negotiations, which Kissinger also considered a mistake; accelerate Vietnamization, which Kissinger had largely ruled out by advising that it might become a unilateral withdrawal that left South Vietnam vulnerable to a Communist takeover; and, Kissinger's choice, "escalate militarily while maintaining essentially our negotiating approach and halting Vietnamization."

Nixon found the escalation option highly appealing. And, in fact, a contingency plan was on the table for possible use after November 1. The plan, which was drawn up by the NSC staff in mid-September, reflected Kissinger's inability to believe "that a fourth-rate power like North Vietnam doesn't have a breaking point." Operation Duck Hook, "a savage decisive blow," named for "all the 'ducks' of American power 'circling in' for the kill," was to "apply whatever force is necessary to achieve maximum political, military, and psychological shock." The initial four-day assault was to include renewed aerial attacks against the North and a blockade of Haiphong, North Vietnam's principal port. After a one-day pause to test Hanoi's receptivity to more productive talks, additional attacks were to include the destruction of Red River dikes, a ground offensive across the DMZ, and greater disruption of North Vietnam's sea and land traffic. The campaign was to continue until Hanoi agreed to meaningful negotiations.

Unlike Johnson, who had resisted suggestions that he consider using tactical nuclear weapons, Duck Hook contained possible "nuclear bombing plans." Ambassador to NATO Robert Ellsworth learned from Larry Eagleburger that the White House, and Kissinger in particular, was talking about using nuclear weapons. Ellsworth told Charles Colson, a Nixon operative, "We'll be out of Vietnam before the year is out. But

the Old Man is going to have to drop the bomb. He'll drop the bomb before the year is out and that will be the end of the war." The planners even prepared a Nixon speech for delivery on the eve of the operation in which he declared America's determination to use its power to force the Communists into a settlement. At the end of September, Nixon told Republican congressional leaders that he would "not be the first President of the United States to lose a war."

Nixon had no intention of resorting to the nuclear option. But he believed that putting U.S. nuclear forces on alert in October as a response to Moscow's increased deployment of nuclear weapons could not only force the Soviets into arms negotiations but also frighten them into thinking that this might be a prelude to using them in Vietnam. Nixon remembered how Eisenhower had used the threat of nuclear weapons against China to force an end to the Korean War.

Duck Hook was hidden from Rogers and Laird, who did not learn about it until Nixon leaked it to the columnists Evans and Novak at the beginning of October. It is surprising that the White House could keep it under wraps for even just a couple of weeks. Mindful that Nixon and Kissinger tried to delay and blunt internal opposition to their initiatives, Laird, who was as much a master of bureaucratic intrigue as Nixon, used a network of officials to keep him informed about White House discussions and decisions. Relying on the National Security Agency, Naval attachés at various embassies, and the Army Signal Corps, which managed secret White House phone conversations, Laird kept close tabs on most everything Nixon and Kissinger were doing.

Although J. Edgar Hoover had warned Nixon in the transition period that the Signal Corps would surreptitiously monitor his phone calls, it wasn't until September 1969 that Nixon found confirmation of Laird's operation. It "gave us something new to worry about," Haldeman recorded in his diary. It obviously made Nixon and Kissinger more cautious about guarding secrets like Duck Hook.

At an NSC meeting on September 12, Nixon tried to arrive at some realistic assessment of his options. He was highly skeptical of Hanoi's interest in negotiations. "For five years we have been kidding ourselves," Nixon said. Phil Habib, one of the U.S. negotiators in Paris, shared the president's conviction: He saw "no give at all" in Hanoi's position during the forty meetings he had attended. Why do they continue the Paris

talks? Nixon asked. "They don't want to seem to be in bad faith before world opinion, and they get advantages in Paris with our press," Rogers replied.

Nixon asked his military chiefs what the result would be if we launched a new offensive. The chiefs doubted that it would make a big difference: "They can carry on. There would be no fatal blow through seeking a no-holds-barred solution . . . [during] a couple of weeks," they answered. Rogers recommended a continuation of Vietnamization. "Most of the public agree with our moves so far," he said. "If we go ahead with reductions, we will get public support . . . We haven't much in the way of choices. If they think we are going for a military victory, the public will leave us."

Nixon believed that a collapse of domestic support would be disastrous: it would destroy our credibility with Hanoi, and we would lose the confidence of Saigon. Kissinger, who had sat quietly through most of the discussion, signaled his doubts about Vietnamization. "We need a plan to end the war," he said, "not only to withdraw troops."

However dearly he wished to exert new military pressure, Nixon gave primacy to his well-honed political instincts: Fearing defeat in Vietnam less than domestic political divisions that could undermine his public standing, he announced an additional reduction of 40,500 troops in Vietnam by the end of the year. America was on the road to a unilateral withdrawal, Kissinger believed. It frustrated and demoralized him. Because he could provide no assurances that a fresh assault on North Vietnam would force Hanoi's hand, he was in a weak position to fight Nixon's decision.

In September, resignations from Kissinger's staff in response to his harsh handling of subordinates weakened his influence in the administration. A column in the *Washington Post* by Joe Kraft undermined Henry's standing with the president. Kraft's assertion that the resignations were the result of a closed White House, which excluded most of the NSC from the government's important foreign policy decisions, angered Nixon. He demanded to know who had leaked the story. Kissinger acknowledged that he had spoken to Kraft prior to the publication of his article, but he assured Nixon that he had been "able to get him to tone down his treatment." It did not reduce Nixon's irritation.

In September and October, as the administration confronted plans

for a monthly antiwar protest in the capital, described as a "Moratorium," Nixon and Kissinger remained hopeful that an honorable settlement was possible; that they could mute domestic divisions encouraging Hanoi's hopes of a unilateral American retreat; and that they could persuade Moscow to pressure Hanoi into greater flexibility in Paris.

Their hope of finding a means to end the fighting and leave behind an independent South Vietnam partly rested on the belief that Henry's Special Study Group could produce a viable peace plan and that world opinion was lining up with the U.S. on ending the conflict. Bolstering these expectations were passing references by the North Vietnamese in Paris to postwar plans. It was clutching at straws.

Since domestic divisions impressed Nixon as the principal deterrent to advances in Paris, he and Kissinger were determined to mount an aggressive campaign against peace activists. When a newspaper story asserted that "despair is developing among policy makers" over Vietnam, Nixon urged Henry to see the columnist "Ted Lewis (alone). He can be very influential with his colleagues." Nixon also instructed Kissinger to lobby against a congressional resolution setting a timetable for troop withdrawals. He was to warn congressmen that such a debate would agitate campuses and be counterproductive in advancing the Paris negotiations.

Nixon was especially eager for the White House to take on Ted Kennedy's criticism of the cautious troop withdrawals and slow-paced reduction of draft calls. "It is absolutely essential that we react insurmountably and powerfully to blunt this attack," Nixon told Haldeman. He wanted Haldeman to "game plan the possibility of some pro-Administration rallies, etc.[,] on Vietnam on October 15," the date set for the first Moratorium. At a September 26 news conference, Nixon dismissed the upcoming demonstration as having no impact on him and likely to encourage Hanoi to continue the war.

At the same time the White House worked to promote support for the war, it increased pressure on Moscow to influence Hanoi. Nixon instructed Rogers to adopt an aloof posture in talks with Gromyko. Rogers was "to intimate that the Vietnam deadlock, which is so obviously due to the position of the Communist side, complicates the whole range of U.S.-Soviet relations."

Sonnenfeldt echoed the message to Gromyko in a conversation with

Georgi Arbatov. Sonnenfeldt complained that Moscow was encouraging Hanoi's hopes that divisions in U.S. opinion would force an American withdrawal from the war. "This was a dangerous business," Sonnenfeldt said. Moscow's support of a war against the United States was a significant impediment to improved relations. "To us, Vietnam was the critical issue," Kissinger told Dobrynin a few days later. "The Soviet Union should not expect any special treatment until Vietnam was solved . . . The train had just left the station," Kissinger reported Nixon as saying. Dobrynin hoped it was an airplane with some maneuvering room. "The President chooses his words very carefully," Henry replied. "I was sure he meant train."

Yet Nixon and Kissinger were convinced that the key to successful negotiations with Hanoi would be less through Moscow's intervention or exchanges in Paris than through solidifying the country behind an "honorable" end to the fighting. Kissinger wanted Nixon to say in a televised address before October 15 that demonstrators were "dividing the country and making it impossible to settle the problem on a reasonable basis."

It was unrealistic of Nixon and Kissinger to believe that the bitter domestic opposition to the war could be overcome by a surge of patriotism. True, on October 1, Nixon could point to a 60 percent vote of confidence from the public in his presidential performance. But it was not a reassuring number alongside those of his three immediate predecessors: Eight months into their terms, Eisenhower, Kennedy, and Johnson all had 75 percent approval ratings.

Nevertheless, Nixon, who had always enjoyed a good fight with political adversaries, saw no alternative to battling the "peaceniks" for a "sensible" outcome to the war. He and Kissinger were certain that the loss of South Vietnam to communism would seriously undermine U.S. credibility with its allies and other developing countries eager for Washington's help against radical opponents. When "the spiritual leaders of American Reform Judaism" came out in support of the Moratorium, Nixon wrote Kissinger: "Someone should tell them the consequence for Israel of an American bug out in Vietnam."

Nixon instructed Pat Buchanan to "get the Hawk columnists going." He also wanted surrogates to start a drumbeat in Congress against a resolution setting a timetable for an American withdrawal. Opponents were

to describe this as the "Massacre Enabling Act" and predict that a Communist takeover in South Vietnam would sentence 500,000 Catholics to death. Nixon himself took the initiative by leaking the Duck Hook plans to the columnists Evans and Novak. They reported that he was "considering blockading Haiphong and invading the North." When an aide gave Nixon advance notice of the column's appearance, he responded: "No problem—no comment from W.H."

As the Moratorium approached, the administration stepped up efforts to counter "the anti-Vietnam war line in the media and . . . the Congress." When *Time*'s Hugh Sidey told Kissinger about a planned article on White House interest in overthrowing Thieu, Henry "gave him hell," saying it was "against the national interest." Nixon promised to "personally attack *Time* if they printed such an article." Henry provided the White House with a list of columnists and congressmen he had given talking points refuting war opponents.

When the FBI informed Ehrlichman that the "heaviest outlay of funds for" the Moratorium was coming from the Socialist Workers party and that the Communist party and other left-wing groups were also involved, Nixon made a "priority" of getting "this out to all columnists" and asked that "our people in Congress hit it." A "Tell it to Hanoi" ad orchestrated by the White House and run in newspapers across the country won Nixon's private praise. Lapel buttons and bumper stickers distributed to many of the eight million members of the American Legion and the VFW encouraged Nixon's hopes that he could blunt domestic pressure for an overly hasty peace.

Nixon and Kissinger deceived themselves into believing that their battle against war opponents was succeeding. They were convinced that the Moratorium, rather than hurting Nixon, was boosting his public approval and strengthening his hand against Hanoi. Henry told Joe Alsop, a pro-war columnist, that "the degree to which the liberals are out of touch with the country is startling."

Five days before the Moratorium, Nixon told Henry, "By '72 the war is going to be over, and he is going to be the man who ended it. If we do it—put it right to the bastards—after all we're in the [right], they [the peace advocates] 're not. There's a lot of rough stuff coming up," Nixon reassured himself, "but the thing to do is to sail along . . . K says for him to point out that he was elected and because of this he has responsibility

for the country. P said it isn't just this issue, but the next one and the next one that comes up. What about Korea? What about Berlin? K said he is convinced that if we yield on this one, we're just inviting the Soviets into a confrontation."

Much of the Nixon-Kissinger rhetoric was a form of autointoxication—a way to reassure themselves that they were courageously serving the national interest against knee-jerk war opponents ready to accept short-term solutions injurious to long-term needs. After eight months of trying to quiet dissent and convince war opponents that the best way to exit Vietnam was through uncritical support of the White House, Nixon and Kissinger faced stubborn and growing antagonism.

At the end of September, despite Henry's plea to antiwar Republican congressmen "to give the President more time and a show of unity," they planned "to hold a memorial service at Arlington cemetery for Vietnam war dead" and to press fellow GOP representatives to support repeal of the Tonkin Gulf resolution, which was symbolic of the miscalculations and deceits now widely associated with involvement in the war. In October, one newspaper described Henry's faltering influence: He had been "a breath of spring after the tired men of the Johnson years. Nine months later Kissinger is tired. Nothing seems to be working." Senator Fulbright promised to hold hearings at the end of October on a troop withdrawal resolution, and Illinois Republican Senator Charles Percy predicted that Nixon would not be able to resist the "widespread" student protest movement.

The *New York Times* did not see how the president could ignore the Moratorium or not be affected by it. Publicly, Nixon gave no hint of concern; privately, he hoped to discredit the demonstration: Haldeman tried to get the TV networks to triple their estimates of Moratorium opponents—"so it looks like [a] failure." The TV networks would only note "the escalating support of the Moratorium." One Nixon congressional supporter, reflecting White House defensiveness, denounced his antiwar colleagues as either " 'self-appointed emissaries of Hanoi' " or "at least unwitting tools." Was there anything they could say that "could get the Doves squawking"? Nixon asked Pat Buchanan. Buchanan feared that "the right has lost any hope." Hugh Sidey saw "the few blocks between the WH and the Moratorium headquarters" as "littered with 'a light-year of man-made misunderstanding.' "

On October 15, the Moratorium, as organized antiwar protests were now called, attracted hundreds of thousands of demonstrators in cities across the country. Adam Walinsky, a former Harvard colleague, urged Henry to understand that the Moratorium was even bigger than the 1968 protests, and "you cannot carry a country that feels this way." Demonstrating that he had something of a political tin ear, Walinsky said, "the President is finished—he is not going to get re-elected and he should realize that is where he is." Walinsky found immediate confirmation for his conclusion in a Gallup poll citing 56 percent approval for a congressional resolution setting a timetable for U.S. troop withdrawals from Vietnam.

Despite the growing popularity of the opposition, Nixon and Kissinger refused to acknowledge its influence. Kissinger took refuge in the observation of a British friend: Vietnam "is not a television serial that can be switched off because the audience has become bored." Nixon instructed Rogers to tell the *New York Times* that its antiwar stance was limiting its power to change the course of events. "They certainly don't influence him," Nixon said. He told Democratic House leaders John McCormack and Carl Albert the same thing: He "stated categorically that he would not allow national policy to be dictated by street demonstrations"—it would mean the triumph of "mob rule." The net effect of the Moratorium, Nixon told Hubert Humphrey, was to raise his public approval rating from 52 percent to 58 percent.

After October 15, Nixon saw the need for a nationally televised Vietnam speech. For the next ten days, he continued to think about announcing Duck Hook in an address. At a minimum, he wanted Hanoi and Moscow to think that increased military action might be in the offing. To this end, he ordered worldwide military steps, including the dispatch of "nuclear capable forces to their . . . operating bases." These measures were to "increase in intensity up to October 30," including further Menu raids on Cambodia and air attacks on the DMZ, "so they know we are getting trigger happy," Nixon said to Kissinger. Although 60 percent of Americans were now opposed to continuing involvement in the war, "there is still a substantial proportion of the population," Nixon told Sir Robert Thompson, a British counterterrorism expert, "which says that we should not take a bloody nose."

Nixon wanted Kissinger to tell Dobrynin that the president was out

of control on Vietnam. He was to say, the president " 'has made up his mind and unless there's some movement,' just shake your head and walk out . . . We've got to lay it on the line, put that flag around us and let the people scream," Nixon told Henry. During a meeting with Dobrynin on October 20, Nixon made a plea and a threat—if Moscow would not "help us to get peace, the U.S. would have to pursue its own methods . . . It could not allow a talk-fight strategy without taking action." In a private conversation with House leaders, he promised not to "proclaim a 'soft' policy toward North Vietnam." At the same time, Agnew, speaking for the president, publicly attacked antiwar leaders as "an effete corps of impudent snobs who characterized themselves as intellectuals."

For all his rhetoric, Nixon decided against Duck Hook, despite Henry's conviction that "we must escalate or P is lost." Most of Nixon's advisers told him that it wouldn't work and would do more to undermine his political standing at home and abroad than to force Hanoi into a settlement.

After Rogers and Laird learned in early October that Nixon was considering such an escalation, they had pressed him not to do it. The administration's objective, Rogers told him, should not be to alienate protestors and millions of other Americans with military actions that wouldn't work, but to disarm antiwar activists by convincing them that we shared their desire for peace. Sir Robert Thompson echoed Rogers's warning that escalation would put the administration at risk with United States and world opinion. He advised that Vietnamization could bring victory in two years. Mike Mansfield warned Nixon that continuing the war "endangers the future of the Nation" by deepening the already bitter divisions in the country.

The left put additional pressure on Nixon to give up any immediate plan of escalation by announcing its conviction that when the president spoke, he would align himself with doves urging a "pull-out and peace." If Nixon's speech failed to confirm this dovish prediction, newspapers warned, it would produce "an enormous let-down and . . . escalation of the protest movement."

Nixon partly rationalized a decision to put Duck Hook aside by hoping that the ongoing signals to Moscow of heightened nuclear readiness might be enough to force Hanoi into serious discussions. Nixon also viewed the suspension of Duck Hook as temporary, telling Henry that

he could always come back to it next summer when he could rally the country around him prior to the 1970 elections.

But it was rhetoric born of frustration. As late as June 1971, he still had thoughts of beating the hell out of Hanoi. "About November of this year," he told Haldeman, "I'm going . . . to play . . . the goddamn . . . hole card. As long as we still got the air force— . . . we're gonna take out the dikes, we're gonna take out the power plants, we're gonna take out Haiphong, we're gonna [pounding the table as he says:] level that goddamn country!"

Nixon remembered that Kissinger advocated "a very hard line [in a speech set for November 3]. He felt that if we backed off, the Communists would become totally convinced that they could control our foreign policy through public opinion." Yet according to Kissinger's recollections, "We finally rejected the military option because we did not think we could sustain public support for the length of time required to prevail; because its outcome was problematical; and because had we succeeded, Saigon might still not have been ready to take over."

Years later, against the backdrop of United States' defeat in Vietnam, Nixon and Kissinger rued their failure to follow through on Duck Hook. "In retrospect, I think we should have done it," Nixon said. "I was worried how it would affect our chances of improving our relations with the Russians and Chinese. And I didn't feel the traffic would bear it within the administration." He feared resignations by Rogers and Laird, and "I just wasn't ready for that." Similarly, Kissinger told Bill Safire, "We should have bombed the hell out of them the minute we took office . . . The North Vietnamese started an offensive in February 1969. We should have responded strongly. We should have taken on the Doves right then—start bombing and mining the harbors. The war would have been over in 1970."

The retrospective thinking ignored the context in which Nixon and Kissinger had decided to back off Duck Hook. Their contemporary judgment on the explosion of opposition that would have resulted from so massive an assault was much more realistic than any later recriminations about how they could have won the war in 1969 or 1970. After the Tet Offensive in January/February 1968, the continuation of U.S. military action at past levels was no longer a viable solution to the conflict. Hardly anyone believed, short of an invasion of North Vietnam, that

additional bombing of the North would compel Hanoi's acquiescence in U.S. peace demands.

Nixon's speech on November 3 reflected current realities. For all the talk about using military power to force Hanoi into a compromise peace, Nixon took a middle way between emphasizing his efforts to end the war and his commitment to unifying the country behind a settlement that assured Saigon's independence and honored the sacrifices of American troops. In the days before the speech, he instructed Haldeman to set up a strike force that would line up media and broad public support for his policies. He wanted Kissinger to emphasize to congressmen and journalists that we had a plan to end the war and that before the next Moratorium on November 15, they help unify the country behind the administration's peace strategy.

Nixon's evening speech from the Oval Office was a thoughtful effort to reassure American and world opinion that the administration was making an all-out effort to achieve peace. Convinced that appearances on TV were as important as substantive statements, Nixon struck an impressive pose: "His voice was stern, his bearing measured and calm, his expression grim," one biographer wrote.

He wanted people to know what had "really" been happening in Paris and Vietnam and what "choices" we had for achieving "America's peace." A quick withdrawal was not the answer. It "would be a disaster not only for South Vietnam but for the United States and for the cause of peace." It would amount to what Nixon described as the "first defeat in our Nation's history and would result in a collapse of confidence in American leadership . . . throughout the world." There was no consideration of the view that America might enhance its global position by abandoning a failed policy that would allow the country to turn its energy and wealth to more constructive things both at home and abroad as de Gaulle had recommended. Fearful that they would be accused of failure in ending the war on satisfactory terms, Nixon and Kissinger refused to accept this sensible realism.

Nixon recounted the several peace proposals he had made to Hanoi that had gone unanswered. He described the many private initiatives he had taken to advance the negotiations, including his letter to Ho Chi Minh and Ho's dismissive response. "No progress whatever has been made," Nixon acknowledged, but it was all Hanoi's fault. The Commu-

nists were convinced that all they had to do was "to wait for our next concession, and our next concession after that one, until" they got everything they wanted. Yet he was not without hope, especially because he believed that the Nixon Doctrine, which he explained in detail, "will bring the war to an end regardless of what happens on the negotiating front." The first practical implementation of this idea was Vietnamization—a plan to make the South Vietnamese responsible for fighting the Communists and assure that American forces would be coming home as the South Vietnamese army (ARVN) replaced them.

Nixon declared this the right way to end the war. He would not give in to the minority of demonstrators whose demands for an unconditional withdrawal would undermine America's "future as a free society." Instead, he asked "the great silent majority of my fellow Americans" for their support. Unity at home was vital to American effectiveness in the Paris talks. "Let us be united for peace. Let us also be united against defeat . . . North Vietnam cannot defeat or humiliate the United States. Only Americans can do that."

The speech demonstrated that Nixon spoke like a hawk but was acting like a dove. As a consequence, he gained no significant ground with either group. His tough language raised doubts among peace advocates that he would follow through on stated intentions to end the war, while Vietnamization convinced proponents of more aggressive military action that Nixon was pursuing a policy more attuned to a war-weary public than to a winning strategy in a stalemated conflict.

Nixon said later that his speech influenced the course of history. He believed that the speech brought a dramatic turnaround in public attitude. The flood of telegrams and letters exceeded even Nixon's fondest hopes—the biggest written response ever to a presidential address and the great bulk of it positive. A telephone poll showed a 77 percent approval rating. "I had the public support I needed to continue a policy of waging war in Vietnam and negotiating for peace in Paris until we could bring the war to an honorable and successful conclusion."

Behind the scenes, however, Kissinger proceeded much as they had before the speech, demonstrating not that the address marked a turning point in their dealings with Vietnam, but that nothing had actually changed. Nixon, who was too keyed up to sleep, kept telephoning Kissinger for reassurance that he had done well, that Henry would be work-

ing to intimidate the media, which Nixon saw as hostile to him as ever, and that Rogers and Laird would be pressured to declare support for the president's policies.

In three phone conversations between 10:20 P.M. and midnight following the speech, Henry was like a therapist calming a panicked patient. Kissinger assured Nixon that the speech "was great" and that "the press, TV commentators are [only] nit-picking, [though ABC's] Frank Reynolds was vicious," and "some liberal commentators were incoherent with rage." Henry asserted, "If we didn't reach the people tonight, it's not possible to do so." Nixon wanted Henry to "be sure you keep your people working all night long—we mustn't let up . . . We'll keep working," Kissinger promised. As for Rogers and Laird, Nixon said, "they should have been ecstatic. But neither showed that—they haven't got the guts. I think they'll have to go." As for Marvin Kalb of CBS, who didn't like the speech, Nixon said, "He's a communist." Nixon was convinced that they would get "a great reaction from the average person."

Haldeman was kept even busier than Kissinger trying to assure the proper response to the speech. For three hours after 10:15 P.M., Nixon called Haldeman between fifteen and twenty times. The staff began "making checks around the country, and I reporting every few minutes to P whenever there was a new item." Nixon wanted him to "hit network management for biased reports . . . Get 100 vicious dirty calls to *New York Times* and *Washington Post* about their editorials (even though no idea what they'll be)." The next day, Nixon was thrilled with the overall positive response. "There probably has never been a day like this," he told Haldeman. "Here was the press last week that we were in the dumps, lack of ideas, etc., but now look at things."

After months of frustration, Nixon deceived himself into thinking that he had turned a corner in ending the war. But his and Kissinger's actions belied this hope. They knew that Vietnamization and expectations of domestic harmony were weak reeds to lean on in reaching a satisfactory settlement.

On November 6, three days after the speech, Nixon and Kissinger had returned to the same hidden actions they believed would be necessary to compel a compromise peace—threats of greater violence against the North and demands for greater Soviet pressure on Hanoi. Nixon wanted Rogers and Laird to initiate a military action that Haig described

to Kissinger as "risking U.S. lives in an effort to either intimidate the enemy or" give the White House "a basis for escalation. Leakage of this directive," Haig warned, "would more than likely result in charges of the latter." Just what Nixon had in mind from such action is unclear, but it is transparent that he still did not see unity at home as sufficient to force Hanoi's hand.

Similarly, when Kissinger met with Dobrynin the same day, he reiterated that major improvements in Soviet-U.S. relations continued to depend on progress over Vietnam. Dobrynin responded "a little plaintively that he could not understand our attitude because the Soviet Union was not making trouble for us in Vietnam; they were not trying to embarrass us; but they could not get us out of a war into which we had gotten ourselves." Dobrynin's observation fell flat.

Because neither military nor Soviet pressure seemed likely to bring an end to the conflict (the heightened nuclear readiness had done nothing to increase Moscow's efforts to end the war), and because public patience with calls for harmony over the war had little sustained appeal, Nixon and Kissinger felt trapped in a losing struggle. Their only real hope now was that Vietnamization would actually work. And though it was difficult to put great faith in the program, it at least gave them a coherent scheme for an exit from Vietnam while they turned their attention to other major foreign policy challenges.

TROUBLES GALORE

*Men of ordinary physique and discretion cannot be
Presidents and live, if the strain be not somehow relieved.*

—WOODROW WILSON

Don't get rattled—don't waver—don't react.

—RICHARD NIXON

The first fifteen months of the Nixon presidency largely centered on Vietnam—how to continue fighting the war; hold domestic opponents at bay; and pressure Hanoi into a settlement that did not cost Saigon its independence and saddle the United States with a military defeat that diminished American sacrifices in blood and treasure and undermined its international credibility.

As Nixon and Kissinger struggled with Vietnam, it became increasingly evident that Vietnam was not only a problem unto itself but also an impediment to resolving other difficulties at home and abroad. Vietnam stood in the way of renewed national harmony and, of less concern to Nixon, serious consideration of domestic issues like segregation and welfare reform. Most important, in Nixon's view, it diminished prospects

for improved relations with Russia and China and left little energy for consideration of Middle East tensions that could provoke not just another war between Arabs and Jews but also a confrontation between the U.S. and the U.S.S.R.

Finding solutions to Arab-Israeli problems was as great a challenge as constructing a graceful exit from Vietnam. For twenty years, since the establishment of Israel, the Middle East had been a battleground. Israel's 1948 War of Independence, the 1956 Suez crisis, and the 1967 Six-Day War were the most dramatic, but hardly the only, explosions of violence in the region. Israel's victory in the 1967 conflict had heightened Arab calls for the destruction of a nation that, they complained, had not only displaced the Palestinians but also seized Egyptian, Syrian, and Jordanian lands.

In 1969, Kissinger had little hope that the United States could significantly alter the course of events in the Middle East. And "by the end of my time in office," he acknowledged, "I had become like all other old Middle East hands; word had become reality, form and substance had merged. I was immersed in the ambiguities, passions and frustrations of that maddening, heroic, and exhilarating region." Engagement with the issues of the area led him into "an agonizing swamp of endless maneuvering and confusion."

Nixon entered the presidency loath to become directly involved in Middle East negotiations, which were at an impasse, with Arab states demanding the return of occupied territories and Israel refusing to consider such demands without guarantees of recognition and future security against renewed attempts to destroy her. To be sure, Nixon wanted to counter the expansion of Moscow's growing military presence in Egypt and the Middle East more generally after the 1967 war. He also had thoughts of linking discussions with Moscow about Middle East problems to Vietnam and arms control. But neither of these considerations convinced him that he should make what he believed would be a largely unsuccessful effort to involve the United States in negotiations between such combative and unbending adversaries.

Besides, he was resentful toward American Jews, Israel's strongest supporters. They principally favored the Democrats, and, Nixon believed, were part of the northeastern Establishment, which had dismissed him as unworthy of high political office. For all his sophistication, or at least

exposure to a much larger world than the one he had known growing up, Nixon was a cultural anti-Semite. He was comfortable enough with individual Jews like Kissinger, William Safire, and Leonard Garment, all of whom he appointed to important positions in his administration. But it was their exceptional competence that persuaded him to put aside feelings of hostility to their ethnic identity.

Nixon's prejudice was of a piece with the attitudes held by many lower-middle-class Americans. He believed that American Jews were more loyal to Israel than to their own country, sometimes describing them as "Jewish traitors." "Nixon shared many of the prejudices of the uprooted, California lower-middle class from which he had come," Kissinger said. "He believed that Jews formed a powerful cohesive group in American society; that they were predominantly liberal; that they put the interests of Israel above everything else; that on the whole they were more sympathetic to the Soviet Union than other ethnic groups; [and] that their control of the media made them dangerous adversaries."

Nixon took some kind of perverse satisfaction from having Kissinger in his inner circle, where he could periodically taunt him with hostile remarks about Jews. After one such diatribe, Nixon goaded Kissinger, " 'Isn't that right, Henry? Don't you agree?' " " 'Well, Mr. President,' " Henry supinely replied, " 'there are Jews and then there are Jews.' " On another occasion, after Kissinger expressed an opinion on Middle Eastern affairs at an NSC meeting, Nixon snidely asked, "Now can we get an American point of view?" After aides reported "an increase in articles suggesting that the Vice President's rough, tough rhetoric is responsible for a rise in anti-Semitic hate mail," Nixon underscored the words "rough, tough rhetoric" and wrote in the margin, "Keep it up."

Henry took care not to arouse Nixon's anti-Semitism by bringing too many NSC Jewish staff members to meetings with the president. Nor did Kissinger hide this concern from associates, who chided him for not confronting Nixon about his prejudice. Kissinger rationalized his acquiescence in Nixon's anti-Semitism by explaining that it was "almost suicidal" to take issue with Nixon on core beliefs about particular groups, be it Jews or journalists. Since most of Nixon's verbal assaults on "enemies" came to nothing anyway, it seemed pointless to argue against his bias. What Kissinger also sensed was that Nixon had sadistic impulses which only a course of psychotherapy could have deterred him from expressing

in exchanges with vulnerable underlings. "For Kissinger, being Jewish was a vulnerability as he saw it," Ehrlichman said, "and he was not fond of being vulnerable. But Nixon liked him to feel that way."

NIXON BEGAN HIS PRESIDENCY by making the state department rather than Kissinger responsible for Middle East negotiations. It was partly a device for insulating the White House from criticism for any failed Middle East initiative. But it also rested on Nixon's concern that Kissinger could not be sufficiently objective about Israel. Nixon "suspected that my Jewish origins might cause me to lean too much toward Israel," Kissinger recalls. Nixon's judgment had some foundation in reality. Kissinger later said, " 'How can I, as a Jew who lost thirteen relatives in the Holocaust, do anything that would betray Israel?' "

Because the Middle East was in a state of perpetual crisis, Kissinger had more influence on developments than Nixon had intended. Indeed, it was in response to Middle East problems, where Henry and Nixon were in continuous agreement during the first year of the administration. And it gave Kissinger a more effective hold on the president's commitment to him than their collaboration on Vietnam, Soviet-American relations, or anything else they did in foreign affairs in 1969.

For Nixon and Kissinger, the Middle East was like a jigsaw puzzle with missing and misshapen pieces. They saw no way to impose a U.S. settlement on the warring parties, but they also understood that the United States could not publicly ignore the region's problems; it was a burden of great power responsibility and an issue with significant domestic political consequences. The challenge was how to put the best possible face on a doomed policy of reconciliation.

In January 1969, the United States had official relations with only one Arab state, Jordan; all the others had broken ties to Washington in 1967 when the Johnson administration had blocked efforts at the United Nations to condemn Israel as an aggressor. Furthermore, when the Security Council, led by Britain, passed Resolution 242 urging Israel's withdrawal from recently acquired territories in return for Arab acceptance of Israel as a sovereign state, the United States voted for it, but played only a limited role in arranging its approval. The resolution had required ambiguous language to assure its passage, which had produced a war of words about its meaning. Washington implicitly acknowledged its inca-

pacity to find a solution to the conflict by refusing to become involved in this rhetorical dispute.

More important, Johnson's decision to have the United States replace France, which had turned against Israel after the Six-Day War, as Tel Aviv's principal arms supplier deepened Arab hostility to the United States. Increased Soviet arms shipments to Egypt, especially of advanced jet fighters, dictated Johnson's decision. Soviet and American backing for respective client states now made Middle East tensions as much an East-West clash as a regional conflict.

Two considerations shaped Nixon's initial response to Middle East problems: their hopeless complexity and lesser urgency than Vietnam. True, Arab-Israeli tensions could touch off another war that might jeopardize Soviet-American cooperation on Vietnam and arms negotiations, but Arab caution about suffering additional reverses in a renewed conflict gave Nixon time, or so he hoped, to design a constructive policy.

Since neither side was ready for serious talks or for war, Kissinger believed that "forcing the issue prematurely will magnify insecurity and instability." By contrast, the state department's Middle East experts, led by assistant secretary Joseph Sisco, believed that the United States could not afford to be passive about the area's troubles and persuaded Nixon that he should accept both a Soviet proposal for bilateral talks between Moscow and Washington and a de Gaulle proposal for Four Power discussions between Britain, France, the Soviet Union, and the United States. Nixon accepted the two-track negotiations as the best way to encourage illusions that an early solution to Arab-Israeli problems might be possible. He hoped it might temporarily inhibit both sides from fighting another war. It was a reasonable response to an intractable problem.

The different outlooks on the Middle East held by the White House and the state department ignited a battle between Rogers and Kissinger. Henry said, Joe Sisco, the department's area expert, spent almost "as much time mediating between Rogers and me as between the Arabs and the Israelis." To force the administration into a more assertive Middle East policy, the department leaked a story to the *New York Times* about Nixon's agreement to the two-track negotiations. The *Times* account undercut Nixon's instructions to the department to keep stories about U.S. involvement in negotiations "low key." The leak also made Nixon less inclined to rely on the department to manage Middle East strategy.

Kissinger saw the department's approach to the area's conflict as a "slippery slope. If we were not careful, we would be asked to break every deadlock by putting forward our own plan—which we would then be asked to impose on recalcitrant parties." It was a formula not only for deadlock in the Middle East but for opposition from Israel's American advocates, who feared interference that undermined direct talks between Israel and Arab opponents resisting recognition of the Jewish state.

To impede the state department, which, Henry privately told President Eisenhower in February 1969, "wanted to start negotiations without knowing what to negotiate about," Nixon instructed Sisco to raise procedural questions with London and Paris about the Four Power talks. At the same time, Nixon dampened Soviet enthusiasm for bilateral discussions, which could provide Moscow with telling propaganda among Arabs, by emphasizing the need for prior cooperation on Vietnam.

Initially, Nixon slowed U.S. involvement in Middle East disputes by insisting that direct discussions with de Gaulle in Paris precede any commitment to an American role. But de Gaulle's insistence that international stability required prompt attention to the region overrode Nixon's warnings that Mideast tensions and domestic constraints precluded an effective U.S. policy.

With Israel's Foreign Minister Abba Eban coming to Washington in mid-March 1969, Nixon accepted a Kissinger formula for laying out broad principles that would do little to facilitate negotiations. At the same time, Kissinger urged pressure on Moscow, London, and Paris, but especially the U.S.S.R., to take coresponsibility for discussions. It was a means to assure against assumptions that Washington would deliver Israeli agreement to a settlement. In response, the state department and the British, French, and Russians pressed the White House for more specific plans to force Tel Aviv's agreement to substantive negotiations.

Middle East realities, however, quickly demonstrated how little could be expected from a U.S. initiative, general or otherwise. Meetings in Washington during March and the first half of April, between Eban (who dazzled everyone with his command of English, intelligence, and skill at diplomacy) and Nixon, Rogers, and Kissinger, and subsequent White House talks with Nasser foreign affairs adviser, Mahmoud Fawzi, a skilled Egyptian diplomat, underscored the fact that neither side was ready to concede anything.

Even King Hussein of Jordan, the most moderate and reasonable voice in the Middle East, could not find a way to break the impasse. "The strength of Hussein's bargaining position did not match his moderation and . . . his available options did not equal his goodwill," Kissinger noted.

Nor, Henry might have added, did the Nixon administration have anything more to offer than bromides. "The United States wanted a settlement which both parties could accept so the suffering of all the people in the Middle East would end," Nixon told Hussein during a meeting in the Oval Office on April 8. When Nixon asked Sisco to describe the current "state of diplomatic play" to guests at a state dinner for Hussein, he declared, "What courage is to the soldier, hope is to the diplomat. But," a note taker recorded, "he did not at any point say he hoped for success." While the king's visit came off as well as could have been expected, the state department acknowledged that it was less than an "unqualified success."

Middle East difficulties had begun to test Nixon's patience. The Israelis particularly annoyed him with their blunt intransigence: He wanted Henry "to get a hard message back to" them. Kissinger advised against getting into "a public controversy with them, just continue what we are doing." Nixon agreed not "to be knocked off course."

At the end of April, when no one in the U.S. government could propose a formula to ease Middle East difficulties, Kissinger and Rogers openly battled at an NSC meeting over how to proceed. Rogers believed it essential to do something and Kissinger warned that any initiative then would only underscore U.S. inability to reduce tensions and would deepen the antagonism both sides already felt toward Washington.

During the meeting, Nixon complained that it was "difficult [to] make peace with Israel. Impossible to make peace without." He wanted "to try to bring the Israelis along with us." Rogers agreed, and compared the clash between Jews and Arabs to a divorce case, which would require an imposed settlement. Nixon favored that idea but said it would have to be done without calling it that. He saw Arab-Israeli tensions threatening radical takeovers in Jordan and Lebanon that could expand Soviet influence in the region and increase tensions with Moscow.

The discussion reflected itself in a National Security Decision Memorandum (NSDM) that read like a blueprint for stasis. The document

was nothing more than a holding action: a means to ensure against embarrassment and a sense of defeat that could add to national frustration over Vietnam and undermine Nixon's domestic political standing.

The Israelis, who justifiably feared that Nixon might try to impose an agreement on them, wanted Nixon to invite Golda Meir, Israel's new prime minister, to Washington, where she could explain Israel's position. In the meantime, she sent Nixon a letter pleading Israel's case.

The diminutive, white-haired grandmother held crystal-clear views about the U.S.S.R., the United States, and Israel's national security. Having fled with her family to the United States from Russia in 1906, when she was eight, she despised her native land's authoritarian regimes—the czars and the Communists. Growing up in Milwaukee, where she had become an elementary school teacher, she developed an appreciation of American democracy. Her residence in Palestine since 1921 had made her a founding citizen of Israel, which she insisted should be free to judge its own best interests. Because the White House was not eager to subject Nixon to "her directness, gravelly voice . . . businesslike manner [and] sharp wit," it put off her visit until the fall.

In the meantime, Nixon had given her written assurances that he would not jeopardize Israel's interests. He also stressed, however, that Israel's assumption that "the passage of time alone would bring the UAR [United Arab Republic of Egypt and Syria] around to a more amenable position" was unrealistic. With almost daily acts of violence intensifying Arab-Israeli differences, Kissinger warned Nixon that "the situation in the Middle East is now the most dangerous we face." His only suggestion was to tell the Soviets that Moscow and Washington needed to pressure both sides into a settlement or risk an ongoing crisis jeopardizing U.S.-Soviet relations.

Nixon sent Sisco to Moscow in July to deliver the message. At the same time, the administration renewed its efforts to reassure the Israelis of American intentions and quiet concerns among American Jews. Nixon announced at a June news conference that he was doing everything possible "to defuse" Middle East tensions, and in September, at the UN, declared support for "a settlement based on respect for the sovereign right of each nation in the area to exist within secure and recognized boundaries."

Neither discussions in Moscow nor Nixon's rhetoric did anything

to advance Middle East talks or quiet Israeli fears that Nixon might sell them out. The pressure from Tel Aviv and the pro-Israel lobby in the United States exasperated Nixon. When the conservative *National Review*, which saw Israel as America's only reliable ally in the Middle East, pointed out that the Soviet navy had access to all the eastern Mediterranean ports that used to be open to Western fleets, Nixon told Kissinger, "This is the weakness in our strong Israeli stance."

Tensions with Tel Aviv over acquiring nuclear weapons also troubled Nixon. Israeli assurances that "it would not be the first to introduce nuclear weapons in the Middle East" were unconvincing. Its reluctance to sign the Non-Proliferation Treaty raised suspicions that it already had or planned to build such weapons. Warnings to Tel Aviv that its possession of nuclear missiles risked a U.S.-Soviet confrontation evoked no direct response. The White House considered tying arms shipments to Israeli promises not to go nuclear, but concerns about domestic political opposition deterred it from making the connection. Yet as Laird and Kissinger told the president, "As we continue to supply nuclear capable equipment (Phantom jet fighters) our leverage on the Israeli nuclear program decreases."

By November, though the White House knew that Israel was moving ahead on its nuclear program, it saw no point in putting additional pressure on Tel Aviv. An Israeli promise not to deploy nuclear capable missiles for at least three years allowed the administration "to say we assume we have Israel's assurance that it will remain a non-nuclear state as defined by the NPT." Nixon accepted Kissinger's recommendation that they "not press the Israelis any further on this subject at this time."

Domestic politics was paramount: John Mitchell warned Nixon that a brawl with Israel, which was certain to become public, would subject him to a storm of congressional and public criticism that would weaken him politically and remove existing inhibitions on congressmen who had been restrained about opposing the administration's Vietnam policy. Nixon followed Mitchell's lead, but when he saw an "absolute failure of the Jewish community to express any appreciation" for his decision to send the Phantom jets to Israel, he bristled at their ingratitude.

Nixon's White House meetings with Golda Meir at the end of September were carefully orchestrated to mute differences. She acted as if tensions between the United States and Israel could only have been the

product of communication breakdowns rather than genuine differences. She hailed Nixon "as an old friend of the Jewish people, which," Kissinger said "was startling news to those of us familiar with Nixon's ambivalences on that score." But Kissinger saw it as shrewd diplomacy. It gave Nixon "a reputation to uphold. And in the event, he did much for Israel if not out of affection then out of his characteristically unsentimental calculation of the national interest," and, Henry might have added, domestic political self-interest. Part of that national interest, as Meir understood, was Nixon's determination not to allow significant Soviet gains in the Middle East, where Israel was a reliable anti-Soviet force. The Soviets could have a "Summit and trade" from him, Nixon told Kissinger two days after he saw Meir, "but I'll be damned if they can get the Middle East."

Meir's shrewd dealings with the Americans included establishing a special relationship with Kissinger, who she assumed would be naturally sympathetic to Israel, given his shared ethnicity and memories of the Holocaust. "To me," Henry remembered, "she acted as a benevolent aunt toward an especially favored nephew, so that even to admit the possibility of disagreement was a challenge to family hierarchy producing emotional outrage. It was usually calculated."

Meir's stroking of Nixon and Kissinger could not insulate her from pressure to consider accepting international discussions about Arab-Israeli differences in return for greater U.S. military support. "In order to do better on hardware, they [the Israelis] must do better on software," Nixon had told her. He "would look at her request [for more arms] sympathetically, and he wanted her to look at his" for greater flexibility in the negotiations.

A state department leak about White House pressure to swap arms for greater Israeli accommodation in negotiations incensed Nixon, who said, "these State people are always around for this purpose." He saw the story as likely to agitate the pro-Israel lobby and wanted to bar Rogers and Sisco from future conversations, but feared that to do so would only add to the controversy.

By the beginning of October, Nixon was fed up with discussions about Middle East negotiations. He saw American relations with Israel as a burden and Moscow as having "as much difficulty with [the] UAR as we have with Israel." It all added up to a continuing impasse. Convinced that the United States could not live with a stalemate, Rogers and the

state department insisted on the importance of continuing discussions with the Soviets. Because Nixon saw any direct order to Rogers to shut down conversations as likely to find its way into the press, with negative repercussions at home and abroad, he secretly asked Len Garment, his principal liaison to American Jews, "to organize some Jewish Community protests against the State Department's attitude on the Middle East." Nixon distrusted and disliked America's Israeli boosters but he was not above using them to stymie his own state department.

With his attention riveted on Vietnam and preparations for his November 3 speech, Nixon put a temporary hold on Middle East talks. He "didn't want anything done with the Soviets next week on any subject," he told Kissinger on October 25, "and that was a command." Any initiative now "would be contrary to the U.S.-Soviet atmospherics sought in conjunction with the Vietnam speech."

With Nixon's speech producing no advance in Soviet-American dealings on Vietnam or the Middle East and no viable plans in sight for breaking the Arab-Israeli deadlock, Kissinger suggested to Nixon that he anticipate criticism "for the rapidly deteriorating situation in the Mediterranean and the Mideast" by making the case to the public "that we inherited an impossible situation."

When Rogers and the state department persisted in their determination to press ahead with Four Power talks, Kissinger said, it was "like a gambler on a losing streak" who "wanted only to increase the stakes." It was "doomed to futility," Henry told Nixon. But unwilling to risk a likely public flap if he simply rejected Rogers's proposal, Nixon passed the problem along to the NSC, where it could be buried in a barrage of position papers. Familiar with the exercise in bureaucratic inertia, Rogers gave a speech on December 9, the day before a scheduled NSC meeting, as a way to publicize what became known as the Rogers Plan, a continuing commitment to Four Power talks that included proposals for Israeli-Jordanian and Israeli-Egyptian settlements.

At a December 10 NSC meeting, Nixon conceded that we would have to continue the Four Power discussions. "I am not always in favor of talking for the sake of talking . . ." he said. "But . . . if the talks break down we will have to deal with this problem in a much more difficult situation." Kissinger agreed that it made some sense to continue the existing discussions, but it would also put unproductive pressure on Israel

that would provoke an uproar in the United States. "Henry has put his finger on the heart of the problem," Nixon responded. "Whether we succeed or fail, we face a question of pressing Israel . . . The basic point is whether we are going to put the squeeze on Israel."

Reluctant to go forward with the Rogers Plan or to entirely reject it, Nixon agreed to accept part of it—the proposal for Four Power consultations on an Israeli-Jordanian settlement. As Kissinger anticipated, the response touched off an explosion of opposition. Golda Meir called it "appeasement of the Arabs" and "the gravest blows to Israel's most vital interests." The Israeli cabinet declared that "Israel will not be the victim of big power or interpower policy and will reject any attempt to impose a solution."

Private assurances of administration determination to stand by Israel did little to quiet the uproar. A decision to provide additional economic and military aid to Tel Aviv was of some help. But it "set in motion," Kissinger said, "a cycle in which every negotiating step of which Israel disapproved was coupled with a step-up of Israeli assistance programs without achieving a real meeting of minds with Israel." As the year ended, Nixon grumbled privately to Henry, "I still can't understand why the Israelis can't kick Nasser [and Egypt] harder and Hussein [and Jordan] less."

At the beginning of March 1970, Nixon ordered Haldeman to instruct Kissinger that "no appointments are to be made by him or members of his staff with those who represented 'the Israeli point of view.'" He was enraged by a Jewish boycott of French President Georges Pompidou's visit to the United States in February. (A French decision to supply Libya with a hundred Mirage jets, most of which seemed likely to find their way to Egypt, provoked the antagonism to Pompidou.) Nixon called the Jewish protests "unconscionable." He did not want anyone seeing him who wanted to discuss "the Israeli economic and military policy. All of this should be done orally," he wrote Haldeman. "I do not want a policy statement circulating around and getting into print." The Middle East and its domestic repercussions were a nightmare from which Nixon saw no likely escape.

NONEXISTENT FOREIGN POLICY gains in a year principally devoted to foreign affairs seemed like a prescription for domestic political disaster. Nixon expected overseas initiatives to be his strongest talking point in a

1972 reelection campaign. But he was eager to hide his preoccupation with electoral politics. And so when he read a *Los Angeles Times* story by Stuart Loory saying that "the entire WH operation is . . . an extension of the campaign organization which is now bending all the affairs of state to the 1972 election," Nixon ordered Haldeman to forbid anyone at the White House staff to see Loory. This made things awkward for Kissinger, who had been leaking information to Loory since 1968 in return for good press coverage.

Beginning in the fall of 1969, the White House devised a public relations strategy to promote public approval of the administration's foreign policy record. At the end of October, they asked "the bureaucracy" to prepare a National Security Study Memorandum (NSSM) that would endorse the administration's "approach to major foreign policy issues." Rumors that the liberal Brookings Institution was developing "an elaborate dossier for use in the 1972 presidential campaign" by "Democratic holdovers at DOD and State" persuaded Nixon to issue a pro-administration end-of-year report on foreign policy.

At the end of November, Nixon expressed concern about "a rash of columns, news magazines, stories, and television commentary before the speech of November 3 indicating that confidence in the President was low." He wondered whether "the press and television commentary had turned around since the November 3 speech." He wanted this information not because he intended to change policies, but in order to "counteract whatever effect they [administration critics] may be having on public opinion."

Reports at the beginning of December indicated that the president had "succeeded in rallying the Silent Majority." A Gallup survey found 68 percent approval for the president, "his highest public rating to date." It convinced the White House that "the President's counteroffensive against his critics was paying off." Pat Buchanan advised Nixon that "with the polls showing presidential popularity rising . . . it is apparent to one and all—that we have clearly won the 'fall campaign.' "

Nixon, who never forgot his defeats in 1960 and 1962 and the limits of his public appeal, was not so sure. He was worried that Kissinger's "backgrounders" on foreign affairs "haven't gotten through." A *Newsweek* article suggesting that he and Kissinger were at odds over foreign policy was adding to the picture of a faltering administration. Nixon urged

Henry to build the case for a unified administration with an effective foreign policy. Kissinger assured the president that he had "consistently made a major point of never permitting a crack to develop between our respective views on foreign policy."

Nixon was convinced that the press corps would never treat him fairly, and he saw nothing they could do to change reporters' minds. "The greatest mistake we can make," he told Haldeman, "is to try to do what Johnson did—to slobber over them with the hope that you can 'win' them. It just can't be done. In fact, the only time we get any kind of a fair break from them is when I take a very hard line on an issue and win so much public support that they have to grudgingly come along or lose their credibility."

All the same, Nixon still tried to influence the news media. He orchestrated a publicity campaign to trumpet his foreign policy achievements. Because the accomplishments were less evident than the disappointments, making the case required sleight of hand. In December, when Henry gave a backgrounder that the media could use for "year-end wrap ups," he offered a convoluted description of the administration's new decision-making process—as if it could be a substitute for substantive gains. When a reporter asked him whether the frustrations outweighed the successes, press secretary Ron Ziegler, half in jest, cautioned Henry to "say the right thing." He responded, "If I say I weigh the accomplishments more, you will accuse me of being a White House puff. If I say I weigh the disappointments more, you will have a big headline. So, you have given me a hell of a question," he joked.

Henry acknowledged that the Paris negotiations were disappointing, but he pointed to "considerable progress in Vietnam." He blamed uncontrollable circumstances for their frustrations, predicted progress in future talks, cited Soviet-American discussions as reducing the likelihood of a war, and praised the Nixon Doctrine as a realistic alternative to the errors of the past.

The White House followed up Kissinger's briefing with Nixon's "First Annual Report on United States Foreign Policy"—a forty-thousand-word, 160-page booklet, titled, "Foreign Policy for the 1970s: A New Strategy for Peace." It was "the first of its kind ever made by a President to the Congress" and was "the longest report made to the Congress, except for a budget message." Although Henry told Max Frankel of the

New York Times that "the President has written every word himself," it was a transparently false claim that Nixon himself never made.

The report said little about the administration's year-long struggles with insurmountable problems around the globe, including principally Vietnam. Details about the past year's national security and foreign policy events were in short supply. Written in the first person, the report avoided "a litany of accomplishments" but rather aimed to present an "integrated, conceptual approach" conveying the president's "recognition and understanding of the tasks which lie ahead in each area" of the world.

Nixon worried that the report might send the wrong message. He wanted to knock down "the assumption that is gaining disturbing currency" at home and abroad "that this administration is on an irreversible course of not only getting out of Vietnam but of reducing our commitments around the world." Consequently, the report stressed the "theme that the Nixon Doctrine rather than being a device to get rid of America's world role" was a means by which the United States could take a more effective part in overseas affairs.

"I realize that . . . the peacenik types . . . will want to find any evidence" supporting their conviction that "the United States should reduce its world role and start taking care of the ghettoes instead of worrying about Afghanistan," Nixon told Kissinger. But "the best social programs in the world" would do us no good if we weren't around to enjoy them. The aim, Nixon said, was to open "an era of negotiation" that would lead to a sustained period of peace.

The Nixon report was a classic example of how officeholders with little to say about past achievements focus on future gains. Since Nixon's first year in the White House had not ended the Vietnam War or produced transparent advances toward peace in the Middle East or reduced tensions in Soviet-American relations, it seemed essential to make the administration's case in terms of better times ahead. Nixon's tensions with the press had less to do with their hypercritical reporting than his realistic self-doubts about administration effectiveness.

The report was supposed to increase Nixon's public standing, but it didn't work. Where his approval ratings in the winter of 1969–1970 stood in the high sixties, largely as a result of the silent majority speech in November and public conviction that he was ending the Vietnam War, support for his job performance fell into the fifties by the spring. In late

March he was down to 53 percent, with only 48 percent approving his "handling of the situation in Vietnam." After fourteen months in office, a lengthy report on future foreign policy accomplishments was insufficient to convince a majority of Americans that the Nixon presidency was a success entitling him to a second term.

IT WAS INCREASINGLY CLEAR to Nixon and Kissinger that the president's reelection depended on withdrawing from Vietnam. Al Haig said, "There was no way the President could ignore" the antiwar opposition, which Nixon contemptuously called "the hysteria." Daniel Patrick Moynihan, Nixon's domestic affairs adviser, told him that "it has become obvious that we cannot 'win' the war, and that those who persist in prosecuting it are likely to 'lose' at home."

Antiwar sentiment had become majority opinion. In the winter of 1970, 84 percent of Americans favored some kind of plan to withdraw U.S. troops from the fighting: While 38 percent were willing to do this slowly or to wait until the South Vietnamese were ready to take over the war, nearly half the public wanted it done immediately or, at most, within eighteen months. Only 7 percent of the country preferred to send more troops and step up the fighting; small wonder that Nixon had shelved Duck Hook.

The erosion of support for the administration's Vietnam policy rested on realistic perceptions that the White House was making no significant progress toward ending the war. It was clear to everyone who cared to see that the United States could not win, even if the war lasted for several more years. Nixon himself privately acknowledged this reality in a note to Kissinger on November 24: "I get the rather uneasy impression that the military are still thinking in terms of a long war and eventual military solution. I also have the impression that deep down they realize the war can't be won militarily, even over the long haul."

It was also evident that the Paris talks were at a standstill. Though the November 3 speech had provided "a definite plan" for ending the conflict, Vietnamization might require U.S. air strikes for the foreseeable future and did not guarantee South Vietnam's autonomy. Nixon's dilemma was how to rationalize getting out if we ended up "losing" Vietnam. "We simply cannot tell the mothers of our casualties . . . in Vietnam that it was all to no purpose," Nixon told Rogers.

Kissinger advised Nixon that despite Vietnamization, they still needed a "coherent" policy that could assure against "defeat." The military option remained irresistible, or at least they wanted the Communists to think so. If "the President should decide tomorrow to bomb the North," Henry told a French journalist in December, "a large majority of the people would support him." The journalist said, "The whole world would be against it." Kissinger replied that "the reservoir of votes and support in the country was on the right and this was a crucial factor which we had to take account of." It was an unconvincing rationalization for justifying the only means Nixon and Kissinger saw available for bending Hanoi to America's will.

Year-end contingency planning for "a military, political, and diplomatic reaction" to increased "enemy action" seemed not only a good way to prepare for such a development but also a means to warn Hanoi that it was risking renewed bombing and expanded attacks. (With a considerable number of government departments involved, Nixon expected leaks and public discussion of the planning.) A decline in American troops killed from over 1,300 in March to 340 in December 1969 was attributed to the continuing air campaign, especially against North Vietnamese bases in Cambodia. Although troop withdrawals and reduced actions were more important in limiting U.S. casualties, crediting bombing raids was useful in justifying any future increase in air attacks.

But a warning from Dobrynin in a private conversation with Kissinger reminded Nixon of why he had put aside Duck Hook in November. Dobrynin cautioned that "if we started bombing the North again or hit Haiphong—that the Chinese would send in engineer battalions which would expand Chinese influence in Hanoi" and increase the likelihood of another war with China.

But backing away from a fight was repugnant to Nixon. He challenged himself with questions of what his hero, General George S. Patton, Jr., the World War II tank commander, an advocate of unrelenting offensive operations, would have done to defeat Hanoi. The answer he saw in Patton's writings and a glorifying film biography was: Rely on aggressive action. Passivity was a prescription for defeat.

Nixon still hoped that a public relations campaign could unite the country behind Vietnamization and force Hanoi into concessions. When the British ambassador asserted that the United States "would have done

well to follow a 'much more selective and restrictive' press policy" in Vietnam, Haig suggested to Kissinger that they "try as discreetly as possible to reduce the press presence in V. Nam . . . It is too late for censorship (as in W.W. II) but [we] can try to cut the opportunities for media coverage (particularly TV) of battle areas." Henry passed the proposal along to Nixon, but it was another unrealistic proposal, which spoke loudly about the administration's bankruptcy in finding a satisfactory end to the war.

At the same time, the president instructed Haldeman to "get a massive campaign going" to tell the public that U.S. POWs were being "ill-treated" by Hanoi. Any positive public comment about Nixon's handling of the war evoked an instruction to praise the commentator, while all negative editorials produced demands that Buchanan and others in the White House arrange protest letters to critical newspapers and magazines.

NIXON'S antipress attacks did nothing to dissuade attentive Americans that the war was a lost cause and that the United States needed to abandon the effort. By contrast, his draft reforms, reducing inductions into the military, made a strong impression on the families of draft-age men and encouraged hopes that he genuinely intended to end U.S. participation in the fighting. Although 62 percent of Americans did not favor an all-volunteer armed force after the war ended, as Nixon proposed, 79 percent supported a year's public enlistment in the Peace Corps or VISTA as an alternative to military service.

In November 1969, a second Moratorium demonstration in Washington by 250,000 protestors and headlines about U.S. troop atrocities at MyLai, a South Vietnamese village, intensified the public's eagerness to end a war that was doing more to divide the country than strengthen its national security. The massacre of women and children by frightened American troops was an assault on America's self-image. How could a nation devoted to human rights be responsible for inhumane behavior some compared to actions by Nazi Germany? Nixon condemned the killings as "inexcusable and terrible" and "a sickening tragedy" that deserved the fullest possible investigation.

But he was also incensed at those who had revealed the details of MyLai. It became an opportunity to vent his anti-Semitism. "It's those dirty rotten Jews from New York who are behind it," he said to aides. He wanted a publicity campaign to counter the fallout from the story. He

believed that war critics saw the tragedy as an opportunity to increase pressure to withdraw from Vietnam. A suggestion that the White House should appoint a Blue Ribbon Commission to investigate MyLai provoked opposition from Kissinger and Haig, who feared that such a probe "would extend the atrocity story into the future."

Nixon instructed Haldeman "to set up a MyLai planning group to figure how best to control the whole problem." The "task force" was to include Agnew, Buchanan, Kissinger, and Herb Klein; and Lyn Nofziger in the press office. They were to come up with "dirty tricks . . . [to] discredit one witness," and were to "get out facts on Hue," where MyLai could possibly be countered with stories about Communist atrocities during the Tet Offensive. Nixon also wanted someone at the White House to put "a good news reporter" to work on a story about a possible lawsuit against Seymour Hersh, the *New York Times* correspondent who broke the MyLai scandal, for allegedly profiting from the story.

When the press tried to blame the atrocity on American generals, Nixon sent word to Earle Wheeler, chairman of the Joint Chiefs, that Nixon would "see to it that they don't get ruined . . . He will not permit the military to be kicked around in this country," Kissinger told Wheeler.

Yet none of these attempts to manipulate domestic attitudes toward the war could directly affect the likelihood of a negotiated settlement. As Kissinger assessed prospects for peace in early January, he concluded that "an enemy determined on protracted struggle could only be brought to compromise by being confronted by insuperable obstacles on the ground. We could attempt this only by building up the South Vietnamese and blunting every effort Hanoi made to interrupt this buildup."

Because Hanoi was stepping up its infiltration of forces into South Vietnam in December and January, Nixon saw them launching a major offensive sometime in the spring. Nixon wanted to respond to the buildup at once and bristled at the resistance of the U.S. commander in Vietnam, General Creighton Abrams, to renewed bombing of the North, which Abrams believed would have little good effect. At a minimum, Nixon wanted Abrams "to step up the attacks now in the South."

Nixon, however, had little confidence that another round of military escalation would settle anything. "I want to look down the road and see when we are going to get this damn thing over with. There is no answer

to winning it," he told Kissinger. But Henry thought it would take a "jolt" to break the stalemate in the talks. "You have a feeling the jolt may start the negotiating pattern again?" Nixon asked. "All right. Fine," Nixon said before Kissinger could answer.

In mid-January 1970, Kissinger persuaded the president to let Vernon Walters propose renewed secret talks in Paris between himself and the North Vietnamese. Walters took every precaution to approach the Vietnamese secretly, lest the press get wind of the initiative and undermine prospects for a positive reply. Hanoi's announcement in late January that Le Duc Tho, a high-ranking member of the Politburo, would come to Paris for the French Communist Party Congress signaled Hanoi's willingness to accept the U.S. invitation. In February, Nixon ordered stepped-up B-52 raids on Communist forces in northern Laos. Since he didn't dare resume bombing of North Vietnam, attacks on their troops and supply lines in Laos seemed a good way to blunt a possible spring offensive and show Hanoi that Nixon was prepared to increase the use of force if they did not negotiate seriously.

On February 16, the North Vietnamese in Paris invited Walters to meet with Mai Van Bo at a safe house. Bo asked Walters to tell Kissinger that Le Duc Tho would be willing to meet with him on February 20 or 21 if he was still in Paris, but that at the very least Bo and Xuan Thuy would be available for discussions. Hanoi saw no significant gains from such secret talks, but accepted the invitation as a way to avoid negative publicity in the United States that could discourage antiwar protestors.

To hide the meeting, Kissinger resorted to what Nixon called "cloak and dagger" tactics: code names for himself, Walters, and the three North Vietnamese counterparts, including Le Duc Tho, who was dubbed "Michael"; claims that Henry was at Camp David when he was flying to France on a military plane allegedly on a training flight; and movements about Paris "slouched down in the backseat of speeding Citroëns eluding inquisitive reporters" and transporting him from Vernon Walters' apartment to a North Vietnamese safe house in a Paris working-class district. "If there was anything he [Walters] enjoyed more than imitating the men for whom he was interpreting," Kissinger said, "it was arranging clandestine meetings." But Henry and the president took special pleasure as well in the hidden maneuvers to advance the peace talks. It was a heady exercise in presidential power: "K all cranked up about his secret trip to

Paris . . . He loves the intrigue and P enjoys it too," Haldeman noted in his diary.

Henry began the talks in a "dingy living room," where "two rows of easy chairs, heavily upholstered in red, faced each other." He had a "sense of anticipation—almost of elation—at what I hoped would be the opening move in a dialogue of peace," he wrote later. "Luckily for my sanity the full implications of what I was up against did not hit me at that first meeting." The gray-haired Le Duc Tho was the picture of composure, a man with "impeccable" manners who initially impressed Kissinger as "someone whose superiority is so self-evident that he cannot derogate from it by a show of politeness approaching condescension." He laughed at Kissinger's jokes, sometimes "uproariously," but he was on guard against a "capitalist" trying to charm him. Henry did not at first recognize that Tho "considered negotiations as another battle," not an opportunity to reach an equitable settlement. Henry came to see that from Tho's perspective "trading concessions seemed to him immoral . . . He had no category for compromise."

Kissinger initially blinded himself to these realities. After a seven-hour discussion on February 20, Kissinger described it to Nixon as "a significant meeting . . . certainly the most important since the beginning of your administration and perhaps even since the beginning of the talks in 1968." The Vietnamese were ready to accept "our proposed procedure for future private meetings . . . and gave the impression of being much more ready for business than before . . . They dropped their demand that the Government of Vietnam be changed as a precondition to substantive talks . . . They did not use the word 'unconditional' when speaking of U.S. withdrawals." Nor was there any "emphasis on a coalition government . . . Our positions are still very far apart," Henry advised the president. But he did not think they would hold to an uncompromising attitude for long. Indeed, he saw "faint suggestions that they may be ready to talk seriously about troop withdrawal on a reciprocal basis." They seemed eager for "a quick settlement."

At another meeting on March 16, the North Vietnamese "went even further than last time in dropping pre-conditions for substantive talks . . . They indicated very strongly that they want to preserve this channel and to work toward an overall settlement . . . They were very anxious to have another . . . [on] April 4." Nevertheless, Henry cau-

tioned that "their basic purpose is not yet clear, and may only begin to emerge over the next few meetings."

On April 4, it became obvious that the talks were as unproductive as ever. Hanoi continued to insist on unconditional U.S. withdrawal from Vietnam, leaving North Vietnamese forces in the South and Thieu's government vulnerable to a Communist takeover. It persuaded Henry that there was no point in continuing the current exchanges. "The general tone of the meeting was harder than in the past two," Kissinger reported to Nixon. The discussions now demonstrated that "there were four or five feet of floor space and eons of perception separating us . . . We were being offered terms for surrender, not a negotiation in any normal sense." Without a change in the U.S. position, Le Duc Tho declared, "there was nothing more to discuss."

The failure of the talks frustrated Nixon, who saw it as a setback to ending the war before 1972. Although he blamed Hanoi for the stalemate, he was also angry at Kissinger for misleading him into believing that something would come of the secret discussions: After reading Henry's last Paris report, Nixon told Haldeman, "It's obvious he [Kissinger] can't negotiate, he makes debating points instead."

Kissinger, however, as the contemporary record demonstrates, clung to the conviction that "we have gained some significant concessions," and took hope from an agreement that neither side ruled out another secret meeting. In time, Henry came to understand that his reporting had been "extraordinarily sanguine." He later saw his optimism as "partly due to my desire to keep the channel alive. Aware of Nixon's skepticism, I fell into the trap of many negotiators of becoming an advocate of my own negotiation . . . The record leaves no doubt that we were looking for excuses to make the negotiations succeed, not fail."

But Kissinger was also telling Nixon what he wanted to hear. Since a continuing stalemate could endanger the president's reelection, he and Kissinger were desperately eager to find a way out. In the end, the talks faltered because Le Duc Tho accurately saw that U.S. public opinion would force Nixon to rely on Vietnamization, a policy that would remove U.S. troops and leave Saigon vulnerable to North Vietnam's superior military power. For the time being, therefore, Hanoi saw "no reason to modify its demands for unconditional withdrawal and the overthrow of the Saigon government."

The failure of the secret spring talks made Nixon more anxious than ever to find a formula for ending the war that could bolster his chances for reelection. In March 1970, the pro-war columnist Joe Alsop told Nixon that "the whole outlook will be radically transformed here at home, if your policy in Vietnam suddenly appears to be a disastrous failure." Nixon saw Alsop's observation as "very perceptive."

THE ERUPTION of a public controversy over Laos at the same time as the secret talks demonstrated how vulnerable Vietnam made Nixon's political standing. After he had approved the B-52 raids against North Vietnamese forces in northern Laos, a *New York Times* report on the bombings provoked congressional and public protests. At the end of January, when a reporter had asked, "How deep is this country's involvement in Laos?" Nixon had answered that Hanoi had fifty thousand troops there and America was helping the Laotian government preserve its independence. In March, in response to the *Times* story, he denied that U.S. ground forces were in Laos, though there were 1,040 advisers, and that any Americans had lost their lives in ground combat. He described U.S. involvement as principally air operations interdicting the Ho Chi Minh trail.

The controversy gave meaning to Alsop's warning. "After years of being overlooked, the secret war in Laos exploded in the U.S. media," a journalist reported. "Instead of shedding light, the emerging information, often fragmentary and distorted, bred doubt and fueled the growing domestic voice against the war in Southeast Asia." The *Philadelphia Inquirer* complained that the administration's statements on Laos amounted to a new "credibility gap," especially Nixon's statement about no loss of life, which was false.

Nixon and Kissinger responded to the domestic criticism with an all-out PR war. "If we stop on Laos, our threat in VN is down the drain," Kissinger told Laird. Henry warned the president that they could not afford to back down on Laos. It could "shatter the progress we have been making to date in Vietnamization and . . . seriously jeopardize any hopes we might have for achieving a negotiated settlement within the framework of my talks in Paris."

Nixon did not need persuading. When an unnamed official publicly disputed his figures on North Vietnamese troops in Laos, he demanded that Kissinger "find out who this was. Have him transferred this week."

He also directed Haldeman to deny published reports that the administration was halting B-52 raids over Laos and rejected proposals to release secret Senate committee hearings that might contradict his statements on air attacks. Briefings by Kissinger and Nofziger helped mute the bombing controversy by the end of March.

But the stories about Laos had put the war back on the front pages of the newspapers, and a coup in Cambodia in March kept it there. Cambodia was a constant administration concern. By the spring of 1970, B-52s had dropped over one hundred thousand tons of bombs on North Vietnamese sanctuaries in eastern Cambodia. At the same time, Nixon directed the defense department and CIA to initiate covert operations in Cambodia against Vietnamese bases, preferably with "non-U.S. assets." The bombing attacks and raids were an open secret. "U.S. aircraft violate Cambodian airspace and strafe Cambodian territory in violation of U.S. guidelines much more often than the U.S. admits," the *Washington Post* reported in February.

The Cambodian coup heightened U.S. worries about widened Communist control in Southeast Asia. With Sihanouk away on an annual holiday in France, General Lon Nol, the prime minister and longtime Sihanouk rival, persuaded the Cambodian assembly to give him power. A staunch anti-Communist with ties to the South Vietnamese government and U.S. military chiefs in Saigon, Lon Nol announced his opposition to North Vietnamese troops in Cambodia and China's use of Sihanoukville as a supply line to Viet Cong and North Vietnamese forces. By the end of March, Cambodian government troops were battling Khmer Rouge, Cambodian Communists, and North Vietnamese forces. When Sihanouk, after being ousted, openly aligned himself with the Chinese, North Vietnamese, and Khmer Rouge, a Communist government in Phnom Penh seemed all too possible.

Although Nixon initially refused to recognize Lon Nol's government, he skirted the issue by endorsing Cambodian self-determination. Believing that Sihanouk might return to power and concerned not to align him with the Communists, Nixon described relations with Lon Nol's regime as on "a temporary basis." On March 20, when Dean Acheson told Kissinger, "Don't let's get drawn into this one," Henry replied, "Oh, no. We have no intention . . . We are saying nothing, and more important, doing nothing."

A pro-Communist regime in Phnom Penh, however, was simply unacceptable to the White House. "Our nightmare," Kissinger said, "was of a communist-dominated Sihanouk government providing a secure sanctuary and logistics base for the VC/NVA." To counter Communist control, Nixon ordered Kissinger to ensure that the Menu bombings continued. Because he didn't trust Laird to carry out his orders, Nixon directed Henry to send duplicate instructions to General Wheeler. "We will get this bureaucracy in shape," he told Kissinger.

Events in Southeast Asia were viewed against a backdrop of reports that South Vietnam remained an unstable client state vulnerable to a Communist takeover. "For the first time, Laird has, in fact, conceded that Vietnamization is a farce," Haig told Kissinger on April 4. Henry endorsed an NSC memorandum urging Nixon to use "a proper provocation" by the Communists "to force a settlement promptly," meaning implementation of the Duck Hook plan. A newspaper report that "corruption and war profiteering are running rampant at all levels in [South] Vietnam" was symptomatic of "the kinds of problems that ultimately could destroy the U.S. effort there." American willingness to "downplay the problems" allowed the "rot from within" to threaten a Communist victory.

These reports, Haig told Kissinger, were "a psychological blow to the President who probably hopes that things in Vietnam are on a much sounder footing." They feared another large withdrawal of American combat troops from Vietnam as a risky proposition. "Thieu's image has badly deteriorated and he faces severe political problems," Winston Lord reported to Henry.

The domestic pressures on Nixon for additional troop reductions, however, were politically irresistible. To say that Vietnamization was faltering or threats to Laos, Cambodia, and South Vietnam made another cutback too risky would have discredited Nixon's five-month-old plan for withdrawal and produced an explosion of politically damaging antiwar demonstrations from which he might never recover. To guard against increased dangers to Saigon and negative domestic developments, Nixon agreed to a very small withdrawal over the next three months, with larger reductions scheduled for 1971.

On April 20, 1970, in an "Address to the Nation on Progress toward Peace in Vietnam," Nixon reported that "progress in training and equip-

ping South Vietnamese forces has substantially exceeded our original ex-
pectations." Problems remained but there were "encouraging trends." To
anyone who had listened to Johnson's public comments on Vietnam be-
tween 1965 and 1969, Nixon's rosy assessments sounded all too familiar.
As with Johnson, they did more to undermine Nixon's credibility than to
bolster domestic support for Vietnamization.

Nixon acknowledged that enemy activity in Laos and Cambodia had
increased, but there had been "an overall decline in [Communist] force
levels in South Vietnam since December." U.S. casualties had fallen to
the lowest level in five years in the first quarter of the year. This allowed
him, he said, to announce the withdrawal of another 150,000 troops
over the next twelve months—reducing U.S. troop strength to 283,500,
roughly half what it had been in January 1969. He also warned that
increased enemy attacks on remaining U.S. forces could bring "strong
and effective measures . . . We shall not be defeated in Vietnam," Nixon
concluded.

At the same time, Nixon was determined to support Lon Nol's gov-
ernment against the Communists. On March 31, he had instructed Gen-
eral Abrams to develop a Cambodian operations plan. On April 9, Nixon
asked Kissinger, "What's the situation about helping the Cambodians?
We aren't doing anything," he complained. Henry assured him that they
were sending money through the Japanese. "Be sure we get the funds to
them," Nixon said. "General Nol's brother has asked for supplies," Kissin-
ger added. "Get it to them!" the president ordered. "I don't want State or
anybody else [involved]. We will do this," he emphasized.

To get things moving on Cambodia, Nixon decided to confer with
American military chiefs in Vietnam. But he wanted it to seem like
"a peace pow-wow" rather than "a war pow-wow." So, they covered
the president's intentions by describing a mid-April trip to Hawaii as
a ceremonial visit to greet the Apollo 13 crew returning from a space
mission.

William Bundy describes Nixon's visit to Admiral John McCain's
CINPAC headquarters in Honolulu as exciting his determination to save
Cambodia from the Communists and simultaneously rescue Vietnam-
ization. "The admiral's staff briefed Nixon in dramatic terms," Bundy
recounts, "with lots of 'big red arrows' . . . pointing to Phnom Penh and
beyond if the North Vietnamese forces were not checked at once—which

could only mean by U.S. forces. It was a far more drastic reading of the situation than was held even in the Pentagon, let alone by Washington intelligence officers." The assumption in Washington was that Hanoi was principally interested in maintaining its sanctuaries in Cambodia, not ousting Lon Nol and bringing back Sihanouk. But Nixon was so impressed with McCain's briefing that he flew him back to California to educate Kissinger about the dangers to American plans for Vietnam from a Communist takeover in Cambodia.

The briefing decided Nixon to increase and more closely supervise military actions throughout Southeast Asia. On April 20, on the plane back to Washington from California, where he had given his troop-withdrawal speech, he told Haldeman that he now intended to bypass Laird and Rogers and issue direct orders to the military about Vietnam and Cambodia.

That afternoon, in response to news that the Communists were stepping up attacks in the border areas and might be threatening Phnom Penh, Nixon instructed that a cable go to Lon Nol "making reassuring noises to the government and telling them of a deposit in a Swiss bank" to finance Cambodian resistance to the Communists. He also wanted a plan for getting AK-47s into Cambodia. When Rogers learned of the president's instructions, he protested. Nixon reaffirmed his intention to transfer the money, but agreed to hold off other actions until after a NSC meeting on the twenty-second.

Nevertheless, Nixon wanted prompt planning for an attack on North Vietnamese sanctuaries in eastern Cambodia bordering South Vietnam. Kissinger asked General Westmoreland whether "the VN can move in and handle it without us, except for artillery and air support." Westmoreland believed so, but didn't think the South Vietnamese could "clear out" the Communists. While it would be preferable to rely strictly on the South Vietnamese, Westmoreland predicted that U.S. forces could do the job at the risk of heavy casualties; they would have "to move into the area and stay there some time."

Nixon now struggled over what to do about Cambodia. He favored forceful action, but feared that it might not save Lon Nol's government and might provoke new antiwar protests. He spent a sleepless night on the twenty-first. Arising before dawn, he drafted a memo to Kissinger: "I think we need a bold move in Cambodia," he wrote Henry.

Assuming that I feel the way today (it is five AM, April 22) at our meeting as I feel this morning to show that we stand with Lon Nol. I do not believe that he is going to survive. There is, however, some chance that he might and in any event we must do something symbolic to help him survive. We have really dropped the ball on this one due to the fact that we were taken in with the line that by helping him we would destroy his "neutrality" and give the North Vietnamese an excuse to come in . . . We have taken a completely hands-off attitude by protesting to the Senate that we have only a "delegation of seven State Department jerks" in the embassy and would not provide any aid of any kind because we were fearful that . . . it would give them a "provocation" to come in. They are romping in there and the only government in Cambodia in the last 25 years that had the guts to take a pro-Western and pro-American stand is ready to fall.

Within minutes, Nixon drafted two additional memos to Kissinger.

A highly agitated president "roars on, in his new energy, with little sleep," Haldeman described Nixon's early morning arrival at the office. Kissinger found himself besieged with instructions. When he told Nixon about plans to withdraw embassy personnel from Phnom Penh, the president "blew his stack . . . No one moves without his permission," Henry told Marshall Green, the assistant secretary of state for East Asia, at 10 A.M. "Don't appeal this; it would just make the President madder than hell."

As Nixon followed Kissinger into an NSC meeting that afternoon, the president joked with Haldeman: "K's really having fun today, he's playing Bismarck." But Nixon was the one imitating the German chancellor. We "need the boldest possible plans," he told the council.

Caution, however, was the watchword of the deliberations: Nixon directed increased "U.S. military assistance—wherever possible through third-country channels. Maximum diplomatic effort to enlist assistance by other interested countries. Authorization for specified shallow cross-border attacks against North Vietnamese/VC sanctuaries in Cambodia, to be conducted by GVN forces in division-size with cross-border U.S. artillery support. U.S. tactical air support should be planned but made available only on the basis of demonstrated necessity."

Nevertheless, Nixon wanted quick and decisive action. He saw a

prompt move into Cambodia by the South Vietnamese as essential. Because they were unaccustomed to conducting division-size operations, Henry doubted the speed with which they could accomplish the mission. "There's a lot to be said for doing it as quickly as possible," Nixon insisted. "I will press it right now," Henry promised.

He followed through by directing General Westmoreland to pressure U.S. military advisers in Saigon to prod the South Vietnamese. Kissinger urged Westmoreland to propose a ten-thousand-man division-size operation to the NSC; " 'it would be a great help . . . I hope you need a political analyst in the Army,' " Henry joked. " 'I'll never be able to go back to Harvard.' 'You're very tough,' " Westmoreland responded. " 'It's a pleasure to do business with you as always,' " Henry replied.

Matters crystallized over the next three days. Kissinger now joined Rogers and Laird in worrying that aggressive action in Cambodia by South Vietnamese troops in conjunction with U.S. forces could precipitate a crisis in the United States, where antiwar leaders in Congress and across the country seemed likely to stage angry protests against any expansion of the fighting. "It's important . . . not to have a complete break with the Congress," Rogers warned Kissinger on the twenty-third. "K was very worried last night," Haldeman noted on the twenty-fourth, "and still is to a lesser degree, that P is moving too rashly without real thinking through the consequences." Henry asked General Wheeler on the evening of the twenty-fourth, "You do think this is worth the flak one is going to take? It is something you would recommend?"

Nixon believed it essential to save Cambodia from a Communist takeover with a combined South Vietnamese–American offensive. He maintained an almost blind faith in military power to bring the right outcome in Vietnam. "Damn Johnson," he told Haldeman, "if he'd just done the right thing we wouldn't be in this mess now." Nixon saw the 1968 bombing halt as counterproductive. "We could have closed the whole thing down if we'd stayed with it in 1968," he said. Poll numbers showing that his approval ratings had increased from 55 percent to 62 percent after his April 20 speech made him confident that an address explaining the Cambodian "incursion" would bring a majority of Americans to his side.

Laird and Rogers disagreed. After Nixon issued a National Security Directive on April 26 authorizing the attack on what they described as

Cambodia's Fish Hook area north of the Parrot's Beak, Laird challenged the president's order. The operations in Cambodia wouldn't "be decisive in the conflict in Southeast Asia. Hanoi [would] be able to replace losses" and might "retrench from any contemplated negotiating plan." The operation would also "risk losing the support of the American people for U.S. operations in Southeast Asia." Rogers's opposition was even more emphatic: "Rogers obviously quite upset, emotional, mainly played on high casualties, little gain," Haldeman recorded.

Nixon wouldn't back down. Henry told him that he would "take heat" from the Congress. "We will take heat for not doing anything," Nixon replied. "Suppose we lose the place, what will they say?" Kissinger answered: "Vietnamization is a failure." Nixon thought they would say, "We screwed up the war . . . They are ready to pounce on us" no matter what we do.

Nixon wanted an all-out counterattack in response to predictable criticism on Cambodia. He instructed Agnew to take on the networks. He intended to pretend that Rogers and Laird were fully behind his decision and instructed Rogers to hit the press for applying a double standard by failing to take account of North Vietnam's aggression. He told Henry to cut out the negative talk about fallout from an incursion. He didn't want to be told more than once what the critics would say. He instructed the White House PR machine to shift into high gear, saying, "now is the time to thank God Richard Nixon is President and that should be said over and over again." They were also to describe the Cambodian decision as "not in the President's best interest during an election year." It "could possibly make him a one-term President." It was a demonstration of "the President's courage and conviction to do what is right for the country."

Kissinger was torn between his conviction that direct U.S. involvement in Cambodia was probably unnecessary, since he doubted that Hanoi was ready to seize control of Phnom Penh, and wanting to remain in Nixon's good graces. With Rogers and Laird opposing Nixon's decision, it allowed a compliant Kissinger to become, more than ever, the president's most important adviser.

"Historians rarely do justice to the psychological stress on a policy maker," Kissinger wrote later. "What they have available are documents written for a variety of purposes—under contemporary rules of disclosure, increasingly to dress up the record—and not always relevant to the moment of decision."

But the transcripts of Kissinger's telephone conversations allow us to come close. And what they show is someone who tried to placate Rogers and Laird and simultaneously side with Nixon. Henry's conversations make clear that one-upping his two rivals was a high priority. On April 27, when Haldeman told Henry that Rogers and Laird would be coming in to see Nixon, Henry replied: " 'It's essential that I'm there.' 'Okay, I understand,' " Haldeman answered. " 'But it's imperative for you to let the President carry the ball at the meeting.' 'I never speak at these meetings,' " Henry joked. But he saw his presence as giving the president an ally in arguing for what he wanted to do, however unwise it might be.

Henry was frustrated when Nixon saw his support as less than 100 percent. He recalled that the president privately made a record of the Rogers-Laird opposition to using American forces and described Kissinger as "leaning against" the decision. But "this was no longer true," Kissinger objected, "I had changed my view at least a week earlier." He believed that Nixon "generously wanted to shield me against departmental retaliation; [but] no doubt he also wanted to live up to his image of himself as the lonely embattled leader propping up faltering associates." Kissinger wanted full credit for having shared the criticism of an unpopular decision.

He gained ground with Nixon on April 29, when news broke of the South Vietnamese assault on the Parrot's Beak and rumors surfaced about the U.S. attack to come on the thirtieth. Encouraged by Kissinger, Nixon assumed that Laird and Rogers had leaked the story of the planned U.S. invasion "in hopes that violent reaction would dissuade P from going ahead with Phase II," the Fish Hook attack. " 'Somebody is calling for the impeachment of the President,' " Haldeman told Kissinger. " 'The excitement is so far out of proportion to anything we have ever had before,' " Henry said. " 'As soon as you move the men into Cambodia,' " Haldeman replied, " 'you have expanded it out of Vietnam. That is going to get them frothing at the mouth and it did.' "

But it wasn't only Nixon's opponents who were agitated; Nixon himself now became manic. On April 28, he blew up at Haldeman over a minor matter: "Chewed me out worse than he ever has as P," Haldeman noted. He understood that it was "basically a release of tensions on the big decision." Nixon began drinking heavily and lost sleep. Late night calls to Kissinger, in which he slurred his words and warned that Henry

would suffer the consequences if the invasion failed, demonstrated the strains on the president. He isolated himself to work on a presentation to the nation on the evening of April 30 after the troops had crossed into Cambodia. He stayed up most of the previous night reworking his speech and then preparing his staff to fight the public relations war over what he was doing.

The speech was ostensibly an explanation of Nixon's decision to extend the war into Cambodia. It was "to protect our men . . . in Vietnam and to guarantee the continued success of our withdrawal and Vietnamization programs." Yet Nixon could only guarantee that he would be withdrawing more American troops in the service of his reelection; Vietnamization was beyond American control. He claimed that since 1954 the United States had "scrupulously respected[ed] the neutrality of the Cambodian people." Nor had we done anything, he said, to eliminate the North Vietnamese sanctuaries in Cambodia. Kissinger repeated these distortions in subsequent background briefings. Nixon depicted Cambodia as "a vast enemy staging area and a springboard for attacks on South Vietnam along 600 miles of frontier."

He presented an apocalyptic view of the stakes in the Cambodian operation. "We live in an age of anarchy, both abroad and at home." He complained of "mindless attacks on all the great institutions which have been created by free civilizations in the last 500 years. If, when the chips are down, the world's most powerful nation, the United States of America, acts like a pitiful, helpless giant, the forces of totalitarianism and anarchy will threaten free nations and free institutions throughout the world."

Nixon concluded his speech with a personal defense of his actions. "We will not be humiliated. We will not be defeated," he said. He cited warnings that his action would defeat his party in the November 1970 elections and make him a one-term president. "I would rather be a one-term President and do what I believe is right than to be a two-term President at the cost of seeing America become a second-rate power." Specifically comparing his decision to those of Wilson, FDR, and JFK in the First and Second World Wars and the Cuban Missile crisis, respectively, Nixon's speech and attack on Cambodia was an exercise in grandiosity. It was as if he was willing himself, the country, and the world into seeing him as a great president rescuing civilization from the barbarians.

Nixon's popularity did not suffer from the "incursion." A majority of Americans approved his decision to enter Cambodia and applauded his speech. But they did not share the president's view of this moment as some grave national or international crisis. When a cross-section of the country was asked between April 29 and May 3 what they considered the nation's greatest problems, the respondents listed controlling crime, reducing air and water pollution, and improving public education. They cited seven other domestic issues as worrisome, but no one saw a world crisis as among the ten top problems.

Despite the public's general approval, the strains of the national debate over Cambodia became almost more than Nixon could bear. The day after his speech, Haldeman described him as "really beat, but still riding on reaction. Really needs some good rest." An outpouring of angry protests from congressmen and senators and university students and faculty enraged him. The Senate Foreign Relations Committee approved a resolution repealing the Tonkin Gulf Resolution as well as an amendment to a foreign military sales bill sharply restricting future operations in Cambodia, including the dispatching of troops, or the use of advisers or air forces in support of Cambodia's army. For the moment, the Senate measures were only a threat. But they signaled the extent to which Nixon and Kissinger might be limited in what they could do in Southeast Asia.

Nixon responded with a belligerence and emotionalism that made some around him fear that he was suffering a nervous collapse. During a visit to the Pentagon on May 1 for a briefing, Nixon seemed "a little bit out of control." One of Laird's aides recalled, "It scared the shit out of me." The journalist William Shawcross describes Nixon's behavior during the briefing as "alarming . . . Agitated, he cut the briefing short and began an emotional harangue, using . . . locker-room language . . . 'Let's go blow the hell out of them,' he shouted, while the chiefs, Laird, and Kissinger sat mute with embarrassment and concern." On his way out of the building, he told applauding employees lined up in the corridors that student protestors were "bums blowing up campuses."

When three of Henry's principal aides—William Watts, Anthony Lake, and Roger Morris—resigned in protest against the invasion and urged him to resign as well, he predicted that Nixon "could have a heart attack and you'd have Spiro Agnew as President. Do you want that? No?

So don't keep asking me to resign." It was an indication of how over-wrought Kissinger believed Nixon was and how dependent Nixon had become on him for support. During the first nine days of May, Nixon had sixteen telephone conversations and seventeen face-to-face meetings with Kissinger, in which Henry repeatedly boosted his morale, putting the best possible face on the results of the invasion and knocking student demonstrators and congressional opponents.

Kissinger kept his balance during the crisis by resorting to humor. "It's easy to get along with me," he told Dobrynin in a telephone conver-sation. "Just cut off aid to NVN." "That's all?" Dobrynin asked. "I have something else," Henry replied, "but that's the major one of this week."

However conciliatory Nixon would be toward critics in public, he was scathing in private: "They hate us, the country, themselves, their wives, everything they do—these liberals," Nixon told Henry on May 8. "They are a lost generation. They have no reason to live anymore." In re-sponse to criticism of his Cambodian decisions from the *New York Times* and the *Washington Post*, Nixon gave "strict instructions" to Haldeman to ensure that "*no one* from the White House staff under any circumstances is to answer any call or see anybody from" either newspaper. By contrast, the *Washington Star, Washington Daily News, New York Daily News, Chi-cago Tribune,* and *Los Angeles Times*, all conservative, supportive media, were to receive "special treatment when Ziegler and Klein may determine it is in our interest."

At the same time, the White House wanted to dismiss state depart-ment officials and foreign service officers opposing Nixon's Cambodian decisions. After some two hundred of them signed a petition criticiz-ing the invasion, Nixon called Undersecretary of State U. Alexis John-son at one-thirty in the morning. "Fire them all!" he shouted into the phone. Fearful that any evidence of direct White House involvement in the "corrective action" would be "a massive assist to those elements who are currently attacking the President," Haig and Haldeman directed that the state department initiate the campaign against the dissenters. The department buried the order.

After visiting the Pentagon, Nixon tried to relax by spending a few hours on the presidential yacht sailing down the Potomac. His military aide, Marine Colonel John V. Brennan, "had never seen him appear so physically exhausted." After two or three drinks, which was usually

enough to inebriate him, Nixon carried on about the customary habit of playing the national anthem as the yacht passed Washington's Mount Vernon home. He wanted it "blasted out," he told Brennan. In a "gruff" tone he had never used before with the colonel, he demanded to know if Brennan approved of his speech. "It was a lonely time for him," Brennan recorded. "He certainly knew my feelings before he asked the question." As they approached Mount Vernon, Nixon anxiously awaited the moment until he could stand at rigid attention, swaying unsteadily from the effects of the drinks. He went to Camp David following the cruise, where he watched *Patton* again and stayed up late calling Haldeman for updates on the offensive and public reactions.

The invasion quickly proved to be counterproductive. By the end of June, after U.S. and South Vietnamese forces withdrew, the North Vietnamese came back into their sanctuaries and widened their control of northeast Cambodia. One American war correspondent concluded that the invasion was a serious error: "It laid waste an innocent country . . . It failed to encourage Vietnamization in South Vietnam and instead heightened disillusion and disgust . . . in the United States, thus helping pave the way for the American withdrawal and the North Vietnamese victory."

Although he would always deny that the invasion had been an error, Nixon knew that the results were more negative than positive, especially in giving the antiwar movement new energy. On May 4, after four students, including two women protesting against the Cambodian incursion, were killed by National Guard troops at Kent State University in Ohio, and newspapers across the country published a photo of an obviously distressed woman kneeling over the body of a dead student, Nixon struggled with guilt for having indirectly caused the deaths. "He's very disturbed," Haldeman described his response to the killings. "Talked a lot about how we can get through to the students, turn this stuff off . . . I am concerned about his condition," Haldeman noted on May 9. "The decision, the speech, the aftermath killings, riots, press, etc.—the press conference, the student confrontation have all taken their toll, and he has had very little sleep for a long time and his judgment, temper, and mood suffer badly as a result." Haldeman feared that there was "a long way to go" in the crisis "and he's in no condition to weather it. He's still riding on the crisis wave, but the letdown is near at hand and will be huge."

To assuage his guilt or make peace with himself, Nixon met with students camped out at the Lincoln Memorial during a Washington demonstration on May 8–9. In the words of Tom Wells, "student protests [had] swept like an out of control brush fire across the country." The *Washington Post* reported that "the nation was witnessing what amounted to a virtual general and uncoordinated strike by its college youth." Student demonstrations occurred at nearly 1,350 campuses nationwide; 536 were shut down, with 51 closing their doors for the rest of the academic year.

Haldeman described Nixon's visit to the memorial as "the weirdest day so far." Following an evening press conference on May 8, Nixon stayed up until 2 A.M. gathering information on the response to his performance. After about an hour's sleep, he awoke and began making more phone calls. When Manolo Sanchez, his valet, came in at about 4:20 A.M. after hearing music coming from the president's bedroom, Nixon suggested that they visit the Lincoln Memorial, which Sanchez had never seen. Encountering some students there, Nixon began a conversation with them, which turned into a rambling monologue about Cambodia, his memories of World War II, and the value of travel in the United States and abroad. Eager to win their approval, he spoke of the suffering of blacks, American Indians, and Mexican-Americans and the need to right historic wrongs. He intended to open relations with China, so that we could get to know "one of the most remarkable people on earth." When that elicited no response, he talked about the Syracuse football team, after learning that one of the students was from that university.

"Most of what he was saying," one student told the press afterward, "was absurd. Here we had come from a university that's completely up-tight—on strike—and . . . he talked about the football team. And surfing." Another said, "He wasn't really concerned with why we were here." As he left, he implored the students not to hate him. He returned to a White House guarded by troops prepared to defend it against potential attacks by demonstrators.

The scene, the journalist Mark Feeney says, was something out of a Frank Capra movie: an encounter between political innocents pronouncing "a string of lump-in-your-throat, patriotic epiphanies—the visit to the memorial, the meeting with the students . . . and if only Nixon had walked back to the White House . . . —it all out-Capra'd Capra, except

that these scenes actually happened and to no less a personage than the president himself." Or as the novelist Philip Roth said, it is difficult to be a fiction writer in America, because reality often outdoes the novelist's imagination.

Kissinger's response to the expressions of opposition was more calculated and rational. He scheduled a series of meetings with dissenters—principally academics, including former Harvard colleagues. He tried to disarm their hostility by warning that they might provoke an antidemocratic upsurge by the right. He lived with indelible memories of Nazi exploitation of national divisions to take power in Germany. "Unlike my contemporaries, I had experienced the fragility of the fabric of modern society," he recalled. "Henry feared the Weimar thing in which he and the Jews would be accused of a bug out in Southeast Asia," Roger Morris explained. "We are saving you from the Right," Henry told staff members who resigned over the Cambodian invasion. "You are the Right," one of them replied.

Sixteen months into his term, despite all the brave talk about gains in the Vietnam War and advances toward a new world order, Nixon was frustrated and depressed. Before the end of the year, he would face new problems that tested his emotional and physical endurance as never before.

Chapter 8

CRISIS MANAGERS

*For the roots of crises, look to powerful men feeling
vulnerable and underestimated. Their dread of weakness,
even imagined fragility, begets belligerence.*

—MAX FRANKEL, *High Noon in the Cold War*

During the Cambodian crisis, Nixon "reached a point of exhaustion that caused his advisers deep concern," Kissinger said. "His awkward visit to the Lincoln Memorial . . . was only the tip of the psychological iceberg." On May 11, Rogers and Kissinger agreed in a phone conversation that the president was emotionally spent. "He can't seem to finish" a sentence, Rogers said. "It's a sure sign he's exhausted." They felt it was essential to meet to discuss Nixon's condition and find a way "to relieve him of some of this" pressure.

Yet Nixon viewed the Cambodian episode as simply another in a series of disasters he had faced in his adult life. And although the stress in each crisis brought him to the edge of emotional exhaustion, it also exhilarated him. Every calamity was a test of his endurance and even manhood, a chance to prove himself. In a 1970 memo to Director of Communications Herb Klein, Nixon wanted him to announce that "RN is resilient and seems to do best when the going is roughest." It is a ques-

tionable assertion. Nixon, in fact, performed more effectively when he could be reflective rather than reactive during periods of stress.

Kissinger believed that Nixon's response to crisis was a window into the man's psyche. "There was no true Nixon"; Kissinger said, "several warring personalities struggled for preeminence in the same individual. One was idealistic, thoughtful, generous; another was vindictive, petty, emotional. There was a reflective, philosophical, stoical Nixon; and there was an impetuous, impulsive, and erratic one." Crises brought forth the stoical Nixon, who could take satisfaction from—indeed, take pride in— his capacity to manage an emergency or disaster.

Nixon also took comfort from knowing that every president struggled with the pressures of the office. When Kissinger told him that Soviet Party Secretary Brezhnev "referred to the 'nervous strain' of his job," Nixon wrote at the bottom of Henry's memo, "And Jefferson complained of 'headaches' every afternoon in his last 3 years as President!"

Unlike Nixon, who relied on his emotional armor to cope with the burdens of making hard decisions, Kissinger took refuge in his intellectual superiority; his belief in his greater understanding of the country's needs and imperatives to defend itself against external threats. Intellectual arrogance born of Kissinger's uncommon brainpower partly explains his capacity to overcome his own weakness and ward off attacks from hostile critics.

This is not to suggest that he was unemotional about the barrage of opposition generated by the Cambodian "incursion." It was "a time of extraordinary stress," he says. "Exhaustion was the hallmark of all of us. I had to move from my apartment ringed by protestors into the basement of the White House to get some sleep." Pickets carrying signs, "Fuck Henry Kissinger," enraged him, as did some of the press, whom he described to Agnew as "bastards . . . calling me a war criminal." He told Rogers: "The doves are the most vicious birds." Ehrlichman joked: "We will dig a moat" around the White House to hold off protestors. "Put piranha fish in it," Henry replied.

When William Watts, a former Rockefeller aide and Kissinger staff secretary since August 1969, resigned over the Cambodian invasion, it incensed Henry. "Your views represent the cowardice of the Eastern Establishment," Kissinger shouted at him. "What the hell did you say to Henry?" Haig asked Watts. "He's furious." Haig lashed out at Watts:

"You've just had an order from your Commander-in-Chief and you can't refuse." "Fuck you, Al," Watts shot back. "I just have and I've resigned." On May 13, when Laird asked Henry if things had "quieted down," he replied, "I'm getting my paranoia under control."

Kissinger's response to critics was essentially a declaration that he was better informed than they were. Nothing comforted him more than what he saw as the success of the Cambodian operation. This included more than five tons of captured enemy documents, "vital documentation of the enemy order of battle in Vietnam, its detailed plans for its campaign to overthrow the Phnom Penh government, and bills of lading for shipments through Sihanoukville that went beyond our highest estimates of Sihanoukville's importance . . . Systems analysts on my own staff," Kissinger asserted, "estimated that our operation destroyed or captured up to 40 percent of the total enemy stockpile in Cambodia."

A defense department assertion that the incursion temporarily deterred twelve thousand North Vietnamese troops from entering South Vietnam gave Kissinger additional satisfaction. His contemporary assessment seemed like an understandable rationalization for so controversial an expansion of the war. But holding to this rosy view nine years later when he published his memoirs seemed more like an apologia than a realistic evaluation of what was gained by an invasion that helped create conditions that ultimately produced disastrous consequences for the Cambodians and no long-term gains for the United States or the South Vietnamese. "Cambodia," William Bundy says, "was indeed a black page in the history of American foreign policy."

NIXON'S HIGHEST PRIORITY in the aftermath of Cambodia was not to consolidate or expand alleged gains against the Communists but to quiet dissent in the United States and repel congressional attacks on executive power. Kissinger saw the domestic agitation as tantamount to "the collapse of our establishment" or the "elite . . . all over the country," which he called "frightening." He complained that university teachers and administrators were presiding over the disintegration of the country's institutions of higher learning and had abandoned their "obligation to keep our society together." He described university teachers and administrators as "cowards."

He was particularly angry at Yale President Kingman Brewster, who

was leading the charge against the administration. "That bastard Brewster at Yale is one of the most despicable people," Henry said to Rogers. "This guy is a cheap grandstander." The real problem was not the imminent collapse of American institutions, but a formidable opposition armed with compelling arguments against the war that Nixon and Kissinger could not easily rebut.

Like Kissinger, Nixon was contemptuous of the protestors, who he believed were endangering his ability to win an honorable peace. Worse yet, Henry and the president thought that "the students wanted to destroy the society." Nixon saw "a death wish." Henry agreed: "The American intellectual community has an investment in defeat," he told the president.

He and Nixon saw a conspiracy on campuses, which was creating "a new and grave crisis . . . They are reaching out for the support—ideological and otherwise—of foreign powers and they are developing their own brand of indigenous revolutionary activism which is as dangerous as anything they could import from Cuba, China, or the Soviet Union," Nixon told national security officials. They were practicing "*'revolutionary terrorism.*'" Nixon instructed his intelligence chiefs to mobilize "every resource . . . to halt these illegal activities." When Nixon read in the *Los Angeles Times* about a Berkeley professor who wanted "the murderous Americans out" of Thailand, he told Kissinger, "A fellow like that—it is treasonable. Give [Governor Ronald] Reagan a call and ask him about it. Find out what funds we might have in his department and pull them out." Kissinger promised to comply.

Nixon asked Tom Huston to draw up a series of counterprotest recommendations. Huston set up an interagency committee on intelligence that recommended several illegal tactics for combating the "New Left" under the aegis of a White House "Group on Domestic Intelligence and Internal Security." Nixon promptly approved the plan in July on the condition that if the actions were uncovered, Huston would protect Nixon by taking responsibility. Irony of ironies, J. Edgar Hoover, who was not about to cede control over domestic spying to a young White House novice, forced Nixon to reverse himself by warning that the Huston plan would result in public disclosures that would embarrass and undermine the president. It saved Nixon from a wild-goose chase; while there were some revolutionaries among the dissenters, the great majority was simply

outraged by what they believed was an unjust war that had cost tens of thousands of American and hundreds of thousands of Vietnamese lives.

But none of this, or anything that Nixon and Kissinger said in private about the student radicals, was for public consumption—either then or in the future, or so they hoped. At the beginning of June, when Kissinger gave Rogers a transcript of some unflattering remarks Nixon had made about opponents, Rogers urged Henry "to keep in mind how they are going to look later on." Rogers objected to Nixon's language: " 'He shouldn't talk that way in the first place . . . Somebody later on will go through his Library and find the thing.' 'Okay, I'll edit that out,' " Kissinger responded, and added defensively, " 'It's hard for me to tell the President what he shouldn't say.' "

Nixon tried to disarm the antagonism provoked by the invasion at a news conference on May 8. "Have you been surprised by the intensity of the protest?" a reporter asked. "No," Nixon replied. "Those who protest want peace." But Nixon asserted that he had made the Cambodian decision "for the very reason that they are protesting." He was confident that what he had "done will accomplish the goals that they want," and lead to "a just peace in Vietnam."

He disingenuously stated his eagerness for a meaningful dialogue with protestors, denied that the country was threatened with revolution or repression, and declared that he had "no complaints" about the "very vigorous and sometimes quite personal criticism" he read in the press and saw on television. (Behind the scenes, he ordered Haldeman to keep everyone on the White House staff from talking to anyone from the *New York Times* or *Washington Post* for sixty days.) Nor did he have any objections to peaceful dissenters, he said. His use of the word "bums" was directed at violent protestors.

He predicted that American troops in Cambodia would begin to withdraw in the following week and that all of them, including advisers, would be out by the end of June. In addition, he had every expectation of continuing the withdrawal program of U.S. troops from Vietnam and hoped that he might be able to reduce the number to 240,000 by the spring of 1971, a cutback of another 185,000.

Because violent protests and counterprotests, including the killing of two students and the wounding of twelve others by state police at Mississippi's Jackson State, a black college, did not abate over the next

four weeks, Nixon moved up a promised report on Cambodia from the end to the beginning of June. In an Oval Office address on June 3, he emphasized the success of the operation, cataloging with the help of defense department films the huge stores of enemy supplies captured in the invasion—the equal to everything captured "in all of Vietnam in all of last year." The invasion had the added benefit of demonstrating the effectiveness of Vietnamization, he asserted. This administration would fulfill its promise to end the war.

Nixon's reiterated intention to conclude the fighting was, Kissinger told the journalist Stewart Alsop, a brilliant sleight-of-hand performance comparable to de Gaulle's action in ending the Algerian war in 1962. Henry called de Gaulle "a great illusionist who staged a retreat from North Africa in a way that made France look more powerful than it actually was." Alsop thought it a perfect analogy to Nixon's policy: " 'I've compared Nixon on Viet Nam to the Wizard of Oz,' " he told Henry, " 'his great clouds of rhetoric designed to conceal the fact that he has embarked on the greatest retreat in history.' HK smiled and nodded agreement. The trick, he says, in effect, is to stage a great retreat and emerge at the other end still a great power, reasonably cohesive at home."

Nixon's message was also aimed at the U.S. Senate, where Republican John Sherman Cooper of Kentucky and Democrat Frank Church of Idaho had proposed a resolution shutting off funds for any operations in Cambodia. Nixon was resigned to its approval, which occurred on June 30, and was ready to accept that he could not maintain a U.S. military presence in Cambodia. But he and Kissinger worried that the amendment would be seen, in Kissinger's words to one senator, " 'as a defeat of the President and . . . a great victory' " for his opponents. Nixon also feared that it could be " 'a signal to the enemy . . . What needs to get home to them is that this vote has no importance at all and no effect.' " But, of course, the Communists and everyone else read the vote as a demonstration that the domestic pressure on Nixon to end the war in Vietnam had become irresistible.

To put domestic divisions to rest, Nixon addressed public concerns about Cambodia and Vietnam again on June 30 in a seven-thousand-word "Report on the Cambodian Operation." It was a rehash of what he had said on June 3. He also agreed to a live hour-long television interview on July 1 with ABC's Howard K. Smith, John Chancellor of

NBC, and Eric Sevareid of CBS. He told the network anchors that the Cambodian invasion was "the most decisive action in terms of damaging the enemy's ability to wage effective warfare that has occurred in this war to date." It was a wildly exaggerated assessment of the "incursion," and said more about Nixon's need to picture it as a success than to face up to the realities in Indochina.

At the same time as the White House took this upbeat view, Nixon and Kissinger privately fretted over the possibility that a Hanoi meeting of senior diplomats might signal the likelihood of a new major offensive or was principally a way to "reassure" them that North Vietnam intended to "fight on."

In the spring of 1970, the administration's inability to find a prompt, satisfactory exit from the war made Nixon and Kissinger almost desperate to achieve some foreign policy victories they could emphasize in the runup to the November elections. "We're in trouble—deep trouble," Ray Price, a Nixon speechwriter, told Haldeman at the end of May. "And it's not the kind that success in Cambodia can get us out of . . . Cambodia was not the cause for the recent round of demonstrations, but only the trigger."

Nixon faced a twofold dilemma: how to make progress on international problems, which would reduce threats to U.S. national security, and how to encourage impressions that his administration was masterful in meeting overseas challenges, for which there was scant evidence. The absence of foreign policy gains during his first eighteen months in office made Nixon almost frantic to ensure impressions of an effective administration.

He was especially worried about press reports of Kissinger-Rogers conflicts that were impeding U.S. diplomacy. He believed they were undermining confidence in the White House, and was more concerned to keep the squabbling out of the public eye than to end it. " 'I'm sorry about how Henry and Bill go at each other,' " Nixon told Bill Safire. " 'It's really deep-seated. Henry thinks Bill isn't very deep, and Bill thinks Henry is power-crazy.' " Safire chimed in, " 'That wasn't the half of it—each thought the other was an egomaniac.' 'And in a sense,' the President responded cheerfully, 'they're both right . . . It's a pity really. I have an affection for them both.' "

In June, Henry complained to Haldeman about the growing severity

of his Rogers problem. Nixon and Haldeman saw Kissinger as increasingly paranoid about his relations with Rogers. When newspaper stories appeared about Henry and the actress Jill St. John, Kissinger told Haldeman that he suspected Rogers of "planting them to try to destroy him." Haldeman noted in his diary, "K in to see me for his periodic depression about Rogers." Henry wanted to force a confrontation and push Nixon to choose between him and Rogers. But Haldeman warned Kissinger that the president would not do it, "especially before elections."

Nixon and Haldeman thought Henry was "obsessed with these weird persecution delusions" about the state department, which he saw as always trying to one-up him. Nixon worried that Henry's neurotic ruminations not only distracted him from effective thinking about foreign affairs but also jeopardized the administration's domestic political standing.

Kissinger's complaint that Rogers had planted a story about St. John to embarrass him was a ploy to defeat a rival. In fact, Kissinger had been promoting a playboy image of himself as a way, in his own words, "to reassure people . . . that I am not a museum piece." He began dating a number of Hollywood beauties and went out of his way to build "a high-visibility social life." On dates with St. John at Los Angeles restaurants frequented by the rich and the famous, Henry would be seen "fondling" her and would run "his fingers through her red curls in a display that other diners sometimes found unseemly." At White House state dinners, he would usually be seated next to the most beautiful woman in the room. While he clearly enjoyed hobnobbing with Hollywood beauties and the envy it provoked from other men, it was his way of turning himself into a larger-than-life celebrity—a public official who would become a national figure more memorable than other members of the Nixon administration and even most of the presidents in the country's history.

In 1970, administration limits in advancing world peace by ending the war was its largest political problem. Vietnam remained Nixon's most frustrating dilemma. Although he had no assurances that they could push Hanoi toward a settlement, he agreed to a North Vietnamese proposal for a cease-fire that left contending forces in place. It was a major concession, allowing Hanoi to keep troops in South Vietnam while they negotiated an agreement. The proposal, according to Safire, who helped

write the speech announcing it, was what Nixon called "grandstanding" or "showboating." It was "presented primarily for its political impact in the States."

On October 7, a month before the November elections, Nixon announced the initiative in a nationally televised address, in which he also proposed an Indochina peace conference that would end the conflicts in Cambodia and Laos. The president's speech was warmly received by Congress and the public, and, Safire said, embraced "by editorial writers who wanted a dramatic offer which they thought would break the logjam in negotiations." When it didn't, it left Nixon as hard-pressed as ever to find ways to trumpet foreign policy gains.

Nixon had no better luck in making Anglo-American relations a talking point in the congressional campaign. Mindful of the president's desire to encourage impressions of foreign affairs mastery, the British Foreign Secretary Michael Stewart warned Nixon and Rogers during May conversations in Washington that their actions were at odds with world opinion and that they risked open dissent from allies unless they made peace in Vietnam and "recognize[d] the need for NATO to be . . . working for détente as well as defence." As the British ambassador told the Foreign Office, the pressure exerted by the foreign secretary demonstrated his understanding of "how damaging it could be if dissent from a U.S. position in NATO became a public issue of contention in an election campaign."

To head off open discussion of Anglo-American differences, Nixon and Kissinger took pains to appease British officials. The " 'President saw positive value in appearing to outsiders and enemies as an unpredictable man,' " Henry told Ambassador John Freeman on June 3, " 'but not to his friends, which is why we tell your government so much.' "

That night, at about eleven-thirty, Nixon, in what the British ambassador described as " 'a very bizarre incident,' " telephoned to say that he was pleased to learn from Kissinger about that day's conversation. Henry " 'much valued' " Freeman's friendship, the president said. " 'After some further amiable remarks of no consequence, the President rang off. I am completely unable to interpret this incident, which astonished me . . . In view of the notorious Lincoln Memorial conversation with a group of protestors a month ago,' " Freeman added, " 'Mr. Nixon spoke seriously and appeared completely rational. Thus, while the telephone call was

probably made on impulse, I don't doubt that he was trying to convey *something* which he considered of importance.' " The charm campaign succeeded in muting public indications of Anglo-American differences but provided no grounds for the White House to describe gains in relations with Britain.

German-American relations were also a source of anxiety for Nixon in the 1970 election campaign. He was apprehensive about Bonn's dealings with Moscow. The election of Willy Brandt as chancellor in 1969, the first Social Democrat to hold the office, brought a dramatic shift in policy. Hard-line Christian Democratic dealings with the Soviets and their Eastern European satellites now gave way to *Ostpolitik*, a policy of détente with the Communists. Nixon and Kissinger feared that *Ostpolitik* would translate into a weakened NATO alliance and Soviet advances detrimental to Western security. It would undercut efforts to make Nixon seem like the leader of a unified anti-Soviet alliance.

In May 1970, Egon Bahr, Brandt's national security adviser, reached tentative agreements in Moscow that acknowledged the post-1945 German, Polish, and Czech borders. Bonn also agreed to recognize East Germany and promised to encourage a European security conference and expand Soviet–West German trade.

Nixon and Kissinger tried to strike a balance between private opposition to Brandt's policies and tepid public approval that would not alienate the Bonn government or provoke American complaints that the United States was standing in the way of a European détente. In June, when state elections created greater German polarization over *Ostpolitik*, Henry told Nixon, we are in a more difficult position than ever. Brandt was now more dependent on expressions of U.S. support for *Ostpolitik*, while Germany's conservative parties "will point its appeal more directly to us to stop Brandt or give some sign of our reservations over his policies."

Nixon, Kissinger, and Rogers, in a rare moment of agreement on a major policy, considered *Ostpolitik* a serious error. When former German defense minister Franz Joseph Strauss told Kissinger that Brandt and Scheel were "fools" who were making a bad bargain with Moscow, which "would mean that we would support the Soviets against you," Henry did not disagree. "The Germans have been out-bargained," Rogers told Henry on the eve of Scheel's July visit. "With Bahr doing the bargaining, the lizard," Henry called him. "I looked over that treaty and I

don't see what the Germans get except a treaty. They must now recognize E. Germany. That will make negotiations horrible [over Berlin] because that puts Berlin in E. Germany." As for Scheel, Henry called him "a total lightweight," and suggested that Nixon do nothing more than "say we agree with the general purpose."

Of course, none of this was for public consumption. Nixon and Kissinger saw it as political folly to openly oppose Brandt's agreements with Moscow, which won worldwide approval after being consummated in a treaty on August 12, 1970. The appeal partly rested on Brandt's public acknowledgment that German defeat in World War II dictated the terms of the agreement; "With this treaty nothing is lost that had not long since been gambled away," he declared in a televised address from Moscow. Brandt also won international approval when, during a trip to Warsaw in December 1970 to negotiate a treaty legitimizing changes in postwar boundaries, he knelt at a monument to Polish Jews at the site of the wartime ghetto. His symbolic act of contrition helped persuade *Time* to designate him its Man of the Year. In the spring of 1971, Brandt stood second only to India's Indira Gandhi as the foreign leader Americans most admired.

Nixon and Kissinger grudgingly accepted Brandt's achievement. "The Soviets assured him that they did not want to split the Western powers," Kissinger told Nixon, "(We should keep in mind that what they do is far more important than what they say.)" Henry also thought it was "optimistic" for Brandt to predict that the agreement with Moscow would help consolidate the West. Instead, he expected *Ostpolitk* to put strains on the Western alliance at the same time it did more to consolidate Moscow's hold on Eastern Europe and East Germany than, as Brandt hoped, expand Bonn's influence in Moscow's satellites. Kissinger called Brandt's policy, "détente without much substance."

Nevertheless, Brandt's popularity in the United States as a statesman intent on relaxing international tensions dictated that Nixon and Kissinger congratulate him on the treaty. They insisted, however, that an agreement on Berlin be a prerequisite of its ratification. They were also willing to follow Brandt's lead in holding a Summit of Western leaders, either heads of state or foreign ministers, but they left the level and timing of such a meeting to future deliberations.

Brandt outfoxed and frustrated Nixon and Kissinger. He stole the

headlines from them without, in their judgment, advancing toward reliable improvements in East-West relations. If there were "any détente with the Soviet Union," Henry said to a Brandt associate, it "would be America's doing."

Time gave Nixon and Kissinger the back of its hand when it said that, "While most political leaders in 1970 were reacting to events rather than shaping them, Brandt stood out as an innovator. He has projected the most exciting and hopeful vision for Europe since the Iron Curtain crashed down."

NIXON'S HOPES of significant foreign policy gains in 1970 inevitably focused on relations with Moscow. Between January 1969 and April 1970, Nixon had held the Soviets at arm's length. Although Moscow seemed eager for an arms-control agreement that could reduce defense spending and allow larger investments in a faltering domestic economy, Nixon linked Soviet help in ending the Vietnam War to serious arms talks. He believed that only a hard line with the Russians could bring results. When he saw an "upswing" in anti-American propaganda at the beginning of 1970, he instructed the U.S. embassy to warn the Soviets about the potential "repercussions." In addition, in April, when he received "an excellent CIA paper describing covert action programs being undertaken to exploit tensions in the Soviet Union and Eastern Europe," he wanted recommendations from Helms on "a more aggressive program."

In April, however, the president's coolness toward Moscow gave way to a sense of urgency about reaching accommodations that could reverse the growing sense of frustration over foreign affairs. Although Nixon had entered office highly skeptical about the value of a Soviet-American Summit that did not promise concrete results, he "threw sober calculation to the winds and pressed for a Summit," Kissinger says. "Tormented by anti-war agitators, he thought he could paralyze them by a dramatic peace move ... He foresaw benefits for the Congressional elections in the fall as well." Early in 1970, when the tone of Soviet messages suggested that they might be ready for concessions that would serve America's national security, Nixon instructed Henry to discuss a heads of state meeting before the end of the year with Dobrynin.

Although Kissinger believed that Nixon's "near obsession," as Henry called it, with a Summit was a serious mistake, he faithfully represented

the president's wishes in a series of conversations with the ambassador. "You, I and the President are the only three people who are aware" of "the subject we discussed," Henry told Dobrynin on March 11. On April 7, Dobrynin described "great Soviet interest in a Summit" and SALT, promised that Moscow would help establish a "neutral government in South Vietnam," and offered to compromise on the Middle East. Kissinger responded that the president envisioned a Summit breaking a SALT deadlock and ratifying an agreement.

During June and July, the Cambodian crisis and the approaching elections made Nixon more eager than ever for a meeting with Prime Minister Aleksei Kosygin. Sensing Nixon's concern to counter the Cambodian difficulties, the Soviet price for a Summit was an accidental-war agreement, which was code for an unwritten Soviet-American agreement to defend against a Chinese nuclear threat. Nixon wanted no part of it. It seemed certain to jeopardize potential dealings with Peking as a counterbalance to Moscow.

After Nixon rejected the suggestion, the Soviets proposed a European security conference. "The Soviet leadership clearly had a long shopping list, and they were not about to satisfy Nixon's eagerness without going through the whole list to see how much of it they could get," Kissinger says. Because Nixon was not going to risk U.S. national security for the sake of a meeting, Kissinger adds, he resisted all of Moscow's demands. In the end "the Soviets achieved nothing." The same was true of Nixon, whose plans for a 1970 preelection Summit came to naught.

But even without a Summit, Nixon hoped for progress in SALT, or at least the appearance of progress, and Soviet-American accommodations in the Middle East that could be advertised as foreign policy gains. With SALT resuming in Vienna in April, the arms talks seemed like a good opportunity for some such result. But the prerequisites for an agreement—trust that each side was not trying to steal an advantage on the other—simply did not exist. There was no genuine meeting of minds. The Soviets wanted the United States to abandon or at least sharply limit its antiballistic missiles (ABMs), while Nixon and Kissinger were eager for limitations on Soviet intercontinental ballistic missiles (ICBMs), which threatened to make Moscow the world's greatest nuclear power.

The negotiations in Vienna were nothing more than a Soviet "tactic," some Nixon advisers believed. Their objective was "to get an advan-

tage and freeze it." From Moscow's perspective, Nixon's intention was to limit Soviet ICBMs at the same time it kept ABMs. His additional demand for on-site inspections of missile silos to ensure against cheating impressed Moscow as a ruse for spying on the Soviet Union. The Soviets were convinced that Washington had ample electronic means to verify any agreement without inspections.

The discussions were an exercise in futility. Three weeks before the talks began, Kissinger said, "there was no consensus; there was a babble of discordant voices." And on the eve of the talks, when Nixon met with the NSC to make final decisions about presentations, the meeting "had all the elusiveness of a Kabuki play."

During the NSC discussion, the experts put forward "complicated technical arguments in which the same facts were used to produce radically different conclusions . . . All of this feinting and posturing was performed before a President bored to distraction. His glazed expression showed that he considered most of the arguments esoteric rubbish." When Gerry Smith, an old-school gentleman whose dress and demeanor were a kind of standing reprimand to arrivistes like Nixon, advocated a ban on MIRVs, Nixon contemptuously declared, "That's bullshit, Gerry, and you know it." After the meeting, Smith privately complained to an aide, "Nobody's ever talked to me that way."

The Vienna discussions were no more productive. When Smith put forward the U.S. proposal on MIRVs, the Soviet delegate began writing copious notes. But as soon as Smith mentioned the on-site provision, the note taker put down his pen. "We had been hoping you would make a serious MIRV proposal," he privately told his American counterpart. Although both sides engaged in technical, mind-numbing discussions and the round of talks lasted four months until August, there were no breakthroughs.

The only so-called winner in the process was Kissinger. Because Nixon had no patience with the arcane details of arms control (his *Memoirs* include next to nothing on pre-1972 SALT) and because Henry had a reputation as an academic expert on nuclear weapons, the president gave him responsibility for the negotiations. Some NSC staff members told Seymour Hersh that "Kissinger's struggle to dominate the SALT process was as much a part of his drive to control the bureaucracy as a matter of intrinsic belief in the necessity of arms control."

In June, after Henry "made the mistake last night of getting P all cranked up about SALT problems," Haldeman recorded, and Nixon secretly discussed SALT with Rogers at breakfast, Kissinger was furious. Henry later expressed regret in his memoirs that his judgments on the arms talks were "swayed by bureaucratic and political considerations more than any other set of decisions in my period in office." Although his outlook would change over the next two years, in 1970, he doubted that an arms agreement would serve U.S. strategic interests.

Perhaps the greatest benefit to Kissinger in 1970 from SALT was the relationship he established with Soviet Ambassador Anatoly Dobrynin. To relieve the tedium and strain of dealing with such complicated and potentially disastrous issues, they engaged in the sort of banter common to friendly rivals. When Henry cautioned Dobrynin against leaks, the ambassador assured him that " 'I never discuss our conversations.' 'I was sure you wouldn't,' " Henry replied. " 'I just wanted you to know that you are now an honorary member of the White House staff,' " which Henry saw as responsible for a variety of press revelations. The Soviet delegate in Vienna " 'has a tendency to mention your conversations and mine,' " Kissinger also told Dobrynin. " 'He probably wants to impress people,' " Anatoly replied. " 'I am delighted to know that that impresses people,' " Henry declared with false modesty.

At the end of July, with SALT at a standstill, Kissinger told Dobrynin, " 'I am sitting on [my] back patio thinking about peaceful coexistence.' 'Good for you, Henry . . . I will be in Moscow thinking in the same way.' 'When you talk to your leaders, I hope you convey that thought to them,' " Kissinger needled him. Dobrynin expected to be away for " 'four weeks—just enough to gain strength to conduct discussions.' 'That will give you an unfair advantage,' " Henry joked. " 'What about you?' " Dobrynin asked. " 'I am working on the budget.' " Henry answered. " 'You are building so many SS-9s. You are upsetting the balance. Don't be gone too long,' " Henry said affectionately, " 'you don't want me to get into mischief.' "

With no apparent progress on a Summit or SALT, Nixon, in spite of past frustrations, felt compelled to reach for improved relations in the Middle East. The dangers of an explosion in the region and Soviet ambitions there made it a compelling concern. At the end of January

1970, Kosygin warned Nixon that renewed Israeli-Egyptian fighting posed "highly risky consequences for . . . international relations as a whole."

Kissinger told the president "that this is the first Soviet threat to your Administration," and it required a "very hard" response. Nixon made a tough reply to Kosygin, but also urged mutual cooperation. He thought that the Soviets were trying to restore the Mideast cease-fire rather than intimidate the U.S. In a handwritten note to Kissinger on a newspaper report that Moscow had used the hotline to ask Washington to rein in the Israelis, Nixon said, the Soviets and Egyptians "are in trouble & are using us to get out."

The apparent Soviet need of U.S. help encouraged hopes of a breakthrough in dealings with the Middle East and Soviet-American relations more generally. The reality, however, did not match Nixon's wishes. Egyptian-Israeli tensions remained insurmountable and Soviet-American differences over breaking the deadlock made a settlement impossible.

Nevertheless, Nixon decided to take on this uphill fight. He tried to push negotiations forward by urging the Israelis to be more flexible in their dealings with Cairo. But his appeal fell on deaf ears. He complained to Henry that the Israelis didn't know who their real friends were. It wasn't "the peace at any price Democrats," but hard-nosed conservatives like Barry Goldwater, Bill Buckley, and Nixon himself. "We are going to be in power for the next three years," Nixon told Kissinger, and unless the Israelis followed our lead, they would risk going "down the tubes."

Nixon, however, saw too much political risk in pushing Israel too hard. Forcing matters with Tel Aviv, he told the cabinet, would provoke "a considerable broadside from the Jewish community . . . , since many of the media is heavily weighted to the Jewish point of view."

Strategic and domestic political considerations influenced Nixon's response to Israeli aid requests. By helping Israel, Nixon told Henry, "We are doing what is in our interest because it screws the Russians." It also satisfied Israel's American friends, whose political clout, despite Nixon's reluctance to admit it, was never far from his mind. Helping Israel also allowed him to put pressure on American Jews to support him in Southeast Asia. Let's "put the hook into the Jewish boys," he told Haldeman in May. "Probably none of [the] Jews in the House voted with us on Cambodia." He wanted Haldeman to tell these congressmen that you "can't

deny the President the right to use his power in Vietnam and be granted the power in Israel."

With the aid decision as leverage, Nixon tried to press Tel Aviv into accepting a proposal originating with Rogers for a ninety-day cease-fire in a sixty-mile zone east and west of the Suez Canal, where there had been ongoing violence. During the cooling-off period, the Israelis and Egyptians were to hold conversations through a UN intermediary about a possible agreement based on the UN's 1967 Resolution suggesting a basis for peace.

The proposal incensed the Israelis. Tel Aviv complained that Washington was tying plane deliveries to the American initiative or setting political conditions on assurances of Israel's national security. In a message to Nixon, Golda Meir bluntly called the proposal "the lowest common denominator of American positions ever put in writing," and warned that if the president went ahead, "Israel would have to express deep disappointment about the decision." She also called the proposal "the worst American formulation with respect to content that Israel had ever seen." Her message was clear enough: She would stir American domestic political opposition to Nixon if he insisted on the Rogers proposal.

Kissinger weighed in with strenuous objections to the Rogers initiative. Henry was concerned not only about Israel's survival but also about allowing Rogers and state to control an issue he believed they were handling badly. On June 16, he sent Nixon a single-spaced, ten-page memo warning that the Rogers proposal would increase rather than diminish the dangers of another war by strengthening Israeli convictions that it needed to attack Egypt before Cairo and the Soviets put Israel's survival in greater jeopardy.

Henry's opposition to state's initiative opened a new chapter in the Kissinger-Rogers struggle. On July 15, understanding how mercurial the president was on Mideast policy, Henry tried to elicit Nixon's backing by warning that the state department intended to take control of policy away from the White House. But Nixon was not convinced. Haldeman described Henry as "building up a new head of steam about Rogers." He thought that Henry was "almost psycho" about the clash of wills and policies. He wanted the president to fire Rogers. Nixon saw Henry as "too self-concerned and inclined to overdramatize, which is true," Haldeman noted in his diary.

In August, Kissinger and Rogers finally had a direct blow-up over the Middle East. After Henry had a meeting with Rabin, Rogers complained to him that, " 'This meeting last night screwed it up so badly.' 'Don't be ridiculous,' " Henry countered. " 'I'm not being ridiculous,' " Rogers shot back. " 'You are being absurd,' " Kissinger shouted. " 'If you have a complaint, talk to the President. I am sick and tired of this.' 'You and I don't see alike on these things,' " Rogers answered. The Israelis had the impression that they had "two channels to the President" and that they could "use them differently." Henry said, " 'There is no separate channel.' 'Why do you think they go to you?' " Rogers asked. " 'To try to end run and get the President to overrule you,' " Henry said with undisguised contempt. " 'That's right,' " Rogers said. " 'But that has never happened,' " Henry assured him. " 'But why give them the impression that it might . . . I don't think you should see these people,' " Rogers ended.

To Rogers's satisfaction, his proposal for a cease-fire and UN mediated talks seemed to break the Middle East deadlock. In conversations with Kissinger, Dobrynin was effusive about Moscow's interest in an agreement. He asserted that the Soviet Union wished to avoid any confrontation over the Middle East, was "eager" for "a political settlement" and was authorized to negotiate with Kissinger, and, if possible, reach an agreement. As Henry told Ambassador Freeman on July 20, Dobrynin was "all smiles and conciliation" about the Middle East. Not surprisingly, then, on July 22, the Soviets and Egyptians announced their agreement to Rogers's cease-fire proposal on the condition that the Israelis accepted as well.

The Israelis, however, continued to see "a great military risk as well as serious political risks in subscribing to the U.S. cease-fire proposal." Meir asked for "more complete assurances with respect to future arms shipments" as a first step toward compliance with the U.S. initiative. On August 5, after the Pentagon had promised to supply Shrike missiles to counter Soviet surface-to-air-missiles (SAMs), Ambassador Rabin informed Kissinger that Israel would agree to the cease-fire.

"Rabin had many extraordinary qualities," Kissinger wrote, "but the gift of human relations was not one of them. If he had been handed the entire United States Strategic Air Command as a free gift he would have (a) affected the attitude that at last Israel was getting its due, and

(b) found some technical shortcoming in the airplanes that made his accepting them a reluctant concession to us." In agreeing to the cease-fire, Rabin cautioned that his government saw no indication that the Egyptians would compromise on any of the major issues between them and Israel.

On August 7, the Egyptians, Israelis, and UN Secretary General U Thant issued guarded statements welcoming the cease-fire. The announcements, however, immediately raised new difficulties for future talks. The Israelis were angry that the UN statement included an assertion that Tel Aviv had agreed to a U.S. peace formula. Privately, Meir expressed shock at this claim, calling it "an insult to the Government and people of Israel. The U.S. has put words in the mouth of the Israeli Government to which it had not agreed. This was dictation, not consultation. It raised the question of whether serious negotiations could follow."

According to Haldeman, Kissinger was another roadblock to the peace process. On August 17, Haldeman described him as "bitter and uptight." He also recorded Nixon as realizing that Kissinger was "basically jealous of any idea not his own, and he just can't swallow the apparent early success of the Middle East plan because it is Rogers's. In fact, he's probably actually trying to make it fail for just this reason."

Neither Israel nor Kissinger would prove responsible for the collapse of the Rogers peace initiative. The Soviets and the Egyptians came to believe that the American proposal was a ruse. They thought that Washington and Tel Aviv expected Moscow and Cairo to reject it and give Israel a justification for attacking Egyptian and Soviet forces. In response, they began moving SAM missiles closer to the Suez Canal as a counter to potential Israeli attacks and an advantage for amphibious forces in a possible canal crossing to regain control of the Sinai. On September 6, the Israelis announced their refusal to participate in UN-sponsored talks as long as the Egyptians violated the cease-fire and stand-still agreement. "The Middle East has deteriorated to a near-critical state," Al Haig told Kissinger on September 7.

A CRISIS IN JORDAN finished off whatever hopes remained for an Egyptian-Israeli stand down. The Six-Day War in 1967 had cost King Hussein, a willing participant in the conflict, control of the Jordan River's West Bank

and East Jerusalem. The setbacks weakened his authority and made him vulnerable to internal attacks by some six hundred thousand Palestinians living in Jordan. The Palestine Liberation Organization (PLO) led by Yasser Arafat, a shrewd demagogue whose traditional Arab headdress, unkempt beard, military garb, and ability to command international attention for the PLO made him popular with the Arab street, and the even more radical Popular Front for the Liberation of Palestine (PFLP) led by George Habash, a sort of thinking man's rebel, found an excuse for eliminating Hussein when he supported the July cease-fire between Egypt and Israel. Assassination attempts against the king in June and early September coupled with lawlessness by armed bands of Palestinians in Amman, Jordan's capital, created a parallel crisis to the Israeli-Egyptian conflict in the Sinai.

The United States had a transparent interest in helping the moderate Hussein remain in power; a radical regime in Jordan supported by the Soviets would have further isolated Israel and increased the likelihood of another Mideast war. When reports of Fedayeen violence in Amman, some of it directed against U.S. citizens, reached Washington in June, the administration considered dispatching troops to prop up Hussein and counter the threat of a Soviet-sponsored Syrian-Iraqi intervention that could provoke an Israeli invasion. The issue involved more than blunting Soviet adventurism, Nixon told the NSC; it also raised questions about U.S. credibility in the region.

Hussein managed to hold his ground during the summer without U.S. forces. But the issue resurfaced between September 6 and 9, when the PFLP hijacked American, Swiss, and British airliners and landed them at a field in Jordan, where they held all the Westerners aboard, including several Americans, hostage. The hijackers demanded the release of Palestinians jailed in various countries, including Israel, for terrorist activities. Though Arafat arranged the release of all but fifty-four of the hostages, he endorsed the PFLP's prisoner demands and insisted on the abdication of Hussein as the price for the Westerners' safe return.

The crisis triggered a new round of discussions in Washington about how to defend "moderate Arabs." The immediate question for the president and Kissinger was what to do if Hussein's government seemed about to fall. Should the United States intervene directly with air and possibly land forces? Or should they encourage the Israelis to fill the vacuum?

On September 8, after a series of all-day meetings, Kissinger was confused about what the administration intended to do. "My confusion . . . was not cleared up when the President wandered into my office ten minutes after the [last] meeting" and directed Henry to sort things out without saying what he wanted him to do. Eight days later, on September 16, the administration was still mulling over its options. Henry told the journalist Marvin Kalb, the crisis "could build into confrontation between the King and Fedayeen or an uneasy compromise. Very precarious."

Nixon and Rogers disagreed about how to help Hussein. The president wanted to "send a threat" that he thought might help "moderates," but Rogers opposed it as likely to "cause these fanatics to react the wrong way." On September 17, when Hussein, with encouragement and support from CIA officials in Amman, launched an attack against the Fedayeen, and Syria and Iraq seemed poised to come to their aid, Nixon used a background interview with American journalists in Chicago to send a blunt warning. Although Rogers and Kissinger "told him to say nothing," Nixon defied their advice and tried to intimidate the Soviets and Arab radicals. "He said the Soviets made their worst mistake in building up missiles in the Middle East. We are going to give the Israelis five times as much as he had planned. The King cannot fall. It is better for us to go in."

Kissinger believed that Hussein could defeat the Fedayeen without U.S. intervention. But Nixon thought otherwise. If Syria and Iraq intervened in Jordan, the president saw the need for U.S. and/or Israeli air strikes. Nixon favored using American air power, and Rogers wanted the Israelis to take on the job. Rogers was particularly worried that if U.S. military intervention failed to beat back a Syrian-Iraqi attack, we would need Tel Aviv "to bail us out" and that "would be awful." While they waited to see what happened, Nixon ordered carrier reinforcements into the Mediterranean. It was as much a way to intimidate the Soviets as to restrain Damascus and Baghdad. By the evening of September 17, however, it seemed clear that Hussein was defeating the Fedayeen and that neither the Syrians nor the Iraqis were going to move.

Nixon was jubilant that he finally had a victory. "The Russians are really stewing right now," he told Henry. "The events leading to the hijacking," Kissinger replied, "—they have been a net loss for the Soviets."

Nixon was convinced that strengthening the Sixth Fleet in the Mediterranean was a "master stroke . . . The Russians know that if they moved they had to deal with us."

Nixon had been too quick to declare victory. On September 18 and again on September 20, Syrian tanks crossed into Jordan in support of the Fedayeen. Washington faced a new crisis. Although the White House expressed public concern about the expanded fighting, warned the Soviets against intervening, put U.S. forces on alert, and reassured Hussein of American support without making any commitments, Nixon was uncertain about an effective U.S. response. Sending troops now seemed out of the question. Richard Russell, chairman of the Senate Armed Services Committee, told Rogers on September 18 that "he would fight with all the strength at his command" the involvement of any U.S. land forces. "Money and matériel are different, but anything involving men he is unalterably opposed to." Russell was echoing the widespread view, "No more Vietnams."

The Syrian intervention provoked fresh arguments between Kissinger and Rogers and Washington and Tel Aviv. Kissinger opposed Rogers's proposal to ask the UN Security Council to address the problem. Nor did he want Rogers to discuss anything with the Soviets for fear he would send them the wrong message. He worried that we did not soften the message of U.S. resolve to act decisively in this crisis. Henry also wanted to give the Israelis a go-ahead on air strikes, while Rogers urged delaying the decision until they had more information on the fighting. He thought Kissinger was pushing Nixon into a "rash decision."

Although Nixon sided with Kissinger, he complained to Haldeman that he couldn't tolerate the infighting much longer and discussed firing Henry or Rogers. Haldeman, however, thought it "would be a disaster" for him to dismiss Kissinger; nor did he believe Nixon would force Rogers to leave. A shake-up in the state department in the midst of a crisis and less than two months before an election would raise questions about the administration's effectiveness.

The latest crisis came to an end when the Jordanians unilaterally defeated the Syrian forces and compelled their withdrawal on September 23. Nixon at once thanked the Israelis for their readiness to join the fighting in Jordan if Syria seemed likely to win. But he wanted to leave no doubt that their collaboration did not constitute open-ended

commitments. "Because circumstances will be different if there is another attack," the state department told Tel Aviv, "we consider that all aspects of the exchanges between us with regard to this Syrian invasion of Jordan are no longer applicable . . . If a new situation arises, there will have to be a fresh exchange."

Kissinger, the NSC, Rogers, and Sisco were reluctant to appear euphoric, but they couldn't resist congratulating themselves on a rare victory. "The whole team has pulled together," Sisco told Henry. "All of us have served the President well." Henry replied, "Joe, this means a lot to me. We will be friends for a long time." Kissinger crowed to a reporter, "For once we've done something right. Our motto is 'You can't lose them all.' "

The White House, which was so hungry for something to use in support of Nixon and the Republicans as the November congressional elections neared, now seized upon the end of the Jordanian crisis to trumpet the president's skills as a foreign policy leader. The crisis provided an "outstanding example of how the President reacts to crises and deals with them," Haldeman wrote Kissinger. "This is one more example of the President at his best and it would be helpful to have that known." However unlikely journalists were to see Nixon's actions as evidence of exceptional foreign policy leadership, Henry promised to get these points across in his contacts with the press.

Meanwhile, the eruption of a parallel crisis in Chile that came off less successfully than the one in Jordan left little chance for Nixon or Kissinger to remain exhilarated or trumpet their ability to save a moderate Arab state from a radical takeover.

LATIN AMERICA WAS NOT HIGH on Nixon's list of foreign policy priorities during his first twenty months in office. After his controversial visit to the region as vice president in 1958, when he faced mob violence, he did not travel to any of the southern republics again until 1967. His visit was part of his pre-1968 campaign effort to burnish his image as a foreign policy expert. He saw little during his stops in Peru, Chile, Argentina, Brazil, and Mexico to convince him that Kennedy's Alliance for Progress had significantly advanced the economic well-being or democratic aspirations of these countries. At a press conference at the end of his stay in Argentina, he praised the government's military dictator and declared, "United States–style democracy won't work here. I wish it would."

Despite his doubts about changing economic or political conditions in Latin America, Nixon felt compelled to announce "a new policy" that could improve living standards and promote political stability in the southern republics. In September 1969, he directed the state department to counter impressions that his administration had "placed the region low on its agenda of priorities." At the end of October, in a speech at the annual meeting of the Inter-American Press Association, he confronted assertions that "the United States really 'no longer cares' " about Latin America by declaring, "We do care."

He subsequently signed off on "a system of generalized tariff preferences" for less-developed countries, especially in Latin America. In May 1970, after the European Economic Community and Japan rejected America's proposal, Kissinger counseled the president to stick with his policy. "We have gained a great deal in foreign policy terms from your original decision, and would lose all of it if we adopted the [EEC-Japanese] tariff quota approach," Henry wrote. "Even though it is not clear whether our scheme will actually be the most liberal in practice, we have succeeded in making it look more liberal and have therefore reaped major foreign policy gains."

Nixon and Kissinger shared the conviction that America's highest priority in Latin America was not to foster democracy or economic growth but to suppress Soviet-Cuban Communist influence. Kissinger told "the Chilean Foreign Minister that 'the South'—at least the Western Hemisphere 'South'—simply did not count in the geopolitical global balance."

In a more detailed account of this June 1969 encounter, Kissinger upbraided the foreign minister, Gabriel Valdés, during a private lunch at the Chilean embassy that Henry had requested. Kissinger's purpose was to answer Valdés's assertion during a White House ceremony for Latin-American ministers that U.S. economic policies toward the region were more self-serving than helpful. The remarks angered Nixon and Kissinger, who called them "arrogant and insulting." During the lunch, Henry contemptuously told Valdés that "Nothing important can come from the South. History has never been produced in the South. The axis of history starts in Moscow, goes to Bonn, crosses over to Washington, and then goes to Tokyo. What happens in the South is of no importance. You're wasting your time." Insulted, Valdés replied, "Mr. Kissinger, you

know nothing of the South." Henry conceded the point, declaring, "And I don't care." Valdés shot back: "You are a German Wagnerian. You are a very arrogant man."

Other Kissinger remarks about the region were as undiplomatic. The most memorable was Henry's assertion that Chile is a "dagger pointing at the heart of Antarctica." In 1973, after Kissinger became secretary of state, Arnold Weiss, a childhood friend, who was serving as legal counsel to the Inter-American Development Bank (IDB), sent Henry a note of congratulations and an invitation to consult with him any time he wished information on Latin America. Kissinger sent a note thanking Weiss for his good wishes, but snidely dismissed his offer of help, "If I need any information on Latin America, I'll look it up in the *Almanac*."

In September 1970, information from U.S. intelligence that Moscow might be building a naval base on Cuba's southern coast at Cienfuegos Bay that could accommodate nuclear submarines evoked memories of the 1962 missile crisis. But the evidence was so sketchy and the Soviet denials so emphatic that neither Nixon nor Rogers wanted to pursue the matter.

By contrast, Kissinger was convinced that the Soviets were testing the administration and that Nixon needed to confront them. When Henry tried to see him in the Oval Office, Haldeman feared that it would expose the president to more carping about Rogers, and resisted Henry's request. But when Henry melodramatically warned that he had disturbing reconnaissance photos of Soviet construction of a soccer field in Cuba, which suggested that they were building a permanent base in violation of the 1962 agreement, Haldeman relented.

Nixon was not convinced that a confrontation was necessary. He told Henry "to play it all down. He did not want some 'clown senator' asking for a Cuban blockade in the middle of an election." In addition, he feared that a public flap over Cuba would force him to cancel a nine-day trip to Europe beginning September 27.

But Henry would not let go of the issue. During the trip to Europe, after he received reports of additional Soviet construction in Cuba, he instructed Haig to take a hard line with Dobrynin. It was a mistake to give Haig, a no-nonsense general with little appreciation for diplomatic subtleties, the assignment. Or it may be that Kissinger anticipated Haig's tough talk. Haig told Dobrynin that they were violating the 1962 ban on

offensive weapons in Cuba and ordered him to dismantle the base or "we will do it for you." Dobrynin flushed angrily, and said "in a loud voice, 'You are threatening the Soviet Union. *That* is . . . intolerable.' "

When told of the exchange, Nixon and Kissinger were "furious . . . You have exceeded your authority," Henry shouted at him over the phone. "You can't talk to the Russians that way. You may have started a war." Kissinger knew better, but he felt compelled to reflect Nixon's distress at Haig's intemperate language. He was undoubtedly pleased that Haig had said what his position of greater authority precluded him from saying.

Nixon was unhappy with Henry's continuing agitation of an issue he wanted to mute. But Kissinger was convinced that his assertiveness had forced the Soviets to back down. He told the British ambassador that "they had collapsed very quickly in the face of his rough attitude." He explained that the episode had produced "an acrimonious debate" with the state department, which he had won. The ambassador was not so sure. He told the foreign secretary that Kissinger "is a vain man, and it is possible that he has somewhat overcoloured his personal role." Shortly after, the foreign secretary told Ambassador Freeman that from "what the President had said [to the prime minister] . . . Dr. Kissinger had made the most of the story." CIA information about Cuba convinced Freeman that Kissinger had exaggerated the Soviet danger there.

Events in Chile in September 1970 raised greater concerns about Communist influence in Latin America. The rise of Castro in Cuba in 1959 had made the Kennedy and Johnson administrations hypersensitive to radical advance in Latin America. Kennedy's answer had been the Alliance for Progress—a policy of fostering economic development across the region that would transform millions of lower- and working-class Latinos into middle-class citizens eager for representative governments rather than right or left authoritarian regimes. Commentators joked that the alliance should be called "the Fidel Castro Plan." "If the possessing classes of Latin America made the middle-class revolution impossible," Arthur Schlesinger, Jr., told Kennedy in 1961, "they will make a 'workers-peasants' revolution inevitable." Because the transformation of the southern republics into American-style democracies was, at best, likely to take generations, the administrations of the sixties saw covert

activities to block Communist takeovers in Latin America as essential to U.S. national security.

Chile, a country with a history of democratic elections, was especially worrisome to U.S. policy makers. In 1964, no Latin American country seemed more vulnerable to a left-wing takeover by democratic means than Chile. The September election pitted Jorge Alessandri, a conservative, against Salvador Allende, an avowed Marxist, and Eduardo Frei, a pro-American centrist. The CIA spent millions of dollars to mobilize voters for Frei and undercut Allende, who, CIA-inspired propaganda predicted, would repress Chilean freedom under a Cuban-Soviet-style government. It was all part of what then-Secretary of State Dean Rusk called "*a major covert effort* to reduce chances of Chile being the first American country to elect *an avowed Marxist president.*" When Frei won 57 percent of the vote, it encouraged the conviction that clandestine intervention in Chile was a sure-fire way to protect U.S. interests.

Despite continuing U.S. efforts over the next six years to expand the Chilean economy and bolster anti-Allende forces, conditions in the country undermined CIA plans to manipulate the 1970 election. Limited to one six-year term, Frei could not run again. But even if he could, inflation and the falling price of copper, Chile's principal export, had eroded his popularity. Radomiro Tomic, Frei's handpicked successor, was a weak candidate whose centrist Christian Democratic party seemed unlikely to win reelection. The alternatives, Alessandri on the right and Allende on the left, were both ahead of Tomic in the summer run-up to the September 4 election.

In January 1970, Edward Korry, the U.S. ambassador in Santiago, had cautioned the administration in Washington against exaggerating dangers to the United States and the hemisphere from developments in Chile. "Chile," he cabled the state department, "is one of the calmer and more decent places on earth; its democracy, like our own, has an extraordinary resilience and the high decibel count in Santiago is mostly the sound of open safety valves and not the hiss of suppressed furies . . . I see little that will endanger U.S. real interests in the country, in the area or in the hemisphere." But Korry, a former United Press International (UPI) journalist and Kennedy appointee, had limited credibility with the White House.

In June, after Viron Vaky, the NSC's principal Latin American ex-

pert, told Kissinger that "the center of political gravity in Chile is left of center," Nixon asked for "an urgent review of U.S. policy and strategy in the event of an Allende victory." The NSC was to assess the consequences of an Allende administration and describe the options "open to the U.S. to meet these problems." In July, in a NSSM prepared by an ad hoc committee, the planners saw no U.S. "vital national interests within Chile," but predicted "a definite psychological setback to the United States and a definite psychological advance for the Marxist idea." One possible remedy was Allende's "overthrow or prevention of the inauguration" by a CIA-backed coup. It would put an end to Allende's prospects of installing a socialist government in Chile, but the committee also warned that a failed coup might reveal U.S. involvement, with "grave consequences for our relations with Chile, in the hemisphere, in the United States and elsewhere in the world."

On the eve of the September 4, 1970, election, Vaky echoed the dangers the committee saw in a U.S.–sponsored attempt to overturn a democratically chosen president. This could be the "administration's Bay of Pigs," he warned Kissinger. "What we propose is patently a violation of our own principles and policy tenets." But aware that such an argument would carry little weight with Henry, Vaky added, "Moralism aside, this has practical operational consequences . . . If these principles have any meaning, we normally depart from them only to meet the gravest threat to us, e.g., to our survival. Is Allende a mortal threat to the United States? It is hard to argue this."

Winston Lord, another principal NSC aide, warned Kissinger that "interference" in Chile "*could completely undercut our policy on Vietnam.* Revelation of our directly moving to reverse the unpalatable electoral outcome in Chile would make a mockery of our stance on South Vietnam" in behalf of self-determination. Besides, the argument that a plurality, rather than a majority, favoring Allende was a justification for interfering rang hollow when set alongside the fact that Thieu and Ky held power with plurality backing.

A state department official who was part of these pre-September discussions about blocking an Allende government and spoke to investigative journalist Seymour Hersh about the shortsightedness of such a policy, said he "considered the operations against Allende 'a stupid effort. It assumed too much reliability from people over whom we had no con-

trol. We were doing something culpable and immoral. Why take these risks.' "

The warnings did not persuade Nixon or Kissinger to drop support for a coup. On September 4, 1970, Allende bested Alessandri with 36.2 percent to 35 percent of the vote. Having won only 27.8 percent of the ballots, Tomic and the centrists were now out of the running. The Chilean Congress, which had a long history of ratifying the front runner in close elections, was slated to meet on October 24. Its endorsement of Allende seemed all but certain, with his ascent to the presidency coming on November 3.

Nixon and Kissinger now launched a series of discussions aimed at blocking Allende from his freely won election. Nixon embraced a warning from an Italian businessman that socialist regimes in Cuba and Chile would turn Latin America into "a red sandwich." One U.S. expert with extensive knowledge of the region belittled the metaphor: "Four thousand miles of heterogeneous societies and regimes would lie between those two slabs of Marxist pumpernickel."

Similarly, the White House ignored others in the state department who thought that drastic action would be a mistake. Nixon and Kissinger, however, believed that "Allende's election was a challenge to our national interest . . . [Chile] would soon be inciting anti-American policies, attacking hemisphere solidarity, making common cause with Cuba, and sooner or later establishing close relations with the Soviet Union," Kissinger wrote later. His analysis reflected current U.S. press assumptions: Immediately after the election, the American media reported sympathetic comments about Cuba by Allende and his determination "to end once and for all Chile's dependence on the United States."

Neither Nixon nor Kissinger, however, was able to pinpoint any direct danger to the United States. Leftist hostility to the U.S. across Latin America was familiar politics. More specifically, even if Allende allied his government with Moscow, it was difficult to believe that the Soviets would want to replicate the Cuban missile crisis by putting offensive weapons into Chile.

Nevertheless, Nixon and Kissinger, convinced that an Allende government represented a threat to U.S. interests across Latin America, were determined to prevent his accession to the presidency. On September 8, the NSC's 40 Committee, the body responsible for covert activities,

discussed political and military means of depriving Allende of the office. The initial feeling was what they called "Track I," "the political/constitutional route in any form is a non-starter." The plan was to bribe and bully the Chilean Congress into selecting Alessandri, who was to resign and allow Frei to run in a new election against Allende. The 40 Committee, however, believed that a prompt coup by the Chilean military, "Track II," was the best hope of barring Allende from power. When U.S. Ambassador Edward Korry cabled the White House on September 12 that a coup by the Chilean military, which he described as in "a customary state of flabby irresolution," was unlikely, the administration decided to pursue Tracks I and II at the same time.

On September 15, 1970, at a White House meeting of the 40 Committee, Nixon told Helms, Kissinger, and Attorney General John Mitchell that he saw a "1 in 10 chance perhaps, but save Chile!; worth spending; not concerned; no involvement of embassy; $10,000,000 available, more if necessary . . . make the economy scream." Helms later recalled that he left the White House meeting with the "impression . . . that the President came down very hard . . . that he wanted something done, and he didn't much care how and that he was prepared to make money available . . . That this was a pretty all-inclusive order . . . If I ever carried the marshal's baton in my knapsack out of the Oval Office, it was that day." Nixon was also determined to hide his policy from state and defense and former CIA director John McCone, whose request to the president to discuss Chile had been turned down. Haig urged Kissinger to ignore McCone as well.

The following day, Helms gave CIA chiefs marching orders from the president. An Allende regime was unacceptable to the United States. The CIA was instructed "to prevent Allende from coming to power or to unseat him." The CIA was "to carry out this mission without coordination with the Departments of State or Defense." Helms had two days to give Kissinger a plan on "how this mission could be accomplished." The program agreed to the next day included consideration of "what economic pressure tactics can be employed," how to strengthen "the resolve of the Chilean military to act against Allende," and what "propaganda" in Chile might "stimulate unrest and other occurrences to force military action." The planners hoped General Roberto Viaux, a conservative whose extreme views had forced his retirement from the military, might

be used to "cause Communist reaction and in turn force [the] military['s] hand."

Kissinger became Nixon's point man in managing the CIA's Chilean operations. Henry consulted with John Mitchell about what to include in a cable to Santiago, with the attorney general signing off on how to give the operation the appearance of legality. On September 22, after discussions with state, defense, and CIA officials, Kissinger approved a cable to the U.S. embassy in Santiago endorsing a Chilean "military take over [of] the government," and a promise of continued aid and "maintenance of our close relationship."

Henry also brought pressure to bear on the British ambassador to discourage his counterpart in Chile from indicating that "we should come together with Allende. It makes it look [like] you are for an Allende victory," Kissinger said. "It can be twisted to mean discouraging any other efforts. This is not the President's view, although it's not out of line with others in our government," including U.S. Ambassador Korry, who saw no chance that "the Chilean armed forces will unleash a civil war or that any other intervening miracle will undo his [Allende's] victory." Henry told Freeman that Korry "seems to have lost his sanity." At a 40 Committee meeting on September 24, Henry planned to "nail down interim arrangements for the handling of Chile," including assurances of "both money and safe havens" for Chilean plotters, should they fail, and keeping Thomas Karamessines, CIA deputy director of plans, at the center of operations and "locked directly to us."

By the end of September, the CIA operatives responsible for changing the political outcome in Chile had little hope of blocking Allende. Frei would not cooperate in promoting a coup, and they saw the need to rely on others to "assist in creating the pretext or flash point for action." During the first two weeks of October, fearful that doing nothing would encourage the view that "the U.S.A. was throwing in the sponge" on Latin America, the 40 Committee "passed the word to the highest levels of the Chilean military that the United States government is willing to support any military move to deny Allende the Presidency." The operatives in Santiago were instructed to "use all available assets and stratagems including the rumor-mill to create at least some sort of coup climate."

By October 15, Kissinger's discussions with CIA officials convinced him that General Viaux, the only Chilean general fully committed to a

coup, "did not have more than one chance in twenty—perhaps less—to launch a successful coup." As a consequence, they agreed to send Viaux a message warning him against "precipitate action," which would not succeed. Henry, with Nixon's approval, also urged that "the Agency should continue keeping the pressure on every Allende weak spot in sight," and that everything possible be done to hide U.S. encouragement to the Chilean military for a coup.

But Karamessines did not think that "wide ranging discussions with numerous people urging a coup could be put back into the bottle." The cable transmitting these instructions to Santiago included a message to other anti-Allende Chilean military chiefs, Admiral Hugo Tirado, General Alfredo Canales, and Brigadier General Camilo Valenzuela, describing "great and continuing interest" in their activities and wishing them "optimum good fortune."

A principal impediment to a successful coup was Rene Schneider, Chile's commander-in-chief, who opposed any interference with the country's constitutional process. To get him out of the way, the CIA arranged with Valenzuela to have Schneider abducted from an Army VIP stag party on October 19 and flown to Argentina. The kidnapping was to be blamed on "Leftists." Over the next three days, the cabinet would resign, Frei would refuse an offer to become president, and the plotters would install a military junta, which would then dissolve Congress—the "military's only unconstitutional act," Valenzuela cynically told his CIA collaborators. The CIA provided submachine guns and tear gas grenades for use in the kidnapping.

But attempts to abduct Schneider on October 19 and again on October 20 failed. On the morning of October 22, however, the plotters succeeded in ramming Schneider's car as he was driving to military headquarters, and after breaking the rear window, they shot him three times and left him to die, as he did on October 25 following unsuccessful surgery.

Nixon and Kissinger denied responsibility for Schneider's death. Kissinger later explained that on October 15 he told Nixon about a conversation with Karamessines in which he said, "That looks hopeless. I turned it off. Nothing would be worse than an abortive coup." The transcript of a telephone conversation with the president that day confirms Kissinger's recollection. Henry's decision rested on an October 9 cable

from Korry, who warned that Chile's military chiefs wanted no part of a U.S. arranged coup. They "would resent an effort to provoke their action by bribery." Moreover, "a significant percentage of officers are ready to adapt to Allende, however watchful of his actions they may be in the future . . . Any attempt on our part actively to encourage a coup could lead us to a Bay of Pigs failure. I am appalled to discover that there is liaison for . . . coup plotting."

Yet in spite of Korry's warnings, Kissinger and the CIA did not abandon long-term plans for a military takeover. In an October 16 CIA cable to Santiago, station operatives were told, "It is firm and continuing policy that Allende be overthrown by a coup. It would be much preferable to have this transpire prior to 24 October, but efforts in this regard will continue vigorously beyond this date. We are to continue to generate maximum pressure toward this end utilizing every appropriate resource."

On October 18, Kissinger sent Nixon a memo, saying, "Our capacity to engineer Allende's overthrow quickly has been demonstrated to be sharply limited. It now appears certain that Allende will be elected President of Chile." The need now was for a longer-term "action program." On October 23, the day after Schneider had been mortally wounded, the 40 Committee told CIA operatives in Santiago, "the station has done an excellent job of guiding Chileans to the point where a military solution is at least an option for them." The station (a euphemism for CIA operatives) was "commended for accomplishing this under extremely difficult and delicate circumstances."

Schneider's death deepened the determination of the Chilean Congress and public to follow democratic procedures and make Allende its president. Generals Viaux and Valenzuela, two of the plotters, were successfully prosecuted for their involvement in Schneider's assassination. However accurate Kissinger was in seeing the attacks on Schneider, about which he had no specific advance knowledge, as unproductive in fostering a successful coup, they were nevertheless the product of the Nixon administration's machinations. To be sure, killing Schneider was never a part of the plan, but the White House could hardly escape responsibility for the outcome. Like the Kennedy-sponsored coup against Ngo Dinh Diem in November 1963, which led to Diem's assassination, the Nixon-Kissinger plotting to neutralize Allende had an unintended but direct connection to Schneider's death.

Despite administration plotting to block Allende's assumption of power, it publicly denied having anything to do with plans for an undemocratic coup or Schneider's demise. On October 22, Kissinger drafted a press release in response to Allende's confirmation as president. "It is now, of course, up to the new government and the people of Chile to choose and shape the nation's future course and policy . . . Few nations have more justification for pride in political and intellectual freedom than Chile . . . We would, therefore, hope that Chile will not violate its own democratic and western tradition" by blocking "the continuation of the constructive relationships which Chile and the nations of the Hemisphere have so long enjoyed."

For Nixon and Kissinger, undemocratic manipulation of Chile's political life by the United States was preferable to a socialist Chile with ties to an undemocratic Cuba and Russia. Similarly, in another expression of hypocrisy, Nixon cabled Frei, "The shocking attempt on the life of General Schneider is a stain on the pages of contemporary history. I would like you to know of my sorrow that this repugnant event has occurred in your country." As one nineteenth-century American spoilsman declared, "Nothing is lost save honor!"

The conciliatory statements were strictly for public consumption. Behind the scenes, the plotting against Allende continued and intensified. On November 3, General Vernon Walters, the U.S. military attaché in Paris whom Kissinger held in such high regard, sent Henry a memo about Latin America. Kissinger was so impressed with Walters's analysis he passed it along to Nixon, who wrote approving notes in the margins. Walters was apocalyptic: "We are engaged in a mortal struggle to determine the shape of the future of the world. Latin America is a key area in the struggle. Its resources, the social and economic problems of its population, its proximity to the U.S. and its future potential make it a priority target for the enemies of the U.S. We must ensure that it is neither turned against us nor taken over by those who threaten our vital national interests."

Walters's warnings apparently trumped Kissinger's convictions about the unimportance of Latin America, or they provided a cynical justification for bringing down Allende. On November 4, Henry lobbied the president to delay an NSC meeting on Chile from November 5 to November 6, so that Nixon could "study the issue" before they met.

"Chile could end up being the worst failure in our administration—'our Cuba'—by 1972," Henry advised the president. The implication that Chile was a political time bomb that could go off during the reelection campaign was not lost on Nixon.

Kissinger followed up with a memo the next day that sounded irresistible national security alarms. Allende's election *"poses for us one of the most serious challenges ever faced in this hemisphere,"* he told Nixon. "Your decision as to what to do about it may be the most historic and difficult foreign affairs decision you will have to make this year."

Was Henry saying that Chile was more important than Vietnam, relations with Moscow or Peking, peace in the Middle East, or SALT? Apparently. His memo described global ramifications from a successful Allende government. It would be bad enough, he warned, that about $1.5 billion in U.S. investments might be lost and that Chile might lead an anti-U.S. coalition in the hemisphere and create a power base for expanded Soviet influence in the Americas. As troubling, "the example of a successful elected Marxist government in Chile would surely have an impact on—and precedent value for—other parts of the world, especially in Italy; the imitative spread of similar phenomena elsewhere would in turn significantly affect the world balance and our own position in it."

For such staunch advocates of foreign policy realism as Nixon and Kissinger, it is difficult to understand their apocalyptic fears about an Allende government. Like the domino theory that helped draw the United States into Vietnam, the idea that a democratically elected socialist administration in Chile would encourage the rise of radical regimes across Latin America and influence developments as far away as Italy rested on a fundamentally flawed assumption or might fairly be described as nothing more than paranoia.

The domestic lives of nations are shaped by internal crosscurrents, not examples in distant lands. Were the latter true, the United States, which had long-standing inclinations to believe in its exemplary powers, would have won far more converts to American-style democracy in the Western Hemisphere than existed in 1970. To be sure, powerful nations had a history of imposing their political institutions on weaker neighbors by intimidation or force of arms, such as in Eastern Europe, but the fear that countries like Argentina, Brazil, and Italy would take their political direction from Allende's Chile was a mistaken calculation.

But as Kissinger noted, "Not everything that is plausible is true, for those who put forward plans for action have a psychological disposition to marshal the facts that support their position."

Once Nixon and Kissinger concluded that Allende posed a danger to the United States, it became a matter of finding the right formula for defeating him. What are our alternatives? Kissinger asked in his November 5 memo. The state department favored a modus vivendi approach: Since we lacked the "capability" to prevent Allende from consolidating power or "forcing his failure," we should learn to live with him. Efforts to overthrow him would produce worse results for the United States than a benign policy of acceptance. By contrast with state, defense and the CIA believed it vital to move quickly against Allende before he consolidated his power and became more difficult to bring down. They saw criticism of the United States for anti-Allende actions as "less dangerous . . . than the long-term consolidation of a Marxist government in Chile."

Kissinger favored a third way to deal with Chile's danger to the United States: covert opposition combined with strong overt responses to hostile moves on Allende's part. It was "essential," Kissinger advised Nixon, that he make crystal clear to all national security officials that he wanted the strongest possible opposition to Allende.

Henry was preaching to the converted. As Nixon stated at the NSC meeting on November 6, he was determined to prevent Allende from leading a shift to the left in Latin America. The United States needed to concentrate on Argentina and Brazil and maintain good relations with the military chiefs in these and other hemisphere countries. Unlike the intellectuals in the region, the military were "power centers subject to our influence." It was crucial that Allende not be allowed to "consolidate himself and the picture projected to the world will be his success. A publicly correct approach is right. Privately we must get the message to Allende and others that we oppose him." Nixon wanted our policy to be "cool and correct," but the aim was to "hurt him whether by government or private business." Nixon directed that the Senior Review Group, an arm of the NSC charged with implementing policy, was to meet at least monthly to monitor Chile policy. On November 9, Henry assured him that the group would hold meetings about Chile every three weeks.

In fact, in November, Kissinger began giving Nixon biweekly reports on Chile and anti-Allende actions. The first of these described "devel-

opments in Chile since Allende's inauguration." Kissinger reported that "key cabinet posts were divided about equally between Communists and the most extreme Socialists," with the Communists dominating economic ministries and the socialists controlling political positions. "Only the military escaped direct control and those appointed to Defense Ministry and command status are not expected to oppose Allende's policies." In addition, the government had "moved quickly to overwhelm and cow opposition press and media using economic pressures, and has been so successful that almost no dissenting voice is heard."

Although reports from Santiago also indicated that Allende was attempting "to create an image of responsibility and moderation" in his management of the economy and had been "cautious and conciliatory" in dealings with Washington, Nixon and Kissinger remained committed to ousting him.

After Allende announced recognition of Castro's Cuba, the administration tried unsuccessfully to persuade Latin American governments to condemn the action. The "Latin response has been lukewarm at best and there appears to be no prospect for any serious action against Chile by the OAS," Kissinger told Nixon.

Economic and financial pressures on Allende seemed more promising—a denial of "new commitments of bilateral assistance," particularly loans and export guarantees, and warnings to U.S. businessmen and labor leaders about Chile's potential instability promised to undermine Chile's economy. The most productive influence, however, seemed to be through the Chilean military, with whom, Kissinger said, we are maintaining "business as usual." On November 30, Laird advised Nixon that he was following through on his decision to increase efforts "to establish and maintain close relations with friendly military leaders in the hemisphere."

On November 25, Kissinger sent Nixon a five-point memorandum describing covert measures: "political action to divide and weaken the Allende coalition"; expanded U.S. embassy contacts with the Chilean military; financial "support to non-Marxist opposition political groups and parties"; support of anti-Allende periodicals and other media; and foreign press stories "to play up Allende's subversion of the democratic process and involvement by Cuba and the Soviet Union in Chile." At the same time, the White House would tell Moscow "that no Soviet presence in

Chile or any other Latin American country (with the exception of existing presence in Cuba) will be tolerated." These operations were to be ongoing and would be reviewed periodically to ensure their effectiveness.

Whenever political difficulties at home and abroad frustrated him, Nixon found comfort in foreign travel, where he could enjoy the ceremonial regard shown a visiting American president and make statesmanlike pronouncements that gave him a claim on history. A trip to Europe from September 27 to October 5, 1970, with stops in Italy, Yugoslavia, Spain, Ireland, and England, as well as a visit to the Sixth Fleet, was justified as a good way to demonstrate U.S. interest in southern Europe, the Mediterranean, and the Middle East.

The places visited, however, were of less importance than the chance to underscore Nixon's focus on international affairs and mastery of national security challenges as Americans prepared to vote in the November congressional elections. The trip, Haldeman told Rogers, was "for political campaign purposes . . . Senate candidates need spotlight on foreign issues." As Nixon flew to Europe on September 27, he "quickly reviewed the schedule, for the first time. It's amazing," Haldeman recorded. "He left the whole thing up to us after the countries and basic format were agreed upon."

The trip met Nixon's expectations. Government officials and crowds lining motorcade routes were friendly and even enthusiastic. "The United States has a great number of friends," Nixon was able to tell reporters at week's end. He also took satisfaction from "universal support" for America's Mideast peace initiative and the understanding that the United States "did not have any expansionist, ulterior motives in playing a role in the Mediterranean." He was able to highlight his concern with Middle East peace when Nasser suddenly died of a heart attack on September 28 at the age of fifty-two. The "tragic loss" was a reminder that all nations needed to "renew their efforts to calm passions . . . and build lasting peace." He was also pleased to find that since his last visit to Europe in February 1969, the continent's leaders had come to understand that the United States was determined to end the war in Vietnam and that it was making progress toward a just peace.

Conveniently ignoring the covert anti-Allende actions he and Kissinger had aggressively set in motion before the trip, Nixon celebrated America's support of self-determination: "There is no foreign leader,

when he speaks candidly, who really fears that the United States, with its power, has designs on dominating that country or interfering in their affairs. This cannot be said of some other powers," he self-righteously declared.

Only a month away from a national election, Nixon rationalized his rhetorical excesses as familiar politics. Nothing about domestic affairs ever energized him quite so much as a national campaign. On September 9, a little less than two months before the vote, Nixon called together his principal political operators. "P really in his element as he held forth . . . on speech content, campaign strategy, etc.," Haldeman recorded.

His strategy for the campaign was to speak in twenty-three states during the three weeks before November 3. He intended to emphasize the Democratic party's identification with unpopular social issues. Nixon told Haldeman and Erlichman to focus public attention on "anti-crime, anti-demonstration, anti-drug, anti-obscenity" issues and "get with the mood of the country, which is fed up with the liberals." Stephen Ambrose wrote that, "At no time in the campaign did Nixon make a point of his accomplishments. Except for his claim that peace was coming sometime soon, and with honor, Nixon did not advertise what he had done as President. Instead, he ran against pot, permissiveness, protest, pornography, and dwindling patriotism." His objective, Haldeman noted, was "to play the conservative trend and hang the opponents as left wing radical Liberals," forcing "them on the defensive . . . as they did us about Birchers in '62."

Their strategy failed. With so little to point to as concrete gains in foreign affairs, with the economy stumbling along suffering 6 percent inflation and nearly 6 percent unemployment, Nixon felt compelled to appeal to public resentments toward potheads, student radicals, or unpatriotic and self-indulged youngsters disrespectful toward him and the country's traditional institutions. Although student opponents gave credence to Nixon's rhetoric with unruly demonstrations, especially at San Jose, California, where they hurled eggs and rocks at his limo and shouted epithets, the politics of antagonism didn't work in 1970, as it had two years before.

Contemporary polls showed voters favoring the Democrats over the Republicans and Nixon. By a 40 percent to 25 percent split, voters saw the Democrats as more likely to keep the country prosperous during the

next few years. Fifty-one percent of Americans expected more people to be out of work during the next six months. As for sentiment on the war, which voters saw as the nation's most important problem, between 55 percent and 61 percent of the country favored removing all American troops from Vietnam by the end of 1971. Although Nixon announced another troop withdrawal in October, it did not convince Americans that he would end the fighting in the coming year.

The results of the election were another discouraging moment in Nixon's uneven political career. The Democrats won 4.5 million more votes than the Republicans and increased their House margin by nine seats to a total of 252 to 183. In the Senate, where the Republicans gained two seats, the Democrats still had a solid 56 to 44 edge. One of Nixon's speechwriters believed that the president's failure to "speak to the hopes, to the goodness, to the elemental decency, of the American people" was what cost the Republicans the election. No doubt Nixon's largely negative campaign helped defeat his party's goal of becoming the congressional majority. But the wild card remained Vietnam. Unless Nixon could convince voters that he was ending U.S. involvement in the war, as he repeatedly promised, his reelection in 1972 would remain in substantial doubt. He refused to let that happen.

Chapter 9

WINTER OF DISCONTENT

Mr. President, it was about this month, in this year of his tenure, that President Kennedy said: "This is the winter of my discontent." And President Johnson . . . felt the same way about the same time in his tenure. How are you feeling these days?

—ABC's HOWARD K. SMITH, INTERVIEW
WITH PRESIDENT RICHARD NIXON, MARCH 22, 1971

My God! What is there in this place that a man should ever want to get into it?

—PRESIDENT JAMES A. GARFIELD, 1881

In the winter of 1970–1971, Nixon believed that his two years as president had been a bust. "The first months of 1971," he said, "was the lowest point of my first term as President. The problems we confronted were so overwhelming and so apparently impervious to anything we could do to change them that it seemed possible that I might not even be nominated for re-election in 1972."

There was little likelihood that the Republicans would deny Nixon a

chance at a second term (even as abject a failure as Herbert Hoover won renomination in 1932). When a journalist wrote that "the prediction of RN not running again is pure nonsense," Nixon instructed that the columnist be given a thank-you call. Nevertheless, it was clear that foreign and domestic problems had eroded his public standing. Pat Buchanan, a conservative speechwriter, told Nixon in January 1971 that his administration was "neither liberal nor conservative" but "a hybrid, whose zigging and zagging has succeeded in winning the enthusiasm and loyalty of neither the left nor the right, but the suspicion and distrust of both."

Public opinion polls bore out Buchanan's judgment. Nixon's approval ratings, which had stood in the sixties and high fifties throughout 1970, had fallen to the low fifties by December and continued their downward slide to 48 percent by June 1971. Straw votes pitting Nixon against Senator Edmund Muskie of Maine, the likely Democratic nominee in 1972, put them in a dead heat. When eighteen-to-twenty-one-year-old students, who would be first-time voters in 1972, were asked to identify the most admired men in recent history, only 9 percent chose Nixon. During a TV interview at the start of 1971, Nancy Dickerson of the Public Broadcasting Service asked the president what had happened to the "lift of a driving dream" he had promised the country in 1968. Nixon defensively replied that "before we can really get the lift of a driving dream, we have to get rid of some of the nightmares we inherited."

Nixon's diminished popularity had occurred in spite of intense efforts in the fall of 1970 to improve his public standing. The president instructed Kissinger to "develop a plan for the more effective presentation of our accomplishments in Foreign Affairs." He especially wanted Henry to promote an image of the president as a great peacemaker. "The President should become known next year as 'Mr. Peace,'" Haldeman told Kissinger. "Here we go again," Haig wrote Henry. "I suppose our best bet is to play along, but I must say some of the rhetoric is a little sickening."

In November and December, Nixon bombarded Haldeman with memos on how to polish his image. Yet all the attempts at improving public impressions of the dour Nixon netted little gain. Nixon blamed his problem on "a basically antagonistic television and press corps." *Time's* Hugh Sidey, however, believed that "the doubt in the country over RN's stewardship is deeper than statistics . . . it comes down to the mystifying business of the man himself."

Nixon also thought that White House aides were tarnishing his reputation. By February 1971, he was so distrustful of almost everyone around him that he began recording all his conversations. He had originally asked Kissinger and others to make memos of discussions so that no one in the administration would be able to offer distorted accounts of what he had said and directed. It was a way of not only holding people to their word but also of ensuring historical accuracy when he wrote his memoirs.

When Henry fell hopelessly behind in providing the memos, Haldeman suggested that Nixon imitate LBJ's habit of secretly taping telephone and office conversations. Nixon agreed. Over the next twenty-eight months, he recorded more than 3,700 hours of conversations on the telephone and in seven locations, including the Oval Office, the Executive Office Building, where he principally worked, the cabinet room, and at Camp David. To avoid involvement in the mechanics of taping, he principally relied on a voice-activated technology, which triggered recording machines placed in the White House basement. Only in the cabinet room did he use manual switches to capture discussions. "The conversations," the historian Erin Mahan, who spent countless hours listening to them, writes, "are extended, multi-topical, raw, often repetitious, and sometimes incoherent." Deciphering them, she might have added, was a Herculean task. But well worth it: The tapes provide an extraordinary chance to hear Nixon's honest thoughts about the personalities and issues central to his presidency, demonstrating in 1971–1972 his obsession with being reelected at the same time he established a foreign policy record advancing international peace that would be the envy of all future presidents.

Nixon believed that the tapes would allow him to make instant refutations of any distortions surfacing in the press from leaks. "The whole purpose, basically," Nixon said to Haldeman and Alex Butterfield, a retired air force colonel who served as a Nixon aide and who helped install the system, "there may be a day when . . . we want to put out something that's positive, maybe we need something just to be sure that we can correct the record." Nixon was also eager to have verbatim accounts that would later be useful in countering assertions that others, especially Kissinger, were the driving force in initiating successful policies. Only two years into his presidency, Nixon was thinking about the claims and

counterclaims likely to surface in future memoirs. Although he saw the tapes as a useful historical tool, he had no intention of sharing them with anyone else. When Haldeman asked whether he wanted transcripts made, Nixon replied, "Absolutely not . . . No one is ever going to hear those tapes but you and me."

Nixon also thought that clashes between Rogers and Kissinger undermined public confidence in his leadership. The competition between the two for control of foreign policy had produced press leaks, which suggested that the administration was in disarray.

Rogers's repeated efforts to promote more accommodating policies on Vietnam, Cambodia, the Soviet Union, the Middle East, and Chile angered Nixon. The issue became particularly acute at the end of 1970 when Nixon complained to Haldeman that the state department was leaking like a sieve and that this represented an effort to undermine him. Nixon asked Haig to compile a list of "press leaks attributable to State which undercut White House policy." He told Kissinger and others that the bureaucracies at state and defense were "deliberately trying to sabotage not only our policy but particularly the Presidency itself."

Kissinger weighed in against Rogers and the state department at a January 1971 meeting with Haldeman, Ehrlichman, Mitchell, and Budget Director George Shultz. Haldeman recorded that Henry "walked into the meeting with huge thick folders . . . documenting his case on the terrible things State has been doing in the public press, and how they've been undercutting him [Kissinger] . . . and . . . disobeyed Presidential orders."

Nixon privately vented his irritation with Rogers. "We all know that on this foreign policy thing—I take Rogers's advice on the PR aspects, but I do not have confidence in [his] judgment on the tough ones," Nixon told Kissinger. But he couldn't bring himself to fire Rogers, partly because of the political consequences. Getting rid of his secretary of state before the 1972 election would reflect poorly on Nixon's judgment in having chosen him in the first place.

But Nixon wouldn't say this to Henry. He defended Rogers by telling Kissinger, "He's valuable." And however difficult it was for Kissinger to accept this, Nixon meant it. Rogers reflected Nixon's wish to be remembered as a peacemaker. Ending the Vietnam War and establishing a more stable world order were central to Nixon's vision, as they were to

Rogers's view of what he hoped to achieve as secretary of state. Nixon never tired of saying that American power "is wholly committed to the service of peace." Nixon also knew that encouraging the peacemaker image was good politics. When an editor asked him at the annual Society of Newspaper Editors dinner what he thought about if he woke up at two or three o'clock in the morning, Nixon replied, "Working for peace." What he really wanted to say, he told Haldeman, was "going to the bathroom."

Yet international realities and Nixon's image of himself as a warrior president trumped his pacifism. General George S. Patton was his ideal, however simplistic Patton's militaristic views had become in the nuclear era. Kissinger and Haig, tough-minded realists, as they saw themselves, appealed to Nixon's conviction that a firm response to adversaries was the best route to a stable world. And in that context, Haig understandably found the rhetoric about peacemaking "a little sickening." Henry thought that such talk was "dangerous . . . We will have the Soviets coming into Europe," he told Safire. "Why do you think we have the Soviets hardlining? Because they think we are weak kneed," Safire responded. "Exactly," Henry said. But the "peacemaker" image represented Nixon's other side, which best expressed itself in having Rogers as secretary of state.

The conflict between Rogers and Kissinger, then, was a natural outgrowth of Nixon's contradictory impulses. And so, in mid-December 1970, when the *Christian Science Monitor* published a lengthy article about the Rogers-Kissinger rivalry, it reflected the outlook of a president who was simultaneously drawn in two directions.

Nixon didn't anticipate that the tensions between the two sides of his foreign policy outlook would become a source of public controversy. While he had no expectation that either Rogers or Kissinger would be docile lieutenants following his every order, he did not foresee the intensity of their bureaucratic war.

Nor did Nixon anticipate the extent to which his national security adviser, whom he barely knew in 1969, would be a prima donna with insatiable demands for attention and approval and exclusive influence over foreign policy. Nixon had a running dialogue with Haldeman about "the Kissinger problem." Henry craved "the ego satisfaction of . . . having people reassure him that he's in good shape," Nixon told Haldeman. Haldeman, who had become a sounding board for Henry's constant

complaints about Rogers and the president's inattention to him, would tell Henry when he would "frequently" threaten to resign that "he is indispensable to the P, and that both he and the P know it, and he's got to stay here."

Nixon's recorded conversations with Haldeman and Ehrlichman are a window into "the Henry problem." Kissinger is "hard to deal with, as you well know, Bob," Nixon said. "He's a goddamn hard man to deal with . . . Henry is just very bad at not letting Haig . . . or [Joint Chiefs chairman Admiral Thomas] Moorer or Laird or anybody else come in and report on anything. He wants to report on everything." In a conversation later that same day with Haldeman, Nixon mimicked Henry's German accent, and said, "He comes in with predictions," and offers ponderous comments on "this one or that or the other one." And there was no arguing with him: He took every challenge to his assertiveness as a personal assault, as if it were an attack on "his integrity or his intelligence or something."

Nixon complained that "Henry's personality problem is just too goddamn difficult for us to deal with. Goddamn it, Bob, he's psychopathic about trying to screw Rogers—that's what it really gets down to." Haldeman believed that the conflict was "insurmountable," but "Henry is clearly . . . more valuable than Rogers." Nixon agreed, but they feared that if Henry "wins the battle with Rogers," he might not be "livable with afterward." Nixon thought he would "be a dictator." If only Henry would cease what Nixon described as his "psychotic hatred" of Rogers.

Henry's competition with Rogers over what went into the annual foreign policy report, for example, incensed Nixon. He saw Henry making "a crisis out of a damn molehill . . . Day after day after day after day." Henry had NSC discussions about "every goddamn little shit-ass thing that happens . . . He has too many meetings. They go on and on and on and on about crap," Nixon moaned. He also complained that Henry liked to "agonize about problems." Henry's habitual lateness also bothered Nixon and Haldeman. "Frankly," Nixon said, "it's Jewish. Jewish and also juvenile . . . It really is as Jewish as hell, isn't it?"

The next day Haldeman noted in his diary that "the K-Rogers problem continues." Nixon wanted him to come up with a plan to deal with it. "Of course, I don't have any," Haldeman conceded. Kissinger and Rogers "just stay on a collision course."

Two weeks later, Nixon had another long conversation with Halde-man and Erhlichman about his continuing difficulties with Kissinger. Henry "was in talking about his problems," Nixon said. Apparently, *Newsweek* ran an article that "talks about his being Jewish," Haldeman interjected. Nixon continued, "Well, he's terribly upset. He feels now that he really ought to resign." But Nixon said that he refused to talk about it. "We've got several big things in the air," he told Henry. Nixon was determined to keep Kissinger on: "He's somewhat more honest than Rogers, in that Henry knows . . . his ego problem. He says, 'I've got an ego.' Rogers is a different fellow [with] a vanity problem," Nixon told Haldeman.

What had set Henry off was his exclusion from Mideast policy dis-cussions. Didn't he understand that if he was involved and something went wrong, Haldeman said, "They're going to say it's because a 'god-damned Jew' did it rather than blame the Americans." Nixon agreed. Henry, Nixon said, had "an utter obsession with having to run every-thing." Nixon tried to reassure him by saying, "Henry, look, now listen to me for Christ's sake. Don't you realize that when I make a decision on Laos or for that matter on the Mideast, or SALT, I will talk to you about it? And what the hell do you care how it gets to me? I'm going to make the decision myself, and I'm not going to be influenced one goddamn bit by Rogers."

Nixon was exasperated by both men. "I'm not going to have a couple of crybabies acting like this," he complained. He had all sorts of other miserable things to deal with, including a vice president, who, "I got to go over and butter his ass up this afternoon—tonight when I should be sleeping." Nixon described the Henry-Rogers conflict as "a shit-ass" busi-ness that had to be stopped, but he conceded that it might be impossible. "Did you know that Henry worries every time I talk on the telephone with anybody?" he told Ehrlichman and Haldeman. "His feeling is that he must be present every time I see anybody important."

Nixon couldn't understand Henry's discontent. He "gets first prior-ity on time . . . always coming in—he knows that. Evening or morning." But even that didn't seem to be enough. "I think he deeply feels that he's the only one that knows anything about foreign policy," Nixon said. Erlichman thought that something else was involved: Working in the government as national security adviser, "this is his being," Erlichman

said. "This whole process is what he really was created for, and he's got to be in a certain relationship to the President."

No doubt, Nixon and Erlichman had identified elements of what drove Henry's behavior. But he simply needed to be top dog. Despite all his success, he remained fiercely competitive. Being treated as less than the best, the most important, the wisest, indeed, the only counselor worth hearing, frustrated and angered him. Arnold Weiss, his childhood friend in Germany who had also fled to America and served in the Army with Kissinger, recalls being introduced to Henry's second wife. " 'Arnie and I were in the Army together,' " Kissinger said. " 'Yes,' " Weiss, who was a lieutenant, teased. " 'I outranked Henry.' 'Yeah, but not anymore,' " Kissinger shot back.

Although newspaper articles appeared about the Rogers-Kissinger battles, most of their struggles were a well-kept secret. Besides, Nixon believed that the ultimate success of his administration rested less on settling internal discord than on ending the Vietnam War and resolving or easing tensions with Soviet Russia and China, between Israel and the Arabs, and, in 1971, Pakistan and India.

VIETNAM STILL CAME FIRST. After the Cambodian incursion, the country was more eager than ever to end its involvement in so costly and demoralizing a struggle. The U.S. military, paying more attention to realities on the ground than to White House rhetoric, acknowledged that "progress in many areas of the war remained elusive." Army commanders told the Joint Chiefs that "time was running out . . . Although there was some hope that the destruction of base areas in Cambodia and Laos might forestall a collapse, the net effect would probably be an eventual Communist victory . . . The war had become a bottomless pit."

Throughout the second half of 1970, Nixon and Kissinger struggled to keep up morale among the American military and the South Vietnamese until they could find a formula for ending the war. In June, Nixon sent a confidential message to national security officials through Henry of how crucial it was to "think in positive terms, particularly on the military and supply fronts, where we have been thinking too defensively." In September, after "NBC had a sharply negative film report" about South Vietnamese troops stripping an evacuated U.S. base and selling everything on the black market, Kissinger was pressed to

counter the report. "The scrawled sign over the base . . . Goodbye and Good Luck" seemed to signal a final chapter in a South Vietnamese-American defeat.

Worse, by 1970–1971, the U.S. military in Vietnam was badly demoralized. All ranks suffered from the belief that they were fighting a lost cause. Thousands of troops had become heroin addicts. It embarrassed the U.S. government, and Nixon wanted the White House PR machine to combat the bad publicity with positive accounts about the U.S. military in the war. "Get our story out fast by the inspired leak route (talk to Safire)," Nixon directed Haldeman.

Although Nixon commissioned a study of drug addiction in the military, no one had a remedy short of ending U.S. involvement in Vietnam. In the spring, when Nixon spoke to West Point cadets, he candidly declared it "no secret that the discipline, integrity, patriotism, self-sacrifice, which are the very lifeblood of an effective armed force . . . can no longer be taken for granted in the Army in which you serve. The symptoms of trouble are plain enough, from drug abuse to insubordination." The task of these future officers was to give "the military ethic . . . new life and meaning for the difficult times ahead."

Nixon understood that ending the war was essential to save his presidency, preserve domestic tranquility, and rebuild the U.S. military. But after twenty months of trying, there was still no end in sight. It had become clear to many observers that Hanoi simply intended to wait until the exhausted Americans left. Yet Nixon and Kissinger clung to the conviction that they could use military pressure to force the North Vietnamese into an agreement that would deliver an autonomous South Vietnam—peace with honor.

By September 1970, Nixon had a greater sense of urgency than ever about finding a peace formula. After a conversation with two conservative senators, Democrat Harry F. Byrd, Jr., and Republican Gordon Allott, who warned of the need to end the war quickly, the president told Kissinger, "We've got the left where we want it now. All they've got left to argue for is a bug-out, and that's their problem. But when the Right starts wanting to get out . . . that's *our* problem." Because Nixon believed that the Cambodian incursion had "gravely undermined" Hanoi's capacity for immediate offensive operations, he had some hope that the North Vietnamese might now be ready for decisive talks. Consequently, in Au-

gust, when Hanoi agreed to another Kissinger meeting, Henry secretly traveled again to Paris to see Xuan Thuy on September 7.

Kissinger was prepared to hear familiar demands for a unilateral U.S. withdrawal and a coalition government without Thieu or Ky. The absence of Le Duc Tho from the meeting made Henry all the more skeptical of good results. But instead of "vituperation," the North Vietnamese surprised him by their friendliness. They "stated their desire for a rapid settlement." Nevertheless, Kissinger warned Nixon against excessive optimism. It was "difficult to judge whether they are just trying to keep us talking or have real intent of moving on to substantive negotiations."

Kissinger's skepticism was well advised. A Communist peace proposal for discussion at a September 27 meeting contained "no real breakthrough on any issue." Hanoi continued to demand unconditional U.S. evacuation of its forces and an abandonment of Thieu's government. The four-and-a-half hour discussion "was thoroughly unproductive and we adjourned without setting a new date," Henry told the president. But he advised against breaking off the channel. He held out hope that this might be the next to last round. Henry couldn't explain why the North Vietnamese had been so friendly at their last meeting, but he concluded that "they are in an undecided state . . . They project a Micawber-like mood of waiting and hoping something good will turn up." It sounded like a better description of Kissinger's outlook than theirs.

To advance the talks, Nixon agreed to make his October 7 offer for a cease-fire in place. The proposal was principally aimed at domestic opinion in the midst of a congressional election: Kissinger doubted that the North Vietnamese would accept it, he told Joe Alsop. "However, it might shut up some in this country." At the same time, Nixon and Kissinger thought the proposal would test Hanoi's willingness "to settle for anything less than total victory. Their demands are absurd," Henry told Safire. "They want us to withdraw and on the way out to overthrow the Saigon Government . . . If we ever withdraw," he grumbled, "it will be up to them to overthrow the Saigon Government—not us."

In making his proposal, Nixon declared that "we are ready now to negotiate an agreed timetable for complete withdrawals as part of an overall settlement." He and Kissinger understood that it could be interpreted as a unilateral pullout. But Kissinger cautioned Bruce and Habib in Paris that "we will not go for . . . a unilateral withdrawal."

With the peace talks deadlocked, Nixon hoped to pressure Hanoi by announcing a speedier pullout of U.S. troops. "The continued progress of the Vietnamization program has made possible an accelerated rate of withdrawal," he announced on October 12. By Christmas, total U.S. forces in Vietnam would stand at 240,000—305,500 fewer "than when I took office." The announcement was aimed not only at American voters but also at the North Vietnamese, who were being told that the South Vietnamese were growing better able to defend themselves. Unless Hanoi agreed to a peace settlement in the near term, it would face protracted fighting against well-equipped U.S. surrogates.

A conversation Nixon and Kissinger had at the White House on October 21 with Laotian Prime Minister Souvanna Phouma, as well as current reports from U.S. intelligence agencies about Hanoi's fighting capacity, encouraged administration hopes of an early U.S. departure from Vietnam. Phouma and NSC analysts concluded that the Cambodian operation and Lon Nol's government had impaired North Vietnam's ability to supply its forces in South Vietnam and was compelled to rebuild its logistics network.

In December 1970, Nixon met with John Paul Vann, a former military officer and a current pacification coordinator in South Vietnam. Kissinger described him to Nixon as "one of the most experienced American officials in Vietnam." Vann, he reported, "is very encouraged by the progress the allied side is making. Like Sir Robert Thompson [the British anti-insurgency expert], he believes we have achieved a 'winning position.' "

Reports from the field added to Nixon's hopes. In December, the U.S. mission in Phnom Penh described a Cambodian military that was holding "the enemy reasonably at bay and . . . improving steadily." Despite cautioning "against any unwarranted optimism," the mission was "encouraged about Cambodia's ability to weather through."

It played perfectly to Nixon's bias. "K—a brilliant analysis," he scribbled on the report. Nixon also told Henry, "If we had not gone into Cambodia, it would not be there. It would be a puppet government. It would be down the tube." Nixon believed that they could win the war if they just had sufficient willpower to focus on the big picture. "Right now there's a chance to win this goddamn war," he told Henry on December 9. "But we aren't going to win it with the people—the kind of assholes

come in here like today saying well now there is a crisis in Cambodia." He complained that they were too preoccupied with "crap" about Chile and Biafra and Guinea. They needed "to concentrate on what can make or break us."

Columnist Joe Alsop further encouraged hopes of victory. The U.S. Senate can "snatch defeat from victory," he told Kissinger. South Vietnam could also be its own worst enemy. "The danger is no longer in Hanoi."

A visit to Cambodia and South Vietnam by Haig later in the month strengthened Nixon's belief that he was making gains in Southeast Asia. Kissinger reported to the president that Haig was "greatly encouraged by the progress since his last visit and especially impressed by the continuing benefits of the Cambodian operation." As for South Vietnam, Haig saw "indications everywhere that the military and overall security situation was improving." Haig told Kissinger that "we are within an eyelash of victory."

Despite all the "good news," Hanoi showed no inclination to concede anything, which should have been an indication of the realities in Vietnam. At the end of October, when Bruce requested a private meeting with Xuan Thuy, the latter said "his schedule is now completely filled." A meeting between them on November 16 underscored their insurmountable differences.

On December 10, Nixon held his first news conference in four months. He emphasized his determination to continue the Paris talks, despite having to deal with "an international outlaw that does not adhere to the rules of international conduct." In a private conversation with Ambassador William Sullivan, who was a member of the U.S. delegation in Paris, Kissinger was more graphic about the North Vietnamese: He called them "barbaric" for refusing to release the names of American POWs. It was "unconscionable" of them to be "playing blackmail with human lives." For diplomacy's sake, Henry agreed to have Sullivan describe their behavior as "inhuman" rather than "barbaric."

Kissinger also had a low opinion of the South Vietnamese. When Ron Ziegler asked him about the president's meeting with Ky, Henry sarcastically replied, Ky promised not to brief the press and "you know that the Vietnamese never lie." "Bull shit," Ziegler exclaimed.

When someone told Henry that Nixon could not be reelected be-

cause of Vietnam, Kissinger disputed it, and added that "anytime we want to get out of Vietnam, we can, and that we will get out of Vietnam before the [1972] election." Nixon wanted to plan the removal of all U.S. troops by the end of 1971, but Henry cautioned that if North Vietnam then destabilized Saigon in 1972, it could have an adverse effect on the president's reelection. He recommended a pullout in the fall of 1972, "so that if any bad results follow they will be too late to affect the election." He had nothing to say about the American lives that would be lost in the service of Nixon's reelection. After two years serving Nixon, Kissinger was as cynical about politics as his chief.

Kissinger's greater concern with Nixon's reelection than South Vietnam's independence was evident in a conversation with Dobrynin in January 1971. Kissinger asked him to tell Hanoi that the U.S. was ready to consider a unilateral withdrawal of forces. In return, "the North Vietnamese should undertake to respect a cease-fire during the U.S. withdrawal plus a certain period of time, not too long, after the U.S. withdrawal; that is the important point," he said. "If the Vietnamese can agree among themselves on a reasonable compromise and if thereafter, war breaks out again between North and South Vietnam, that conflict will no longer be an American affair; it will be an affair of the Vietnamese themselves, because the Americans will have left Vietnam . . . Such a process will spare the Americans the necessity to carry out a protracted and practically unfruitful negotiation about a political solution for SVN when the U.S. forces have withdrawn." In short, the U.S. was asking a decent interval between its withdrawal and the collapse of South Vietnam, if Hanoi could engineer it.

WITH THE PEACE TALKS stalled and the dry season coming on, Nixon anticipated another North Vietnamese offensive in early 1971 comparable to the Tet campaign in 1968. The president wanted something "dramatic in North Vietnam," NSC aide Winston Lord told Kissinger, "that maybe will make the other side negotiate." As a result, in mid-December, Haig carried a proposal from Nixon to Thieu for an offensive that could blunt a stepped-up Communist campaign in the coming months. Thieu and U.S. military and diplomatic chiefs in Saigon had been discussing a more elaborate plan—a bold thrust into Laos at the northern end of the trail, just below the DMZ, against the key town of Tchepone.

Nixon was enthusiastic and sent Laird and Joint Chiefs Chairman Admiral Moorer via Paris, where they were to discuss the state of the peace talks, and then on to Saigon to discuss an offensive. On January 18, after the trip, Laird reported that the Paris delegates had "no specific hope" of progress. But they all thought the negotiations remained a useful "posturing" vehicle. In Saigon, Thieu told Laird that talk of ending the war in 1972 was premature. He predicted that "the war would go on for many years and that we should be talking about U.S. participation."

As for a South Vietnamese attack on the Ho Chi Minh trail in Laos, all hands were optimistic that it would bring good results. "On balance," Laird reported, "South Vietnamese competence was especially high." Admiral Moorer believed that "the South Vietnamese forces were getting better all the time." Nixon and Rogers agreed on the need to exclude U.S. ground forces and advisers from the operation, but endorsed the use of bombing, airlifts, and artillery support. Nixon predicted that despite our limited role, "we would get some real heat" for "expanding the war into Laos." Nevertheless, he believed that such an operation might "prove decisive in the overall conduct of the war."

Despite the numerous failures that had plagued past U.S. military planning, only Helms raised serious questions. He predicted that "the ARVN would run into a very tough fight in Laos" that would defeat the mission. Moorer agreed, but said "that it would probably be the enemy's last gasp." Kissinger forecast that "it would take the enemy a long time to recover." Rogers warned that "an ARVN defeat would be very costly to us."

Nixon refused to entertain any concept of loss. "The operation cannot come out as a defeat," he said. He wanted to hedge his bets by setting "very limited goals such as interdicting the trail." He wanted it "packaged as a raid on the sanctuaries." Still, he had every hope that the South Vietnamese could carry it off. But "if they were not able to do it, then we must know that also."

U. Alexis Johnson at state warned about the risks to the United States from a failed assault. Johnson told a meeting of the WSAG that he was "very skeptical" of Saigon's ability to succeed. He feared an offensive would cause the collapse of the Laotian government and possible Communist control of northern and central Laos. The operation also risked an outburst of opposition to the administration in the Congress and at the UN.

Speaking for Nixon, Kissinger refused to be deterred. The operation "would block the North Vietnamese from launching a major offensive until the end of the dry season of 1972 . . . That means that we would gain an extra dry season to continue our Vietnamization program and protect our withdrawals." The assault "would in effect end the war, because it would totally demolish the enemy's capability." Nixon matched Henry's optimism. "The enemy's situation had deteriorated badly," and they "had been taking a beating as the ARVN grew stronger. This spring's campaign could have a major impact," he told Kissinger, Moorer, and Haig on January 26. Their optimism was as unwise as it was boundless.

Rogers also refused to fall in line. At a meeting with the president on the following day, he seized on a Nixon statement, supported by Laird, that Vietnamization would probably succeed "with or without the operation." Then why do it? Rogers asked. The risks were considerable. The enemy already knew that an attack was coming. If the South Vietnamese were "set back in the operation . . . it would serve as a defeat for both Vietnamization and for Thieu."

Nixon and Kissinger still thought the risks worth taking. "It was a splendid project on paper," Kissinger said later. "We allowed ourselves to be carried away by the daring conception, by the unanimity of the responsible planners in both Saigon and Washington, by the memory of the success in Cambodia, and by the prospect of a decisive turn."

The "chief drawback" of the plan, Kissinger candidly wrote later, "was that it in no way accorded with Vietnamese realities. South Vietnamese divisions had never conducted major offensive operations against a determined enemy outside Vietnam and only rarely inside." After ten years of training by American military advisers and billions of dollars in military equipment, Kissinger acknowledged that "the South Vietnamese divisions were simply not yet good enough for such a complex operation as the one in Laos." It seems astonishing that the White House failed to understand this at the time.

"Lam Son 719," the code name for the invasion of Laos, proved to be a disaster. The South Vietnamese forces were no match for the North Vietnamese, who inflicted substantial casualties on the ARVN. Armed with Russian-supplied shoulder missiles, the North Vietnamese also took a heavy toll of U.S. helicopters, which ferried ARVN troops in and out of battle. After a month's fighting, Thieu, disturbed by the heavy losses,

ordered a withdrawal from Tchepone, which had been evacuated by the North Vietnamese as a way to draw ARVN into a trap. The "retreat," William Bundy wrote later, "quickly turned into a rout. Forces returning by road were mercilessly strafed and shelled, and many had to be taken out on U.S. helicopters. The exhausted South Vietnamese panicked, forcing their way onto helicopters or clinging to their skids. As these landed at the American base at Khe Sanh, in South Vietnam, journalists and photographers could see and depict vivid pictures of demoralization and defeat."

Nixon later called the attack a "military success but a psychological defeat, both in South Vietnam, where morale was shaken by media reports of the retreat, and in America, where . . . news pictures undercut confidence in the success of Vietnamization and the prospect of ending the war."

At the time, Nixon put the best possible public face on the defeat. The attack deprived the Communists "of the capacity to launch an offensive against our forces in South Vietnam in 1971," he said. Privately, however, he was distressed at how poorly the South Vietnamese performed. "If the South Vietnamese could just win one cheap one . . . Take a stinking hill. . . . Bring back a prisoner or two. Anything," he said to national security advisers at the end of February. When the South Vietnamese Air Force failed to attack North Vietnamese trucks because they were "moving targets," Nixon exploded, "Bullshit. Just, just, just cream the fuckers!" He thought their excuse "ridiculous."

In March, Haig, who had gone back to Saigon to evaluate the offensive, reported that the South Vietnamese had lost all enthusiasm for the operation. "The extended period of intense combat has convinced the ARVN commanders that the operation should be called off as quickly as possible." After some of the ARVN troops panicked, Nixon said, "it took only a few televised films of ARVN soldiers clinging to the skids of our evacuation helicopters to reinforce the widespread misconception of the ARVN forces as incompetent and cowardly." Nixon said nothing about why the impression of ARVN as incompetent was so widespread. Nor did he complain about Haig's earlier prediction in December that we were "an eyelash" from victory.

Nixon refused to acknowledge Saigon's failure. Like some coach in a half-time pep talk to a losing team, he told Helms and Kissinger that

the United States had to win. "If we fail in Southeast Asia," he said in March, as a South Vietnamese defeat in Laos was becoming evident, "this country will have suffered a blow from which it will never recover and become a world power again . . . You can't fail after staying through six years . . . We've got to win. And by winning . . . I mean assuring a reasonable chance for South Vietnam to live in peace" without a Communist government imposed on it. He did not mention that he saw such a setback on his watch as an unacceptable blight on his presidency and his reelection prospects.

From the start of the operation, Nixon was determined to give it the appearance of success. He wanted any dissent from this view to be sharply attacked. "We should whack the opponents on patriotism, saving American lives, etc." he instructed Haldeman. "The main thing, Henry, on Laos," he told Kissinger in March, "I can't emphasize too strongly: I don't care what happens there, it's a win. See? And everybody should talk about that."

As the military situation deteriorated, Nixon began attacking the reporters covering the fighting. They "load their statements," he told national security officials. "The press and the editors are against the war, so they will report this way." He told Kissinger, "The news broadcasters are, of course, trying to kill us." He wanted everyone to be extra careful about what they said to newsmen. Journalists should leave a briefing saying, "That was a very poor briefing . . . That's what we want the cocksuckers to have," Nixon said.

Although he knew better, Kissinger confirmed Nixon's impulse to blame the press for the defeat. He told the president, its treatment of the Laos operation was "vicious . . . If Britain had a press like this in World War II, they would have quit in '42." When the ARVN became bogged down and doubts arose about whether they should focus on getting to Tchepone or simply cutting the supply roads through Laos, Nixon blamed the news media for creating the impression that Tchepone was a principal target of the offensive, which, of course, it had been. Nixon endorsed a plan to control the news coming out of Saigon. We must "not let the goddamn war be decided in the press," he told Henry.

A majority of Americans refused to see the Laos operation as a success. Only 19 percent in a Gallup poll thought it would shorten the war. Forty percent believed it would lengthen the conflict and 15 percent

concluded that it would make no difference. Sixty-five percent of the country did not think Nixon was "telling the public all they should know about the Vietnam War."

Gallup reported that Nixon now had the same credibility problem on Vietnam as Lyndon Johnson. Only 41 percent of Americans approved of Nixon's handling of the war, with 46 percent disapproving. Seventy-three percent of an opinion survey favored bringing all U.S. troops out of Vietnam by the end of the year. On March 30, Haldeman recorded that the polls were showing "us the lowest we've been." To combat the slump, Charles Colson, a White House aide, suggested to Nixon that they try to pay off pollster Lou Harris. "We can buy him," Colson said. After Haldeman followed Nixon's instruction to offer Harris a polling contract, Colson said, we will find out "how much of a whore Harris is." Although there is no evidence of wrongdoing on Harris's part, he began performing services for the Nixon White House.

Nixon and Kissinger devised a plan to raise the president's approval ratings. They would announce a South Vietnamese victory in Laos and describe their departure as a successful mission. Nixon told Henry, "We will say, well, they have accomplished their objective. They have destroyed the caches. They have done this and now, according to plan, they're withdrawing."

In conversations with opinion leaders like Governor Ronald Reagan, Billy Graham, entertainer Bob Hope, and several columnists, Kissinger said, "The President wanted me to give you a brief call to tell you that with all the hysteria on TV and in the news on Laos, we feel we have set up everything we set out to do: Destroyed more supplies than in Cambodia last year. Set them back many months . . . We achieved what we were after."

Nixon made the same arguments in an interview on March 22 with ABC-TV's Howard K. Smith. Everyone at the White House had "seen what I said last night," Nixon told Kissinger the next day, "—so they have the line. We must all follow the line." Henry promised to distribute "written guidance" to all the president's aides after checking them with Nixon and Haldeman.

On April 7, Nixon took to the airwaves again to repeat the same points to the American people. The offensive in Laos had succeeded. It demonstrated that Vietnamization was working and that Saigon had

a diminished need for U.S. forces. The way to "dramatically" end the debate "as to whether Laos was or was not a success," Nixon told Henry before making the speech, was to announce "a bigger troop withdrawal." He told the country, "I am announcing an increase in the rate of American withdrawals." By December 1, another 100,000 U.S. troops would leave Vietnam, reducing American forces to approximately 150,000 men, about one third of the number when Nixon took office. "Whether or not we survive," meaning win reelection, Nixon also told Kissinger, "is going to depend upon whether we hold public opinion. And we can do it with this."

The polls did not bear out his prediction. "President Nixon has said that if we leave South Vietnam in a position to defend herself, we will have peace in the next generation. Do you agree or disagree?" Gallup asked. Seventy-two percent disagreed. Sixty-one percent of Americans now thought we had made a mistake in sending troops to fight in Vietnam.

Nixon also used his speech to renew pressure on Hanoi to begin final peace negotiations. Encouraged by Kissinger, Nixon hoped that the North Vietnamese would agree to end the war. In March, Henry told him that he thought the North Vietnamese might be ready to "get this thing wound up." But if the negotiations collapsed this summer, Kissinger cynically advised Nixon to blunt the failure by charging "our critics with wanting a Communist victory in South Vietnam."

Hanoi did not share Nixon's and Kissinger's outlook. With the Laos offensive going their way and Nixon under so much pressure to pull out before November 1972, the North Vietnamese believed they had the upper hand. In April, UPI reported from Paris that the Communists were hinting "in private that they're confident Nixon will have . . . to make concessions first if [the] war is to be resolved." In the middle of the month, the U.S. delegates sent word to Nixon that a negotiating session yielded no results: "Hanoi's fundamental demands [were] unchanged." The North Vietnamese showed no interest in giving the Americans a decent interval after they withdrew before trying to topple Thieu's government. They continued to insist that Nixon abandon Thieu now. By the end of the month, Nixon had decided to let Henry return to Paris once or at most twice more before giving up on the negotiations.

With mastery of Vietnam still so elusive, Nixon wanted to focus

public attention on foreign policies that go "far beyond the urgent immediate problem of Vietnam." He told Haldeman, "Once we remove the Laotian issue . . . we'll be drawing some good cards in our strong suit on foreign policy." In particular, he wanted to put Sino-American and Soviet-American relations at the center of the administration's public diplomacy. He also hoped it might speed the war to a conclusion. "The Russians are pulling away from" Hanoi, Kissinger told Nixon in March, and "the Chinese can't supply all the goods." A principal benefit from better dealings with both Communist super powers could be pressure on Hanoi to end the fighting.

APPROACHES TO THE CHINESE and Soviets might not only influence dealings with Hanoi but, more important, improve Sino-American and Soviet-American relations and give Nixon something to boast about in his reelection campaign.

At the end of 1969, the White House had told the Chinese government that it was ready for renewed contacts and discussions in Warsaw. In November, Undersecretary of State Elliot Richardson had instructed the American embassy in Bucharest to pass along a letter from Theodore White, a journalist famous for his writings about World War II China, to Premier Chou En-lai, proposing a visit to the People's Republic of China (PRC). The Romanians were asked to emphasize that White had close contacts with Nixon and Kissinger and that his visit could promote greater understanding between the United States and China.

In January 1970, after the state department relaxed limits on Sino-American trade in nonstrategic goods, U.S. and Chinese representatives met secretly in Warsaw. The United States proposed direct discussions in either Washington or Peking, reiterated its opposition to Soviet aggression against China, and declared its neutrality on reintegrating Taiwan into China, as long as the dispute was peacefully resolved. At a subsequent meeting in February, the Chinese stated their interest in a visit to China by a high-level American representative, but made a Taiwan settlement a precondition.

Developments in the spring and summer of 1970 temporarily halted further discussions. An agreement to another Warsaw meeting on May 20 fell victim to the Cambodian incursion. America's "brazen" invasion had ruled out any immediate additional talks. But the Chinese did not

close off the likelihood of future contacts. "Only the timing, not the fact, of a meeting was deemed 'unsuitable,' " Kissinger recalled.

During the summer, the state department announced U.S. willingness to resume the Warsaw talks and the White House further relaxed bans on trade with China. Then, in a *Time* interview at the end of October, Nixon said he hoped to visit China before he died. At the same time, Kissinger asked President Ceauşescu of Romania, who was in the United States for the twenty-fifth anniversary of the UN, to tell Chinese leaders that "we do not believe that we have any long-term clashing interests."

After a sharp internal policy conflict, the Chinese had decided to pursue a rapprochement with the United States. In September 1970, however, public White House opposition to the PRC's admission to the UN further slowed the process. Nixon saw the UN decision as an interim step. In November, he told Kissinger, "It seems to me that the time is approaching . . . when we will not have the votes to block admission. The question we really need an answer to is how we can develop a position in which we can keep our commitments to Taiwan and yet will not be rolled by those who favor admission of Red China."

On December 8, the Chinese sent word through the Pakistani ambassador in Washington that Chou En-lai, Chairman Mao, and Vice Chairman Lin Biao were interested in peaceful negotiations about Taiwan and the Strait of Taiwan. They said that a special Nixon envoy would be most welcome in Peking.

Nixon and Kissinger immediately decided on a positive reply. They believed that the Chinese were interested in discussing mutual national security needs, but had confined their message to Taiwan lest they be seen as supplicants asking U.S. help against the U.S.S.R. Nixon suggested a preliminary meeting in some convenient location as a prelude to high-level talks in China. "The meeting in Peking would not be limited only to the Taiwan question," he explained, "but would encompass other steps designed to improve relations and reduce tensions between our two countries. With respect to the U.S. military presence in Taiwan, however, you should know that the policy of the United States Government is to reduce progressively its military presence in . . . East Asia and the Pacific as tensions in this region diminish." Kissinger said later, "The last sentence was designed to encourage Chinese interest in a settlement

of the war in Vietnam." It also signaled that Nixon was committed to withdrawing U.S. ground troops from the conflict.

Nixon and Kissinger shared a desire with the Chinese to keep their exchanges secret until they could portray them as successful. On December 10, in the midst of the discussions, Nixon told reporters that he had "no plans to change our policy with regard to the admission of Red China [Nixon's hostile term for the Communist regime] to the United Nations at this time." In the long run, however, he was determined to "have some communication and eventually relations with Communist China." Nixon was eager to hide the prospect of near-term advances in relations because it could jeopardize the talks by stirring conservative opposition and deprive him of a reelection surprise.

Mao understood Nixon's political agenda. He told Edgar Snow, the journalist, "The presidential election would be in 1972, would it not? Therefore . . . Mr. Nixon might send an envoy first, but was not himself likely to come to Peking before early 1972."

In December, when the *Christian Science Monitor* published a story saying that the state department was behind talks with China, Kissinger urged the paper's bureau chief to understand that this was not a state department but a Nixon initiative. Neither he nor Rogers deserved the credit. It was an accurate description of how the China policy had evolved.

Nixon wanted no doubt about his primary role in this new departure toward the PRC. On December 24, at a background press briefing, Henry reiterated what he had said to the *Monitor* reporter. He also explained that they would be "applying the same principles that I have indicated govern our relationship to the Communist world in general." They wanted the Soviets to believe that a China initiative was not aimed against them.

On January 11, Kissinger received a new message from Peking through the Romanian ambassador. It was much like the December note, with the important addition that "since President Nixon had visited Bucharest and Belgrade, he would also be welcome in Peking." The Chinese references to Bucharest and Belgrade, both capitals notable for their independence from Moscow, signaled their interest "above all in the Soviet challenge." They were also upping the ante by explicitly suggesting that Nixon rather than "a special envoy" come to China. Nixon was reluctant to "appear too eager. Let's cool it," he told Henry.

The Chinese were as cautious as the Americans. As with Cambodia, the offensive in Laos brought a suspension of exchanges. In February, Peking publicly rebuked the United States for expanding the war into Laos, but at the same time a Chinese foreign ministry official confided his government's belief to the Norwegian ambassador that American policy toward China was moving in a new direction.

At a February 17 news conference, Nixon emphasized that the actions in southern Laos "present no threat to Communist China . . . It is directed against the North Vietnamese." In the president's annual foreign policy report released at the end of February, Nixon referred respectfully to the People's Republic of China and declared it in everyone's interest to draw "750 million talented and energetic people" into "a constructive relationship with the world community." He also stressed U.S. determination to do nothing to exacerbate tensions between Moscow and Peking, which was "inconsistent with the kind of stable Asian structure we seek."

In March, with Mao's government reiterating its determination to replace Taiwan as the legitimate representative of China in the UN, Nixon reminded journalists of his eagerness for improved relations, but not at the cost of Taiwan's expulsion from the world organization. Shortly after, the White House tried to mute the president's qualifying remarks by declaring its interest in additional Warsaw talks and the freedom of all Americans to travel to mainland China.

An opening to China would give "us maneuvering room with the Russians," Nixon told Haldeman. With Tass, the Soviet news agency, publishing a story about the developing dialogue between the United States and China, Nixon told Kissinger, "that shows that they must be hysterical about this damn thing. Because they said, 'this removed the mask of U.S.–China'—shit, we don't have any relations with China." He also told Henry: "Let's face it, in the long run it is so historic. You know, you stop to think of 800 million people, where they're going to be, Jesus this is a hell of a move."

In March and April, however, Nixon worried that U.S. public opinion might impede a rapprochement. Most Americans were antagonistic to Communist China and particularly to seeing it replace Taiwan in the UN. "We have the problem," the president told national security officials, "of convincing our own people that there's a good strong reason

to change our position." In April, after the Chinese invited the U.S. Ping-Pong team in Japan to visit China and journalists coined the phrase "ping-pong diplomacy," Nixon worried that this "doesn't help us with folks." It was helpful "with intellectuals, but . . . people are against Communist China, period. They're against Communists, period. So, this doesn't help us with folks at all," he told Colson. "It's just what these intellectual bastards—" he added, and broke off in mid-sentence.

Nixon was reluctant to "make too much hay out of China, because they might pull the rug out from under us; and we don't want to get our neck out that far." Kissinger worried about this as well. He believed that the Chinese had the upper hand in the exchanges. "All they have to do is lift a finger and the U.S. comes running," he told Herb Klein. He feared that "a big enterprise with the Chinese" could give them the power to "kill what we are trying to do with the Soviets, which is the big play" in the administration's diplomacy.

During a session with newspaper editors on April 16, Nixon spoke candidly about prospects for a shift in Sino-American relations. "Now it is up to them. If they want to have trade in these many areas that we have opened up, we are ready. If they want to have Chinese come to the United States, we are ready. We are also ready for Americans to go there." Although no additional meetings were currently on the agenda, Nixon added, "We are ready to meet any time they are ready to meet . . . We certainly have the door open."

And if the Chinese walked through it, Nixon and Kissinger wished to assure that the president got credit for the achievement. "The big thing now is that we get credit for all the shifts in China policy, rather than letting them go to the State Department, which of course had nothing to do with it—in fact opposed every step the P took because they were afraid any moves toward China would offend Russia," Kissinger told Haldeman.

Nixon hoped that an opening to China would also make a difference in U.S. domestic affairs: "We've got to destroy the confidence of people in the American establishment," Nixon told Henry. "And we certainly as hell will, if we succeed in . . . the Communist China thing. That's why I say now, if it goes and the Soviet thing goes, we're not going to let these bastards take the credit for it. We've got to take credit every time we turn around."

Nixon believed that a revolution in U.S. relations with Peking and Moscow would deprive establishment liberals of issues they had used against conservatives for years. The sea change in American diplomacy would not only move the world closer to a stable international order but also make Nixon and the Republicans the new leaders in advocating a progressive approach to foreign affairs. It was an astonishing shift away from the anti-Communist rhetoric that Nixon had previously used to advance his political career. It was also a demonstration of how pragmatic he could be to achieve something he believed would establish him as a great president.

KISSINGER WAS RIGHT: Russia was "the big play" in the Nixon foreign policy plan. Improved relations with China were a large part of the diplomatic revolution they envisioned; but détente with Moscow was essential if they were to avoid a Sino-American rapprochement that increased hostility between the U.S. and the U.S.S.R.

In the summer of 1970, Pat Buchanan urged Nixon not to let Americans become too hopeful about better Soviet-American relations. During the fall campaign, he suggested that Agnew declare that "we are moving with caution hopefully toward settlement of outstanding conflicts," but Moscow had taken "tremendous strides in seapower and strategic weapons," which should restrain any "euphoria" about a détente. Nixon thought it was "very good advice."

Buchanan did not need to caution Nixon and Kissinger. Between the fall of 1970 and the spring of 1971, Soviet-American differences created substantial doubts about détente. On October 1, Henry told the Yugoslav foreign secretary that he "had three mutually contradictory interpretations" of Soviet policy: "first, that the Soviets are seeking accommodation with Germany but do not want a general détente, and in fact might adopt a tougher stance toward the U.S.; second, that the Soviets want détente; and third, that they do not know what they want."

Later that month, Dobrynin complained to Kissinger about the poor state of Soviet-American relations. "The United States had already decided to adopt a hard line and it was whipping up a propaganda campaign in order to get larger defense budgets and perhaps affect the election . . . It was the consensus of all their senior officials that relations with the United States had never been worse since the Cuban missile

crisis." Henry responded that "the problem was how to turn this present impasse in a more fruitful direction." Dobrynin promised that when Gromyko met the president at the UN, he would look to the future rather than focus on the difficulties of the past. Kissinger said that the president would give "a very conciliatory speech" to the General Assembly.

Nevertheless, Kissinger saw a post-Stalin Soviet Union, which lacked "a strong central point of decision making," as a dangerous adversary. Their uncertain leadership, coupled with an increased military capacity, might lead them into reckless actions endangering relations with the West. Moscow reciprocated the suspicions—it saw the Nixon administration as rash. Press leaks about their private meetings were not helping things, Dobrynin complained to Kissinger in November. Moscow saw the newspaper stories as an irresponsible attempt to put pressure on it.

By the end of November, Nixon detected a hardening Soviet policy resulting from expectations of a Nixon defeat in 1972. They might be thinking, he told Kissinger, "Any kind of détente between now and '72 would come up against a very tough bargainer and might help him get re-elected, whereas waiting after '72 might reduce his chances of getting re-elected and thereby increase the chance for them to make a better deal after '72 than before. I am convinced that the Soviet leaders are influenced more by internal American political considerations than we like to believe." Nixon speculated that Democrats like Averell Harriman were behind the current Soviet response to his administration. Nixon's paranoia was hard at work here. Should he lose in 1972, he could rationalize his defeat as the result of Soviet influence on American politics spurred by Moscow-connected Democrats.

As the year came to an end, Dobrynin told Kissinger, six to nine months into Nixon's presidency, Moscow saw the administration as "more conciliatory." But difficulties over the Middle East and Vietnam "had created a bad impression." Henry agreed: "We both knew that relations between our two countries have worsened in the past couple of months," he replied. But in a measured statement, he urged Dobrynin to understand that "the President continues to seek better relations and concrete results—negotiation instead of confrontation is no idle phrase." Henry cautioned "that distrust has begun to set in on both sides . . . We are at a crossroads in our bilateral relationship. We have the choice between letting this chain of events continue and making a fundamental

attempt to set a new course . . . The President has asked me to reaffirm to you his desire to improve our relations."

In the last ten weeks of 1970, three issues seemed to impede better relations with Moscow: an inability to arrange a Summit and impasses over SALT and the Middle East.

By the time Nixon met with Gromyko in October 1970, he had given up on a Summit before the November elections. Nevertheless, he was eager for a Soviet commitment to such a meeting in 1971 that he could announce before voters went to the polls. Dobrynin told Kissinger that the Soviet government hoped to host a Moscow Summit next June or September, but resisted any announcement in October of plans for a meeting. The Soviets had no intention of giving the Republicans an October surprise that could help them add congressional seats in November.

In late December, another Kissinger-Dobrynin conversation about a Summit was less than cordial. Henry now cautioned the ambassador against leaks from Moscow about the possible meeting. The administration saw no immediate political benefit from public knowledge and feared that rumors of a meeting that might not pan out could become a political liability. Kissinger complained that earlier Soviet failures to respond positively to a 1970 date or reveal plans for 1971 talks "had made an extremely painful impression."

SALT also frustrated Nixon's hopes of reduced Soviet-American tensions. After the largely unproductive April to August Vienna talks, negotiations were scheduled to resume on November 2 in Helsinki. But skepticism at home and abroad that Moscow would give ground on limiting its ICBMs and Washington its ABMs dimmed prospects of a breakthrough. Suspicions of Soviet intentions abounded in the United States, where Vice Admiral Hyman Rickover predicted that by 1975 Moscow's military capacity "will be ahead of us in virtually all respects." Although political sentiment in America favored reducing military expenditures, national security concerns trumped interest in arms limitations. "There has not been an arms race," Rickover said. "The Soviets have been running at full speed all by themselves." Nixon asked Kissinger, "What is the answer we give to this growing opinion? Rickover has enough of a following to get this across."

The Helsinki talks, one participant told Bill Bundy, was " 'the na-

dir' of the whole negotiation." Bundy himself said: "It was hardly the way to conduct a major negotiation: a President not really interested, his principal assistant [Kissinger] intervening without the knowledge or concurrence of the negotiating team, and the team left to fend for itself." Henry told Dobrynin on December 2 about the U.S. delegation in Helsinki, "They have no authority and [are] not given authority and will not be given authority." Bundy conceded that "any arms control negotiation was pioneering, and not likely to move rapidly in the best of circumstances, but with better handling the morass of 1970 might well have been avoided, and more progress made in ways favorable to U.S. interests." At the end of the year, SALT prospects were less than robust and negotiations were contributing little, if anything, to a Soviet-American accommodation.

In the fall of 1970, after the satisfactory outcome of the Jordan crisis in September, Nixon and Kissinger believed that they had a good chance of easing differences with Moscow over the Middle East. During his trip to Europe at the end of September, Nixon told Italy's President Giuseppe Saragat that U.S. and Israeli firmness in response to Soviet recklessness and the Syrian invasion of Jordan had headed off a more serious crisis between the U.S. and the U.S.S.R. Three days later, during a conversation with Yugoslavia's Tito, Nixon "observed that some thought the Soviets wanted chaos in the area." Tito disagreed, "saying that the Soviets did not want war and, with their strong influence in the area, would not permit escalation." Although Nixon remained skeptical of Moscow's intentions in the region, he replied, "We are not discouraged and will continue to press every opportunity for peaceful solution to the problem."

The Soviets had no intention of turning Middle East tensions into a direct confrontation with the United States. On October 6, Dobrynin offered soothing advice to Kissinger: "The most effective means of preventing events like those which occurred in Jordan is a speedy attainment of a peaceful settlement in the Middle East as a whole." He urged a renewal of mediation discussions through the UN's Gunnar Jarring. Nixon was receptive to Dobrynin's urgings. He hoped that the rescue of King Hussein from Palestinian radicals had improved "chances for a lasting peace in the Near East," he told state and national security officials.

Kissinger was less hopeful. His exchanges with Dobrynin went be-

yond optimistic platitudes. Dobrynin coupled friendly advice with a warning that "the Soviet Union could not be intimidated by a show of U.S. force. He asked whether we really thought that one additional U.S. carrier in the Eastern Mediterranean would make the Soviet Union back down . . . If the Soviet Union acted when its national interest was involved, then it would act with great force." Kissinger saw the Soviets as in retreat in the Middle East, where they "are trying hard to cut any losses . . . They now want to wipe the slate without drawing any consequences for the broader spectrum of their relations with us."

Yet Moscow was not about to concede anything to Washington on the Middle East. With discussions there at a standstill, the Egyptians and Soviets launched a propaganda barrage in the second half of October blaming the United States and Israel for the deadlock and warning that the cease-fire along the Suez Canal was in jeopardy. When ABC newsman John Scali reported that "the Soviets seem less concerned with peace than with maximum support" for Nasser's replacement, Anwar Sadat, Nixon agreed. Another meeting between Kissinger and Dobrynin underscored the ongoing problems. Dobrynin described a conversation between Rogers and Gromyko as offering little new: "Both sides restated their familiar positions and it was a deadlock."

By the beginning of November, Kissinger could only tell Nixon that "We are again adrift in the Middle East, being guided, day-to-day, by tactical considerations . . . I see no evidence of a disciplined adherence to a solid long-term strategy." Kissinger's complaint was as much against Rogers as Moscow and the Arabs. He wanted Nixon's authorization to press the state department to rethink its approach to the region.

Because no one had answers to the Middle East impasse, Nixon was willing to give Henry a say in administration deliberations about the Arab-Israeli conflict, but he was ambivalent about Kissinger's involvement. As Nixon told Haldeman, "anybody who is Jewish cannot handle" Middle East policy. Henry might be "as fair as he can possibly be [but], he can't help but be affected by it. Put yourself in his position. Good God . . . his people were crucified over there. Jesus Christ! Five—six million of them popped into big ovens! How the hell is he to feel about all this?"

Haldeman agreed: " 'What he ought to recognize is that even if he had no problems at all on it, it's wrong for the country, for American

policy in the Middle East to be made by a Jew.' 'That's right,' " Nixon interjected. " 'And he ought to recognize that, because then if anything goes wrong,' " Haldeman added, " 'they're going to say it's because a god-damned Jew did it rather than blame the Americans.' "

The extent of Middle East difficulties registered more forcefully than ever in the last two months of 1970. In November and December, the Soviets increased the supply of antiaircraft weapons sent to Egypt. In response, Golda Meir asked Nixon to guarantee aircraft deliveries after 1970. She also asked that the United States remind Moscow of its commitment to Israel's survival and security and pledge to veto any Security Council resolution imposing a territorial settlement on Israel.

Although promising to maintain the existing supply and finance relationships and to shun any Security Council proposal on the occupied territories, Nixon hedged his commitments by saying he needed more time before making concrete promises on supplies and said nothing about guaranteeing a veto.

A discussion on December 8 in Washington between Nixon and Jordan's King Hussein raised additional concerns about the Middle East. "Stresses and strain have increased in the Middle East since 1967," the king said. "The number of extremists has grown. There is greater disunity among the Arab states . . . He feared that the Middle East is changing from one of Arab-Israeli involvement to one of major power involvement." They foresaw a possible disaster. Nixon was less than optimistic about negotiations. "There is no guarantee that if talks were to begin we would get the results we hope for," he told the king, "but continuing as we are will get us nowhere."

Nixon and Rogers pressed Tel Aviv to rejoin UN-sponsored discussions at once and warned that if it impeded the negotiations, "the Big Four would step in and if that did not work, then the Security Council would move in." Meir characterized the message as "one of the greatest blows she had received for a long time from the U.S. . . . She feared that U.S. and Israel were on a collision course."

Kissinger considered the Nixon-Rogers message a mistake. He told Nixon that "we do not have the climate of confidence in which pressure from us will yield real progress toward talks and ultimate resolution." The Israelis countered by threatening to open direct negotiations with Moscow, which would boost Soviet prestige in the region and undermine

U.S. influence. Despite the unlikelihood of Israeli-Soviet cooperation, Tel Aviv saw the mere suggestion as counteracting American pressure.

Although Kissinger hoped that he and Dobrynin might find some common ground for Middle East discussions, nothing turned up in the closing days of the year. In a conversation on December 22, Dobrynin complained that the U.S. "was trying to push Moscow out of the Middle East," and characterized it as provocative.

In a year-end summary of Soviet-American differences over the Middle East, Kissinger saw little progress toward a settlement and described the Soviets as reaching for "hegemony in the region." They had substantially increased their military presence in Egypt and the Mediterranean more generally. Henry was gloomy about improving Arab-Israeli relations. He saw little likelihood of "progress toward a settlement." Unless we had "a game plan," we could be "sucked step-by-step into a major crisis" with the Russians.

At the start of the New Year, Don Kendall, Pepsi-Cola's chief executive officer, who had wide international contacts, gave Nixon and Kissinger some hope that the Russians might alter their stance on the Middle East. Kendall told Kissinger that a top Soviet writer at *Izvestia*, the official Soviet newspaper, described the Kremlin as eager for an arms-control treaty and a Mideast agreement. The arms race and their involvement in Egypt were "too much of a drain on them. Too many problems at home for a drain of a protracted period of time." Wouldn't the American-Jewish community make it difficult for Nixon in the midst of a reelection campaign to support an agreement that would be unpopular in Israel? the Soviet journalist asked. "The Jewish community didn't put him in office and he would do what he had to," Kendall replied.

Although the Jewish vote had largely gone against Nixon, he didn't believe he could simply write it off in 1972. He was especially mindful of sympathy for Israel among a majority of American voters. In January, Kissinger told national security officials that the president wanted questions about arms supplies to Tel Aviv out of the way before November 1972. An escalating debate in which "everyone is trying to outdo everyone else in an election year" would serve neither the national interest nor the president's popularity.

"There is no denying that there is a political campaign coming in this country in 1972," Nixon said. "A number of politicians are already

making it plain that they will make political capital out of their support for Israel . . . We will provide arms, long-range agreements with Israel, and guarantees . . . *But* if any Israeli leader feels that Israel by taking advantage of internal U.S. politics can have both arms and that kind of support from the U.S. and then refuse to act—even to discuss—then he is mistaken." Nixon's rhetoric was largely bluster. Trapped between Israel's determination to assure its security and widespread American support for Tel Aviv, as well as domestic pressure to quit Vietnam, Nixon vented his frustration in private outbursts. Although the Israelis and their American supporters angered him, Nixon had no intention of letting political opponents win any advantage in the contest to be seen as a firm supporter of Israel.

As Kendall had reported, the Russians were eager for a stand-down in the Middle East. "The future of Soviet-U.S. relations is in our hands, and I want you to know that we are going to make a big effort to improve them," Dobrynin told Kissinger in January 1971. He proposed discussions between them for "a realistic Middle East agreement." Nixon wrote in the margin of a Kissinger memo, "K—See what he has in mind."

In two more meetings during the first week of February, Dobrynin said that Moscow "viewed the Middle East situation as extremely alarming . . . and hoped that a channel could be established between Dobrynin and myself on these negotiations." The Soviets "did not believe that our present approach [through the state department] would come to any good end," Henry told Nixon.

Although Kissinger was convinced that only his control of Mideast policy could bring an upturn, Nixon was skeptical. On February 26, Haldeman recorded that "the K-Rogers thing goes on . . . now because of the Middle East. Henry persists in rushing in to the P and telling him we're about to get into a war in the Middle East. The P asks him what he wants to do about it. He doesn't have any ideas, except that he wants to take over. The real problem is that Henry becomes extremely emotional about the whole thing." During a White House meeting, "the P had been very tough on Henry, on the grounds that he didn't have any solutions . . . The P's becoming impatient with the whole situation . . . He told Henry, before Rogers came over, to prepare a set of questions that they wanted the P to ask Rogers . . . The P asked the questions, and Henry concluded afterward that the answers were all unsatisfactory, but

was unable to tell the P what he considered satisfactory answers . . . So, we're back in the stew on that one."

The acrimony revolved around Nixon's frustration with the insurmountable problems between Israel and its Arab neighbors, especially Egypt, which demanded Israel's withdrawal from the Sinai. No one in the administration had an effective plan for breaking the deadlock. Cairo promised a commitment to nonbelligerency if Israel returned to its pre-1967 borders with Egypt. But Kissinger saw this as "something less than an unqualified acceptance." The Israelis rejected a return to prewar borders, and only a commitment on both sides to consider plans for a mutual pullback from the Suez Canal, where their armies confronted each other, as a prelude to its reopening kept peace discussions alive.

In March, Middle East problems reached a new low and agitated Nixon's fears that the outcome would be another war and a possible U.S. confrontation with the Soviets. Moscow publicly denounced Israel's obstructionism and predicted dire consequences from a failure to reach a political settlement. Following the Soviet lead, the Egyptians also took a tough public stance. Anwar Sadat, who had come to power in October 1970 and seemed to be continuing Nasser's policy of friendship with Moscow, warned Nixon on March 6 that he would not extend the cease-fire and was ready to resume the fighting with Israel. In March, he warned that his soldiers were eager to start "the battle of liberation" by the end of the month.

Israel was just as difficult to deal with. In early March, during a White House meeting with President Shazar, Nixon predicted that eventually the "well may run dry on the flow of U.S. assistance" and that it was time for Israel "to seriously explore all possibilities for a negotiated settlement." Shazar resisted the pressure, saying that a solution to Middle East problems "could only be achieved through direct agreement between the parties."

Golda Meir and Abba Eban were blunter. Mrs. Meir complained that the "U.S. was not acting in the spirit of allowing free negotiations without interference as the President had promised." Eban told Kissinger that Israel could not promise to satisfy Arab demands for a return to prewar borders. He emphasized that ideas enunciated by Secretary Rogers were unacceptable. Kissinger urged Eban to counter Rogers by putting "forward a position that had a reasonable chance of starting discussion."

But Meir and Eban rejected the suggestion. Nixon now complained that "the Israelis make friendship awfully tough." He told a leader of the American-Jewish community that Israel's unyielding approach to negotiations weakened its international position.

Nixon also said that "he resented Israeli efforts to suggest a breach existed between the State Department and the White House," which of course it did. The Israelis knew about the split in the U.S. government between Rogers and Kissinger, and believed it weakened Nixon's ability to pressure either them or the Arabs. With Rogers demanding that Nixon use a hard line with Israel to compel greater flexibility in negotiations and Kissinger warning that it would damage U.S. relations with Tel Aviv, risk another Arab-Israeli war, and undermine the president's domestic standing, Nixon, who had no better idea of what to do, found it impossible to set a clear course.

April brought no better results. "The diplomatic situation drifts," Hal Saunders told Kissinger in the middle of the month. A conversation between the U.S. ambassador and Meir the next day covered "no new ground." It added "to the general impression that the Israelis are digging in on their current position." What are our priorities? Kissinger asked at an NSC meeting. "How can we influence these talks if we don't know what we want?" They needed to find some formula that could advance the discussions. But with no idea of how to force Israel's hand, the White House fell back on the belief that neither Tel Aviv nor Cairo would provoke a war from which they had nothing to gain.

With nothing constructive to announce, Nixon believed it best to keep a low profile about the Middle East. He rejected a suggestion that he discuss it in a news conference. "The only plus . . . is to show he's standing firm during a week of turmoil," Haldeman recorded in his diary, "but the minuses of having to talk about Vietnam and the Middle East, etc., that we don't want to talk about overweigh this."

IN THE FIRST MONTHS of 1971, with the administration unable to say anything new about ending the Vietnam War or settling Mideast difficulties, Nixon and Kissinger hoped that SALT, which were scheduled to resume in Vienna in March, might give them something to cheer about. In January and February, Kissinger suggested to Dobrynin that they commit themselves to "an ABM only agreement," provided that it

was coupled with simultaneous discussions of limitations on offensive weapons, including a "freeze on new starts of offensive land-based missiles during the negotiations."

Under pressure from arms control advocates to focus the talks on banning ABMs, Nixon and Kissinger hoped to get something from the Soviets in exchange for limitations on defensive missiles. At the same time, they were determined to keep control of the negotiations in Washington as a way to assure that credit for any agreement went to the president rather than Smith and his colleagues in Vienna.

Kissinger found himself fighting a three-front war. He believed it essential to put a lengthy section about SALT in the annual foreign policy report as a way to signal that this was a White House initiative. He wished to say in the document that "The most important area in which progress is yet to be made is the limitation of strategic arms. Perhaps for the first time . . . agreement in such a vital area could create a new commitment to stability, and influence attitudes toward other issues."

Nixon and Rogers were reluctant to raise false hopes for arms limitations. It doesn't "make a goddamned bit of difference whether SALT's in the State of the World or not," Nixon told Haldeman, "you know, it's—nobody gives a shit except Henry." Haldeman took Kissinger's side: "Except," he said, "the SALT thing—the SALT stuff in there was really about the only news there was in the whole thing."

At the same time as he fought with Nixon and Rogers, Henry also battled to convince the Soviets of the benefits of a SALT agreement. Moscow, which wanted to curb ABMs but needed time to catch up to the United States in MIRV technology, delayed answering Kissinger's January proposal. Although Henry cautioned that an ABM agreement alone would not be very fruitful, he described the U.S. as without a time limit for negotiation of offensive weapons, but suggested eighteen months to two years.

When Henry also declared that they "foresaw limitation only on the number of missiles, not on modernization," it largely gave Moscow what it wanted. Kissinger reported to Nixon that after he handed Dobrynin a letter from him to Kosygin about SALT, the ambassador signaled a keen interest in moving ahead by making constructive suggestions. Dobrynin understood that Moscow needed to make a decision before the talks resumed in Vienna on March 15.

Kissinger was too optimistic. Preoccupied with domestic economic problems and slated to hold a Party Congress at the end of March, the Soviets were unprepared to answer the U.S. proposals. On March 12, a Soviet reply refused to link discussions about defensive and offensive weapons. Moscow proposed an ABM agreement in 1971, with discussions "in principle" of a freeze on ICBMs coming in 1972. There was no commitment, however, to reach an agreement on offensive missiles. The Soviets were ready to discuss them in Vienna, but Dobrynin explained that while the Party Congress was in session, he would be unable to give answers to any additional U.S. counterproposals.

Nixon and Kissinger were determined to reach an agreement, which they believed crucial to foreign policy gains in general and Soviet-American relations in particular. During a March NSC meeting, they emphasized the importance of negotiating a SALT treaty, and winning support for it in the United States and abroad. "This is a big fight," Nixon told Kissinger and Ron Ziegler. "It affects our dealings with the Russians. It affects our dealings with the Congress. Don't you realize the importance of this?" He saw the foreign policy implications as "enormous."

But so were the domestic ones; indeed, Nixon and Kissinger saw more domestic than international gains from a SALT agreement. Neither he nor Nixon believed that a treaty would change strategic fundamentals. "I'm not so sure that the SALT thing is going to be all that important. I think it's basically what I'm placating the critics with," Nixon told Kissinger in March. Henry agreed. "We can afford the SALT agreement we are now discussing," he told Nixon and Haldeman in April. "That won't be a disadvantage. It won't mean a damn thing."

The payoff would be in moving the U.S. and the U.S.S.R. toward détente and in disarming domestic political opponents. Coupling public statements assuring the administration's commitment to a strong national defense with an unprecedented arms control treaty, Henry said, would "break the back of this generation of Democratic leaders." Nixon replied, "That's right. We've got to break—we've got to destroy the confidence of the people in the American establishment." It would also help with long-range plans to bolster the country's national security. "We can't do much about building a strong defense for the United States during this term because Congress won't support us," Kissinger told Haldeman.

"What we have to do is get reelected and then move into the defense setup at that time."

The Soviet military, which Dobrynin described as "certain vested interests," jeopardized prospects for SALT. "Henry obviously was very much depressed because the general developments had not been what he had hoped," Haldeman recorded. He accurately suspected "that his SALT plans had probably fallen through."

Kissinger's distress also revolved around stalled Summit plans. In January 1971, Kissinger-Dobrynin exchanges all but settled a commitment to hold a meeting in Moscow either in late July or early September. Dobrynin stressed Moscow's desire for "concrete achievements, not just general goodwill." Nixon was in full agreement, and instructed Henry "to work out the preliminary details of the agenda."

But with Middle East and SALT discussions largely on hold, substantive gains at a Summit seemed out of reach. A February Kissinger-Dobrynin meeting "broke up in a rather chilly atmosphere."

By April, however, Kissinger was hopeful that America's emerging reconciliation with China coupled with domestic pressure on Brezhnev to reduce arms expenditure and increase consumer goods would improve chances for a SALT treaty and a Summit conference. But when Moscow asked for an agreement on East German control over West German access and ties to West Berlin as the price of a Summit, Kissinger reacted "very sharply . . . We had proposed a Summit meeting over a year ago," Henry told Dobrynin, "in order to make some progress in basic Soviet/American relationships." He doubted that the president would agree to any preconditions as the price of a meeting.

"I blew my top, I mean deliberately," Henry told Nixon. "They're thugs, and they always try to pick up some loose change along the way, and they just ran up against the wrong guy. You just don't give them any loose change."

Nixon directed Kissinger to give Dobrynin an ultimatum on a Summit. "I told him," he reported to the president, "that we had been proposing a Summit for a year now but they had never taken it up, that their interest had been sporadic, and that the next time they raised the subject they should be prepared to announce it and should understand that linkage to any preconditions was unacceptable—it could not be used as a lever on other negotiations." Dobrynin replied that there must be a mis-

understanding. Moscow was setting no preconditions on the talks; they were ready to meet.

At the end of April, however, with still no concrete commitments on SALT or the Middle East, a Summit remained more a hope than a certainty. But with nineteen months to go before he had to face voters again, Nixon remained optimistic that he could turn foreign affairs into a winning platform in 1972.

At a minimum, he intended to put a positive face on his administration's record. On April 29, despite all the recent frustrations over foreign policy and his private fulminations against the press, antiwar demonstrators, and Kissinger and Rogers for their distracting turf wars, he gave a masterful performance in a news conference covering domestic dissent, Vietnam, Laos, and China. He was the soul of rationality: He wanted the same thing war opponents demanded—peace; he had nothing but respect for the many reporters in the room who disagreed with his policies; he hoped someday to visit China and end that vast country's isolation; and he had no desire to play Peking off against Moscow; we were seeking good relations with both Communist powers and had every hope that they would ameliorate their differences.

Nixon's public presentation demonstrated the power of the country's traditions of comity and consensus, and his effectiveness as a politician. He understood that Americans expected their president to be a unifying rather than a divisive leader. At the time, if the public heard his private conversations, with all his blue language and angry attacks on opponents and collaborators dividing his administration, it would have been the end of his presidency. (Nixon never thought that the recorded conversations made between 1971 and 1973 revealing the seamy side of his personality and political cynicism would ever see the light of day; otherwise, it is inconceivable that he would have recorded the real man, giving vent to his anger and wishes to punish opponents to the full extent of his powers.)

Whatever Nixon's impulses to engage in political combat, which had been so much a part of his public career and reflected his true instincts, he understood that Americans wanted their president to shun polemics as much as possible and unify rather than divide the country. Nixon was overwhelmingly self-interested, but he was someone who shrewdly presented himself as a wise president always putting the larger national interest ahead of self-serving ends.

THE BEST
OF TIMES

~ *Chapter 10* ~

THE ROAD TO DÉTENTE

My highest priority in foreign policy is to build a struc-
ture of international relations that will help to make a
more stable and enduring peace in the world.

—RICHARD NIXON, "TALKING POINTS ON CHINA," JULY 17, 1971

By April 1971, after twenty-seven months in the White House, Nixon and Kissinger had settled into a working relationship that aimed at ending the war in South Vietnam without a Communist takeover and ensuring a second Nixon term, when he would be freer to build a new structure of international peace.

They had no illusions that they could put an end to war; regional or small conflicts would continue to plague the world. But they hoped to prevent another global disaster, which would be even worse than World Wars I or II. As Nixon told the journalist Allen Drury in the spring of 1971, "Whoever is President of the United States, and what he does, is going to determine the kind of world we have." He wished to fulfill Woodrow Wilson's dream of bringing an end to "big" or "general" wars. "Of course, there will be brushfire explosions," he said, "things like Pakistan, Nigeria, things like that. But any Soviet leader who comes along—or, any Chinese leader, for that matter—will know what I know:

that if he begins a major war, he almost instantly kills seventy million of his own people. The same applies to me and my successors. I don't think that kind of national suicide is feasible any longer, for any sane man."

The international stability Nixon imagined depended on accommodations with Russia and China, America's most likely adversaries in any large-scale conflict. In the spring of 1971, better relations with each of the Communist superpowers remained more a hope than a reality. Despite past frustrations, Nixon and Kissinger remained optimistic that Moscow and Peking could be drawn into productive discussions that would promote détente and simultaneously serve the president's prospects for a second term.

Nixon believed that international achievements would ultimately be the measure of his effectiveness and standing as a president. But that was for the long run, for the judgment of history. In the short run, doing something newsworthy, spectacular, if possible, was essential for his reelection, or so he believed. "The P's view is," Haldeman noted, "that if we don't get SALT, if we don't get the Summit [with the Soviets], if we don't get a Vietnam settlement, all during this summer—and all of which are likely, but not certain—then he's got to go for a trip to China this fall. Henry is very strongly opposed to any trip to China this year, but understands the P's theory."

In May, foreign policy gains finally began coming together. Specifically, the Soviets signaled their willingness to announce an agreement with the United States about SALT. On May 13, after Moscow had indicated its readiness to go forward, Kissinger and Dobrynin struggled to fashion mutually acceptable language. "I have worked for nine years and it's the first time that the whole government has worked on each sentence," Dobrynin told Henry. "If you get a big promotion," Kissinger joked, "it will be because of my showing you attention." Dobrynin replied, "It's sometimes better not to have attention. It's a little dangerous."

On May 20, Moscow and Washington issued identical statements promising to work out an agreement in the coming year that would limit the deployment of antiballistic missile systems (ABMs). They also expected to reach agreement on limiting offensive strategic weapons. The announcement then held out hopes for a Summit. In response to press questions about other discussions with Moscow, Nixon intended

to say, "I have often said that negotiations in one area can lead to progress in others."

Mutual self-interest motivated the announcement, which Nixon and Kissinger saw as a crucial moment in Soviet-American relations. Henry was "very pleased and thought he's gotten over the first hurdle in his series of negotiating plans," Haldeman noted. Kissinger told former National Security Adviser Mac Bundy that a breakthrough on SALT was "a significant turning point," which opened the way to discussions about "trade and related fields." Nixon was delighted because they had "finally progressed to the point of something that we can actually take to the people." Kissinger agreed, telling the president that progress on SALT would "make a tremendous splash."

To assure his political gain, Nixon wanted everyone to understand that he was the driving force behind the negotiations. "The USA-U.S.S.R. commitment had been made at the highest level," he told a bipartisan group of House and Senate leaders. Everyone at the White House was instructed to emphasize that "this is by far the most important foreign policy achievement since the end of World War II." The SALT discussions in 1971 were no match for the Truman Doctrine, the Marshall Plan, NATO, the peaceful resolution of the Cuban Missile crisis, the Limited Test Ban Treaty, and the ongoing anguish over Vietnam, but in an election season foreign policy hyperbole was hardly unprecedented.

The Soviets echoed Nixon's enthusiasm for the announcement. Ping-pong diplomacy with the Chinese had made Moscow eager to impede a possible Sino-American agreement aimed against Russia. "There wouldn't be a chance of a Russian play [on SALT] . . . a year before the election if we didn't have the Chinese warming," Nixon told Kissinger.

Moscow had other reasons for cooperating with Washington on arms talks. They were viewed as an essential prelude to an agreement with West Germany on defining its ties to West Berlin, an enduring source of East-West tension in 1971. Kissinger saw the linkage between the two issues—in early May, he told Nixon that we should stonewall the Soviets on Berlin if they impeded the SALT talks.

Moscow also expected détente to lead to expanded U.S.-Soviet trade, especially in grain sales, which it badly needed to feed its people and others in Eastern Europe. Moreover, the Soviets were intent on reaching agreements on mutual troop levels in central Europe as a way to ensure

against the creation of a large German army, which reminded them of their terrible World War II losses.

NIXON AND KISSINGER believed that the prospect of a major advance in Soviet-American relations would have a salutary effect on discussions with China and efforts to end the Vietnam War. On April 27, the Pakistani ambassador delivered a note from Chou En-lai to the president apologizing for the long delay in answering Nixon's December message suggesting a preliminary conversation between Chinese and American representatives about a high-level U.S. visit to Peking. Chou's message said, "As the relations between China and the U.S.A. are to be restored fundamentally, a solution to this crucial question can be found only through direct discussions between high-level responsible persons of the two countries. Therefore, the Chinese Government reaffirms its willingness to receive publicly in Peking a special envoy of the President of the United States (for instance, Mr. Kissinger) or the U.S. Secretary of State or even the President of the United States himself."

Although the announcement of the SALT agreement with Moscow was not yet in hand, Nixon and Kissinger believed that it was fear of a U.S.-Soviet accommodation that was motivating Peking's initiative. "They're scared of the Russians. That's got to be it," Nixon told Henry on April 28. Henry believed that Peking saw the visit as a deterrent to a Soviet attack and wanted to delay the visit for as long as they could and at least until the spring of 1972.

The evening after getting Chou's message, Nixon and Kissinger agreed on a positive response. They saw a visit to China as not only transforming relations with Peking but also "creating a diversion from Vietnam in this country for a while . . . We need it for our game with the Soviets" as well, Kissinger said.

They now went back and forth over who should travel to Peking. Henry badly wanted the assignment, but Nixon wasn't ready to offer it and seemed to take some perverse pleasure in raising other names with him. Nixon said he was considering David Bruce, but his involvement in the Paris talks might make the Chinese uncomfortable. "How about Nelson" Rockefeller? Nixon asked. "Mr. President, he wouldn't be disciplined enough," Henry objected. "How about [U.N. Ambassador George H. W.] Bush?" Nixon suggested. "Absolutely not," Henry replied; "he is

too soft and not sophisticated enough." Nixon responded, "I thought of that myself." Nixon came back to Rockefeller and asked Henry to "put Nelson in the back of your head."

Kissinger made an indirect case for himself by implying that no one was more conversant with Nixon's thinking about international matters than he was. Moreover, Henry described distinctions between the Chinese and the Russians that appealed to Nixon. "The difference between them and the Russians is that if you drop some loose change, when you go to pick it up the Russians will step on your fingers and the Chinese won't," Henry said. "Mr. President, I have not said this before, but I think if we get this thing working, we will end Vietnam this year . . . Once this thing gets going—everything is beginning to fit together."

When Kissinger discussed the question of Nixon's emissary again the next day, he made the case more directly for himself. He told the president and Haldeman that he was "the only one who could really handle this." He also said, "I don't want to toot my own horn but I happen to be the only one who knows all the negotiations." Nixon now agreed: "Oh hell fire, I know that," he said. "Nobody else can really handle it." Nixon now dismissed Rockefeller as an "amateur," and "you can't get amateurs in a game of this importance," he said. "Jesus Christ, I could wrap Rockefeller around my finger and he'll never know it." Henry exclaimed, "That's right," in a private demonstration of disloyalty to his former mentor. A silent nod of assent would have at least preserved him from the embarrassment which should attend this revelation.

Nixon laid out a scenario for a secret Kissinger visit to Pakistan to meet with Chinese officials, followed by a presidential visit to Peking in the spring of 1972. Kissinger suggested that before Nixon went, he should reveal his plans at a press conference. "Press conference, shit," Nixon declared. "I wouldn't call a press conference." He intended to announce it in a prime-time televised speech. "Let the world rock," Haldeman said. "Let it rock," Nixon enthused. "The hell with the press conference. Why let them [the journalists] piss all over it?" Haldeman added: "Drop your bomb and leave."

On May 10, 1971, Kissinger asked the Pakistani ambassador to forward a message from the president to Chou En-lai. "Because of the importance he attaches to normalizing relations between our two countries," Nixon said, he was "prepared to accept the suggestion . . . that he

visit Peking." He asked that a secret discussion between Kissinger and Chou or some other appropriate Chinese official take place in China as a prelude to the president's visit. Nixon also emphasized that Kissinger's trip be "strictly secret." Nixon remained concerned to assure against an explosion of opposition from friends of Taiwan and against allowing Henry to steal some of the thunder from what Nixon now saw as his greatest potential triumph as president. He preferred that Henry meet his Chinese counterpart in Pakistan, allowing Nixon to become the first high-level American official to visit Communist China.

At the end of May, when Nixon received polls showing an American majority supporting Communist China's entrance into the UN, he saw it as evidence that the public was ready for reconciliation with Peking. "A majority of people now favor the admission of Red China," he told Rogers, "they're sort of following what we've done."

On June 2, the Pakistani ambassador brought Kissinger Chou En-lai's reply to Nixon's latest letter. The Chinese were ready to receive Kissinger in Peking as a prelude to a Nixon visit. They were prepared to have each side freely raise "the principal issue of concern to it." If the Americans insisted on secrecy, they would conform to their wishes, but they were willing to make the meeting public. Barring that, they suggested a public announcement following successful talks.

Kissinger was "ecstatic" at Chou's reply. He arrived "out of breath" and "beaming" at the White House to tell Nixon. "This is the most important communication that has come to an American President since the end of World War II," Henry said. Chou's willingness to discuss broad global issues rather than just Taiwan made the response especially satisfying. An elated Nixon brought out a bottle of very old Courvoisier brandy. He proposed "a toast not to ourselves personally or to our success or to our administration's policies which have made this message and made tonight possible." Having celebrated their achievement, Nixon now suggested they "drink to generations to come who may have a better chance to live in peace because of what we have done." Kissinger thought that Nixon's toast reflected "the emotion and rekindled hope that out of the bitterness and division of a frustrating war we could emerge with a new national confidence in our country's future."

To give resonance to the private communications, on June 10, after consultation with Congress, the White House announced a further

relaxation in trade restrictions with China. Export controls on a wide variety of products were lifted, including an end to a requirement that 50 percent of all food shipments to Communist countries had to go on U.S. ships. The announcement was not only a concession to the Chinese but also to Moscow, which was being rewarded for the SALT declaration with the prospect of increased U.S. grain exports.

Throughout June, Nixon and Kissinger conferred repeatedly about Henry's trip to Asia beginning July 1. The plan was for Henry to consult with David Bruce in Paris about the peace talks and then go on to Vietnam, Thailand, India, and Pakistan, as a prelude to secretly traveling on a Pakistani jet to Peking. Although elated at his participation in a history-making event, the unavailability of a presidential plane brought out Kissinger's petty side. Because Nixon, Agnew, and Laird were using the three aircraft in that category in early July, Henry had to settle for "a command plane from the Tactical Air Command filled with electronic equipment, extraordinarily uncomfortable, and with engines so old-fashioned that it required long runways. On takeoff, one had the feeling," he complained, "that the plane really preferred to reach its destination overland."

Henry's plane may have had something to do with Nixon's envy at having Kissinger precede him to China. Sending Kissinger on a less than VIP plane was a way to diminish an achievement Nixon wanted for himself. He surely understood that Kissinger would be less than happy with the travel arrangements. He was right. For all his success as a professor, author, and now prominent and powerful member of the Nixon administration, Kissinger remained overly sensitive to anything he considered even the smallest personal slight.

Since this was Henry's first publicized fact-finding trip as national security adviser, it stimulated new tensions with Rogers. "It was painful enough to see me and the NSC staff dominate the policy process in Washington"; Kissinger wrote, "it was harder still to accept the proposition that I might begin to intrude on the conduct of foreign policy overseas." Haldeman tried to smooth matters over with Rogers, who warned that current tensions between India and Pakistan made Henry's visits to those two countries unwise. Haldeman countered Rogers's objections by advising that Pakistani president Yahya Kahn had a private communication from the Chinese which he wanted to hand directly to Kissinger. It was a way "to lay the groundwork" for later informing Rogers about

Henry's real mission. It would allow Rogers to save face by saying that he had been briefed about the real purpose of Henry's trip. But the Yahya communication did not appease Rogers.

When the *New York Times* published an article on June 28, predicting that Kissinger would go to Peking sometime in 1972 as the president's representative, the Rogers-Kissinger conflict intensified. Nixon instructed Haldeman to keep Henry "calmed down" and to blunt the press leak by directing Ziegler to "have no comment on these speculative stories."

In response to Nixon's wishes, Henry and Rogers tried to maintain a civil attitude toward one another. In a telephone conversation between them on the afternoon of June 28, Kissinger promised that he would avoid comments to the press on his trip, including backgrounders. Rogers assured Henry that no one at state had leaked the *Times* story. Henry described the China part of the account as "wishful thinking. They want me in Outer Mongolia," he joked. "Not a bad trip if you want to get away from it all," Rogers countered. "I love the food," Henry added. To further appease Rogers, Nixon invited him to spend two weeks with him at San Clemente while Henry was in Asia.

On the morning of July 1, as Kissinger was about to leave, Nixon spent almost two hours with him giving final instructions on what he should say to Chou En-lai. Nixon approved of an opening statement Henry crafted that discussed philosophical matters. But Nixon counseled against any lengthy "philosophical talk." He said, "I've talked to Communist leaders. They love to talk philosophy, and, on the other hand, they have enormous respect if you come pretty directly to the point." His success in talking to them was because "I don't fart around . . . I'm very nice to them—then I come right in with the cold steel . . . You're never gonna sell them a damn thing" with philosophy. "They're bastards; he [Chou]'s a bastard."

Henry acknowledged that he needed more "cold steel" in his statement. Nixon also advised him to keep Chou off balance "with surprise, this is terribly important." He instructed Henry to make clear that the president is a tough customer. Say: "This is the man who did Cambodia; this is the man who did Laos; this is the man who will . . . protect our interests without regard for political considerations . . . You've gotta get down pretty crisply to the nut-cutting . . . the stuff that really counts."

With Kissinger cabling the president on July 7 that he would fly to Peking the next day, Nixon felt compelled to bring Rogers more fully into the picture. On July 8, he informed him that the message Yahya Khan handed Kissinger was an invitation to come to China at once. To hide his movements, Kissinger's aides told the press that a stomach upset had forced him into a retreat at President Yahya Kahn's home in Nathiagali. In fact, he was on his way to Peking, Nixon told Rogers, and predicted that it was a prelude to a presidential visit, which would include Rogers.

According to Haldeman, "Rogers took it all extremely well." He recorded five days later, Rogers "didn't raise any objection except to the idea of Henry backgrounding, and was most gracious in congratulating Henry on the work he had done, both on China and on Vietnam." The previous day, Haig, under instructions from the president, had informed Rogers about Henry's secret meetings with the North Vietnamese in Paris. For the moment, Rogers stifled his injured pride and played the good team man.

Kissinger's meetings in Peking impressed Kissinger and Nixon as, in Nixon's words, "the most significant foreign policy achievement in this century." In a report on the discussions, Kissinger told Nixon, "We have laid the groundwork for you and Mao to turn a page in history. The process we have now started will send enormous shock waves around the world . . . If we can master this process," Kissinger concluded, "we will have made a revolution." The hyperbole was partly the product of a hunger for a big foreign policy gain after two and a half years of frustration over Vietnam, unyielding Soviet-American and Middle East tensions, and unmanageable events in Chile.

Yet Henry was no Pollyanna. He also warned against "illusions about the future. Profound differences and years of isolation yawn between us and the Chinese. They will be tough before and during the Summit on the question of Taiwan and other major issues. And they will prove implacable foes if our relations turn sour. My assessment of these people is that they are deeply ideological, close to fanatic in the intensity of their beliefs." He also worried that our opening to China might "panic the Soviet Union into sharp hostility. It could shake Japan loose from its heavily American moorings. It will cause a violent upheaval in Taiwan . . . It will increase the already substantial hostility [to the United States] in India." Nevertheless, Henry came away from the visit hopeful about the likely consequences of a Sino-American rapprochement.

As the records of the conversations in Peking make clear, Kissinger had reason for optimism. Not the least of these was the evident Chinese eagerness for a dramatic shift in relations. They signaled their seriousness of purpose by sending four important Chinese officials to Islamabad to accompany Kissinger and his NSC aides, Winston Lord, John Holdridge, and Dick Smyser, to Peking. The point was not lost on Kissinger or Nixon: Henry asked Haig to "be sure and tell the President that our friends sent a four-man delegation to meet him." Nixon thought it "very interesting."

The almost five-hour plane ride and arrival in Peking a little after noon on July 9 deepened Kissinger's impression of how serious the Chinese were about altering relations. During the trip, while they sat around a table in "easy conversation," the Chinese asked about the insistence on secrecy. They wondered whether the Americans were reluctant to acknowledge the contact with China's Communists? Was this a variation of John Foster Dulles's refusal to shake Chou's hand at a conference in 1954? The Chinese made clear that the humiliation had left an unhealed wound. Kissinger explained his presence as a demonstration of regard and interest in a new relationship.

A senior member of the Politburo and three other high-ranking officials met the delegation at the airport and escorted them to a comfortable guest house overlooking a lake in a secluded park once the province of Chinese royalty. Tea and a sumptuous meal filled the afternoon until the arrival at four-thirty of Chou En-lai for initial talks that would last for almost seven hours.

Chou's presence was a transparent demonstration of Peking's interest in ending the twenty-two years of Sino-American hostility. As Kissinger later told the president's senior staff members, "I talked with Chou for 20 hours. This is more than all the Western ambassadors put together have talked with Chou En-lai in all the years they have had diplomatic relations . . . The Chinese talk when they have something to say; they don't talk for talking's sake."

As premier under Mao Zedong, the seventy-three-year-old Chou was second in command of China's hundreds of millions of people for the entire life of the Communist government. He was a historical figure whose command of world affairs was nothing less than "stunning," Kissinger said. "Urbane, infinitely patient, extraordinarily intelligent, subtle, he moved

through our discussions with an easy grace that penetrated the essence of our new relationship as if there were no sensible alternative." He "was one of the two or three most impressive men I have ever met," Kissinger added. And Chou clearly considered America a country to be reckoned with and Kissinger a worthy counterpart. Chou was well schooled not only in American events but also Kissinger's background and outlook.

Because there were no specific issues to settle between them except Taiwan, and that was too complicated to lend itself to any quick solution, the purpose of the meeting was primarily to establish a measure of confidence and trust as a prelude to Nixon's visit. They needed to bridge "two decades of mutual ignorance," Kissinger writes, and so, "Chou and I spent hours together essentially giving shape to intangibles of mutual understanding."

"Reliability is the cement of international order even among opponents," Kissinger believed. And so his opening statement, which he had prepared under Nixon's watchful eye, was a bow to Chinese national pride. "We come together again on a basis of equality," Kissinger said. Although Henry later described his remarks as "long and slightly pedantic," they struck exactly the right note: "Because of its achievements, tradition, ideology, and strength," the PRC was entitled to an equal role "in all matters affecting the peace of Asia and the peace of the world." There would be no point in arguing about the superiority of one country's ideology over the other, he declared. That was for the future to decide.

The principal purposes of their meeting were to work out the details of President Nixon's visit, and more important, to lay the groundwork for discussions with Chairman Mao. Kissinger went directly to the heart of the matter—Chinese concern about any Soviet-American "collusion" against them. Kissinger promised that the United States would "never collude with other countries against the People's Republic of China, either with our allies or with some of our opponents." The president had authorized him to say "that the U.S. will not take any major steps affecting your interests without discussing them with you and taking your views into account."

Chou welcomed Kissinger's acknowledgment of China's equal standing in the world. "All things must be done in a reciprocal manner," Chou said. As important, it was essential to understand that the settlement of specific problems could only follow from an agreement on fundamentals.

For China, the primary issue was Taiwan. "If this crucial question is not solved, then the whole question will be difficult to resolve."

While not disputing the importance of Taiwan for China, Kissinger said that America's greatest current concern was ending the war in Vietnam. But, Kissinger explained, it must be a peace that did not undermine America's world position. Any other end to the war—the defeat of America's commitment to Saigon's autonomy—would run counter to China's interests. "If we are to have a permanent relationship, it is in your interest that we are a reliable country." Only a peace with honor would assure friends and enemies that the United States means what it says. It would serve their mutual needs if China would help in bringing an acceptable end to the war.

Chou countered by urging a U.S. military withdrawal from all of Asia—South Korea, Japan, the Philippines, Indochina, and Thailand—and support for self-determination everywhere. "What we strive for," Chou declared, "is that all countries, big or small, be equal."

Kissinger assured Chou that the United States had no interest in long-term occupations. Its engagements all over the world were against traditional inclinations. We found ourselves involved in an unwanted hegemony, Henry explained. In the future, American intervention would occur only if a superpower threatened to establish control by force over a weaker nation. The great worry in this regard, Chou noted, was the Soviet Union. Chou ended the first day's conversation by graciously declaring that he had "come to understand not only your philosophy but also your actual policies."

The discussion skirted controversial issues. It was the measure of how determined both sides were to reach an accommodation on improving relations that they made conscious efforts to mute their differences, which had been so substantial for so long.

The tone changed dramatically on the second day. Reluctant to be seen as courting U.S. support, Chou took a hard line in their next meeting. After a morning touring the Forbidden City with its fifteenth-century Imperial Palace, which "awed" Kissinger and his party, the talks resumed in the Great Hall of the People—an edifice Kissinger described as "undecided between Mussolini neoclassicism and Communist baroque."

In opening the discussion, Chou aggressively stated Chinese suspicions of its three international adversaries—America, the Soviet Union,

and Japan. Chou's monologue, or what Kissinger described as "Chinese Communist liturgy," declared "that Taiwan was part of China; that China supported the 'just struggle' of the North Vietnamese; that the big powers were colluding against China . . . ; that India was aggressive; that the Soviets were greedy and menacing to the world; . . . [and] that America was in difficulty because we had 'stretched out our hands too far.' "

Chou described a possible conspiracy by Washington, Moscow, and Tokyo to occupy and divide up China. "You can say that such things will never happen," Chou declared, but warned nevertheless that it might, and that China would fight a long-term struggle to free itself from the three oppressors. Although Chou took care not to set the settlement of these issues as a precondition, he did question the point of a presidential visit while so many of the tensions he described remained unresolved.

Kissinger later described himself as responding "equally firmly," saying there could be no conditions on Nixon's acceptance of Peking's invitation, and then launching "into a deliberately brusque point-by-point rebuttal." But the record of what he said reveals not a sharp refutation of Chou's attack, but a conciliatory statement aimed at softening differences and securing Chinese agreement to the president's visit. Sensing that Kissinger's eagerness for Nixon's trip gave him considerable leeway to denounce U.S. policies, past and present, Chou assumed correctly that Kissinger would not enter into a sharp debate about the relative virtues of U.S. and Chinese actions. So Chou could not have been surprised when Henry urged patience and understanding with each other. "We should not destroy what is possible by forcing events beyond what the circumstances will allow," Kissinger said.

As for Nixon's visit, Kissinger cautioned that "the only President who could conceivably do what I am discussing with you is President Nixon. Other political leaders might use more honeyed words, but would be destroyed by what is called the China lobby [the doctrinaire anti-Communist supporters of China's defeated Nationalists in Taiwan] in the United States if they ever tried to move even partially in the direction" of friendship with Peking.

After lunch, Chou reverted to the cordiality of the first day. He proposed that the president come to Peking in the summer of 1972. Kissinger thought a spring visit might be best—before the U.S. presidential election got into full swing and the Summit could be set down to reelection politics.

A final evening and subsequent morning of negotiations subjected Kissinger to the Chinese Communist tactic of giving the obvious grudgingly. They postponed scheduled talks and kept the conversations going until early the next morning over not "an elaborate communiqué but . . . a statement of a paragraph or two announcing a presidential visit to Peking." Trying to make it seem that the Americans were supplicants and that Nixon would come to China primarily to discuss Taiwan, the Chinese drafted a statement which was put into acceptable form only in the hour before Kissinger left Peking on the afternoon of July 11.

After Kissinger sent Nixon a one-word message, "Eureka," confirming that the visit had been arranged, Nixon asked for a written report of the discussions before Henry arrived at the California White House on July 13. Nixon wanted not only a detailed account of the talks but also assurances that nothing would leak to the press before he gave a speech to the nation on the evening of July 15 revealing Henry's trip and Nixon's plan to visit China before May 1972.

In a telephone conversation with Haig on July 11, Nixon wanted to ensure that Kissinger and Rogers did not eclipse him in winning credit for the China initiative. "Once this hits," Nixon told Haig, "the pressures . . . from the papers and magazines who want to see Henry will be just impossible. I will of course have a heart to heart with him. They will want to play on his ego. The magazines will want him for a cover. He is not to cooperate . . . It will project him into an enormous position in the press interest. They have a lot of tricks that they will try to play to get to see him. If they want to do a cover, fine, but with no cooperation."

Nor did Nixon want the state department and Rogers in particular to discuss anything with the press. "The people at State will be speculating all over the place," Nixon said. "I think I will just have to issue an order that there is to be absolutely no speculation and that anyone who does speculate is subject to removal." As for Rogers, he asked Henry to prepare "a highly sanitized version of his discussions" that will keep him from knowing "everything that went on."

Nixon had to be talked into letting Henry give a background press briefing. He was sure "the press will try to give K the credit in order to screw the P," Haldeman recorded Nixon as saying. Kissinger convinced him that he could "shoot that down." Nixon then instructed Henry to tell reporters "how RN is uniquely prepared for this meeting and how

ironically in many ways he has similar characteristics and background to Chou . . . Strong convictions; came up through adversity; at his best in a crisis, cool, unflappable; a tough bold, strong leader, willing to take chances where necessary; a man who takes the long view, never being concerned about tomorrow's headlines but about how the policy will look years from now; a man with a philosophical turn of mind; a man who works without notes . . . [while] covering many areas; a man who knows Asia . . . ; a man who in terms of his personal style is . . . steely . . . subtle and almost gentle."

Nixon's comparison of himself to Chou was so preposterous that Kissinger never used any of it in his press briefings. Chou would have been highly amused to know that the man Dulles would not shake hands with was now the standard for measuring presidential excellence.

After Nixon "shocked" the world with his announcement, he "reveled" in his triumph, but not quite believing "what he had just announced." Although "the media were nearly unanimous in their praise," there were some complaints, especially about Nixon's secrecy. The White House argued that public knowledge of Kissinger's trip would have fueled speculation and inflated expectations that could not be realized. Moreover, if the conversations had led to a dead end, they would have exacerbated tensions with Peking and created a sense of failure that added to international gloom about the future. Kissinger believed that Bill Safire had it right when he said: "The most dangerous of all moral dilemmas: When we are obliged to conceal truth in order to help the truth to be victorious."

But secrecy had its drawbacks. It added to long-standing beliefs about Nixon's untrustworthiness. His and Kissinger's growing reputation for deviousness intensified existing tensions with the press, and, along with admiration for a sensible China policy, provoked fresh public suspicions about a president and an administration that, as with Cambodia, seemed all too willing to act with little regard for congressional participation. Besides, the risk of a failed Chou-Kissinger meeting was considerably less than what the White House described; Peking had already made clear its desire for a Nixon visit.

The Nixon-Kissinger attraction to secrecy was a way to ensure their control over a policy for which they wanted exclusive credit. Neither man could rise above his affinity for backdoor operations or their own

political interest to see that so large a shift in foreign policy was best done as part of a national dialogue rather than as the product of their inventiveness in managing foreign affairs.

Yet there were potential drawbacks to an open discussion of any rapprochement with China. It might have touched off a fierce debate that would have made it more difficult to convince the Chinese that Americans favored a new day in Sino-American relations. Besides, as Nixon and Kissinger understood, the boldness of their fait accompli, however much an administration rather than a national initiative, largely silenced critics and created a stable consensus for something that seemed so transparently sensible.

IN HIS BRIEF, four hundred-word announcement of the opening to China, Nixon emphasized that the new relationship with the PRC was "not directed against any other nation." But, of course, Nixon and Kissinger saw the China initiative as a useful way to pressure the U.S.S.R. "The beneficial impact on the USSR is perhaps the single biggest plus that we get from the China initiative," Henry told the president. But they saw advantages in muting the connection. "Pressure on the Russians is something we obviously never explicitly point to," Kissinger also advised Nixon. "The facts speak for themselves."

The White House did not want the opening to China to exacerbate tensions with Moscow. Nixon and Kissinger feared that it might move Russia to strike a relatively weak China with nuclear weapons in order to eliminate a two-front threat. Nor did Nixon and Kissinger believe that they could use détente with Moscow to directly pressure Peking; it might recoil from improved relations with Washington and "reexamine its options with the Soviet Union." As Mao would later tell Nixon, we should not try to stand "on China's shoulders to reach Moscow."

Difficulties between the two Communist superpowers, however, gave anything the United States did with one or the other resonance in both nations' capitals. The opening to Peking pressured Moscow into a Summit Nixon had been seeking since 1970. Conservative criticism of the SALT announcement made Nixon more eager than ever for a further advance in Soviet-American relations. Bill Buckley warned in the *National Review* that Nixon would lose in 1972 unless he won significant concessions from the Soviets for having agreed to an arms accord with them.

During a meeting at Camp David on June 8, Kissinger pressed Dobrynin for an answer on a Summit. "I . . . point[ed] out to Dobrynin that we had been talking about a Summit for 14 months, and there was nothing we were going to find out that we did not already know. It, therefore, now simply came down to the issue of whether a Summit was wanted." Despite assurances in April that Moscow had no preconditions for a meeting, Dobrynin answered that a Summit would be in order after Berlin negotiations were concluded. Henry objected to the "blackmail," and warned that if an agreement were not reached by the end of June, it would mean delaying a meeting until next year. Moscow was unconcerned. It called for "further substantive progress" in relations before committing to a high-level meeting at the end of the year. With the trip to China looming and expectations for a commitment to a Chinese Summit early in 1972, Kissinger had high hopes that the announcement in July of improved Sino-American relations would force Moscow to shift ground.

It did. On July 19, after he had asked Dobrynin to meet with him, the ambassador rushed back from New York. Henry was eager for Dobrynin's response to the China announcement. "Dobrynin was at his oily best and, for the first time in my experience with him, totally insecure." Henry didn't mince words: "The Soviet response has been grudging and petty, especially on the Summit meeting," he complained. Soviet willingness to consider a year-end meeting was unacceptable; he considered it a "rejection." "Dobrynin in reply was almost beside himself with protestations of goodwill." Moscow was eager for a meeting, but "would we be willing to come to Moscow before going to Peking?" Henry said, "No," but softened the refusal by declaring U.S. readiness to announce plans for a Moscow Summit before Nixon went to Peking. Dobrynin expressed regret that Kissinger had not given him some advance warning of his trip to China; "it might have affected our decision."

At the end of July, though Moscow was in no hurry to announce an agreement to Nixon's visit, lest it seem like a direct response to the president's announcement on China, they were committed to a Moscow meeting, and Dobrynin agreed with Kissinger that they "should now focus on working things out constructively in the future."

On August 5, Nixon sent Brezhnev a placating letter. He assured the party secretary that he was mindful of the need to always consider the

"legitimate interests of both sides." Each of them had too much power to continue as antagonists that could provoke a terrible disaster. For the moment, he wished to make clear that America's "better contacts" with the PRC and "my forthcoming visit to Peking have no hidden motives." The new relationship with China was not aimed at the Soviet Union, but would contribute "to a wider normalization of international relationships." Nor were better ties to any Eastern European country, an area "historically of special concern to the Soviet Union," meant to detach any of them from connections to Moscow. Nixon praised the progress toward arms control and hoped that they could work together toward peace in the Middle East and Southeast Asia.

Although the Soviets welcomed Nixon's expressions of friendship, they did not trust his professions of innocence about the Peking Summit. They wondered if the president's failure to mention anything in his letter about a Moscow meeting indicated that "we were no longer interested in it." When Kissinger assured Dobrynin that this was not so, the ambassador said that a formal invitation would arrive in the next two weeks. And so it did, though it would take until October 12 for a mutually acceptable announcement of a Summit meeting in the spring of 1972.

With the promise of a Summit and possible advances on arms control ahead, Soviet-American relations, like Sino-American relations, seemed to be taking an upturn. At the end of September, after Gromyko saw Nixon at the White House, he told Kissinger how "enormously impressed" he was by his conversation with the president. Both of them had "conducted the discussions in shirt-sleeves." Nixon's emphasis on the special importance of Soviet-American interactions especially pleased Gromyko. He said that Brezhnev held the same exact view. As Dobrynin escorted Henry to the door, he thought the meeting with Gromyko was "one of the best he had attended, and he had never seen his minister so relaxed."

Both Nixon and Kissinger now felt as if their nearly three-year effort to reduce international conflicts, maintain U.S. security, and lead the world toward greater stability was paying off. But Henry cautioned against taking anything for granted. He refused to attach any significance to Gromyko's "relaxed" attitude, for example. At the end of their meeting, when Gromyko invited him to come to Moscow before the Summit, Henry responded, "I have given you a way for me to be able to do that"

(meaning, connect my visit to Vietnam). Gromyko snarled, "Always linkage." Neither Kissinger nor the president assumed that a new world order was imminent.

Moreover, they now found themselves thrown on the defensive by hard-line anti-Communists. California businessman Henry Salvatori wrote Haldeman on July 21 that the China initiative was creating "serious doubts and consternation among the President's conservative supporters." Nixon commented to Haldeman on "how stupid the Birchers [John Birch Society anti-Communist ideologues] were in attacking us on this, because they should see this . . . [as] against the Russians and be delighted with it." On July 22, Kissinger passed along a letter from a conservative friend warning that Moscow and others would see "China policy as but a symptom of our overwhelming desire to seek reconciliation and disengagement any way and everywhere." Nixon responded: "This memo brilliantly points up the dangers of our move . . . Our task is to play a hard game with the Soviets and to see that wherever possible—including non-Communist Asia—our friends are reassured."

In August, a number of conservative businessmen close to California Governor Ronald Reagan signed a public statement expressing great concern about Nixon's détente policies with Russia and China. In an off-the-record meeting with eight of them, Kissinger tried to relieve their fears. He urged them to remember that when Nixon entered office in 1969, Vietnam had divided the country and the Soviets had equaled U.S. military power.

What had Nixon done to meet these problems? According to Kissinger, he had overcome "violent" congressional and bureaucratic opposition to an ABM system, which had opened the way to negotiations that seemed likely to rein in Moscow's drive for missile superiority. We were asking for a freeze on the development of land-based missiles, Henry explained. If we achieved it, the United States would be conceding nothing and the Soviets, who were building them at a rate of approximately 120 a year, would be the losers.

As for Vietnam, the administration was holding out against critics who were ready to abandon the Thieu government. "We will not participate in an overthrow of an allied government," Kissinger declared. "Today the prospects of a negotiated settlement are good; and if they do work out, it will have been as a result of the painful months that we

have endured in the recent past." As for China, the Chinese had given up "their revolutionary virginity" by inviting the president to Peking. Necessity had brought us together with the Chinese. It was an effective way to restrain Moscow. "Up to July 17 Dobrynin and the Russians were insolent in their dealings with us. Since July 17 we have had their full attention. Nor should anyone see the opening to China as a sellout of Taiwan at the UN. China had the votes to replace Chiang's government and only a two-China policy would allow Taipei to keep a seat in the world body.

The need, Henry asserted, was for conservatives to line up behind the administration as a counterweight to the liberals. But Kissinger's appeal did not persuade the men at the meeting. If we are declining militarily, one of them said, why doesn't the president simply make an open appeal to the American people? It would chase liberals "up the road." That's a political issue, Henry responded, and declared himself unqualified to discuss it. "The only viable strategy," another said, "is to gain and retain clear military superiority." Henry protested that he was not sure what that meant. "I must be candid," a third member of the group declared, "my prior opinion still holds . . . the Administration has a different strategic analysis from the one I support."

Nixon and Kissinger saw the SALT and China announcements as foreign policy breakthroughs that not only advanced the cause of peace but also disarmed most of their liberal critics, who favored arms control agreements and efforts at reconciliation with Peking. Liberal backing, however, had come at the price of conservative opposition. For most people on the right, communism was an anathema with which free peoples could not live. They feared that détente and accommodation would lead not to a more peaceful world but to the defeat of democratic institutions at the hands of ruthless authoritarian regimes. They were astonished that Nixon, who had built his political career on uncompromising anticommunism, would now cozy up to Moscow and Peking.

Kissinger, by contrast, with his long-running connections to Harvard and Rockefeller moderates, was, in their view, part of the liberal foreign policy establishment. Many conservatives viewed his rhetoric about helping Nixon rescue U.S. foreign policy from the clutches of left-wing politicians and soft-minded government bureaucrats as an unconvincing cover for doing largely what a Democratic administration under

Hubert Humphrey would have done. In the summer of 1971, the rise of conservative opposition to the administration's foreign policy joined with ongoing difficulties in Vietnam, the Middle East, and Chile to cast shadows over the gains in dealings with Moscow and Peking.

Yet in retrospect, détente was not the product of a sellout to liberals or a president who had lost his moorings. It flowed naturally from earlier events and assessments of current realities. There was a long history of Soviet accommodation to the West between the 1920s and 1940s, followed by the Test Ban Treaty in 1963 that made détente in the 1970s less than unprecedented. More immediately, the growth of the Soviet nuclear arsenal in the sixties to levels comparable to the United States was a compelling argument for reining in Soviet-American hostility that could result in a mutually destructive nuclear war. As Nixon and Kissinger tried to make clear to conservatives, their China policy and development of MIRVs were fresh means of containing Soviet power, not giving in to it. In short, détente was foreign policy realism which guarded against national devastation and any sort of major Soviet victory in the Cold War.

Twenty years later, critics could argue against détente as an unnecessary policy that may have extended the life of the Soviet regime. But that complaint rested on the reality of Communist collapse. In the context of 1971, no one foresaw the Soviet demise in two decades. Sensible realism compelled accommodation to a superpower Russia that shared a capacity with the United States to produce a nuclear holocaust.

VIETNAM REMAINED Nixon's and Kissinger's greatest frustration. The war had become a national disaster, a constant irritant, and a divisive force in American life. At the end of March 1971, after a military court had convicted Lieutenant William Calley of premeditated murder in the My Lai massacre and sentenced him to life imprisonment, Nixon decided to confine him to barracks while Calley appealed his sentence. The court's decision and Nixon's action provoked criticism, adding to the unrelenting controversy that the White House dearly wished would go away. (In April 1974, Calley's sentence was reduced to ten years, and the secretary of the Army paroled him in November.)

A series of antiwar demonstrations following the Laos invasion also upset the president. In the spring of 1971, "that uneasily dormant beast of public protest—our nightmare, our challenge, and, in a weird way,

our spur—burst forth again," Kissinger recalled. When the future sena-
tor and Democratic presidential candidate John Kerry appeared before
the Senate Foreign Relations Committee, he called the war "the biggest
nothing in history," and famously said, "How do you ask a man to be the
last man to die for a mistake?"

The White House had no clear idea of how to combat the protestors.
"This fellow Kerry . . . was extremely effective," Nixon told Kissinger
and Haldeman. The plan was to do nothing that provoked a confronta-
tion with Vietnam Veterans Against the War. Pat Buchanan suggested
waiting until "the 'crazies' came to town. If we want a confrontation, let's
have it with them." They would be a more "advantageous enemy."

To disarm what the White House saw as some of its more reasonable
opponents, Nixon agreed to see college student leaders. The meeting left
him with a sense of hopelessness about changing minds. "It's just crap,
you know," he told Haldeman. "We have to sit and talk to these little
jackasses . . . Why don't I just . . . scratch all this crap, really, bullshit,
all these meetings, this therapy meeting with the little assholes . . . and
recognizing that we have a great crisis in this country in terms of under-
standing, recognizing that probably nobody can solve it."

Nixon thought he could afford to ignore the unreachable students,
but he couldn't be so casual about members of Congress, especially sena-
tors who were increasingly aggressive about pressuring the administra-
tion to withdraw from Vietnam. In seventeen House and Senate votes
between April 1 and July 1, some members of Congress wanted to set
a fixed date for U.S. military withdrawal. Nixon and Kissinger op-
posed these resolutions less because they saw them undermining South
Vietnam's survival than because they feared accusations that the Nixon
administration had a significant part in losing Vietnam.

By the spring of 1971, domestic pressure for U.S. withdrawal cre-
ated a heightened sense of urgency in the administration about ending
the war. At the end of April, Kissinger told the president, when I go
to China, "I will tell the foreign minister . . . we must get it [the war]
settled. That's why we wanted to meet with you secretly . . . get the war
in Vietnam over with." Nixon wanted Henry to tell Chou that "before I
get there [to China], the war has to be pretty well settled."

In the following week, Nixon told Haldeman that on the second an-
niversary of the start of troop withdrawals, which was coming up in June,

they had to "have some Vietnam movement . . . We have to move decisively and crisply for domestic reasons." Conditions in Congress made it imperative that they show some greater progress. Nevertheless, Nixon remained determined to do everything possible to back Saigon. "He's as hard line as he's ever been about running out the war on a proper basis as we see it," Haldeman said.

Prospects brightened a bit in May. The North Vietnamese asked Henry to return to Paris for a new round of talks at the end of the month. Moreover, Thieu advised Ambassador Bunker in Saigon that his army would soon be ready to fight without the support of U.S. troops. As Henry was about to leave for Paris, Nixon hoped for a breakthrough that would rid them of the war. When Kissinger reported that the journalist Marquis Childs said that "the Democrats look sick; all they talk about is Vietnam," Nixon responded, "You tell him Vietnam is finished . . . The main thing is what is going to happen to Russia, China, the Middle East and the economy of the U.S."

The hopeful notes struck by Nixon and Kissinger were wishful thinking. With the president's approval ratings falling below 50 percent, and 61 percent of the public declaring American troops in Vietnam a mistake and favoring their withdrawal by no later than July 1, 1972, Henry returned to Paris eager for any hint of a settlement. Nixon instructed Kissinger to make a "final offer," coupled with the warning that "time for negotiations is running out."

Kissinger carried a seven-point plan with him to Paris. It promised to set a date for total withdrawal of U.S. troops in return not for North Vietnamese withdrawal but a commitment to end infiltration into South Vietnam, Laos, and Cambodia. This was a major departure from earlier insistence on mutual commitments to end North Vietnamese and American involvement in the fighting. It reflected the Nixon administration's assessment that its drawdown of U.S. troops was depriving it of the capacity to compel Hanoi's departure from the South. Saigon's political future, which Hanoi had consistently demanded not include Thieu, was to be left to the South Vietnamese, who were slated to have national elections in the fall.

"Once again," Kissinger said, "the American and Vietnamese delegations faced each other [in a dingy living room] across a narrow strip of carpet and a chasm of misperception," which, Henry might have added,

was principally on his side. The North Vietnamese were unyielding in their conviction that they could outlast the Americans and take control of South Vietnam.

Hanoi's unbending attitude enraged Nixon. In a June 2 conversation with Kissinger and Haldeman, he banged his desk and threatened dire consequences if North Vietnam did not end the war soon. Nixon claimed that if he had been in office in 1966 and 1967, he would have committed sufficient resources to have won the war.

And if need be, he would do it now, or so he said in a private tirade. "If we don't get any Soviet breakthrough, if we don't get the Chinese, if we can't get that ensemble, we can't get anything on Vietnam, the situation is deteriorating—about November of this year, I'm going to take a goddamn hard look at the hole card . . . I'm not talking about bombing passes [or trails] . . . we're gonna take out the dikes, we're gonna take out the power plants, we're gonna take out Haiphong, we're gonna level that goddamn country! Now that makes me shout," Nixon said at the top of his voice while pounding his desk. Kissinger chimed in, "I think the American people would understand that." Nixon went on, "The point is we're not gonna go out whimpering, and we're not gonna go out losing."

With Xuan Thuy making public statements urging Congress to set a deadline on American withdrawal, Kissinger told Nixon on June 8, "I am seeing Dobrynin and I will lay it into him. Tell their little yellow friends to stop these games. We are not going down quietly." Kissinger spoke with Dobrynin on June 3, 7, and 21, but said nothing about Vietnam. Henry was covering his bets—he hoped additional Paris meetings at the end of the month might bring significant results, but if they didn't, he would remain in good standing with Nixon by supporting his emotional outbursts about decimating Hanoi.

On June 13, a new problem erupted over Vietnam. The *New York Times* began publishing excerpts of "The Pentagon Papers," a secret multivolume documentary history of the Vietnam War prepared at Robert McNamara's request. The publication of classified materials outraged the Nixon White House: Nixon and Kissinger agreed it was "treasonable" because "it serves the enemy." They thought it would further erode domestic support by revealing hidden actions under Kennedy and Johnson that had propelled the country into the conflict. Moreover, they feared

that additional debate and dissent would weaken Nixon's ability to pressure Hanoi into an honorable settlement.

The initial impulse, however, was to stand aside from the controversy. "I think our best bet is to keep clear," Haig told Haldeman. While it might undermine the war effort, it seemed unlikely to have any political impact on the Nixon White House. "If it keeps it in the headlines about eight years ago, this is not so bad," Haldeman said. Haig wanted press secretary Ron Ziegler to "take the position you inherited this thing," he told Nixon, "and you have been trying to wind it down." Nixon replied, "Yes, and to accomplish our goal. Let's say this is a fight with the Democratic party and we are not going to get into it."

Nevertheless, Nixon wanted "to be awful rough on the *New York Times* in terms of future leaks." He ordered Haldeman to put out the word that "under *no circumstances* is anyone connected with the White House to give any interview to . . . the *New York Times* without my express permission." But he wasn't ready to prosecute the *Times*: "My view is to prosecute the goddamn pricks that gave it to 'em," he told Erlichman.

After further consideration of what the publication of the Papers meant for the presidency and some prodding from John Mitchell and Lyndon Johnson, Nixon decided to seek an injunction against the *Times*'s additional release of government records. Bill Rogers thought the White House had to respond: "You can't wink at a violation of the law," he told Kissinger. Henry agreed. "It's an outrage," he said. "Inimical to the national interest. In Britain," where a national secrets act would have made it a crime, "no one would publish this."

Walt Rostow, LBJ's national security adviser, told Kissinger that "Johnson and all of us feel there's [a] serious matter for the fate of the country." They saw a threat to governmental power, and promised to support any legal action to stop further newspaper publications. Kissinger agreed with Rostow that it was up to Nixon to move against the *Times*. Henry told Nixon, "The press has no freedom to publish highly classified materials."

On June 15, Mitchell won a temporary restraining order against the *Times*. Nixon decided to file criminal charges. He saw two dangers to the government from the *Times*'s action. It jeopardized the executive's ability to get candid advice from aides, and made it more difficult to

deal with other governments. "The fact that some idiot can publish all of the diplomatic secrets of this country on his own is damaging to your image," Kissinger advised the president. "And it could destroy our ability to conduct foreign policy. If the other powers feel that we can't control internal leaks, they will never agree to secret negotiations." Nixon called Neil Sheehan, who was writing the *Times*'s stories, a "pluperfect son-of-a-bitch. We have to protect the integrity of the process of consultation and our relationships with foreign governments," he told the National Security Council.

The internal discussion now turned to the search for the source of the leak. It brought Kissinger under suspicion and jeopardized his standing with Nixon. If someone on Henry's staff were responsible, it would have destroyed the president's already shaky faith in the NSC and possibly made him reluctant to rely on Kissinger for the secret diplomacy he was conducting with the Vietnamese, Soviets, and Chinese.

Kissinger took pains to exonerate himself. On June 14, when Rogers briefed him on who had access to the Papers and pointed out that he was on a list to receive them, Henry said, "I never had it . . . I didn't know it existed." He defended himself by saying that he "thought Laird leaked it." But Rogers doubted that the leak had come from the government. Copies of the material were in the possession of several people outside the current administration. Relieved to hear this, Henry reiterated his innocence: "I didn't know the thing existed. I am certain I have never seen it."

The search for the culprit intensified on June 15. In conversations with Laird, Agnew, and Nixon, Kissinger echoed his concern that anyone would go public with such sensitive material, including Henry's role in the 1968 Paris negotiations. He repeated his ignorance of the existence of such a study and promised to help find the guilty party.

On June 16, the name of Daniel Ellsberg surfaced as the possible culprit. A former *New York Times* reporter mentioned him in a radio discussion as someone who had access to the documents and the motive as an antiwar activist. That afternoon, Henry Rowen, the head of the Rand Corporation in Santa Monica, California, where Ellsberg had copied the Papers, told Kissinger that suspicion had fallen on Ellsberg and that "his ex-wife is firmly convinced he is" the one. Ellsberg told his son that "he had done something at great risk, he was going to jail . . . His ex-wife is

concerned about his stability . . . I think it is more than possible that he is the source." Kissinger responded, "That is what I think, too."

If Kissinger was relieved to hear that the culprit had probably been identified, he was thrown on the defensive again the next day during a conversation with *Newsweek* reporter Henry Hubbard. Hubbard recounted a discussion with Ellsberg, who claimed that during a conversation at Nixon's San Clemente home Kissinger told him that there was a copy of the Pentagon Papers at the White House. "He is a liar," Kissinger said angrily. Although he did not deny meeting with Ellsberg in September 1970 at the California White House, Kissinger said, "He never talked to me about it. We have never had a copy at the White House. I can prove I didn't even know of its existence." Henry acknowledged that Ellsberg "is a brilliant guy," and that he had asked him in 1969 as a former Pentagon official and architect of the war to join six other analysts in writing a National Security Decision Memorandum (NSDM) on our options in Vietnam.

Despite his denial, Kissinger was eager to keep his ties to Ellsberg quiet. Henry wanted to know how important it was for Hubbard to mention their connection. Hubbard doubted that the magazine would want to get into too much detail on Ellsberg's background, but he cautioned, "You are liable to get involved."

The ties to Ellsberg renewed Kissinger's fears of an unwelcome impact on his credibility with the president. Consequently, when he saw Nixon on June 17 and they discussed Ellsberg, Henry said, "That son-of-a-bitch. I know him well. He is completely nuts . . . He always seemed a little bit unbalanced." Henry also called him "a genius . . . one of the most brilliant men I ever met."

Much of the June 17 taped conversation remains embargoed, but Haldeman, who was present, said that Henry gave a "premier performance," an outburst which exceeded anything he had ever before seen from him. He leveled charges against Ellsberg that went "beyond belief," assertions that he was a drug addict, had sex with his wife in front of his children, and shot at innocent peasants from a helicopter while in Vietnam. Erhlichman, who was also at the meeting, remembered Kissinger's saying that Ellsberg was "a fanatic, known to be a drug abuser and in knowledge of very critical defense secrets of current validity, such as nuclear deterrent targeting." Erlichman took away the impression that

Ellsberg was "a very serious potential security problem beyond theft of the largely historical Pentagon Papers." It echoed what Henry had already said to Nixon in front of Charles Colson. Colson remembered his saying that Ellsberg was "the most dangerous man in America today" and had "to be stopped at all costs."

"By the end of the [June 17] meeting, Nixon was as angry as his foreign affairs chief. The thought that an alleged weirdo was blatantly challenging the president infuriated him," Haldeman recalled. Nixon told Kissinger that "any intellectual is tempted to put himself above the law," especially if they were "Eastern schools or Berkeley." Kissinger did not dispute Nixon's characterization of leading intellectuals. Nixon felt "strongly that we've got to get Ellsberg nailed hard on the basis of being guilty of stealing the papers. That's the only way we are going to make the case of the press having done something bad and having violated the law in publishing stolen documents." As for the press, he said, "Goddamn newspapers—they're a bunch of sluts." Nixon told Henry, "I don't give a goddamn about repression, do you?" Neither did Henry, who said, "No."

Kissinger makes no mention in his memoirs of his attacks on Ellsberg. He rationalized going after him and the *Times* based on a current conviction that the publication of the Papers jeopardized the ongoing negotiations with Hanoi; it might be convincing the North Vietnamese that they didn't have to settle with the United States because Nixon had no recourse but to capitulate to their demands. "I do not believe now that publication of the Pentagon Papers made the final difference in Hanoi's decision not to conclude a settlement in 1971," Kissinger wrote in 1979. "But neither those who stole the Papers nor the government could know this at the time." It is an unconvincing argument. Hanoi did not need the publication of the Papers to convince it that the public, press, and Congress were fed up with the war and wanted out under almost any terms as soon as possible.

Later in June 1971, as Kissinger was about to return to Paris for another meeting with the North Vietnamese, Nixon doubted its good results. But not because of the Pentagon Papers, which the Supreme Court decided on June 30 the *Times* had a First Amendment right to continue publishing. Rather, the opposition to the war was made abundantly clear by the passage on June 22 of the Mansfield Amendment to a Senate bill:

It called for a mandatory withdrawal of U.S. forces from Indochina nine months after the bill's enactment and an end to all military operations after the release of all American POWs. The vote on the amendment was 57 to 42, which the White House saw as "pretty strong" and a victory for the antiwar forces.

The amendment enraged Lyndon Johnson, who, Haldeman reported to the president, said "I'm going to do everything I possibly can to beat the dirty rotten sons of bitches in 1972." LBJ called Clark Clifford, his defense secretary, who had turned against the war, a "silly motherfucker." Nixon complained that talking to congressmen was "the most miserable thing I deal with." They are "spineless, incompetent people." But he refused "to be all depressed about it." In a conversation with Mansfield, he told him that they had ongoing secret negotiations and that "this action of the Senate may have destroyed it." He warned him that the failure of negotiations would likely force him to bomb "the hell out of them."

Mansfield's Amendment discouraged Nixon's and Kissinger's hopes of a positive response from Hanoi. Henry "got very cranked up about it," Haldeman noted, "because . . . it will mean not much chance for his negotiations in Paris." Henry called the amendment "the most irresponsible performance I have ever seen for public short-term political gains." Since the Communists were currently thinking things over, he told Kansas Republican Senator Robert Dole, "this is not the time for us to be put under more heat. These people [the Democratic senators] are prolonging the war."

Henry "is very depressed about what's happened," Nixon told Haldeman. "I just had to buck him up. I said, 'It's going to come out all right. These boys [senators] have total disregard about national security. There's nothing you can do about it. They're going to pay a price.' "

Henry saw a drawback to keeping his Paris talks secret. If he could have revealed the administration's peace proposals, it might have reined in the Senate, created stronger domestic support for the president in the negotiations, and made the North Vietnamese more forthcoming. But he wasn't sure, and secrecy, including the imminent trip to China, was now so much a part of how he and Nixon had operated for over two years that it seemed all but impossible to abandon.

Nixon now considered aborting Kissinger's stop in Paris and "flushing the whole deal." He told Henry, "This is it; he's got to get it settled."

If he didn't, Nixon intended to end the negotiations and publicly blame it on Mansfield and the other fifty-six senators who voted for his amendment. Nixon said he had a plan for leaving Vietnam should the negotiations fail. He would rely on "a total bombing of the North to eliminate their capability of attacking." Since air attacks on the North between 1965 and 1968 had had a limited impact on Hanoi's offensive capabilities, it is difficult to understand Nixon's reasoning. He was undoubtedly thinking about targets such as the Red River dikes and more massive assaults on Hanoi and Haiphong. But this risked unwelcome U.S. domestic turmoil similar to the aftermath of the Cambodian incursion.

Nixon and Kissinger were relieved to find that Hanoi was more pliant in the latest round of talks Henry had with Le Duc Tho and Xuan Thuy in Paris on June 26. Henry sent word to the president through Haig that "this was the most serious session they had had." Nixon wanted to know if the North Vietnamese seemed affected by "the Senate action." Haig didn't think that came up. "It was all businesslike—not propagandistic. That was what surprised Henry." Although "he was enthusiastic about the tone," Kissinger was still uncertain about "where it would lead."

Eager to keep the negotiations going until 1972, when they believed electoral pressures would force Nixon into a settlement, Hanoi gave the appearance of flexibility in the talks. The ploy worked. "There is nothing we lose by waiting right now," Kissinger advised the president. Nixon agreed and told Kissinger: "Time to give in, Henry . . . We fought for years, we went through Cambodia, we've gone through Laos . . . Let's face it. We've done [what we could]. And now? Who knows?"

With Kissinger set to leave on his Asian trip on July 1, he and Nixon agreed to craft a response to Hanoi after he returned. That day, however, the North Vietnamese published a new proposal calculated to appeal to U.S. public opinion. They would exchange American POWs for the withdrawal of U.S. forces, and called for a cease-fire and an end to the war. Mindful that Hanoi's plan would win a positive response in the United States and abroad, the White House publicly described it as having good and bad points, but that Hanoi would do better to "conduct these negotiations within the established forums."

In private, Nixon and Kissinger fumed at being unable to reveal the contradictions between Hanoi's private and public statements. Its pretense at being flexible rather than unbending in its demand for an

unconditional U.S. departure was hidden from public view. Nixon suggested canceling an upcoming meeting Bruce was scheduled to have in Paris. But Kissinger thought it would be better to go, "blister them, tell them at the next leak the channel is closed." Nixon instructed Henry to advise the Chinese that he would protect U.S. interests in dealing with Vietnam and that unless there was a settlement he would have to resort to harsh measures. Bruce was instructed to give the Vietnamese a tough response without completely rejecting their proposals.

At the same time, Nixon bombarded Kissinger and other associates with strong talk about the Pentagon Papers and Vietnam, which was aimed more at making Nixon feel good than compelling effective action. On June 29, after Ellsberg had surrendered to authorities, Nixon told his cabinet that the government was full of "well-intentioned sons of bitches . . . who . . . are out to get us . . . We've checked and found that 96 percent of the bureaucracy are against us; they're bastards who are here to screw us." Ellsberg thought he was serving the country, but he had betrayed America like Alger Hiss and the Rosenbergs had. Nixon said he intended to "prosecute" Ellsberg.

On June 30, after the Supreme Court handed down its *New York Times* decision, Nixon ordered Colson to "do whatever has to be done to stop these leaks . . . This government cannot survive, it cannot function if anyone can run out and leak." He told Kissinger, Haldeman, and Mitchell not to "worry" about Ellsberg's trial. "Try him in the press . . . We want to destroy him in the press." He reminded them of the Hiss trial and reminisced about how he had leaked everything and got "Hiss convicted before he ever got to the grand jury." The hypocrisy of leaking to punish leakers didn't seem to occur to him. As for the *New York Times*, he said, "Those sons of bitches are killing me . . . We're up against an enemy, a conspiracy. They're using any means. *We are going to use any means.* Is that clear?" he asked, doubtful that they would take his ramblings all that seriously.

But they did. In August, when Erlichman told the president that he could arrange "a black-bag" job or break-in of Ellsberg's psychiatrist's office in Beverly Hills, California, to get the information needed to smear him in the press, Nixon wanted the operative to "do whatever he considers necessary to get to the bottom of the matter—to learn what Ellsberg's motives and potential further harmful action might be." In September, a

team of burglars rifled the psychiatrist's files, but found nothing on Ellsberg. "We had one little operation. It's been aborted out in Los Angeles," Ehrlichman told Nixon, "which, I think, is better that you don't know about."

As Kissinger traveled to Vietnam, India, and Pakistan on his way to China, Nixon besieged him with "missives . . . to toughen up our stance in Paris and bring matters to a head." The hallmark of his approach to the negotiations was "ambivalence." He deluged Kissinger with "tough-sounding directives not always compatible with the plan, and some incapable of being carried out at all. The reason may have been his unease with the process of compromise or the fear of being rejected even in a diplomatic forum," Kissinger later wrote.

It is difficult to understand how anyone could work for someone as volatile and irrational as Nixon sometimes was. Most likely, Kissinger and others rationalized their collaboration as helping to save Nixon from himself. After all, he was a democratically elected president and they saw themselves as serving the national well-being by reining him in. Yet what seems so striking in the record is how often the people around Nixon catered to his outbursts and flights of fancy rather than calling him back to reality by challenging some of his most unsavory and unenforceable demands. It was a way to remain at Nixon's side but it was a disservice to sensible policy making. It also speaks volumes about the reluctance of high government officials to alienate a president and perhaps force their departure from an office they believe gives them the chance to shape history-making events.

On his way back from China, Kissinger traveled through Paris, where he secretly met again with the North Vietnamese on July 12. The preludes to the talks were familiar. Nixon, emboldened by the likelihood of improved relations with Peking, pressed Henry in "graphic and bloodcurdling terms" to demand a prompt settlement of the war. Convinced that only secret exchanges would allow for a prompt agreement, Henry, code-named General Kirschman, sneaked out the backdoor of the ambassador's residence, where he slouched down in General Vernon Walters's car, wearing a hat as a disguise. They drove to the North Vietnamese safe house for additional talks in the living room furnished with a rectangular table covered by a green cloth.

The pluses in the exchanges seemed to outweigh the minuses. The

North Vietnamese were eager for "serious negotiations," Kissinger told the president. "They repeatedly stressed—in an almost plaintive tone—that they wanted to settle the war." They seemed ready to agree on a cease-fire, a return of prisoners, a withdrawal date, and the neutralization of Laos and Cambodia.

The sticking point was U.S. resistance to abandoning the Thieu government. But even here, the North Vietnamese showed some flexibility. They saw Thieu's continuing presence in Saigon as making a settlement "difficult" rather than "impossible," as they had previously said. Kissinger saw "a better than even chance that they will shift their position on the political issue and will do it by the next meeting," which they agreed should be on July 26.

The meeting on July 26 was another disappointment. While the Vietnamese went "far toward our position on all non-political points," they stubbornly clung to the demand that we oust Thieu, if need be by some "conspiratorial device" rather than the electoral process slated for the fall. As Henry interpreted it, control of South Vietnam, for which they had sacrificed so much, would elude them if Thieu, bolstered by Vietnamization, remained in power. The North Vietnamese promised to study our position further over the next three or four weeks, but Henry was uncertain whether they had "the imagination and confidence to go our way." Also, they made clear that America's new relationship with China would have no significant effect on the bilateral talks. The only certainty, Henry told Nixon, was that they would have to give a definitive response at the next meeting, which would be on August 16.

As they waited for the August 16 meeting, Nixon and Kissinger agreed to remain quiet about prospects for peace. At an August 4 news conference, however, Nixon declared that eventually critics of his policy would see that the United States had gone and was "going the extra mile on negotiations in established channels." He assured the press that we were not missing any opportunities to reach a settlement.

Public statements by Hanoi "blasting" Peking for its dealings with the United States raised doubts about the likelihood of a breakthrough. A North Vietnamese buildup at the DMZ further troubled Nixon and Kissinger. The concerns were borne out at the August 16 meeting. Le Duc Tho's absence from the talks immediately signaled that nothing would be settled. Thuy began his presentation on "a very hard note," complaining

that we had escalated the conflict with new air raids. Kissinger "replied in the toughest language he had ever used with them, accusing Thuy of having brought me there under false pretenses." It quickly became clear that they remained at an impasse over U.S. unwillingness to abandon Thieu.

"Despite the absence of a breakthrough," Henry agreed to meet with them again in a month. He explained his decision to Nixon as a way to continue to maintain a channel in case they decided to settle; and to keep them from escalating the fighting during South Vietnam's electoral campaign. "We have nothing to lose," Henry concluded, "except my 36 hours of inconvenience, and we achieve nothing by backing off now." Although Nixon resisted, wishing "to break off the increasingly sterile contacts," Kissinger "just managed to persuade him" to go along with "the flicker of hope" tied to another session.

Kissinger's memo and recollections in his memoirs of the Paris exchanges and Nixon's response do not entirely square with the transcript of a telephone conversation he and Nixon had fifteen minutes after Kissinger returned to Washington at 10 P.M. on August 16. Nixon was in an exuberant mood. His speech the previous night on a domestic economy plagued by increasing unemployment, inflation, and a falling dollar had won a positive response. Kissinger was fawning in his praise: "We stirred them up a little," Nixon said. "It was absolutely spectacular!" Kissinger exclaimed. "The thing that's so interesting about your style of leadership is that you never make little news, it is always big news . . . You are a man of tremendous moves." It was essentially a repeat of what Kissinger often said to buck up and ingratiate himself with Nixon. "Mr. President," Kissinger told him, "without you this country would be dead."

As for the Paris talks, Kissinger conceded that they were "essentially a holding action." But he brimmed with optimism: "I think we are moving toward a settlement," he declared. He recounted how "absolutely brutal" he had been with Thuy, saying "it is absolutely a waste of time to talk to you . . . you don't have any instructions." Henry made his case for another meeting by promising that if nothing happened in September, "that will be it." He predicted that Hanoi would settle in November after the South Vietnamese elections. "They have no place to go." Kissinger also suggested to Nixon that he let him secretly go to Hanoi. But Nixon wanted no part of what he called "Henry's delusions of grandeur

as a peacemaker." Nixon didn't think it would work and would become known, which "would be a disaster."

Nixon, however, did not resist Kissinger's agreement to return to Paris in September. He was drawn to the possibility that he could follow an announcement in October of a forthcoming Moscow Summit with a triumphant declaration in November of peace in Vietnam. Both men had personal stakes in ending the war. Not only would it fulfill domestic and international hopes for peace in Southeast Asia but it would also be counted as their personal triumphs. For Nixon, it could mean assurance of his reelection, and for Kissinger, it would be considered the product of his negotiating skills and personal diplomacy. There was too much at stake for the country, the world, and themselves to abandon even the slightest hope that additional meetings could end America's longest and most disastrous war.

The North Vietnamese continued to see reasons to draw out the negotiations. They hoped that in return for ending the war and the repatriation of POWs, the Americans could be drawn into abandoning Thieu and acquiescing in Hanoi's takeover of the South. As long as Kissinger agreed to continue the talks, the Vietnamese harbored hopes that the Americans would give in on the political issue. In August and September, after Thieu's political rivals dropped out of the presidential race, Hanoi assumed that U.S. embarrassment at "a rigged election" would make Nixon more receptive to abandoning Thieu.

But the president and Kissinger were still determined to back Thieu. They declared developments in the South Vietnamese election an internal matter in which we would not interfere. If we turned on Thieu, Henry told the president, we would do for the North Vietnamese "what they could not accomplish themselves, namely, overthrow the South Vietnamese Government." Nixon rationalized support of Thieu by stressing that abandoning him would irreparably damage "the whole structure of stability in Asia." Henry agreed. But domestic political pressure was also a consideration. Dropping Thieu would compound Nixon's difficulties with conservatives, who were already put off by his openings to China and Russia.

In September, after former ABC diplomatic correspondent John Scali, who had taken a public relations post at the White House, saw South Vietnamese Ambassador Bui Diem, he reported his conversation to Kissinger. Diem was deeply discouraged by political developments in

Saigon and was considering a trip home to urge Thieu to make the election more democratic. "I told Henry, as he was standing in his anteroom, 'The Vietnamese Ambassador seems quite unhappy.' Henry looked at me, snorted and walked away without a word."

When Henry met with Xuan Thuy in Paris on September 13, Le Duc Tho was absent again. That meant that nothing productive would come out of the discussion. The meeting lasted only two hours, the shortest Henry had with the North Vietnamese. No doubt feeling emboldened by the latest turmoil in Saigon over the election slated for October 3, Thuy spouted familiar homilies about the need for a change in South Vietnam's government. The only agreement was to reopen the talks if and when either side had something new to offer.

The stalemate provoked fresh recriminations in the United States. When the *Washington Star* published a Pentagon leak on September 14 saying that all U.S. troops would be withdrawn from Vietnam by the coming spring, Nixon and Kissinger were beside themselves with anger. Because General Creighton Abrams in Saigon was viewed as a possible source of the story, Nixon and Kissinger considered recalling "the son-of-a-bitch." But fearful that it would look like the collapse of American resolve, Nixon suggested getting someone "second in command that will keep him from drinking and talking too much." Kissinger called Joint Chiefs Chairman Admiral Moorer to read him the riot act. "The President just called me for the third time screaming," he said. "No military officer is to say one goddamn word about withdrawals."

On September 18, Kissinger sent the president a long memo on Vietnam. He was preaching to the choir when he warned against giving in to Hanoi. It would provoke a crisis of confidence in the United States and around the world, where friends and foes would see us as abdicating our responsibilities. Henry wanted to make yet one more try at a negotiated settlement. He suggested offering Hanoi an election six months after a peace agreement was signed. Thieu would leave office one month before the vote and an international commission would supervise the election, which would be open to all parties, including the Communists. Nixon agreed to Henry's proposal on September 20 and Thieu followed suit three days later. Hanoi rejected it. It remained convinced that U.S. domestic divisions would force an American withdrawal before Nixon had to face the electorate in November 1972.

The North Vietnamese refusal to reach a settlement did not entirely discourage Kissinger. He saw a faint hope in the stalemate. In late August, he described the war to Haldeman as "a real heartbreak . . . because we really won the war, and if we just had one more dry season, the opponents [the South Vietnamese] would break their backs. This, of course, is the same line he's used for the last two years, over and over," Haldeman confided to his diary, "it's amazing how it sounds like a broken record."

The administration's many critics in the Congress and the press disagreed with the Nixon-Kissinger resistance to ending the war promptly and leaving South Vietnam to its fate. They saw a continuation of the conflict as doing more to undermine the country's confidence in itself than additional pointless fighting and loss of life, American and Vietnamese. Nor did critics believe that many people at home or abroad would complain that the United States was shirking its duty. American sacrifices in blood and treasure for Vietnam were already more than any reasonable person could have expected the United States to make. Moreover, critics predicted that other governments would view the United States as coming to its senses by closing out the war rather than complain that we could not be trusted to combat future Communist threats. They wanted the administration to follow Vermont Senator George Aiken's prescription, "Declare victory and leave." Nixon's "peace with honor" was an equally acceptable disguise for American defeat.

ALTHOUGH THE MIDDLE EAST was less in the public eye than the administration's struggles over Vietnam, it remained a daunting problem which seemed even more impenetrable than the difficulties with Hanoi. In the spring and summer of 1971, the White House found itself unable to do anything right in the region. "Frankly, Bill, nothing really can happen there," Nixon told Rogers in April. The deadlock would have to become apparent to all parties before they would enter into serious talks, Nixon and Kissinger agreed.

In September, when Nixon saw Gromyko, the Soviet foreign minister urged the president to exert America's considerable influence over Israel. Nixon reminded him of "an old Hebrew proverb which, in discussing the question of which sex was stronger, pointed out that God had created Adam out of soft earth and had then created Eve out of Adam's

hard rib. If the Minister had ever met Golda Meir," Nixon said, "he would recognize the truth of this saying."

Like the Middle East, Chile remained a source of concern and frustration to the president and Kissinger. After Allende's assumption of the presidency on November 3, 1970, the administration used economic and covert political actions to weaken him. The White House put up "an invisible economic blockade" of Chile, "intervening at the World Bank, IDB [Inter-American Development Bank], and Export-Import bank to curtail or terminate credits and loans." In August 1971, when the president and board vice chairman of Anaconda Copper asked Kissinger to support international credits for Chile if they provided fair compensation for expropriations of copper companies, Kissinger refused. "If we agree to open up international credits," Henry said, "we may just be speeding up the process of establishing a communist regime in Chile." Foreign aid to Chile from U.S. government agencies and international institutions fell by 70 percent from $29.6 million in 1970 to $8.8 million in 1971.

At the same time, the administration stepped up anti-Allende covert operations. Although a National Intelligence Estimate in 1971 predicted that Allende "had a long, hard way to go" to establish a Marxist regime in Chile, which "was not inevitable," and a state department intelligence report concluded that Allende was not providing financial aid or training to export insurgency, the CIA engaged in extensive covert operations against him. The administration increased spending from $1.5 million in 1970 to $3.6 million in 1971 on anti-Allende economic and political measures.

In public, Nixon gave no hint of U.S. determination to control Chile's internal political developments. On December 30, 1970, when he granted an interview to Chile's departing ambassador, a member of Frei's Christian Democratic party, Nixon declared "that the U.S. was not concerned with the internal system selected by the people of Chile"; only "the present Allende foreign policy was of concern to this country."

The covert efforts to weaken and impede Allende's domestic policies were initially unsuccessful. Despite U.S. opposition, Allende expropriated and redistributed foreign holdings. On November 30, 1970, after reading a CIA analysis of conditions in Chile, the president told Kissinger, "Korry put his chips on the Christian Democratic party—and so did state—that was a mistake." Henry replied, "State didn't put the chips

on anybody. The consequences are that we have suffered a major defeat in Latin America."

Korry, who remained as ambassador in 1971, was a concern to them. In December, the state department told him that he was being recalled without a promise of another appointment. During a visit to the United States, Korry went to see Henry Raymont, a former colleague at UPI, at the *New York Times*. Raymont remembers Korry as agitated, pacing up and down. Korry then described his dismissal to Kissinger as "terribly unsettling." Henry tried to soften the blow: " 'Of course, and you don't deserve it.' 'I don't know where I go from here . . . with four kids,' " Korry added. " 'You don't deserve to have to panic, and don't,' " Henry reassured him. "We will do what we can . . . I am prepared to intervene."

More than compassion was at work in Kissinger's promise to help Korry. In February, Haig warned Kissinger that "we must be very cautious in our dealing with this individual who has the ability and fund of knowledge to stir some embarrassing speculations in the months ahead. His own background and demonstrated emotionalism in the past would suggest that we must continue to be very cautious both in our communications with him, and, more importantly, in considering his future."

In March, Haig reported his concerns "about the future status of Ambassador Korry." It was worrisome: "He holds a great many secrets, including the fact that the President both directly and through you communicated to him some extremely sensitive guidance," Haig wrote Kissinger. "I can think of nothing more embarrassing to the Administration than thrusting a former columnist who is totally alienated from the President and yourself, as well as the Secretary of State, out into the world without a means of livelihood." It seemed essential to offer Korry "a suitable alternate assignment."

The following day, Kissinger carried Haig's concerns to Rogers. "I am worried that [Korry] is dangerous," Henry told Rogers in a phone conversation. "We ought to find some job for him. I am terrified of his knowledge of some of these considerations in the 40 Committee [which planned secret operations] and what he will do when he is defected. I don't like him; he has been a disaster there . . . He sat in on two 40 Committee meetings when we discussed [Chile's] parliamentary ratification. He sent a long back channel of what to do. He is nutty enough to write a long exposé. He is broke, too."

In May, Nixon directed that Korry be offered a "prestigious" post, "though not necessarily substantively important." Although Rogers described him to Kissinger as "crazy," he agreed to "find a place for him." In July, the White House announced that Korry would be replaced in Santiago in the fall and would be assuming another ambassadorial position. When Korry was still without a new assignment in January 1972, state was told to "get him a good position. I believe this is essential as does Henry," Haig wrote a White House aide. But Korry did not receive another appointment and found a job in the private sector.

The problems with Chile and the Middle East were more an irritation in the fall of 1971 than a crisis. True, Vietnam remained a constant and painful concern, but Nixon and Kissinger were not without hope that they could force a settlement before the elections in November 1972. The big news for them was that they had achieved breakthroughs in their dealings with China and Russia and could look forward to significant additional gains in the coming year.

1. Nixon with his three brothers, Harold, Donald, and Arthur. The deaths of Arthur and Harold cast a shadow over Nixon's early life.

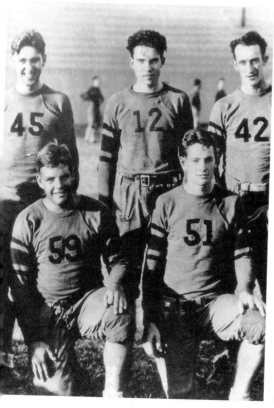

2. Nixon as a member of the Whittier College football team. His campus activism, including elections to student offices, foretold a political career.

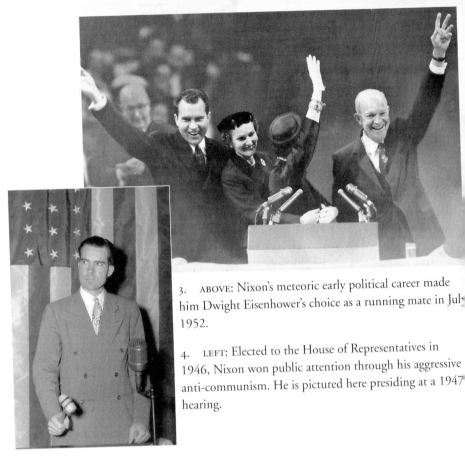

3. ABOVE: Nixon's meteoric early political career made him Dwight Eisenhower's choice as a running mate in July 1952.

4. LEFT: Elected to the House of Representatives in 1946, Nixon won public attention through his aggressive anti-communism. He is pictured here presiding at a 1947 hearing.

5. Eight years after losing to John F. Kennedy in 1960, Nixon won the presidency in a close race with Lyndon Johnson's vice president, Hubert Humphrey. He is pictured here campaigning in 1968.

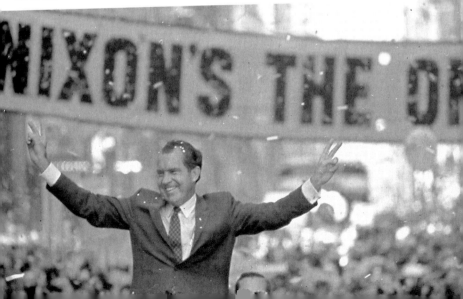

Kissinger, at age 11, with his younger brother, Walter, and their parents. They fled Ger-
many in 1938, finding refuge in America from Nazi persecution of Jews.

Kissinger's brilliance won him a tenured professorship at Harvard. He taught his last class
December 1968, before joining the Nixon administration as National Security Adviser to
President.

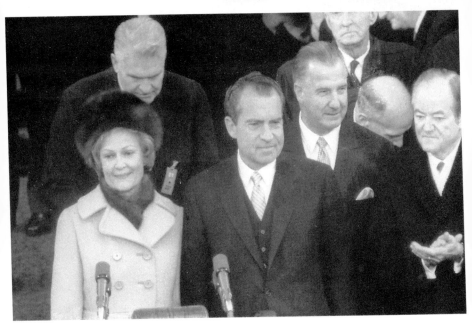

8. Nixon, vice president Spiro Agnew, and Humphrey at Nixon's January 20, 1969, inauguration.

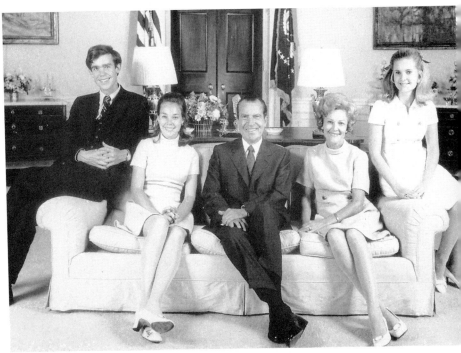

9. Nixon's family—David and Julie Eisenhower, Pat, and Tricia—pictured here in Jun 1969, was an anchor in the president's tumultuous presidency.

10. H.R. (Bob) Haldeman, Nixon's chief of staff, insulated the president from unwanted distractions that limited his attention to foreign policy, his chief White House concern.

11. John Erhlichman, Nixon's White House counsel responsible for domestic programs, reinforced Haldeman's efforts to keep domestic issues from eclipsing foreign policy.

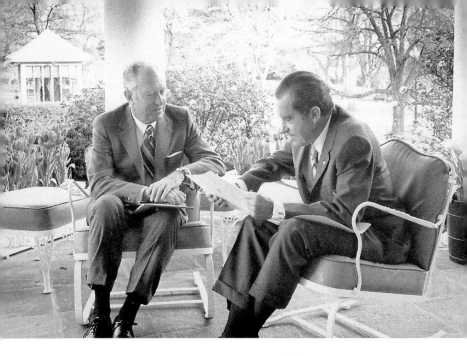

12. ABOVE: Although Nixon kept him as secretary of state until September 1973, William Rogers was more a figurehead than a significant player in the making of foreign policy.

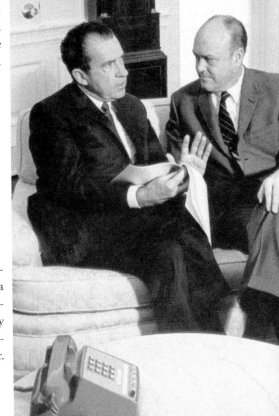

13. RIGHT: Secretary of Defense Melvin Laird also took a backseat to Nixon and Kissinger in setting defense policy generally, and fighting the Vietnam War in particular.

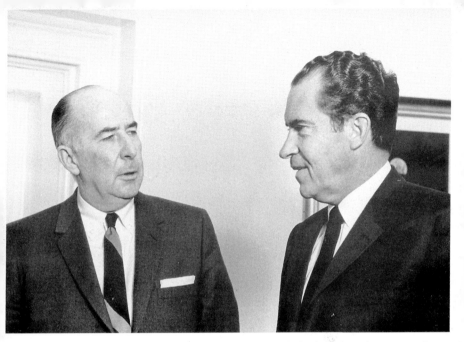

14. Attorney General John Mitchell was Nixon's principal adviser on domestic politics, and left the cabinet to run the president's 1972 reelection campaign. He was a principal figure in the Watergate scandal.

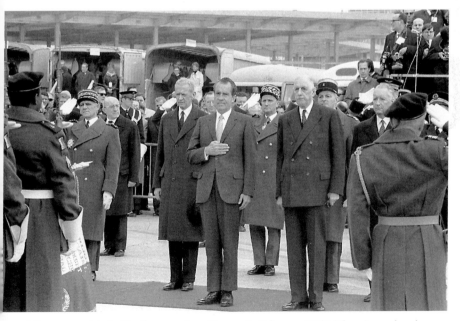

15. Nixon met with de Gaulle on a trip to Europe in February 1969. The trip, and exchanges with the French president, were meant to demonstrate Nixon's mastery of world problems.

16. In 1969, Israeli Premier Golda Meir was held at arms' length by Nixon, who saw Middle East problems as a distraction from ending the Vietnam War and altering relations with China and the Soviet Union.

17. Nixon met with South Vietnam's president, Nguyen Van Thieu, in the summer of 1969. Thieu, who wanted assurances of his country's survival, was as much a problem for Nixon and Kissinger in trying to end the Vietnam War as were the North Vietnamese.

18. Ambassador Anatoly Dobrynin, pictured here with Kissinger, was the White House's back channel to the Kremlin.

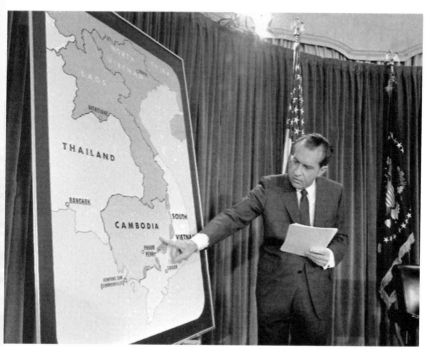

19. On April 30, 1970, after an explosion of public opposition, Nixon used a national TV address to justify the Cambodian invasion as sure to shorten the Vietnam War.

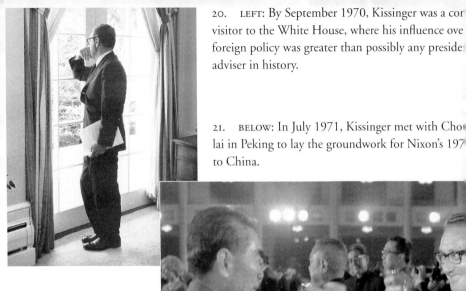

20. LEFT: By September 1970, Kissinger was a con[...] visitor to the White House, where his influence ove[...] foreign policy was greater than possibly any preside[...] adviser in history.

21. BELOW: In July 1971, Kissinger met with Cho[...] lai in Peking to lay the groundwork for Nixon's 197[...] to China.

22. LEFT: In November 1971, India's Prime Minister Indira Gandhi met with Nixon at the White House to disarm his hostility toward her country's dealings with Pakistan. It failed to avert what became known as the tilt toward Karachi in the December Indo-Pakistan war.

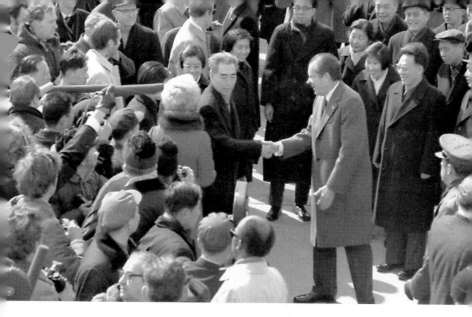

23. ABOVE: In February 1972, Nixon ended 25 years of Sino-American hostility by visiting Peking and establishing a new relationship with Communist China. He and Chou En-lai underscored the change in relations with a very public handshake.

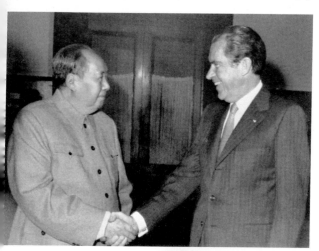

24. LEFT: Nixon and Mao Tse-tung found common ground during the president's visit on implicit agreement to check Soviet power.

25. RIGHT: In May 1972, Nixon met with General Secretary Leonid Brezhnev in Moscow to sign arms control and trade agreements

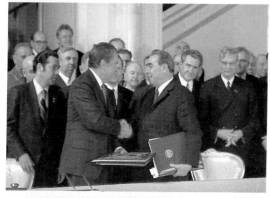

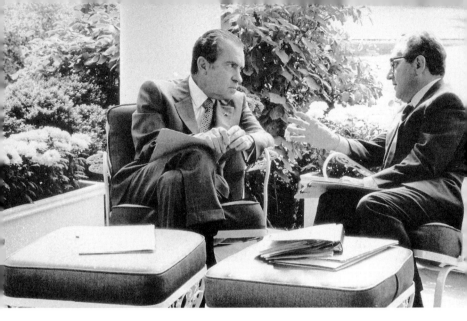

26. By September 1972, Kissinger was not only Nixon's indispensable counselor on foreign policy but also a considerable asset in the president's reelection campaign.

27. On October 26, 1972, after three years of tortuous negotiations with the North Vietnamese in Paris, Kissinger misleadingly announced at a Washington press briefing that peace was at hand. Al Haig, his principal deputy, stands with arms folded to Kissinger's right.

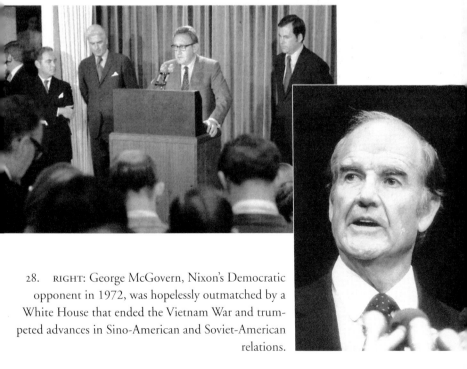

28. RIGHT: George McGovern, Nixon's Democratic opponent in 1972, was hopelessly outmatched by a White House that ended the Vietnam War and trumpeted advances in Sino-American and Soviet-American relations.

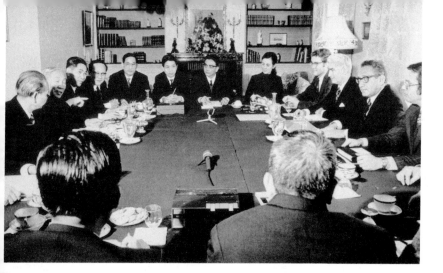

29. Kissinger had to return to Paris in January 1973 to complete peace discussions after America's "Christmas bombing" had forced Hanoi into a settlement.

30. Because the war continued in muted form, Kissinger traveled to Hanoi in February 1973 to try to persuade North Vietnam's Prime Minister Pham Van Dong that agreeing to South Vietnam's autonomy would serve his country's long-term interests.

31. In April 1973, Nixon met with Thieu in California as a way to boost his regime and encourage continuing opposition to Hanoi in Saigon.

32. In July 1973, a Brezhnev-Nixon meeting in California was a way to advance détente and bolster Nixon's image as essential to U.S. national security at a time when he was losing public support because of Watergate.

33. LEFT: In September 1973, Nixon made Kissinger secretary of state. It was not only a way to reward his achievements as national security adviser but also a means to insulate Nixon from Watergate criticism.

34. RIGHT: Shortly after becoming secretary of state, and nine years after his divorce from Ann Fleischer, Kissinger married Nancy Maginnes, a socialite who had worked for Nelson Rockefeller.

35. After the outbreak of the Yom Kippur War in October 1973, Kissinger negotiated a settlement with the Egyptians (above) and the Israelis (below).

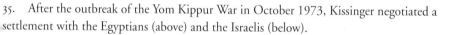

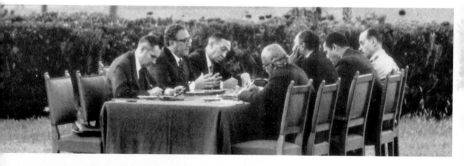

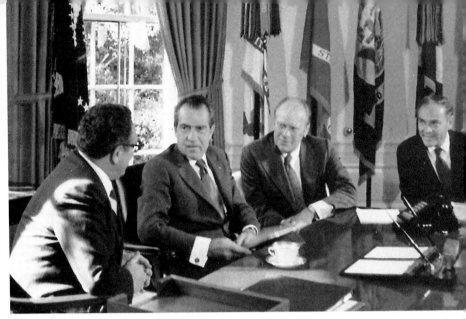

36. In October 1973, Nixon, Kissinger, and Al Haig, who had replaced Haldeman as chief staff, met with Gerald Ford to discuss his appointment as vice president.

37. ABOVE: In June 1974, in a desperate attempt to rescue his presidency, Nixon and Pat flew to the Middle East, where he met with Sadat, among others.

38. RIGHT: On August 9, 1974, threatened with impeachment, Nixon became the only president to resign from office. His departing gesture from the door of a helicopter put a false face on his ruined presidency.

DÉTENTE IN ASIA: GAINS AND LOSSES

In the Indo-Pakistan war, we have turned "disaster into defeat."

—KISSINGER TO NIXON, DECEMBER 16, 1971

Every visit to China was like a carefully rehearsed play in which nothing was accidental and yet everything appeared spontaneous.

—KISSINGER, *White House Years*

Nixon entered the fall season of 1971 in an upbeat mood. The Summit meetings in Peking and Moscow scheduled for the first half of 1972 moved him to tell Colson, "International affairs is *our* issue." If he were to be reelected, it would be because of foreign policy gains. In particular, détente with China and the Soviet Union seemed likely to help end the Vietnam War, and, more important for the long run, substantially reduce Cold War tensions. "Our goal today," Nixon told a meeting of organized labor in a November speech, "is to win a peace that will end wars and that goes beyond . . . ending the war that we are in." It was a restatement of Nixon's Wilsonian vision. Unlike so much

else in Nixon's public life, this rhetoric was not at variance with his private beliefs.

Vietnam remained a dark cloud over the administration's promises of improved international relations, but Nixon's pronouncements in the autumn about bringing home the troops and ending the war could not have been more optimistic. A draft extension bill in September 1971 that allowed him to maintain a significant force in Vietnam contradicted his declarations on an early end to the conflict. Instead, he emphasized that a commitment to strong armed forces gave him the wherewithal "to negotiate for peace in this critical period."

He and Kissinger remained confident that they could force a settlement. On September 30, when Henry met with Gromyko, he said, "we were now in the last phase of the war and we were determined to end this one way or the other." He predicted that peace would come in the winter of 1971–1972 as a result of America's unilateral action, meaning a massive military campaign to end the conflict, or through negotiations. He tried to pressure Gromyko by declaring that the unilateral course would risk détente and a conflict between the U.S. and the U.S.S.R. Kissinger said that he was "prepared to go secretly to Moscow to meet for three days with a suitable personality from Hanoi." Gromyko considered this an interesting proposal, but he did not think that Moscow had the wherewithal to force Hanoi into a settlement.

More than ever, Nixon tried to strengthen America's hand in the Paris negotiations by combating defeatism in the press, the Congress, and the public. In October, when stories appeared in the media about crewmen on the aircraft carrier *Coral Sea* petitioning Congress to bar the ship from another combat mission in Vietnam, and of plans for a total U.S. troop withdrawal before the end of 1971, Nixon ordered Kissinger to "knock down" these stories, "fire whoever is making trouble," or at the very least, "muzzle the dopes" putting out such reports.

In public, the president exuded confidence about ending the war. On September 25, at a briefing in Portland, Oregon, for northwest media executives, he described significant progress toward an honorable peace—three hundred thousand troops out of Vietnam, casualties at a fraction of 1968 levels, the likelihood of American POWs coming home, and a non-Communist South Vietnamese government. In a nationally televised talk on November 9, Nixon said he hoped to end the war and

realize a goal not seen in the twentieth century—"a full generation of peace." At a news conference on November 12, he announced that 80 percent of America's troops—365,000—had been withdrawn from Vietnam and another 45,000 of the 184,000 left would depart in the next two months. In yet another speech on December 1 before a national youth group, he declared that he was ending the war.

In private, Nixon and Kissinger were not so sure. They discussed the possibility that they would have to resort to another round of military action. But they faced renewed congressional discussion of mandating the withdrawal of all U.S. forces from Vietnam by June 1, 1972, and it angered them. "The irresponsibility of people is unbelievable," Henry complained to a congressman. "If our policy weren't working, but it is," he added, ignoring the stalemate in the secret Paris negotiations. Henry warned that Congress might destroy all possibility of negotiation and faith in U.S. reliability. The idea that allies and foes would see a prompt U.S. withdrawal as sensible realism formed no apparent part of the Nixon-Kissinger outlook. They were too wedded to a settlement on U.S. terms to accept the likelihood that an end to the Vietnam conflict, on whatever conditions, would be seen as in the larger national interest.

The Middle East remained as much a dilemma as Vietnam. On September 30, Gromyko and Kissinger tried to find some formula for advancing peace talks. The Soviets were ready to bar additional arms shipments and withdraw military forces from the region and would guarantee an interim peace arrangement but on the condition that it included provisions to work toward a final settlement.

Kissinger did not see how the two could be definitively linked. The "discussion at the moment concerns theology," he said. An interim agreement would be more theory than substance, which would not necessarily turn into an acceptable final settlement. Besides, Henry cautioned, "there was no possibility of implementing a final agreement before the American election." Commitments to provisions that did not entirely satisfy Israel would provoke an outcry in the United States that would be most unwelcome in an election year. Henry suggested to Gromyko that they secretly reach an interim understanding, which could be turned into a final settlement at the Moscow Summit in May 1972. They agreed that neither Egypt nor Israel should be kept abreast of the talks and that Henry and Dobrynin would begin exploratory discussions in late October.

It was all a form of wheel spinning: "Have you had a chance to talk to the President about the Middle East," Henry asked John Mitchell on October 7. "No," Mitchell replied. Well, "the Israelis will never accept" preliminary Soviet-American discussions, Henry said. "They are climbing the walls now." Besides, Henry warned, if the Soviets thought we were trying to squeeze them out of the Middle East, it would undermine prospects for a successful Summit.

Divisions between Kissinger and Rogers and between the United States and Israel—let alone between the United States and Russia— made a Middle East settlement at the end of 1971 impossible. Public and private initiatives by Rogers and the state department in October to pressure Israel into trading occupied lands for Arab recognition threw Kissinger into a rage and provoked sharp Israeli objections. When Mitchell told Nixon and Kissinger on October 9 that "the Middle East situation is being screwed up" by state, Henry exploded, "Do you know what that maniac [Rogers] did now?" Sisco was going to mediate between the Israelis and the Egyptians at the UN. The outcome would be Soviet and Egyptian convictions that "we are screwing them." And Rogers was doing this without "one word to us . . . The insolence, incompetence, and frivolity of this exercise is beyond belief," Henry shouted.

Alongside developments in Sino-American and Soviet-American relations, the Middle East had become a sideshow that commanded limited attention at the White House, except as a bureaucratic battleground and a negotiating subject that could produce more harm than good. Nixon complained that all the back and forth on the Middle East was a lot of "bull shit." Henry thought it would be "suicide to get involved in these negotiations because it will turn the Jews and everyone else against me." Yet if the U.S. stayed on the sidelines, he feared "a blowup in the Middle East next spring." The best solution he and Nixon saw was to talk to the Soviets at the Summit about an interim agreement; it seemed calculated to head off a 1972 Middle East war.

By CONTRAST with the Middle East, China commanded the White House's full attention. In July, after announcing his intention to visit China early in 1972, Nixon obsessed about how to exploit it politically. He wanted Ehrlichman to accompany Kissinger on a fall trip to arrange

the details of the 1972 meeting. Ehrlichman's presence could minimize Henry's public image as the architect of the dramatic change in China policy. Nixon's preoccupation with winning exclusive credit for the China initiative angered Kissinger, who successfully objected to having Ehrlichman on the fall trip as likely to discourage impressions that the president deserved exclusive credit for the China initiative.

Nixon ordered Kissinger, Haldeman, and Ehrlichman to stimulate press discussion of how much the visit was the result of his leadership and how important it would be in changing international relations. Nixon was determined not to allow any other public official to "dilute the effect" of his trip; he wanted to get the greatest possible "mileage" or "leadership credit" for it. It was part of what Kissinger called "the monomaniacal obsession of the Nixon White House with public relations."

Although, unlike Nixon, he did not have to run for reelection, Kissinger's similar private weakness made him susceptible to the same "obsession." He was as determined as the president to milk the opening to China for as much personal credit as possible. After Nixon told Ehrlichman that Henry was excluding him from the trip, Ehrlichman and Kissinger got into an ugly exchange at a White House meeting. It was ostensibly over Henry's sloppy administrative procedures and Ehrlichman's intention to bypass him. Henry "blew and said . . . nobody's going to go around him." Harsher words followed and Henry stalked out of the room shouting that no one could speak to him that way. It was a double standard for someone who had a reputation for verbally abusing his subordinates.

Kissinger's real battle with Ehrlichman was over his competition with the president for introducing the China policy. But Ehrlichman wasn't the only one trying to eclipse Henry. In September, when Rogers learned that Kissinger would be returning to Peking, it provoked another White House fight. "It will be one of those continuing agony type things," Haldeman confided to his diary. The following week, when Rogers told the *New York Times* that reports of domestic tensions in China over Mao's leadership made Kissinger's trip uncertain, Henry "raved on and on" in a conversation with Haldeman about Rogers's attempt to "ruin things with the Chinese." After they confirmed their desire for Kissinger's visit and the press credited Rogers with forcing Peking to do it, Henry was "practically beside himself again."

Insistence that the Chinese accept a large press contingent and a

ground station to broadcast live TV pictures back to the United States also troubled Kissinger. Nixon and his PR advisers saw these conditions as supremely valuable for his reelection campaign. Henry saw the PR concerns as distracting from longer-term consequences. He feared that the trip would be viewed as a "circus" staged for television. He also saw it provoking an adverse reaction in China and around the world.

But Nixon ignored Henry's concerns. It produced some testy moments with the Chinese, Kissinger says. "Even in the millennia of their history the Chinese had never encountered a Presidential advance party, especially one whose skills had been honed by the hectic trips of a candidate in the heartland of America . . . When I warned Chou En-lai that China had survived barbarian invasions before but had never encountered advance men, it was only partly a joke."

As Kissinger was landing in China on October 20, Nixon asked Haig to remind Henry that he should arrange separate meetings with Mao and Chou with only interpreters present. Nixon wanted to "make it clear," he told Haldeman, "that Henry isn't manipulating the entire operation, but rather, the P[resident] is clearly in command."

The message was not lost on Kissinger. His five days in China from October 20 to October 25 required a balancing act that would advance the two governments toward a successful Summit and enhance his prominence as a diplomat by preparing the way for a presidential visit in which he would stand in Nixon's shadow.

There was never any question as to who would hold center stage when Nixon arrived in Peking in late February, the date quickly agreed upon for the president's visit. But well-publicized October meetings in Peking allowed Henry to command worldwide attention. His presence at a Chinese opera—"an art form of truly stupefying boredom"— before five hundred select Chinese officials, "ostentatious public visits" to Peking's major tourist attractions, the Great Wall, the Ming Tombs, and the Summer Palace, in view of the Chinese "masses" and a North Vietnamese news photographer "served Chinese domestic necessities" and international politics.

The public diplomacy gave Henry visibility on a level with heads of state and celebrities that he craved but could not have imagined attaining as the president's national security adviser. The notoriety was heady stuff that whetted his appetite for additional public attention, but also intensi-

fied Nixon's envy. The October trip to China not only exhilarated Henry but also put him more than ever on guard against the president's antagonism to someone who seemed to be eclipsing him. Deference to a jealous president became a fixed ritual in their always competitive relationship.

Putting the American delegation on display signaled Chinese determination to reach understandings that would bring Nixon to Peking. In private, Chou and Kissinger outdid each other in expressions of good will. In his opening remarks on October 20, Chou applauded Henry's skills as a diplomat and described the Chinese as "confident" that his visit "will be a success."

Kissinger avowed the president's determination to improve Sino-American relations. Although the Chinese gave no indication that their fear of Soviet intentions spurred their interest in a rapprochement with America, Kissinger had no qualms about exploiting these concerns. He made transparent references, which are strikingly absent from his memoirs, to Soviet efforts to discourage Nixon's policy. "We have received much unasked-for advice from other countries," Henry declared, "especially one other country . . . pointing out the physical limitations of China's power, and therefore, the limitations of concentrating attention on China."

At the same time, Kissinger made clear that he was not proposing an overt Sino-American alliance against Russia. "We do not look at the normalization of our relationship as a means to drive a wedge between the People's Republic and their old friends. And it would be shortsighted if either side tried to use this normalization to end alliances of the other side."

The point was not lost on Chou: "We do not wish that because of your new policy you will become in conflict with the Soviet Union," he said. "We want relaxation of tensions." Without mentioning "any particular country," Henry declared that until they had solidified Sino-American friendship, they "should not give those . . . opposed to this new direction an opportunity to say it's only a trick to destroy existing relationships." In short, neither side would spell out the pressure their rapprochement would put on Moscow: For Peking, it was a means to discourage Soviet aggression against it; for Washington, it was a way to prod the Soviets into arms control and pressure Hanoi to end the Vietnam War.

Technical arrangements for the president's visit were agreed to

quickly and with some humor. Henry warned that the requirements of a presidential visit would far outrun what had been needed for his two stays in China. Henry joked that upon their arrival in Shanghai American communications experts might connect all the cities' phones to the White House. Nixon's visit would require "several battalions" of technical people.

Kissinger described the press corps as a more difficult problem. The *New York Times*, Henry said, viewed itself as a "sovereign country." "I was afraid the Prime Minister had had to deal with [retired columnist] Walter Lippmann and James Reston in one year; and that is a degree of invasion no country should be required to tolerate." Although Chou declared himself "not afraid of that," Henry sarcastically described Reston as granting him "an interview before I left. He doubted that I could perform my duties without his advice about how to treat the Prime Minister."

Chou agreed that the technical details of the president's visit could be settled amicably. Substantive matters would be more of a problem. They acknowledged that they faced major difficulties over Taiwan, Indochina, Japan, the Soviet Union, Korea, and a growing dispute between India and Pakistan. Chou conceded that Nixon's principal purpose in Peking was to resolve political differences that could permit normalization of relations. He also agreed that Kissinger's catalog of problems were the principal barriers to détente except for Russia, which Chou dismissed as not "a main issue. The main issue," he asserted, "is China and the United States." He refused to acknowledge that Washington's dealings with Moscow were of more than passing interest to Peking.

Kissinger's and Chou's greatest challenge was to craft a communiqué for release at the end of Nixon's visit. Henry had convinced the president not to include Ehrlichman in the October discussions as a way to limit speculation that a White House aide had entered into substantive agreements before Nixon had gone to China. The objective was to convince the world that Nixon and Mao had personally negotiated any agreement that emerged from their talks.

In fact, Kissinger and Chou skillfully negotiated an announcement that essentially codified the new relationship between Washington and Peking. Henry arrived in China with a draft statement Nixon had agreed to: "It followed the conventional style," Kissinger writes, "highlighting fuzzy areas of agreement and obscuring differences with platitudinous generalizations."

After reading the American draft, which Kissinger himself described as an exercise in "banality," Chou gave a "scorching" response, declaring that the communiqué had to acknowledge "fundamental differences," lest it have an "untruthful appearance." Mao and Chou apparently saw any soporific pronouncement on the new Sino-American relationship as too big a departure from the recent past, in which hostile descriptions of U.S. imperialism had been part of a daily propaganda barrage. Moreover, the Chinese were determined to avoid publication of a document that Moscow could use against them in the competition for hearts and minds in the Third World, where anti-Americanism was a given.

A Chinese counter draft, replete with unacceptable language about U.S. misdeeds that would have embarrassed any American president who signed it, became the basis for a compromise statement. During a nearly nonstop twenty-four-hour session, the two sides hammered out a statement that muted the problem of Taiwan, the chief difference between them. Henry came up with a brilliant pronouncement that greatly impressed Chou. He explained that he adapted the "ambiguous formula" from a state department document written in the fifties. "The United States acknowledges that all Chinese on either side of the Taiwan Straits maintain there is but one China. The United States Government does not challenge that position."

Kissinger's language conformed to what both Chinese Communists and Nationalists could agree on—namely, that Taiwan was part of China. Nothing was said however about which of the opposing Chinese governments should govern both the mainland and Taiwan. That decision was left to the Chinese, but with the American understanding that it would not be the result of force. The Nationalists on Taiwan were put off by the formulation—the much greater likelihood that Peking rather than Taipei would control "one China" made the Nationalists unhappy with the document. Because Henry had no direct communications with the White House during these discussions, he and Chou agreed that the final language of the communiqué would await the president's arrival in China. As Henry departed the guest house, Chou, speaking to him for the first time in English, said: "Come back soon for the joy of talking."

The PRC's admission to the UN coupled with Taiwan's expulsion on October 25—a much discussed possibility for three years—eclipsed Kissinger's successful negotiations in China. Nixon was furious that so

many countries in the General Assembly beholden to the United States voted to oust Chiang Kai-shek's government. By the fall of 1971, he knew that the United States could no longer bar the PRC from the Security Council; nor, given evolving relations with Peking, was he eager to prevent it. He had hoped, however, to appease Taipei and its conservative supporters in the United States by convincing a majority at the UN to let Taiwan keep its General Assembly seat.

Nixon had George Bush at the UN and the state department lobby NATO allies, Israel, Ireland, Laos, Latin American and African countries to follow the U.S. lead in supporting Taiwan's continuing membership. But past favors and a variety of future promises failed to ensure a successful outcome. "At least half of these countries just don't have any goddamn business to be fooling around with that," Nixon complained to Kissinger about their negative votes. As he explained to Rogers, he was particularly incensed at the Israelis, the Venezuelans, the Irish, the Panamanians, the Greeks, the Turks, as well as the African countries. After the African states lined up against Taiwan, Nixon instructed Haldeman: "Kick the cannibals, and don't put us too much on the side of foreign aid."

Nixon instructed Henry not to return to Washington until the afternoon of October 26, ostensibly to mute speculation tying Henry's discussions in China to Taiwan's ouster. Kissinger, however, saw the decision to delay his return as Nixon's way of diminishing his visibility. "The President was becoming restive at the publicity I was receiving," Henry noted. "Nixon, like any other President, had no intention of being upstaged by his own Assistant." When Kissinger arrived at Andrews Air Force Base on October 26, he was delivered to "a distant corner" of the landing strip that was "inaccessible to newsmen and photographers."

Kissinger's suspicions were well founded. As Henry landed, Nixon told Haldeman, "We've got to move now to get K under control on backgrounders." The president "doesn't want him to give so many, because he feels they build up the man who's doing the backgrounding, rather than the P."

Yet it was not so easy to rein in Kissinger. After almost three years in the White House, he had honed his skills as a self-promoter. His effectiveness in crafting a communiqué with Chou and his first-hand knowledge of the discussions with the Chinese made him indispensable to Nixon in finalizing arrangements for the Peking Summit.

Moreover, reports to Nixon that Rogers was taking credit for the administration's China policy moved him to have Kissinger give press briefings that would set the record straight. Haldeman and the president understood that Kissinger had become "the biggest asset we've got" on foreign policy and his considerable influence with the press could make a difference in public perception of the administration's China achievement.

Kissinger used a briefing to range over a number of foreign policy issues that normally, the *Chicago Daily News* reported, would have been "handled by the President or Secretary of State." He "emerged in the briefing as a 'quotable' source after years of anonymity . . . And his performance tended to confirm the view held by many that Kissinger has preempted the turf of Rogers." Another reporter said, "The effect of the [news] conference on State was similar to that of an atomic bomb."

IN THE FALL OF 1971, differences in the administration and the country over White House China policy posed little threat to a major transformation in Sino-American relations. A larger danger to rapprochement with Peking and détente with Moscow came from rising tensions in South Asia. A disastrous cyclone in November 1970, which had taken two hundred thousand lives in East Pakistan, had undermined Yahya Khan's government. Ineffective rescue and relief operations had weakened his standing and contributed to a decisive political defeat in December elections.

Long-standing tensions between the Punjabis, who dominated the central government in West Pakistan, and the Bengalis in the East now erupted into a full-scale crisis. With only their shared Muslim religion to tie East and West together and India providing a thousand-mile geographical divide between the two parts of the country, threats of secession by the Bengalis were an ongoing part of Pakistan's twenty-four-year history. After Yahya refused to honor the election results, which favored the Bengalis, and rioting erupted in Dhaka, the capital of East Pakistan, he sent forty thousand troops to suppress the uprising. The arrest of Sheikh Mujibur Rahman (popularly known as Mujib), the head of the anti-Yahya political party, provoked additional turmoil.

Unrelieved suffering from the cyclone, coupled with brutal repression by Yahya's troops, who may have killed as many as five hundred thousand men, women, and children, sent millions of refugees (80 percent of whom

were Hindus) across the border into India's West Bengal region. The Indians responded with private and public expressions of support for East Pakistan's independence that threatened to touch off an Indo-Pakistan war.

Nixon and Kissinger initially resisted involvement in a crisis they saw little chance of influencing. They were especially concerned not to jeopardize their ties to Yahya, who was so instrumental in opening contacts with Peking. In March, at a Senior Review Group Meeting, Henry stated that "the President will be very reluctant to do anything that Yahya could interpret as a personal affront." He advised against having the American ambassador say anything about the crisis to the Pakistanis. The group agreed to recommend a policy of "massive inaction" to the president.

Nixon agreed that a hands-off approach would best serve U.S. interests. But American diplomats in Dhaka viewed a neutral stance as unwise and immoral. In April, they described the administration's silence in the face of indescribable horrors and the suppression of the election results as "moral bankruptcy" and an acquiescence in authoritarian rule at a time when Moscow was speaking up for Pakistani democracy.

The protest provoked Nixon's and Kissinger's wrath. "If we get in the middle of this thing," the president told Henry, "it would be a hell of a mistake. The people who bitch about Vietnam bitch about it because we intervened in what they say is a civil war. Now some of those same bastards . . . want us to intervene here—both civil wars." In response to the pressure, however, Nixon agreed to increase aid to the Bengali refugees, and privately urged Yahya and Indian Prime Minister Indira Gandhi to avoid a full-scale war. Nevertheless, he continued to resist suggestions that he or any outside power mediate the conflict. He acknowledged that East Pakistan's autonomy was probably inevitable, but he wanted it to come from Pakistan's "own arrangements."

At the end of May, when the White House received news of Indian troops massing on East Pakistan's border, Nixon and Kissinger were determined to deter New Delhi from toppling Yahya's government. If the Indians moved, Nixon told Henry, "By God, we will cut off economic aid." Kissinger replied, "And that is the last thing we can afford now to have the Pakistan government overthrown, given the other things we are doing." Three days later, Nixon complained that " 'the goddamn Indians' were promoting another war." Henry agreed. "They are the most aggressive goddamn people around."

The president and Kissinger had less interest in what the Indians or Pakistanis did to each other than in assuring that nothing sidetracked Henry's trip to China and the revolution in Sino-American relations. Our objective should be to "buoy up Yahya for at least another month while Pakistan served as the gateway to China," Henry told Nixon at the beginning of June. "Even apart from the Chinese thing," the president replied, "I wouldn't . . . help the Indians, the Indians are no goddamn good."

In July, on his way to Peking, Kissinger discussed the crisis with Pakistani and Indian officials in Islamabad and New Delhi. Before he left, Joe Sisco urged him to take a tough line with Indira Gandhi. Sisco complained that "you people in the W[hite] H[ouse] don't understand how serious" the situation is. "We know," Henry countered. "At the end of the monsoons, India will attack." Sisco advised him to tell the Indians, "we know you are supporting the guerrillas . . . There's too much kiss ass on this thing." Henry responded, "That's not my specialty." (Given his stroking of Nixon, was he mocking himself?)

Kissinger's meetings with the Pakistanis were cordial, but, predictably, the Indians complained that U.S. support of Pakistan was encouraging a "policy of adventurism," which China was also promoting. Gandhi saw little chance of a political settlement: "She did not want to use force and was open to suggestions," she told Henry, "but the situation is unmanageable now and is being held together only by willpower." Henry warned the Indians that a war "would be a disaster for both countries and . . . the subcontinent would become an area for conflict among outside powers." He also assured them that "we would take the gravest view of any unprovoked Chinese aggression against India."

Kissinger recalls returning from his trip with "a premonition of disaster." He expected India to attack Pakistan after the summer monsoons. He feared that China might then intervene on Pakistan's behalf, which would move Moscow "to teach Peking a lesson." If a South Asian war were confined to the principals, Nixon and Kissinger saw it as of limited consequence. But they feared that a conflict would not only jeopardize the China initiative and provoke a new round of dangerous tensions with Moscow, but also endanger Nixon's reelection, which he believed would depend greatly on ending the war in Vietnam and achieving some breakthrough in the Cold War. At this time, Kissinger states, "no one could

speak for five minutes with Nixon without hearing of his profound distrust of Indian motives, his concern over Soviet meddling, and above all his desire not to risk the opening to China by ill-considered posturing."

Nixon described the Indians in an NSC meeting on July 16 as " 'a slippery, treacherous people.' He felt that they would like nothing better than to use this tragedy to destroy Pakistan . . . He said that we could not allow—over the next three to four months until 'we take this journey' to Peking—a war in South Asia if we can possibly avoid it." Kissinger agreed. He called the Indians "insufferably arrogant," and eager for a conflict that would allow them to overwhelm Pakistan and take on China. "Everything we have done with China will [then] go down the drain."

An Indo-Russian treaty announced on August 9 convinced Nixon and Kissinger that there would be a war, which would probably ruin their foreign policy. Henry described the agreement as a "bombshell." It assured India of Soviet support against China in a war with Pakistan. And vice versa: "If you read it [the treaty] literally," Kissinger told Rogers, "it says that India has to support the Soviet Union in any situation that involves the threat of war." Henry saw Moscow as throwing "a lighted match into a powder keg."

Former assistant secretary of state for Far Eastern Affairs William Bundy disagreed: "Nixon and Kissinger—with their strong tendency to see great-power ties as the key to regional situations—judged the positions of both China and the Soviet Union to be far stronger and more committed to the opposing sides than was probably ever the case." They refused to believe that Moscow's action was a defensive response to the emerging rapprochement between Washington and Peking. But the Soviets were less intent on provoking a South Asian crisis, in which they could inflict a defeat on China, than on countering what they saw as a U.S. anti-Soviet offensive in Asia through collaboration with China and Pakistan.

In the late summer and fall of 1971, the administration's highest priority in South Asia was to avert a war. Conversations with Indian and Soviet officials became repeated warnings against an Indian attack on Pakistan. In September, when the Indian ambassador to the United States, Lakshmi Jha, asked Kissinger what "interest the United States had in keeping East Bengal a part of Pakistan," Henry replied that our

aim was to head off not secession but a war that could turn "into an international conflict." In October, in another conversation with Jha, who predicted a military outbreak by the close of the year unless there was a political settlement, Henry warned that America would cut off all economic aid to New Delhi if it started a war.

To make the case for war, Indira Gandhi traveled to several Western capitals, including Washington, at the beginning of November. Nixon agreed to see her as a last-ditch effort to head off a conflict. Two conversations on November 4 and 5 were case studies in heads of state speaking past each other.

During a morning meeting on November 4 in the Oval Office, they agreed to discuss tensions in South Asia, with a second days' meeting to focus on Sino-American relations. No easing of tensions was evident from the morning's exchanges. Nixon emphasized what America had been doing to relieve tensions between India and Pakistan. We had sent relief aid to the nine or ten million refugees who now had congregated on both sides of the Indian–East Pakistan borders. Nixon warned that military action might serve India in the short run, but would work against its political interests over time. Moreover, a war might pose grave dangers "for the whole framework of world peace."

Largely ignoring the president's remarks, Gandhi responded with a bill of particulars against Pakistan. Although she denied any interest in destroying India's Muslim adversary, she said that partitioning the subcontinent had "left the peoples of the area restive and dissatisfied." Pakistan's hatred of India had generated the 1947 and 1965 wars, she asserted, and U.S. arms shipments to Pakistan had outraged Indian public opinion. Pakistan, moreover, was beset by separatist movements that destabilized the region. "It was no longer realistic to expect East and West Pakistan to remain together." India's military presence on the East Pakistan border and the treaty with Moscow were deterring President Yahya from a "holy war."

Nixon asked her how a solution could be achieved, but she would only say that "India's major concern was the impact of the situation on India itself." Nixon's concern about the dangers to world peace from a South Asian war made no impression on her. She had a parochial absorption with India's problems, but she also rejected arguments that a South Asian war necessarily translated into larger Cold War dangers.

Nixon took her unresponsiveness to his observations as both indifference to compelling international threats and arrogance toward someone she considered socially and intellectually inferior. Her response incensed him. He showed up forty-five minutes late for their second meeting without an explanation. In private, he called her a "bitch" and much worse. "Nixon's comments after meetings with her," Kissinger says, "were not always printable."

Henry's weren't much better. On the morning of November 5, before they saw Gandhi again, Kissinger described the Indians as "bastards . . . They are starting a war there" with the objective of destroying all of Pakistan. "To them, East Pakistan is no longer the issue," Henry said. "Now, I found it very interesting how she carried on to you yesterday about West Pakistan." He thought that the president had scored points in the exchanges with her. "While she was a bitch," he said, "we got what we wanted . . . She will not be able to go home and say that the United States didn't give her a warm reception and therefore in despair she's got to go to war."

Nixon put the best possible face on the conversation as well. "We really slobbered over the old witch," he said. Kissinger replied: "You slobbered over her in things that did not matter, but in things that did matter, you didn't give her an inch." As an aftermath to the talks, she told a journalist that "the times have passed when any nation sitting 3 or 4 thousand miles away could give orders to Indians on the basis of their color superiority to do as they wished." Reading her comment in the press, Nixon told Henry: "This is the heart of her anti-Americanism. She doesn't seem to mind the color of our aid dollars."

Gandhi reciprocated the hostility by later describing Nixon to another journalist as a cipher. According to Gandhi, during their conversation, he had Kissinger do most of the talking. He would say a couple of words and then turn to Henry and ask, "Isn't that right, Henry?" She complained that the president "was unwilling to accept my assessment of any situation." Nixon certainly was not receptive to her verbal attacks on Pakistan, but the documentary record of their November 5 conversation does not bear out her description of who did the talking. The official transcript in Nixon's National Security files drawn from an audiotape is a dialogue strictly between the president and the prime minister.

More convinced than ever that a war would jeopardize everything

they had been aiming at in foreign affairs, Nixon and Kissinger now intensified their efforts to head off a conflict. But it was a one-sided démarche against India. In their judgment, the aggressor, with Soviet backing, was New Delhi. Never mind that the state department, the Congress, the press, and the attentive U.S. opinion thought otherwise. Yahya's unrestrained campaign against the Bengalis, which had cost so many lives, had largely destroyed his standing in the United States, where India, whatever the truth about its intentions, was generally seen as an exponent of peace.

When a full-scale war finally erupted on December 3, the CIA could not say which country had initiated the hostilities. Nevertheless, Nixon and Kissinger blamed New Delhi. India's attack "makes your heart sick," Nixon told Henry. "For them [the Pakistanis] to be done so by the Indians, and after we have warned the bitch . . . We have to cut off arms . . . When India talked about W. Pakistan attacking them, it's like Russia claiming to be attacked by Finland."

With Rogers counseling restraint on announcing a military cut-off to India, Kissinger told him, Nixon "is raising Cain again. I am getting hell. He wants it [a statement] to tilt toward Pakistan." Later that morning at a Special Actions Group (SAG) meeting, Henry described himself as "catching unshirted hell every half-hour from the President who says we're not tough enough . . . He really doesn't believe we are carrying out his wishes. He wants to tilt toward Pakistan, and he believes that every briefing or statement is going the other way."

Despite the CIA's analysis, Henry reported to Nixon that "It's more and more certain it's India attacking and not Pakistan." Nixon responded: "Everyone knows Pakistan [was] not attacking India . . . It's a tragedy, the Indians are so treacherous."

Nixon saw at least one domestic benefit from the war. It would discomfort American liberals, who would have to choose between China and India. "You realize this is causing our liberal friends untold anguish, Henry," the president said. Kissinger agreed, and predicted that "in terms of the political situation, we won't take any . . . [more] immediate flak, but in six months the liberals are going to look like jerks because the Indian occupation of East Pakistan is going to make" Pakistan's treatment of the Bengalis look benign. Henry reported that the liberal press was still blaming Pakistan for the war, but was "beginning to tilt against India."

Nixon replied, "We got to make it tilt more, because we know they are totally to blame . . . We know the Paks don't want this."

Although they thought it would do nothing to affect the outcome of the war, Nixon and Kissinger agreed to promote a discussion at the UN Security Council, where the Soviets promptly vetoed a cease-fire resolution. "The Security Council is just a paper exercise," Henry said, but "it will get the *Post* and *Times* off our backs. And the Libs will be happy that we turned it over to the UN." The important thing, Nixon asserted, was to get "some PR out" putting "the blame on India."

The Soviet veto triggered a fresh discussion of the war's impact on American foreign policy. "What we are seeing here," Kissinger advised Nixon on December 5, "is a Soviet-Indian power play to humiliate the Chinese and also somewhat us." They believed it essential to vigorously support another UN resolution. A retreat would mean doing "away with the gains of the last two years . . . If the Chinese come out of this despising us, we lose that option. If the Russians think they backed us down, we will be back to where we were in May and June." It would then resonate in the Middle East, where we would lose our ability to pressure the Russians and the Egyptians into any sort of settlement.

With Nixon's agreement, Kissinger called in the Soviet Counselor of Embassy Yuli Vorontsov. Henry threatened Moscow with a serious setback in Soviet-American relations if it participated "in the dismemberment of another country. The President did not understand how the Soviet Union could . . . work on the broad amelioration of our relationships while at the same time encouraging the Indian military aggression against Pakistan." Brezhnev needed to understand that "we were once more at one of the watersheds in our relationship." Vorontsov was taken aback, and hoped that Nixon had no intention of canceling the Summit. He was confident that Moscow would be eager to entertain a U.S. solution to the South Asian crisis.

With India defeating Pakistani forces and the increasing likelihood of an independent East Pakistan or Bangladesh emerging from the conflict, Nixon and Kissinger became all the more antagonistic to Gandhi. They saw India's success as a defeat for the United States in its dealings with Moscow. In a conversation on the evening of December 6, they agreed that it was essential to take a hard line with the Soviets: "You'll be better off, Mr. President, 6 months from now," Kissinger said. "If they

lose respect for us now, they'll put it to us." Nixon worried that he had been "too easy on the goddamn woman when she was here." He thought he had been "suckered" in their talks. Kissinger regretted that he had not urged the president "to brutalize her privately." He thought Nixon should have warned her that he would seize "every opportunity to damage her." Nixon declared, "She is going to pay," and he and Kissinger drowned each other out in professions of determination to punish her.

They also agreed on a message to Peking saying that if the Chinese felt compelled "to take certain actions . . . you should not be deterred by the fear of standing alone against the powers that may intervene." Nixon wanted an intelligence report on Indian war plans leaked to the press. It "will make her [Gandhi look] bad."

It was more than a little reckless to promise the Chinese support against the Soviets. Were they suggesting joining China in a war against Russia? Such a verbal commitment, however vague and private, was more a demonstration of unfettered emotions than thoughtful consideration of the challenges posed by the South Asian crisis. None of this, of course, was for public consumption. Nixon instructed Henry to give a background press briefing in which he made clear that the United States shared no responsibility for the conflict, unlike the Russians and the Chinese. Henry was to say: "The Russians have an interest in India. The Chinese have a hell of an interest in Pakistan. We only have an interest in peace. We're not anti-Indian, we're not anti-Pakistan. We are anti-aggression."

A CIA cable on December 7 reporting an Indira Gandhi press briefing further inflamed Nixon and Kissinger. She chided the United States for its pro-Pakistan policy and predicted that the new nation of Bangladesh and a shrunken Pakistan with diminished military power to challenge India would emerge from the war. When Nixon and Kissinger discussed developments in South Asia on the following day, Henry was more convinced than ever that Soviet support would allow India to turn Pakistan into "a state akin to Afghanistan." It would have a disturbing impact on other countries threatened by Soviet power, particularly in the Middle East, and might encourage the Chinese to turn away from the United States.

The wisest response to Soviet-Indian aggression, Henry advised the president, was to increase pressure on the Indians and Moscow to dis-

courage New Delhi from crippling Pakistan. It might risk the Summit, but "the Summit may not be worth a damn if . . . they kick you around. We have only one hope now. To convince the Indians the thing is going to escalate. And to convince the Russians that they are going to pay an enormous price." Nixon summed up Henry's advice: If we let things go, "it will certainly screw up the South Asian area . . . Your greater fear, however, is that it may get the Chinese stirred up so that they do something else . . . And it will encourage the Russians to do the same thing someplace else."

To counter the Indians and the Soviets, they agreed to urge the Chinese to move troops to their Indian border, to deploy a U.S. carrier force in the Bay of Bengal, and send another tough message to Moscow. Even if Pakistan were dismembered, Henry concluded, "We will still come out all right" if they compelled the Soviets to "maintain their respect for us."

On December 9, they began acting on their hard-line policy. Nixon seized on a conversation at the White House with the Soviet agriculture minister, Vladimir Matskevich, to send Moscow an additional blunt message. The bewildered minister, "a bubbly and beefy man," who had no license to discuss . . . foreign policy, listened passively to a Nixon monologue on current hopes and dangers in Soviet-American relations. Prospects for friendship between their two countries were greater than ever, but the South Asian war placed "a great cloud over" a new relationship, Nixon said. The war was poisoning Soviet-American relations; it was pushing their countries toward a confrontation: "The Soviet Union has a treaty with India, but the United States has obligations to Pakistan. The urgency of a cease-fire must be recognized."

The same day, Nixon ordered that a carrier group go from Vietnam to the Bay of Bengal. Kissinger told him that he was going "back and forth" on the question of whether to deploy this force. No one would believe that the ships were there to evacuate two hundred Americans from East Pakistan. Instead, "The Indians will scream we are threatening them," Henry warned. Nixon thought that was fine. "Aren't we going in for the purpose of strength?" he asked. Kissinger thought it would allow him to make a case to the Chinese for moving troops to the frontier. When Kissinger saw Vorontsov the next day, he told him, "we're moving some military forces . . . In effect, it was giving him sort of [a] veiled ultimatum."

On the afternoon of December 9, in a lengthy backgrounder with the press, Kissinger tried to quiet complaints that the United States was lining up with Pakistan against India. *Time* called the administration's "blatant partiality toward Pakistan . . . both unreasonable and unwise." Kissinger told the reporters that the White House was "neither anti-Indian nor pro-Pakistani . . . but opposed to the use of armed forces across borders to change the political structure of a neighboring state." He justified a cut-off of economic aid to India as a condemnation of aggression. He called the reports of an American tilt in the war as "totally inaccurate."

On the evening of December 10, Kissinger went to New York to meet secretly with two of China's UN representatives at a shabby hideaway apartment. The session was part confessional and part conspiracy. With only UN Ambassador Bush, and Kissinger aides Haig and Winston Lord present on the American side, Henry confided, "We tell you about our conversations with the Soviets; we do not tell the Soviets about our conversations with you. In fact, we don't tell our own colleagues that I see you. George Bush is the only person outside the White House who knows I come here." He then described his conversations with Vorontsov, which "are known only to the White House and only to you." He reported on the pressure they were exerting to rein in Soviet backing for India's aggression, including a warning that it could lead to a Soviet-American confrontation. He described the movement of U.S. warships into the Indian Ocean as a demonstration of American resolve.

"I come now to a matter of some sensitivity," he said. Intelligence information that China was eager to know about the disposition of Soviet troops "on your borders." The U.S. was ready to share what information it had. More important, Kissinger reported the president's desire to assure Peking that if it "took measures to protect its security" in response to the situation on the Indian subcontinent, "the U.S. would oppose efforts of others to interfere with the People's Republic." The president also wanted the PRC to understand that "if East Pakistan is to be preserved from destruction," it was essential to intimidate the Indians and the Soviets. He advised the Chinese that Gandhi was intent on destroying "the Pakistani army and air force" (in fact, an intelligence report said only "armored and air force strength") and annexing a part of Kashmir. "This is what we believe must be prevented and this is why I have taken the liberty to ask for this meeting."

The Chinese ambassador thanked Kissinger for the information and promised to forward it to Chou. However, he complained about the difference in Kissinger's presentation and America's public posture. Kissinger's tough talk did not square with the U.S. government's "weak" public position. In its statements to the Pakistanis, Indians, and Soviets, it supported a cease-fire and political negotiations, but failed to advocate a withdrawal of Indian forces from East Pakistan. It meant giving life to "another Manchukuo," the puppet state the Japanese had created in Manchuria in the 1930s. "I may look weak to you, Mr. Ambassador," Henry countered, "but my colleagues in Washington think I'm a raving maniac." The ambassador described political negotiations as "completely unacceptable." Henry answered: "We are talking to you to come to a common position." His objective in asking for their meeting was "to suggest Chinese military help, to be quite honest . . . not to discuss with you how to defeat Pakistan," or arrange for an independent Bangladesh.

On Sunday morning, December 12, with no response from Moscow to the warnings to Vorontsov and Matskevich, Nixon decided to send a hot-line message to Brezhnev. "Does that sound like a good plan to you?" he asked Kissinger. "It's a typical Nixon plan," Henry enthused. "I mean it's bold. You're putting your chips into the pot again. But my view is that if we do nothing, there is a certainty of disaster. This way there is a high possibility of one, but at least we're coming off like men. And that helps us with the Chinese." Reassured, Nixon said it showed that " 'the man in the White House' was tough."

It is astonishing that in the midst of a major international crisis the principal American policy makers would be fretting over whether they came across as "tough." Impressing foreign adversaries as firm about U.S. national interests made sense, but there was something less than rational about "coming off like men." It was as if the contest with Soviet Russia was a test of Nixon's manhood. Personalizing a great crisis or turning any political debate into a battle over a leader's identity or sense of self is never calculated to serve the national interest. In the end, it is amazing how well Nixon and Kissinger did in making foreign policy in spite of unacknowledged impulses to make decisions partly based on their amour propre.

The Nixon and Kissinger conversation now focused on what the Chinese would do. Henry was angry at being told that U.S. policy was

"weak." So far, Peking had done nothing. "We are the ones who have been operating against our public opinion, against our bureaucracy, at the very edge of legality," Kissinger said. Until the Chinese moved some troops, they shouldn't say another word. As they were speaking, Haig brought a message that the Chinese wanted a face-to-face meeting in New York "on an urgent basis." This call for a meeting, Henry said, was "totally unprecedented. They're going to move. No question, they're going to move."

Nixon and Kissinger discussed the potential results of Chinese action. If China menaced India, they anticipated a Soviet military response. If the U.S. then did nothing, Henry predicted, "we'll be finished." Nixon asked: "So what do we do if the Soviets move against them? Start lobbing nuclear weapons in, is that what you mean?" Kissinger replied: "If the Soviets move against them . . . and succeed, that will be the final showdown . . . We will be finished. We'll be through."

Henry wondered whether it would be better to call the Chinese off, but answered himself by saying, "We can't call them off." If we did, it would destroy the China initiative. Nixon agreed that it would not only destroy the rapprochement with Peking but would also jeopardize any advance in relations with Moscow. They quieted their worries by reassuring each other that the Soviets would back down from a confrontation with China and the United States. Henry said they simply couldn't let Pakistan be swallowed by India or allow China to be "destroyed, defeated, [or] humiliated by the Soviet Union. It will be a change in the world balance of power of such magnitude that the security of the United States for, maybe forever, certainly for decades" would be altered.

Nixon agreed that they had to face down Moscow. But he thought it best not to think in terms of "Armageddon . . . When I say the Chinese move and the Soviets threaten and we start lobbing nuclear weapons, that isn't what happens." At least, he hoped that would be the case. Kissinger agreed. "We don't have to lob nuclear weapons. We have to go on alert."

When Nixon met with French President Georges Pompidou the next day in the Azores, he reflected on the "sober, somber fact" that a nuclear war could kill 70 million Americans and 70 million Russians. "It is essential," he told Pompidou, "that the two nations pursue the negotiating track rather than the confrontation track. We have impressed this on the Soviets with regard to Southern Asia in the last 24 hours."

Nixon and Kissinger assumed that a Sino-Soviet war would at least allow them to "clean up Vietnam." But Nixon didn't think the Russians would attack China. "Well," Henry said, the Russians "are not rational on China." They agreed that as soon as the Chinese did something, they would have to caution Brezhnev about taking military action. Henry told Nixon that his decision was nothing less than "a heroic act."

A message from the Soviets later that morning assured Washington that India had no intention of attacking West Pakistan and that cease-fire discussions were underway. Because the assurances about New Delhi lacked "concreteness," Nixon cabled Brezhnev that they needed to continue "closest consultations . . . I cannot emphasize too strongly that time is of the essence to avoid consequences neither of us want."

To their surprise and relief, the Chinese message, which Haig picked up in New York on the afternoon of December 12, said nothing about moving troops to the Indian border. Instead, appreciating that independence for East Pakistan was a foregone conclusion, Peking said it was prepared to endorse an American UN proposal for a standstill cease-fire and forego a demand for mutual troop withdrawals.

The crisis now petered to a conclusion. Between December 14 and 17, Indian forces completed their conquest of East Pakistan and agreed to a cease-fire in the West with no occupation of additional Pakistani territory. Although Nixon and Kissinger put the best possible face on the outcome, the result of the war was essentially a victory for India and its Soviet ally, which declared the emergence of Bangladesh from the ruins of East Pakistan a triumph for Socialist and democratic principles.

Nixon and Kissinger expressed satisfaction at having preserved West Pakistan and privately asserted that their pressure on Moscow had been decisive in restraining Indian ambitions. "You saved W. Pakistan," Kissinger told Nixon. "If it hadn't been for us, Pakistan would have been destroyed." Both of them saw limits to their success. "As far as public opinion is concerned, I don't think they give a damn," Nixon said. Henry agreed and acknowledged that the best they could do was "turn disaster into defeat," or into "a net minus." Most important from their perspective, the war had not destroyed the scheduled Summits in Peking and Moscow.

William Bundy's conclusion that "Nixon and Kissinger's policy on the Indo-Pakistan war was replete with error, misjudgment, emotional-

ism, and unnecessary risk taking" has considerable merit. A reconstruction of their day-to-day response to the crisis suggests that they were feeling their way through the crisis. Bundy's additional assertion that their policy was fashioned out of an "overriding emphasis on balance-of-power factors" suggests a degree of rational calculation that was also a part of the mix. Their underlying assumption, in Kissinger's formulation, was not to "allow a friend of ours and China to get screwed in a conflict with a friend of Russia's," which was a crude way of saying that they needed to maintain a balance between the two Communist superpowers.

Their highest priority, however, was to prevent the conflict from aborting the 1972 Summit meetings in Peking and Moscow. Such an outcome not only would have wrecked their strategy of playing China and Russia off against each other but would also have made the Nixon presidency a failure and jeopardized the likelihood of a second term. The South Asian conflict produced unwelcome results, but it left rapprochement with China and détente with Moscow intact. Yet the White House could take only so much credit for the achievement. Peking's and Moscow's determination not to let the war overwhelm what they saw as their larger interests—keeping the transformation of relations with the West on track—was an even bigger factor.

CASUALTIES OF THE TWO-WEEK CONFLICT were Kissinger's reputation for honesty and his ties to Nixon. To be sure, the press relied on backgrounders with Kissinger for vital information and he and the president conferred repeatedly during the crisis; but leaks to the press revealed that Henry was exceeding his authority and not being candid about U.S. policy. It put strains on his relations with Nixon and almost drove him out of the White House.

Nixon, with a long history of surviving personal political crises, faced the Indo-Pakistan war with what might be described as controlled anxiety. For Henry, the war burdened him with concerns he had never confronted before. During his almost three years in the White House, he had struggled with issues of war and peace in every part of the world. Each problem had the potential for long-term disaster. But in every instance, he saw himself advancing the United States toward diminished conflict and greater security. The South Asian problem, however, was another

matter: It seemed to demand U.S. reactions that could lead directly to a great power war, possibly a nuclear holocaust.

From the start of the Indo-Pakistan war, Kissinger went into a funk that was ostensibly about renewed difficulties with Rogers and the state department. Between December 7 and 14 Henry registered repeated complaints with Haldeman and the president about his differences with state over how to deal with Pakistan and India. But his objections were more strident than usual and included repeated threats to resign. Nixon confided to Haldeman that he was "quite shocked" at how Henry had "ranted and raved" at Haig during a phone conversation, telling Haig that he "had handled everything wrong" and calling George Bush "an idiot" for his performance at the UN. Nixon believed that something more pronounced was going on with Henry, something beyond his policy differences with state. Haig told Haldeman that Henry had a sense of failure about South Asia and seemed to be physically exhausted.

Two developments on December 14 added to Kissinger's distress. On a plane trip back from the Azores meeting with Pompidou, Henry told three reporters that unless the Soviets became more active in restraining India, the president might have to consider canceling the Moscow Summit. When the warning led the evening television news, the White House denied that Nixon was considering such a drastic step. Privately, the president's press spokesmen explained that Kissinger had overstepped his authority. "I blew it, I was just damn stupid" to have spoken so freely to hostile reporters, Henry told a friendly journalist.

He suffered a greater embarrassment that day when the *Washington Post* ran a front-page story by columnist Jack Anderson that described a White House "tilt" toward Pakistan in its war with India. The report, which included verbatim quotes, contradicted everything Nixon and Kissinger had been saying about administration evenhandedness and raised the possibility of a credibility gap like the one that had plagued Lyndon Johnson.

A White House investigation of the leak turned up evidence that Charles Radford, a Navy yeoman serving as liaison between the Joint Chiefs and the NSC, had passed documents to Anderson, and as troubling, had provided the Chiefs with secret Kissinger-Nixon memos. Personally opposed to White House policy toward India, where he had served in the U.S. embassy, and offended by the Nixon-Kissinger distor-

tions about administration neutrality, Radford had leaked transcripts of WSAG Meetings to Anderson revealing the Nixon-Kissinger insistence on a "tilt." Under orders from Pentagon admirals to watch for White House materials that Nixon and Kissinger were withholding from the JCS, Radford, who had access to Henry's secret files in burn bags, made copies that he regularly passed along to the Chiefs. Although Nixon was angry that his Chiefs were spying on him, he refused to fire anyone lest it "blow up the whole relationship with" them.

Nixon was angry at Kissinger and worried about his reaction to the revelations. "The real culprit is Henry," Nixon told Haldeman and Ehrlichman on December 23. "We'd all like to find somebody else to blame—the goddamn state department or the defense department. But Henry could never see anything wrong with his own" staff, Nixon added. "That's his problem. He doesn't want to admit to himself this could be" his fault. Nixon didn't want to talk to Henry about the problem. "I won't have Henry have one of his childish tantrums. I will not discuss it with him . . . I don't want another crisis." Nixon instructed Haldeman and Ehrlichman to talk to him. "Henry is like a child. He won't know how to handle it. What to do, so forth," Nixon said.

On December 24, after Ehrlichman gave Kissinger evidence of Radford's spying, he "began striding up and down loudly venting his complaints. 'He [Nixon] won't fire [Joint Chiefs Chairman] Moorer,' Henry shouted. 'They can spy on him and spy on me and betray us and he won't fire them! If he won't fire Rogers—impose some discipline in the Administration—there is no reason to believe he'll fire Moorer. I assure you all this tolerance will lead to very serious consequences for the Administration!' "

Irritated at Henry's intemperate comment to the press about the Moscow Summit and especially at Radford's skullduggery at the NSC, Nixon limited Henry's access to him. "I am out of favor," Henry told a journalist. Regular morning meetings with the president were canceled and Nixon would not take Henry's phone calls. On the afternoon of December 24, Henry "walked in, unbidden," to Nixon's EOB office, Ehrlichman remembered. "In a very low, somber voice he spread gloom and doom. 'I tell you, Mr. President, this is very serious. We cannot survive the kinds of internal weaknesses we are seeing.' Henry left when he had delivered his load of melancholy."

Having been embarrassed by the repudiation of his Summit threat and by Anderson's revelations about the "tilt" policy, Kissinger was incensed at Nixon, Rogers, the White House staff, and now the Joint Chiefs for their abuse of his and the president's right to have private exchanges: "I was beside myself," he said. "I was outraged." Haldeman described him in his diary as "absolutely convinced now that Rogers is engaged on a total plan to destroy Henry and he's putting out all the stuff that makes Henry look bad . . . Henry's at a point now where he's so emotional about the issue that he's not really thinking it through clearly; and he's much more concerned with what's being done to him, than what the problem is for the P."

John Scali, who had assumed the job of improving Nixon's public image, was incensed at Kissinger for undermining the president's credibility. "Henry has practically taken leave of his senses," Scali complained to Haldeman. "He's lying to the press, lying to the Secretary [Rogers], and worst of all, lying to the P. . . . Scali thinks there's going to be a substantial problem for Henry with the press, because a number of them realize he's lied to them and are out to get him."

Kissinger seemed so troubled that Nixon, who had had psychiatric counseling after his 1962 defeat, suggested to Ehrlichman that Henry get such help. Ehrlichman believed that Henry had serious problems: He saw him as "very insecure," as someone who "cared desperately what people wrote and said about him." Henry could be "devastated by press attacks on his professional competence." He also felt besieged by state department bureaucrats. "How could I survive in this Government where half the town is laying for me?" he asked a *Newsweek* reporter. "You know there is nothing half the bureaucracy would like to find more than me with no support from the President."

Nixon asked Ehrlichman to talk to Kissinger about getting therapy and to ask Al Haig as well to discuss the matter with Kissinger. But Ehrlichman "could think of no way to talk to Henry about psychiatric care." He wasn't sure it would help him, and he didn't want to confront him "with the President's apparent lack of confidence in his mental stability." When Ehrlichman raised the issue with Haig, Al sprang to Henry's defense. Reading the suggestion as a smokescreen for firing Henry, Haig declared that Henry was essential to the president's effective conduct of foreign policy.

As the year came to an end, Kissinger mulled over his problems in a conversation with Haldeman. Henry described himself as "going through a period of very deep thinking and serious evaluation." He felt that Nixon had "lost confidence in him." Haldeman saw Kissinger as "very uptight," and Henry admitted that "he was egotistical and nervous . . . but also said that he felt he was a great value to the P." Though he mentioned the possibility of moving into "a very low key position," one with less visibility and tension, he immediately negated the suggestion by remarks about "being essential to the China trip and so on."

Robert McNamara, Johnson's secretary of defense, who had resigned in 1967 after coming close to a nervous collapse, called Henry to commiserate with him. "It is a tremendous accomplishment that you are staying here so long," McNamara said. "I know what you are paying and I really admire you."

However stressed Kissinger was, however strained his relations with Nixon, there was little chance he was going to resign or be forced out. He had considerable resiliency, and Nixon simply could not afford to let him go. Not only did he know too much that could embarrass the White House and possibly defeat Nixon in 1972, Henry also was indispensable to the success of the president's trips to Peking and Moscow, but especially Peking. Without Henry, the ties to Chou En-lai would have been frayed, if not lost, and possibly a chance for a declaration announcing significant steps forward in Sino-American relations. As a consequence, by the beginning of 1972, Nixon and Kissinger were back in regular contact. Daily conversations about current and future issues were resumed as if there had been no hiatus.

When Kissinger spoke at the annual dinner of the Washington Press Club in January, Henry joked that Democrats were eagerly watching his appearance: "They wanted to see if a man who has been assassinated can commit suicide . . . As you know, I have been a somewhat controversial character lately . . . A question that I ask myself just before retiring every night, as I look under the bed: 'Is someone trying to get me?' " He assured the audience that he got along with everybody, including secretaries Laird and Rogers. Laird "assured me that his confidence in me is unbounded. As evidence of that, he has recommended that I go along on the first space shuttle." Should "I accept, he will urge the President to let the shuttle stay in orbit an extra month."

As for Rogers, when Henry proposed to him that they continue a situation room discussion in the White House mess, Rogers agreed, but asked, "before we go to your office, couldn't we get a bite to eat?" Speculation that he would announce his resignation at that night's small dinner audience was false. "After all, there are twenty-thousand people in the State Department alone who want to be there for *that* occasion." When he got to China in February, he planned to ask about the methods "used to frighten the bureaucracy during the Cultural Revolution," the Chinese upheaval of the sixties defending Communist orthodoxy.

As 1972 began, Nixon was determined to get the press and public focus back on larger foreign policy matters. He was particularly concerned to disarm conservative hostility to détente. He sent Kissinger to Los Angeles to talk to people on the right fretting over the upcoming Summits. In an off-the-record luncheon talk at Perino's restaurant, Henry defended Nixon's foreign policy. He described the "tilt" toward Pakistan as frustrating Soviet ambitions and serving "world peace." He portrayed Vietnam as an inherited war that the president would end in an honorable way. The president was rebuilding the nation's defenses despite the resistance of a hostile Congress and a critical press. He was using a newfound relationship with China to force Moscow into accommodations serving U.S. national interests. This would not entail the betrayal of Taiwan. When the history of this period is written, Henry concluded, it will celebrate the opening of an era of foreign affairs in which the United States established a more stable international order.

Yet Nixon understood that to win reelection in 1972 he needed to focus less on disgruntled conservatives, who seemed unlikely to desert him, than on the broad electoral center, which principally wanted to end the Vietnam War. That "bitch of a war," as Lyndon Johnson had described it, remained a political liability that Nixon could not remove unless he brought home U.S. ground troops and POWs and preserved at least the appearance of Saigon's autonomy.

In December, Nixon complained to Moscow that the Soviets had failed to push Hanoi into conclusive negotiations. He described himself as ready to escalate U.S. military actions if Hanoi intended "to rely on a military solution." To give substance to his warning, Nixon ordered renewed bombing of North Vietnamese military targets for five days in

response to attacks on unarmed reconnaissance planes and the shelling of Saigon on December 19.

On January 2, during a nationally televised interview with CBS's Dan Rather, Nixon emphasized how effective this latest round of bombing had been. Eleven days later, he announced the withdrawal of seventy thousand more U.S. troops over the next three months. By May 1, the American ground force in Vietnam would have shrunk to 69,000. U.S. casualties in January stood at a six-year low, and on January 7, the networks reported that there were "no ground combat deaths for the first time in 7 years."

Publicly, Nixon described the success of Vietnamization as allowing him to withdraw American troops. But in private, he and Kissinger feared that a North Vietnamese offensive during the February trip to China could "create a super crisis" by cutting South Vietnam in half. It would embarrass both the president and the Chinese. The biggest North Vietnamese buildup in four years seemed like the prelude to a major offensive. Nixon believed it essential to counter this growing threat. It could "discredit Vietnamization and undermine Thieu . . . and weaken our position both at home and vis-à-vis Peking," Nixon said. "I just don't believe you can let them knock the shit out of us." The only response he saw was airpower, and pressure on Saigon to strengthen its forces.

Nixon reflected his sense of urgency about the impending threat in comments to the NSC. "I will not accept any failure which could be attributed to a lack of available U.S. support or shortcomings in our own leadership or decisiveness. We must do all we can to assist the South Vietnamese and to ensure that they have both the means and the will to meet Hanoi's challenge this year."

When Rather asked the president if his actions on Vietnam and the timing of the upcoming Summits were politically motivated, Nixon denied it. He assured Rather that "those decisions have no political connotations whatever." Nor did he believe that Johnson had political motivations when he announced a bombing halt on October 31, 1968, which was Nixon's way of saying, Isn't that what the Democrats did to try to defeat me?

Haldeman's diaries and Nixon's memos demonstrate that foreign policy actions were closely linked to election-year politics. Haldeman recorded that Nixon reminded Kissinger every day "about the trouble Nix-

on's in on Vietnam." Nixon decided to announce the additional troop withdrawal and follow this up later in the month by revealing Henry's secret talks in Paris with the North Vietnamese, whom he intended to blame for the deadlocked negotiations. "This he figures will be a major blockbuster on the Vietnam thing," Haldeman wrote. His "first announcement will suck all the peaceniks out, and the second move will chop them all off."

Because Nixon refused to promise that he would remove all ground troops from Vietnam until POWs were repatriated, he hoped to mute dissent over the war by eliminating the deployment of draftees to Southeast Asia. While some 8,000 draftees a month had gone to Vietnam during 1970, the number had fallen to between 2,500 and 5,800 through September 1971, with 1,200 in November and only 500 in December. During the next six months, between 400 and 700 would be deployed each month, and after that, the number was likely to fall to about 300. A "no draftees to Vietnam" policy was now a realistic possibility, an NSC aide told Kissinger.

If he were going to win reelection, Nixon believed that he had to eliminate the bureaucratic battling that had produced leaks and undermined impressions of him as fully in command of foreign policy. He wasn't sure that he could control Henry. On January 13, he told Haldeman that "maybe we've got to bite the bullet now and get him out. The problem is, if we don't, he'll be in the driver's seat during the campaign, and we've got to remember that he did leak things to us in '68, and we've got to assume he's capable of doing the same to our opponents in '72."

But Kissinger was not about to leave, and Nixon saw more risk in showing Henry the door than in keeping him on. Consequently, on January 18, he sent Kissinger and Rogers a memo summarizing discussions he had instructed Haldeman and Mitchell, who was managing Nixon's reelection campaign, to have with them about a "clear operating procedure" on China, the Soviet Union, the Middle East, Cuba, and Chile. Nixon told Haldeman, "The only winner from our failure to work together would be our enemies both at home and abroad."

Kissinger yielded grudgingly to Nixon's pressure. When Haldeman and Mitchell met with him and Haig, "Henry kept interrupting us as we tried to start telling what the situation was. And we had to listen to a 45-minute tirade from him, at the end of which he emotionally said,

'Tell me what your proposition is, and I'll do it. I'm not here to strike a treaty with the P.' [Yet] every time when we tried to tell him, he'd interrupt again, and go off." Nor did the conversation settle anything. Within days, Henry was complaining that Rogers was "psychopathic."

Nixon and Haldeman agreed that Henry and Rogers were both flawed men, but that Henry was of greater value to the administration than Rogers. For the time being, they saw nothing to do but "figure out a way to continue to live with both of them." If they could "fuzz" the conflict or "ride through it until after the election," they could then get rid of Rogers.

In the meantime, Nixon felt compelled to rein Rogers in on the Middle East. Haldeman was to remind him that dealings with Israel had significant domestic implications: "We can't have the American Jews bitching about plane deliveries, and we can't push Israel too hard and have a confrontation . . . We must not let this issue hurt us politically." Nixon also wanted Mitchell to remind Rogers that in 1968 Jews gave $8 million to Humphrey during the last two weeks of the campaign. "We've got to be careful about their potential influence," Nixon emphasized. Kissinger told Mitchell in January, "We must get Sisco to open the [military] pipeline this year. Sisco says we will sell planes in July 1973." Mitchell responded, "That's silly and not consistent with what the President said." Kissinger promised Rabin that they would provide Israel with between twelve and twenty-four fighters over the next twelve months. Rabin didn't need to be told that election-year politics were Israel's best friend.

The greater political danger, however, remained the war. The Vietnam "debate is not a winner" for us, Kissinger told the president. "I know that," Nixon replied. "The American people want us out." Nixon hoped to enlist public support for his end-the-war policy with a nationally televised speech on January 25. Nixon was eager to speak before an expected North Vietnamese offensive. Otherwise, it might seem like a reaction signaling weakness and a desperate need to make peace.

The speech was a brief against Hanoi for failing to agree to generous terms put forward during Kissinger's secret negotiations in Paris. Nixon revealed that Henry had made twelve trips to see the North Vietnamese representatives, but their insistence on toppling the Thieu government had stymied the talks. Nixon characterized his peace proposals as still

open to negotiation and urged the American people to rally behind their government in its pursuit of peace. "Let us unite now, unite in our search for peace—a peace that is fair to both sides—a peace that can last."

Nixon simultaneously wrote Brezhnev urging him to pressure the North Vietnamese into an agreement that would benefit Soviet interests as well as those of the United States. The alternative, Nixon warned, would be increased fighting that could only "serve to complicate the international situation."

Nixon had small hope of a positive response from Hanoi or Moscow. The real target of his address was the U.S. electorate. But Nixon was concerned to ensure that the press and the public not see his speech as part of the presidential campaign. How, he asked Kissinger, do we answer charges that we are doing "this to embarrass the Democrats?" Henry suggested they say that public misunderstanding of the administration's actions had become "so enormous" that the president needed to clear the air with a description of how hard they had tried to end the war.

Privately, they had almost no hope that anything would come of Nixon's appeal, but they made it because antiwar sentiment in the United States left them no alternative. "The tragedy is," Kissinger told Nixon, "—if there were a six year presidency—we could do it [end the fighting] by having a hundred thousand men there. Then we could do it." Nixon replied, "Well, we can't do it." Henry conceded that "It can't even be considered."

The White House hoped that the speech would be a public relations coup. But when the *New York Times* and *Washington Post* described the reaction as "mixed," Nixon assumed that they had won no converts. As a follow-up, they needed an effective PR campaign to overcome a negative press, which was unwaveringly critical toward the administration's failure to end the war.

At a briefing for Republican congressional leaders, Nixon, Rogers, and Kissinger denounced the North Vietnamese as "masters of 'delphic utterances,'" who were using political opponents of Nixon's policies as "dupes." Nixon urged them "to take the speech and fight back." Barry Goldwater told his congressional colleagues that "they ought to take this [the president's] proposal and, with regard to Democratic doves, 'shove it down their throats and then shove it up the other end until it meets someplace.'"

Reverting to campaign tactics that had carried him to victories in the past, Nixon now demanded that everyone at the White House slam Democratic critics as "the party of surrender," which wanted "a Communist South Vietnam. We should drop the subtleties and fight," he told Haldeman. He told Colson and Haldeman: "It is vital to sustain a massive counterattack on the partisan critics of our proposal." They should be described as "consciously giving aid and comfort to the enemy . . . They want the United States to surrender."

A *Washington Post* editorial calling his speech "The Same Old Shell Game" infuriated Nixon. He instructed Ziegler to remove *Post* reporters from the list of press people accompanying the president to China in February. "They deliberately screwed us, and we are going to have to get back at them."

Kissinger believed that Nixon's firm stand on Vietnam was having an impact on Hanoi. On February 14, when Walters sent word from Paris that the North Vietnamese wanted to have a luncheon meeting with Kissinger on March 11, Henry was "ecstatic." Their unprecedented invitation to a meal and the promised presence of both Xuan Thuy and Le Duc Tho convinced Henry that there would be no offensive and that it might be the prelude to a peace agreement. He was sure that the buildup of U.S. airpower and the likelihood of the president's reelection were forcing Hanoi into a settlement.

Likewise, he believed that the administration's refusal to abandon Vietnam had persuaded the Chinese and the Soviets to invite Nixon to their respective capitals. The Summits "would have been impossible had we simply collapsed in Vietnam," he wrote later.

Kissinger's assumptions about a North Vietnamese offensive, Hanoi's interest in a settlement, and the impact of the administration's Vietnam policy on Moscow and Peking were wishful thinking. Hanoi had every intention of striking fresh military blows at Saigon in the spring of 1972 and of holding to its demand for an end to Thieu's regime. Moreover, neither the Soviets nor the Chinese were receptive to improved relations with the United States because it continued to fight in Vietnam. It was America's capacity as a superpower that made all the difference. With the unilateral withdrawal of U.S. troops and the questionable reliability of South Vietnamese forces, U.S. defeat in Vietnam seemed like a foregone conclusion. But America's capacity to incinerate a major adversary

made it a threat and an asset in the rivalry between Moscow and Peking. Détente with the Soviets and Chinese rested not on anything we did in Vietnam but on the benefits each of them saw in having the United States as a kind of ally or, at least, not an adversary in their struggle with each other.

NIXON PREPARED for his trip to Peking beginning February 17 with characteristic care. He wished to anticipate and consider every possible development to assure against anything that might detract from what he saw as a great asset in his reelection campaign and the overall record of his presidency.

In January, he sent a party of eighteen national security and public relations officials, led by Haig and Ziegler, to spend a week in China preparing for the Summit. Because a significant part of the preparation involved TV coverage, which Nixon believed essential to give his trip the resonance he wanted in the United States, print journalists began complaining that the White House was making "a TV spectacular out of it." But he dismissed their objections as "inevitable," and predicted that the importance of the trip would dwarf all the critical harping. "People think that China is the overriding event of our time," Nixon told Kissinger, and the press was "panting" after the story.

Before going to China, Nixon took counsel from a number of books and asked André Malraux, France's cultural affairs minister under de Gaulle, whose fame as a philosopher and writer had brought him together with Chou and Mao Zedong, to help him understand them. In a White House conversation, Malraux admitted that his knowledge of Mao and events in China were not up to date, but he described his contacts with Mao as "very close." Nixon asked Malraux why the Chinese leaders wanted to meet with him. Malraux thought it was "inevitable"—the product of a desire for U.S. economic help in raising China's standard of living. China, he asserted, was indifferent to the outside world, except as it threatened her. The Chinese had "never helped anyone. Not Pakistan. Not Vietnam. China's foreign policy was a brilliant lie. The Chinese do not believe in it; they only believe in China."

In contrast to Malraux's analysis, which put little emphasis on the Sino-Soviet split, Kissinger urged Nixon to see broad-gauged geopolitical developments behind the invitation to Peking. Mao and Chou were

"hard realists who calculate they need us because of a threatening Soviet Union, a resurgent Japan, and a potentially independent Taiwan . . . Assuring the security of their country and their system for their successors must preoccupy them." They hoped to use the United States to help fend off any foreign attack.

As for Chou, he was a statesman on a level with de Gaulle. He was also an actor who was not easy to read. "Although he will sometimes state agreement with what you say, he will often merely nod, and you cannot be sure whether this gesture means comprehension or accord." Kissinger had never met Mao, but he had heard that he was even more impressive than Chou. Where Chou was "the tactician, the administrator, the negotiator, the master of details and thrust and parry," Mao was "the philosopher, the poet, the grand strategist, the inspirer, the romantic. He sets the direction and the framework and leaves the implementation to his trusted lieutenant . . . They will make a truly imposing and formidable pair."

Nixon summed up Henry's analysis by saying that "the three points Mao wanted before he died: (1) China must be united—that means Taiwan; (2) China should be a great nation, respected; and (3) economic progress." Henry replied: "That third point they will want to do on their own." Nixon responded, "You can be sure we won't raise it."

Although they were about to enter into conversations that would affect the lives of hundreds of millions of people, Nixon and his entourage couldn't rise above political image-making and petty bickering. On the plane across the Pacific, Nixon, Haldeman, Kissinger, and Ziegler debated the advantages of holding a press briefing during a stop in Hawaii. Henry thought it a bad idea: it would convince the Chinese that the trip was "just a PR venture." Ziegler suggested that he hold "a reception for the press, rather than a substantive briefing." Henry wanted to do this himself, but accepted that neither the president nor he should be directly involved. Nixon told Ziegler to stress the importance of bipartisan support for the meetings in Peking. "Can we act as a nation or simply as a babble of voices?" he wanted Ziegler to say. It was essential, Nixon stressed, to control the media and create the impression that the president was engaged in difficult negotiations in which he acquitted himself effectively.

Nixon constantly fretted over the competence of his staff to produce the desired results. During the week he spent in China, Nixon "had a

really tough time sleeping," and he "brooded over the problems he was dealing with, the lack of understanding of him by the press and others that are bothering him," Haldeman recorded.

After landing in Hawaii, Haldeman and Henry had "an incredible chat with Mrs. Nixon, who wasn't the least bit interested in getting any advice from any of us, particularly Henry, on how to handle things," Haldeman wrote. As a shadow figure who had been kept in the background, she was antagonistic to Nixon's aides and any attempt to use her for their purposes. Nixon and Henry also argued over the best way to begin the discussions with the Chinese. Nixon rejected Henry's advice that he read an opening statement and engage in "long, drawn-out historical and philosophical discussions with Chou."

When they landed in Peking at eleven-thirty on the morning of February 21, Nixon insisted on leaving the plane alone. Rogers, Kissinger, and the rest of the White House cast were to wait until the president could be filmed shaking hands with Chou. "We had been instructed on this point at least a dozen times before our arrival in Peking," Henry recorded. Nixon was determined not to share the spotlight before the millions of viewers at home and around the world as television captured the historic moment. The Nixon party was upset by the absence of anyone in the streets as they drove to the guest houses in the center of the city. But Nixon instructed everyone to get out the line that they had expected neither crowds nor hoopla on their arrival; it was, of course, exactly what Nixon hoped would greet him.

Public relations or image making was not absent from the Chinese side. "The reception was understated in the extreme." All the notables greeting the Americans at the airport were attired in drab Mao jackets, suggesting no distinction in status. Anyone knowledgeable about the Communist government, however, understood that someone's place in line coincided with his position in the government hierarchy. The Chinese consciously assigned their American visitors to particular guest houses according to their status.

A tone of grandiosity on both sides marked the visit. Consciously acting on a world stage, Nixon, Kissinger, Mao, and Chou reinforced each other's sense of importance. It was as if they shared a conviction in their common greatness, which their coming together made all the more real to themselves and believable to millions of fascinated onlook-

ers. "Your handshake," Chou told Nixon during their ride into Peking, "came over the vastest ocean in the world—twenty-five years of no communication."

Shortly after their arrival, a summons came from Mao to the president and Kissinger, but not the secretary of state, who was transparently a man of less importance, to see China's emperor in the Imperial City, where he presided over the Kingdom of Heaven, which is how the Chinese traditionally viewed their domain. It was all evidence, as Kissinger remarked later, "that the mystery and majesty of the eternal China endured amidst a revolution that professed to destroy all established forms. There were no trappings that could account for the sense of power Mao conveyed."

Nixon and Kissinger described this first meeting with Mao in tones of hushed awe. Henry called it "our encounter with history." The seventy-eight-year-old Mao, who had suffered several strokes that had impaired his capacity to move and his ability to speak, was helped to his feet on their arrival. He stood holding Nixon's hand for about a minute. The conversation, which lasted a little over an hour, half of which was consumed by translations, was notable for its understatement on Mao's part. As a way to mute the Taiwan question, for example, Mao introduced Chiang Kai-shek into the discussion by declaring that Chiang "doesn't approve of this." Describing the name-calling between them, Mao said, "Actually, the history of our friendship with him is much longer than the history of your friendship with him," signaling, as Kissinger appreciated, that the Taiwan issue was one for the Chinese to settle themselves.

The contrast in style between Nixon and Mao was on display in their relatively brief conversation. Eager to get down to business and score points, Nixon, mindful that his reputation as a fierce anti-Communist might remain a bar to trust, declared that past disagreements should not shape current decisions. "What brings us together is a recognition of a new situation in the world and a recognition on our part that what is important is not a nation's internal political philosophy," he said. "What is important is its policy toward the rest of the world and toward us." When Nixon ticked off the countries—Japan, Korea, Vietnam, and the Soviet Union—that were of importance to both of them, Mao responded, "All those troublesome problems, I don't want to get into very much. I think your topic is better—philosophic questions." When Nixon made refer-

ence to the upcoming election in the United States, Mao repeated the point: "Those questions are not questions to be discussed in my place. They should be discussed with the Premier."

Nixon was eager to flatter Mao. Despite his initial resistance to Kissinger's suggestion that he engage Mao in "historical and philosophical discussions," he told Chou that he would like to talk with the Chairman about "philosophic problems." When Mao asked about this, Nixon responded: "I have read the Chairman's poems and speeches, and I knew he was a professional philosopher." Kissinger interjected, "I used to assign the Chairman's collective writings to my classes at Harvard." Mao declared, "Those writings of mine aren't anything. There is nothing instructive in what I wrote." Nixon objected: "The Chairman's writings moved a nation and have changed the world." But Mao insisted: "I haven't been able to change it. I've only been able to change a few places in the vicinity of Peking."

Nixon brought the conversation back to the present: "We know you and the Prime Minister have taken great risks in inviting us here. But having read some of the Chairman's statements, I know he is one who sees when an opportunity comes, that you must seize the hour and seize the day." Mao dismissed the reference to his words by joking: "I think that, generally speaking, people like me sound a lot of big cannons." Chou laughed.

Lighthearted banter disguised the seriousness of Mao's remarks. "Mao would deliver dicta," Kissinger wrote later. "They would catch the listener by surprise, creating an atmosphere at once confused and slightly menacing. It was as if one were dealing with a figure from another world who occasionally lifted a corner of the shroud that veils the future, permitting a glimpse but never the entire vision that he alone has seen."

"I voted for you during your last election," Mao declared with a broad smile. You "voted for the lesser of two evils," Nixon said. " 'I like rightists,' Mao responded, obviously enjoying himself . . . 'I am comparatively happy when these people on the right come into power.' " Nixon reinforced the point. In America, "at least at this time, those on the right can do what those on the left can only talk about." Kissinger added, "There is another point, Mr. President. Those on the left are pro-Soviet and would not encourage a move toward the People's Republic."

As they departed, Mao, in a slow shuffle, walked them to the door,

confiding that he had not been feeling well. "But you look very good," Nixon assured him. "Appearances are deceiving," Mao replied, perhaps suggesting that the Americans would have to give substance to their friendly words.

Meetings over the next seven days were carefully orchestrated. Mornings were given over to touring, with TV cameras giving Americans a glimpse of China's monuments and long history. More important to Nixon, it encouraged pictures of him as a world statesman accorded honor and respect in a distant land. Fortunately, the images resonated more forcefully than his words: "This is a great wall," he told the press in a comment about the Great Wall memorable only for its banality. Afternoons were reserved for conversations between the president and Chou and evenings were given over to banquets with hundreds of people, including sumptuous eating, drinking, and elaborate toasts punctuated by shouts of *gam bei* or "bottoms up," compelling toasters and recipients of the toasts to empty glasses of *mao-tai*, which Henry likened to combustible airplane fuel. The banquets were also carried on live television in the United States between 6 A.M. and 8 A.M.

The afternoon discussions were most notable for their high-flown rhetoric and limited substance. "We cannot cover up with protocol and fine words the differences we may have," Nixon declared. "It does not serve the cause of better relations to put a cosmetic covering over fundamental differences of opinion. The conventional way to handle a meeting at the Summit like this, while the world is watching, is to have meetings for several days . . . and then put out a weasel-worded communiqué covering up the problems." Chou agreed: "If we were to act like that we would be not only deceiving the people, first of all, we would be deceiving ourselves." Nixon reinforced the point: "That is adequate when meetings are between states that do not affect the future of the world, but we would not be meeting our responsibility for meetings . . . which will affect our friends in the Pacific and all over the world for years to come."

Chou's pronouncement hardly squared with his history as the premier of a totalitarian state, where press and dissenting opinion were strictly controlled. Moreover, Nixon's statements little reflected his determination to limit access to their conversations. "The Chairman can be sure," he told Mao, "that whatever we discuss, or what I and the

Prime Minister discuss, nothing goes beyond the room. That is the only way to have conversations at the highest level." Not even his own secretary of state would have full access to the records of these talks, Nixon confided. "I'm determined where the fate of our two countries, and possibly the fate of the world is involved, that we can talk in confidence," Nixon added. It was essential that both sides feel free to speak frankly, which would be undermined by "disclosures to the press." Public announcements should be approved by both sides. It was no problem for his government, Chou declared. "We can immediately reach agreement on that."

The conversations contained no surprises. Nixon mostly elaborated what Kissinger had stated about Taiwan, Moscow, Japan, South Asia, and Vietnam in his earlier visits. And Chou deepened Nixon's and Kissinger's impressions of a government fearful of being encircled by hostile powers led by the Soviet Union. The task of the new Sino-American relationship was resisting "hegemonic aspirations," which was code for Soviet ambitions. China had no intention of intervening in the Southeast Asian conflict, whatever its sympathies for North Vietnam. The emphasis was on ensuring a shared perspective on the dangers to international order.

Because the conversations yielded no dramatic substantive commitments (continuing official ties to Taiwan ruled out recognition of Communist China), it seemed essential to issue a communiqué that signaled the significant change in Sino-American relations.

Kissinger labored for twenty hours with his Chinese counterpart to find words that accommodated the needs of both sides on Taiwan and the Soviet Union. Where the Nixon administration was under domestic pressure not to abandon Taiwan, Mao's government couldn't afford to depart from its insistence on the withdrawal of U.S. support for Taiwanese independence.

They settled the issue by a U.S. acknowledgment that there was only one China of which Taiwan was "a part." In return, the Chinese agreed to a declaration that the U.S. government "reaffirms its interest in a peaceful settlement of the Taiwan question by the Chinese themselves. With this prospect in mind, it affirms the ultimate objective of the withdrawal of all U.S. forces and military installations from Taiwan. In the meantime, it will progressively reduce its forces and military installations on Taiwan as the tension in the area diminishes." In short, America's with-

drawal rested on an implicit Chinese Communist commitment to avoid a military resolution of its differences with the Nationalists in Taipei.

More important, the two sides signaled their shared determination to advance toward "the normalization of relations" and resist Soviet expansionism. They declared their opposition "to efforts by any other country or group of countries to establish such hegemony . . . Both sides are of the view that it would be against the interests of the peoples of the world for any major country to collude with another against other countries, or for major countries to divide up the world into spheres of interest."

With the conference coming to a close, Nixon became anguished over whether the Summit would be seen as a great accomplishment. On February 27, the Americans flew to Shanghai before leaving for home on February 28. In the middle of the night, Nixon called Haldeman and Kissinger to his suite on the upper floor of a modern hotel in the center of the city. Nixon couldn't sleep, despite consuming several *mao-tais.* He must have been thoroughly sloshed, having drunk a half dozen before and during lunch and several more during dinner.

He insisted on a discussion with his exhausted aides about the results of the past week. He had little confidence that the press, with which he felt locked in unrelenting conflict, would understand "what really has been done." He consoled himself with the thought that his success "will come out eventually." The conversation later moved Henry to describe Nixon as this "lonely, tortured, and insecure man" who was begging for "confirmation and reassurance." Because the achievements were genuine, "it was easy to give Nixon the reassurance he wanted," Kissinger says.

But Kissinger's positive outlook didn't erase Nixon's doubts. He pressed Henry on the plane ride back to the United States to take pains "to cover the right wing." On his return, he provided guidelines to Rogers, Laird, and Kissinger on the administration's public approach to discussions about the Summit. When he briefed congressional leaders on February 29, he couldn't resist chiding the press. He reported that he told Mao and Chou, "If you don't believe what the press says about me, I won't believe what the press says about you." He described one reporter's conclusion that the U.S. and the PRC had come together because "their philosophies were not that far apart" as "naïve." It was mutual "cold-blooded interest" that had brought them together.

Although Nixon understood perfectly what had led to the revolution

in relations with China and was right to believe that long-term judgments would be almost universally positive, he could not let go of the uncertainties that drove his ambition—no triumph, however great, could satiate his quest for acceptance or, perhaps better stated, self-esteem. If his complaint to his therapist after the 1962 defeat that he was someone of little worth had some connection to his life experience, his gloomy ruminations after his success in China speak volumes about his inner life. To be sure, there was press criticism and complaints from the right that he had sold out Taiwan, but the more universal reaction to the Summit was enthusiastic approval.

"We encountered the curious phenomenon," Kissinger said, "that success seemed to unsettle Nixon more than failure. He seemed obsessed by the fear that he was not receiving adequate credit." He could not accept the reality that actions speak louder than posturing. "The conviction that Nixon's standing depended less on his actions than on their presentation was a bane of his Administration," Kissinger observed. "It conveyed a lack of assurance even during his greatest accomplishments. It imparted a frenetic quality to the search for support, an endless quest that proved to be unfulfillable."

~ Chapter 12 ~

THE WARRIORS AS PEACEMAKERS

In the arts of peace Man is a bungler.

—GEORGE BERNARD SHAW, 1903

We must be patient—making peace is harder than making war.

—ADLAI STEVENSON, MARCH 21, 1946

In the weeks after Nixon returned from China, widespread approval for his dramatic shift in relations with Peking muted most of his concerns about the reaction to the Summit. ABC's Howard K. Smith reflected press and public opinion when he declared that "Mr. Nixon deserves credit for a master stroke both opportune and statesmanlike." Nixon reveled in the praise: "Chuck," he wrote Charles Colson, "tell him RN thought his analysis was *Excellent* (Brilliantly concise and perceptive.)"

Kissinger was also personally buoyed by the China Summit. His presence at all the important meetings and Rogers's absence projected him into the headlines as the administration's principal collaborator with the president in revolutionizing U.S. foreign policy. When Kissinger

reported the results of the trip to the White House staff, which stood and applauded, he joked: "I didn't expect you to stand, but I at least thought you would kneel." His presentation strengthened impressions of someone with exceptional understanding of the country's international challenges. "What has been started in China can be a turning point in diplomatic history," he said. "However, for us to do it we have to pursue it with wisdom." He disputed "right-wing opponents," who believed that "only the most rigid anti-communism can make us survive. We can no longer afford this. We gave up a total preponderance of power . . . we are now in the position that every other nation has been throughout history. We need wisdom and judgment in order to survive, and we cannot simply rely on assumed moral superiority and overwhelming productive capacity."

Because it was such a success, Nixon was keen to keep the China trip before the press and the public. As the story waned in the month after his return, he complained to Haldeman that "we've let China dissipate as an issue because we didn't exploit it." He believed that the media would resist any concerted effort to revive discussion of his achievement. "The media simply aren't going to give us any breaks whatever in keeping alive a story which they know might help us," he told Haldeman. It was the news cycle rather than any concerted effort to undermine Nixon that accounted for the media's shifting focus, but Nixon's hatred of the press blinded him to this reality.

At the same time Nixon fretted over the press's animus, he complained about Kissinger's "proclivity to build himself as the power behind the throne." Media descriptions of Henry as the architect of administration foreign policy angered him. A Bill Mauldin cartoon said it all: a Washington, D.C., tourist pointing at Nixon in a limo told his son, "Look! It's Dr. Kissinger's associate!"

Nixon snidely began to refer to Kissinger as "Sir Henry." He instructed Haldeman to give Kissinger talking points that put the president at the center of any renewed China discussion. To bolster the president's standing as a foreign policy leader, Henry was to describe him as "better prepared than anyone who has ever held this office" to conduct negotiations and as having the discipline not to dull his reactions by drinking or eating during discussions and the stamina to be effective despite the length of the sessions. But

Vietnam problems made it difficult to focus positive attention on Nixon's leadership.

IN MARCH, with American intelligence predicting that the North Vietnamese would stage a massive spring attack, Nixon fixated on its likely repercussions in the emerging reelection campaign. He feared that the Democrats would make it a major issue at their July convention and hammer on his failure to end the war. Moreover, he had little confidence that the Paris negotiations would produce a settlement before November. "Hell, I don't care what we're hearing from the goddamn Vietnamese," he told Kissinger, "I've never felt they were going to do anything anyway." He believed it essential "before the Democratic convention . . . [to] make a final announcement of some type" on troop withdrawals "or we will be in very serious trouble." He pointed to a Harris poll saying that "the public won't feel RN has fulfilled his pledge to end the war unless there's a negotiated peace or ceasefire by November."

On March 30, Hanoi launched the expected offensive. Having failed to control South Vietnam "by political subversion or military infiltration, they have now launched a massive conventional invasion of South Vietnam," Haig and Kissinger told Nixon. "They have launched multi-division offensives across the DMZ, across the Cambodian border toward Saigon and across the Laotian border into the Highlands." With only ninety-five thousand U.S. troops, including just six thousand combat-ready forces, left in the country, the South Vietnamese had to do all the ground fighting; U.S. sea and airpower remained available to join the fighting.

Kissinger and Haig counseled the toughest possible response: A failure to answer what they saw as indirect Soviet-supported aggression would "irreparably" damage U.S. credibility. Henry believed that "If we were run out of Vietnam, our entire foreign policy would be in jeopardy." Nixon told Republican congressional leaders that "if this offensive succeeds . . . you will have a more dangerous world . . . If the United States fails at this . . . no President can go to Moscow, except crawling. If we fail, we won't have a credible foreign policy."

With the press describing the offensive as producing "a rout," "disarray," and a "crushing" blow to Saigon in "the first real baptism under fire for Vietnamization," Nixon saw détente and his election at stake.

When Kissinger rationalized the possibility by saying "we've done everything we can," Nixon bristled: "That's a question that we can't even think about. If the ARVN collapses? A lot of other things will collapse around here . . . We're playing a Russian game, a Chinese game, and an election game," Nixon said. Kissinger responded: "That's why we've got to blast the living bejeezus out of North Vietnam."

Kissinger cabled Ambassador Bunker in Saigon that the president refused to allow South Vietnam's defeat, and ordered the U.S. military in Saigon to assure against this. Nixon graphically told Kissinger, "We are not going to let this country be defeated by this little shit-ass country." At the same time, Nixon instructed Haldeman to attack Democrats for being defeatists.

The real issue was Nixon's reelection, not world peace. They could not let South Vietnam "unravel before November," Nixon and Kissinger agreed. Nixon was convinced that the collapse of Vietnam would give the lie to Vietnamization and mark out his strategy of détente as appeasement of China and Russia. He then expected the right to reject him for having been weak and the left for having sacrificed additional American blood and treasure in support of a lost cause.

Almost desperate now to save South Vietnam from a Communist takeover, he threw all the sea and airpower he could muster into the fight, including B-52s, American superbombers, which he planned to use against North Vietnam when the weather allowed. There were limits, however, to what he could do without provoking new antiwar protests. He was walking a fine line between battling Hanoi and touching off domestic turmoil that would weaken him in the political campaign. He took solace from the hope that the North Vietnamese offensive was more the product of desperation to defeat Vietnamization than a demonstration of strength and that a U.S. counterattack might force Hanoi to end the war. Kissinger concurred. Because the North Vietnamese were throwing everything they had into the offensive, a defeat would force them to negotiate, or so Kissinger hoped.

It is understandable that Nixon and Kissinger saw the collapse of Vietnam in 1972 as impermissible. It seemed certain to undermine Nixon's reelection bid and further demoralize the country, which had lost over fifty thousand lives in the war, including more than twenty thousand during Nixon's tenure. The idea, however, that it would inflict a decisive defeat on

the United States in the Cold War was a gross exaggeration. Neither Moscow nor Peking saw any great advantage to themselves from a North Vietnamese victory that humiliated the United States. On the contrary, they wished to see a quick end to the conflict through a negotiated settlement that removed the war as an issue between themselves and Washington. To be sure, both of them supplied Hanoi with the wherewithal to fight, but it was part of their rivalry for international leadership of communism as much as a commitment to seeing a socialist victory in Southeast Asia.

Nixon and Kissinger now struggled over how to deal with the Soviets. Both agreed that Moscow could influence Hanoi's behavior, but Nixon was more inclined to threaten the Soviets with a near collapse of Soviet-American relations than Kissinger. "Henry, with all of his many virtues," Nixon recorded in a diary, "does seem too often to be concerned about preparing the way for negotiations with the Soviets. However, when he faces the facts, he realizes that no negotiation in Moscow is possible unless we come out all right in Vietnam."

Yet for all Nixon's tough talk and Kissinger's reluctant conformity to his dictates, they both saw the Moscow Summit as vital to their larger designs and were eager to preserve it. True, in conversations with Dobrynin on April 3, and again on April 6 and April 9, Kissinger left no doubt that he believed Moscow had some responsibility for Hanoi's offensive. But Dobrynin countered Henry's complaints with soothing assurances that Moscow had not dictated Hanoi's actions, saw no reason for their governments to clash over Vietnam, and predicted that the U.S. and South Vietnam would not lose the war.

The striking feature of Kissinger's conversations with Dobrynin in early April was not Henry's harping on the dangers to Soviet-American relations from North Vietnam's offensive, despite Nixon's wishes, but the extent to which they continued to find common ground for a Summit and improved relations. They focused less on Vietnam than on SALT, the Middle East, and bilateral issues.

Dobrynin reciprocated the goodwill. At the meeting on April 9, he assured Henry that Moscow had encouraged Hanoi to resume peace negotiations with him in Paris on April 24, 1972. During an April 12 discussion, Dobrynin urged Henry to make a pre-Summit trip to Moscow to accelerate preparations for the Summit and discuss Vietnam with Brezhnev and Kosygin.

The previous day Brezhnev had seen American Secretary of Agriculture Earl Butz in the Kremlin, "the first American official visitor Brezhnev has talked to since 1963," and *Pravda* had run the story on its front page. Kissinger believed it signaled Soviet eagerness to keep relations with the U.S. "on an even keel." Brezhnev promised a "big welcome" for the president in Moscow and predicted that they would find many things in common.

On April 15, in response to U.S. air attacks, Hanoi canceled the April 24 meeting. Nixon wanted Henry to consider canceling his pre-Summit trip to Moscow as a signal that Hanoi was jeopardizing the Summit. But he was reluctant to let Vietnam scotch his Moscow visit; it seemed certain to undermine his chances in November. He told Kissinger that maybe he shouldn't run again and speculated on who his successor should be. According to Nixon, "Henry threw up his hands and said that none of them would do, and that any of the Democrats would be out of the question . . . Henry then became very emotional," and said that "I shouldn't be thinking this way or talking this way to anybody . . . The North Vietnamese must not be allowed to destroy two Presidents."

Nixon "longed for the Summit," Kissinger recalled. "To be the first American President in Moscow stimulated his sense of history . . . To be sure, he often spoke of canceling the Summit. But anyone familiar with his style knew that such queries, like occasional musings about his dispensability, were really a call for reassurance," which Henry readily gave him.

On the evening of April 15, after further discussion with Kissinger, Nixon agreed to let him go to Moscow on April 20. They convinced themselves that a U.S. counteroffensive, including air raids on Hanoi and Haiphong, were saving Saigon from defeat and might force Hanoi into a settlement. Public sympathy in the United States for Nixon's response also buoyed him. He now expected to go to Moscow in May having shown that the U.S. could not be defeated and that the Soviets and the world would have to see him as a president who refused to give in to enemies or abandon its friends.

Nixon believed that the Moscow meetings would greatly improve his chances of winning in November. A successful conference advancing Soviet-American détente on top of the achievement in Peking and a possible end to the war would give him a powerful case for reelec-

tion. Kissinger was also more than eager for the Summit; it promised to provide another boost to his reputation for effective statesmanship. Henry "desperately wants to get to Moscow one way or the other," Nixon confided to a diary. "Vanity can never be completely dissociated in high office from the perception of national interest," Kissinger acknowledged. "My eagerness to go was no doubt affected by the dramatic."

Nixon now signed off on a secret Kissinger trip to Moscow as a prelude to his arrival in May. Nixon directed Kissinger to closely follow his instructions about his conversations in Moscow. Detailed directives could ensure that he and not Henry received ultimate credit for any gains at the Summit. Also, he believed he had a degree of expertise about Soviet leaders that Kissinger lacked.

A Nixon conversation with Pompidou about Kosygin and Brezhnev at the end of 1971 had added to his feeling that he understood them better than Henry. Pompidou's impressions of the Soviet leaders rested on three meetings with each of them. "Kosygin's temperament is not very gay," he said. He was essentially an economist and technician and was "fascinated by industrial progress."

By contrast, Brezhnev was "a Ukranian and a Southerner. He was jovial and cordial and liked to eat and drink. He was folksy," enjoyed good living and cars and owned several foreign models. He was easy to talk to, but "he was very tough. He was permanently conscious of the importance of military power but was also aware that he had to raise the living standards of his fellow citizens." He looked to the West to help him produce more consumer goods. But international power was never far from his mind. He still dreamed of "sharing the world with the U.S. China disturbed this idea." His greatest current fear was China's long-term power, with Germany running a close second. He wished to use the United States to blunt the danger from both rivals. The president should never forget that for the Soviets "an arrangement means retreat nowhere and advance whenever possible."

Nixon thought Pompidou's comments "very perceptive," and believed that the key to dealing with Brezhnev was forcing him to help end the war in Vietnam. It was the price Nixon wished to extract for détente, specifically, an unspoken alliance against Chinese ambitions and reduced arms budgets and greater trade to help increase the availability of consumer goods.

Nixon instructed Henry to see Brezhnev as "simple, direct, blunt and brutal." He predicted that the Soviets would not want to talk about Vietnam but rather the Summit and the potential agreements they might reach on arms control and trade. "Our goal in talking to him is solely to get action on Vietnam," Nixon explained. Henry needed to be "tough as nails and insist on talking about Vietnam." Kissinger promised to follow the president's instructions.

On Henry's arrival in Moscow, the Soviets whisked him in a limo through deserted streets to a comfortable guest house in the city center overlooking the Moscow River. The quarters reminded him of his residence in Peking, only in Moscow he was isolated by a surrounding wall. Gromyko met with him the first evening and set an "effusive" atmosphere "with endless protestations of eagerness to have [the] Summit and willingness to settle *all* issues." Brezhnev was apparently going to "conduct all discussions," and "Gromyko said they had some 'concrete considerations' regarding Vietnam."

Kissinger now found himself caught between Nixon's stubborn determination to extract Soviet promises to help end the war and Brezhnev's insistence on the limits of Soviet influence. Nixon also worried that the Soviets would be "slobbering around" Henry, and he would need to watch out "for their flattery—they are masters of it." He saw them trying to get him to the Summit by tricking us with illusory concessions on arms limitations.

Nixon cabled Henry in Moscow that he should accept no arrangement that would antagonize conservatives, who were already unhappy about the China trip. Indeed, he feared the subsequent announcement that Henry had gone to Moscow would be taken as a sign of weakness, especially if we backed off the bombing of North Vietnam.

On April 21, Henry cabled a summary of his first four-and-a-half hour meeting with Brezhnev. The premier's "protestations of eagerness to have the Summit no matter what the circumstances were at times almost maudlin . . . Brezhnev is very forceful, extremely nervous, highly unsubtle, quite intelligent but not in the class of other leaders [Mao and Chou] we have met." Brezhnev asked Henry to "confirm and reconfirm . . . the desire of our government to hold the Soviet-American Summit." He saw the meeting as of "immense importance," not just "historic but epoch-making."

Kissinger reported that "4/5 of the meeting dealt with Vietnam. I gave him just enough about the Summit to whet his appetite but nothing concrete and refused to discuss specifics." Brezhnev was ready to help bring about another Paris meeting between Henry and the North Vietnamese, but "he seemed less sure about how to help in substance." Henry also asked permission to continue the meetings through Monday, April 24, rather than end on Sunday, as Nixon had instructed.

When Haig read Kissinger's cable to Nixon on the phone, the president exploded in anger. He described Brezhnev's comments on the Summit as meaningless "bullshit . . . We've really got to get Henry stiffened up," he told Haig. "All that bullshit . . . all that crap." He was determined to begin additional bombing of North Vietnam on Sunday and he wanted Henry to leave that day, no matter what. "Henry better understand that Brezhnev is playing the typical sickening game. He is being taken in. We have got to stiffen him up. He loves to sit back and philosophize for the history books . . . Henry is so easily taken in by flattery." Haig said, "He thinks the Summit is more important to you than Vietnam." Nixon responded, "It is not. We have got to give up the Summit in order to get a settlement in Vietnam . . . Vietnam is ten times more important than the Summit . . . Tell him no discussions of the Summit before they settle Vietnam and that is an order!"

Plagued by poor communications between Moscow and Washington and a time lag that did not allow cables to keep up with daily discussions, friction between Nixon and Kissinger intensified. In response to a rebuke from Nixon for having failed to put exclusive attention on Vietnam, Kissinger uncharacteristically challenged the president's judgment. "I am astonished both by the tone and substance of your communications," Henry cabled Haig on April 22. "Lectures about how we should have acted are highly inappropriate. We need support, not constant strictures . . . If the President does not trust me, there is not much that can be done."

Henry then explained his strategy: "Brezhnev wants a Summit at almost any cost. He has told me in effect that he would not cancel it under any circumstances. He swears that he knew nothing of the offensive. He told me that he did not step up aid deliveries. Even though untrue, this gives us three opportunities: (A) We may get help in deescalating or ending the war. (B) If not, we can almost surely get his acquiescence in

pushing [our military actions] to the limit. (C) We can use the Summit to control the uproar in the United States . . . What is all the excitement about?" Henry asked sarcastically. "There is no chance of my trading talks for an end to bombing. No one has suggested it."

Kissinger was much more rational than Nixon about how to advance U.S. interests in the current dealings with Moscow. His cable partly aimed to disarm Nixon's fear that they would be taken into camp by the Soviets and that it would cost them détente and Nixon's reelection. Remembering the setback Eisenhower and he had suffered when Khrushchev had canceled the May 1960 Paris Summit, Nixon feared that Brezhnev might do the same in 1972. He believed it would put his reelection in jeopardy and thought it best to beat Brezhnev to the punch. Kissinger not only tried to convince Nixon that Brezhnev wouldn't cancel but also that holding the Summit would strike favorable chords with the electorate.

Kissinger also urged Nixon to understand that Moscow could not control Hanoi, but that they could be persuaded to help with Vietnam. "Not only the Summit but a virtually settled SALT agreement would have appeared to be hostage to Vietnam," Kissinger wrote later. "If we had abandoned both, the domestic uproar from the press, academia, and Congress might have been uncontainable."

As Kissinger understood, the president was "highly ambivalent" about how to proceed with the Soviets. Nixon was delighted that his strong reaction to Hanoi's offensive had boosted his domestic standing, but he couldn't shake the feeling that the continued bombing of North Vietnam would provoke Brezhnev into canceling the meeting.

He mistakenly assumed that the Soviets were as invested in Vietnam as he was. He believed that Brezhnev was lying about Soviet aid to North Vietnam and that his power to rein in Hanoi was much greater than he acknowledged. Nixon complained to Haig that Henry was "breastfeeding" the Soviets, and they were trying to force us "to mute" things in Vietnam as the price of a Summit. "The President remains very strong both on the Vietnam issue and his attitude vis-à-vis the Soviets," Haig cabled Kissinger on April 22. "I am passing this on to you so that you will be fully aware of climate here and not in an effort to badger you or to make your most difficult tasks more so."

Another cable that day from Haig underscored Nixon's unbending insistence on forcing Moscow to do something about Vietnam, regard-

less of the consequences for a Summit. He urged Henry to understand that the Soviets were "not going to be helpful on Vietnam" and were colluding with Hanoi in trying to overrun Saigon. "As you can see from foregoing," Haig advised, "the situation here is almost as difficult as you have found it there."

Convinced that the wisest course was to go forward with the Summit, Kissinger privately "railed at Nixon's 'idiocies.' " In two cables on April 23, he told the president that "he had no business approving the Moscow trip" if he persisted in his "attitude." "I am reading your messages with mounting astonishment," Henry wrote. "I cannot share the theory on which Washington operates. I do not believe that Moscow is in direct collusion with Hanoi."

Henry emphasized that Vietnam was an impediment to Moscow's desire for détente. "What in God's name are they getting out of all this?" Henry asked rhetorically. "They see me three days after we bomb Hanoi. Their agreeing to a public announcement [of my trip] must infuriate and discourage Hanoi. They are willing to see the President while he is bombing North Vietnam." Henry urged Haig to "keep everyone calm. We are approaching the successful culmination of our policies."

Because Nixon was worried that Kissinger might resign in a huff, which would be a serious political blow to him, and excited at the prospect of another successful Summit that could advance international stability and his reelection campaign, Nixon largely gave in to Henry. He cabled him, "There is absolutely no lack of confidence in your toughness, your negotiating skill or in your judgment as to how to evaluate the talks you are having." He agreed to let Henry stay until Monday afternoon if it would "make some contribution on Vietnam."

Nevertheless, while he struck more reasonable notes on the value of holding a Summit, he continued to doubt whether Henry's trip would be seen as worthwhile without some concrete evidence of progress on ending the war. He conceded that Henry's visit sent a message to Hanoi and opened the door to future Soviet help with Vietnam. But he also anticipated "a rising chorus of criticism from political opponents on the left and from our hawk friends on the right for going to Moscow and failing to get progress on the major issue." Moreover, he thought that a SALT agreement would give Kissinger more to crow about than him and wouldn't "mean that much to the average American." He conceded,

however, that a Summit was "vitally important" to America's long-term interests and would "be infinitely more productive than the Chinese Summit."

Kissinger objected to the president's qualifications about the value of his Moscow trip. "It is my firm conviction," he cabled Haig as he prepared to fly home on April 24, "that without my trip to Moscow the Summit would have collapsed and the delicate balance of our Vietnam policy would have disintegrated beyond repair." With Hanoi accepting a May 2 date for a resumption of secret talks in Paris, Henry attributed it to "Soviet pressure." He also saw indications of Soviet movement on Vietnam in information that a principal Brezhnev deputy was traveling to Hanoi.

As for SALT, he had arranged for an announcement the following week, with the breakthrough to be described as the result of "a direct exchange between him [Nixon] and Brezhnev." His "own role in this, including the Moscow trip, can be easily eliminated. I have not exactly taken credit for . . . the whole plethora of secondary agreements in which I have had a major role," he cabled Haig. He was also bringing back a statement of principles to be signed at the Summit, which "will be hailed as a major event at the end of May."

When Henry arrived home, he went directly to Camp David, where he and Nixon had a "tense" meeting. "The P was all primed to really whack Henry, but backed off when he actually got there. Henry obviously was very tense," Haldeman recorded. "He was very distressed that he had been sabotaged and undercut, and he greeted me very frostily, but the P broke that pretty quickly as the meeting started. We all came out in good spirits." Averse as ever to any direct confrontation that would alienate Kissinger, who had served him so faithfully and could inflict serious damage on him if driven to resign, Nixon sat on his irritation.

BUT THEIR DIFFERENCES, especially over how to deal with Vietnam, continued to create tensions. As Haig described it to Kissinger, Nixon was "very testy" over the decision to resume the Paris talks. He thought an announcement about Henry's Moscow visit would encourage impressions that Washington was returning to the negotiating table under pressure from Russia; indeed as a partial payment to the Soviets for agreeing to a Summit.

Kissinger tried to soften Nixon's opposition by assuring him that if renewed talks in Paris—a plenary session on April 27 and a secret visit on May 2—failed to produce "major progress, we must make . . . a major onslaught on Haiphong." He also assured the president that the American public would see the resumption of discussions with Hanoi not as a sign of weakness but of progress. When Brezhnev replied to a Nixon letter about Henry's recent visit to Moscow by declaring that "we cannot have 100-percent assurance that everything will go just the way it is desired" on Vietnam and urged U.S. restraint in its military actions, it intensified Nixon's conviction that Moscow and Hanoi were colluding to ensure Saigon's collapse.

On April 26, Nixon spoke to the country about current events in Vietnam. The speech was more notable for Nixon's worries about the impact of Vietnam on the presidential election than his plans for peace. He began his talk with a review of what he had previously said about Vietnamization as the path to an honorable peace. He asserted that Saigon's effectiveness in the current fighting demonstrated that the policy was working and allowed him to withdraw another twenty thousand troops. He announced a resumption of the Paris talks on April 27, which he had agreed to because of effective resistance to Hanoi's invasion, or so he wanted Americans to believe.

He concluded by warning against divisions in the country over Vietnam. The United States could be defeated only if Americans failed to stand together, he said. The stakes were not simply South Vietnam's freedom but America's world leadership and the future peace of the world. The unspoken message was that the success or failure of the president's foreign policy and his reelection rested on the outcome in Vietnam. The war had taken on an importance to Nixon in both domestic politics and foreign affairs that had little to do with current realities.

The challenge, once again, was to sell the public on the wisdom of what he was doing. "We've had the most brilliant foreign policy in this century," Nixon told Haldeman, with characteristic hyperbole, "but we've sold it the worst." Their PR couldn't overcome "an iron curtain in the press." To counter press criticism, Nixon wanted Colson to apply the "nutcutters . . . in a brutal, vicious attack on the opposition."

In late April, Hanoi launched attacks against provincial capitals as a prelude to Kissinger's meeting with Le Duc Tho on May 2. With the fate

of South Vietnam once more in the balance, Nixon wondered if Henry should cancel his trip to Paris. "I have decided to cancel the Summit unless we get a settlement. We can't go to the Russians with our tail between our legs," he told Henry on April 29. Kissinger agreed. "We can't go if we are totally on the defensive as a result of Russian arms." Fretting again about the likely domestic response and what it would mean for his political standing, Nixon cited "the image of our putting our arms around the Russians at the time their equipment is knocking the hell out of Vietnam."

"As usual," Kissinger asserted, "it was part of the Assistant's task—expected by Nixon—to winnow out those 'decisions' that he really did not mean to have implemented." Nixon's frustration was understandable, but his constant, intemperate talk, which was apparently no more than that, raises troubling questions about his rationality in times of crisis and stress. What if Kissinger had taken his words at face value and advised Dobrynin that Hanoi's attacks had killed the Summit? Surely, presidents need to mean what they say in private when they are not publicly posturing for political gain.

The run-up to Kissinger's May 2 meeting caused further friction between him and the president. At the plenary Paris session on April 27, the North Vietnamese gave no ground to American pressure to end the current invasion. On April 30, when Le Duc Tho arrived in Paris for his latest meeting with Kissinger, he insisted that the U.S. would have to meet Hanoi's demands. His "excessively harsh and unyielding statement," Kissinger told Nixon, "may reflect Hanoi's conviction" that the U.S. was in a weak bargaining position.

Although Nixon reluctantly allowed Henry to return to Paris, he laid down new tough guidelines. He told him to guard against North Vietnamese ploys to trick the United States into delays, which would lose our government "the best chance we will ever have to give them a very damaging blow . . . You have only one message to give them—settle or else!"

Nixon wanted Haig to reinforce his message to Henry. He told Haig on May 1 that Henry had mistakenly predicted a slowdown in current North Vietnamese attacks and had discouraged him from beefing up airpower in the areas under attack. He also complained to Haig that Henry "is so . . . anxious about the talks . . . He doesn't realize that what hurts us most

is to appear like little puppy dogs when they are launching these attacks. What really gets to them is to hit in the Hanoi-Haiphong area . . . And you tell Henry I think we have got to step these up and to hell with the negotiations, and he may have to reconsider going there at all."

With the South Vietnamese performing poorly in the latest battles, Nixon became increasingly agitated about the possibility of Saigon's defeat and the consequences for his reelection. If the North Vietnamese "think they've got the South Vietnamese by the balls," he told Kissinger, "they'll just be as tough as hell, and tell us to go to hell. That is why we'll have to bomb Hanoi and Haiphong."

On orders from Nixon, Haig sent Kissinger a memo outlining dire alternatives. "Should we not consider . . . scrapping the Summit, alerting all U.S. forces to include strategic forces . . . calling up U.S. reserves, forming an amphibious marine force . . . to seize the port of Haiphong and the Capital of North Vietnam, with the view to getting our prisoners and seizing Hanoi's leadership? Should we start preparation of a Presidential address which threatens all-out U.S. reaction?"

Mindful of the limited results of earlier bombing attacks against North Vietnam and the explosion of public dissent likely to follow any of the actions Haig proposed, Kissinger persuaded Nixon to let him go to Paris on the off-chance that the North Vietnamese were hurting even worse than the South Vietnamese and were blustering as a prelude to a settlement. Nixon and Kissinger took some comfort from the belief that, one way or another, the war would be over "by August, because either we will have broken them or they will have broken us, and the fighting will be over."

As Henry was about to get on the plane for Paris, Nixon urged him "to do a little acting, because these people—like the Russians—are liars and actors. I would simply say . . . As you know I am deeply dedicated to peace and I have been able to influence the President in that direction, but I owe it to you to say I can't control him . . . And that you heard what I said and you have never known him to understate what he will do. He has public support." Nixon hoped that a dose of the "madman" medicine might restrain the North Vietnamese.

It was an unrealistic hope. The North Vietnamese were not ready to concede anything under threats, nor would the fighting end by summer. The meeting in Paris began with Hanoi's hope that it was on the verge

of victory—South Vietnam seemed in danger of collapse. Consequently, Kissinger's three-hour discussion with Le Duc Tho and Xuan Thuy produced nothing but acrimony. Nixon instructed the U.S. delegation to suspend conversations after a meeting on May 4 unless there was an indication of some movement on Hanoi's part.

Nixon and Kissinger found themselves in a trap partly of their own making. If they had ended America's role in the fighting with declarations of hope that Saigon had the wherewithal to survive, they would not have faced the dilemma of how to rescue Vietnam without jeopardizing the Moscow Summit. From the start of Nixon's presidency, they had accepted that ending U.S. involvement in the fighting was an inescapable political requirement. Having sacrificed so much blood and treasure already, most Americans wanted to hear that we had done all we could for Saigon and the time had come for it to accept responsibility for its fate with only American logistical support. But having sold itself on the idea that U.S. credibility and even world peace depended on South Vietnamese autonomy, the White House couldn't fully face up to the reality that America's political will to save Vietnam had all but disappeared. Moreover, Nixon's talk about the greater importance of Vietnam than the Moscow Summit hid the extent to which Nixon and Kissinger saw a new relationship with Soviet Russia as indispensable to the success of their foreign policy and the president's chances for a second term.

In the week after Kissinger returned from Paris, he and Nixon struggled to find means to back up their rhetoric about not abandoning Vietnam and preserving the Summit. Nixon proposed a two-day bombing strike: He believed that American public opinion, which did not want us to "look like pitiful giants," favored such action. Nixon was increasingly reluctant to proceed with Summit planning: "toasting Soviet leaders and arriving at agreements while Soviet tanks and weapons are fueling a massive offensive against our allies is ludicrous and unthinkable." Yet Haig accurately read Nixon's pronouncements as "not a conviction but rather a 'Devil's Advocate' position."

When Henry arrived in Washington on the evening of May 2, he joined the president, Haig, and Haldeman on the presidential yacht *Sequoia* for an assessment of their dilemma. Neither Nixon nor Kissinger wanted to cancel the Summit, but they also wanted to arrive in Moscow without looking weak, which could be the case if Hanoi was on the verge of defeat-

ing Saigon. Possibly "nothing is going to have any effect on the situation in the South," Henry said. "I couldn't agree more," Nixon replied. "That's the tragedy of this situation," Henry added. "Right!" Nixon exclaimed.

They also agreed, however, that some overt military action against North Vietnam was essential on the off-chance that it would make a difference in the fighting. Whatever its military consequences, it would counter complaints that the president was a paper tiger who talked tough and did nothing of consequence. At the same time, they feared that strong action could provoke a Soviet cancellation that would shatter the president's foreign policy and undermine his standing with the public.

Consultations over the next two days with Kissinger, Haig, Haldeman, and Treasury Secretary John Connally, a tough-talking Texan to whom Nixon had taken a special shine, seemed to convince Nixon that he shouldn't cancel the Summit—polls, in fact, showed "strong popular demand" for the meeting. Plenty of theatrics marked the discussions, with Nixon pacing up and down his hideaway office, pretending one minute to be General Patton and the next Douglas MacArthur puffing on a corn cob pipe. But there was no chance he was going to give up the Summit. "We can't pull the Summit," he told Henry in an early evening phone call on May 3. In a conversation with Harry Dent, a down-the-line conservative from South Carolina, Nixon asked what he thought about his going to Moscow, but before Dent could answer, Nixon said, "We're going of course."

At the same time, however, Nixon decided to mine Haiphong harbor to cut off the flow of oil and other supplies to Hanoi. It was "a less aggressive move than the bombing" and seemed less likely to provoke a Soviet cancellation. Indeed, the U.S. government planned to tell Moscow that the alternative would have been a U.S. decision against the Summit or an American postponement coupled with aerial attacks against Hanoi and Haiphong that might cause the loss of Soviet ships and lives.

Nixon's decisions had less to do with saving South Vietnam than with electoral politics. Polls showed that Americans wanted him to retaliate against North Vietnam and hold the Summit. Several of his advisers believed that mining Haiphong to disrupt North Vietnamese supply lines was more symbolic than substantive; it would not alter the outcome of the current offensive, and given other supply routes into North Vietnam, would have little impact on the outcome of the war.

In an Oval Office speech to the nation on the evening of May 8, Nixon put less stress on cutting off supplies to North Vietnam by mining its harbors and bombing its rail lines than on the value of a U.S.-Soviet Summit. A letter from Brezhnev on May 6 had deepened worries about possible Soviet reluctance to meet. Brezhnev had warned Nixon that stepped-up military action in Vietnam by the United States could undermine Soviet-American relations. An end to the Vietnam War, he said, "would in many ways clear the road for serious progress in the relations between our two countries."

Nixon used his address to speak directly to the Soviets. "We expect you to help your allies," he said, "and you cannot expect us to do other than to continue to help our allies, but let us . . . help our allies only for the purpose of their defense, not for the purpose of launching invasions against their neighbors. Otherwise the cause of peace . . . will be seriously jeopardized."

Nixon's criticism of Moscow was coupled with a strong appeal for continuing recent gains in their improving relations. "Our two nations have made significant progress in our negotiations in recent months," Nixon declared. "We are near major agreements on nuclear arms limitation, on trade, on a host of other issues. Let us not slide back toward the dark shadows of a previous age. We, the United States and the Soviet Union, are on the threshold of a new relationship that can serve not only the interests of our two countries, but the cause of world peace. We are prepared to continue to build this relationship. The responsibility is yours if we fail to do so."

Like Nixon and Kissinger, Brezhnev saw relations with its superpower rival as more important than the conflict in Vietnam, especially since the North seemed headed for an ultimate victory. During the three days after Nixon's speech, both sides stroked each other with an eye to saving the Summit. On May 9, Nixon ordered Kissinger to go all out in creating the impression that "I am absolutely determined to end the war and will take *whatever steps are necessary* to accomplish this goal . . . We should go for broke."

Yet at the same time, he wanted Henry to make clear that this was nothing like the confrontation with Moscow over Cuba in October 1962. Unlike Kennedy, he had not put a blockade in place, which would have required stopping Soviet and other supply ships heading for North Viet-

nam. Mining would be sufficient to close North Vietnam's ports. That morning, Henry called in Dobrynin to tell him that "in areas outside Southeast Asia, we have continued to do business as promised."

On May 11, the controlled Soviet press offered muted criticism of U.S. mining of the harbor at Haiphong, while the Soviet economics minister told the American press that he was confident the Summit would occur. A letter from Brezhnev to Nixon that day implicitly confirmed the minister's statement by saying nothing about their meeting in Moscow. Lingering doubts about Soviet commitment to the Summit disappeared on May 12, when Dobrynin told Kissinger that his government would be asking procedural questions about the meeting in the next two days. "We have passed the crisis," Henry told the president. "I think we are going to be able to have our mining and bombing and have our Summit too."

Moscow's decision to go ahead with the Summit buoyed Nixon. He wanted his staff to use the Soviet commitment against political opponents. News accounts depicting him as angry, rash, and intemperate in risking the Moscow meeting by expanding the air and sea war incensed him. He described the descriptions of him as "180 degrees from the truth." He wanted the public to have an image of him showing "calmness and coolness" under fire, while making wise decisions. He ordered a concerted campaign to compel apologies from "commentators, columnists and editorial writers" for predicting that "the mining of Haiphong would lead from everything to World War III to cancellation of the Summit . . . This is again the most devastating proof . . . that whatever we do and however it comes out, we are going to be torn to pieces by our liberal critics in the press and on television."

The administration's attacks on the press changed no one's mind about the war. Nor did they score points with the electorate in the developing presidential campaign. None of these efforts at PR were as consequential as the realities on the ground in Vietnam or in the upcoming Moscow talks. As the president's trip to Peking had demonstrated, genuine gains in relations with Communist adversaries that reduced the chances of war or set in place what Nixon called the structure of peace were far more important to his presidential standing than tendentious battles with critics.

Yet Nixon could not let go of the feeling that arguments with political opponents and the Vietnam conflict were contests that had to be

won. Although the South Vietnamese, with expanded U.S. military help, were more effectively holding the line against Hanoi's offensive, Nixon wanted them to do even better. "You tell Abrams, God dammit," he told Haig on May 16, "I want him and Thieu and the rest of them to think in terms of trying things. I don't want them to make big mistakes, but it's sitting on their asses and not trying . . . do you understand?"

Among other things, such as doubling the number of B-52s, Nixon wanted the CIA to step up its propaganda war, which he complained had been "terribly weak." He asked Haig, "Are they playing the dirty tricks game?" Haig replied, "CIA has the black broadcast threatening invasion." He also reported that they were dropping millions of leaflets stressing that North Vietnam was being devastated and that "their homeland is finished." Nixon was pleased: "I feel this is the time now if the tide of battle is turning to pour in the propaganda," he said. "We want to be sure to pour terror into the hearts of the enemy." Specifically, he suggested frightening the North Vietnamese with reports that two U.S. Marine divisions would invade the Hanoi-Haiphong area between June 1 and June 15. He thought that rumors of riots in North Vietnamese cities and of all women and children being evacuated from Hanoi might persuade some North Vietnamese troops fighting in the South to desert and return to their homes to defend their families.

As he was about to leave for Moscow, Nixon directed Kissinger and Haig to assure that "there be no abatement whatever in our air and naval strikes while we are gone." Press stories saying that we are letting up need to "be knocked down instantly." Nothing "could hurt us more in the minds of public opinion than some suggestion that we made a deal with the Russians to cool it in Vietnam while trying to negotiate agreements with them in Moscow."

TWO DAYS BEFORE Nixon left for Moscow, he invited Dobrynin to meet with him in Camp David. He wished to discuss procedural matters at the Summit. Specifically, he wanted to ensure that the "special channel" or Kissinger-Dobrynin back-channel discussions be hidden from Rogers. Rogers had to accompany him on the trip, but he wanted the Soviets to understand that the secretary of state was not important. He candidly told Dobrynin that where Brezhnev relied on Gromyko, he did "not rely on Rogers." He "thought it would be better if Gromyko were not

present" at his meetings with Brezhnev, "because that would raise the issue of having Rogers present." Dobrynin "thought the matter could be handled." On the plane to Europe, Nixon and Haldeman discussed how to give Rogers enough symbolic visibility to satisfy him without involving him in major substantive issues.

The bigger challenge was to draw Brezhnev and Kosygin into commitments that served U.S. interests as well as their own. To this end, Kissinger tried "to capture the flavor and style of the principal Soviet leaders" in an eight-page memorandum to the president. Brezhnev, the Communist party general secretary and Nixon's most important counterpart, needed this meeting as a way to boost his stature and authority in the Kremlin's "never-ending power struggle," Henry explained. He needed to fix his "image as a brutal, unrefined person; he was trying to live down his long history of drunkenness" and this would move him to act as a gracious host. Although he could be earthy and profane, he would avoid being vulgar or "obscene" in the talks. He would work hard "to keep his demeanor . . . within the decorous limits of a middle-class drawing room."

Whatever his personal limitations, Brezhnev would be a formidable opponent. He wasn't "as acute" or "combative" as Khrushchev, but he would be on top of the significant issues and would forcefully defend Soviet interests. He would rely on the familiar Soviet tactic of arguing that his opponent's interests would be well served by accepting a Soviet-sponsored position, and "how much the history books will praise you for the effort."

To give Nixon a clearer sense of Brezhnev, Kissinger described him in American terms, as "a tough and shrewd union boss, conscious of his position and his interests, alert to slights." He would resort to flattery, especially "when he wants you to be 'statesmanlike' and 'generous' . . . He will tell you that he wants you re-elected." He has powerful memories of World War II and a genuine abhorrence of war, "though, of course, he uses fear of war in others to obtain political ends." He was not without regard for our use of power in Vietnam, though he would never say so, and he deeply resented and disliked the Chinese. "He may appeal to the similarities that Russians and Americans have, compared to the Orientals." His animus was partly fed "by the knowledge that the Chinese regard him as a crude thug who has no right to claim Lenin's or even

Stalin's inheritance." Partly because of his difficulties with China, "Brezhnev has important business to do with you now . . . Moscow has to get a grip on the Teutonic past so it can deal with a Mongolian future."

As for Kosygin, he was "clearly subordinate to Brezhnev in power and authority." Nevertheless, he would have a say on "sensitive issues . . . He is a manager-type and therefore tends to be pragmatic on operational questions. He wants to get things done and gets impatient with interference from party watchdogs and bureaucrats." But he could also be "rigid and orthodox . . . on ideological matters." He was impatient "with clumsy Party interference in management of the country" and tended to circumvent "Party apparatchiks." He had "the reputation of being dour," but also as someone who would impress Nixon as "composed." In comments on foreign affairs, despite strong feelings, he would "put his case in rational and concrete terms."

The description of the two Soviet leaders was not only an appraisal of what Nixon could expect in Moscow but also a way to bridge the gap between him and the Soviets. In significant respects, Brezhnev and Kosygin were described as similar to Nixon: Like the president, Brezhnev was engaged in a "never-ending power struggle" with opponents; his outward graciousness hid a crude use of language and a struggle with excessive drinking; he understood all the important issues under discussion and would be a formidable defender of his nation's interests; he resented slights, had a genuine horror of war, was prone to ethnic or racial bias, and was eager to reduce international tensions.

Kosygin was even more a mirror image of Nixon: He was a pragmatist who had no patience with uncooperative bureaucrats; despite strong, even passionate, feelings about international questions, he would come across as in command of himself and a formidable advocate who spoke convincingly on a number of subjects. The Kissinger memo seemed calculated not only to prepare Nixon for the difficult negotiations ahead but also to evoke his sympathy for ambitious, up-from-the-bootstrap leaders eager to leave a constructive mark on history. In short, Brezhnev and Kosygin could be seen as Russian variations of Nixon.

The day before he left for Moscow, Nixon told congressional leaders that previous Summits "generated a spirit of Vienna, Geneva, Camp David, and Glassboro, but we wound up with flat beer as far as agreements were concerned. I wanted the Summit prepared not for cosmetics . . . but

to cover substance. This is why we have taken so much time to arrange this meeting." He believed that they had meticulously laid the groundwork for successful discussions that would produce major agreements on a variety of subjects, or so he wanted congressional leaders to think.

As he traveled to the Summit, Nixon was divided between euphoria at being the first American president to visit the Kremlin and skepticism about ruthless Communists who remained determined to defeat the West by subversion and stealth. Kissinger reinforced Nixon's ambivalence. In another pre-Summit memo, he warned the president that any one meeting could not wash away the years of hostility between Moscow and Washington. The SALT agreement coupled with future economic ties would be a big step forward. But the contest for power and influence in Europe and Asia would not disappear. Yet the virtual standoff in nuclear weapons and the dangers they posed to human survival compelled the United States to seek some kind of accommodation despite doubts about Moscow's long-term intentions.

The domestic political consequences for Nixon from the right shadowed his trip to Moscow. Since the SALT agreement, which would be the most prominent outcome of the Summit, was likely to arouse greatest concern, Nixon instructed Kissinger and Haig to plan a campaign to avoid "a massive right-wing revolt." While "liberals will praise the agreement, whatever it is," he told them, they "will never support us—the hawks are our hard-core, and we must do everything that we can to keep them from jumping ship after getting their enthusiasm restored as a result of our mining operation in the North." They would need to convince conservatives that "the President is not being taken in and that the military totally supports what we are doing."

The president's arrival in Moscow on May 22 underscored American impressions of the Soviet Union as a strictly controlled society. The reception was no more spontaneous than what the president's party had experienced in Peking. A small crowd kept at a proper distance on one side of the terminal building watched as a line of dignitaries greeted the Americans, who were then driven at breakneck speed through empty streets to the Kremlin. There, in the Tsar's Palace, behind red-brick walls, Nixon and his entourage were isolated, as they had been in Peking's Forbidden City, from the press and the millions of Russians, whose drab existence was hidden from the visitors. Convinced that well-concealed listening

devices were present in all the guest quarters, including the rooms in the vast nearby Hotel Rossiya, where Rogers and his state department aides were housed, Nixon took to holding private conversations in his American bulletproof limousine parked in the courtyard outside his residence.

As in China, when Mao followed Nixon's arrival with an unplanned meeting, Brezhnev invited Nixon to his Kremlin office within an hour of his coming. On this occasion, however, Nixon went alone, without Kissinger or even an American interpreter. Henry "was beside himself," one Soviet observer recalled. "This could be the most important meeting of the Summit," Kissinger exploded, "and there's no telling what he's saying in there."

Kissinger need not have worried. If the transcript of the conversation, which was made by a Soviet interpreter, is to be trusted, the two-hour discussion was something of a predictable love fest—two experienced politicians stroking each other for self-serving reasons. Having staked their prestige on holding the Summit, which had created worldwide interest and expectations of significant agreements, neither man could afford to disappoint domestic and international hopes.

The discussion was notable for expressions of mutual regard and the burdens they shouldered in coming together for the sake of their people and all humanity. The difficulties of long flights, memories of an earlier meeting in the fifties, eagerness to be honest with each other punctuated their opening remarks. Brezhnev took pains to denounce "opponents . . . acting under various guises and pretexts" of antagonism to Soviet-American cooperation. "There is no need for me to name them—this is easily understood even without that," Brezhnev said of the Chinese. Brezhnev also tried to score points by mentioning how difficult Vietnam had made it for him to come together with the president. He hoped that Nixon would take it as a measure of Soviet commitment to détente. Brezhnev also recalled the years of cooperation in World War II. "It is that kind of relationship I should like to establish with the General Secretary," Nixon responded.

Nixon was particularly concerned to assure that a declaration of basic principles Kissinger had worked out with the Soviets during his April visit would be hidden from Rogers and the American press. "I trust we can make it appear as if this question arose and was settled in the course of discussions this week," Nixon said. "I hope you will help us play this out in this way," he said. Brezhnev was happy to agree.

The discussion ended with a mutual pronouncement on the dangers of being dragged into a war by other adversaries. The greatest peril, Nixon said, was not a war directly between them but a conflict "in completely different areas of the world. That is what we should avoid." Brezhnev agreed: "We should try and avoid all that is linked with war," he said, with no mention of their arms race or the fact that Moscow and Washington were the greatest suppliers of weapons to opposing nations all over the world.

Three meetings on May 23 launched the conference. An afternoon plenary session in St. Catherine's Hall, an ornate room in the Tsar's Palace with a beige-covered rectangular table for the eleven participants on each side to face each other, produced little of consequence. The presence of so many White House and state department aides, Kissinger said, guaranteed "that Nixon would say nothing significant."

The session mainly focused on expressions of good intentions and procedure. The agreements reached at the current Summit should become the basis for additional talks and accommodations in the future, they agreed. A SALT treaty would leave each side with enough weapons to "destroy each other many times over," Nixon pointed out. Trade agreements amounting to several hundred million dollars should grow into the billions. Brezhnev hoped they could speak "in terms of a 3-4 billion dollar credit for 25 years at 2 percent per annum."

Brezhnev joked that the United States would do well to import Russian vodka and suggested that he and Kissinger found a company with monopoly rights to sell it. "Dr. Kissinger already makes enough at his job," Nixon dryly observed. They agreed to hold signing ceremonies every afternoon before the press on secondary matters that would help create a congenial atmosphere for larger commitments. They also instructed subordinates to work out the final details of the arms control agreement and other issues in dispute.

At the two additional sessions, the president and Kissinger met with Brezhnev, first in St. Catherine's Hall for two hours and then in Brezhnev's Kremlin office for two and a half hours. Brezhnev emphasized that he and his colleagues were enthusiastic about the statement of Basic Principles written during Kissinger's earlier visit. Nixon joked that Kissinger had given everything away and "now I will have to take it back again."

The afternoon and evening talks focused on SALT. The objective,

Nixon said, was to strike a balanced agreement that would inhibit objections from critics eager to complain that one side or the other had given away too much. Brezhnev agreed, but the discussion provoked irritation and tensions, especially over submarine-launched ballistic missiles (SLBM), which Brezhnev complained gave the United States an advantage over the U.S.S.R. Nixon responded that the size of Soviet missiles gave the U.S.S.R. a counterbalance. Nixon urged some give and take on both sides. By the end of the session, Brezhnev thought that they had reached an understanding.

The first day's sessions exhilarated Nixon and Kissinger. They believed that they had largely wrapped up the SALT agreement, which they expected to cite as the principal achievement of the Summit. But difficulties with Rogers and news that American conservatives would attack the SALT commitments dampened their enthusiasm. Nixon's designation of Kissinger to work on a final communiqué incensed Rogers, who told Henry, "You obviously cooked up this deal." He then told the president, "he might as well go home . . . He's stomping around with all sorts of threats," Haldeman recorded.

Haldeman also noted that "we're going to have a hell of a problem with the conservatives at home." Haig cabled Kissinger the text of a press conference by a conservative congressman, declaring, "It's better to have the Summit flop than to risk the future security of the nation." Nixon began "pushing hard for the Joint Chiefs . . . to work on selling the hawks," Haldeman noted. Nixon also eased his Rogers problem by assigning him principal responsibility for economic negotiations and discussions of a possible European security conference.

The two-hour midday session on May 24 focused on economic and European matters. Nixon emphasized that he would need a settlement of outstanding lend-lease debts from World War II to win congressional approval for Soviet Most Favored Nation (MFN) status on trade and cautioned that European affairs, particularly NATO force levels, could not be settled without consultations with allies.

"Do you think the time will come when there are no allies on your part or on ours, that we are common allies?" Kosygin asked. "It will take time," Nixon responded, loath to even hint at negotiations to dismantle NATO. "That's what we want to achieve," Kosygin answered. "As long as you have your allies and we ours, we are at loggerheads." Nixon coun-

tered, with implicit reference to the twenty-seven-year Soviet domination of Eastern Europe, "Small nations object to having their fate decided by larger ones." He then softened his remarks by declaring that "we wouldn't want to anger Albania." When the laughter subsided, Gromyko exclaimed sarcastically, "That is a very noble intention."

Both sides added to the mirth by declaring their interest in a joint manned-mission to Mars. Nixon said he was ready to go along. Kosygin suggested he come too. "It will take nine months. We will get to know each other very well," Nixon declared. "We will take cognac," Kosygin responded. "Perhaps there should be a preliminary flight of foreign ministers," Gromyko volunteered. "If the foreign ministers don't come back," Nixon deadpanned, "we won't go." Brezhnev thought that Kissinger's presence on such an adventure would "keep him away from submarines," on which he had been outspoken in defense of the U.S. negotiating position.

A three-hour meeting the night of May 24 was less friendly. After a signing ceremony in the Kremlin, Brezhnev and Nixon headed for Brezhnev's dascha on the outskirts of Moscow. Persuaded by Brezhnev to leave without Kissinger or his secret service agents, Nixon survived a forty-minute drive at breakneck speed, which was followed by a "frenetic" hour ride on the Moscow River in Brezhnev's hydrofoil. Kissinger, two NSC aides, and frustrated secret service agents caught up with Nixon at the dascha, where Brezhnev, Kosygin, and Soviet President Nikolai Podgorny subjected the Americans to a dressing down on Vietnam.

When shortly into the evening discussion Brezhnev described the Middle East and Vietnam as acute problems, Nixon launched into a lengthy response about his Vietnam policy. He cautioned against allowing "a collateral issue" to bar progress on more important matters. He then defended his record on Vietnam, describing America's negotiating position as "very forthcoming." But he acknowledged that the conflict was the only major international issue clouding their relations. He was eager to end the war; it was in their mutual interest.

Brezhnev gave no ground on Vietnam. He described the United States as engaged in "very cruel military actions . . . [and] a shameful war." Vietnam in no way threatened the United States, Brezhnev said. America's current bombing of North Vietnam belied professions of eagerness for peace. The war, moreover, was impeding substantial improvements in U.S.-Soviet relations.

Brezhnev asserted that U.S. prestige would not fall but rise as the result of a prompt end to the fighting. Brezhnev warned that the moment might come when Hanoi would agree to let forces from other countries join them against the United States. "That threat doesn't frighten us a bit, but go ahead and make it," Nixon bristled.

Nothing was more telling in Brezhnev's monologue about Vietnam than his recounting of a conversation with Kissinger during his earlier visit to Moscow. "Dr. Kissinger told me," Brezhnev said, "that if there was a peaceful settlement in Vietnam you would be agreeable to the Vietnamese doing whatever they want, having whatever they want after a period of time, say 18 months. If that is indeed true, and if the Vietnamese knew this, and it was true, they would be sympathetic on that basis" to reaching an agreement. In short, Kissinger was reverting to the suggestion that if Hanoi agreed to a settlement and allowed for a subsequent decent interval—eighteen months—the United States would not interfere in any renewed fighting.

If you are willing to let Saigon fall to North Vietnam, Brezhnev was asking, why not end the war now? The answer, of course, was that the administration wanted at least the appearance of a successful negotiation. Moreover, Hanoi was not about to settle on terms allowing Thieu's government to stay in place. It simply did not trust that the United States would allow a North Vietnamese victory over the South at any time. "The Vietnamese attach greater importance to their fear of being tricked in a settlement" than to a peace agreement, Brezhnev told Nixon. While the American government might not put troops back in Vietnam, it could still use massive sea and airpower to help deny Hanoi its ultimate victory.

Although one Soviet official told his American counterpart that the pronouncements on Vietnam were staged to make a record for the North Vietnamese and others eager for Moscow to stand up to the United States, the vehemence of the remarks suggest something more than a political charade—genuine feelings of outrage at the American Goliath for unrelenting attacks on a North Vietnamese David.

Nixon and Kissinger would later describe the president's response to the verbal assault as "very tough." Nixon did "a magnificent job," Henry told Haldeman. But Nixon's response was neither very tough nor magnificent. Eager not to jeopardize the Summit over Vietnam and con-

vinced that he could not cajole the Soviets into pressing Hanoi into any dramatic shift in its negotiating posture, the president blandly described the conversation on Vietnam to the Soviets as "very helpful." He promised to "continue our search for a negotiated end to the war."

Nor were the Soviets going to allow Vietnam to become a deal breaker. Besides, a Soviet government that had no apologies for its repression and domination of Eastern Europe, most strikingly Hungary in 1956 and Czechoslovakia in 1968, could not be unmindful of the irony in demanding U.S. regard for Vietnam's self-determination. In short, Moscow had no intention of sacrificing its self-interest for the sake of Vietnam or any other nation that formed a bar to détente with the United States. A genial, sumptuous dinner with much drinking and bantering followed the three-hour confrontation. "We had gone from good humor to bellicosity back to joviality in five hours," Kissinger said.

Although the Summit discussions continued for three more days—on May 25, May 26, and May 29—the outcome of the conference was largely settled. True, Nixon and Kosygin—Brezhnev was absent—conferred for almost two hours on May 25 about economic issues, and Nixon and Brezhnev spent two and a half hours on May 26 discussing the Middle East. But they were unable to settle either of these issues. Consequently, they agreed to establish an economic commission that would continue to discuss Lend-Lease, bank credits, trade, and MFN differences and to have Kissinger and Dobrynin use the "special channel" to address Middle East problems.

On the evening of May 26, Nixon and Brezhnev cemented their personal relations in a dinner conversation about China and a visit to the United States. Brezhnev confided details to Nixon about Chinese political divisions and "repeatedly referred to himself and the President as Europeans" and their mutual difficulty in understanding the Chinese mind. They agreed that China's population and potential made it essential for both their countries to consider it a major factor.

Nixon hoped that Brezhnev could come to America in 1973, after the Vietnam problem had disappeared. He hoped that they could replicate the sort of relations that existed during World War II. Brezhnev thought that the results of the current Summit would make Americans sympathetic to his visit. Nixon predicted that he would receive "a good reception" in the United States, and assured him that "he need not worry about demonstrations . . . we know how to handle them."

At eleven that evening, Nixon and Brezhnev announced the agreement to a SALT treaty limiting ABM sites and a temporary freeze on the numbers of ICBMs and SLBMs. Nixon, who feared "a revolt by his constituency on the right," and suspected a conspiracy by the Eastern Establishment to impugn the treaty and defeat him, instructed Henry to defend the treaty in a press conference. For an hour, at one o'clock in the morning in the ballroom of a Moscow hotel, Henry, who was exhausted from lack of sleep over three days, briefed the press on the most important arms control agreement to that point in history.

The SALT agreement, as several experts pointed out, was flawed. It did nothing to inhibit a "MIRV explosion," which produced a huge expansion in the number of nuclear warheads on both sides over the next decade. Operating without the help of U.S. experts, who might have anticipated and inhibited some of this growth, Nixon and Kissinger agreed to the treaty anyway. "The first strategic arms agreement actually produced a sizeable buildup in strategic weaponry," one expert said. The Soviets were determined to protect their freedom to catch up with the United States in MIRVed missiles, and Nixon and Kissinger were so eager to win a SALT agreement that limited ABMs, both sides largely pushed the MIRV issue aside.

Yet at the same time, the agreement marked a watershed in U.S.-Soviet relations. "Never before have two adversaries, so deeply divided by conflicting ideologies and political rivalries, been able to agree to limit the armaments on which their survival depends," Nixon announced. The agreement implicitly acknowledged the pointlessness of the nuclear arms race—a competition for weapons that no sane government could expect to use without unprecedented damage to people everywhere and the planet they inhabited.

The rest of the Summit reflected the overall improvement in relations. At their final meeting in Brezhnev's Kremlin office on the morning of May 29, Nixon promised "that privately or publicly I shall take no steps directed against the interests of the Soviet Union. But the General Secretary should rely on what I say in private channel, not on what anyone else tells him. There are not only certain forces in the world," Nixon said, playing on Soviet concerns about China, "but also representatives of the press who are not interested in better relations between us." There were some enemies Nixon could not reconcile with.

That afternoon, at a larger session of Summit participants in St. Catherine's Hall, Brezhnev emphasized that nothing in their deliberations had been "aimed against any third country." He praised the agreements and the promise of future cooperation resulting from their discussions, especially on economic matters. He acknowledged that Vietnam and the Middle East remained unsolved problems, but stated their intention to continue consultations. Skeptical that the media would give them their due, Nixon cautioned again that "superficial observers, sometimes in the press, would judge the meeting only by the agreements signed . . . The results will be determined more by how the agreements are implemented," telling the Soviets that honoring their commitments would be essential to sustaining the Summit's achievements.

The session ended on a sour note. After Nixon stated that Rogers would be leaving for a NATO meeting in Bonn to report on the Summit, Kosygin asked "whether Secretary Rogers would be going there to do away with NATO." Nixon answered sarcastically: "Maybe in about ten years," indicating that he saw no likelihood of such a development in the foreseeable future. "That was a long time," Kosygin declared as the conference adjourned.

Nixon's public pronouncements on the results of the Summit could not have been more upbeat. A statement of "Basic Principles" of Soviet-American relations and a joint communiqué, both issued on May 29, endorsed "peaceful coexistence" as mandatory in a nuclear age. He joined the Soviets in promising to do all in their power to achieve general and complete disarmament, inhibit conflicts increasing international tensions, and promote universal national self-determination. The communiqué described the statement of basic principles as opening "new possibilities for the development of peaceful relations and mutually beneficial cooperation between the USA and the USSR."

Characteristically, Nixon privately anguished over the results of the meeting. There was a Wilsonian, even utopian, quality to the rhetoric that he knew would raise doubts among thoughtful observers. Universal disarmament, an end to war, Soviet-American harmony, it was all too good to be true. He wondered whether he should give a nationally televised speech on his return. He doubted "if the interest in all this is worth hyping." He told Haldeman that "this is a newspaper commentary story and that it's of great interest to our people [that is, commentators] but

not to the folks. This concerns him and the idea of going back and doing a big return speech."

In the midst of a presidential reelection campaign, however, a triumphal speech was irresistible. In an appearance before a joint session of Congress on June 1, Nixon celebrated the Summit's achievements. "Everywhere new hopes are rising for a world no longer shadowed by fear and want and war," Nixon said. The country had a chance to realize "man's oldest dream—a world in which all nations can enjoy the blessings of peace." The Summit marked the end of the Cold War era and the start of "a new era of mutually agreed restraint and arms limitation between the two principal nuclear powers."

DESPITE THE HYPERBOLE, Nixon's performance and speech substantially boosted his public standing. Where in January he held only a one-point lead in a trial heat with his most likely Democratic opponent and had an approval rating of just 49 percent, in June, he held a nineteen-point lead over George McGovern, the front-running Democrat, and his public approval had risen to 60 percent. Sixty-eight percent of Americans viewed him as somewhere between fair and very effective in improving prospects for world peace. Kissinger now also gained public favor as a superstar. A Chicago newspaper said he "ceased being a phenomenon. He has become a legend, and the word is not lightly used."

But Nixon being Nixon, he couldn't shake feelings of gloom and doom. A report from Haig and Colson on May 31 that editorial writers were lining up against the SALT agreement as a "capitulation" raised doubts about Senate approval for the treaty and the president's reelection. After his speech to the joint session, Nixon called Haldeman at home to say "he's had the feeling all along that the speech was dangerously anticlimactic, and that we probably should have just finished the trip and let it go at that."

When his concern about the speech proved unwarranted, he worried that they would not be able to sustain the political momentum provided by the Summit. He expected the Democrats to refocus the country's attention on Vietnam, which remained a source of political vulnerability. On June 1, Haig told Kissinger that "Colson and the maniacs [Kissinger's term for Nixon's White House inner circle] are running wild under Haldeman to lay on a host of SALT and post-Summit exploitation

operations . . . These will include press briefings by you." Nixon asked Kissinger to review the records of their Moscow conversations for "anecdotes and colorful phrases" that he could use in continuing promotion of Summit results. "I am not interested here in substance," Nixon said, "but only in anecdote and phrase-making material."

Kissinger was resistant to overselling an agreement that seemed to be selling itself. "Let me tell you something as a friend," Henry said to Ken Clawson, a *Washington Post* reporter, who had become the White House communications director. "This operation suffers from one thing above all—compulsive huckstering—we are doing so well that we don't need to create stories. Why should we turn ourselves into a bunch of whores." He thought it would be "nuts" for him to hold another press briefing. Henry said he would "take full responsibility" for not participating in this public relations campaign. "Just tell them I am a son-of-a-bitch as always."

Having begun as the administration's academic expert on national security, Kissinger had taken on the additional role of political operative. He was not entirely comfortable in the part. At the beginning of July, when Clawson pressed him to sit for a half-hour ABC interview, which would be "part of the merchandising package that's coming out of the Russian trip," Henry asked Clawson not to use the word "merchandising with me," and objected, "is this one of those Colson hotshot ideas?" Clawson agreed to use different language, but said the idea was approved by Haldeman. Henry thought it would be better for him to do an interview reviewing the administration's whole foreign policy, but he gave in: "I'll do what people ask me to do. I don't give a damn," he said, without meaning it.

No one could work for Richard Nixon without being drawn into the abrasive political competition that had been a mainstay of his twenty-five-year public career. When journalists began describing Kissinger as a Nixon campaign fund-raiser and outright partisan, he tried to persuade them that he was above the battle. "I will never under any circumstances ask anyone for money," he told Rowland Evans. Nor would he speak at a fund-raiser. "I will never say anything that is directed at McGovern. I will talk about our foreign policy and answer questions . . . [but] I have no intention to speak publicly during this campaign . . . I have no intention of engaging in private partisan activities." When he spoke to groups about foreign affairs, he intended to ignore McGovern and the

Democratic platform. "Somebody has to keep some degree of unity in this country after all of this is over," Henry told Evans, "and that's going to be my effort whoever wins or loses." He repeated his commitment of neutrality to Peter Lisagor and Hugh Sidey. Some issues need to be kept "above politics," he said.

Behind the scenes, Kissinger was ardently pro-Nixon. In June, he suggested to the president that he brief potential Democratic nominees, Humphrey, McGovern, and Muskie on administration foreign policy as a way to blunt their criticism. Henry told Nixon: "It has the advantage that we can then say, he [or they] knew and he [or they] went ahead anyway" in attacking us. "Good, Good," Nixon declared.

Kissinger regularly discussed the campaign with Nixon, emphasizing the crucial importance of his victory. He described the Democratic party platform as "the most cynical thing I've ever seen." Henry called it "dishonest" and a "disgrace." He complained that the Democrats had nothing to say about Nixon's achievements with Peking and Moscow. All they talked about was Vietnam, Israel, and the defense budget, which they proposed to cut. At the same time, Henry told Dobrynin that if the North Vietnamese try to beat Nixon by playing "domestic politics here, we will do what we did in May. We will break off and escalate . . . Then we will . . . try to force them to their knees."

On July 7, Kissinger told Nixon, "What I think we have to move heaven and earth about is the election, Mr. President. It's the most important election of the century. It really is." Henry denounced McGovern to Nixon as a radical intent on "revolution." It is hard to believe that Nixon took Kissinger's hyperbole all that seriously, but Kissinger must have believed that such overstatements further boosted him with the president.

IN JUNE, however much Nixon wished to keep the public spotlight on the Peking and Moscow Summit achievements as the surest path to reelection, he felt compelled to focus on Vietnam. During the first ten days of the month, Nixon and Kissinger took hope from the results of the bombing and mining campaign. At the beginning of May, when he had launched the attacks on the North, Nixon told Kissinger, Haig, and Connally that he would not allow the United States to lose in Vietnam. "I'm putting it quite bluntly," he said. "South Vietnam may lose. But

the United States cannot lose . . . Whatever happens to South Vietnam, we are going to cream North Vietnam . . . For once we've got to use the maximum power of this country . . . against this shit-ass little country."

By late June, B-52s were releasing bombs over Vietnam every forty-one minutes. "Oh, boy," Nixon told Kissinger. "This is punishing those people, believe me . . . That's a bigger artillery barrage than they had at Verdun." Kissinger agreed: "Oh, much more," Eighteen B-52s were equivalent to "a thousand planes in World War II," he pointed out.

Hanoi acknowledged that the latest U.S. air and sea attacks had taken a serious toll on its forces and morale, but promised to sustain its battle against U.S. aggression. On June 9, Kissinger told the president that Saigon's prospects were "substantially brighter" as a result of the counteroffensive. Evidence that Peking and Moscow were more intent on improved relations with Washington than coming to Hanoi's aid "engendered a sense of isolation in the North." With opinion polls in the States showing majority support for the administration's firm response to Hanoi's attacks, Nixon believed he was in an improved position to return to the Paris talks. Consequently, he proposed to Hanoi that Henry and Le Duc Tho hold another secret meeting at the end of the month.

On June 20, the North Vietnamese agreed to return to the negotiating table in July. Hanoi's decision rested on the understanding that its current offensive would not force Saigon's collapse and on the considerable losses it was suffering from the American attacks. Moreover, a new concession offered by the United States in Moscow made renewed negotiations more appealing. Nixon had committed the United States to a tripartite electoral commission that could include Thieu's government, the Viet Cong, and neutrals. Because Thieu would "hardly perceive equal representation with the PRG [Communists] as a fair bargain" and because the proposal had the potential to drive "a serious wedge between us and the GVN" over "the problem of power in Saigon," an NSC aide told Henry, the White House hid the proposal from the South Vietnamese.

During June and July, as the presidential campaign heated up, Nixon and everyone in the White House devoted themselves to the president's reelection. Nixon kept a close eye on every domestic and international development that could influence the outcome, especially negative news about foreign affairs. Continuing criticism of the SALT treaty and

complaints about the stalemate in Paris particularly concerned him. Assertions by Senator Henry Jackson that Nixon had made damaging SALT "concessions" and that the treaty might burden the U.S. with higher defense costs provoked fear that the White House was paying a high political price for the accord. A journalist's observation that Nixon had gotten "nowhere in securing Russian help on VN" and that Moscow was continuing to aid Hanoi to dispel North Vietnamese concerns that the Summit meant a betrayal of its war goals raised doubts about Nixon's claims of progress in ending the war.

Reports from the Swedish ambassador in Hanoi of bombing damage to dikes and dams in the Red River delta and from American journalists that Nixon's use of military pressure had failed to advance the peace talks added to the fear that Vietnam remained a political minefield for the president. The White House fretted over McGovern's assertion that within ninety days of becoming president he could have all the troops out and an end to the war. "This line should be hit hard," Colson was told. When NBC showed Swedish film clips of North Vietnamese "children severely wounded by new 'perforation' bombs and film of civilian residences in ruins," the White House attacked the coverage as "fishy" and demanded that other "impartial foreign press" be given access to the victims and sites.

In fact, in June and July, most of the news for Nixon was quite good and encouraged expectations of a substantial reelection victory. Some prominent conservatives, led by Barry Goldwater, agreed to back the president's SALT treaty. "We have got the establishment working for us," Kissinger told Nixon. McGeorge Bundy said, "he'll organize any group we want to support the treaty . . . The impact in the country is just unbelievable. If Hubert Humphrey, who is about the biggest coward in politics, calls up—and I bet you it is going to be in all the newspapers that he called to offer support" of the SALT treaty.

On July 12, Nixon also found good news in McGovern's presidential nomination. Most commentators saw him as a relatively weak challenger: On domestic issues, he seemed well to the left of likely voters; on foreign affairs, his slogan, "Come Home, America," made him seem like an isolationist with little understanding of America's security needs. When Gallup asked which party seemed most likely to keep America out of World War III, the Republicans enjoyed a 37 percent to 26 percent advantage over the Democrats. Twenty-five percent saw no difference between the parties, giving Nixon an eleven-point lead on this crucial issue.

In general, foreign policy was a winning issue for Nixon. "I think we have public opinion in good shape at the moment," the president told Kissinger on June 3, "and I must say it's hard to realize just a week ago we were in Leningrad." Henry replied, "That's right. Well, it's even harder to realize the tremendous transformation in the public attitude that this trip has produced." Nixon said, "More than the China trip." Kissinger agreed: "More than the China trip. And we used to think that we could never repeat the China trip; that this would be sort of a dull working trip, with its pluses, but not any major" achievements.

The improved relations with Peking and Moscow kept paying political dividends. Between June 19 and 23, Kissinger had another well-publicized visit to China; it demonstrated that the Soviet Summit had done nothing to set back recent gains in Sino-American relations. Kissinger believed that Peking remained attached to the new connection as an essential counterweight to the Soviet Union.

The conversations in Peking, which focused on Vietnam, also provided reasonable assurances that the Chinese had no intention of prolonging the war. But in case the Chinese had ideas about expanding their help to Hanoi, "I gave them a very tough warning," Henry told Nixon, "saying that if any organized Chinese units appeared in Vietnam, even if they were labor units, it would affect our relations severely."

Kissinger emphasized to Chou, that "the future of our relationship with Peking is infinitely more important for the future of Asia than what happens in Phnom Penh, in Hanoi or in Saigon." He explained that the American government needed to end the war "in a way that does not affect our entire international position and . . . the domestic stability of the United States." Chou wanted to know what the United States would do if a civil war resumed after it withdrew its forces. Kissinger replied that if renewed fighting occurred at once, it would say, "This was just a trick to get us out and we cannot accept this." However, if there were a longer pause in the fighting, "it is much less likely that we would go back again, *much* less likely." Chou reminded him that he had said this in 1971. Kissinger did not dispute the point.

Détente with the Soviet Union yielded additional political benefits. Nixon's and Kissinger's private exchanges with the Soviets following the Summit resonated with good intentions. Brezhnev wrote Nixon on June 21 to say that all Soviet ministries and agencies were determined to implement what they had agreed upon, and that people everywhere

were more optimistic about international affairs as a result of improved Soviet-American relations.

Five days later, Kissinger had an "extremely cordial" meeting with Dobrynin at the Soviet embassy. Dobrynin asked how the Chinese addressed him during his visits. As "Excellency," Kissinger said. "That fitted in well with my vanity." If he had known that, Dobrynin replied, he would have counseled Brezhnev to do the same. "But now it was too late, because I was beyond the 'Excellency' level with Brezhnev, who considered me as a co-worker . . . Dobrynin volunteered the fact that the Soviet press had handled my visit to China in a very restrained way . . . It indicated the good basis which our relationship had reached."

In July, exchanges with the Soviets included commitments to have Kissinger visit Moscow again in September and begin discussions of a possible agreement banning the use of nuclear weapons against each other. The unexpected expulsion of Soviet military personnel from Egypt in mid-month gave the White House an additional benefit from the Summit meeting. Sadat saw the Moscow talks, which had transparently ignored Egyptian-Israeli tensions, as a demonstration that the Soviets had no intention of pressing Washington for a Middle East settlement in 1972. In response, the Egyptian president insisted that Soviet forces leave his country. Kissinger assured Dobrynin that the U.S. would not try to exploit this for unilateral advantages. The Summit conversations not only had the unintended consequence of pushing Soviet forces out of Egypt but also, as UPI stated it, of discouraging U.S. officials from expressing "their pleasure at a development which they undoubtedly welcome."

In what Kissinger described as "a stupid letter," Brezhnev tried to put the best possible face on the Soviet embarrassment by telling Nixon that the withdrawal from Egypt was in response to their discussions at the Summit about solving Middle East problems. Kissinger privately called the assertion a case of "amazing chutzpah." More important, the explanations from Moscow and Washington did nothing to reignite tensions over Soviet-American differences in the Middle East, and gave Nixon additional good press as an effective foreign policy leader.

FOR NIXON AND KISSINGER, the politics of foreign policy in the presidential campaign continued to revolve around Vietnam. The failure of Hanoi's spring offensive to conquer South Vietnam gave the White

House a propaganda victory: Vietnamization was working, the American government could withdraw the rest of its troops over the next several months, and the White House was achieving "peace with honor."

At the same time, however, Nixon was reluctant to see an end to the war in the three months before the election. He feared a domestic political outcry that reelection politics rather than realistic expectations of South Vietnam's autonomy were driving the settlement. "There's a strong and growing feeling among high Administration officials," CBS's Marvin Kalb reported, "that NVN is going to wait out US elections and if there's to be a breakthrough before then, it'll be RN who'll have to yield, not Hanoi." Nixon also had polls telling him that peace would deprive him of an issue on which blue-collar Democrats were ready to vote for him. His political strategy about Vietnam was to combine military action with continuing negotiations. "You should inform Thieu," Kissinger cabled Bunker on June 24, "of . . . the game plan with respect to the negotiating scenario, emphasizing again that this scenario is predicated upon the need to muster maximum domestic support by employing a blend of forceful action on the battlefield, combined with domestic flexibility on the negotiating front."

By contrast with Nixon, Kissinger saw reasons to settle during the campaign. He doubted that Nixon would be in a better position to force Hanoi into a settlement after the November election. "The most amazing thing is that nobody—not Brezhnev or any communist is as hard on us on Vietnam as our own people," Henry told Joe Alsop. "No communist has dared to make the demands that the Democrats are making." Kissinger feared that even a renewed electoral mandate for Nixon would not be enough to prevent a Congress under Democratic control from cutting off funds for the war and leaving South Vietnam to its fate without continuing U.S. support.

Kissinger also believed that the failure of Hanoi's offensive and its fear that Nixon's reelection would allow him to unleash even greater force made the North Vietnamese eager for a prompt settlement. "I think we are going to finish Vietnam this summer," Henry told John Mitchell in June. Unlike the president, Mitchell thought it would be "a tremendous plus." Kissinger asked: "You wouldn't think it would hurt your campaign?" Mitchell replied: "No, indeed."

Haldeman, however, speaking for the president as an anonymous

source to *Time*, voiced skepticism that anything would come of immediate additional peace talks. From Paris, where he had gone for July 19 negotiations with Le Duc Tho, Kissinger cabled Haig, "If the Nixon aides quoted by *Time* are not shut up, we won't have to worry about a break up . . . Has Haldeman a better game plan? . . . Please brutalize everybody with a presidential directive to shut everybody up." Kissinger expected a breakthrough to come in September if polls showed that McGovern was well behind the president.

Kissinger took additional hope for an agreement from the conversation he had with Le Duc Tho and Xuan Thuy on July 19. The six-and-a-half-hour meeting was the longest session they had ever had. A cordial tone was a welcome change from past encounters. Although "the substance of the meeting was ambivalent," Kissinger believed it could "presage major progress . . . toward a settlement." He saw reason to think that the North Vietnamese might eventually agree to a cease-fire and back off from their political demands for Thieu's ouster. They left open the possibility of negotiations between Thieu's government without Thieu and the PRG, "a significant move." They declared an interest in reaching an agreement before the end of the president's term.

However, they also betrayed their distrust of promises that the United States would not involve itself in any future fighting by asking "several times if we would be prepared to respect whatever agreements are reached, signed and unsigned." Kissinger assured them that he separated military and political issues not because we had any intention of tricking Hanoi. We were acting "in good faith"; we had no intention of returning to Vietnam after our withdrawal, whatever the political outcome in the South. "The tone of the North Vietnamese was more acceptable than it had ever been . . . and the discussions left open the possibility that there might be a settlement," Kissinger told Dobrynin on his return home. But if there weren't, "we must do what it takes to end this war. We must stop at nothing," Henry told Nixon at the end of July.

Nixon found himself in a very strong position in the summer of 1972. Trial heats in May and June between the president and several potential Democratic opponents showed Nixon to be the odds-on favorite against all comers. After the Democrats had settled on McGovern, the polls suggested Nixon was probably unbeatable. Where between 53 percent and 57 percent of the electorate consistently favored the president, McGovern was able to command only 37 percent of the vote.

By any rational calculation, Nixon could expect to win in November. In June, White House aides Pat Buchanan and Ken Khachigian prepared an "Assault Book," which included "enough McGovern statements, positions, votes not only to defeat the South Dakota Radical—but to have him indicted by a Grand Jury. *If* we can get these positions before the public; and *if* the election hinges upon issues—only with enormous effort could we boot this election away," they told Haldeman.

Nixon thought that McGovern was vulnerable to attack as "a fanatical, dedicated leftist extremist." He favored "peace-at-any-price" and would be the architect of "a second-rate United States." Nixon wanted someone in the administration to explain that "the only thing keeping this war going is McGovern." Hanoi would not settle as long as it had hope that a McGovern presidency would bring the negotiations to an end on their terms. That point has "got to be made by somebody sometime," Nixon told Kissinger.

Former president Lyndon Johnson agreed. He told Haig "that he considered a McGovern Presidency a disaster. He stated that as a lifetime Democrat, he could not vote Republican but he would not vote Democratic either." Johnson said that he had no intention of attending the Democratic convention and he was advising other prominent Democrats against supporting McGovern.

Rational assessments of Nixon's political strength, however, took a backseat to convictions that politics were too unpredictable to assume that current voter sentiment wouldn't change in the months leading up to the election. In addition, nonrational impulses shaped Nixon's campaign: specifically, his paranoia about political enemies. To be sure, he had plenty of real adversaries, who fought very hard to defeat him, and sometimes did, as in 1960 and 1962. But Nixon habitually distorted their intentions and exaggerated their influence, especially in 1972. His conviction, for example, that the media were out to get him was not without substance. But for the most part, they were simply doing their job—trying to get at the truth behind the facade of good intentions and successful actions every White House presents as political reality.

Nixon's view of enemies as unscrupulous or willing to bend rules and resort to almost anything in their determination to end his political career was a classic case of psychological projection—ascribing your outlook and behavior to others. It allowed him to rationalize cutting corners and even breaking laws to counter their alleged tactics. When it came to

break-ins, Nixon told Haldeman in June, "the Democrats had been do-
ing this kind of thing for years and they never got caught . . . Every time
the Democrats accused us of bugging we should charge that we were
being bugged and maybe even plant a bug and find it ourselves!" As a
consequence, in the spring and summer, the Nixon campaign, with his
explicit blessing, reached for dirty tricks to supplement the substantive
reasons voters had for favoring the president.

In a 1994 editorial note in his published diary inserted after the en-
try for June 30, 1972, Haldeman said:

> From this point in time until the election on November 8, my days
> were spent increasingly on the reelection campaign . . . You will cer-
> tainly see in this section the importance we put on staying in office,
> and though it may look as if we played rough in this pursuit, we were
> no rougher than many other candidates, Republican or Democrat.

By 1972, the White House was already practiced in illegal secret
operations. There were of course the secret trips and negotiations Nixon
and Kissinger believed essential for the success of their foreign policies.
But there was nothing illegal about these actions, though they were part
of an atmosphere in which Nixon aides assumed that behind-the-scenes
maneuvering, including illegalities, were acceptable.

After Soviet leaders publicly praised George McGovern as someone
who "recognizes the depth of America's crisis and surged to the fore with
a clear, simple program," Nixon instructed Kissinger to "warn Dobrynin
on interfering in American politics." At the same time, however, Nixon
had no objection to having Israeli Ambassador Rabin tell "the American
Jewish community that the President has done more than any other chief
executive to sustain the existence of the state of Israel." The Committee
to Reelect the President (CREEP) was directed to distribute Rabin's re-
marks to "the more than 100 Jewish newspapers" and to mail them "as
widely as possible to Jewish community leaders throughout the country."
In addition, as another demonstration of the connections between for-
eign affairs and electoral politics, Harold Saunders told Kissinger in July,
the danger that the Israelis would object to any U.S. Middle East initia-
tive was "too great [to try] during election season."

More important, wiretaps on White House staff members and news-

men beginning in 1969, the Huston Plan sanctioning surreptitious break-ins, the use of the IRS to punish enemies, the break-in at Ellsberg's psychiatrist's office, and clandestine efforts to block Allende's accession to the presidency in Chile were all part of an atmosphere which Nixon established in his conversations and instructions to subordinates. In May 1972, for example, after former Alabama Governor George Wallace was shot in Maryland during his campaign for the Democratic presidential nomination, the White House unsuccessfully tried to persuade the FBI to describe Arthur Bremer, the gunman, as a left-wing Democratic supporter of Senator Edward Kennedy.

Most famously, of course, CREEP sanctioned the break-in at the Watergate complex in Washington, D.C. The objective was to plant bugs in Democratic party offices, which could provide information on their campaign plans. Given Nixon's substantial lead in the race and the small likelihood that McGovern could find effective means to overcome it, it was not only illegal but also pointless. The withdrawal of U.S. troops from Vietnam and the likelihood of an early settlement combined with the dramatic steps in relations with Soviet Russia and China to make Nixon all but unbeatable. And while the arrest of the Watergate burglars on June 17 raised unanswered questions about White House involvement, the scandal did not yet have the force to drive a sitting president from office. A principal Nixon objective during the remaining months of the campaign was to hide even hints of Oval Office connections while convincing voters that he was the country's best hope for an honorable end to the war and prospects for long-term peace.

~ *Chapter 13* ~

TAINTED VICTORIES

Finishing second in the Olympics gets you silver. Finishing second in politics gets you oblivion.

—Richard Nixon, 1988

In August 1972, as Nixon prepared to accept renomination at the Republican convention and face voters in the fall campaign, he ensured that everything during the next three months revolved around his reelection. More than ever, foreign policy—whether about Vietnam, Russia, China, or the Middle East—became the captive of domestic politics. As he had told Kissinger at the end of March, trips to China and Russia would greatly enhance his political prospects. "It's good to go to China and good to go to Russia, because we're going to have to use everybody in the campaign." He expected Henry to do "a television thing" after each trip. "We need foreign policy up front and center in that period too," he added.

None of this was for public consumption. On the contrary, the strategy was to attack McGovern for trying to politicize national security. Nixon intended to quote Harry Truman's admonition that politics should always be kept out of foreign policy. "We are not Republicans, we are not Democrats, we are Americans," Nixon told the American Legion

in August. Reverting to the theme he had used so effectively throughout his political career, he wanted everyone in his campaign to say that "the Democrats are unpatriotic"; they should be described as putting political gain ahead of national security.

Because Nixon actually did believe that the Democrats were using foreign affairs for political advantage, especially Vietnam, he intended to outdo them in the same game. He publicly subordinated détente, for example, to appeal for Polish-American votes with anti-Soviet gestures, which he and Kissinger privately cleared with Moscow. They promised not to directly attack the Soviets and explained that unlike the president's visit to Romania, a stop in Poland on the way home from Moscow was the product of "domestic considerations." Dobrynin saw no problem with a Nixon visit to Warsaw, and said that Nixon's promise not to embarrass them would greatly impress Brezhnev. "We've got a lot of mileage out of checking that Polish visit with" the Soviets, Kissinger told the president.

Where trolling for ethnic votes was standard election year politics that foreign governments largely ignored, they saw suspended efforts to resolve overseas conflicts for domestic political reasons as irresponsible. Brezhnev, for example, complained that they could not afford to delay confidential discussions about the Middle East. But the White House resisted for fear that leaks would have negative repercussions on the president's popularity. And this, despite warnings from Sadat that "if RN thinks he is going to have a quiet time in the area as he is running for re-election, he has another surprise coming."

Similarly, when Moscow placed a $25,000 educational fee on Jewish émigrés, "a major issue in Israel," the White House refused to comment. "The Russian issue is flooding my desk," Leonard Garment, a special consultant to the president on Israel and Jewish affairs, told Kissinger. "Is there a more self-serving group of people than the Jewish community?" Henry replied. "None in the world," Garment said. "You can't even tell the bastards anything in confidence because they'll leak it," Henry complained. Garment thought that "between now and November a certain amount of theater is needed to keep the lid on." Kissinger saw this as the proper strategy.

No foreign policy issue was more beholden to domestic politics than Vietnam. As in July, Nixon and Kissinger remained at odds over how best

to end the war. Nixon continued to believe that Hanoi would never settle without the additional use of U.S. military power and that a peace agreement before November would be seen as a cave in jeopardizing support from his conservative base. "On this whole business of negotiating with North Vietnam," Nixon told Haldeman, "Henry has never been right." He described Kissinger's Vietnam dealings as "folly." Nixon confided to his diary: "I am inclined to think that the better bargaining time for us would be immediately after the election rather than before."

Kissinger was anything but indifferent to the president's political judgment and reach for a second term. But he was confident that as Nixon's reelection became more apparent to the North Vietnamese, they would be receptive to a settlement that spared them from savage attacks Nixon would be free to mount after November 7.

Because Nixon believed it was also good politics to continue the Paris talks, he allowed Henry to resume the negotiations. In an eight-hour meeting on August 1, the longest ever, the North Vietnamese appeared to be more forthcoming than before. Although the two sides remained far apart on political matters, Kissinger saw another meeting in thirteen days as a good idea. Nixon agreed to let Henry keep at it, and congratulated him for a "splendid job on what must be a very tedious exercise." On August 3, when Nixon read a UPI assessment of the negotiations saying "critics doubt that the administration would turn much tougher in Vietnam peace bargaining after November," Nixon wanted the assertion disputed.

At the August 14 meeting, around a beige-covered table in the same shabby apartment in the Paris suburb, the discussion over seven and a half hours produced no breakthroughs. Henry believed that Hanoi now faced an agonizing choice—either to settle now and take its chances on winning political control in the South or wait and face Nixon's wrath after the election. He was confident the North Vietnamese would make peace before November.

Despite Henry's optimism, Nixon remained determined to wait until after the election. In a note to Haig, Nixon declared: "Al—It is obvious that no progress was made and that none can be expected." Nixon thought the Democrats would attack him for failing to end the war. But John Connally urged Nixon to discount their criticism: "The war isn't hurting us . . . We want to keep the issue focused on Vietnam, because

[alongside of McGovern's statements calling for a rapid pullout] it's to our benefit."

Nixon saw the Paris negotiations as a way to blunt complaints from the peace camp. He told Haig, "The talks are fine" for the time being, because it was restraining the left or what Haig called "these bastards here at home." Nixon said, "This is a brilliant game we are playing," and "Henry really bamboozled the bastards."

The closer they got to November, however, the more reluctant Nixon became to reach a settlement—it "could be interpreted as a politically motivated pull-out or a less than satisfactory compromise . . . for which McGovern could claim credit."

In his opposition to a preelection settlement, Nixon had an unacknowledged ally in Thieu. The South Vietnamese president was incensed that Kissinger had not provided him with fully accurate reports of the Paris discussions. Eighteen years later he would tell Walter Isaacson that Henry had treated South Vietnam like an American puppet. "There was no effort to treat us as an equal, for he was too arrogant for that. We wanted to be part of the negotiations, but he was working behind our back and hardly keeping us informed."

Kissinger understood that Thieu would neither agree to leave North Vietnamese troops in the South nor concede the Communists a part in overseeing national elections through a Committee of National Reconciliation. Consequently, he had kept Thieu in the dark about these proposals. When they came to the surface during a Kissinger visit to Saigon in August, Thieu obliquely rejected them. Undiplomatic rudeness—canceling meetings and coming late to others—demonstrated his unhappiness. Thieu was as frustrated by his dependence on the Americans as by their concessions. "Insolence is the armor of the weak," Kissinger said later. "It is a device to induce courage in the face of one's own panic."

Kissinger remembered that he "left Saigon with a false sense of having reached a meeting of the minds." Henry rationalized Thieu's obstructionism as more the product of cultural differences than genuine Vietnamese resistance to his concessions. Nixon, however, read Thieu's opposition for what it was—a determination to avoid an agreement with the North Vietnamese until they were militarily defeated.

Nixon shortly sent Thieu a letter, which could only have encouraged him to block any compromise with Hanoi. He assured Thieu that "the

United States has not persevered all this way, at the sacrifice of so many American lives, to reverse course in the last few months of 1972. This I . . . will never do." Thieu assumed that Nixon was as intent on making Hanoi cry uncle as he was.

Despite his determination to wait until after the election to make peace, Nixon agreed to let Henry return to Paris in September. Polls persuaded him not to abandon the talks: Eighty-one percent of a Gallup survey favored a candidate ending the war. McGovern's promises to that effect made Nixon nervous about abandoning the negotiations. Another Gallup poll revealed that a breakdown of the talks over keeping Thieu in power appealed to only 29 percent of Americans. Forty percent were ready to see a coalition government and 21 percent were indifferent to who ruled South Vietnam.

To woo voters, Nixon told Stewart Alsop on August 22 that "the war won't be hanging over us in a second term." Is this "just politics or is there substance to it?" a reporter bluntly asked the president at an August 29 news conference. There was no breakthrough in the negotiations, Nixon acknowledged. But he emphasized that Saigon's success in blunting Hanoi's offensive had increased prospects for a settlement. Moreover, he announced another twelve-thousand-troop reduction that brought U.S. forces in Vietnam down to twenty-seven thousand. Was he falling short of his promise to end the war before the close of his term? Was there any likelihood that the United States would still be bombing North Vietnam in two or three years? he was asked. He had largely satisfied the aim of ending U.S. involvement, he answered. He called suggestions that we would continue bombing "ridiculous." The South Vietnamese were fully capable of defending themselves.

DURING THE FIRST WEEK in September, despite White House reluctance, the focus shifted back to the Middle East. The state department wished to restart a dialogue with the Israelis about possible ways to reduce tensions, but Kissinger and Haig moved to shore up White House efforts "to keep a lid on things for the present."

The assassination of Israeli athletes by Arab guerrillas at the summer Olympics in Munich on September 5 made Arab-Israeli tensions an issue the White House could not continue to ignore. At an Oval Office meeting on the following day, Nixon urged walking a delicate line between

sympathy for Tel Aviv and warnings against excessive Israeli retaliation. Because the *New York Times* and McGovern favored U.S. withdrawal from the games and because such a move seemed likely to heighten international tensions over the Middle East, Nixon and Kissinger agreed to oppose it. Nixon emphasized the need for an effective public relations response to the crisis both to reduce chances of a Middle East explosion and to satisfy domestic opinion.

After Marvin Kalb reported that the "White House seems worried about the Munich tragedy giving McGovern a chance to enhance his stature with U.S. Jews," Nixon scribbled on his news summary, "H[aldeman]—a very good example of why K[issinger] must never do Kalb interview."

IF THE WHITE HOUSE expected to come back to Middle East problems after November 7, it hoped to put a permanent end to the Watergate break-in investigation. During an August 29 news conference, when a reporter asked whether it would be a good idea to appoint a special prosecutor, Nixon cataloged the inquiries by the FBI, Government Accounting Office (GAO), Senate Banking Committee, and a full-scale investigation by White House Counsel John Dean that would make a special prosecutor superfluous. These investigations, he said, allowed him to offer categorical assurances that no one at the White House was involved in "this very bizarre incident." Dean, who was watching Nixon's televised news conference in a hotel room, said later that he "damn near fell off the bed . . . I had never heard of a 'Dean investigation,' much less conducted one."

In the first half of September, Nixon became increasingly confident that Watergate was becoming a nonissue. Forty-eight percent of a Gallup survey said they knew nothing about the "scandal." In August and September, only between 2 and 3 percent of Americans saw "corruption in government" as the country's most compelling problem. More important, on September 15, the Justice Department announced seven indictments for wiretapping and theft, and predicted that no one else would be charged. Five days later, the judge in a civil suit brought by the Democratic National Committee against CREEP delayed the case until after the November election. Two weeks later, Chief U.S. District Court Judge John Sirica issued a gag order prohibiting public comments about

the Watergate burglars' trial. On October 3, Pat Buchanan and Mort Allin, who prepared the daily news summaries, told the president that "Watergate is out of the news."

Because he knew that the full story of Watergate, especially White House involvement in trying to hide CREEP's connections to the break-in, could destroy his presidency, Nixon could not forget it. He described in his memoirs "a rather curious dream" he had in October "of speaking at some sort of a rally and going a bit too long and Rockefeller standing up in the middle and taking over the microphone on an applause line . . . It is a subconscious reaction. It is interesting."

Clearly, he had premonitions of being ousted or replaced by someone more popular. And it's reasonable to speculate that Rockefeller was a stand-in for Kissinger, whose prominence was beginning to match the president's. In a conversation about Henry's possible presence at the Republican convention, NBC's John Chancellor predicted that reporters would besiege him for interviews. "You are probably the most interesting news story aside from the Vice President and the President himself in terms of personality," Chancellor said.

When Stewart Alsop wrote a column saying it was in the national interest for Henry to become secretary of state, "because . . . a Nixon without Kissinger is a scary prospect," Henry complained to Joe Alsop, "If he wants to get me out of here this month, he could not have written a better article." At the end of 1972, when Gallup asked Americans to name the most admired men in the country, Kissinger stood fourth behind Nixon, Billy Graham, and Harry Truman.

WITH WATERGATE ostensibly out of the way in September, Vietnam was the one issue Nixon saw jeopardizing his reelection. He continued to fear a peace agreement that could raise complaints of a cynical sellout to ensure his victory. For entirely different reasons, Thieu shared Nixon's determination to avoid a quick settlement. In this alliance of strange bedfellows, Kissinger and the North Vietnamese lined up in behalf of peace. As Henry had anticipated, by September Hanoi had concluded that a preelection settlement would serve it better than a post-November arrangement forced on it by a U.S. air campaign.

Between September and November, Kissinger found himself waging a two-front political war for peace against Saigon and the White House.

As he moved toward the next Paris meeting on September 15, Henry tried to persuade the president to dismiss Saigon's objections to a settlement.

Haig informed Kissinger that Nixon was "extremely reluctant" to follow his advice. Nixon's resistance rested on polls telling him that Americans wanted to leave Vietnam with a sense of victory (or so Nixon wanted to believe). He was willing to let Henry resume peace talks, but on the condition that he made a record that would appeal to hawks more than doves.

Kissinger saw the September 15 meeting with Le Duc Tho as the prelude to a final settlement. Henry told Nixon that Tho suggested completing a deal by October 15. When Henry agreed to that, "Tho came across the table, shook hands . . . and said, 'We have finally agreed on one thing, we will end the war on October 15.' "

News accounts raising doubts about the president's ability to make an honorable peace before the start of a second term made Nixon receptive to additional talks in Paris. He was afraid of an October surprise engineered by McGovern and Hanoi that could cost him the election. Specifically, he thought that the North Vietnamese might invite McGovern to Hanoi, where they would turn over half or more of the POWs, indicating that the Democrat would be better able to reach a settlement. Nixon's concern said more about his suspicious nature and affinity for unprincipled politics than about political realities.

At a September 20 NSC meeting, Nixon said there would be no break with Thieu and "we will end this war with dignity." The NSC did not miss the point—Henry could keep talking in Paris, but they would not sell out Thieu nor would they likely reach a settlement until they had brought the North Vietnamese to their knees in the days after the election.

Kissinger's return to Paris increased tensions between him and Nixon. Henry came away from a two-day meeting in late September with a heightened sense of optimism. Not only did the conversations take place in a more congenial setting—a suburban house given to the French Communist party by famed Cubist painter Fernand Léger—but Tho and Thuy were insistent about completing an agreement within a month's time, hopefully during three days set aside for additional discussions beginning October 8.

Kissinger understood that Thieu would not find the prospect of an October settlement to his liking. But he hoped that a face-to-face meeting might weaken or even end his resistance. Believing Thieu would foil Henry's plans, Nixon agreed to let him go back to Saigon. The president "feels strongly," Haldeman recorded, "that, as far as the election's concerned, we're much better off to maintain the present position."

Nixon's worries about a settlement jeopardizing his reelection mystified Henry—an unpublished September poll that *Time's* Hugh Sidey gave Kissinger put Nixon thirty-nine points ahead. Also, potential problems with domestic opinion and the Congress from any postelection air campaign gave an October agreement some appeal to Nixon, but not enough to sell him on a "quick peace."

Nixon wanted Thieu to block an October agreement, but he also wanted to assure that his obstructionism would not extend to a postelection settlement. He told Kissinger and Haig that Thieu shouldn't "assume that because I win the election that we're going to stick with him through hell and high water. This war is not going to go on. Goddamnit, we can't do it . . . We can't let it hurt our relationship with the Russians and the Chinese . . . We've got to get the war the hell off our backs in this country."

Nixon hoped that a new offensive against the North would convince Thieu that he was secure from any immediate assault by Hanoi. Nevertheless, Nixon wanted assurances that Thieu would follow his lead. On October 4, in a meeting with Haig and Bunker, Thieu and his National Security Council refused to support a settlement that left North Vietnamese troops in the South and created a commission giving the Communists a possible say in South Vietnam's political future. Reports that Thieu carried on like some frustrated child, shedding tears at what he described as a betrayal of his country, bothered Nixon less than Thieu's warning that if the Americans went ahead "we shall be obliged to clarify and defend publicly our view on this subject."

Nixon and Kissinger were entirely cynical about any settlement reached with Hanoi and future U.S. relations with Saigon. If a peace agreement were ever signed, Henry told the president, "I believe that the practical results will be a ceasefire and . . . a return of prisoners." Nixon interjected: "Then we'll say screw them." Henry didn't disagree: "And then they'll go at each other with Thieu in office. That's what I think."

Nixon offered Thieu firm assurances that we would not jump at an immediate settlement in October. But he also made clear that Thieu would not dictate the ultimate terms and timing of a settlement. Nixon threatened his political, if not his personal, demise. "I would urge you to take every measure to avoid the development of an atmosphere which could lead to events similar to those which we abhorred in 1963," he wrote Thieu. The message to Thieu could not have been clearer: If you defy me, I will not hesitate to subject you to a political coup like the one that ousted President Ngo Dinh Diem and took his life in November 1963. The additional unspoken message was: You can help me block an agreement now, but when I ask you to sign one later, you had better comply.

Kissinger remained at odds with Nixon's resistance to an October settlement. On October 3 and 4, as news came in of Thieu's opposition to an agreement, Henry had "a complete tantrum" over suggestions that Nixon hold a press conference to clarify the negotiations, Haldeman recorded. "Henry actually believes that we still have a 50-50-chance of pulling something off with the North Vietnamese this weekend and he's scared to death that the P will louse it up . . . The P doesn't feel there's any chance of settling, and that probably it's not desirable anyway, because any possible interpretation of a sellout would hurt us more than it helps us."

When Kissinger resumed the Paris talks on Sunday, October 9, it was the culmination of a four-corner clash over settling the Vietnam War. Kissinger functioned as a surrogate president, making all the negotiating decisions without seeking Nixon's direct approval. To head off White House objections, he had brought Haig with him. "I had Haig in Paris because I didn't trust him behind my back anymore," Henry wrote later. He sent Nixon cables urging against any "public statements" about the substance of the talks. "We are at a crucial point."

Kissinger's distrust of Haig was well deserved. As ambitious as anyone in the administration, Haig's hard work and effective manipulation of Nixon, Haldeman, and Kissinger himself had brought him rapid advancement. After only nine months at the NSC in October 1969, he had been promoted from colonel to brigadier general. He had brought himself to the president's attention not only by tireless work but also by keeping the president and Haldeman informed about Henry's machi-

nations, occasionally showing them transcripts of Kissinger's telephone conversations. Lawrence Lynn on Henry's NSC staff, who developed an intense dislike for Haig, described him as "excessively ambitious, manipulative, ingratiating, crafty, not at all intelligent, a dissembler, and untrustworthy." Yet Haig's one-upping of Kissinger rested on more than ambition; he also had strong differences with him on Vietnam, encouraging Nixon's affinity for military actions over Henry's commitment to negotiate an end to the war.

Nixon agreed that no one in the administration should say anything. But he bristled at Henry's failure to tell him what was happening. Haldeman recorded on October 9 that Nixon was "adamantly opposed to Henry going on to Saigon and Hanoi from Paris. He wants him to come back to Washington for a progress report first."

In response to a request that Henry provide more details about the discussions, he sent a one-paragraph message: "The negotiations during this round have been so complex and sensitive that we have been unable to report their content in detail . . . we know exactly what we are doing, and just as we have not let you down in the past, we will not do so now."

Nixon did not dispute Kissinger's insistence on a free hand in the negotiations. He had no intention of getting into a public fight with him. Had he abruptly brought Henry back from Paris, he believed it would jeopardize his appeal to voters as a peacemaker. Nor did he need to assert direct opposition to a Kissinger-crafted peace. He was confident that he could rely on Thieu to block anything Henry produced in Paris.

Kissinger believed that North Vietnamese concessions in meetings between October 8 and October 11 assured a settlement before the U.S. election. After hearing on October 8 what the North Vietnamese were offering, Henry asked for a recess. He and Winston Lord "shook hands and said to each other: 'We have done it.' " Kissinger saw it as his "most thrilling moment in public service." (But Vietnam, he told me thirty-two years later, turned out to be the greatest disappointment of his eight years in high office. This of course would not become apparent until he witnessed the takeover of South Vietnam by Hanoi in 1975. He may have been disappointed, but his contemporary comments about the possibility of a South Vietnamese collapse make it difficult to believe that he was surprised.)

Henry and Haig arrived back in Washington on October 12, where they met Nixon in his EOB office. Kissinger triumphantly announced, "Well, you've got three for three, Mr. President (meaning China, the Soviet Union, and now the Vietnam settlement) . . . The P was a little incredulous at first," Haldeman recorded. Nixon asked for the details of what Henry had achieved. "The net effect," Kissinger explained, "is that it leaves Thieu in office. We get a stand-in-place cease-fire on Oct. 30 or 31." It was to continue until a political settlement definitively ended the war. There was also to be a National Council of Reconciliation, but it had to operate by unanimous vote, which meant that Thieu had a veto over anything it proposed. Sixty days after a cease-fire the United States would withdraw all its troops and all POWs would be returned. The American government would also provide an unspecified aid program of reconstruction to Hanoi.

Nixon focused not on the terms of the agreement, but on Hanoi's willingness to accept U.S. aid as the most significant development in the talks. He thought it signaled an implicit Communist acknowledgment that their system was inferior to ours.

Despite an outward show of satisfaction, Nixon continued to believe that South Vietnam's future security depended on continuing air attacks that would limit Hanoi's freedom to launch a post-agreement offensive. He revealed his resistance to Henry's peace deal by showing no interest in its "details." Every time Henry tried to plow through a description of the agreement, Nixon kept interrupting, asking Haig "if he really was satisfied with the deal, because he had been basically opposed to it last week." Haig thought the settlement was okay, but worried about winning Thieu's approval. Nixon saw it as unlikely. In "the cold gray light of dawn" the next day, Haldeman recorded, Nixon believed that Thieu would probably kill the agreement.

Thieu remained the key to delaying a settlement until after November 7. With Henry scheduled to go back to Paris to cement the agreement and then on to Saigon to see Thieu, Nixon wanted Kissinger to take Haig or Haldeman with him to prevent Henry from browbeating Thieu. But Kissinger resisted and talked Nixon into letting him take William Sullivan from the state department, who Haldeman described as "Henry's man."

Nixon and Haig were convinced that "Henry is strongly motivated

in all this by a desire for personally being the one to finally bring about the final peace settlement." They saw this as "a major problem in that it's causing him to push harder for a settlement." Haig thought the best way to handle it was to give Henry "every possible evidence . . . of total support so that he won't feel that he has to prove anything."

After Kissinger returned to Paris on October 17 and told Nixon that he and Tho had resolved almost every problem, Nixon made his opposition to Henry's push for an agreement clearer. "Our leader is adamant," Haig cabled Henry that night "about the next leg . . . not taking place unless a firm agreement with full support by Thieu is assured."

On October 19, as Kissinger arrived in Saigon, Nixon sent him a follow-up message that was a masterful attempt to serve both his re-election campaign and an autonomous South Vietnam. He instructed Henry to tell Thieu that he endorsed the peace agreement as in the best interest of his country. (Should this cable become public knowledge, no one could deny Nixon's eagerness for peace.) At the same time, Nixon assured Thieu that if Hanoi broke the agreement in the days ahead, "I will without hesitation take all appropriate steps to rectify the situation." (No American conservative could accuse Nixon of abandoning a staunch anti-Communist ally.)

Yet Henry was also put on notice that he could not force the agreement on Thieu. Nixon had no intention of allowing McGovern to claim, as his campaign was saying, that a settlement before the election "would be a great confirmation of McG's campaign for peace." Nixon told Kissinger, "Your mission should in no way be construed by him [Thieu] as arm-twisting . . . which might have been undertaken in conjunction with my own domestic elections." If there were to be a peace agreement now, Thieu would be joining "with us as equal partners" in ending the war.

Kissinger ran into a predictable explosion of opposition from Thieu. When Henry arrived at Thieu's office, he was ushered into the military operations room, where Thieu had assembled his National Security Council, which had received an advance copy of the peace agreement in the form of a captured North Vietnamese document. Thieu was incensed at having to learn about Henry's settlement from the Communists, and even angrier at the provisions of the agreement that left North Vietnamese forces in the South. Kissinger described the session as "tense and emotional." Henry put the best possible face on the three-and-a-half-

hour conversation, reporting that "I cannot yet judge whether Thieu will go along with us."

In fact, Thieu, as he later said, "wanted to punch Kissinger in the mouth." Thieu's nephew and press assistant, Hoang Duc Nha, gave voice to Thieu's anger. A young man in his early thirties, American educated, with affectations learned from watching Hollywood movies ("the early Alan Ladd in a gangster role," Kissinger said), Nha, after listening to a half-hour "seminar" by Kissinger, indignantly objected to being given a copy of the treaty in English. "We cannot negotiate the fate of our country in a foreign language," he declared. He insisted on a Vietnamese translation of the document. After reading it, he asked for sixty-four points of clarification, especially about North Vietnamese forces in the South, the Reconciliation Council, and likely U.S. responses if the agreement collapsed.

Seizing on Thieu's demands, Nixon cabled Henry that there could be no settlement before the election. It would have "a high risk of severely damaging the U.S. domestic scene, if the settlement were to open us to the charge that we made a poorer settlement now than what we might have achieved had we waited until after the election." After November 7, they would be in a strong position to force matters with Thieu if need be.

Nixon wanted Kissinger to tell Thieu that "if he persists in resisting all efforts to settle the conflict . . . we will be forced to work out bilateral arrangements with the Democratic Republic of Vietnam which could risk all that we have worked so diligently to achieve."

Because Nixon feared that Kissinger might yet disarm Thieu's resistance and force him into a prompt settlement, he instructed Haldeman "to poll quickly on whether people expected to see a Vietnam settlement before the election." In the run-up to November, Nixon's greatest interest was not in the terms of the settlement ending the war but in what impact they might have on his appeal to voters.

"What are the things" Thieu is insisting on? Nixon asked Haig on October 22, as if he knew nothing about the points of contention between Thieu and Kissinger. "Well, Thieu wanted some changes which got the troops out of the South," Haig replied. "Well, we can't get that," Nixon said, suggesting that he had never paid much attention to a central condition of the settlement that seemed certain to agitate Thieu's opposition. Although Haig put most of Kissinger's cables from Saigon

before Nixon, "more often than not," Haig told Kissinger, the president did not choose to read them. Nixon's principal interest was in a settlement that assured Saigon's independence for the short run or until he could be reelected and in an outcome that did not appear as a defeat for him or the United States.

Nixon's inattentiveness to the discussions in Saigon combined with Thieu's resistance to a settlement to frustrate and enrage Kissinger. At a meeting with Thieu on October 22, Thieu unequivocally refused to sign the Paris agreement. "Thieu has just rejected the entire plan or any modification of it," Kissinger cabled Nixon. "His demands verge on insanity."

In private, after he got back to Washington, Henry had nothing but contempt for all the Vietnamese. He told Nelson Rockefeller, "Those maniacs in Saigon are not playing . . . There are two explanations: either they have lost their minds or they will eventually give in, but only after they prove . . . I can't arrive there and hand them something." Henry did not spare the North Vietnamese: "The Vietnamese, North and South, are really maniacs . . . You never can be sure that one of them won't do something suicidal." He said to Rogers, "They're both insane."

Thieu's resistance had provoked threats from Kissinger. "If you do not sign, we are going to go out on our own," Henry warned. "Why does your President play the role of a martyr?" he asked Nha, who was translating. "I am not trying to be a martyr. I am a nationalist," Thieu replied. "This is the greatest failure of my diplomatic career," Henry said, revealing his concern with the personal defeat attached to Thieu's decision. "Why?" Thieu asked contemptuously. "Are you rushing to get the Nobel Prize?"

Kissinger also attacked Haig, who Henry now saw as a significant rival for influence with Nixon. He criticized him for taking a narrow, military man's view of the war. "Many wars have been lost by untoward timidity," Henry told him. "But enormous tragedies have also been produced by the inability of military people to recognize when the time for a settlement has arrived."

The object now was to encourage public impressions of progress, despite the collapse of prospects for any immediate settlement. Henry talked Thieu into a brief meeting on the morning of October 23 as he prepared to return to Washington. It would encourage press speculation

that they had "a solution in hand," he said. When a reporter at the airport asked Henry if it was a productive trip, he replied, "Yes, it always is when I come here."

As he headed home, Kissinger suggested to Nixon that he offer Hanoi the chance to meet again in Paris to iron out problems raised by the South Vietnamese. The schedule Henry proposed would now carry the talks beyond the election. Haig replied at once that Nixon was comfortable with Henry's timetable. He hoped that "we can maintain the aura of progress through November 7." Reports that Democrats would attack a preelection settlement as no better than what could have been arranged three and a half years ago reinforced Nixon's aversion to an immediate agreement.

Within hours of returning to Washington on October 23, Kissinger launched a press campaign. Since he refused to give the journalists any details about the current state of the negotiations, the only purpose in talking to them was to encourage the view that the talks remained on track and would produce a settlement in the near future. "We should look optimistic," Henry told press secretary Ron Ziegler, when they agreed to set up a photo-op on October 24. Nixon urged Henry to speak with Bill Buckley, because "our problem is on the right." Buckley was to be told that "the issue now is 'peace with honor' or 'peace with surrender.' " They were making substantial progress toward the first alternative, Henry told him.

Kissinger gave an off-the-record interview to Max Frankel, Washington bureau chief of the *New York Times*. Frankel reported White House sources as predicting that "a cease-fire could come very soon." Only "a supreme act of folly in Saigon or Hanoi" could stand in the way. Charles Colson remembers that when Henry told Nixon that he had briefed Frankel, the president "was so mad his teeth clenched." But Nixon was angry not at Henry's conversation with Frankel, but at the possibility that "now everybody's going to say that Kissinger won the election."

On October 24 and 25, Saigon and Hanoi revealed the terms of the negotiations. Thieu railed against a false peace, while Hanoi demanded that Nixon honor a commitment to sign the agreement by October 31. The pronouncements from the Vietnamese gave Nixon the chance to assert that he had made substantial progress toward ending the war. He instructed Henry to hold a televised press conference on October 26,

which was a departure from administration practice. (Henry's German accent had been a reason to keep him away from a mass TV audience.) But Nixon couldn't resist getting Henry before the press and the public trumpeting their advance toward peace. As he shortly wrote Thieu, "Dr. Kissinger's press conference was conducted on my detailed instructions."

Henry used the conference to answer both the South and North Vietnamese and convince voters that the administration was about to make peace. "Ladies and gentlemen," he declared, "we have now heard from both Vietnams, and it is obvious that a war that has been raging for ten years is drawing to a conclusion." He said that he was speaking at the president's direction and then famously announced: "We believe that peace is at hand." His objective, Henry explained later, was to compel Thieu and American conservatives to accept the agreement and to reassure Hanoi that the remaining differences were relatively minor.

He had nothing to say, however, about serving Nixon's election prospects by convincing voters that the president had honored his promise to end the war. More than two years later, Kissinger would try to convince McGovern that his remarks were not motivated by political considerations but strictly foreign policy concerns.

It was a continuation of the attempt to portray himself as above the political battle. No one can question his sincere interest in ending the war as quickly as possible, but electoral politics was a central consideration as well. Charles Colson, Nixon's principal White House election strategist, told Henry that his press briefing was nothing less than brilliant. The results were "spectacular," Colson said, "no matter what happens now for the next ten days, the election is settled. You've settled it." McGovern's "dead. He's gone, you finished him; you killed him." Henry responded, "Aren't you nice? I appreciate that."

When Colson suggested that Henry call the pollster Lou Harris, who's been "awfully helpful to us," Henry said, "Okay." Colson added, "It will influence his poll over the next week . . . And the poll for this weekend, if it says any closing [by McGovern], he will not print." Henry laughed. "That's not bad. To have him on our side like that," Colson said. "That's not bad," Henry echoed. Again, there is no clear evidence beyond Colson's characterization to indicate wrongdoing on Harris's part.

Scali called Henry to tell him how pleased the president was with all the briefings; "he thought that you did a good job" today. Nixon himself

told Henry that it was most important to convince people that "we're not going to a Communist coalition" and that "we won our objectives."

Yet Haldeman describes Nixon as unhappy with Kissinger's performance, but not because he thought voters would interpret Henry's remarks as indicating that an agreement would be signed before November 7. Nixon was angry that Henry was getting credit for the peacemaking rather than him. According to Haldeman, he told Ziegler that "K was getting the play . . . where the P had hoped that he could go before the nation and make the announcement." Yet Nixon feared any pronouncement from him about peace would be attacked as cynical politics.

While Nixon didn't want to risk a political backlash by taking personal credit for a settlement, he couldn't privately repress feelings of rivalry with a subordinate who was eclipsing him as the administration's peacemaker. Celebrations in the press of Kissinger's brilliance as a master diplomat, who had "cajoled, wheedled, lectured, using all the arts of negotiation," increased Nixon's anger.

Yet not everyone was ready to praise Kissinger and the administration's accomplishment. Given the details of the agreement, allowing North Vietnamese troops to remain in the South and the Communists a say in South Vietnam's political future, reporters at Henry's press conference wanted to know why this settlement could not have been made in 1969. Henry dismissed the suggestion as unrealistic. But the question would become a constant point of attack by critics complaining that Nixon and Kissinger got no more in 1972–1973 than they could have had four years before.

Haldeman recorded on October 28, "The big problem now is for the next ten days, to keep the thing from blowing up either on the North or the South, so that we don't have an adverse reaction set in prior to the election."

To keep Saigon quiet, Nixon wrote Thieu an appeasing letter. Kissinger's press conference was meant to discourage talk of Thieu as an "obstacle to peace with an inevitable cut-off by Congress of U.S. funds." He warned against "constant criticism from Saigon . . . Disunity will strip me of the ability to maintain the essential base of support which your government and your people must have in the days ahead." Kissinger instructed Bunker to reinforce the president's message. In short,

cooperate with us in ending the war and we will be able to respond to any renewed aggression by Hanoi. Thieu was too dependent on U.S. help to break entirely with Washington.

Hanoi was more of a concern. Nixon tried to appease the North Vietnamese by limiting bombing to below the twentieth parallel, but he and Henry worried nevertheless that they would publicly denounce Washington's failure to end the fighting. With polls showing public skepticism of White House explanations that an agreement needed final tweaking before it could be signed, Nixon and Kissinger were greatly relieved on November 4 when Hanoi agreed to another private meeting in Paris on November 14.

Because they had to keep the agreement to the meeting secret until after it occurred, Nixon was eager to find some other way to refute charges from McGovern that talk of additional negotiations was a ruse. With pollster Lou Harris telling the White House that "once you've gotten hopes up, you want to keep . . . the public expecting that we're on the verge of it all being over," Nixon suggested leaking a story that Kissinger would be returning to Paris, and that they say "no comment" when asked about it.

On November 1, Henry told NBC's Richard Valeriani that "we are in the pre-private meeting stage. But this is not for quotation." On November 6, Nixon told Kissinger that his final campaign speech would "hit the peace issue, because it's the only one that really matters . . . Some of the Washington boys are jittery because of his [McGovern's] last-minute charges that we never did have peace and it's a fraud." Henry thought it was a proper response to that "filthy son-of-a-bitch," McGovern, whom he also described as "despicable." Nixon told the country that he had "complete confidence" that they would "soon" end the war on honorable terms. If Hanoi wouldn't cooperate after November 7, Nixon told Kissinger, "we'll bomb the bastards."

On November 3, in a "totally off-the-record" meeting with foreign correspondents, Kissinger offered a defense of U.S. actions on Vietnam that was part realism, part fantasy, and part deception. Despite having lots of information about U.S. politics, Henry asserted that Hanoi did not have "a coherent understanding of how our system works." Yet they knew enough about U.S. conditions to see that domestic opinion forced Nixon into a settlement, and that his eagerness for another military of-

fensive against them was as much behind the refusal to sign before November 7 as Thieu's resistance. "Hanoi knows very well what we want," Henry acknowledged. But he refused to concede that Thieu stood in the way of an agreement. He misleadingly blamed Hanoi for refusing to help clarify some linguistic ambiguities that he was confident could be overcome in another Paris meeting.

"Why then is Thieu so nervous?" a correspondent asked. Henry said it was his anxiety about being forced into "a political contest rather than a military one . . . He and his colleagues are much more comfortable in a military contest than with the unknowns of a political one. And of course he is also trying to show that he is not a U.S. puppet. Now, when we have people who have been slaughtering each other for 25 years, we cannot expect them to approach a settlement with exactly western rationality." Never mind that Thieu was genuinely concerned about the continuing presence of North Vietnamese troops in the South and whether the U.S. would reassert its military power should Hanoi launch a fresh attack.

Henry discounted Thieu's fears as greatly overdrawn. He saw "no uncertainty about the military situation at present." Saigon had a million-man army and a huge police force, which far outstripped the weakened North Vietnamese forces in the South. Events during the next three years—Saigon's inability to resist Hanoi's military might without massive U.S. bombing—make Kissinger's assessment seem either purposely misleading or profoundly mistaken.

Asked at the briefing whether he and Nixon were thinking of the peace settlement as providing a "decent interval," Henry assured the journalists "that there is no hidden agreement with North Vietnam for any specific interval after which we would no longer care if they marched in and took over South Vietnam." It was as if Nixon's suggestion to Brezhnev in May 1972 that he pass this idea along to Hanoi had never been made. Since the North Vietnamese distrusted such a proposal, believing it a trick to get them to settle, Henry apparently saw it as a moot point.

ON NOVEMBER 7, as the country was voting, Kissinger sent Nixon a note of appreciation, telling him "what a privilege the last four years have been." He was confident that Nixon would win. But whatever the outcome, "it cannot affect the historic achievement—to take a divided nation, mired in war, losing its confidence, marked by intellectuals without conviction

and give it a new purpose and overcome its hesitations . . . It has been an inspiration to see your fortitude in adversity and your willingness to walk alone."

The note was part of a Kissinger pattern of flattering the president with unqualified praise, which Kissinger himself described as "obsequious excess." He accurately saw that Nixon needed the flattery and that his influence with the president partly depended on providing it. But Kissinger did have genuine regard for Nixon's talents. He viewed him as a man of considerable intelligence whose foreign policy skills produced important achievements, reduced international tensions, and offered a more stable world with diminished risks of a great power confrontation and possible nuclear war.

Yet Kissinger also understood that he was making a deal with the devil. His comment in 1970 that he had "never met such a gang of self-seeking bastards" or "real heels" as the men around Nixon; his knowledge of the administration's illegal wiretapping, which he had actively supported; his understanding that Nixon fostered an atmosphere of dirty tricks in which subordinates abused presidential power, including Colson's uncorroborated claim just a few days before the election that Lou Harris was ready to hide unfavorable poll numbers, made him a collaborator in what he knew was a corrupt administration. "It is the part of my public service about which I am most ambivalent," he said later about his involvement in the wiretapping. But he took no responsibility for a contribution to "the mind-set that had bred the [Watergate] scandal."

Henry complained to Nixon about "intellectuals without convictions," but he could not have been thinking of the many academics across the country who spoke, wrote, and marched against the Vietnam War. These intellectuals described Henry as the one without convictions or as someone whose personal ambitions overwhelmed his integrity. When a correspondent asked him his personal plans for 1973 and beyond, he denied giving it any thought. "I just haven't had time to think about it or make plans." But like so many others in Washington, his ambition, as was said of Lincoln, was a little engine that never ceased running.

Henry wanted to be secretary of state; he "let me know that he would resign if he didn't get it," Nixon said later. He saw compromising principles for the sake of his ambition as an acceptable price. He rationalized the compromise with thoughts of all the good he could do. But if his

later ambivalence is to be trusted, he seems to have paid a small price for what others with greater integrity think was a Faustian bargain which should cast a long shadow over his historical reputation.

On November 7, Nixon won a massive electoral victory. He beat McGovern in the popular column by 60.7 percent to 37.5 percent. It was the third widest margin in presidential history. Only Johnson with 61.1 percent in 1964 and FDR with 60.8 percent in 1936 eclipsed him. Nixon won forty-nine of the fifty states; Massachusetts alone voted against him. As Joe Tumulty, Woodrow Wilson's secretary, said after Warren Harding thumped James Cox in 1920, "it wasn't a landslide; it was an earthquake."

Yet Nixon seemed to take small satisfaction from his landmark victory. The day after the election, he predicted that opponents would see the outcome as the result of McGovern's weaknesses rather than his strengths. They would point to a diminished voter turnout of 54 percent, a fall off of over 6 percent from 1968 and 10 percent from 1960. They would mock him for being the only twice-elected president who couldn't win a majority for his party in either house of Congress.

After all his years in public life as a divisive figure, Nixon had not suddenly morphed into a popular hero. His victory in 1972 was largely the consequence of voter inclination to back an incumbent against someone who seemed too "liberal" on domestic policy and too soft on foreign affairs. His suggestion for a 50 percent cut in the defense budget particularly troubled voters. The Watergate break-in had raised fresh concerns about Nixon's integrity, but nothing led directly to him at the time of the election and, more important, he had all but ended the war. The troops were home from Vietnam and a settlement seemed within reach. Moreover, as president, Nixon had shown himself to be less doctrinaire than many feared: He supported some liberal domestic reforms and sensibly moved toward a generation of peace with dramatic shifts in Sino-American and Soviet-American relations. To a majority of voters, he had earned another four years.

Yet Nixon couldn't pause to savor his triumph. His conviction that his opponents would now double their efforts to disrupt his second term or make his next four years a disaster, as he said was the case with most second terms, made him almost morbid about his victory. He saw the price of reelection as a fresh round of conflict with domestic enemies. He

predicted that unless he brought in new staff his administration would be like an "exhausted volcano . . . We can't climb to the top and look down into the embers," he told Haldeman, "we've got to still shoot some sparks, vitality, and strength, and that we get some of that from new people, both in the Cabinet and here in the staff." Hopes of putting Watergate accusations and other complaints of dirty politics aside by giving his White House a new look also animated his efforts to appoint people who could not be seen as responsible for earlier behavior.

Haldeman suggested that Nixon let Ehrlichman and him go, "that both of us are tarnished, not just with the campaign scandal question, but more importantly the problems of the isolation of the P, riding roughshod on Congress and on the press." Nixon said that he had considered Haldeman's points, but saw him and John as indispensable. He would "have a major shakeup at State and Defense," though he would need "to keep Henry for a while because of the ongoing foreign policy activities." He wanted "total discipline on the press, they're to be used as enemies, not played for help." As for the Republican party, he thought its members would blame him for the poor showing in the congressional elections. "Make sure that we start pissing on the party before they begin pissing on me. Blame bad candidates and poor organization."

Specifically, he gave Haldeman and Ehrlichman marching orders about a host of concerns. The new personnel should not necessarily be brainy or impressively competent, but loyal. He wanted a smaller staff, which would mean less time talking to aides. He said, "Eliminate the politicians, except George Bush. He'd do anything for the cause." Nixon wanted ethnic quotas, which he opposed as public policy, but suited his private political purposes. There were too many Jews and not enough Italians and Mexicans in his administration, he said, but he doubted if they could find any of the latter who would meet their requirements. They needed "plenty of blacks," even if some of them were "incompetent." He conceded that "Genius needs to be recognized—e.g. HAK. Henry is a rag merchant, starts at 50 percent to get 25 percent. That's why he's so good with the Russians." Nixon's intelligence never deterred him from applying ethnic stereotypes to anyone he considered an enemy or just a rival.

The restaffing of the administration registered on Kissinger as a sort of purge that would make few members of the government happy. "There's a

White House dinner tonight . . . for the old and new Cabinet—it's going to be a happy little group," he told Katharine Graham of the *Washington Post.* Some of the participants would be there with "daggers in their backs and some with knives in their fronts." He undoubtedly wondered which group he might end up in.

In the weeks between the election and the start of his second term, Nixon planned to end the Vietnam War. Unless he rid himself of the Vietnam muddle, he was sure it would continue to divide the country and consume administration energy that could be expended in more productive ways.

The challenge remained to close out the war in a way that made good on his promises to bring home the POWs and secure Saigon's future. Since Thieu was the principal impediment to a settlement, Nixon instructed Haig to carry a letter to him in Saigon. Haig seemed like a better choice than Henry since Thieu was so angry at him. Henry weighed in by telling Haig that Nixon would not stand for a repetition of Thieu's obstructionism. Specifically, Thieu should understand that antiwar liberals would dominate the next Congress, which would deny Saigon future support unless it agreed to end the war.

Nixon's letter was a warning and an admonition. He expressed "deep disappointment" at the rift in their relations and declared Thieu's attacks on the agreement "unfair and self-defeating." Although they would try to pressure Hanoi into revisions, he considered the settlement "excellent," and believed that Thieu should endorse it and describe their accomplishment as "the military victory the agreement reflects." Continuing opposition to the settlement would likely result in "disaster" for Thieu's country.

Thieu was unyielding. "Have you ever seen any peace accord in the history of the world in which the invaders had been permitted to stay in the territories they had invaded?" he asked Haig. Thieu directly answered Nixon in a letter on November 11, asserting that the continuing presence of North Vietnamese troops in the South would defeat the cause of an independent South Vietnam and make their mutual sacrifices "purposeless." Nixon replied at once that "more important" than anything stated in the agreement was "what we do in event the enemy renews its aggression." Nixon promised "swift and severe retaliatory action" if Hanoi

broke the agreement. Thieu remained skeptical that he could rely on future U.S. military support.

Kissinger's return to Paris on November 19 for separate meetings with the North and South Vietnamese produced predictable frustrations. During the four days between November 20 and November 23, both sides impressed him as more maniacal than ever. Le Duc Tho and Xuan Thuy railed against Saigon's demands for revisions in the settlement. "We have been deceived by the French, the Japanese, and the Americans," Tho complained to Kissinger about Vietnam's long history with its occupiers, "but the deception has never been as flagrant as now . . . You told us this [was a done deal] and you swallowed your words. What kind of person must we think you to be?"

Henry advised Nixon that the North Vietnamese "demonstrated absolutely no substantive give and in fact drastically hardened their position . . ." He added in another cable: "It is obvious that . . . we do not have an acceptable deal . . . It is very possible that we will have to face a breakdown in the talks and the need for a drastic step-up in our bombing of the North."

With Hanoi proving to be so unyielding, Kissinger tried to persuade the South Vietnamese to be more flexible. Although he reminded Pham Dang Lam, the chief of the South Vietnamese delegation in Paris, of Nixon's intention to proceed without them if they would not compromise, it was to no avail. "If you think a clash between Washington and Saigon is in your interest, you are in for a surprise," Henry said. He predicted "an endless civil war in which you will end up with nothing—with no agreement and no U.S. support."

On November 24, as the discussions reached a stalemate, Nixon instructed Henry to renew threats to the North and South Vietnamese of dire consequences. He was to tell Tho and Thuy that the president was calling him back to Washington for consultations and that he was "prepared to authorize a massive strike on the North in the interval before the talks are resumed." When Henry delivered the message, Tho responded, "Threats have no effect on us! We have been fighting against you for ten years . . . Threatening is a futile effort! . . . Our people will never give up."

Nixon repeated his now familiar message to Thieu that the United States would abandon him and his country to its fate if he did not accept the negotiated settlement. "You must tell Thieu that . . . either he trusts me and signs . . . or we have to go it alone and end our involvement in

the war." In a last-ditch attempt to salvage the talks, Henry convinced the North Vietnamese to postpone another meeting until December 4, while Nguyen Phu Duc, Thieu's special assistant for foreign affairs, traveled to Washington to meet directly with the president.

The North and the South Vietnamese saw the Nixon-Kissinger warnings as empty rhetoric. Hanoi did not dismiss the likelihood of renewed bombing, but it continued to assume that the same public pressures that had compelled Washington to accept a settlement would limit Nixon's freedom to rely on military power for very long. A likely domestic uproar against fresh attacks would force Nixon back to the peace table. Nixon did not disagree. On November 24, he described "a massive strike on the North" to Kissinger and Haig as "a high risk option" that would put them in "a public relations corner . . . The cost in our public support will be massive." Nevertheless, "we must take our lumps and see it through."

Nixon's message did not resolve Thieu's dilemma. If he signed an agreement that left Hanoi with a military advantage, U.S. domestic opposition would probably make it impossible for Nixon to give more than limited military support. Thieu's doubts about his army's capacity to meet another North Vietnamese assault without substantial U.S. backing put him in an impossible position. If he didn't sign the agreement, the U.S. would probably abandon him. If he did, Washington wouldn't be able to give him the sustained help his government and country needed to survive. It seemed best to take his chances on blaming Hanoi for the failure of the talks and the possibility that the Americans, after all their losses, would not walk away and allow a South Vietnamese–American defeat.

THE DEADLOCK in the negotiations made Nixon angry and provoked renewed tensions with Kissinger. As a part of the constant discussions in November about revamping his administration, Nixon wanted to get rid of Rogers, who presided over a state department Nixon thoroughly distrusted. The prospect of Rogers's removal raised immediate questions about Henry's future. But reluctant to have it appear that Kissinger was displacing him, Rogers refused to leave until June. It incensed Henry, who lamented his fate in having to live with someone he considered incompetent and an impediment to his policies and ambitions.

Nixon, in fact, was inclined to rid himself of Rogers and Henry as well. "I'm going to fire the son-of-a bitch," Nixon told Admiral Zumwalt

at the time. "P really feels that he [Kissinger] should leave by midyear," Haldeman noted in his diary on November 21.

Nixon directed Haldeman to meet with Haig about the "K problem." Haldeman told Haig "that we'd probably have to bite the bullet soon, but in the meantime we had to get things under control. Al said he understood perfectly, he was very concerned. Henry, in his view, is completely paranoid . . . was in absolutely terrible shape in Paris last week and handled things very badly . . . the screwup was Henry's fault, in that he committed to final negotiation and settlement before he really should have, which really screwed things up with the North Vietnamese and South Vietnamese." With associates like Nixon, Haldeman, and Haig, Kissinger had reason to be paranoid.

As much as anything, Kissinger's growing prominence provoked Nixon's hostility. Henry's pronouncement that "peace is at hand," coming after the successful Summits in Peking and Moscow, gave him public standing equal to, if not above, the president's. When rumors circulated in the fall that Henry would be named *Time*'s man of the year, Nixon pressed Ehrlichman to make sure that his "genius" was "recognized, vis-à-vis HK." If *Time* made Henry the man of the year instead of him, Nixon told Haldeman, it "would really create a problem."

Henry was sensitive to public demonstrations that he was eclipsing the president. "The publicity I received caused him [Nixon] to look for ways of showing that he was in charge," Kissinger said later. "I was beginning to sense an emerging competitiveness that was certain sooner or later to destroy my effectiveness as a Presidential Assistant and that was accelerated by the emotions of the concluding phase of the Vietnam War." Henry tried unsuccessfully to head off shared billing with Nixon on *Time*'s end-of-the-year cover. He joked with a *Time* reporter, "Well, I didn't want this job after all. Can you sort of make my picture infinitesimal?" Seriously, he said, "it's going to make my life unshirted hell." Nixon angrily described the *Time* cover as "another self-serving grab for publicity by Henry." The editors at the magazine saw a cover with both the president and Kissinger as a reasonable answer to the rivalry that Henry made clear to them was a part of White House life.

In November, an interview Kissinger gave to Italian journalist Oriana Fallaci, which Henry described as "the single most disastrous conversation I ever had with a journalist," intensified differences with Nixon.

Although several colleagues warned him against talking to Fallaci, the allure of speaking with a reporter who wrote about international celebrities was irresistible.

Because Fallaci recorded the interview, Kissinger found it impossible to deny embarrassing quotes and paraphrases. Fallaci described Henry as saying, "China has been a very important element of the mechanics of my success. And yet that's not the main point . . . The main point arises from the fact that I've always acted alone. Americans like that immensely. Americans like the cowboy who leads the wagon train by riding alone on his horse, the cowboy who rides all alone into the town with his horse and nothing else . . . This amazing, romantic character suits me precisely because to be alone has always been part of my style."

When the interview became public knowledge in the middle of November, it opened Henry to Nixon's increased resentment and public ridicule. "The notion of Henry Kissinger as Clint Eastwood had a certain goofy charm," Walter Isaacson said. "He had never been on a horse in his life, and he could be merciless in ridiculing Nixon's own Walter Mitty fantasies . . . Still, it was not a portrait destined to appeal to the other man in the White House who was proud of being a loner." Henry made fun of himself, asking a *Time* reporter about his man-of-the-year cover picture. "Can I be on a horse? There's one part of a horse's anatomy that I've learned very well here." He added, "She sure killed me."

Nixon didn't mind that a cunning journalist had "shafted" Henry. But the suggestion that Henry was taking credit for the China initiative or that he had acted "alone" enraged him. He wanted Haldeman to tell Henry that "the EOB and the Oval Office and the Lincoln Room have all been recorded for protection, so the P has a complete record of all of your conversations." They would show that "Henry doesn't make the decisions, and when they are made, that he wavers the most." Moreover, Nixon had "written the total China story for his own file from before the Inaugural." Nixon also ordered Haldeman to "get from K's office all the memoranda from and to the P, and get them into the P's files." It should be made clear to Henry who was going to write the authentic history of this administration. "We've got to quit paying the price for K," Nixon told Haldeman.

Kissinger's return from Paris on November 25 brought him and Nixon into fresh tensions over Vietnam. Duc's arrival in Washington compelled

them to reach some definitive conclusions on whether they could salvage the peace agreement. Nixon favored an unequivocal message to Thieu that either he accepted the agreement or the United States would proceed without him. Henry agreed that they needed to be tough, even "brutal" with Duc, whom he described as someone who "moved from abstract definition to irrelevant conclusion with maddening, hairsplitting ingenuity." But where he clung to hopes of pressuring Saigon and Hanoi into a settlement, Nixon saw little prospect that either of them would compromise. Henry refused to accept that the talks were irretrievably deadlocked.

Nixon was more realistic about Thieu's opposition to a settlement. Thieu, "a shrewd, paranoiac mandarin," Henry called him, gave Duc a letter for Nixon. It repeated his refusal to leave North Vietnamese troops in the South, and implored Nixon to convince the Congress not to cut off aid. Nixon responded by telling Duc that without a settlement he could not control the U.S. Congress. More important, he assured him that an agreement would lay the groundwork for renewed military operations should Hanoi break the treaty. Having heard all this before, Duc was not impressed and repeated Saigon's insistence on a North Vietnamese evacuation. Kissinger assured Duc that they would make the president's commitment a part of the formal record of their talks.

Nixon saw the meeting as unproductive. He told Haldeman that at the end of the day, the South Vietnamese seemed determined to go it alone. Nixon thought it was now impossible to change Thieu's mind. It was confirmed for him the following day when Thieu suggested through Duc that Nixon proceed bilaterally with Hanoi, and Saigon would continue on its own. Duc reported that "Thieu felt it would be preferable to die now than to die bit by bit." Nixon described Duc's theatrics to Kissinger as "just nonsense."

In response, Nixon emphasized to Duc the importance of closing ranks, or how "fatal" a split between our two countries would be. He said that failure would be "disastrous" and would amount to Thieu's "suicide." His warnings were aimed more at the historical record than at Thieu, who wouldn't budge.

As demonstrated by a meeting Nixon held with the Joint Chiefs on November 30, he was convinced that his only alternative now was to blame Hanoi for the stalemate and then launch a massive bombing campaign that could force a settlement. Polls showed that while the American

people "do not like the war, they . . . reject surrender and humiliation," he told the Chiefs. Nixon ordered them to review and strengthen contingency plans for three-day and six-day strikes against the North. The plans should "include the resumption of mining and the use of B-52s over Hanoi." He wanted an "all-out" attack. "It cannot be a weak response but rather must be a massive and effective one." Nixon "asked Laird for his views on congressional support if the agreement on Vietnam failed. Laird replied that further congressional support would be impossible." Nixon predicted that "our aid would be cut off in two weeks."

If he had read the Gallup polls carefully or filtered out his bias that Americans put some kind of victory ahead of withdrawal, he would have seen how little support he could expect from the country for renewed bombing to keep Thieu in power and fend off a North Vietnamese takeover in the South. A September survey showed that only 21 percent of Americans favored Thieu's continuation as president, with 32 percent opposed to him and 47 percent holding no opinion. When asked what kind of government Americans wanted to see in Saigon after U.S. troops left, only 29 percent favored a South Vietnamese regime; 40 percent preferred coalition rule, and 21 percent said it made no difference.

At the end of November, 47 percent of a survey thought the South Vietnamese would lack the wherewithal to resist Communist pressure after America withdrew, while 31 percent hoped that Saigon would be able to stand up to North Vietnam. Thirty-seven percent of Americans wanted to continue postwar military aid; but pessimism about Saigon's future and weariness with U.S. expenditures in what seemed like a hopeless cause moved 52 percent to favor a cutoff.

Nixon's plans to bomb the North should they fail to reach a settlement or should Hanoi violate peace terms rested not on the popular will but on questionable convictions about America's national interest. What Nixon banked on, as he told Kissinger, was that most of the American people "don't give a damn." He assumed that "no draftees to Vietnam, low casualties, etc, means the American people are not going to be shocked. They're just disappointed, not enraged, by the settlement not coming off . . . This is the right track on public opinion." However small the cost of continued bombing might be, Americans had no enthusiasm for more U.S. military action that seemed to promise no better result than in the past.

As Kissinger prepared to return to Paris for the December 4 meeting, Nixon saw only domestic political reasons for holding more talks. He candidly told Henry that another meeting, in which they took a hard line with Hanoi, would be a way to counter all that right-wing "crap" that "we sold out." He also worried that news reports from Saigon saying that Nixon had presented them with an ultimatum would add to difficulties getting any kind of continuing support from Congress. If he had to resort to renewed bombing, he thought it would be seen as a concession to Saigon, which all along had wanted to continue the war.

Kissinger arrived in Paris still hoping that he could wring commitments to a treaty from both sides. He intended to tell the North Vietnamese that if they didn't settle, the United States would continue to expand the bombing, and warn the South Vietnamese that if they didn't agree to peace, we would abandon them. "So, it's a little touchy to play both sides against the center," Haldeman noted.

When Henry reported to Nixon that the first day's meeting with the North Vietnamese went nowhere and that he thought Nixon should go on television to rally the American people for expanded attacks on Hanoi, the president privately described Henry as out of "touch with reality." Nixon saw Henry's suggestion as putting the blame on him for the failed negotiations. "K is trying to cover his own mistakes," he told Haldeman. "He can't bear to come back and face the press, because he knows they'll attack this time . . . It's clear that he wants the P out as the blocking back to clear the way." Instead, Nixon instructed Henry to keep the talks going, so as to make "the record as clear as possible . . . that the responsibility for the breakdown rests with the North Vietnamese." If the talks collapsed, he wanted Henry to return and make it public through a direct report to the press. It was his way of assuring that Kissinger and not he would be seen as the central figure in the failed negotiations.

Nixon resisted additional suggestions from Henry declaring the negotiations over. He thought it was better to suspend them, blame Hanoi for the impasse, and use expanded bombing to force the North Vietnamese back to the peace table. Once an agreement was reached, he believed he would have stronger public backing for renewed attacks on the North Vietnamese should they violate the treaty. If the U.S. simply walked away from the talks, Nixon assumed that the left would condemn him for

rejecting peace and would assure substantial congressional and public opposition to additional air attacks against Hanoi.

Yet Nixon believed that bombing the North would not be enough to secure a settlement. He would have to bring Thieu into line. He directed Agnew to go to Saigon. This was "not a negotiating mission," he told Agnew. "You are to convince Thieu, as the leader of the hawks, that there will be no support for him unless he goes along." Agnew was then to describe Nixon's bombing plans to Thieu. Should Hanoi renew its aggression against the South, Nixon promised "to use the B-52s to take out the power stations, communications, and the rest. And that is my maximum plan for knocking them out—even including the dikes," Nixon said.

Before Agnew could go, Thieu responded to indications of additional U.S. pressure with a speech to his national assembly. On December 12, he announced that he would never sign an agreement leaving North Vietnamese troops in the South. Privately, he expressed doubts about Nixon's pledge to meet treaty violations with an expanded air war.

Thieu's defiance fueled Hanoi's intransigence. Kissinger cabled Nixon that the North Vietnamese had become "more ludicrous and insolent" in their talks. "Hanoi is almost disdainful of us because we have no effective leverage left." In response, Nixon ordered Henry to suspend the discussions and return home for consultations. He was to tell the North Vietnamese that with no "political considerations" to hold him back, the president would not be deterred from whatever course of action he considered appropriate. "There are no understandings now during this period of recess—each side will . . . do what its interests require."

The collapse of the negotiations increased the Nixon-Kissinger tensions. Nixon blamed the failure on Henry. "The South Vietnamese think Henry is weak now because of his press conference statements," the president told Haldeman and Ehrlichman. "That damn 'peace is at hand'! The North Vietnamese have sized him up; they know he has to either get a deal or lose face. That's why they've shifted to a harder position."

Nixon and his two aides thought that the failure was playing havoc with Henry's stability. "Henry was very down when he left for Paris," Haldeman said. "He's been under care. And he's doing some strange things." After reading *The Will to Live*, a book by Dr. Arnold Hutschnecker, his former physician and therapist, Nixon recommended it to Haldeman as providing a road map to what Nixon called "K's suicidal

complex. He also wants to be sure I make extensive memoranda about K's mental processes and so on for his files," Haldeman recorded.

As Henry returned from Paris, Nixon complained about a James Reston column in the *New York Times*, which "had to come from K." Nixon took exception to Henry's suggestion that they "just increase the bombing below the twentieth parallel." He told Haldeman that "if we want to step it up, we've got to make a major move and go all out." When Haig reported that Henry "was very touchy in a phone conversation," Nixon said that "K is showing too many signs of insubordination." He told Haig that Henry's outlook is "half rational and half irrational." He and Haig agreed that they ought to keep Henry away from the press and send him "for a rest . . . to Mexico or any place where it's hard to get on the telephone."

Kissinger was frustrated and depressed by his inability to bring the negotiations to a successful conclusion. He felt "isolated and devastated" on the return plane trip from Paris. At Andrews Air Force Base, when a reporter asked if he thought peace was at hand, he resorted to comic self-deprecation: "That's a good phrase. Wonder who used it?"

He was furious at all the Vietnamese. "They're just a bunch of shits," he told Haig. In a telephone conversation with a journalist friend that afternoon, when she urged him to get peace for her sake, he replied: "At this stage, I have to do it for me or I'll lose my mind. You know, when you meet with two groups of Vietnamese in the same day, you might as well run an insane asylum." The next morning, when he met with Nixon to discuss their options, he called them "Tawdry, filthy shits. They make the Russians look good." He subsequently described Thieu to Nixon as "this insane son-of-a-bitch." As for the North Vietnamese, they were a bunch of "bastards" who "have been screwing us."

Nixon's concerns about Kissinger had less to do with his emotional state than with their rivalry. Nixon saw Henry as using the press to defend himself against criticism for the breakdown in Paris and to position himself to get the lion's share of the credit for any settlement. He worried that Henry was selling the press on the idea that he had peace in his grasp and that the president had pulled back from the settlement. After Henry met with the president in the Oval Office on the morning of December 14, Haldeman confronted him about press leaks. "It was really kind of hysterical," Haldeman wrote. Henry denied talking to reporters and

"didn't understand why we didn't trust him when he says he doesn't talk to these people." After Haldeman read him direct quotes from a story, Henry "hemmed and hawed a bit" and acknowledged phone conversations with the journalists.

Nixon's objective with Kissinger was not to isolate him—that would have implied a total collapse of the talks and White House disarray—but to make him an instrument of the president's purposes. Nixon instructed Henry to hold a press conference on December 16. He sent him two detailed memos, totaling seven pages, on exactly what to say. To ease Henry's embarrassment at his "peace is at hand" statement, Nixon instructed him to assert that the press had "gone overboard in being more optimistic than they really should have been . . . and failed to recognize adequately the caveats" about the several "sticky matters that had to be worked out."

He also directed Henry to make clear that the president had set the goals for a settlement that was within reach, but still needed working through if we were to get a stable, long-term peace rather than one leading to another war. Henry was to explain that Hanoi was making preparations to continue the fighting. Nixon then wanted Henry to say that both the North and South Vietnamese shared responsibility for the slowdown in the negotiations and to announce the president's intention "to step up pressure on both sides for a faster settlement."

The news conference was a prelude to a massive bombing campaign begun on December 18. Nixon insisted that the air attacks start while Congress was in recess for the Christmas break. If it was in session, he would have to explain his action to Senate and House leaders, and risk an explosion of opposition. "One of the beauties of doing it now," he told Henry, "we don't have the problem of having to consult with Congress." We need to "move on it right now, move, move, move," he told Haig, "get the damn thing going."

They did, and over the next twelve days, with a stand-down on Christmas, U.S. air forces led by B-52s blasted Hanoi and Haiphong with around-the-clock attacks. The objective was to break North Vietnam's will to fight and convince Thieu that Nixon meant what he said about responding to any future violations of a peace agreement.

The assault was a capstone to an eight-year air war in which the United States unleashed more tonnage on Vietnam than it had used in all

theaters during World War II. A hundred B-52s was "like a 4,000-plane raid in World War II," Kissinger told the president. "It's going to break every window in Hanoi." And, of course, much more: The *Washington Post* described the assault as "the most savage and senseless act of war ever visited, over a scant ten days, by one sovereign people over another." It was "a stone-age tactic," Democratic Senator Mike Mansfield said. The United States paid a price for the air assault, losing fifteen B-52s during the Christmas bombing, as opponents sarcastically dubbed the attacks, fourteen more than had been lost in the war to that point. The devastation from the raids, however, forced the North Vietnamese to agree to return to the peace table in January.

By contrast, despite Nixon's hopes, the bombing had little impact on Saigon. Thieu remained unreceptive to renewed pressure from Washington. When Barry Goldwater was quoted in the press as saying that "if Thieu bucks much more, the U.S. should adopt a 'hell-with-him attitude,'" Nixon instructed that Thieu should see this. More directly, Nixon sent Haig back to Saigon with a personal letter that he asked Thieu to "treat with the greatest secrecy." Nixon's letter, underscored by Haig's oral comments, told Thieu that the bombing was a message to Hanoi that they could expect more of the same if they broke the peace treaty. Thieu was also urged to understand that his refusal to end the war was encouraging Hanoi's resistance to an agreement and that a failure to join in a settlement would mean a definitive end to U.S. support. Collaboration with Washington in ending the conflict would assure Thieu of future U.S. military aid.

Thieu signaled his continued resistance to Nixon's demands by keeping Bunker and Haig waiting for over four hours before meeting with them on December 20 and by characterizing Nixon's letter as an "ultimatum." In a written reply, Thieu asked Haig to carry to Washington, he refused to settle without an evacuation of North Vietnamese troops and a U.S. commitment to oppose Communist claims to a role in governing South Vietnam.

Kissinger advised Nixon that Thieu's letter was the last straw. It "seems to leave us little alternative except to move toward a bilateral arrangement." At a meeting with Kissinger and Haldeman, Nixon concluded that we would have "to go out alone." During the discussion, Henry "said with some glee that Haig has now joined the club—that

he got kicked in the teeth by Thieu." He repeatedly "blasted Thieu as a complete SOB" and referred to the "South Vietnamese as SOBs, maniacs, and so on." They agreed that they should go ahead with the North Vietnamese and not give Thieu another chance. When Hanoi agreed to resume talks on January 8, the White House, without consulting Saigon, announced a bombing halt above the twentieth parallel on December 30.

Haig thought it was a terrible mistake. He believed that the only chance to save South Vietnam was an unrelenting bombing campaign that forced Hanoi to evacuate its troops from the South. Nixon, however, told Haig that if he kept up the air assault he would face impeachment. Besides it was difficult to imagine that more bombing of the North would compel it to do what it had resisted for the last eight years.

As the year came to an end, Nixon and Kissinger could look back on an impressive record of improved relations with Peking and Moscow, an extraordinary electoral victory, and the likelihood that the Vietnam War, after many false starts, would be coming to a close. But the New Year seemed freighted with ongoing concerns: A settlement promised little assurance of Saigon's autonomy; the simmering Watergate scandal could turn into a distracting problem; the Middle East might erupt in a regional war that could undermine Soviet-American relations; and Allende's government in Chile could destabilize Latin America, or so Nixon and Kissinger believed.

THE WORST
OF TIMES

— Chapter 14 —

NEW MISERIES

Everything is a crisis. It is a terrible lousy thing . . . It is never dull, is it?

—NIXON TO JOHN DEAN, MARCH 13, 1973

At the start of his second term in January 1973, Nixon believed he had to end U.S. involvement in Vietnam immediately. He thought it would free him to make additional foreign policy gains in China and the Soviet Union, head off another Middle East crisis, shore up faltering relations with European allies, and make some headway in containing communism in Latin America. On January 3, Haldeman recorded that the president "still hasn't clearly focused on getting down to work on the second term . . . I think until he gets Vietnam settled, everything else is going to pretty much stay in the background."

In January, Gallup polls made clear that Americans had lost patience with the war, leaving Nixon no choice but to make peace. Sixty percent of the country now said that sending in U.S. troops had been a mistake. Sixty-seven percent complained that the administration was not telling the public all it should know about the war. As for bombing the North, 46 percent approved and 45 percent disapproved. Should we resume bombing Hanoi and Haiphong if Hanoi rejected "reasonable peace

terms"? Forty-four percent opposed and only 42 percent favored more bombing above the twentieth parallel. Despite Nixon's landslide election, it included no mandate to continue the war. During the first week of January, the House and Senate Democratic caucuses passed resolutions eliminating funds for all military operations in Indochina. Only Hanoi's failure to release U.S. POWs and threats to withdrawing U.S. forces could override the cutoffs.

When Kissinger met with Nixon on January 6 at Camp David to discuss Henry's return to Paris on January 8, the threat that the Democratic majorities in Congress would turn the caucus votes into mandatory resolutions moved Nixon to urge Kissinger "to settle on whatever terms were available . . . The war-weariness has reached the point that . . . [it] is just too much for us to carry on." As he bade Henry good-bye, Nixon added: "Well, one way or another, this is it."

Nixon's prediction rested largely on the conviction that the bombing was compelling Hanoi to end the war. Although the North Vietnamese put up a brave front by declaring that the latest U.S. attacks had been unable to subdue them, they acknowledged that the air campaign had been destructive across North Vietnam, including Hanoi and Haiphong.

At a plenary meeting on January 4, the North Vietnamese declared their readiness to end the war. They wanted to sign a treaty by January 20, the start of Nixon's second term. Between January 8 and 13, Kissinger and Le Duc Tho reached agreement on a final settlement. The discussions, however, were not without acrimony. As they shook hands before the talks began, Kissinger told Tho, "It was not my fault about the bombing." Tho was not appeased: "You have tarnished the honor of the United States," he said. "Your barbarous and inhumane action has aroused the general and tremendous indignation from the world peoples." When Tho repeated these complaints, Henry bristled, "I listened to the adjectives the first time but I think you should eliminate them." Tho said he was showing "great restraint."

Thieu's government remained the principal impediment to a settlement. Before he left for Paris, Kissinger tried to convince three South Vietnamese diplomats Thieu had sent to Washington that he and the president had no illusions about the North Vietnamese. "They are SOBs," Henry said. "They are the most miserable bastards . . . They are totally treacherous." Yet Kissinger tried to convince the diplomats that

peace arrangements with them would hold up. A weakened Hanoi would not be in a position to overturn Thieu's government, and should they try, Nixon was ready to respond with effective force.

Nixon was especially concerned that Thieu's opposition not cast a shadow over his Inauguration on January 20. He wanted to announce a settlement on January 18. To make clear to Thieu that he had no wiggle room left, on January 12, the White House announced an end to the air attacks on North Vietnam. Haig was sent to Saigon to tell Thieu that the U.S. would sign the agreement no matter what he did.

Although Thieu finally succumbed to Nixon's pressure, he tried to impede the signing by questioning the procedures. "When you deal with the Vietnamese," Henry told a friend, "it's like training rattlesnakes." As Thieu gave in, he complained again about the presence of North Vietnamese troops in the South. South Vietnamese Vice President Ky privately "described the agreement as a 'sellout.' " The continuing occupation of parts of the South by the Communists made the rest of the agreement about future plans for political arrangements seem irrelevant.

To give the appearance of solidarity between Saigon and Washington, Thieu sent his foreign minister to the signing ceremony in Paris. "Without physical participation by them, it's a great loss of face," Kissinger told Nixon. Nixon, who knew next to nothing about the Saigon government beyond Thieu and Ky, asked Henry if the foreign minister was Thieu's nephew. "No," Henry replied. "The nephew is that little bastard who is the Minister of Information. The Foreign Minister's an ass." Nixon, however, thought his presence in Paris "a very good idea"; it would suggest U.S.–South Vietnamese unity to Hanoi and American conservatives who doubted the viability of the settlement.

Although he said nothing to the South Vietnamese, Nixon doubted that the treaty would end the fighting. Hanoi did little to hide its intentions of eventually seizing control of South Vietnam. Kissinger advised Nixon against saying that this is a "lasting peace or guaranteed peace, because this thing is almost certain to blow up sooner or later."

Nixon agreed. He intended to tell the country, "The fact that we sign an agreement does not mean that peace can be lasting." And if it weren't, he hoped the South Vietnamese had the wherewithal to resist on their own. Should that prove false, he hoped the Congress and the country would endorse a U.S. military response. As Haig told Thailand's

prime minister during his January mission to Southeast Asia, "We think that with a settlement the United States people will support the need to enforce it."

In a speech to the nation on January 23, Nixon could not resist describing the settlement as a "peace with honor." Nor could he resist saying that "this agreement will ensure a stable peace in Vietnam and contribute to the preservation of lasting peace in Indochina and Southeast Asia."

On January 24, when Kissinger briefed the press on the agreement, he reinforced Nixon's assertions. North Vietnamese troops in the South would be no problem in the long run because the settlement prohibited infiltration and "the normal attrition of personnel" would ultimately eliminate them as a risk to Saigon. If the agreement broke down, would "the United States ever again send troops into Vietnam?" a reporter asked. "I don't want to speculate on hypothetical situations that we don't expect to arise," Kissinger evasively replied.

Reporters also asked how the current agreement differed from one that could have been reached four years earlier and why the treaty included a provision for the replacement of South Vietnam's war matériel if the fighting was in fact at an end. Unlike earlier North Vietnamese proposals, the current agreement assured Saigon's political future, Henry answered, without acknowledging that a likelihood of future fighting could topple Thieu's government. He did concede, however, that additional military supplies were an insurance policy against the possibility that the war might resume.

Nixon and Kissinger ignored the realities of Saigon's opposition to the settlement and muted their conviction that the agreement was only a respite in North Vietnam's battle to conquer the South. Kissinger privately told a reporter that "If we play it skillfully . . . we can quiet it [South Vietnam]—at least for a while, which is the primary objective." The same day, when another journalist in a phone conversation asked if "a year or two of reasonable inactivity" seemed possible, Henry said, "There are three chances out of four that that's the way it will work out."

He was more candid and pessimistic with Marvin Kalb: "These maniacs," he said, referring to the North and South Vietnamese, "they'll probably start the war again on the first of February . . . No, no," he added, "that's not going to happen . . . It may break down eventually

but . . . it's just complicated enough so that it's got to work for a while." When Ehrlichman asked him about South Vietnam's prospects following the cease-fire, Kissinger replied, "I think that if they're lucky, they can hold out for a year or two."

The ink was hardly dry on the peace agreement before threats of more fighting surfaced. Le Duc Tho announced at a January 24 news conference that the Vietnamese "people are determined to continue their struggle," and he predicted that they "will certainly be reunified." At another news conference the following day, a representative of the Viet Cong declared that "no force could hinder the inexorable historical revolution of the Vietnamese people." On January 30, America's TV networks described South Vietnam as "still at war." The cease-fire "was breached on a scale that involved intense fighting from one end of the country to the other." On January 31, when reporters asked Kissinger about the on-going fighting, he counseled patience: "They have been fighting for over 25 years," he declared. He had every hope that "the necessary pressure could be brought to bear to maintain the peace."

Relief in America at an end to the war and the prospect of almost six hundred American POWs coming home made praise for Nixon's accomplishment almost universal. Newspapers across the country uncritically approved of the president's "peace with honor." One paper, borrowing from Churchill's description of Britain in World War II, described the achievement as the president's "finest hour."

Nixon focused not on the praise but the extent to which Kissinger was being lauded for the settlement at his expense. He told Haldeman and Ziegler that he wanted "a plan on the PR side that we can ride with . . . so we can control Henry." All stories coming out of the White House needed to stress that the president had been "totally in charge." Nixon directly prodded Henry to describe his primacy in public discussions of the settlement. Speaking to Henry of the Paris negotiations, Nixon said: "You've been through a lot." Henry replied, "We've all been through a lot." Nixon answered, trying to put Henry in his place: "Well that's my job . . . You're just a paid hand. I'm the guy that gets all the glory." Haldeman briefed the White House staff on "selling our line the way that [Arthur] Schlesinger built up Kennedy, which needs to be done in the case of the President."

Although Kissinger told Nixon that the press was always "looking

for some way to take away the glory from you," Henry believed he deserved the principal credit for ending the war and privately encouraged the media to give him his due. In the week after Nixon's speech, Henry had numerous private conversations with journalists in which he did not resist suggestions that he was the architect of the administration's success. "I just have a hell of a time thinking of myself as such an enormous public figure," he disingenuously told Barbara Walters. "But you are," she replied. "I know that," Henry acknowledged. *Time* agreed: "HAK is back on top now with his darkest days behind him," the magazine declared in its January 30 issue. When someone told him that ABC news was reporting that Nixon planned a press conference in which the last item on his agenda would be "a tribute to Henry Kissinger," Henry declared, "Well, well deserved."

Kissinger's celebrity enraged Nixon. CBS's Harry Reasoner incensed him by nominating Henry for a Nobel Peace Prize. Nixon complained to Haldeman that when Henry appeared before Congress, he neglected to "say that without the President's courage we couldn't have had this . . . K is very popular, got good applause, including from our opponents, and a standing and prolonged ovation at the House, but he didn't make our points," Haldeman recorded. "The rift between Henry and the P is not created by leaks. It's fed by Henry's own nuances . . . We have to have Henry build the P."

A James Reston column predicted that if there were a break between Nixon and Kissinger, Henry would "be free to resign and write the whole story of the Paris talks," which "would probably be highly embarrassing to Mr. Nixon." Nixon worried that Kissinger was compiling a collection of national security files that would allow him to outdo the president in writing an authoritative memoir. In early January, Nixon "raised his concern [with Haldeman] about the K papers, and all the P's papers on national security that K is holding, including Henry's phone calls [which Nixon knew Kissinger was making transcripts of], and conversation memos and cables and so on, which he wants to be sure to get a hold of and stay on top of as much as possible."

IN JANUARY, however, Nixon had bigger worries than Kissinger's competition for public approval over ending the war and taking credit for the administration's foreign policy successes. Newspaper coverage of the

Watergate break-in trial was beginning to command renewed attention, and Nixon hoped that the burglars—"our people" Nixon called them—would "take the Fifth Amendment rather than get trapped into testifying." Suspicions about a Nixon role in the break-in reached into the highest echelons of his party. Barry Goldwater told William Buckley that "he had had a conversation with Nixon that was so cynical that he was appalled." He also told Buckley that he asked himself, " 'Who could have been crazy enough to do that [Watergate]?' and the name came back 'Nixon.' " White House counsel John Dean suggested to the president that they turn off talk of a congressional investigation by insisting that Congress also look into bugging of the 1968 Nixon campaign by Johnson and the Democrats. Dean was setting up a congressional strategy group, including Charles Colson, to ferret out "the Hill guys' vulnerabilities and see if we can't turn off the Hill effort before it gets started."

Nixon wanted to intimidate LBJ into putting pressure on congressional Democrats to avoid a Watergate inquiry. John Mitchell was to ask Cartha ("Deke") DeLoach, a former assistant FBI director, whether "the guy who did the bugging on us in '68 is still at the FBI, and then [L. Patrick] Gray [the current director] should nail him with a lie detector . . . which would give us the evidence we need."

But when a Texas reporter called Johnson to ask about bugs on Nixon's 1968 campaign plane, Johnson "got very hot and called Deke." He denied that his White House ever tapped Nixon's plane, and threatened that if the Nixon people touched this, he would release intercepted cables from the South Vietnamese embassy in Washington to Saigon demonstrating that the Nixon campaign had interfered in the 1968 peace negotiations by discouraging Thieu from a preelection settlement. With DeLoach's recalling that a request for bugs on RN's plane had been turned down and Nixon unwilling to embarrass himself by having to face questions about his campaign's skullduggery in '68, the White House abandoned the idea of pressuring Johnson to help block a Senate inquiry.

An alternative proposal was to have "the IRS run audits of all members of the Congress. It may be that this is not a good idea," Nixon told Haldeman, "because it may stir up a lot of friends as well as others." To blunt possible criticism, Nixon suggested auditing "all top members of the White House staff, all members of the Cabinet, and all members of

Congress." Nixon wanted an oral rather than a written report; it would leave no record of what they had done.

Because he believed that congressional and media opponents would attack him about Watergate and the Vietnam settlement, saying it could have been reached four years before and that cease-fire violations demonstrated its ineffectiveness, Nixon directed the White House staff to use the peace agreement as a weapon against them. He shared the conclusion of a *Buffalo News* columnist that "RN haters will never forgive him for . . . not only getting peace, but the 'peace with honor' he has consistently called for."

Nixon instructed that "Every commentator, columnist, college professor, etc., that has hit us, should be badgered all out now—in the *Congressional Record*, with letters—a total attack basis," Haldeman told Colson. "We should hit those who sabotaged and jeopardized the peace all the way—who lied about the facts, etc." He wanted Henry to attack congressional and media opponents for having favored "an abject surrender and defeat for the United States."

The counterpoint Nixon saw to these attacks was an all-out effort to build a long-term structure of peace. He told congressional leaders in early January that he looked forward to further gains in Soviet-American relations. A second Russian Summit in the spring would bring another round of arms control negotiations. He also intended to reassure the Europeans that his focus on Peking and Moscow did not mean any downturn in U.S. concern with Europe. Nor had he forgotten about problems in Latin America, though they were less urgent than those in other parts of the world. When a journalist observed that "Richard Nixon has a peace plan that goes beyond VN to the world, and he has 'his own Metternich and his hopes for a place in history,' " Nixon instructed Colson to circulate this.

IN REALITY, Nixon had his doubts about achieving long-term peace everywhere, especially in the Middle East. At San Clemente, after he had concluded a phone conversation with Yitzhak Rabin, Shelley Buchanan, Pat's wife, asked the president "what the prospects for Israel were. 'The long run?' Nixon responded. He extended his right fist, thumb up, in the manner of a Roman emperor passing sentence on a gladiator, and slowly turned his thumb over and down."

Nixon's reluctance to stake his prestige on a Mideast settlement rested on his and Kissinger's pessimism about easing the region's conflicts. Before Nixon went to Moscow in 1972, Kissinger had warned against brokering discussions that could quickly end in a stalemate and cast a shadow over the May Summit. Yet Nixon believed that he needed to find a solution to the region's problems before the Democrats returned to the White House. A Democrat was likely to be totally pro-Israel and this would guarantee Soviet influence among Arabs for some time to come. If the United States were to maintain significant influence in the Middle East, it would need to strike a bargain with Moscow: the withdrawal of its military forces from Egypt in return for Israeli concessions on territories.

Although Nixon had considered entering into serious Mideast discussions with the Soviets in Moscow, the potential domestic political fallout in the election and the small likelihood of compelling either Israeli or Egyptian compromises made Nixon decide against new initiatives before the end of the year.

Sadat's expulsion of Soviet military personnel from Egypt in July had reduced Nixon's sense of urgency about doing anything. Moreover, the determination to end the Vietnam War before focusing on Mideast talks had pushed the region's problems aside.

After the November election, Nixon and Kissinger remained reluctant to push a Middle East peace plan. They wanted an understanding with Egypt and Israel that future talks would be productive. But with Sadat demanding a promise of total withdrawal as a prelude to talks and Meir refusing to promise a return of occupied territories, prospects for a settlement remained dim. Ever alert to anything that might eclipse his standing as the administration's lead dog in all major negotiations, Kissinger also warned Nixon that Rogers "will now run wild and try to win one" in the Middle East.

Nixon shared Henry's reluctance to rush into anything that could embarrass the administration. Yet with Sadat warning that the status quo would provoke another war, which could bring a renewed Soviet military presence in the Middle East, Nixon decided to approach Brezhnev in December 1972 about finding a means to revive negotiations.

"I have no answers," Nixon candidly told Rabin in January, "but we cannot let the Middle East explode again." He and Rabin agreed that

small political steps or a step-by-step approach seemed the only realistic possibility. "The hatred will continue," Nixon told Rabin. "That is a fact of life. I cannot accept the proposition that progress is impossible, but it is prudent to assume distrust until you have proof of the opposite."

Nixon and Kissinger agreed to hold off on Middle East discussions until Golda Meir visited the White House on March 1. Shortly before Meir arrived in Washington, an NSC assessment of Sadat's negotiating conditions suggested little room for maneuver either with Egypt or with Israel. Sadat had made clear that he had no interest in an interim agreement that left Israel in possession of Egyptian territory lost in the '67 war. Harold Saunders told Kissinger that negotiations might last as long as twenty-five years.

As Henry told the president on the eve of Meir's visit, the Israelis preferred the status quo "to any settlement imaginable now . . . The problem now is to construct a situation in which the Israelis might get some show of Arab willingness to negotiate seriously on solutions that would contribute to Israeli security and legitimacy while the Egyptians might get an indication of Israeli willingness to consider restoration of their sovereignty in the Sinai." The key to any progress with Meir, Henry asserted, was to assure her that we would not try to impose a settlement.

Kissinger also suggested that Nixon might want to hold off on doing anything. But Nixon saw this as irresponsible. "Absolutely not," he told Henry. "I have delayed through two elections and this year I am determined to move off dead center—I totally disagree. This thing is getting ready to blow."

In their meeting with Meir, Nixon and Kissinger tried to find some formula for drawing Israel into talks with Egypt. Meir began the discussion in the Oval Office by congratulating Nixon on improving international prospects for peace—"a direct assault by the weapon of flattery," Kissinger called it. Although pleased by her praise, Nixon did not wish to be seen as some sort of soft-minded idealist: He assured her that he remained "realistic about the dangers which still existed." He urged her to counsel fellow socialists against illusions. "They talk about the golden rule," Nixon added. "My rule in international affairs is do unto others as they would do unto you." Kissinger interjected, "Plus 10 percent." Nixon said, "Woodrow Wilson was the biggest idealist in this office. When he went to Versailles, the pragmatists gobbled him up."

Turning to current problems, Nixon declared it essential to break the deadlock in negotiations. He promised not to use arms commitments to Israel as a device for pressuring her into talks. Meir reciprocated Nixon's assurances by declaring Israel's eagerness for negotiations with any Arab country anytime, anywhere.

As long as Sadat refused to open talks unless Tel Aviv promised to evacuate captured lands, Meir's pledge was an empty gesture. Nixon then suggested that she agree to have Henry explore matters with both the Egyptians and the Soviets. Henry would make no commitments: "Henry is a master of fuzzy language," Nixon explained. "Tell the Chou story, Henry," Nixon directed. Kissinger reported Chou's observation that " 'Kissinger is the only man who can talk for 1½ hours without saying anything.' " Nixon conceded, "Maybe it won't work, but I think we should try. We won't broker for you, but we should know the outline of what you want."

Meir was confident that Henry's conversations with the Egyptians and the Soviets would not "deliver Israel to them. We know better." Nixon urged Meir to take hope from Henry's mediation. "If we, as the middle man, are talking to both sides, you are in a good position, because we tilt to you." Meir agreed to a back channel between Kissinger and Simcha Dinitz, the new Israeli ambassador in Washington, with Meir restricting information about the talks to her office.

The meeting pleased Meir: Nixon promised more planes than his subordinates were offering; and a settlement brokered by the Americans seemed a distant prospect, at best. "The longer there was no change in the status quo the more Israel would be confirmed in the possession of the occupied territories," Kissinger said of Meir's goal. He didn't take much hope from Meir's visit. But he wasn't especially worried about the impasse: Although Egyptian national security adviser Hafiz Ismail had warned him that "if there weren't some agreement, then there would be war," Kissinger didn't take it seriously. "A war? Egypt? I regarded it as empty talk," Henry wrote later.

THE MIDDLE EAST could not compete with Asia, Russia, or Europe for the administration's attention at the start of Nixon's second term. On February 7, Kissinger began a twelve-day trip to Asia aimed at holding things together in Southeast Asia and assuring Peking that the upcoming Summit in Washington with Brezhnev was in no way aimed at China.

Developments in America and Vietnam, Laos, and Cambodia in the two weeks immediately before and after the peace agreement was signed in Paris made Kissinger's journey essential. Gallup polls demonstrated that despite Nixon's promises to Thieu of continuing support in response to additional fighting, a large majority of Americans opposed renewed U.S. involvement. Although 70 percent of a survey expected North Vietnam to continue trying to conquer the South, only 38 percent favored giving Saigon additional war supplies. Seventy-one percent declared themselves against renewed bombing of the North and 79 percent rejected suggestions of reintroducing U.S. ground forces to help save the South from a takeover. On February 2, Hubert Humphrey said he was ready to cosponsor a bill "preventing US going back into VN as people are 'fed up' w/VN."

The polling data provided a chilling backdrop to events in Southeast Asia. The Paris accord, Navy Chief, Admiral Elmo Zumwalt said, was "a sham peace held together with a plan to deceive the American public with the rhetoric of American honor." To neither the North nor the South Vietnamese, William Bundy asserted, "did the ineffectuality of the Paris agreement come as a surprise—both assumed that the war would go on and that the agreement would be used mainly to pillory the other side while doing all one could for oneself."

The peace accord brought no discernable decrease in the violence. In the last days of January, the Viet Cong launched an unsuccessful offensive to seize the provincial city of Tay Ninh in hopes of making it their capital. The U.S. consul in Saigon saw no end to the conflict in 1973.

Nixon and Kissinger worried that a continuation of the fighting would open them to ridicule as having reached a settlement that ended American involvement in the conflict and brought home the POWs, but cynically left Vietnam, Laos, and Cambodia with neither peace nor security against Communist control. "Peace with honor" could become a term of scorn critics could use against the president.

On February 5, Kissinger told Nixon that Laos remained at war. On February 6, Joint Chiefs Admiral Thomas Moorer advised Henry that Hanoi was "pressing hard to push supplies down toward the DMZ." Henry asked, "Could those sons of bitches be planning an offensive?" Moorer didn't think they had immediate plans for a large-scale attack. In the meantime, they were "trying to replace losses, trying to protect their

forces [against South Vietnamese violations of the cease-fire], and then in the final analysis they of course would like to have that option a year or so from now."

Cambodia and Laos especially concerned Nixon and Kissinger. The Cambodians, Henry told Bill Rogers, "are basically a bloody-minded bunch of sons of bitches." He had some hope that they could persuade the North Vietnamese to stop the fighting in Cambodia, but Hanoi could not convince the Khmer Rouge to halt their campaign against Lon Nol. In response, Nixon ordered renewed, unannounced bombing of Cambodia. Should questions be asked, the White House was to describe it as "simply a minor bit of unfinished business that would soon result in a cease-fire."

Similarly, Nixon instructed Moorer to use B-52 bombers against North Vietnamese troops, who were continuing to fight in Laos. It produced quick results: "The bombing we did in Laos has stopped them," Moorer told Kissinger on February 20. "We have been really pouring it on," as the president had asked. The attacks produced media and congressional protests, but a cease-fire on February 22 spared the administration from further domestic complaints. The bombing, however, was not enough to force Hanoi to remove its troops from Laos, where they remained despite objections from the United States.

Kissinger set out on his trip believing that "the proper mixture of rewards and punishments" could persuade Hanoi "to maintain the unequal equilibrium in Indochina." An initial stop for a day in Bangkok, Thailand, brought Kissinger in contact with the uncertainties that the peace agreement raised throughout Southeast Asia. Would the United States respond to North Vietnamese violations of the cease-fire? Thai officials asked. Kissinger assured them that "we would not stand idly by" if Hanoi committed "massive violations of the agreement."

On the morning of February 9, Kissinger traveled to Vientiane, Laos, for a day before heading to Hanoi for three days of discussions. Saigon and Phnom Penh were omitted from the schedule: Saigon because "Thieu's venomous hatred" of Kissinger made such a visit "unproductive"; and Cambodia because it would have encouraged discussion that Henry was persona non grata in Saigon—the only Indochinese capital he would have skipped.

In Laos, the Paris accords were viewed with "hope overshadowed by

foreboding." Souvanna Phouma, the head of Laos's neutralist govern-ment, urged Kissinger to help stop the fighting and preserve his country from a North Vietnamese takeover. And though the B-52 attacks would force Hanoi to honor the provisions of the peace agreement mandating a halt to hostilities in Laos, the future of the country rested on the ultimate outcome of the conflict between Hanoi and Saigon.

Kissinger's three days in Hanoi were "the equivalent of stepping onto the moon." (The metaphor made perhaps unconsciously apt by the cra-tered landscape Kissinger saw surrounding the city.) The visit was aimed at both American and North Vietnamese audiences: it was to demon-strate to America's antiwar opponents that the White House had every intention of achieving reconciliation with the North Vietnamese, while also hoping to convince Hanoi that it could gain more by honoring the peace treaty than by breaking it.

"The atmosphere in Hanoi was a mix of isolation, oppressiveness, paranoia and ambivalence," Kissinger reported. "There was a feeling of being *cut off from the world*, reflected in . . . the astonished stares of the citizens which were neither friendly nor sullen but those of curi-ous zoo watchers; and the substantive conversations which underlined that Hanoi's leaders have dealt little with the outside world and trav-eled less."

The first meeting with Prime Minister Pham Van Dong was less than reassuring. While Dong promised to implement the Paris agreement, he gave Kissinger the impression that Hanoi had not yet decided on whether to use the settlement "to bring about a period of relaxation or as an in-strument of political warfare to achieve their objectives in a more subtle way." Henry cautioned against the latter and thought that the Christmas bombings gave his warning considerable resonance. He also emphasized that U.S. help with reconstruction required a quid pro quo.

The conversations did not leave Kissinger very optimistic. Except for Le Duc Tho, with whom he had a reasonably cordial connection, Dong and his cohorts were "a hardened group of revolutionaries." They were "morbidly suspicious" and prone to a conspiratorial outlook. (Much like Nixon and his aides, Henry might have concluded.) Henry believed that dealings with them would, at best, be "very difficult."

The final joint communiqué issued in Hanoi and Washington gave little hint of ongoing problems. But realities on the ground were more

clearly reflected in an NSC decision to have the CIA and defense department submit a weekly report on cease-fire violations.

A Kissinger cable to Tho following the conversations in Hanoi bluntly confronted the ongoing difficulties: The Paris agreement "must be considered an instrument for conciliation, rather than an opportunity for political warfare." But Hanoi seemed intent only on the infiltration of war matériel and building toward a military advantage. Hanoi's objective in encouraging impressions of a durable peace through Henry's visit and the communiqué was to hold the Americans at bay while it moved doggedly toward conquest of the South and dominance in Indochina.

Nixon also did not object to creating false impressions. With the continuing difficulties in Indochina and a Senate investigation and newspaper reports about Watergate launching his second term on wrong notes, he was as attentive as ever to creating positive images that could ensure public support for foreign policy initiatives that he hoped would be the landmarks of his second four years.

White House efforts at image management did not escape the understanding of the press. James Reston, for example, described the administration as "more skillful in dominating the news" than any other he'd ever seen. It called news conferences when things were going well and avoided them when there was trouble. "They know all tricks in advertising and PR book and quite a few, like bugging Watergate, that are not in the books." Yet Reston counseled media restraint: "RN is president but he's not government and he is not going to live in the White House forever." With a Senate committee chaired by Sam Ervin of North Carolina preparing Watergate hearings, Reston's analysis in February 1973 was prophetic.

A UPI reporter also penetrated the veneer of Nixon's PR efforts. He wrote that Nixon "resents his critics for being stingy in their praise" of the Paris peace. He was "angered" at their failure to give him his due. "Worst of all, the 'silent majority' remained silent," and so *the White House considered a PR blitz aimed at drumming up the sort of excitement that followed V-J day."* Because the story embarrassed Nixon, he directed Ziegler to "prepare a report on who was responsible for this kind of statement."

Nixon's image-making wasn't simply in the service of promoting his political standing. He also considered it essential as an antidote to the de-

moralization over Vietnam. "If we can get people in this country proud of their world role and the record in Vietnam," he told state department officials, "then there is much to be accomplished. But if you tell them that it was all in vain, we will never get them to try again." He believed the country desperately needed a renewed sense of pride in its world leadership.

In January 1973, the "Year of Europe" became a major part of Nixon's second-term PR campaign. "We have been to the People's Republic of China. We have been to the Soviet Union. We have been paying attention to the problems of Europe," Nixon told a news conference on January 31, "but now those problems will be put on the front burner."

Although he and Kissinger had agreed to have consultations with European leaders "at the highest level" and to work toward "a new declaration on the model of the wartime 'Atlantic Charter,' " it was no more than a public relations ploy. On February 15, when Nixon met with NATO chief General Andrew Goodpaster, he complained that "except for the British, Greeks, and Turks, our allies had been very critical of us during the recent bombing, pandering to their leftist constituencies. The President said that the U.S. always turned the other cheek, but in this case, what had been a United States alliance of interest and friendship was now just an alliance of interest." Nixon added that he would not forget how British Prime Minister Heath had stood by him. Except for Heath and possibly Pompidou, there would be "no more toasts, no more state visits." Whatever the Year of Europe might bring, it would be notable for how "the warmth has gone from the relationship."

During his visit to China from February 15 to 18, Kissinger emphasized to Mao and Chou that the United States did not take its European allies too seriously as a factor in international affairs. "Europe had very weak leadership right now," Henry said. "They cannot do anything anyway. They are basically irrelevant." Even if Kissinger exaggerated the extent to which Europe was fading from the center of America's security needs, the comments were more than rhetorical flourishes intended to puff up the Chinese.

In March, Nixon told Kissinger that he did not see Europe's economic or political unity as in America's interest. The Europeans were becoming more rivals than collaborators. Nixon wanted to build a new coalition made up of the United States, Japan, and underdeveloped

countries. None of this, Nixon said, was for public consumption. To give substance to his idea for reorienting U.S. foreign policy, he asked Haldeman to discuss with Henry a possible trip to Latin America and Africa.

KISSINGER'S CHINA VISIT was the highlight of his trip. Twenty hours of talks with Chou and almost two with Mao were more comfortable than ever. His meeting with Mao "was splashed across the top half of the *People's Daily* and a film on our trip ran for twelve minutes on national television." Henry saw the developing friendship with China as second only to that with Britain. Mao and Chou were amazing world statesmen. And though "our ideologies and views of history clash, objective factors induce tacit cooperation for at least several years."

The basis for the transformation in relations rested on mutual fears of Soviet aggression. "The Soviet threat is real and growing," Mao warned. "The present 'goal of the Soviet Union is to occupy both Europe and Asia' . . . We can work together to commonly deal with a bastard," Mao said to mutual laughter. The United States "would never participate in a policy to isolate you," Kissinger assured him. Moreover, Washington opposed a Soviet attack on China, "because the danger to us of a war in China is as great as a war in Europe."

To facilitate the improved relations, they agreed to establish liaison offices in both capitals and to maintain back-channel contacts between UN Ambassador Huang Hua and the White House. Kissinger promised to expand trade with the PRC, but not strictly for commercial purposes. It would serve mutual political needs.

Kissinger's enthusiasm for the China connection did not escape the press. Nixon wanted the original of a newspaper cartoon depicting Henry bounding into the Oval Office in a Mao jacket and cap, arms flung wide gripping the little red book of Mao's pronouncements, and Nixon, seated with arms outstretched and palms up, saying, "Don't tell me how it went with Mao . . . Let me guess."

HOWEVER MUCH THE WHITE HOUSE wanted to shift its focus away from problems in Indochina, difficulties with the North and South Vietnamese, Laotians, and Cambodians kept its attention riveted on Southeast Asia. At the beginning of March, Le Duc Tho complained to Kissinger about Saigon's "blatant violations" of the Paris accords, and attacked the

United States for encouraging these violations. Kissinger fired back that Hanoi was sending massive amounts of military equipment, supplied by the Soviets, and men into South Vietnam. He warned Dobrynin that the Soviet help could not be considered a friendly act.

South Vietnam's actions also troubled Henry. In a meeting with Ambassador Tram Kim Phuong to discuss a Thieu visit to the United States in early April, Kissinger urged Saigon to rein in its use of force against the remaining North Vietnamese troops in the South. The ambassador described Saigon's actions as defensive and asked that the president publicly reaffirm his intention to use massive retaliation against Hanoi for treaty violations. Kissinger asserted that the tough warnings they were giving North Vietnam in private were better than public pronouncements that could create a sense of crisis. Henry didn't say that any public warnings to Hanoi would be seen as a confession that the peace agreement was falling apart.

When the ambassador pressed the point, Kissinger replied that it wouldn't do any good to reopen the public debate about Vietnam. "What we were trying to achieve," Henry candidly declared, "was a situation where our people didn't give a damn any more about Vietnam. It would then allow the United States to be more effective in helping Vietnam preserve its independence."

Yet however much the White House wanted to play an ongoing role in Indochina, opinion polls demonstrated that Americans were not interested in combating treaty violations. Nixon also met resistance from senators to reconstruction aid for North and South Vietnam. "His only other tool [for curbing Hanoi] would be to bomb them, and of course, we cannot do that," he told them. John McClellan, the chairman of the Armed Services Committee, asked, "Can you buy peace, Mr. President?" Nixon thought so, but McClellan was skeptical: "You have given them enough," he said. "You stopped bombing them." At a cabinet meeting on the following day, Rogers warned that if they didn't work out aid arrangements with North and South Vietnam, "the whole thing will be a failure."

Kissinger reported to Nixon on March 9 that aside from considerations of aid, the agreement was in serious jeopardy. Despite warnings, Hanoi continued to infiltrate men and matériel and was holding open the option of resuming the war. When someone told Kissinger, "Do you

realize this is the first time a German ever ended a war?" he replied: "Maybe that's why it's still not over."

By the middle of March, with no indication that Hanoi would cease violating the treaty, Kissinger proposed a two- to three-day air strike against the Ho Chi Minh trail. When Nixon resisted, Kissinger warned that "We can't permit a total flouting of the agreement within weeks. We will have lost all we have won in the last four years." Elliot Richardson, the new defense secretary, thought that bombing the trail for forty-eight hours would do little good. Nixon wanted to rely on aid to Hanoi to rein them in. But he wasn't sure Congress would provide the funds.

The press began raising questions about the viability of the settlement. A Knight-Ridder reporter described the Paris accords as nothing more than a " 'hard-eyed swap' of POWs for U.S. withdrawal. That's 'another way of saying it looks more and more' like RN adopted [the] strategy of critics which he 'long officially rejected. There is plenty of window dressing in the deal to make it look like more' than a simple swap, but U.S. officials seem concerned only with POWs. But when other things in the accord have gone wrong, such as North Vietnam violations, the U.S. has carefully 'looked the other way.' "

Despite growing doubts about the viability of the cease-fire, the public didn't seem to care. Regardless of the outcome for the Vietnamese, Americans were content to end the country's participation in the fighting. Seventy-seven percent in a Harris poll published on March 5 gave the president high marks for "working for peace in the world." Seventy-two percent approved of his "bringing the war in Vietnam to a close," and 62 percent were happy with the terms of the settlement.

The White House was relieved at the public's limited interest in the continuing violence in Indochina. If the public paid attention to the massive influx of men and supplies from North to South, which gave Hanoi increasing capability for offensive military operations, it would have refuted Nixon's assertions about "peace with honor." So would events in Cambodia, where the Communists were trying to surround Phnom Penh and topple the Lon Nol government.

To maintain the fiction that all was well with the cease-fire and to boost Saigon's confidence in White House promises to defend South Vietnam, Nixon met with Thieu in San Clemente on April 2 and April 3. Although Thieu accepted the California venue for the meeting, he wanted

to meet in Washington, where he could also speak to congressmen and -women and the D.C. press corps. Despite concerns that he would face a hostile reception in the Capitol from critics of his undemocratic regime and officials fearful that he would try to draw the United States back into the war, Nixon agreed to let him go East.

In the private talks in California, there was little to discuss. Thieu focused on Hanoi's treaty violations and their long-term intention to control the South. He voiced optimism about his army's effectiveness, but acknowledged that if the pace of the current infiltration continued, they would be in trouble. Nixon promised to react strongly to any big Communist offensive, but refused to give public voice to his commitment. Because he was eager to sustain the idea that peace with honor was working, the final communiqué of the talks said nothing about treaty violations. It promised only "vigilance" against "the possibility of renewed Communist aggression."

During a private moment between John Negroponte, a diplomat involved in the peace negotiations, and Hoang Duc Nha, Thieu's press secretary, Negroponte apologized for imposing a losing agreement on Saigon: "We really screwed you guys," he said. Negroponte later told the journalist Neil Sheehan that the terms Kissinger agreed to in Paris "helped to ensure that we did lose the war."

Thieu's visit to Washington spoke volumes about American indifference to continuing involvement with Vietnam. Few congressmen and no administration notables attended a White House state dinner hosted by Spiro Agnew. It was as if he were a toxic agent, and Nixon made no effort to decontaminate him. Thieu used a press conference to assure Americans that he had no need for U.S. troops and expected his own forces to handle any future Communist threats.

Despite Thieu's assertions about his army's ability to ensure South Vietnam's security, difficulties across Indochina continued to worry the White House. The fate of South Vietnam, Laos, and Cambodia remained as uncertain as ever. On April 6, the White House sent Haig and an NSC team to evaluate and discuss political and military conditions in Vientiane, Phnom Penh, and Saigon. Haig was instructed to "put starch into the people with whom you meet." Kissinger warned him, however, against becoming "too explicit in your discussions of what we might do under different circumstances . . . We may, in fact, be unable to deliver."

Haig's findings were not encouraging. When he reported to Nixon, the president asked, "Will there ever be a real ceasefire or will some level of fighting continue? What can we do to stop the shooting which still goes on?" Haig had no satisfactory answers. His report largely reiterated what Nixon and Kissinger already knew: "The systematic undermining by Hanoi of the basic provisions of the agreement in South Vietnam, Laos, and Cambodia are converging to threaten the fundamental framework of the accords. The evidence is irrefutable."

By the middle of April, the White House and the North Vietnamese were locked in a fruitless debate. Hanoi and the Viet Cong denounced South Vietnamese violations of the accords, while Nixon and Kissinger declared Communist actions intolerable. Kissinger told Dobrynin that if "these violations continue, I would guarantee some decisive American counteraction and we would be back to the situation of last year." The only ray of hope was a Hanoi commitment to a Kissinger-Tho meeting in Paris in mid-May to discuss saving the peace.

Kissinger's threat of "decisive" action was no more than rhetoric. He and Nixon told Bunker in Saigon that they wanted to resume bombing in South Vietnam and Laos. But Bunker advised against renewed air strikes in the South. He feared it would destroy hopes that the cease-fire would hold or could be rescued.

Watergate was more of a problem. On March 30, the media had revealed that James McCord, one of the Watergate burglars, had informed Judge John Sirica, as he was about to sentence the burglars, that senior White House officials and members of CREEP had advance knowledge of the break-in. Two weeks later, it was clear that the highest administration officials—Mitchell, Haldeman, Ehrlichman, Dean, Colson, and others—were vulnerable to prosecution and that Agnew was under investigation by a grand jury for bribery during his tenure as Maryland's governor.

"I've tended to become too depressed, and actually obsessed would be a better word, with the problems of the moment," Nixon confided to a diary. "But compared with the massive problem we had with regard to the war and what we have gone through over the past four years," he reassured himself, "these problems do not appear all that difficult."

Renewed bombing in South Vietnam or against North Vietnamese troops and supplies coming down the Ho Chi Minh trail became po-

litically more difficult, if not impossible. It would be seen as an attempt to divert attention from Watergate and even a possible move to resume U.S. involvement in the fighting. "Mr. President, if we didn't have this goddamn domestic situation," Kissinger told Nixon on April 21, "a week of bombing would put them . . . this Agreement in force." Nixon responded, "Yeah, well, we'll still do it." But it was empty talk. They joked that Watergate had the advantage of putting news about limited bombing in Laos and domestic inflation on the back pages of the newspapers.

But it wasn't Watergate that inhibited renewed military action in Vietnam. The country wasn't interested in hearing about how U.S. inaction would destroy peace with honor—70 percent of Americans believed that North Vietnam would try to take over South Vietnam in the next few years, while 54 percent assumed that Saigon would not be able to resist effectively. Foreign leaders echoed American sentiment—86 percent of seventy foreign government officials said that the United States had diminished its prestige by its involvement in Vietnam; two-thirds called intervention a mistake and predicted that Hanoi would eventually gain control in the South. In March, when Americans were asked what is the most important problem facing the country, 59 percent said the high cost of living; only 7 percent cited the situation in Southeast Asia.

"By the end of April 1973," Kissinger wrote later, "our strategy for Vietnam was in tatters." He blamed it on Watergate, but it was a convenient excuse for a failing Vietnam policy. The scandal that engulfed the administration and eroded Nixon's credibility made it difficult for him to react forcefully to Hanoi's defiance. But even without Watergate, there was precious little support in the Congress and the country for more bombing in Southeast Asia. Nixon took note of a March 26 news summary describing a *Parade* poll showing 54 percent of Americans opposed to a return of U.S. troops to South Vietnam even if it were threatened with a Communist takeover. He underlined *Parade*'s conclusion that "Americans are tired of war, weary of foreign adventures, reluctant to serve as [the] world's conscience." In early April, the Senate voted a ban on economic help to Hanoi without congressional approval. On May 10, the House prohibited appropriations for military action in Cambodia, and on May 31, the Senate cut off funds for operations in Cambodia and Laos.

The problem for Nixon and Kissinger was the same one that had

driven them to end the war in January: Congress and the public wanted a decisive conclusion to U.S. involvement in the fighting. Moreover, only a limited minority of the country shared Nixon's and Kissinger's fears that allowing peace with honor to dissolve would have any significant impact on America's long-term international influence and power. A collapse of the peace agreement would be a reversal for the president and Kissinger, who had invested so much of their standing in it, but not for a majority of the nation, which was simply eager to end what it saw as a bad chapter in the country's history.

During the last days of April, with new revelations about White House involvement in a Watergate cover-up surfacing, Kissinger worried that the scandal was crippling the presidency. He told White House counsel Leonard Garment on April 21, "if this goes much further, we won't have a foreign policy left . . . This is without a doubt the most depressing period that I know in our history." Henry told Garment the following day, "There may not be the possibility of keeping the President out of it," meaning Watergate.

On the evening of April 29, after Nixon had decided to announce the resignations of Haldeman and Ehrlichman and Dean's firing, he called Henry. He was "nearly incoherent with grief." He said, "he needed me more than ever," Kissinger recalls. "The nation must be held together through this crisis . . . I hope you will help me protect the national security . . . now that Ehrlichman is leaving." After watching Nixon's speech to the nation on April 30, Kissinger concluded that "no one watching Nixon's genuine desperation and anguish could avoid the impression that he was no longer in control of events."

Kissinger later claimed that he "had no idea what he [Nixon] was talking about" when the president asked for his help in protecting national security. Although he never said so directly, he wanted Henry's aid in using foreign policy to deflect attention from Watergate. Nixon's immediate hope was that they could divert media focus from the scandal by following through on the Year of Europe. In the almost three months since he had promised to make Europe a centerpiece of 1973 foreign policy, Nixon had demonstrated little interest in advancing the idea. The need to find a quick foreign policy fix as a response to the deepening Watergate crisis, however, brought the Year of Europe back into focus at the end of April. Nixon's private disdain for a dramatic improvement in

relations gave way to a decision to speak about the issue on April 23 at New York's Waldorf-Astoria to a group of senior media executives.

Possibly too upset by Watergate to appear before a live audience or convinced that Henry would better command the attention and approval of such a group, Nixon asked Kissinger to replace him. Henry was surprised by the invitation to give a major foreign policy address. Mindful of how little real hope they placed in a new era of European relations, Kissinger sensed that Nixon was using him for his political purposes. As he later said in his memoirs, the president's "strange mixture of calculation, deviousness, idealism, tenderness, courage, and daring evoked a feeling of protectiveness among those closest to him—all of whom he more or less manipulated."

Although Nixon continued to see Henry as a competitor for public prominence and had tried to deflate him by asking Haldeman to "build Haig as the unsung hero" in the Vietnam negotiations, Nixon understood that Kissinger was the administration's greatest asset and his best hope for changing the public discussion from Watergate to foreign policy. As Haig told Henry, Nixon "went on and on" about "how much he counted on you." Ever mindful of the president's envy of his growing fame, however, Henry bristled when a Norwegian journalist on April 7 told him, "I'd like to find out a bit more about you, as the most discussed person in the world." Henry responded, "For the sake of my internal position, don't say that."

Because Henry understood that the president wanted the speech to represent a major departure and because making a groundbreaking proposal flattered his vanity, Kissinger boldly called for a "new Atlantic Alliance." As Kissinger biographers Marvin and Bernard Kalb wrote, it was calculated "to evoke wartime memories of unity at home and abroad." Kissinger predicted that the president would travel to Europe before the end of the year, where he would work to create "a new relationship" among the Atlantic nations. To Kissinger's and Nixon's satisfaction, James Reston immediately compared Henry's speech to Secretary of State George C. Marshall's landmark Marshall Plan of 1947.

Still, the response to the speech was less than what Nixon or Kissinger had hoped. During the question period following Henry's address, the audience showed itself more interested in his take on Watergate than on any initiatives toward Europe. In response, Kissinger tried to defend

Nixon and urged the media to consider the scandal's impact on foreign affairs: "I have no question that the president will insist, as he has said publicly, on a full disclosure of the facts." As for those accused of crimes, Henry urged against prejudgments and the need "to remember that faith in the country must be maintained." Except for the *New York Times*, newspapers featured Henry's remarks about Watergate rather than the Year of Europe and criticized him for trying to diminish the importance of the scandal.

Although, as he later acknowledged, it was impossible to believe that Nixon's principal aides had acted without his tacit approval, Kissinger had no qualms about trying to protect him. True, he saw a weakened president as undermining the administration's foreign policy, but he also saw Nixon's potential demise as ending his direction of foreign affairs and prospects for becoming secretary of state. A combination of fidelity to national security and personal ambition made Henry loath to take anything but the most relaxed view of Watergate.

The negative response from the press to his speech frustrated and angered Kissinger. "Well, on the *Washington Post*," he told Joe Alsop, "the impression is that the major speech was on Watergate with the secondary theme on Vietnam and a paragraph or two on Europe thrown in." Alsop, who shared Henry's concerns about neglect of foreign dangers, replied, "We are now like a house with the roof on fire and the cellar flooding and the housewife constantly talks about the immorality of the chambermaid." Henry called Philip Geyelin at the *Washington Post* to complain about the paper's coverage, but he received no satisfaction. "With all due respect to you," Geyelin said, "I don't think it's General Marshall at Harvard."

With talk of presidential involvement deepening the Watergate crisis and concern that additional gains in Soviet-American and Sino-American relations might be difficult to achieve, Nixon and Kissinger saw Europe as vital to the president's standing. Yet Kissinger worried that the Europeans "think we are aiming at a perpetuation of U.S. hegemony," and that discussions with allies would not resonate with the press and the public the way their initiatives with Peking and Moscow had. "It is easy to get dramatic PR from talking with opponents, but talks with allies are technical and complex," he said.

A meeting between Nixon and French President Pompidou in Iceland at the end of May further discouraged hopes of exciting interest in

European relations. Pompidou saw no reason to hold a European Summit. "I see no need for an unusual procedure," he said, "by which I mean not going outside embassy channels."

Kissinger saw the domestic antagonism to Nixon over Watergate as a "bloodlust" that was not only bringing the president down but also limiting their freedom of action in foreign affairs: The administration was losing its ability to make credible commitments or confront adversaries. It was being "deprived of both the carrot and the stick."

Ironically, in the spring of 1973, as the administration's weakening position at home undermined its influence abroad, it turned increasingly to international relations to rescue it from a domestic political collapse. Kissinger's assessment of what they might face in trying to make 1973 the Year of Europe convinced Nixon that Soviet-American relations would be more important in helping him save his presidency. He thought the planned Summit in Washington with Brezhnev in June might produce results that could encourage convictions that Nixon was indispensable to world peace and needed to command the country's support through a second term.

The Soviet Summit had been in the planning since Nixon left Moscow in the spring of 1972. Preparations speeded up in the early months of 1973 following the Paris peace accords. In an exchange of letters, Nixon and Brezhnev hoped that arms control talks and Middle East difficulties as well as trade and economic relations could be productively addressed during a June meeting.

Nixon and Kissinger saw further improvements in relations with Moscow as a contribution to détente and international stability. On March 18, Nixon told his cabinet that the upcoming Summit represented "a watershed in world history. Either we move forward on a constructive basis as we began last year, or we stop. If it is the latter, the world will be a dangerous place . . . A lot is riding on the visit." Not the least of which, Nixon believed, was an effective counter to Watergate.

Democratic Senate Majority Leader Mike Mansfield was convinced that Nixon's Soviet policy was wise and necessary for world peace. In April, with Democratic Senator Henry Jackson and Republican congressman Charles Vanik threatening to tie the president's hands in Soviet-American trade negotiations unless Moscow further relaxed restrictions on Jewish emigration, Mansfield described their behavior as "outrageous." He said,

"It was an outrageous way to treat the President . . . a man who is trying to do all of these things with [Moscow] for peace. Jackson wants SALT II and MBFR [mutual balanced force reductions] to fail. Tell the President I'm behind what he's trying to do," Mansfield told a go-between. "If Jackson and others succeed in their efforts, they are going to head this country toward a major wave of anti-Semitism." Nixon predicted that "A storm will hit American Jews if they are intransigent."

Nixon hoped a Soviet Summit could be a forceful argument against undermining his authority. In March, when he met with senators, some of whom were about to investigate White House ties to Watergate, he pointedly urged them "not to weaken our bargaining position . . . He told them that the Soviet Union wanted to do business with us in the worst way and Brezhnev wanted to succeed in his Summit meeting when he came to Washington. 'We are going to make him pay a hell of a price for that success.' "

At the beginning of May, Nixon had a sense of urgency about convincing the Congress and the public that he was indispensable for better relations with Moscow and world peace. In his Fourth Annual Foreign Policy Report to Congress, he said that the success of the Moscow Summit had opened the way to "a new era in international relations . . . but we have only witnessed its initial phase." The United States and the U.S.S.R. could "move from coexistence to broad cooperation and make an unparalleled contribution to world peace," but the implicit message was, only if Nixon and Kissinger could be left unimpeded by political opponents all too ready to bring them down.

Billy Graham and Lou Harris encouraged Nixon's assumption that foreign policy could rescue his presidency. On May 2, Graham urged Nixon to take note of a news report that "people are starting to realize that this whole Watergate situation is overblown and unfair. The American people," Graham advised, "need to be diverted from Watergate."

Harris relayed polling data to the president showing that his approval ratings in handling foreign affairs had increased from April to May. On five counts—bringing home the POWs, working for peace, Soviet relations, ending the Vietnam War, and dealings with China—public assessments of Nixon's performance were stronger than ever. By contrast, the president's handling of the domestic economy, which was struggling with mounting inflation, received much lower ratings. A con-

tinuing steady course in foreign affairs was Nixon's best prescription for effective leadership.

And in the spring, success in foreign affairs was equated with a notable Summit. On May 1, Nixon sent Brezhnev a glowing assessment of prospects for their talks. He was sending Kissinger to Moscow for preliminary discussions. On trade, arms control, nuclear war, European security, the Middle East, and problems implementing the Paris accords, Nixon predicted concrete results as well as symbolic gains.

Scotty Reston told Kissinger, as he was about to leave for Moscow, "I got the impression that . . . President Nixon put on a big television show and had many things to announce at the end of his meeting in the Kremlin, and they [he and Brezhnev] are hoping the same thing will be true here." Henry replied, "That is correct."

Kissinger's trip to the Soviet Union from May 4 to May 9 was an exercise in mutual cordiality. He met with Brezhnev for twenty-five hours during four days at Brezhnev's country home some fifty miles north of Moscow, where they took time out for boating and hunting. Kissinger interpreted the hospitality as Brezhnev's wish to make the coming Summit "the crowning achievement of his political career." It was also a way for Brezhnev to combat domestic political opponents critical of his economic and foreign policies.

At the conclusion of the talks, Ziegler released an announcement describing the discussions as comprehensive and constructive. When Henry returned from Moscow, he told John Oakes of the *New York Times* that "there was no tough bargaining. You know when you deal with the Russians there always is murderous bargaining, but there was nothing that was in anyway unusual."

The rosy picture of Brezhnev's warmth and the meetings' potential results hid a number of problems that made groundbreaking agreements unlikely. "On at least two occasions," Henry reported to Nixon, Brezhnev "was apparently infuriated by our position on the Middle East and the nuclear agreement [for the prevention of a war], but preferred to postpone our meetings until he had calmed himself, rather than launching into a tirade directly at me as he had done last year."

Brezhnev was most interested in mutual commitments on avoiding a nuclear conflict. But it required "bitter disputes" to reach terms of agreement. And Soviet reluctance to move beyond the general prin-

ciples of a SALT II agreement to concrete limitations placed a nuclear war prevention agreement in jeopardy. "B. must be made aware of major disappointment in Summit if we come up only with general [SALT] principles," Nixon cabled Kissinger. Henry replied that he had stressed the point to Brezhnev, but the general secretary showed no inclination to accommodate the United States position. Henry thought that the Soviets might "want to be much more advanced in their MIRV technology before negotiating."

On the Middle East as well, Kissinger and Brezhnev found themselves at odds. The Soviets were worried that a new war in the region would erupt shortly before or during Brezhnev's visit. They wanted to impose a settlement on Israel and the Arabs—Israeli withdrawal from occupied territories in return for recognition of its existence. But the Soviet position was little different from the one voiced by their Arab allies, and after much discussion, the Soviets backed away from it, leaving Middle East negotiations in limbo.

Vietnam and China were other contentious matters without simple solutions. Kissinger made clear that the collapse of the Paris peace arrangements could undermine Summit plans and U.S.-Soviet relations generally. "Be sure Brezhnev knows that any major hostile action by North Vietnam between now and time of his visit would have disastrous effect here," Nixon warned. "Relationship of Vietnam situation to Brezhnev trip to the United States can hardly be lost on Soviets," Henry replied.

China posed an equal danger to Soviet-American progress. Brezhnev arranged what Henry called "a very private meeting" to bring up China. Following a boar hunt, which repelled Kissinger, who refused to be more than an observer, Brezhnev excoriated the Chinese during a picnic lunch. He "went quite far in denouncing the Chinese and warning of their perfidy," Kissinger reported. Brezhnev struck some ominous chords, warning of a confrontation or even an attack on China. He saw China as "the only threat to the U.S.S.R." and suggested joint action against Chinese nuclear facilities, or at least U.S. passivity if the Soviets acted. Kissinger thought that Sino-Soviet tensions could provoke a major crisis in the next twelve to eighteen months.

Despite all these differences, Kissinger left Russia hopeful that the June meetings would be productive. The May discussions, however, gave

little reason to think that the Summit would give Nixon a chance to affirm the advent of a new era in Soviet-American relations. But even if it didn't, the May meetings and upcoming Summit served another purpose, allowing Nixon to focus on something other than Watergate. "Make sure he [the president] gets some reports daily on key foreign policy matters to get his mind turning again on this subject," Kissinger cabled Brent Scowcroft, his new deputy at the NSC. Scowcroft had replaced Haig, who had become Haldeman's replacement as the president's chief of staff.

Brezhnev remained eager for the June Summit as well. He wrote Nixon on May 13 that he expected them to sign a prevention of nuclear war agreement, which would be "a great thing of real historical importance." He also put the best possible face on the SALT negotiations, and predicted that the adoption of a general agreement in June would be an impetus to those talks. He said nothing about their differences over China, but devoted most of his letter to Middle East dangers, which he described as explosive and calculated to discomfort both of them should another war erupt. He promised to make an all-out effort to solve Mideast problems.

Nixon's reply three days later was equally upbeat. He predicted significant new accomplishments, saying the meeting would be a "milestone" in Soviet-American relations. In addition to international benefits, better relations promised to help both men quiet domestic opposition. Nixon's growing need to combat Watergate problems encouraged wishful thinking about his ability to resolve differences with Moscow.

If foreign policy were going to rescue Nixon from corrosive Watergate revelations, the starting point remained Vietnam. A collapse of the Paris settlement promised to undermine Nixon's reputation for effective world leadership at home and weaken his ability to act constructively abroad. At the end of April, Kissinger and Eric Severeid agreed in a telephone conversation on the importance to the world of having a united America and of making the Paris peace agreement stick. "You've been abroad," Henry told him, "you know what America means to the world, and it's just painful to see it always tear itself apart." If the president is going to get anything done in Europe during a possible fall trip, Severeid said, "he has got to get this damn thing quieted down in Indochina."

Kissinger looked forward to meeting with Le Duc Tho again in Paris in mid-May. "What do you expect to do there?" Scotty Reston asked

him. "Get back to what you thought your understanding was?" Henry cautioned, "Well, we won't get to it in every detail, because the SVN aren't keeping everything either. But get back to enough of a modus vivendi to permit some peaceful evolution to continue."

As Kissinger was preparing to leave for Paris, he found himself at the center of an administration scandal that threatened to undermine his credibility with the press and the public. In March, *Time* had published a story about administration wiretaps. White House denials had largely muted the allegations. But in May, when acting FBI director William Ruckelshaus informed a federal judge that a tap at the NSC had recorded a conversation between Morton Halperin and Daniel Ellsberg, the judge dismissed charges against Ellsberg for having leaked the Pentagon Papers.

Journalists began asking about Kissinger's role in the tapping. At a news conference on May 12 to discuss his Russian trip, the press queried him about the Halperin-Ellsberg wiretap. He put out a lot of double talk that obscured his part in the administration's tapping. "Do you know about the Halperin bugging?" Joe Kraft bluntly asked him in private after the press conference. Henry refused to go beyond what he had said earlier that day.

When officials at the FBI told *Washington Post* reporter Bob Woodward and Seymour Hersh of the *New York Times* that Kissinger had authorized several of the taps, they and other journalists began pressing him for an explanation. "My comment," he privately told Forrest Boyd of Mutual Broadcasting, "is that it was my duty as head of the National Security [Council] to discuss with the director of the FBI how to safeguard information. I didn't propose any particular investigation to him."

Peter Lisagor confronted Henry more directly: Acting FBI director Bill Ruckelshaus "said you had a meeting with Hoover . . . and asked, because of your fear of NSC leaks, the FBI to . . . take some action." Henry took temporary refuge in not having read the transcript of Ruckelshaus's comments. A column by Joe Kraft on May 15, which Henry characterized to Kraft as "the most skunky thing that I have seen anybody do," described Kissinger as part of "the decision to bug." Although he acknowledged that he had received summaries of the taps, Kissinger told Kraft that he "did not participate in the decision" to secretly monitor his NSC associates.

Henry told Scotty Reston that "the method was not chosen by me, that it was done in the context only of discovering the mishandling of sensitive information, and that my part of it . . . will be shown to have been to the benefit of innocent people." While Reston was willing to take Henry at his word, he urged him "to make clear where the original order came from." Reston hoped that the revelations did not "make it impossible for you to negotiate, but you have an awful weak hand now," Reston said. "I think the motives were honorable and had to be conducted in the interest of the country," Henry told Hersh. Nevertheless, Hersh headlined a story on May 17, "Kissinger Said to Have Asked for Taps." With Kissinger threatening to resign, Haig publicly defending him as "being smeared with the muck of Watergate, an affair with which he had no connection," and Nixon giving Henry cover by announcing, "I authorized this entire program," Kissinger was able to go off to Paris with his reputation largely intact.

As Kissinger was about to leave, Nixon called to wish him well. Henry had become an indispensable figure in the battle to use foreign affairs to salvage his administration, and Nixon tried to buck him up. "I want you to know in these days when you are worried about Kraft and the rest, have a few laughs. Everything's gonna come out." Henry replied, "We're gonna get these knocks." Nixon commiserated, "Sure haven't we always. Now don't be down . . . You've got a big important mission."

With a Gallup poll showing Kissinger as the most admired American— Billy Graham ranked second and Nixon third—and descriptions of Kissinger on his fiftieth birthday in May as "public celebrity number one" and a world statesman comparable to Britain's Lord Castlereagh and Germany's Bismarck, one can sense the perverse pleasure Nixon took in seeing his principal rival for political prominence in the United States squirm under the glare of unfavorable publicity.

Despite all the accolades, the administration's scandals were also tarnishing its principal star. The columnist Jack Anderson told Henry that John Mitchell informed Senate Watergate investigators that Kissinger was present at a White House morning strategy meeting on how to respond to the Watergate break-in. "He's a God damned liar," Henry exploded. He categorically denied ever having "attended a meeting at which Watergate was discussed."

Although Anderson agreed not to print the allegation, no one in

the White House could escape suspicion. In describing a celebrity party for Henry's fiftieth birthday at New York's Colony Club, for example, William Safire, who had left the administration to become a *New York Times* columnist, noted the absence of some prominent figures from the celebration: "These days, even Frank Sinatra thinks twice about being seen in the company of Administration officials." When asked to name the best gift given to Henry at the party, CBS's Walter Cronkite replied, "They gave him a pardon."

THE NEGOTIATIONS IN PARIS reopened past tensions with both Hanoi and Saigon. Thieu especially irritated Kissinger with unacceptable demands that Henry described as "insolent and patronizing." He warned Thieu that if he were not more flexible, the United States would proceed without Saigon and it would then be impossible to generate renewed support for South Vietnam in Congress and the country more generally.

At the opening meeting on May 17, Kissinger spoke bluntly to Le Duc Tho. Their agreement was "now in serious jeopardy." After describing various violations, Kissinger declared, "I could, if I so chose, go on for hours cataloging your countless violations of the Agreement, but that would serve little purpose." Instead, he wanted to work out ways "to implement the Agreement and bring real peace to Indochina." Tho was "affable and businesslike," and Henry was optimistic that they would "reach an agreement on all outstanding points," a cease-fire in South Vietnam and a precise date for a Laos withdrawal. Cambodia, where Hanoi had little control over the Khmer Rouge, however, remained a stumbling block.

By the next day Tho had "turned tough and insolent," and demanded "renegotiation of significant portions of the Agreement." Nevertheless, Henry hoped that threats of serious military consequences if they failed to reach agreement would pressure Tho into concessions.

As Kissinger would acknowledge later, the discussions with Tho were nothing more than a "charade." After six days of talks, they agreed to meet again on June 6 to sign a communiqué recommitting themselves to a cease-fire and withdrawal from Laos, but the agreement was a fiction. The White House had an intelligence report describing Hanoi's belief that Watergate was immobilizing the Nixon presidency and deterring it from the use of military force. In due course, the NLF and Hanoi would be able to overwhelm South Vietnam without interference

from the United States. Though Kissinger warned Tho that the failure to reach some kind of agreement on Cambodia by June 6 would jeopardize the communiqué, the North Vietnamese were unconcerned. They saw American warnings and threats as empty rhetoric.

Wishful thinking by Nixon and Kissinger overrode unpleasant realities. "Excellent job against great odds," Nixon wrote on Henry's final report. At a cabinet meeting on May 25, Nixon reported cease-fire violations in South Vietnam had been dropping. He instructed cabinet members to say: "The agreement was a good one. It has brought back the POWs and our troops. We didn't make peace just to get our troops out. We want the agreement to work in order to strengthen the chances of peace in the area." Henry cautioned against saying anything about Cambodia. "Laos we can get under control."

Haig urged cabinet members to stress that "The President is here to stay and we want to get on with the work before us." Len Garment, White House counsel, planned to release a statement that could counter speculation in the headlincs about White House involvement in a Watergate cover-up. He described it as essential to disentangle national security from Watergate.

Increasingly, the administration's survival with some sort of political influence seemed to depend on subordinating Watergate to foreign policy gains. With this in mind, describing the Paris peace accords as a success that needed little more than renewed tweaking in negotiations between Kissinger and Le Duc Tho was irresistible. But Nixon, who knew how vulnerable Watergate made him, was not sure. "Look, they've [the press have, expletive deleted] on everything we've done, the Shanghai Communiqué, the Russian Summit, everything else. We could do something that was perfect and they're going to [expletive deleted] on us, so let's not worry," Nixon unconvincingly told Kissinger on his return from Paris.

The return of the POWs also provided a compelling opportunity to push aside Watergate and celebrate the Nixon-Kissinger foreign policy achievements. In a "color report" on a dinner honoring the returnees, the White House milked the occasion for all it was worth. It was a "rain-drenched day and night," the report said. "There was water everywhere, but no Watergate this evening." The largest sit-down dinner in White House history was punctuated by standing ovations for the president and

Kissinger. When the actor John Wayne toasted the president by thanking him "not for any one thing, just for everything," it brought a roar of approval. The impact of the statement, considering the Watergate sludge the President has been enduring, was enormous . . . If ever there was a night to answer the question: "Is it worth it?" this was the night. And the President knew it.

IN THE SHADOW
OF WATERGATE

*After our short time on this great stage is completed . . .
do we leave the memory only of the battles we fought . . .
of the viciousness that we created, or do we leave . . . a
world in which millions of . . . young children . . . grow
up in peace.*

—RICHARD NIXON, JULY 31, 1973

*A politician is a statesman who places the nation at his
service.*

—GEORGES POMPIDOU, DECEMBER 30, 1973

By the beginning of June 1973, daily newspaper reports on the Watergate scandal were greatly distracting Nixon. On Sunday, June 3, a *Washington Post* headline, "Dean Alleges Nixon Knew of Cover-up Plan," left him feeling "discouraged, drained, and pressured." He asked Haig whether he thought he should resign. Haig's "answer was a robust no." Despite "reassurances from his aides that there was nothing to worry about, Nixon knew they were dead wrong." On June 4, he told Ziegler: "God, I'm worn out." However much he wished to free himself from the

daily strains of attacks in the press, he could not imagine letting go of the presidency or turning the office over to Spiro Agnew, for whom he had little regard.

The Watergate crisis also distressed Kissinger. "I'm extremely depressed," he told Rowland Evans on June 4. "I think there's a death wish in this country right now on every side . . . Looking at it from the national point of view, what possible purpose is served if the President is forced out of office." Evans cautioned that if Nixon was implicated in the cover-up, "the Democrats and the Republicans are going to feel impelled . . . to see that justice is done on grounds that if it isn't you don't have a country worth living in." More concerned with stability than ferreting out the truth about Nixon and Watergate, Henry refused to believe that Nixon would be seen as "totally vulnerable."

Kissinger was appalled at apparent leaks to the press from the FBI. "I think it is murderously dangerous, and I think the FBI must be brought under brutal control," he told Stewart Alsop. "This has the objective consequence of subverting the whole machinery of government." A Joseph Kraft column lauding J. Edgar Hoover as "the only man with integrity that emerged out of this whole affair" made Henry want to "puke."

Despite his distress, Nixon was determined to soldier on, as he had done all his life. He and Kissinger agreed that a resignation was out of the question. "There is no lack of confidence in you whatsoever," Henry told him on June 10. Speaking as an uncritical partisan in the sort of language that had marked Nixon's early career, Henry added, "The trouble is that some of these Democratic senators . . . These bastard traitors we have in this country . . . These bastards are now trying to deprive you of any success." Nixon responded, "It is traitorous . . . But we've survived before and we can do it again . . . I'm not considering resignation." Henry predicted that "a resignation would be a national catastrophe . . . You can go down in history as a man who brought about the greatest revolution in foreign policy ever."

Kissinger's hyperbole does him no credit. Whether he believed his own rhetoric or was simply trying to boost a demoralized president, calling Democratic senators justifiably investigating Nixon's ties to Watergate "traitors" and foreseeing "a national catastrophe" if Nixon resigned undermines Kissinger's reputation for objectivity and good judgment. It also raises questions about his willingness to say almost anything privately

to Nixon in the service of his ambition to preserve his relationship with Nixon and become secretary of state. Kissinger would have done well to take counsel from Calvin Coolidge's observation that "It is difficult for men in high office to avoid the malady of self-delusion. They are always surrounded by worshipers . . . They live in an artificial atmosphere of adulation and exaltation which sooner or later impairs their judgment."

In the midst of the Watergate scandal, Nixon and Kissinger were determined to focus on national security matters, which was the closest thing to a partisan-free zone that could mute public discussion of White House wrongdoing. Nixon and Kissinger understood that assuring national safety is a president's first job, but with Nixon so weakened at home, could he act effectively abroad? They certainly saw this as a concern, but they couldn't accept the possibility that resignation might be in the national interest.

THEY REMAINED HOPEFUL of achieving foreign policy gains, which first and foremost required averting a new crisis in Vietnam. Nixon and Kissinger worried that the scheduled reaffirmation of the January peace agreement at a Paris meeting on June 6 might collapse. "With these maniacal Vietnamese," Henry told a British friend as he was about to return to Paris, "you never know whether they are putting you through a period of agony."

Within hours of reopening the Paris discussions, Kissinger knew that he faced another round of misery with Hanoi and Saigon. Because they could not come to an agreement on how to rein in the continuing violence in South Vietnam or end North Vietnam's presence in Cambodia, Kissinger persuaded Le Duc Tho to delay release of a communiqué until June 7. But the postponement did not appease Thieu, who rejected the pronouncement on reaffirming the cease-fire as a way for Hanoi to deter U.S. military retaliation while it continued to subvert his government. Henry instructed the embassy to advise Thieu not "to commit suicide in such a stupid way." If he refused to sign, Henry wanted him to understand that "the Congress would kill him off with dispatch and delight." Ignoring Kissinger's threat, Thieu leaked his rejection of the communiqué to the press.

Nixon was "outraged" but refused to force an open crisis with Saigon, which would raise questions about peace with honor and reduce his chances of elevating foreign policy over domestic problems. Privately,

Nixon gave Thieu an ultimatum—sign the communiqué or face "the disastrous consequences I have so often described to you." Kissinger advised Nixon that if Saigon fell in line, it would be evident to the president's critics that he continued to be an effective foreign policy leader, who should remain in power.

Although Nixon and Kissinger understood that a public reaffirmation of the January accord would leave South Vietnam's future unsettled, they also knew that widespread domestic opposition to renewed military action against Hanoi and Nixon's weakened political position made it impossible for him to do more than pretend that the communiqué advanced prospects for peace in Indochina.

Nixon now forced the Saigon "maniacs," as Kissinger continued to call them, to sign the agreement pledging anew to end the fighting in all of Indochina. Fresh warnings that Thieu was "risking everything" and assurances about South Vietnam's future security persuaded Thieu to sign. Although the release of the communiqué on June 13 gave Nixon the domestic cover on Vietnam he needed in the Watergate crisis, it allowed Hanoi to continue subverting the South and left the future of Laos and Cambodia in continuing jeopardy. The communiqué was a confession of helplessness on the part of the United States.

EXTRACTING THIEU'S AGREEMENT freed Nixon to focus domestic attention on Brezhnev's visit to the United States beginning on June 18. Nixon and Kissinger persuaded themselves that the meetings would yield good results. They expected a prevention of nuclear war agreement, which did no more than express rhetorical opposition to a nuclear conflict, to "be of truly historical importance," or so Nixon told Brezhnev. It would create conditions "where wars of any kind and the use of force will no longer afflict mankind"—the fulfillment of Woodrow Wilson's highest hopes. Yet Nixon also acknowledged that a SALT II agreement was still not on the horizon, that tensions in the Middle East remained "explosive," and that problems in Indochina required renewed attention.

In private, Nixon worried that Watergate would limit his freedom to make commitments to Brezhnev and that the Soviets were losing confidence in him as a reliable partner in the reach for détente. Nixon took a Brezhnev comment on his "indifference" to attacks on the president as an indication of Kremlin concern about Nixon's waning powers.

Although Kissinger would later acknowledge the impact of Watergate on Soviet views of the Summit, at the time he assured Nixon that his domestic troubles were unimportant in shaping Soviet-American relations. Soviet behavior "has not a thing to do with Watergate," Henry said. He assured Nixon that the Summit was going to be as successful as last year.

Picking up on Kissinger's optimism, Nixon declared, "Oh, for crying out loud, when Harry Truman was 20 to 23 percent in the polls, he was still pulling off Marshall Plans, and that's what we're in for." Nixon had his history wrong (it wasn't until the Korean War that HST's approval ratings fell into the twenties), but he was more interested in reassuring himself than getting the sequence of events in Truman's presidency right. Despite his political troubles, he wanted to believe that he could still achieve big things in foreign affairs. Indeed, he solaced himself with thoughts that world peace might depend on his continued presence in the White House.

The Summit was a test of Nixon's ability to strengthen détente and convince a majority of Americans that he was indispensable to international stability. In deference to Nixon, or more out of a reluctance to air America's dirty laundry in direct view of the Soviets, the Senate Watergate committee suspended hearings for six days between June 18 and June 23.

Whatever Soviet doubts there were about Nixon's freedom to serve their interests through further Summit discussions, Brezhnev treated him as an essential partner in their pursuit of world peace. For Brezhnev, as for Nixon, a failed Summit would have been a blow to his political standing, which a weak domestic economy made shaky. A successful conference or, at a minimum, the appearance of a productive meeting served the political needs of both leaders.

After an opening private conversation in the Oval Office on the morning of June 18, Nixon and Brezhnev told aides that they were trying to cement the good personal relations they had established a year ago in Moscow. During a three-hour afternoon session, Brezhnev declared his conviction that "there are no situations that you can't find a way out of."

Brezhnev was signaling a Soviet eagerness to push the United States toward some kind of accommodation on the Middle East, where he

knew Egypt might start a new war and provoke a Soviet-American crisis. When Nixon suggested that Rogers and Gromyko meet separately on the Middle East at Camp David, Brezhnev wanted to "instruct both of them . . . to come to an agreement. Otherwise it will be said that they tried and tried and tried, and couldn't get their work done."

Brezhnev could not have been more upbeat during the afternoon discussion. He described last year's Summit as "historic"; it had put "an end to old history" and begun a "new history." They would sign agreements in the coming week that future historians would regard "as truly epoch making." He grandly compared their discussions to Newton's discovery of gravity. They were formulating a policy of accommodation that would make other nations gravitate toward peace.

The afternoon exchanges also revealed the peculiar personal sides of both men. During a lengthy opening statement lasting almost forty-five minutes, Brezhnev called attention to two watches he was wearing—one on Moscow time and one on Washington time. The two timepieces would allow him to keep track of his body rhythms, he explained. "It is the only way you can tell when to go to the bathroom," Nixon crudely joked. But taking Nixon literally, Brezhnev explained that he was confused as to whether he was seven hours ahead or behind his normal time. When Brezhnev caught Rogers and Kissinger looking at their watches (they were struggling with hunger pangs as the supposedly brief meeting turned into a marathon talk fest), he questioned their inattentiveness like a teacher pained at his students' loss of interest in his lecture.

Not to be outdone by Brezhnev, Nixon launched into comments that stimulated additional remarks by the general secretary. Brezhnev then could not resist showing the president a cigarette case with a timer that helped him control his impulse to chain-smoke. Worried that his weariness would not allow him to appear at his best, Brezhnev complained as the afternoon session ended that when he made his dinner speech that night, it would be 5 A.M. in Moscow.

Two nights later at Camp David, Brezhnev's disconnected remarks suggested continuing jet lag. After lengthy toasts praising his Soviet colleagues attending the conference, he described a visit to Finland during which he "heard that they had published a book about Khrushchev containing 800 or more jokes . . . Better one agreement between us than 800 jokes," he declared. He then "spoke in glowing terms of Voroshi-

lov, his predecessor as Soviet President in the fifties." One of Brezhnev's bored colleagues whispered to Sonnenfeldt that "as Voroshilov got older he used to say that his head was getting more and more like his arse—it couldn't think any longer."

Mindful of extensive television coverage of his visit and understanding that he could ingratiate himself with the president and possibly make him more receptive to Soviet demands, Brezhnev's comments to the press about the value of the meeting could be read as an implicit pro-Nixon appeal to Senate investigators. Nixon's public rhetoric of self-congratulation matched Brezhnev's. The Summit was serving "the vital interests of all mankind."

Yet the effort to promote the week-long Summit as a landmark occasion comparable to the 1972 meetings in Peking and Moscow fell short of the mark. True, the two sides could point to ten agreements on agriculture, trade, transportation, science, education, and peaceful uses of atomic energy as well as a Prevention of Nuclear War (PNW) treaty that voiced rhetorical horror at a nuclear war. But PNW included no pledges against using nuclear weapons, and nothing in these agreements amounted to a fundamental change in relations.

Both sides saw the PNW agreement as the best news coming from the Summit and tried to make it seem like a major achievement. "Be as positive as possible in your press briefing—" Nixon instructed Henry about his public discussion of PNW. He wanted Henry to build up PNW as a "great initiative" by the president and the general secretary.

As William Bundy pointed out, Kissinger's claim at the time that the PNW agreement "had been a 'significant landmark' showed his desire to dramatize new events in foreign policy as an antidote to the damaging Watergate news—a motive he admitted in his memoirs." In reality, Bundy said, the agreement was little more than "an exercise in defensive American diplomacy."

The inability to complete a SALT II agreement reining in offensive weapons or to say anything of consequence about relations with China or Middle East peace negotiations underscored the Summit's limitations. The SALT discussions "are now pretty well at a standstill," Nixon acknowledged in a June 20 discussion with Brezhnev. He was eager to announce their intention to reach an arms agreement by 1974, which they could then present to the press at a third Summit in Moscow. He had

little idea of what a final SALT arrangement would look like, but he believed that the current Summit would be viewed as inconsequential if they didn't make a concrete statement about when a nuclear arms treaty would be concluded.

China's absence from any public comment was a notable omission. The private discussion about China demonstrated what little confidence the two superpowers had about a future without war. Brezhnev was scathing—he said that Mao was ready to "let 400 million Chinese die" so that the 300 million left could dominate world politics. They wouldn't agree to ban the use of nuclear weapons. "These people are ruthless."

A general statement in the Summit's final communiqué about the Middle East signaled that the two superpowers had no formula for defusing Arab-Israeli tensions. At a morning meeting between Kissinger and Gromyko and Dobrynin on June 23, they agreed to omit anything "substantial" in the communiqué about the region. When Kissinger expressed concern that the press not picture them as at odds on the region, Gromyko said, "but the reality is that there is disagreement on fundamental points."

The statement gave no indication that Moscow or Washington had some magic formula for advancing Mideast peace talks; to the contrary, it suggested that the two sides had their differences, which served Soviet wishes to convince Arab allies that Moscow was defending their interests in discussions with Israel's U.S. friend. It seemed calculated to head off the sort of hostile reaction from Cairo after the May 1972 Summit, when the communiqué gave no indication that Brezhnev had pushed the Americans to pressure Israel, and Sadat then expelled Soviet military advisers from Egypt.

On the last night of the conference in San Clemente, after Brezhnev and Nixon had retired, Kissinger received a phone call asking him to wake Nixon for an urgent conversation with the general secretary. At 10:45 P.M. Nixon met with Brezhnev in his study for an unscheduled session in which Brezhnev tried to bully him into an agreement on the Middle East. Fearful that Sadat would resort to war without some indication that negotiations were a serious possibility, Brezhnev pressed Nixon to agree to a formula that could launch meaningful discussions.

Nixon knew that the Soviets would instantly leak any U.S. agreement to the Egyptians and protested that accepting some formula would

not necessarily lead to fresh talks. Brezhnev kept up a verbal barrage for two hours, but won no more than a commitment from Nixon to do his best to advance Middle East negotiations. Brezhnev was ready to accept an oral commitment to the withdrawal of forces from occupied territories, but Nixon wouldn't budge, and the conference ended with nothing more than the general statement of mutual eagerness to settle Middle East difficulties.

With Watergate pushed below the fold of the front pages, Kissinger told the president that "it was an outstanding week." Nixon replied: "Ahhh, it better be. For what we put into it—I mean six meals with this guy was about enough to break anybody . . . Every night for six nights." Henry thought "it was worth it . . . I think it showed the American public what the important aspects of our policy are." Nixon responded: "I hope so."

Kissinger was less sure in retrospect. In his memoirs, he complained that by the conclusion of the conference the Soviets understood that Watergate overshadowed the Summit. He believed that it made Moscow "less willing to expend capital on preventing adventures by friendly nations—and thus it surely contributed to the Middle East war" in October.

But Kissinger said nothing about how a president free of Watergate could have changed the outcome in the Middle East. The failure at the Summit to arrive at some effective strategy for bridging Egyptian-Israeli differences was not the result of Watergate or a want of Soviet or American imagination but the consequence of circumstances beyond Soviet-American control. When Egypt's foreign minister visited Moscow in early July, Dobrynin told Kissinger that "Egyptian foreign policy sometimes seemed to be made by madmen." Watergate unquestionably undermined Nixon's freedom to act effectively overseas, but the Middle East was one place where he had little ability to shape immediate events.

In the days following the Summit, it was clear that the meeting had limited positive resonance in domestic and foreign affairs. Dobrynin complained to Kissinger about the post-Summit "lack of enthusiasm in the [U.S.] media." Kissinger blamed the desultory response on press preoccupation with Watergate. In a follow-up conversation, Dobrynin declared his government's indifference to the Watergate debate "as long as it was clearly understood that President Nixon intended to stay." Henry

assured him that "there was no question about that," and he urged Do-brynin to communicate that to Moscow.

THE SUMMIT PROVOKED anti-American sentiment in China. The PNW agreement, however limited, especially worried the Chinese. They told the White House that "the agreement aims at the domination of the world in all respects by the two nuclear hegemons . . . This agreement precisely meets Soviet needs, making it easier for the Soviet Union to mask its expansionism, attack soft spots and take them one by one."

The Chinese now postponed a Kissinger visit to Peking for early August. Henry thought it was a response to "a paralyzed Presidency." But Kissinger was too quick to blame every foreign policy stumble on Watergate: The Chinese delayed Henry's arrival only briefly to mid-August. Whatever the cause of the delay, it suggested a problem in Sino-American relations that made it more difficult for Nixon to press the foreign policy case for himself against Watergate investigators.

On June 25, testimony by John Dean that Nixon was aware of the cover-up threw the president on the defensive and made it difficult for the White House to focus public attention on foreign relations. "As soon as other countries recognize how little authority there is left here, we are just going to be in murderous difficulty," Kissinger told Mel Laird on June 28. The next day, Nixon felt compelled to accept a congressional ban on all military activities in Indochina beginning on August 15. Nixon understood that to oppose the restraint would have put him on the wrong side of public opinion. He had enough troubles with Watergate without taking on an unpopular argument on behalf of administration freedom to continue fighting in Southeast Asia.

Henry saw the constraint as a disaster for U.S. foreign policy in general. It would convince the Chinese "that we have become irrelevant," he told Jacob Javits. "This is a dramatic dismantling of our foreign policy," he advised Bill Buckley.

Nixon and Kissinger would have been pursuing the same foreign policies with or without Watergate. Nor can the scandal explain every constraint on them abroad. The inhibitions on the White House in Southeast Asia, for example, were less the consequence of Watergate than of public and congressional opposition to continued military action in Vietnam, Laos, or Cambodia. The president's dealings with Moscow,

Peking, NATO, and the Middle East, however, remained relatively unin-
hibited. Watergate may have made adversaries and allies less cooperative
than before, but the president's domestic crisis did not impede him from
efforts to advance relations with any of them.

True, domestic critics saw Nixon trying to use foreign affairs to insu-
late himself from unsettling questions about his behavior in the scandal.
And the White House hoped that foreign policy could head off growing
talk of bringing him down. But at the same time as Nixon and Kissinger
believed that foreign policy could change the domestic conversation,
they continued to make national security considerations central to their
oversea's actions.

Nevertheless, Nixon and Kissinger had little reason to complain
about critics who saw them as principally focused on the political ben-
efits from foreign policy. The administration's many hidden actions and
abuses of power made cynicism about their intentions entirely under-
standable. Some forethought about the consequences of their secret mili-
tary and diplomatic actions might have spared them from many of the
political and personal attacks they now struggled to combat.

AT THE BEGINNING OF JULY, the strains on Nixon from allegations of
wrongdoing had become almost unbearable. He might have recalled
Woodrow Wilson's observation that "men of ordinary physique and dis-
cretion cannot be Presidents and live, if the strain be not somehow re-
lieved." But having passed through so many other life crises, he viewed
himself as capable of meeting the emotional and physical challenge. He
saw stoicism as a defense against any sort of pain. In December 1972,
after he had broken a bone in his foot, which he had banged against the
side of the swimming pool at Camp David, he refused to see a doctor.
Although he was "limping very badly," he said that "wearing a shoe is just
as good as having a splint." He didn't "want to make a big fuss about it."

For eighteen days after the Watergate hearings resumed on June 25,
Nixon was preoccupied with almost daily news accounts of potentially
impeachable offenses. Revelations about $703,000 in government spend-
ing on his San Clemente residence, including $132,000 in landscaping,
coupled with Dean's testimony that the White House had an "enemies
list," some of whose members were slated for IRS audits, raised addi-
tional questions about the president's honesty. Demands from the Wa-

tergate committee for presidential records that could clarify conflicting assertions from Dean and the White House about the cover-up produced a confrontation between Nixon and Sam Ervin. On July 7, Nixon told Ervin that he would "not testify before the Committee or permit access to Presidential papers."

On July 12, Ervin called Nixon to ask his voluntary cooperation or face a committee subpoena. Nixon, who awoke that morning with a "nearly unbearable" pain in his chest that increased with every breath, spoke in a subdued voice. He left no doubt, however, about his intentions. He refused Ervin's request and rebuked him: "Your attitude in the hearings was clear. There's no question who you're out to get." Ervin replied: "We are not out to get anything, Mr. President, except the truth." Dr. Walter Tkach, Nixon's personal physician, told him that he had a 102°-degree temperature and pneumonia. At the end of the day, after chest X rays confirmed Tkach's diagnosis, Nixon entered the Bethesda Naval Hospital at 9:25 P.M.

As news of the president's hospitalization spread, staff members at Bethesda speculated that the cause was not viral pneumonia but alcoholism or, as someone at the hospital put it, "the need to dry Nixon out." Nixon's drinking had become an item in the Washington gossip mill. Morose and depressed by the assault on his presidency, Nixon would make late-night phone calls which were notable for their slurred speech and incoherence.

Nixon's paranoia, which was a constant part of his political outlook, became a topic of journalists' discussions. They began asking whether Nixon's hospitalization was for something other than pneumonia. The print media reported that Nixon saw the Ervin committee as out to "get him" in a "witch hunt." Remembering that his book *Six Crises* showed "a man repeatedly on the edge of nervous exhaustion," some in his administration wondered whether this seventh crisis was more than Nixon could handle.

During Nixon's hospitalization between July 12 and 20, Dr. Tkach and Ron Ziegler gave daily press briefings. Reporters at once began asking whether the president's "condition is from over-work or from over-concern or something?" Tkach responded: "Anyone can suffer a viral pneumonia." The skeptical journalists wanted to know when the president became ill. "He was supposed to look so well and feel so well last

night," one of them said during the July 12 briefing. "Considering the seriousness of it," another one stated, "I hope you will take this question in the spirit in which it is asked. Is what you described to us all that is wrong with the President?" Tkach said, "Correct," and asserted that his statement rested on completed medical tests.

Although subsequent briefings were attended by pulmonary specialists at Bethesda and Georgetown hospitals and the doctors assured the press that the president was in sufficient command of his faculties to carry on "essential work," the journalists continued to ask about the president's mental health. Predictions that Nixon would likely suffer "considerable malaise and uneasiness and a feeling of a lack of energy that may continue for some period after leaving the hospital" provoked additional questions about Nixon's emotional stability.

Was the president's illness the consequence of "fatigue"? one journalist asked. The doctors would concede no more than that it could have been a factor. One reporter wanted to know if Senator Ervin would be permitted to visit him, if he saw a need for a meeting. Another asked how much of the usual workload the president would be able to carry. Tkach's speculation that Nixon would be capable of less than a quarter of his normal work routine increased press suspicions about Nixon's actual condition. "Is there a letter of understanding between the President and the Vice President that should he become so ill that he couldn't carry out the duties of his office, that the Vice President would automatically take over?" someone asked.

On the third day of Nixon's hospitalization, one reporter complained that he was getting a contradictory picture of the president's condition. There was the portrait of "a man who is flat on his back and using a device to breathe with and running a temperature of 102 . . . On the other hand, I am getting a picture of a man . . . who can make executive decisions, consider policies . . . I have trouble reconciling these two pictures of a sick president." Tkach was quick to squelch any suggestion that Nixon was non compos mentis: "His sensorium is not clouded by any means," Tkach declared. "He is very alert. He is tired, he is fatigued, he is sick . . . but . . . his mind is very active and clear." Was Tkach concerned about guarding the president from "mental exhaustion"? UPI's Helen Thomas asked. Tkach said he was, but he couldn't reveal topics the president discussed. She wanted

to know if Tkach thought that "Watergate contributed to the illness." Tkach said he could not answer that.

On the fourth day, when Tkach explained that Nixon was suffering "the expected malaise, fatigue, and lack of energy that is seen with prolonged bed rest and convalescence from a viral infection," the reporters wanted to know if Ziegler was discussing Watergate with the president. Ziegler refused to reveal the content of their conversations. Did the president's "lassitude" keep him from reading the news summaries? Did his phone calls include any from Garment or White House counsel Fred Buzhardt? Was Watergate part of the daily discussions?

Fresh Watergate questions were prompted by Alexander Butterfield's revelations to the Ervin committee on July 16 that Nixon had a White House taping system that had captured thousands of conversations since February 1971. Believing that "the White House taping system would never be revealed," Nixon "was shocked by the news . . . The impact of the revelation . . . was stunning," he wrote later. "Haig and I spent several hours in my hospital room talking about what the revelation of the existence of the tapes would mean." One thing was clear: Nixon could anticipate demands from the committee for access to the tapes, which could clarify whether the president or John Dean was telling the truth about Nixon's knowledge of the cover-up.

Continuing reports from the doctors that the president was suffering the sort of normal "malaise" associated with his illness led one reporter to ask if Nixon is "despondent." No, "his spirits are just fine," one of the pulmonary physicians replied. How could the president be in "excellent spirits" if he was suffering from a "malaise"? "Can malaise be defined as depression?" the reporters then asked. "No," Tkach emphasized. "Malaise is a physical effect or feeling, it is a tiredness, an achiness. It is not connected with a depression."

Dr. D. Earl Brown, a psychiatrist and the commanding officer at the Bethesda Naval Hospital during the president's confinement, saw Nixon every day. He denied that the president was suffering from any emotional disorder. Nixon's problem was strictly viral pneumonia, Brown said. Indeed, if he had observed any mental difficulties, he would have been the first to propose a psychiatric evaluation and treatment.

Nixon's conversations with Kissinger during his hospitalization reveal his paranoia about political enemies. "Al told me your Georgetown

crowd clapped when you told them the news last night" about my illness, Nixon said on the afternoon of July 13. "No," Henry replied, "they were really quite concerned." Shifting his focus to the journalists, Nixon declared: "All these reporters whose only interest is to write my obituary won't write it too soon." Nixon believed that he was giving "our friends in the liberal community . . . some happiness by getting sick." Henry fed his paranoia by telling him that his enemies didn't want him sick because it gained him public sympathy. "I don't think they want you sick, I think they want you politically destroyed." The focus of these conversations, however, was foreign policy issues about which Nixon was lucid and rational.

Eager to refute journalists' speculation that he was physically or emotionally incapacitated, Nixon left the hospital on July 20 against the advice of his physicians. Brown, who rode down in the elevator with him from his sixteenth-floor suite, said he looked "awful." But he pulled himself together to speak to the White House staff and the press first at the hospital and later in the morning at the Rose Garden.

Nixon was determined to shun the advice of his doctors, who were urging him "to slow down a little now and take some time off and relax a little more . . . No one in this great office at this time in the world's history can slow down," he said. "This office requires a President who will work right up to the hilt all the time. That is what I have been doing. That is what I am going to continue to do . . . Another bit of advice, too, that I'm not going to take . . . I was rather amused by some very well-intentioned people who thought that perhaps the burdens of the office . . . some of the rather rough assaults that any man in this office gets from time to time, brings on an illness and, after going through such an illness, that I might get so tired that I would consider either slowing down or even, some suggested, resigning . . . Any suggestion that this President is ever going to slow down . . . or is ever going to leave this office until . . . he finished the job he was elected to do . . . that is just plain poppycock."

Nixon defiantly hit out at his Watergate tormentors. His job was not to "wallow in Watergate," as some were doing, but to make "the great decisions . . . that are going to determine whether we have peace in this world for years to come. We have made such great strides toward that goal." The message was clear enough—don't let Watergate deter us from

getting on with the big foreign policy job "that we were elected over-whelmingly to carry forward in November of 1972."

But the public was skeptical of anything Nixon now said. His well-known history of hardball politics and opponents' assertions about his affinity for deviousness had eroded his credibility. The public now dis-approved of the Nixon presidency by a 49–40 percent count. This represented a 28 percent drop in six months, the sharpest such tumble in forty years. With the *Chicago Tribune* announcing, "Facts Batter Sense of Trust," Nixon told Haig and Ziegler, "This is the basic problem."

During the following week, to counter the bad news, Ehrlichman and Haldeman defended the president in testimony before the Ervin com-mittee as unaware of any cover-up, and Nixon put the focus on foreign affairs by hosting White House visits from the Shah of Iran and Japan's prime minister. Nixon remained convinced that foreign policy could trump Watergate: "The public . . . has the sense to put it all in . . . per-spective and they think," Nixon told Kissinger, "well now, there's Wa-tergate, there's foreign policy, and there's other things. And overall, we come out pretty well." Kissinger encouraged his assumption—he urged the president to believe that reporters at the *Washington Post* were having "second thoughts" about what they had "wrought."

On July 31, in a toast to Japan's Kakuei Tanaka at a state dinner, Nixon vented his anger at the national obsession with Watergate: "Let others spend their time dealing with the murky, small, unimportant, vi-cious little things," he declared. "We have spent our time and will spend our time in building a better world." Late that night, Henry called to tell Nixon how moving his toast was. It pleased Nixon, who was confident that his administration would be remembered not for Watergate but the fact that "they moved the world a few inches toward more peace." Yet Nixon's efforts to focus press and congressional attention on the larger picture did not change the public mood.

Nixon concluded that he had to reestablish his credibility and au-thority by speaking to the country. Kissinger urged him not to debate the Watergate charges, but to maintain that the evidence of White House wrongdoing is inconclusive, and then assure the public that all the "charges against me are false."

Although he would later assert that Nixon could not have escaped the belief that "there was guilty knowledge to hide" without releasing the

tapes, Henry said nothing about using them to establish the president's innocence. Instead, he encouraged Nixon to acknowledge that he had exercised poor judgment in entrusting high public office to people who acted unwisely, but that he had "taken steps to prevent a recurrence of these events." He counseled Nixon to urge the country to think about the future and to pledge untiring personal efforts to assure better national and international conditions. Kissinger was more graphic with Haig about the impression Nixon needed to convey: "He has to be a national President. He has to be the father of his country now—not a raving maniac."

Nixon began a public campaign to end questions about his personal wrongdoing. He convinced himself that the country was ready to move on. "It's sort of the dog days of August," he told Kissinger on August 12, "and except for the *Washington Post* and *New York Times* most of the country doesn't give one god-damn about what the hell happens in Watergate. They are sick of it, tired of it." Kissinger mirrored Nixon's sentiment: "I think that is right . . . On foreign policy, Mr. President, within three months we'll be back where we were."

By uncritically reaffirming Nixon's belief that he could drive Watergate off the front pages with discussions of world peace, Kissinger did the country a disservice. If Henry believed that Nixon was innocent of high crimes and misdemeanors that could drive him from office, he should have urged him to put all the exculpatory evidence before the Ervin committee. If he thought that Nixon was guilty of impeachable offenses, then his advice to simply deny involvement made him complicit in the president's cover-up.

Kissinger undoubtedly worried that impeachment and possible conviction of the president could play at least temporary havoc with the country's national security. He told a friend in July 1973, "At no crisis in the last fifteen years did I think the country was in danger. But I genuinely now believe that we could suffer irreparable damage." Yet, as he acknowledged, "it is easy to overestimate the ease with which foreigners can understand, much less manipulate our internal conflicts." The idea that foreign competitors and adversaries would be able to exploit a domestic political crisis in the United States overlooked the fact that orderly processes for a succession existed and no transition would strip the country of its military power and the readiness of the public to rally to its leaders in response to any significant foreign threat.

No analysis of Kissinger's behavior can ignore the possibility that his ambition to become secretary of state as much as worries about national security animated his opposition to the president's political demise. "Do you consider yourself a very ambitious man?" a Norwegian journalist asked him in April 1973. "There are two kinds of ambition," Henry replied, "to do something and to be somebody. Maybe I am in the first sense." Yet he didn't deny that aiming to be somebody was part of his persona. Like Nixon's, Kissinger's ambition was a ceaseless force that moved him to rationalize cutting corners with assertions that he was serving the national interest or saving Nixon from himself.

In a nationally televised speech from the White House on August 15, instead of following Henry's advice and looking past the charges against him, Nixon spoke like a defense lawyer offering refutations of accusations. "My consistent position from the beginning has been to get out the facts about Watergate, not to cover them up," he declared. He also tried to answer those who wondered why he wouldn't release the tapes of White House conversations. The loss of presidential confidentiality "would set a precedent that would cripple all future Presidents by inhibiting conversations between them and the persons they look to for advice." He would not "destroy that principle, which is indispensable to the conduct of the Presidency."

The initial response to the speech gave Nixon additional hope that he might now be able to mute public concern about the scandal. Lou Harris reported that "press reaction has been initially cynical while political reaction has been very supportive even from formerly spongy elements."

The Sindlinger poll reported a more divided public response. While 60 percent of those questioned wanted Nixon to release his tapes, half of them believed it would exonerate the president. Releasing the tapes would undermine the presidency, 56 percent of the poll agreed; 68.9 percent of the survey favored having the country "get back to business." Less than 10 percent of the country saw Watergate as the nation's number one problem. Sindlinger believed "that we have turned the corner and established a base for successfully moving out of Watergate."

But Watergate was no longer an issue that could be settled in the media or the court of public opinion. A subpoena from the Ervin committee for the tapes had placed Nixon's fate in the hands of the judi-

ciary; the content of his conversations as captured on the White House recordings would decide his guilt or innocence. "The one continuing problem with Watergate is the issue of the tapes," Lou Harris advised the president. While "the general public had not been able to understand the arguments on either side," it wanted "the issue resolved," which would not be the case as long as Nixon refused to open them to investigators.

Nevertheless, Nixon continued to assume that his battle for political survival depended on persuading the public that fulfilling his foreign policy goals was more important than Watergate. He believed himself locked in a familiar battle for political survival against journalists and political enemies. On August 20, he went to New Orleans to speak to the Veterans of Foreign Wars convention, which honored him with its annual peace award. As he walked toward the entrance to the city's Convention Center trailed by reporters and press cameramen, Nixon turned in anger to Ziegler, shoving him toward the journalists with the shouted instruction to keep the press away from him: "I don't want any press with me and you take care of it!"

His speech to a cheering audience recounted the foreign policy achievements of his administration. The great task ahead was "to build a lasting peace" and to sustain administration initiatives toward Peking and Moscow as well as European allies. He identified neo-isolationists as a deterrent to America's continuing central part in international affairs, but it was Watergate that was principally undermining the administration's foreign policy: Only "a strong America—strong in its military defense, but also strong in its vision and its will to act like a great nation" could achieve "a generation" or "even a century of peace." Nixon's intemperate act in the Ziegler incident, which raised questions about Nixon's emotional stability, overshadowed anything he said in his speech.

Two days later on the grounds of his San Clemente home overlooking the Pacific, Nixon held an unscheduled press conference. It had been over five months since his last appearance before the press and over fourteen months since he had allowed live TV coverage. Nixon's decision to hold a news conference was partly a response to reports that the incident in New Orleans suggested that he had gone "off his rocker." He hoped to demonstrate that he was physically and emotionally in command of himself. But his appearance before the media was counterproductive.

Press reports described him as "clearly nervous. He slurred and mispro-
nounced several words and his voice quavered noticeably."

Nixon hoped to press home the theme that foreign affairs were much
more important than Watergate. He aimed to replace front-page stories
about the scandal with news of William Rogers's resignation as secretary
of state and Henry Kissinger's appointment as his successor. Kissinger
would also remain as national security adviser in order to assure a more
effective foreign policy. Nixon then used the announcement to praise
Rogers's participation in "one of the most successful eras of foreign policy
in any administration in history."

The attempt to focus attention on the administration's peace pro-
gram fell flat. As soon as he opened the floor to questions, the journalists
barraged him with queries about Watergate: the tapes, his resistance to
releasing them to investigators, the cover-up, wiretaps, the bombing of
Cambodia, the Ellsberg case, allegations against Agnew of taking bribes
as governor of Maryland, Nixon's capacity to govern, and whether he was
considering resigning.

After thirty minutes of hostile questions about the scandal and the
president's possible guilt, Nixon pointed out that he was yet to have "one
question on the business of the people." He said he would not resign
and asked Americans "to recognize that whatever mistakes we have made,
that in the long run this Administration, by making this world safer for
their children, and . . . making their lives better at home . . . deserves high
marks." The reporters immediately resumed asking about Watergate.

In his memoirs, Nixon mentioned Kissinger's elevation to the state
department in a sentence. It revealed none of his anguish about adding to
Henry's standing as the administration's leading foreign policy figure who
had eclipsed the president. "One of the more cruel torments of Nixon's
Watergate purgatory was my emergence as the preeminent figure in foreign
policy," and the necessary choice as secretary of state, Kissinger recalled.

Henry had no illusion about Nixon's preference for someone else—
Kenneth Rush, the seasoned diplomat and deputy secretary of state, or
John Connally, Nixon's secretary of the treasury since February 1971
and the man Nixon wanted to succeed him as president. But Watergate
changed everything. "With the Watergate problem," Nixon said later, "I
didn't have any choices." Kissinger thought that the decision "must have
been torture for Nixon."

Nixon's characteristic affinity for intrigue and his personal awkwardness preceded Henry's selection. Because Kissinger was threatening to resign unless he was chosen, which would have undermined Nixon's efforts to have foreign policy eclipse Watergate, he felt compelled to select Kissinger. Haig's recommendation of Henry also influenced the president's decision. Haig's advice was partly the result of his conviction that Henry's selection would assure against a competitive struggle with Kissinger "for access to Nixon. A soothing side effect of Kissinger's confirmation as Secretary of State," Haig believed, "was that he now outranked me again, at least in theory, and this restored not merely the appearance but also the reality of cordial relations between us."

Nixon asked Haig to facilitate Kissinger's appointment by arranging Rogers's resignation. Nixon couldn't bring himself to confront the friend he had treated so shabbily during his four and a half years at state. Rogers initially refused to give Nixon an easy out. "Tell the president to go fuck himself," Rogers told Haig. He would need to ask him personally for his resignation. But ever the gentleman, Rogers responded to a presidential invitation in mid-August to see him by presenting Nixon with a resignation letter at their meeting.

On August 21, the day before his news conference, Nixon asked Henry to join him for a swim in his San Clemente pool, ostensibly to discuss foreign policy issues. "Suddenly, without warmth or enthusiasm," Nixon, who was floating on his back, told Kissinger that he would begin his press conference by announcing Henry's appointment as secretary of state. Henry, who was sitting on the steps of the pool, blandly or "lamely," as he described it, replied that "I hoped to justify his confidence."

Nixon's grudging reluctance registered clearly in his announcement. He did not invite Henry to attend the news conference, and by contrast with the praise he lavished on Rogers, Nixon tersely declared, "Dr. Kissinger's qualifications for this post, I think, are well known by all of you ladies and gentlemen, as well as those looking to us [sic] and listening to us on television and radio." Kissinger would also maintain his position as assistant to the president for national security affairs. The dual appointments were Henry's way of avoiding the kind of competition that had dogged relations between him and Rogers; Henry intended to be the only master of foreign policy. However, it undermined the purpose of

having an NSC that was meant to strengthen the government's ability to debate and arrive at wise foreign policy decisions.

"I had achieved an office I had never imagined within my reach," Kissinger recalled somewhat disingenuously, "yet I did not feel like celebrating. I could not erase from my mind the poignant thought of Richard Nixon so alone and beleaguered and, beneath the frozen surface, fearful . . . while I was reaching the zenith of acclaim."

In assuming responsibility for the country's foreign policy in the midst of Watergate, Kissinger felt as if he had become "the focal point of a degree of support unprecedented for a nonelected official. It was as if the public and Congress felt the national peril instinctively and created a surrogate center around which the national purpose could rally . . . I, a foreign-born American, wound up in the extraordinary position of holding together our foreign policy and reassuring our public." Although Kissinger would acknowledge that his exceptional situation had much more to do with "a national instinct for self-preservation" than any personal merit he brought to the office, he could not resist the picture of himself as a national savior to whom the country rallied at a time of painful disarray.

No doubt, portraying himself as under such a heavy burden both flattered Kissinger's ego and heightened his sense of responsibility about taking on an undeniably difficult assignment. But he was not quite the indispensable man he thought himself to be. True, he had an impressive hold on the public's imagination in the summer of 1973. But there were other highly competent foreign policy experts, such as Kenneth Rush, who could have conducted diplomacy and defended the national interest with competence equal to Kissinger's.

It was transparent to anyone who heard or read Nixon's introduction of Kissinger at his swearing-in ceremony on September 22 that the president was not entirely happy with Henry's promotion. On the face of things, Nixon's words praising Kissinger for his "poise, strength [and] character" represented a solid endorsement. But Nixon's revelation that Henry felt besieged during his Senate confirmation hearings and that Nixon had to ask him, "Do you still want the job?" raised questions about whether Henry had the toughness to handle the office. Frivolous comments about Henry's being the first secretary since World War II who didn't part his hair seemed to imply that Nixon was reaching for things to say about Henry's distinction.

More telling, Nixon cautioned Kissinger to understand that foreign policy successes depended on teamwork rather than the work of just one person. Anyone aware of Nixon's reluctance to see Henry receive excessive credit for the administration's first-term diplomatic successes concluded that Nixon was signaling Henry against trying to take control of foreign policy away from a weakened president.

Kissinger was mindful of the limits any one person could play in conducting a nation's diplomacy. "A foreign policy achievement to be truly significant must at some point be institutionalized," he declared in his memoirs. "No government should impose on itself the need to sustain a tour de force based on personalities. A foreign policy to be lasting must be carried by the understanding of those charged with the regular conduct of diplomacy and over time must be implanted in the heart and mind of the nation." In other words, it was fine for him to have set in motion major changes in Sino-American relations by establishing a special relationship with Chou and Mao, and for him and Nixon to have dramatized the opening to China as a way to sell the country on their initiative, especially after Vietnam had made foreign affairs an object of scorn and skepticism. In the long run, however, neither he nor the president could sustain this shift in relations without a national commitment—from the Congress, the media, and the public—to so bold a departure in dealing with an avowed enemy.

Yet Kissinger's intellectual understanding did not square with his personal inclinations. His tenure as secretary of state was marked less by any bureaucratic reforms or efforts to make foreign policy by consensus than by Kissinger's individual imprint on the office.

Whatever the limitations of the moment and the future, Kissinger understandably had a great sense of satisfaction from becoming secretary of state. "Mr. President, you referred to my background," Henry said at his swearing-in ceremony, "and it is true, there is no country in the world where it is conceivable that a man of my origin could be standing here next to the President of the United States." At the age of fifty, he had achieved international notoriety and appointment to one of the highest offices a naturalized citizen could hold.

His personal life had now also settled into a comfortable pattern. He had warm relations with his teenage son and daughter, whom he often saw on weekends, and Nancy Maginnes, a woman he had been dating

for nine years, had agreed to marry him. Marriage to the thirty-nine-year-old Maginnes, an Episcopalian and member of a Social Register family, was, according to someone in Nelson Rockefeller's circle, a wish realized. "For a Jewish kid from Germany wanting acceptance, the Maginnes type would be his dream. The right schools, the right clubs, the right kind of people." The marriage also signaled the end of stories about Henry's playboy visits to Los Angeles. His public image as secretary of state needed a more serious cast than the one associated with his highly visible Hollywood excursions.

At six feet, the blonde, green-eyed Nancy towered over Henry, but they were a congenial match—her designer clothes, self-confidence, and transparent intelligence complimented Henry's brilliance, charm, and worldly connections. Henry became acquainted with her in the early 1960s when they worked for Rockefeller—she as a researcher and he as a foreign policy adviser who reviewed Nancy's papers. They had begun dating in 1964, agreed to marry in the spring of 1973, and set a wedding date for October after Henry entered the secretary's office. But the press of public business would delay the marriage until March 1974.

EVENTS IN THE AUTUMN OF 1973 crowded out Kissinger's private plans. First, there were confirmation hearings before the Senate Foreign Relations committee, which ran on for ten days from September 7 to 17. Although the Senate would approve of Henry's appointment on September 21 by a vote of seventy-eight to seven, there were awkward moments when senators asked about his involvement in the administration's wiretapping in 1969–1970. A majority accepted his assertion that he had done nothing to initiate the taps, but had provided names to the FBI to stop leaks of sensitive information jeopardizing national security. The questions angered Nixon, who urged Henry to remember the "bastards" on the committee who gave him a hard time. When Bill Safire criticized the committee in a column for being too gentle with Henry about the tapping, Nixon exploded: "What a jackass. Is he off his rocker?"

Events in the autumn were more distracting. By the winter of 1971–1972, the economic pressure Nixon and Kissinger had brought to bear against Allende's government in the fall of 1970 had begun to bite. In December 1971, the undersecretary of state for Latin America advised Kissinger that the administration's policy of undermining the Santiago

government had helped create internal problems that Allende had exacerbated by nationalizing foreign-owned companies and implementing policies that had led to "production and food shortages, labor indiscipline, an inflation rate of about 20 percent . . . sharply depleted reserves and sagging copper prices," Chile's principal export. There was evidence of growing popular discontent, most notably a march protesting food shortages that had resulted in violence and repressive police action. The secretary recommended quietly maintaining pressure on Santiago without provoking a confrontation that Allende could use to rally domestic political support.

A column by Jack Anderson in the *Washington Post* on March 21, 1972, citing documents that revealed collaboration between the CIA and International Telephone and Telegraph (ITT) to block Allende from taking office in 1970, touched off angry demonstrations in Chile and increased White House determination to hide its efforts to oust him.

The CIA, which now devoted over $6 million to help Allende's domestic opponents, took every precaution to avoid overt indications of its subversive activities. In October 1972, after a series of strikes had made a coup by the military and opposition political parties seem possible, the CIA and state department officials discussed how the U.S. government should respond to potential requests from Allende's opponents for aid. Neither the CIA nor the state department's Latin American experts believed a coup was imminent and concluded that "if and when the Chilean military decided to undertake a coup, they would not need U.S. Government assistance or support to do so successfully . . . Given the Chilean military capabilities for an unaided coup, any U.S. intervention or assistance in the coup *per se* should be avoided."

Over the next five months, U.S. officials hoped that covert support for opposition political groups could lead to a decisive defeat for Allende in March congressional elections. If anti-Allende candidates could win two-thirds of the congressional seats, the CIA expected him to be impeached and replaced by a pro-American government. However, when Allende's Popular Unity party gained two Senate seats and six in the lower House, the CIA was forced to take a new tack. Suggestions that the CIA station in Santiago accelerate its efforts to enlist the Chilean military in plans for a coup were greeted by skepticism in the state department and among senior CIA officials. Only if there was "much more solid evidence that

[the] military is prepared to act and has a reasonable chance of succeeding" would officials in Washington support a more aggressive effort to develop additional contacts with the Chilean military. Continuing economic problems and social unrest triggered an Army putsch on June 29 that failed badly. Kissinger reported to Nixon that loyalist forces supported by pro-government crowds routed the rebels.

While Nixon and Kissinger were no less eager now for an end to Allende's rule, they were determined to avoid any direct U.S. support for a future coup and to keep all indirect help entirely hidden. The emphasis was on what clandestine operators described as plausible deniability. In August, as prospects for another, more effective coup emerged, the CIA wanted to add another million dollars to support "opposition political parties and private sector organizations." But the U.S. embassy in Santiago and the White House preferred to let developments in Chile go forward without additional U.S. interference. Besides, the Chilean military knew where the Nixon administration stood on Allende's government and its willingness to support a new regime. Consequently, when a successful coup occurred on September 11, 1973, in which Allende was killed, CIA Director William Colby told Kissinger that "while the Agency was instrumental in enabling opposition political parties and media to survive and maintain their dynamic resistance to the Allende regime, the CIA played no direct role in the events which led to the establishment of the new military government."

The White House at once took pains to refute newspaper stories saying that the administration knew of the coup twelve to fourteen hours ahead of time, which of course it did. Kissinger wanted the state department not only to deny that it had advance knowledge of the coup but also that "we do not support revolutions as a means of settling disputes." Technically, Kissinger was right—U.S. officials did not directly participate in planning or executing the coup; nor did any representative of the United States play a part in Allende's death.

But as Nixon and Kissinger agreed in a conversation on September 16, American involvement in Allende's ouster was significantly greater than they would let on in public. "The Chilean thing is getting consolidated and of course the newspapers [are] bleeding because a pro-Communist government has been overthrown," Henry said. "Isn't that something," Nixon responded. "I mean instead of celebrating—in the Eisenhower pe-

riod we would be heroes," Henry said. "Well we didn't—as you know—our hand doesn't show on this one though," Nixon exclaimed. "We didn't do it," Henry declared. "I mean we helped them—created the conditions as great as possible." Nixon agreed. "That is right. And that is the way it is going to be played. But listen, as far as people are concerned, let me say they aren't going to buy this crap from the Liberals on this one." Henry emphatically agreed. "Absolutely not." Nixon added, "They know it is a pro-Communist government." Kissinger agreed again. "Exactly. And pro-Castro." As far as Nixon was concerned, all Henry needed to say was that "it was an anti-American government all the way." Kissinger echoed the point: "Oh, wildly."

Administration actions in the days and weeks immediately after the coup belied Kissinger's assertion that "we do not support revolutions as a means of settling disputes." On September 13, the state department cabled the embassy in Santiago—"We welcome [the coup's head of government] General [Augusto] Pinochet's . . . desire for strengthened ties between Chile and the United States. The USG wishes [to] make clear its desire to cooperate with the military Junta and to assist in any appropriate way. We agree that it is best initially to avoid too much public identification between us. In [the] meantime, we will be pleased to maintain private unofficial contacts as the Junta may desire."

On September 18, after the Junta asked for flares and helmets to use in combating opponents, state reiterated its eagerness to help, but only after a brief delay. "We strongly believe [that] domestic and international considerations make this very brief delay highly advisable in overall interests of new GOC as well as in our own." On September 20, a WSAG meeting chaired by Kissinger agreed to recognize the new government on September 24. The U.S. ambassador in Santiago was instructed "to discuss, with the Junta, Chile's middle- and long-term economic needs."

Reports of severe repression, including possibly as many as four thousand deaths, did not impede White House support for the new regime. Some were the result of battles between Allende loyalists and coup supporters. But as many as fifteen hundred killings were the result of executions, with thousands of other Chilean backers of Allende's Popular Unity party arbitrarily imprisoned and tortured. "Two U.S. citizens, Charles Horman and Frank Teruggi, seized by military squads at their homes following the coup . . . were similarly executed." In a report by a

Chilean National Commission on Truth and Reconciliation issued after the end of Pinochet's rule in 1990, the Chilean military was charged with "the murder, disappearance and death by torture of some 3,197 citizens," a program of "state-sponsored terror."

Although the U.S. government did not know the full extent of the new regime's brutality immediately, it certainly knew at once that this was a ruthlessly repressive government which would use every means to hold on to power and hide the extent of its actions. On September 20, Frank Mankiewicz, Bobby Kennedy's former press secretary, told Kissinger that foreign correspondents in Chile were beginning to report "that there are probably a lot more people dead, and there may be you know torture going on and . . . it's not your classic Latin American coup." Mankiewicz characterized what he was hearing as "most ominous." Henry begged off on doing anything until he was confirmed as secretary of state.

On September 28, Kissinger was told that the Junta was in control, with "virtually all the resistance wiped out." But fearful of "lingering terrorism," the Junta was continuing to deal "very harshly" with suspected opponents. The same day, Senator Ted Kennedy publicly criticized the Nixon administration for its failure to say anything about "the coup which toppled a democratically elected government, or over the deaths, beatings, brutality, and repression which have occurred in that land." Kennedy asked Congress to pass a resolution discouraging Nixon from giving economic or military aid to Chile without evidence that Pinochet was "protecting the human rights of all individuals, Chilean and foreign." Although the assistant secretary of state for inter-American affairs believed that "outside opinion, and particularly . . . ours," could have "some degree" of influence on the Chilean government, the White House brushed aside Kennedy's criticism and proposal for checking human rights abuses.

U.S. officials preferred to see Pinochet not as ruthless in suppressing all opposition but as a professional soldier forced into politics by a patriotic determination to save his country from a left-wing dictatorship. He was described by U.S. intelligence as "mild-mannered; very businesslike. Very honest, hard working, dedicated. A devoted, tolerant husband and father [who] lives very modestly . . . He is well known as a military geographer and has authored three geography books, at least one of which is used as a secondary-school textbook." He could be "gracious and elo-

quent" and was responsive to "a frank, man-to-man approach." At a state department staff meeting on October 1, Kissinger said, "We should understand our policy, that however unpleasant they [the Chileans] act, the [new] government is better for us than Allende was."

On October 12, Pinochet told the American ambassador that "Chile greatly needed our help, both economic and military assistance. He added that if the Junta government fails, Chile's tragedy will be permanent." The ambassador responded that the congressional discussion of the Kennedy resolution, the Horman and Teruggi cases, and the human rights problem in general ruled out prompt action. But "I reiterated assurances of the good will of the USG and our desire to be helpful. I noted that we had some problems which would oblige us to defer consideration of Chilean requests," but aid would be forthcoming.

As events would make clear over the next three years, Kissinger championed the Chilean government's requests. Taking warnings from Pinochet to heart that abandoning his government would produce dire consequences not only for Chile but also for U.S. national security in the hemisphere and all over the world, Kissinger consistently battled to maintain aid to Santiago. He saw a choice between "being soft on the human rights issue, and undermining the future of U.S. foreign policy."

The issue to Kissinger was not just Chile but a more general impulse to punish other U.S. allies for human rights abuses that could open the way to left-leaning regimes around the globe. Were "human rights problems . . . in Chile that much worse than in other countries in Latin America?" he asked state department aides. "Yes," the assistant secretary for Latin America said. "Is this government worse than the Allende government? Is human rights more severely threatened by this government than Allende?" Kissinger pressed his point. The assistant secretary reaffirmed the difference: "In terms of freedom of association, Allende didn't close down the opposition party. In terms of freedom of the press, Allende didn't close down all the newspapers." The assistant secretary conceded that "in terms of human rights . . . you have an argument. There was arbitrary arrest and torture" under Allende.

The response did not persuade Kissinger. He sarcastically told the Chilean foreign minister, "The State Department is made up of people who have a vocation for the ministry. Because there are not enough churches for them, they went into the State Department."

Few issues during Kissinger's tenure as national security adviser and secretary of state generated more controversy than his Chilean policies. He was and remains hypersensitive about the criticism. "It may seem strange that in a book describing my stewardship of affairs I should feel obliged to include a chapter on the downfall of Chile's President Salvador Allende," he writes in his memoirs. He described arguments that the United States planned his overthrow and was involved with the plotters as left-wing "political mythology." In Kissinger's telling, Allende's failure was the result of "his own incompetence and inflexibility."

Yet the reality is more complicated than Kissinger describes. The documentary record irrefutably demonstrates a Nixon-Kissinger determination, first, to prevent Allende's accession to power, and when that failed, a concerted effort to bring him down by use of America's considerable economic means and covert CIA funding of Allende's political opponents. It is accurate to say that U.S. operatives did not take a direct part in the coup that toppled Allende, and it may be reasonably argued that Allende's policies would have sooner or later led to his ouster. But it is impossible to argue this with any certainty since the United States made a significant contribution to destabilizing his government and fostering the conditions that persuaded the Chilean military to move against him. Whether the successor regime could have lasted for seventeen years without the initial backing of Washington between 1973 and 1977 is another part of the history that will be argued about for the foreseeable future.

Whatever history's judgment, Allende's ouster was of more than passing satisfaction to Nixon and Kissinger. They certainly thought that their steadfast opposition to Allende's rule had contributed to his political demise. Privately, they delighted in having "created the conditions as great as possible" that brought him down, and their skill in keeping their part so well disguised ("our hand doesn't show on this one"). In the midst of Watergate, they would have loved to take some credit for what they saw as a major gain for U.S. foreign policy in the hemisphere. But worried that any discussion of a U.S. part in Chile's change of government would provoke both a domestic and an international outcry, they kept their counsel.

BY CONTRAST, they could take advantage of the spectacular news on October 16 that Kissinger and Le Duc Tho had been awarded the Nobel Peace Prize for their work in ending the Vietnam War. Domestic and in-

ternational conditions, however, inhibited the White House from giving full voice to an administration triumph. Kissinger believed that Nixon received the news with mixed feelings. He yearned to be seen as a great American peacemaker, but the shadow of Watergate deterred the Nobel committee from giving Nixon his due for, as Kissinger generously put it, having made "the major decisions that had ended the Vietnam War." The fact that war continued in muted form across Indochina cast an additional shadow over what might otherwise have been a moment for national celebration. One newspaper made the point perfectly when it asked if Henry's prize was an "Honor without Peace?" Le Duc Tho's refusal to accept the award, "because the Paris agreement was not being implemented," confirmed feelings at home and abroad that the Oslo committee might have done better to call this year's peace prize "the Nobel War Prize."

In September and October, new domestic problems overshadowed Allende's replacement by a repressive pro-American regime and Henry's Nobel award. During the summer, Elliot Richardson, Nixon's new attorney general, told Haig that he had sufficient evidence to indict the vice president on as many as forty counts of wrongdoing as governor of Maryland, including accepting bribes and income tax evasion. After Nixon's lawyers reviewed the evidence, they recommended to the president that Agnew resign; but having Agnew as vice president was a kind of firewall against Nixon's impeachment. At the same time, however, it would deepen suspicions of Nixon's corruption if he tried to cover-up or sidetrack a compelling case against Agnew.

In August, Nixon backed down from a decision to ask for Agnew's resignation when the vice president launched a public defense of the charges against him as the product of a conspiracy. In September, after initially agreeing to a plea bargain with Richardson that would allow him to avoid prosecution in exchange for his resignation, Agnew reversed course and stated his intention to ask the House for an impeachment inquiry. He hoped this might forestall criminal proceedings against him in Maryland. But by October 9, Agnew caved in—he reached an agreement with Richardson that in return for freedom from prosecution, he would plead nolo contendere to a charge of income tax evasion and resign the vice presidency.

Nixon saw Agnew's resignation as another blow to presidential authority. He was especially concerned that the Russians would recoil from dealings with a weakened administration and turn away from détente, trying instead to reestablish better relations with Peking. It also worried Kissinger, but he urged the president to believe that "the more we function as a government the more these things will be seen as aspects of the past." Nixon hoped that in the end the Russians wouldn't see the Agnew problem as all that important.

Three days after Agnew quit, Nixon temporarily eased the crisis by announcing that he was asking Congress to confirm Gerald Ford, the popular, unassuming twelve-term Michigan congressman and Republican House minority leader, as vice president. At least three people close to Nixon believed that he selected Ford not simply because he would be a popular choice but because, as with Agnew, the House would not consider him competent to serve as president. The Democrats apparently were supportive of his selection as someone who seemed likely to be an easy mark in the 1976 presidential election. As Ford himself would say later, "I'm a Ford not a Lincoln." Yet such modesty would be an inducement rather than a deterrent to impeaching a president who had so overreached himself.

The eruption of an additional Watergate-related conflict on October 20 promptly washed away the relief felt at Ford's selection. In May, after the Haldeman and Ehrlichman resignations and Dean's firing, Richardson had appointed Harvard Law professor and Kennedy Democrat, Archibald Cox, as special Watergate prosecutor. Nixon couldn't have been unhappier with the choice, privately calling Cox a "partisan viper." At the end of July, after Butterfield's revelation about the White House taping system, Cox joined the Ervin committee in asking Nixon for seven tapes of conversations with John Dean. When Judge John Sirica instructed the president to comply, Nixon asked the U.S. Circuit Court of Appeals to overturn Sirica's ruling. But the Appeals court insisted that the White House release the tapes. Nixon then proposed a compromise: He would give summaries of the tapes to Sirica and ask Mississippi Senator John Stennis to verify the accuracy of the summaries by listening to the tapes.

The compromise was a ploy for dismissing Cox. Nixon knew that Cox was unlikely to accept summaries of the tapes—with or without Stennis's verification—which would then free the president to have an

excuse for firing Cox for insubordination. On October 19, Nixon released a statement describing the proposed compromise and invoked foreign affairs as a principal reason for bringing the Watergate conflict to a prompt conclusion: He would not appeal the circuit court's decision to the Supreme Court, he announced, for fear that the White House would be "paralyzed" in dealing with international dangers. The Nixon compromise also directed the special prosecutor to agree to forgo subpoenas for additional "tapes or other Presidential papers of a similar nature."

At a news conference on October 20, Cox stated that summaries were unacceptable as evidence in possible Watergate trials. Nor would he agree to the president's restriction on requesting additional tapes as inhibiting his freedom to conduct a full investigation. In response, Nixon instructed Richardson to fire Cox. "Brezhnev would never understand if I let Cox defy my instructions," Nixon told Richardson in a White House conversation. When Richardson refused to carry out Nixon's order and offered his resignation, Nixon asked him to hold off for a few days while he dealt with a Middle East crisis. Richardson turned him down, saying, contrary to the president's thinking, he was acting in the larger public interest.

It was another demonstration of Nixon's attempt to have foreign policy trump Watergate. After deputy attorney general William Ruckelshaus also refused to execute Nixon's order, Robert Bork, the solicitor general, complied. The White House then announced the firing, resignations, elimination of the special prosecutor's office, and return of the Watergate investigation to the Justice Department.

The "Saturday Night Massacre," as the press dubbed the events of October 20, deepened rather than relieved Nixon's troubles over Watergate. Members of Congress, the press, and public compared Nixon's actions to those of a dictator or someone with no genuine regard for the rule of law. The president's approval rating fell to an unprecedented 17 percent. "The 'firestorm' following Cox's dismissal and his superiors' resignations had given a new momentum to events," Watergate historian Stanley Kutler wrote, "a momentum that . . . ensured that Nixon could not thwart any investigation of his actions."

Similarly, Nixon's ill-advised actions during October provoked Congress into passing a War Powers Act. Disillusionment with presidential leadership in taking the United States into the costly and unsuccessful

Vietnam conflict made Congress eager to rein in the executive's war-making authority. Although Kissinger told the Foreign Relations committee during his confirmation hearings that a war powers bill "will make war more likely" by encouraging other governments to see the United States as less able to counter international aggression, the Congress ignored his advice.

On October 12, with Nixon resisting court-ordered release of his tapes, the House had passed a War Powers Act that required the president to notify Congress within forty-eight hours of military actions. After sixty days, the president would have to cease using force unless Congress authorized its continuation. The Senate had followed the House lead on October 14 by passing a similar bill. On October 24, Nixon vetoed the law as a "serious challenge to the wisdom of the Founding Fathers" and an assault on the president's constitutional authority.

Nixon fought back against the mounting tide of opposition in a news conference on October 26. He tried to focus attention on a Middle East crisis and disarm criticism of his recent Watergate actions by announcing that he was turning over tapes to Judge Sirica and appointing a new special prosecutor. Reporters were not appeased. They pressed him on Watergate issues, asked if he were considering resigning, and wondered whether his loss of standing with the public was not also eroding his ability to conduct foreign policy. He defiantly attacked the media coverage of recent events, saying the press's "frantic, hysterical reporting" was undermining public confidence in him. Nevertheless, he would not be deterred from doing his job. Was he angry with the press? a reporter baited him. "Don't get the impression that you arouse my anger," Nixon said. "I'm afraid, sir, that I have that impression," the reporter responded to much laughter. "You see," Nixon replied, "one can only be angry with those he respects."

The reporters wanted to know if Nixon had any plans for regaining the confidence of the people. He candidly replied that he would continue working to build a structure of peace with initiatives toward Europe, the Soviet Union, and the People's Republic of China.

On November 7, the Congress overrode Nixon's veto of the War Powers Act. The act proved to be much less effective in reining in presidential war-making power than believed at the time. It was principally symptomatic of the distrust for a president who could not escape the

shadow of Watergate. The act did less to inhibit the presidency than to demonstrate that Nixon had lost his capacity to govern. Texas Republican Senator John Tower saw the Congress as moved by "the hysteria of Watergate and desire to punish this President." He warned Congress against making "the power of the President . . . a victim of our emotions on Watergate." But nothing Nixon could say or do now could sidetrack the court inquiry into his actions; on October 22, two days after Cox's firing, the House Judiciary Committee began discussing impeachment proceedings against the president.

NOT EVEN A WAR Egypt and Syria launched against Israel on October 6, a conflict that continued through the domestic battles of the next three weeks, could divert attention from the White House crisis. It was not from want of trying—the White House made every effort to focus public concern on what was possibly the most serious international crisis of Nixon's presidency. The conflict had the potential to draw the United States and the U.S.S.R. into a wider war, but also to open the way to a new round of Middle East negotiations that could relieve many of the tensions that had destabilized the region since the creation of Israel in 1948. The burden of Watergate compounded the difficulties of avoiding the dangers and seizing the opportunities raised by the war.

Initially, the outbreak of fighting did not reflect well on the White House. How could the onset of another Middle East conflict have surprised an administration so avowedly attentive to foreign affairs? Most everyone in the Israeli and American governments agreed that the Egyptians would not dare to start a war that they could not win. In May 1973, Egyptian National Security Adviser, Hafiz Ismail, reinforced this assumption by telling Kissinger that "military action would be 'too adventurous' now." It may have been part of Egypt's plan to surprise Israel and its supporters, but Kissinger took Ismail at his word.

Washington and Moscow were not indifferent to the possibility that a new Mideast war could draw them into the conflict. But their inability to come up with viable proposals for muting Arab-Israeli tensions encouraged inclinations to rely on wishful thinking that the two sides were unlikely to fight another war.

In August, during a conversation with Kissinger, Dobrynin "turned to the Middle East in a rather resigned way." He acknowledged that "he

did not know what the bargaining conditions would be." Only if the Arabs could demonstrate a significant capacity to match Israel's military strength, would they have a chance of regaining lost territories and pride that could open the way to some kind of lasting truce. And since the gap in military capacities between Israel and the Arabs seemed as great as ever, Dobrynin did not anticipate an outbreak of fighting any time soon.

Sadat believed that Egypt could best come to terms with Israel by standing up to it in another war and had made every effort to prepare his armed forces for the conflict. Consequently, he shrewdly surprised Tel Aviv on the morning of October 6, Yom Kippur, the holiest day on the Jewish calendar, by attacking Israeli forces in the Sinai while Syria struck at them in the Golan Heights. A combination of effective preparations for the attack and the surprise allowed the Egyptians and Syrians to win opening-day victories.

The White House promptly defined its response to the conflict as assuring, first, that the United States and the U.S.S.R. not be drawn into the fighting, which could threaten a nuclear confrontation between the two superpowers. Second, it intended to ensure against any decisive Israeli or Egyptian defeat. If the conflict produced something resembling a standoff, it could open the way to a viable peace arrangement, which had eluded negotiators since 1967. Moreover, the White House wanted to avoid the appearance of one-sided backing for Israel. The war could produce an oil embargo by Arab states and hurt not only the United States but also NATO allies and Japan, risking serious tensions with them. Third, Nixon, Kissinger, and Haig hoped that they could convert the crisis into a comeback for the president against domestic opponents, who increasingly believed that they could drive Nixon from office.

While Kissinger was clear on the first two aims in response to the war, he was uncertain about the third goal. Could a politically crippled president effectively deal with the hour-to-hour and day-to-day decisions confronting his administration in the evolving crisis?

Because Henry was not sure, he centered control of the crisis in his own hands. For two and a half hours after he heard about war dangers from the Israelis at 6 A.M. on October 6, he did not consult Nixon, who was in Key Biscayne, Florida, where he had taken shelter from mounting judicial and congressional pressures. At 8:35 A.M., Henry called Haig, who was with the president, to report on developments in the Middle

East. He said, "I want you to know . . . that we are on top of it here." To ensure that the media not see Nixon as out of the loop, Henry urged Haig to say "that the President was kept informed from 6 A.M. on . . . I think our domestic situation has invited this" war.

Forty-five minutes after speaking with Haig, Kissinger asked Dobrynin to meet with him in the afternoon. They needed "to first not have everything we have achieved destroyed by maniacs on either side, and after quieting it down to see what can be done constructively." When Kissinger finally called Nixon at 9:25 A.M., the president left matters in Henry's hands. But he asked that Kissinger "indicate you talked to me."

At 9:35 A.M., Kissinger called Haig again. They discussed how to work with the Soviets to bring the fighting to a halt. When Haig reported that Nixon was considering returning to Washington, Henry discouraged it. He also urged Haig to keep Nixon's "Walter Mitty tendencies under control." Later in the day, Kissinger sent the absent president a detailed summary of the fighting.

Over the next three days, Kissinger oversaw the diplomatic exchanges with the Israelis and Soviets about the war, which had become a fierce struggle with significant losses on both sides. Golda Meir's requests for military supplies, which were beginning to run low, came not to Nixon but to Kissinger. Although he consistently described himself as representing the president's wishes, outsiders saw Henry as the principal U.S. official through whom business was conducted. On October 7, for example, a Brezhnev letter to Nixon was a response to "the messages you transmitted to us through Dr. Kissinger." On October 9, a message to King Hussein of Jordan urging continued noninvolvement in the conflict came not from Nixon but Kissinger. Similarly, on the same day, it was Kissinger, not the president, who briefed a bipartisan group of congressional leaders about the war.

Between October 6 and 9, the days immediately preceding Agnew's resignation and of White House preoccupation with an imminent appeals court ruling on the tapes, Kissinger consistently took the lead in deciding how Washington should respond to the war. This is not to suggest that Henry bypassed the president. To the contrary, he spoke to him repeatedly during these four days. But it was Henry who initiated the calls, kept track of the fighting, and proposed U.S. reactions to developments. On the evening of October 7, for example, Nixon asked Kissinger

if there was any message from Brezhnev. "Oh, yes, we heard from him," Henry replied. Nixon wanted to know, "What did he say?"

On October 9, the Israeli ambassador called Kissinger at one-thirty in the morning to warn that Israel was losing the war and desperately needed supplies. Kissinger discussed the issue later that morning with defense secretary James Schlesinger. Schlesinger resisted a major rearmament of Israel as likely to provoke an Arab oil boycott. He believed that it was one thing to assure Israel's survival, but another matter to endorse its hold on captured territories. Kissinger also opposed guaranteeing Tel Aviv's long-term occupation of the Sinai, the West Bank, and the Golan Heights, but he wished to assure against a decisive Arab victory that could do as much to undermine long-term peace prospects as a one-sided Israeli success. Later that afternoon, he persuaded Nixon to ignore Schlesinger's advice and allow him to begin a large-scale resupply of Israel that would allow it to achieve a balanced outcome to the fighting.

A distracted Nixon was content to let Kissinger set policy direction, but he was eager to create the impression that he was managing everything. On the afternoon of October 7, when Henry suggested what the White House should tell the press about U.S. policy, Nixon responded, "You go ahead and tell Ziegler whatever you want." At the same time, the Florida White House described Kissinger as "in constant contact with the President." On the evening of October 7, Nixon told Henry, "PR is terribly important."

On October 10, with the Egyptians and Syrians continuing to give the Israelis a hard fight, Hal Sonnenfeldt, Kissinger's NSC aide, advised him that the Soviets were stalling on supporting a cease-fire at the UN. The possibility of an Israeli defeat would give Moscow the opportunity to expand its role in the Middle East. Moreover, Sonnenfeldt speculated, "Watergate, Agnew, energy jitters, the President's stake in détente—all of this and more may lead the Soviets to judge that their room for maneuver is considerable."

On the same day, while Nixon decided on Agnew's replacement, he and Henry did not discuss pressing Middle East issues. During a conversation with Haig about Agnew's departure and a possible replacement, Kissinger said, "Al, I wonder if I can take your mind off the domestic for a bit." They needed to consider what to do about a UN cease-fire resolution. Did Haig understand "that this may draw some flack . . . And the

president is aware?" Henry asked. Kissinger wanted Nixon to understand that what they did could have serious repercussions both in the Arab world and among Israel's American supporters. During a conversation with Ziegler, Kissinger urged him "not to talk [to the press] about the Vice President, but speak firmly and positively about foreign policy."

Nixon's inattentiveness to the international crisis continued into October 11. During a morning telephone conversation with Kissinger, he focused on press stories that "we are not supporting Israel. I will not tolerate this," Nixon exclaimed, "and if I hear any more of this I will hold him [the Israeli ambassador] responsible." Nixon wasn't interested in the fact that problems arranging supply shipments to Israel had provoked the press reports. His principal concern was less in bolstering the resupply effort than in ensuring that his domestic political standing not be further eroded. (It was Kissinger who took responsibility for Israel's resupply.)

At seven fifty-five that night, Brent Scowcroft, Haig's replacement as Kissinger's deputy at the NSC, called Kissinger to report that the British prime minister wanted to speak to the president in the next thirty minutes, which was one-thirty in the morning in London. Although it would be only eight-thirty in the evening in Washington, Kissinger asked, "Can we tell them no? When I talked to the President he was loaded." Scowcroft suggested that they describe Nixon as unavailable until the morning, but that the prime minister could speak to Kissinger. "In fact, I would welcome it," Kissinger told Scowcroft to say.

What seems most striking in this exchange is how matter-of-fact Kissinger and Scowcroft were about Nixon's condition, as if it were nothing out of the ordinary. It was as if Nixon's drinking to excess had become part of the routine with which they had to live. They showed no concern at having to deny the prime minister access to the president. Since Henry was the one principally dealing with the crisis, they were comfortable having Kissinger confer with Prime Minister Edward Heath, America's most important ally.

Although Nixon would publicly pronounce on U.S. policy in the Middle East at a White House ceremony for Vietnam Medal of Honor winners on October 15 and would privately discuss the current crisis with Arab foreign ministers on October 17 and with his cabinet on October 18, it was Kissinger who continued to dominate policy discussions. After the medals ceremony, Scowcroft asked Henry if he had heard the

president's remarks, "Yes, I am throwing up all over," Kissinger replied. "He made it sound like we were sending in troops and the press got it that we were considering intervention." Neither Kissinger nor Haig trusted Nixon to deal with the Middle East. When U.S. oil executives sent the president a memorandum on the dangers to their interests from the war, Haig passed it first to Kissinger for comment before sending it on to Nixon.

Between October 6 and October 19, Moscow and Washington tried to outdo each other in supplying their respective Middle East clients. Abundant supplies of aircraft, artillery, tanks, antiaircraft missiles, and ammunition produced battles that exceeded in men and matériel the North African clashes during World War II.

Although exchanges between Brezhnev and Kissinger emphasized their mutual eagerness for continued discussions promoting détente, the Middle East conflict increasingly threatened to undermine prospects for better relations. Initially, with the Egyptians and Syrians doing well in the fighting, the Soviets resisted calls for a cease-fire. But at the end of two weeks, with the conflict turning against them and Israel in control of parts of Egypt's Sinai Desert and Syria's Golan Heights, Brezhnev became insistent on a truce. On October 19, he urgently asked that Kissinger fly to Moscow for prompt discussions on ending the war. With the Israelis on the verge of defeating the Egyptians and the Syrians, Kissinger shared Brezhnev's interest in halting the conflict before Israel thoroughly routed them and made productive postwar Arab-Israeli negotiations as unlikely as before the current fighting.

On October 19 and October 20, as Kissinger flew to Moscow, Nixon's first concern was the rapidly escalating conflict with Cox, Richardson, and Ruckelshaus. He was giving Henry full authority to negotiate for him, Nixon wrote Brezhnev. Any commitment Kissinger made would have his "complete support." He then asked Kissinger to tell Brezhnev that he remembered his warning at San Clemente about a war and wanted Henry to say that "only the U.S. and the Soviet Union have the power and influence to create the permanent conditions to avoid another war . . . The Israelis and Arabs will never be able to approach this subject by themselves in a rational manner."

Kissinger bristled at what he considered Nixon's ill-considered intervention. He cabled Scowcroft. "I was shocked at the . . . poor judg-

ment in the content of the Brezhnev letter." Henry was eager to string out the negotiations with Brezhnev until the Israelis consolidated their gains and established better conditions for future negotiations. But the grant of "full powers" Nixon described to Brezhnev made it impossible for Kissinger to delay commitments to a cease-fire by saying he had to consult Washington. In addition, Henry saw any agreement to negotiate independently of Israel as a prescription for failure in future talks. "My position here is almost insoluble," he complained. "If I carry out the letter of the President's instructions, it will totally wreck what little bargaining leverage I still have." Because he considered Nixon's instructions "unacceptable," he intended to follow a more appropriate course. He cabled Haig: "I am counting on you to get this situation under control and quickly."

Nixon lodged no objection to Kissinger's decision to follow his own counsel in the negotiations, though he was unhappy at Kissinger's assumption of presidential authority. He made his annoyance clear to Scowcroft, who urged Kissinger to understand that Nixon was trying to demonstrate "his leadership in the crisis." His actions "were designed to illustrate that he was personally in charge . . . The development of this [current] domestic crisis gave additional impetus to efforts Saturday to show that the President's ability to govern was unaffected by the Watergate related turmoil." Scowcroft also assured Henry that he and Haig "are doing our best" to manage the president.

Nixon was in no position to argue with Kissinger. Scowcroft advised Henry on October 20 that Nixon "was devoted exclusively to the Watergate tape crisis." The next day Scowcroft described the president as in a "subdued mood" and "very relaxed with respect to the Middle East issue . . . My overall impression of the President's mood is that he is quite preoccupied with the domestic situation and much more passive toward your mission and the Middle East crisis." With the White House almost desperate now to illustrate the virtue of having Nixon as president, Scowcroft seized upon Kissinger's observation that "a quick Middle East settlement . . . [would] demonstrate to our critics the concrete benefits of détente," or the virtue of having a president who understood how to deal with Moscow.

With Kissinger and Brezhnev agreeing on October 21 to put cease-fire and long-term negotiating proposals before the Security Council, Haig congratulated Henry on "your Herculean accomplishment." But he warned him that "you will be returning to an environment of major

national crisis" brought on by the "Saturday Night Massacre." Because the situation was "at a stage of white heat, the ramifications of the accomplishments in Moscow have been somewhat eclipsed . . . For this reason it is essential that . . . a major effort be made to refocus national attention on the President's role in the Middle East settlement, an impeachment stampede could well develop in the Congress tomorrow, although we are confident that cooler heads will prevail if the President's assets are properly applied."

Haig explained that Henry would need to join Nixon at a bipartisan congressional leadership meeting at the White House on October 23. Henry would report on Middle East developments, "lacing this report with heavy emphasis on the President's accomplishments thus far and the need for national unity and a steady hand in the critical days ahead." Henry was also asked to brief the press and "refocus national attention on the critical events in the Middle East, and to emphasize above all the crucial role of Presidential leadership." Haig said he was mindful of "the risks that might be associated with hyping the Middle East at a critical juncture in the negotiations." But with Nixon's political survival at stake, Haig saw it as necessary to make the case for the president.

Kissinger shared Haig's conviction that they needed to boost the president in the midst of the Watergate crisis. Henry believed that "we could preserve the strength and coherence of our foreign policy only if we ensured beyond peradventure that we would not let Watergate affect our actions."

Consequently, on October 23, he called a number of congressmen to stress Nixon's part in arranging the UN-sponsored cease-fire in the fighting with the help of the Soviets. But he resisted a Nixon proposal that he hold an open meeting with news chiefs, in which he described Nixon's "indispensability" in managing foreign affairs. It struck him as "public relations . . . overkill." It was one thing privately to argue against undermining Nixon's effectiveness in foreign relations, but it was another to overtly make a case that would inject Henry directly into the domestic political conflict and make it seem that he was using foreign policy to blunt a crisis of confidence in the president. It could encourage cynicism about foreign policy and undermine public support for crucial actions overseas.

Kissinger and Haig had a possible alternative to "hyping the Middle East at a crucial juncture in the negotiations, though they apparently

never considered it." The Twenty-fifth Amendment to the Constitution provided for suspension of presidential authority when the chief executive was "unable to discharge the powers and duties of his office." It required a written declaration from a disabled president, which Nixon would not have given, or from a majority of "the principal officers of the executive departments," which, according to Haig, was never discussed. And for good reason. Nixon undoubtedly would have fought any such suggestion as an internal political coup. The cabinet would then have needed to demonstrate that the president was incapable of meeting his responsibilities. But one can only imagine that Nixon would have risen to the challenge by demonstrating his capacity to speak coherently to the public. In addition, with no sitting vice president—Ford was not confirmed until December 6—suspending Nixon's authority would have meant turning to House Speaker Carl Albert, a Democrat. It would have provoked complaints that the cabinet was reversing the results of the 1972 election.

Was Nixon in fact that unstable or so distressed that he couldn't deal effectively with a foreign crisis? The answer is "yes" and "no." The contemporary evidence, to which the press and public were not privy, demonstrates that Nixon was not functioning at full capacity. In addition, there are now Kissinger's recollections that in October 1973 "Nixon no longer had the time or nervous energy to give consistent leadership."

Yet he was rational enough to convince himself and others around him that he could manage the Watergate challenge at the same time he relied on Kissinger, Haig, and Scowcroft to deal with Middle East problems. As Kissinger said of the president's response to the war, "as always in crises, Nixon was clearheaded and crisp." And Nixon himself emphasized the point at his October 26 news conference. When Jerald terHorst of the *Detroit News* asked how he was "bearing up emotionally under the stress of recent events," Nixon replied, "rather well . . . the tougher it gets, the cooler I get."

But this was a president who was erratic or not in full control of his emotions. If the well-being of the nation had been his first priority, he would have considered speeding Ford's confirmation and temporarily stepping aside until the Watergate crisis was resolved. It would have allowed an acting president to devote his full attention to overseas problems. Because Nixon understood that a full airing of his Watergate actions would permanently bar his return to the Oval Office, he would not

suspend his presidential powers. He believed it better to let the Watergate battle continue in the courts, where he hoped executive privilege might give him enough cover to avoid impeachment and conviction for high crimes and misdemeanors.

As developments in the week after Kissinger returned from negotiations in Moscow made clear, the Middle East crisis remained too dangerous to have a distracted president in command. Initially, on October 23, Kissinger was convinced that "events of the last two weeks have been on the whole a major success for the United States." He told a meeting of state department officials that without détente "this thing could have easily escalated." He also believed that they were now in "a better position to bring about a permanent settlement."

His euphoria was short-lived. On the afternoon of October 23, Moscow and Washington began exchanging messages on the hotline about Israeli and Egyptian violations of the cease-fire. The Soviets were particularly concerned about the Egyptian Third Army, which was cut off in the Sinai and at Israel's mercy for resupply of food and medical provisions. By 10 P.M. on October 24, Brezhnev complained that Israel was ignoring the cease-fire and proposed a joint military intervention to implement the agreement. Brezhnev warned that if the United States would not agree to this, Moscow might decide to act alone. Earlier that evening, Kissinger had cautioned the Soviets against unilateral action. "We were determined to resist by force if necessary the introduction of Soviet troops into the Middle East regardless of the pretext on which they arrived," Kissinger recalled.

In the midst of these developments, Nixon called Kissinger. But not to discuss the Middle East; he was, Kissinger said, "as agitated and emotional as I had ever heard him." The call confirmed what Haig had told Kissinger on the evening of October 23: "How is his frame of mind?" Henry had asked. "Very down, very down," Haig had replied. Nixon was anguished over the possibility that the House might impeach him. When he spoke to Kissinger at 7:10 in the evening on October 24, Nixon said: "Now that you have your ceasefire abroad, how are you going about a ceasefire at home?" Henry replied, "I have been calling various people again." He said that he had told Senator Henry Jackson that "the primary thing is to keep our authority and if he is that interested in Israel he better get in line." Kissinger warned others in Congress, including Hubert

Humphrey, "that this thing is on a razor's edge and we need the full authority of the government and keep in mind what is at stake."

Nixon wanted Kissinger to use a briefing on October 25 to tell congressional leaders of "his central, indispensable role in managing the Mideast crisis." He was distraught, telling Henry that his enemies wanted "to kill the President. And they may succeed," he said. "I may physically die." Kissinger said later, "We were heading into what could have become the gravest foreign policy crisis of the Nixon Presidency . . . with a President overwhelmed by his persecution."

After receiving Brezhnev's message, Kissinger and Haig agreed to convene a meeting at the White House of national security officials. Haig had convinced Henry to shift the meeting from the state department to the White House as a way to give the impression that Nixon was "a part of everything you are doing." Nixon in fact was asleep. "Should I wake up the President?" Henry asked Haig during a 9:50 P.M. conversation. "No," Haig answered. A half-hour later, Haig asked Kissinger, "Have you talked to the President?" Kissinger replied, "No, I haven't. He would just start charging around . . . I don't think we should bother the President." They thought he was "too distraught to participate in the preliminary discussion." (Was he on sedatives that would not allow him to function effectively?)

It was an amazing turn of events: None of the seven officials who met for over three hours until 2 A.M. had ever been elected to anything by voters. Yet they were setting policy in a dangerous international crisis. Kissinger rationalized Nixon's absence by saying that he had never attended WSAG meetings. However, the WSAG had never confronted a crisis of this gravity before. More important, the group made decisions that should only come from the president, though Kissinger and Haig were confident that they reflected the President's views. Others at the meeting were not so sure: "You and I were the only ones for it," Kissinger reminded Haig the next day. "These other guys were wailing all over the place." Less than halfway through the meeting, they agreed to direct U.S. military forces to raise their level of readiness from Defense Condition or DefCon IV to DefCon III, "the highest stage of readiness for essentially peacetime conditions." The alert was coupled with a message delivered to the Soviet embassy at 5:40 in the morning on October 25. While reassuring Brezhnev that increased numbers of UN observers

could effectively police the cease-fire, the message described "your suggestion of unilateral action as a matter of the gravest concern involving incalculable consequences."

The message and the alert, which became worldwide news, had an immediate desired effect. The Soviets and the Egyptians declared their readiness by the afternoon to accept a larger observer force, which would not include U.S. or Soviet troops. Washington then announced that the alert would end by midnight. Although it would take until October 28 to establish a stable cease-fire, the crisis had ended with Soviet-Egyptian acceptance of the proposal for an expanded UN role.

Throughout the Middle East war, Nixon had passively conceded decision making to Kissinger. Although the White House issued a memo describing Nixon's decision to increase the alert level of U.S. forces on the night of October 24–25, it was Kissinger and the six other national security officials who chose to do it.

On October 25, after the alert had succeeded in restraining Moscow from sending troops to Egypt, a reporter asked Kissinger, "Was this [alert] a rational decision by the President?" Kissinger told Nixon, "[I] said it was [a] combination of the advice of all of his advisers—that the President decided to do this." Henry told Haig, "I think I did some good for the President." Haig replied, "More than you know." They agreed that without the alert "we would have had a Soviet paratroop division in there this morning," Henry said. "You know it, and I know it," Haig responded. "Have you talked to the Boss?" he asked. "No," Henry said at 2:30 in the afternoon. "I will call him. Let's not broadcast this all over the place otherwise it looks like we (cooked) it up."

When Kissinger called Nixon, the president asked Henry to come to the White House for appearances' sake. "You did a hell of a job," Nixon told him. Nixon wanted Henry to tell the press that the president had saved Israel and that Speaker of the House Carl Albert (the next in line for the presidency without a vice president) wouldn't have been up to the challenge.

Although Kissinger was willing to promote the fiction that Nixon effectively managed the crisis, he continued to doubt the president's capacity for current sensible leadership. After Nixon's news conference on October 26, in which he described himself as pressuring Brezhnev into a settlement, Kissinger told Haig, "The crazy bastard really made a mess

with the Russians." He said Nixon's description of the "massive move-
ment of Soviet forces" was "a lie." His depiction of a Soviet back down
was true enough, "but why rub their faces in it?" Henry said. He feared
that the president's remarks would make it "look like he is taunting Brezh-
nev . . . This guy will not take this. This guy over there is a maniac also."
As far as Henry was concerned, Nixon "just looked awful."

When Haig reported that "we are getting great reaction" to the han-
dling of the crisis, Kissinger urged Haig not to tell Nixon, "or he will
do it again. You know what he did. He made Brezhnev a Khrushchev,"
meaning Nixon had humiliated Brezhnev the way JFK had embarrassed
Khrushchev in the Cuban Missile Crisis.

Nixon and his aides were distressed at the intrusion of Watergate
tensions into the making of foreign policy. Kissinger believed that Mos-
cow never would have threatened unilateral military intervention in the
Middle East if Nixon had been "a functioning President . . . They find a
cripple facing impeachment and why shouldn't they go in there?" Henry
told Haig. In addition, Kissinger was upset at accusations that the alert
was done for domestic political reasons. "If our country has reached the
point where people think that the government orders an alert for other
than overwhelming reasons then we are in an impossible situation," he
told James Reston.

But the way through this problem was not passing off power to
subordinates or trying to mute discussion of whether the president had
committed impeachable offenses. Rather, it was for Nixon to have sus-
pended his authority until his culpability could be determined. In the
meantime, either Gerald Ford or House Speaker Carl Albert, neither of
whom was tainted by Watergate, could have sat in his place. But Nixon
refused to believe that either of them could effectively replace him, and
Kissinger reinforced his assumption. "Can you see Carl Albert in this
crisis?" Henry asked the president on the evening of October 24. "He
would be running it from Walter Reed hospital," Henry said, suggesting
that Albert would have a nervous collapse. "And Gerry Ford, fond as I
am of him, just doesn't have it."

Kissinger neglected to say that a new acting president, especially a
Democrat, would reduce Henry's and Haig's authority. Nixon, Kissinger,
and Haig believed themselves irreplaceable. They assumed that they had
an understanding of foreign policy that Ford and Albert lacked. Either

of them might scrap the initiatives that had been put in place over the previous four and a half years and jeopardize the national well-being, or so Nixon and his collaborators feared. Better, then, in their judgment to leave a crippled president in place and rely on a secretary of state and chief of staff to continue building the administration's "structure of peace."

The fact that the crisis ended without a Soviet-American military confrontation and with a groundbreaking agreement by Egypt to hold direct talks with Israel to rescue its Third Army, which was still surrounded, represented a significant gain for Nixon's foreign policy. The Yom Kippur War then became not a cautionary tale of the need for an engaged president but a reinforcement of the belief that a weakened president could rely on skilled subordinates to effectively manage an overseas crisis. Moreover, the success was an argument for discouraging investigators from pursuing Watergate charges that might play havoc with the country's national security by bringing Nixon down.

THE NIXON-KISSINGER PRESIDENCY

"I am not President until this G[od]D[amn] constitutional amendment" allowed a foreign-born to hold the office. Of course, there is nothing in the Constitution *"against [my] being emperor."*

—Henry Kissinger joking with
Brent Scowcroft, January 30, 1974

My way of joking is to tell the truth. It's the funniest joke in the world.

—George Bernard Shaw, 1907

On October 30, the House Judiciary Committee, by a partisan vote of 21 to 17, granted Peter Rodino of New Jersey, its chairman, subpoena powers to open impeachment hearings against the president. Nixon countered the committee's action on November 1 by announcing the appointments of Ohio Republican Senator William Saxbe as the new attorney general and Texas Democrat and former head of the American Bar Association Leon Jaworski as the new Watergate special prosecutor. Both men were notable for their independence from White House influ-

ence. Although Jaworski had chaired "Democrats for Nixon" in Texas in 1972, one Texas Republican privately warned Nixon that Jaworski was "an extreme liberal"; the president would "live to regret" his appointment.

On the same day, news that two of the nine tapes subpoenaed by Sirica were missing eclipsed the good impression made by the Saxbe and Jaworski appointments. A White House explanation that the missing conversations were not recorded deepened suspicions that Nixon was hiding his involvement in the scandal. The revelation produced a fresh barrage of public calls for Nixon's resignation, from some Republicans as well as Democrats.

For Kissinger and Haig, the principal challenge was still to make foreign policy an effective argument against impeaching the president. Specifically, they hoped to use the Middle East cease-fire to Nixon's advantage by turning it into viable peace talks.

For Kissinger, it was like being in the eye of a storm. He had to deal with a distracted president, unbending Israeli and Egyptian negotiators, and a U.S. defense secretary convinced that we needed to send troops to the Middle East to ensure the continuing flow of oil to the West. "He is insane," Kissinger told Haig about Schlesinger. "I do not think we can survive with these fellows in there at Defense—they are crazy . . . Will you please help me with him?" Henry asked Haig.

Nixon pressed Kissinger to ensure that congressmen saw the president as indispensable to effective Middle East negotiations. On October 29, after Henry had a closed-door session with the House Foreign Affairs committee, he told Nixon, "I really hit them about the crisis." The president asked: "They got the feeling that the President was on top of the damn thing?" Henry replied: "Absolutely. I told them. This constant attack on domestic authority is going to have the most serious consequences for our foreign policy." Nixon complained that he had "to deny that publicly," but he urged Kissinger to "say it because it is totally true."

Arranging a longer-term truce between Tel Aviv and Cairo was as daunting a task as bringing the Vietnamese together. "I think these various maniacs are going to work me into a nervous breakdown," Kissinger complained to Nixon about the Israelis and Egyptians. When Henry told Haig that he was "working on the oil problem," Haig declared, "Good . . . that is where we have to get something." But Henry feared

that Nixon might jeopardize his efforts: "We will get it," he told Haig, "as long as we keep him [Nixon] from getting over eager . . . He shouldn't give any bullshit about how much he loves Cairo and how much he wants to go there."

As he prepared to go off to the Middle East on November 6, Kissinger wanted Haig and Scowcroft to assure him that Nixon was under control. Specifically, he worried that Dobrynin might get in to see the president and extract unwise commitments. "I have to talk with you about how to conduct yourself while I am gone," he told Scowcroft. "I am sure the Russians will try something . . . to get hold of the President. It is essential they don't get anything I didn't give them."

Nixon, Kissinger, and Haig shared the conviction that talk of impeaching the president was jeopardizing their foreign policy. They endorsed Nixon's impulse to fight back with everything at his command. "Don't be panicked by the *New York Times* calling for resignation," Nixon told Kissinger as he was about to depart on his trip. "I don't pay any attention to it," Kissinger assured him. Nixon reinforced Kissinger's resolve by saying that his opponents "don't really realize what that would do to the country . . . We're going to stand firm, old boy," Nixon declared. Henry said that the current battle was nothing more than what had been going on since the start of Nixon's presidency. Nixon was confident they could survive, even with his approval rating at only twenty-five percent.

Kissinger's strategy in his Middle East talks, first in Morocco and Tunisia, and then in Egypt, Jordan, Saudi Arabia, and Iran was to establish a more durable truce between Cairo and Tel Aviv; and by so doing, convince the Arab states that successful negotiations ran through Washington and not Moscow and that an oil embargo, which they had started against the West and Japan in response to America's resupply of Israel, was counterproductive to their long-term interests. The oil-producing states understood otherwise. Withholding cheap energy from the West was an effective means of punishing it for supporting Israel and compelling it to meet at least some Arab demands.

On November 7, Kissinger met with Sadat at the president's palatial headquarters in suburban Cairo. He was the child of Egyptian peasants whose aristocratic bearing made him seem taller and more imposing than Henry had anticipated. Both of them affected a "nonchalance" that belied the seriousness of their meeting. It may have expressed their mutual

determination to find common ground in meeting the grave differences that separated them. Once they set aside initial diplomatic inanities, they quickly agreed to extend the existing cease-fire and to propose additional steps to Israel on behalf of disengagement. They also agreed to a resumption of diplomatic relations, which had been broken since the 1967 war. Relying on their considerable skills as master psychologists, the two men eased existing hostility between their countries by convincing each other that a prompt agreement would serve their respective interests. "K— Congratulations—great job," Nixon scribbled on a Scowcroft memo summarizing the results of the talk.

Nixon tried to capitalize on Kissinger's success. Understanding that effective White House leadership to overcome a gas shortage produced by the oil embargo offered a significant opportunity to raise his standing with the mass of Americans, Nixon spoke to the country on the evening of November 7. Because it was a problem that required national solutions to which every American could contribute, Nixon tried to rally the country by proposing a variety of conservation measures and congressional action that could increase energy supplies. Not content to focus public attention on the energy problem, however, he closed his speech with a recitation of administration achievements, a defense of his integrity, and a rejection of suggestions that he resign. Because his closing remarks came across as self-serving, he did more to exacerbate than ease his Watergate difficulties.

As a follow-up to his speech, Nixon had Haig cable Kissinger in Cairo that "due to overriding necessity to reinforce confidence here, the President feels strongly that there should be no, repeat, no announcement of any easing of oil restrictions . . . if you are also able to add this feather to your cap." Nixon wanted any announcement to come from the White House, but only after he had met with Saudi Arabia's King Faisal in Washington. Haig predicted that such a development would "assist us in dramatically healing recent wounds." Haig said he sensed a sharp upturn in public approval.

Kissinger replied at once pledging his commitment to a White House announcement on any oil accord. But he warned that an invitation to Faisal to meet in Washington would be "total insanity." An easing of the oil embargo would be far easier to arrange as an unannounced de facto action than a "public Arab policy . . . Invitation to Faisal would be in-

terpreted throughout Arab world as U.S. collapse. It would magnify, not reduce, Arab incentives to keep pressure on us via oil weapon." Kissinger "absolutely insist[ed] that P.R. tendencies must be kept under control. We could lose everything if these hotshot schemes are allowed to wreck negotiations." He threatened to resign—if Nixon insisted on following his proposed course, he did not see "how it was possible for me to continue in this job."

Kissinger couldn't resist parodying Nixon's demand for public credit. "If present negotiating phase produces dramatic success," he told Haig, "perhaps we can arrange ecumenical joint communiqué at presidential tête-à-tête with Faisal and Golda in a New York synagogue just at Christmas Hanukkah season. Would be great photo opportunity." Henry's message made its point: "Touché!" Haig responded. "Your message is clear. All is under control and President has accepted overwhelming logic."

For another week, between November 8 and 14, Kissinger traveled to Jordan, Saudi Arabia, Iran, Pakistan, China, and Japan. The only notable discussions were in Riyadh and Peking. Persuading the Saudis to ease the oil embargo was crucial for ending the energy crisis. Kissinger won a sympathetic hearing when he pointed out that the embargo strengthened the hand of the president's opponents in the United States, who were also Saudi antagonists. The Saudis hoped to get the oil flowing again after Washington announced plans for a Middle East peace conference Kissinger intended to schedule for Geneva in December.

In China, Kissinger received his "usual cordial welcome" with warm approval for U.S. efforts to reach a Middle East settlement without significant Soviet involvement. Mao's expressions of support for the president privately and in front of the Chinese press pleased Nixon. Mao worried, however, that Watergate might return the Democrats to power and result in an isolationist policy. Henry assured Mao that the president was "sure to master the situation."

The visit ended with "a positive joint communiqué" that expanded the Shanghai declaration of 1972 to oppose hegemony in every part of the world, not just "the Asia-Pacific region." More important, normalization of relations would now depend only on "the principle of one China as opposed to requiring the practice" or making it a reality.

Haig cabled Kissinger that Nixon saw the press reports on his trip as "a major plus for the White House." Because Watergate continued to

be their greatest problem, however, they were eager for references to the president at all of Henry's press briefings. Haig reported that a diagnosis of "hyper-paranoia" was the best description of the Washington scene. Scowcroft described the president as "really active with the Congress this week." Although these had been "grueling" sessions, Nixon "was very tough but kept his cool, stayed restrained, and managed most of the time to be on the offensive."

Yet the harder Nixon fought to save his political life, the worse matters seemed to become. His "offensive" came across to most people as defensive and unconvincing. On November 12, an attempt to explain the two "missing conversations" raised further suspicions that Nixon or someone else in the White House had destroyed them.

Worse, on November 17, during a question-and-answer session in Orlando, Florida, with four hundred Associated Press editors, they embarrassed the president with questions about his honesty and commitment to the rule of law. Could the republic survive his tenure, one asked. They pressed him on everything from the missing tapes to his possible part in the Ellsberg break-in, his defense of Ehrlichman and Haldeman, failure to ask John Mitchell about Watergate, abuse of executive privilege, improper use of government funds for personal gain, and evasion of income taxes.

The tough questions penetrated the veneer of calm Nixon tried to maintain throughout the mortifying ordeal. "Scowling fiercely, his body tense, his hands clasped behind his back, he leaned forward," Stephen Ambrose said. "Beads of sweat popped up on his brow." Speaking to the larger television audience watching the event, he plaintively declared: "I made my mistakes, but in all my years of public life, I have never profited, never profited from public service . . . And in all my years of public life, I have never obstructed justice. And . . . I welcome this kind of public examination, because people have got to know whether or not their President is a crook. Well, I am not a crook. I have earned everything I have got."

His performance was reminiscent of the Checkers speech in 1952, but the twenty-one years since of suspicions and recriminations about his personal integrity and political actions made his self-justification less than convincing. He came across as too full of self-pity, too engulfed by charges of illegal actions to be believable. He had lost the one essential element an officeholder needs to sustain his political power—credibility.

Even if he could remain in office for the rest of his term, he had squandered the public trust. He was now, at best, a lame-duck president.

More than ever, it fell to Kissinger at this point to manage foreign policy. While the president spent most of his time speaking out on the energy crisis, reiterating his innocence of any wrongdoing, and urging an end to calls for his resignation, Kissinger worked sixteen-hour days trying to hold things together. "Our domestic situation is obviously of grave concern in every country," Henry told his state department staff on November 19. They worried "whether we will be able to sustain any foreign policy to which other countries can gear themselves."

Henry had his hands full with everything from Vietnam, where a cease-fire was proving as illusive as ever, to arranging the Geneva Middle East conference, managing détente with the Soviets, and trying to end the oil embargo that was disrupting the United States and allied economies.

Managing the president had also become something of a full-time job. On November 17, Kissinger complained to Haig that Nixon's statements on the "oil thing" are "totally contrary to my strategy and just about kill us . . . My strategy has been and it has worked at least somewhat to tell the Arabs if they want progress, they better lift the oil" embargo. He saw Nixon's belief that advances in Middle East talks would restart the flow of oil as contrary to his conviction that relaxed restrictions on oil would facilitate Middle East negotiations.

Renewed press reports of strains between Nixon and Kissinger did not help the president's standing. The *New York Times* printed a story saying that Henry had "told an associate" that his "phone had been tapped." Henry admitted to Haig that "I maybe said that at one time," but he denied saying anything about wiretaps recently. Similarly, when Haig mentioned rumors quoting him "as saying the President, if he keeps it up, in a few weeks will suffer from a nervous breakdown," Henry emphatically denied it. "The opposite is true," he told Haig. "That's the newest one," Haig said. "That they are trying to push that he has a mental problem." Henry assured Haig that he had never said a word about the president's mental condition. "On the contrary, I always say it is amazing what he has withstood."

Given Kissinger's affinity for describing people as maniacs, the reality of Nixon's erratic response to calls for his resignation or impeachment, and Henry's complaints about Nixon's suggestions during the Middle

East crisis, it's entirely plausible that he described the president as in less than full control of himself. But regardless of whether he had said anything that found its way into news stories, it is clear that during the Yom Kippur War Henry saw Nixon as performing much less effectively than in the past and as presiding over a besieged administration with diminished prospects for major foreign policy accomplishments.

The state of Nixon's presidency registered clearly on former defense secretary Robert McNamara. He told Kissinger that he was urging Henry's former aide Larry Lynn to reenter the government. "I said I despised Nixon more than he did. I told him the only place to do any good today is with you, with . . . a very weak executive there is no chance in hell he could do anything outside more important than he would be able to do with you. I told him it was a tremendous opportunity compared to whatever opportunities there might be outside" the state department and NSC.

Kissinger's dominant role in Middle East policy making was apparent during a White House briefing of congressional leaders on November 27. Henry did almost all the talking. Nixon offered a brief summary at one point during the hour-plus meeting, but he was uncharacteristically subdued. Although he said nothing about his tense relations with Congress over the impeachment hearings in the House, his silence was indicative of how angry he felt at lawmakers who were considering his impeachment. Public revelations five days before that the tape of a June 20, 1972, White House conversation with Haldeman had an 18½-minute gap had raised additional suspicions about a cover-up of Nixon's role in Watergate and had made an impeachment more likely.

Nixon also was unhappy about the lack of a congressional response to his appeal for an energy program. His speech of November 7 had fallen on deaf ears. With the Senate holding hearings that laid blame for oil shortages more on big oil companies than producer embargoes and the Congress poised to do no more than maintain price controls and require allocation plans that met the needs of the country's different regions, Nixon largely lost hope that he could respond to the energy problem in a way that might help reestablish his standing with the public.

Kissinger's continuing centrality in Middle East negotiations underscored the limits of Nixon's influence. Exchanges between Henry and Sadat, Egyptian Foreign Minister Fahmy, and the Egyptian ambassador in Washington included no mention of Nixon. Moreover, as Kissinger

prepared to travel to Europe and the Middle East again beginning on December 10, he spoke not to Nixon but to Gerald Ford about the upcoming discussions. "I have asked Brent Scowcroft to keep you informed of my trip and to keep you posted," he told Ford. Kissinger had never been so solicitous of Agnew. But during the first week of December, with Nixon so distracted by assaults on his authority, Henry saw Ford as the responsible executive authority.

Because Nixon's denial about being a crook had generated more bad press than expressions of public support, he felt compelled to back up his assertion with what he saw as exonerating documents. On December 8, he released a statement accompanied by a sheaf of papers about his financial affairs during his presidency. His "full disclosure of . . . assets and liabilities, expenses and income," however, did little to quiet suspicions that he had cut corners to enrich himself.

Between December 10 and December 22, Kissinger was fastidious about reporting to Nixon through Scowcroft on his meetings, first, with NATO allies and then with Arab and Israeli officials prior to and during the Geneva conference.

But Kissinger could not hide the extent to which he was managing the Middle East negotiations. Prior to the conference, when tensions erupted with Tel Aviv over Palestinian participation in Geneva, the role of the United Nations, and the return of POWs from Syria, Kissinger put considerable pressure on Israel to come to the talks. Henry warned Meir that a failure to participate in the discussions could lead to another outbreak of fighting and "the impossible position we would be in in trying to support Israel in [the] face of its failure to go to the conference."

In response to Kissinger's pressure, friends of Israel inside and outside of Congress launched an attack on him for usurping authority. "We are seeing the beginnings of . . . a systematic attempt by Jewish groups to portray me as operating alone, without Presidential guidance, and without checking with him," Henry cabled Scowcroft from Riyadh. "The purpose is clearly to show that I am carrying on a solo act, without the support or backing of the President. Their purpose is to . . . wreck our Mideast policy." Henry was eager to learn who in Congress was making such claims. He stated that nothing he had said publicly could support assertions that he was operating on his own. He asked Scowcroft to pass this on to the president.

Despite Henry's denials, Nixon's domestic woes had reduced his attentiveness to the details of Middle East policy, and Kissinger, aided by Haig and Scowcroft, had become the principal responsible party overseeing negotiations. It did not make Nixon happy, but he felt that his Watergate troubles gave him no choice. They saw no likelihood that "the present difficulties would disappear," Haig told Henry, and they would have "to continue to cope" with these problems. Haig assured Henry that his management of the negotiations was "a great source of comfort at a difficult time domestically."

After ten hours of meetings on December 17 with Meir and members of her cabinet, the Israelis agreed to attend the Geneva meeting from December 21 to December 23. Kissinger made the meeting possible by a commitment to limit the initial sessions to public speeches followed by the creation of committees to address Arab-Israeli problems; the United States was to play the role of mediator. Although the Soviets were a Geneva co-sponsor, they were promised no part in the subsequent negotiations. Nor was the UN assigned any role in the future discussions; Kissinger saw it as likely to impede rather than facilitate the talks.

Nixon was delighted that Kissinger had managed to bring the Middle East combatants together while limiting Moscow's role. On the eve of the conference, he sent Henry a congratulatory message for his "crucial role in this great enterprise." When the president suggested a more substantive part for himself in facilitating the discussions, Kissinger vetoed it. Nixon wanted to issue a statement tying a promise of $2.2 billion in aid to Israel to its flexibility in the negotiations. Henry warned Scowcroft that any such statement "would have catastrophic consequences in Israel," where it would be seen as a prelude to forcing Israel's hand in negotiations by trading aid for withdrawal from occupied territories. Kissinger believed it would jeopardize Tel Aviv's commitment to come to Geneva. "You should discuss this entire question with Haig urgently," Kissinger concluded.

If Kissinger had any serious qualms about preempting Nixon's management of Middle East policy, the results of his actions allayed them. He was elated about the outcome of the Geneva meeting. It came "off with no serious hitches," he told Nixon. "We got two Arab states—Egypt and Jordan—and Israel around the same table." They avoided "taking positions that could close the door to further negotiations . . . We kept Soviets engaged procedurally without their assuming a significant substantive role."

At the same time, Kissinger reported to Nixon on another foreign policy success of a sort. On December 20, on his way to Geneva, he stopped in Paris to see Le Duc Tho. At the beginning of the month, the NSC had concluded that "Communist violations of the cease-fire have, from the outset, been massive, unceasing, and cynical." Hanoi's actions raised "grave doubts" about the peace agreement. The need was to ensure against the success of any future Hanoi offensive.

On December 7, during a meeting with South Vietnamese Foreign Minister Vuong Van Bac, Kissinger had promised to do all he could to meet Saigon's needs, though he cautioned that Watergate made things uncertain. Yet, he said, "We did not go through all this agony to have the cease-fire agreement broken." He could not resist a barb at Thieu, however. He shared a "secret wish" with Bac that Thieu would have to negotiate with Golda Meir "to see who would get our anti-tank weapons."

Kissinger saw his December 20 meeting with Tho as a welcome surprise. Tho discussed the need to restore the cease-fire. Henry thought it signaled Hanoi's uncertain military prospects. It convinced him that the North Vietnamese were weaker than he had believed and that the South had been handling its defense effectively.

Yet Henry's success in the various talks did not impress Nixon as a likely antidote to his Watergate troubles. On December 19, Mel Laird, who had served since June as Nixon's counselor on domestic affairs, resigned and stated that a House vote on the president's impeachment "would be a healthy thing." Rodino responded by declaring that his judiciary committee hoped to make a decision on impeachment by April.

On December 20, Barry Goldwater had dinner at the White House with nine other guests, including speechwriters Pat Buchanan and Ray Price, White House counselor Bryce Harlow, and the president's daughter and son-in-law, Julie and David Eisenhower. After the guests had assembled in the second-floor living quarters, where Pat Nixon greeted them, the president entered, moving "quickly among us, rapidly jumping from one topic to another," Goldwater recalled. "Then, unexpectedly, his mind seemed to halt abruptly and wander aimlessly away. Each time, after several such lapses, he would snap back to a new subject. I became concerned. I had never seen Nixon talk so much, yet so erratically."

After they sat down for dinner, Nixon rambled on about whether he should take the train to Key Biscayne for a Christmas holiday. He

asked Goldwater what he thought. "I was upset about Nixon's obsession with Watergate and lack of leadership," Goldwater said. "What was so important about a trip to Florida? . . . Such gibberish coming from the President of the United States, when the mood of the country was approaching a crisis, worried me . . . The whole conversation was without purpose." Goldwater blurted out, "Act like a President." After a few moments of embarrassing silence, "Nixon continued his ceaseless, choppy chatter." Goldwater asked himself "the unthinkable: Is the President coming apart because of Watergate?" The answer seemed to be yes.

Nixon was preoccupied with whether the House would impeach him. He suddenly asked Goldwater: "How do I stand, Barry?" After Goldwater told him that sentiment was divided between those who wanted him to go and those who wanted him to stay, Nixon gave no response. After several moments of "complete silence," Nixon spoke. "His mind had rolled back to the family vacation, and he was riding the rails to Florida again . . . Nixon was making no sense . . . I asked myself whether I was witnessing a slow-motion collapse of Nixon's mental balance."

Nixon's monologue then focused on foreign policy. Pat, Julie, and David complained that Kissinger was taking too much credit for administration gains. "The President ruefully admitted that Kissinger was grabbing a lot of headlines. However, he firmly insisted . . . he was making the real decisions . . . Dinner ended on a somber, strained note with several stretches of silence—all except for the President. He jabbered incessantly, often incoherently, to the end." Although Harlow told Goldwater the next day that Nixon had been drunk before and during dinner, Goldwater could not shake the feeling that "all might not be well mentally in the White House."

Admiral Elmo Zumwalt, Chief of Naval Operations, recalled a similar encounter with the president on December 22. Before a breakfast meeting at the White House between Nixon and the Joint Chiefs, Zumwalt showed Schlesinger a statement he intended to make about the need for increased Navy funding. Schlesinger "vehemently" urged against doing it. "The President is paranoid. Kissinger is paranoid. Haig is paranoid. They're down on the Navy and to present facts like these to them will drive them up the wall."

Although Zumwalt reined in his remarks, he got "to deliver only a small fraction of it," because "the President used the ostensible budget

meeting to engage in a long, rambling monologue . . . about the virtues of his domestic and foreign policy. He repeatedly expressed the thought that the eastern liberal establishment was out to do us all in . . . It was clear that he saw the attacks on him . . . as part of a vast plot by intellectual snobs to destroy a president who was representative of the man in the street."

Zumwalt did not see Nixon as "a haggard, palsied, drunken wreck" described in "the Washington rumor mill . . . But to me he did present the very disturbing spectacle of a man who had pumped his adrenalin up to such high pressure that he was on an emotional binge. He appeared to me to be incapable of carrying on a rational conversation, much less exercising rational leadership over a nation involved in a score of complicated situations, embarked on dozens of hazardous enterprises."

The two episodes are a part of Nixon's long history of battling inner demons. There is ample evidence that Nixon struggled with excessive drinking, suffered from paranoid fears, relied on medications to manage his personal problems, and consulted a psychotherapist to help him function—both before and during his time in the White House. One *Newsweek* journalist described Nixon during his presidency as a "walking box of short circuits."

The full story of his struggle with emotional difficulties, however, remains unavailable—closed off in his medical records, which Dr. John Tkach, the son of Nixon's personal physician, Walter Tkach, intends to deposit in the Nixon Library in Yorba Linda, California. "My plans are," Tkach wrote me, "to transfer these many large boxes to the Nixon Library with the stipulation that they remain sealed for 75 years." Tkach believes that releasing the records "now would violate confidentiality, and there are some things about the Nixons," he adds, "that are so confidential I shall never reveal them." My argument to him that the public interest or the public's right to know whether the president was incapacitated and should have had his authority suspended under the Twenty-fifth Amendment did not convince him. There are also numerous taped telephone conversations between Nixon and Walter Tkach at the Nixon Library that might deepen our understanding of Nixon's physical and mental health, but they are currently closed under privacy limitations that only Nixon heirs can lift.

John Tkach offered the tantalizing comment to me that "there were significant attitudinal changes in Nixon between the Eisenhower days

and Nixon's presidency. Excluding medical records, much of what I know can be figured out by reading between the lines. Look for what's missing," Tkach counseled, "what things don't fit together in a way that makes sense." Exactly what he had in mind is unclear.

Yet for all Nixon's emotional problems, it seems fair to say—unless other evidence eventually surfaces from the closed records—that he was more erratic than incapacitated. And though at times he seemed out of control, the fact that he relied on psychotherapy and medications to rein in his psychological difficulties suggests a greater degree of self-awareness and reasonableness than might otherwise be assumed.

Nixon matched his bouts of incoherence and paranoia with enough focused resolve and good sense to convince himself and Kissinger that he could still be an effective president. On the same day he saw the joint chiefs, for example, he released a cogent statement on the energy crisis. He reprimanded Congress for not passing an emergency energy bill, but praised the majority of Americans for responding positively to his calls for conservation and urged legislators to promptly pass an energy act when they returned in January.

Because Kissinger saw the rational as well as the irrational side of the president, he assumed that Nixon would not step down and that both the national well-being and his personal standing required him to do everything possible to help Nixon sustain an effective foreign policy. On December 26, he told Nixon that he had lobbied Nelson Rockefeller to "support you and to do it publicly . . . I said it is imperative for the country."

Kissinger also encouraged Dobrynin to promote full support for the president in Moscow as a way to ensure détente. When Henry told Nixon that he would be holding a press conference on December 27, which would make the case for the president's effective foreign policy leadership, Nixon approved and told him to say that they would be meeting at the western White House over the next few days for additional consultations on the State of the Union and the Middle East.

As the year came to a close, Nixon and Kissinger engaged in some autointoxication. On December 29, when the *Washington Post* criticized the administration's Mideast policy, Henry told the president, "They are out to get you . . . They know this will be another big win for you in foreign policy." Nixon replied, "We will win more . . . We will show them

and don't you get discouraged." Henry reinforced Nixon's illusions: "We are going to hold this together," he said. "This is an attack on our institutions and it has nothing to do with you or Watergate." He also urged the president to understand that the Soviets had a big stake in "your continuing in office."

Nixon ended the year with private resolutions not to resign. He rationalized his decision by convincing himself that the press would be the principal winner if he quit, while the institution of the presidency in general and his foreign policy in particular would be the principal losers.

"The answer—" he told himself in diary notes made at 1:15 A.M. on the morning of January 1, "fight." In another note made at 5 A.M., he called upon himself for self-control: "Above all else: Dignity, command, faith, head high, no fear, build a new spirit, drive, act like a President, act like a winner. Opponents are savage destroyers, haters. Time to use full power of the President to fight overwhelming forces arrayed against us." It was the outcry of a besieged president denying responsibility for the disaster that had engulfed him, and hoping that he could find the wherewithal to survive yet another crisis threatening to end his political career.

ALTHOUGH NIXON REMAINED in California until January 13, where he had greater physical, if not psychological, distance from his troubles, he could not entirely insulate himself. On January 4, the White House released a letter to Sam Ervin rejecting a subpoena for "some 492 personal and telephone conversations of the President . . . from mid-1971 to late 1973 for which recordings and related documents are sought." A second subpoena asked for "thirty-seven categories of documents or materials," including the president's Daily Diary for almost a four-year period. Nixon refused to comply, saying it would destroy presidential confidentiality and "irreparably" injure the office of the president. It was now an all too familiar clash with the Senate committee, which was destined to end up in the courts.

In the court of public opinion, however, it was another Nixon loss. A Gallup poll released on January 6 showed the president's approval rating at only 29 percent. Sullen, depressed, and troubled by insomnia, Nixon found an outlet for his feelings at the piano, which he played in the hours between waking and dawn.

Kissinger, who was with the president in San Clemente during the first week of January, provided some solace to him through conversations with journalists. On January 2, in a background session with three print and three TV reporters, Henry discussed administration plans for disengagement talks between Egypt and Israel and the oil embargo. The reporters wanted to know whether the president can "travel abroad when there is the prospect of impeachment?" Henry insisted that "While he is President he should act as President." The journalists then asked, "What impact would impeachment proceedings have on diplomacy?" Henry said, "None. Maybe down the road. But none now."

The reporters pressed the question of whether Kissinger's communications with Nixon were as substantial as before the current Watergate troubles. "Some in the White House said you didn't communicate as often as before, on this [recent] trip." Henry bristled. "Who told you that? Only Haig and Scowcroft know. I sent a full report every day. I see him automatically every day for a half hour, usually more. Before the trip we consult; we know where I'm going. On the way I don't need detailed instructions. I talk to Haig and get the Presidential mood of things—what he's worried about—and operational things with Scowcroft. These stories are totally wrong." At a news conference the next day, when a reporter asked about leaks describing Kissinger as running foreign policy for an impaired president, Henry said, they were "totally incorrect."

The reporter's questions and Kissinger's answers had private and public consequences. On the evening of January 4, after returning to Washington, he called Nixon in California. Mindful that he might need to blunt future assertions about operating without presidential oversight, he briefed Nixon on a meeting he had that day with Israel defense minister Moshe Dayan. He reported significant progress on a disengagement plan for Egyptian and Israeli forces in the Sinai. He also described newspaper headlines saying "You're in full control of foreign policy." Nixon wanted to know why Henry thought "they're printing it now." Henry credited his statements to the reporters.

Kissinger's assurances, however, were not enough to convince journalists and the public that Nixon was in charge of his administration. As long as he remained in California, the feeling continued to grow that others were running the government. Scowcroft told Kissinger that some of Vice President Ford's "statements and activities" seemed "to be com-

pletely uncoordinated with the White House . . . It is a serious and growing problem and, with the President away, Ford is becoming a sort of President in absentia."

Kissinger was preoccupied with advancing Middle East negotiations. Because the Egyptians wouldn't agree to direct talks with the Israelis, Henry believed it best for him to travel at once to Cairo and Tel Aviv rather than wait until the Geneva conference reconvened. Mediating between Sadat and Meir would free him from Nixon's potentially unproductive interference and that of slow-moving Geneva committees, which would have to consult their respective governments. Nor would he then have to give Moscow even a symbolic role at another session in Geneva.

Nixon was reluctant to let Henry go. He was focused less on a disengagement agreement between Israel and Egypt than the need to lift the oil embargo. With more Americans seeing the energy crisis as a bigger issue than Watergate, Nixon believed that a direct part in responding effectively to the oil crunch could boost his approval ratings. A 387 percent increase in oil prices between October and December had convinced 54 percent of Americans that the country was heading into a recession. On January 10, the White House released letters Nixon wrote to oil-producing and oil-consuming nations proposing a Washington conference in February to develop policies that could propose constructive means to satisfy the needs of both producers and consumers.

Nixon worried that if Henry arranged an end to the oil embargo during his trip, he would get credit for something Nixon saw as vital to his political survival. He doubted that Kissinger would put the president's political needs above his ambition for another major diplomatic success. Kissinger understood Nixon's leeriness about his personal drive to become a great secretary of state. When Leonard Garment asked Kissinger to name someone for an administration job "who knows the government, who can write and talk well, who is very smart and ambitious and is prepared to be really nasty," Henry replied, "I may take the job. You just described me."

Kissinger tried to assure Nixon that any success in Middle East negotiations would be described as the president's. In a conversation with Haig on the morning of January 8, Kissinger reported that Sadat was eager for him to come to Egypt and seemed ready to reach a rapid settlement. Henry feared that "if we don't wrap this thing up fast, it will never

happen." He wanted Haig to tell Nixon that "I'm perfectly willing to give him a terminal date for my tenure, and that I'm off his back then . . . I'd be perfectly happy to resign as soon as this agreement is signed . . . And tell him we will stage it so that the embargo . . . lifting will be done by him. Anyway, he can have my resignation."

In the afternoon, with still no answer from Nixon about his trip, Kissinger complained to Scowcroft that "instead of throwing our hats in the air at [Sadat's invitation], we're dancing around." Scowcroft explained that the White House was preoccupied with answering ongoing scandal allegations. "That's where our priorities have gone," Scowcroft said. Henry responded that if they were attentive to the national interest, "we would be in touch with Fahmy. There are no earthly reasons to hesitate. If he [Nixon] refuses it, I will certainly leave." Scowcroft shared Henry's conviction that Nixon's concern to lower Kissinger's profile was partly behind his reluctance to agree to Henry's return to the Middle East.

The planned release of the letters to the concerned oil countries that would put the president at the center of efforts to ease the energy crisis persuaded Nixon to let Henry go. But Nixon insisted that an announcement about Henry's return to the Middle East come from the White House. Henry also promised to hold a joint press briefing with William Simon, the administrator of Nixon's Federal Energy Office, about the February conference. By doing it with Simon, Henry told Haig, it would make the announcement "more clearly presidential." Haig responded, "And that's the big thing."

Kissinger flew to Egypt on January 11, landing at Aswan, some four hundred miles south of Cairo, where Sadat had a winter residence. Although Henry arranged to arrive at 8:30 in the evening, so that he could enjoy a night's sleep before beginning discussions in the morning, Sadat insisted on seeing him at once.

Their discussions were a demonstration of how two negotiators set on a common goal use flattery, humor, and charm to reach accord. On January 14, as they met for three and a half hours to consider proposals Kissinger had brought back from Israel, they played effectively on each other's needs and vanity. If they were able to reach agreement, Henry joked, it would be described as "a Kissinger plan." If they failed, it would be called "a Sisco plan." Fahmy chimed in, "I told Joe, if it is a Joe plan,

we'd send him to the Valley of the Queens. We'd preserve him." To much laughter, Henry shot back: "Why preserve him?"

Kissinger presented himself as Egypt's ally against Israeli manipulation. Henry described himself as rejecting an Israeli demand that a disengagement agreement include an Egyptian withdrawal from some of its territory along the Suez Canal. "I didn't think it right that Egypt had to give up this territory. They wanted me to present this and come back to them. I said no." After presenting Sadat with Israel's "full plan," Kissinger said, it "caused us unbelievable anguish to produce—even though you won't like it." When Henry asked if he should "sum up our understanding of our conversation," Sadat replied, "Please. You are much cleverer." To which Henry responded, "But not as wise."

Fahmy was less taken with Kissinger than Sadat. Fahmy doubted Henry's sincerity when he cursed the Israelis and made fun of their leaders. He was trying "to convince us that he was on our side," Fahmy said. "Unfortunately, his rather obvious ruses were fairly effective with Sadat," who told Henry, "You are not only my friend. You are my brother."

Golda Meir, who had her share of differences with Henry, nevertheless, like Sadat, saw his vital role in the negotiations. After Sadat wrote her a letter, she replied, "It is indeed extremely fortunate that we have Dr. Kissinger who we both trust and who is prepared to give of his wisdom and talents in the cause of peace." As Henry himself recognized, it wasn't any idea he brought to the discussion that made a difference. It was the need for an intermediary who had the confidence of both sides.

The extent to which Kissinger had become the principal U.S. actor in the January negotiations was reflected in a cable Henry sent Scowcroft after his initial meeting with Sadat. He asked Scowcroft to discuss his report with Haig and "then pass it on to the President unless you and he believe that it would trigger frantic—and thus—extremely harmful—activity. You should not show the report if you feel there is any danger that you cannot control the reactions."

Henry was worried that Nixon might leak news of a Sadat initiative to end the oil embargo as a way to boost his public standing. It seemed certain to weaken Sadat's influence with other Arab leaders, who had not yet been consulted. Convinced that Nixon would wait until there was an actual agreement to restore oil supplies, Scowcroft and Haig reported Henry's discussion with Sadat to the president.

To squeeze every possible political advantage from any Middle East settlement, Nixon wanted Kissinger to come home to stage a public appearance with him as a prelude to any announcement. It was meant to suggest that the president had a direct part in wrapping up the details of a cease-fire. But when Henry refused to leave the Middle East until he had firm commitments from Cairo and Tel Aviv to an agreement, Nixon made the announcement on his own in a nationally televised statement on January 17.

To Nixon's dismay, it was Kissinger whose reputation gained the most from what was now described as the secretary's shuttle diplomacy. By contrast with Nixon's approval ratings in the high twenties, Henry had 85 percent support from the public. Nixon earned some collateral appreciation for Henry's performance, but it was simply not enough to restore public confidence in his presidency.

On January 19, Nixon gave another national White House talk about the energy crisis. With millions of Americans convinced that U.S. energy companies were purposely creating oil and gas shortages to line their pockets, Nixon offered assurances that the tripling of prices at the gas pumps was the consequence of foreign actions. He praised Americans for efforts at conservation, promised to guard against excess profits by U.S. oil companies, and committed his administration to work toward energy self-sufficiency.

Although he said nothing about the likelihood of a restoration of oil supplies from the Middle East, he had begun working behind the scenes with American oil executives to pressure Saudi Arabia into lifting its embargo. Kissinger urged him not to rely on the oil men to reverse Riyadh's action: "You should emphasize to the President that our best hope is Sadat," Kissinger cabled Scowcroft on January 19, "and we must keep our oil men out of this affair, their interests are parochial and they clearly do not have the ear of the [Saudi] King." Sadat was assuring him that the embargo would be lifted by January 28 and that he would "make a statement giving credit to the President." Henry acknowledged that Sadat might be unable to fulfill his promise, but he warned Nixon that any other action seemed likely to fail.

After a largely unproductive five-hour discussion in Damascus with Syria's President Hafez al-Assad on January 20, in which the Syrians demanded progress in negotiations with Tel Aviv as a prelude to ending the

embargo, Kissinger put additional pressure on Nixon not to make premature statements about Arab intentions. A cable from Scowcroft saying that the president wanted to announce a lifting of the embargo in his State of the Union address on January 30 triggered a sharp Kissinger rebuke: "There is no possible way to arrange the lifting of the oil embargo in such a way as to permit the President to make the announcement of its lifting," he cabled Scowcroft.

Henry warned that if "the President now indicates to the Arabs the vital importance to the United States and to him of ending the oil embargo—and ending it with an announcement from Washington—we will give strength to the Arabs in their determination to deal with us harshly."

When Nixon complained to Riyadh about its failure to honor promises about lifting the embargo and threatened to publicize Saudi unreliability, the foreign minister warned, in what Kissinger described as a "cool (and not incorrect) response, that he would them make it known that our request [for ending the embargo] had as often been geared to Nixon's domestic necessities as to the American national interest—underlining the humiliating position in which Watergate had placed us." In this conflict between Nixon and Kissinger over how to deal successfully with Arab oil producers, Henry was clearly more mindful of the national interest than a president trying to overcome an international difficulty as a way to save his political life.

The climate of suspicion and recrimination generated by the numerous revelations about White House skullduggery cast a shadow over Kissinger's mediation and muted praise for a major foreign policy achievement. On January 18, CBS's Dan Rather pointed to administration "detractors" who asserted that in October, three days after the "Saturday Night Massacre," "the U.S. called a general alert and now, two days after the 18-minute tape-gap episode, we get a Middle East agreement signed." It reflected a depressing degree of cynicism that foreign policy actions were the captives of domestic politics.

Press accounts during his January trip accusing him of collaboration with Nixon's Plumbers incensed Kissinger, who had previously denied these allegations under oath before congressional committees. Henry called news stories that he had something to do with wiretapping former defense secretary Laird "a vicious, malicious, outrageous lie." With stories also circulating about the military chiefs spying on Kissinger in 1971

to obtain information he was withholding from them, Henry demanded that the White House deny these accounts.

"The recent spate of articles," he told Scowcroft, "are being turned by some opponents of the administration, by some members of the administration, and by some former members of the administration into an attack on the last person of standing in the administration." He asserted that people need to put the national interest above all this scandal mongering. On his first day back from the Middle East, he told Hugh Sidey, "It really was a moving thing to see the beginning of trust develop between people who've been fighting for 30 years. And we are so absorbed in every other thing that we can't even focus on it."

Kissinger's complaint had merit. It was distressing that White House transgressions were eclipsing a major step toward peace in a region that threatened the tranquility not only of local states but also East-West stability. A possible answer was for Nixon to suspend his authority under the Twenty-fifth Amendment until he could be cleared of wrongdoing or to resign and allow the government to focus anew on vital national security and domestic issues. But Nixon continued to put his political survival ahead of the national well-being and to make the reasonable argument that suspension or resignation would make America more like a parliamentary democracy; it would be a change in the country's system of government that was at variance with the Constitution.

In January, talk of Nixon's resignation was a constant part of the political discussion. When rumors emanating from Israel on January 23 described Nixon as about to resign, Kissinger told Ziegler, "If the President leaves and Ford takes over, I will stay." Nixon, who refuted all such talk, asked Henry later that day, "How's your confidence? You're not getting discouraged?" Henry replied, "Not at all," and praised the president's continuing effective leadership.

Publicly, Nixon and Kissinger seized every opportunity to describe the president as in charge and his tenure as synonymous with the national good. In a background briefing with the editors and reporters of the *Washington Star*, Kissinger said Nixon was in full control of Middle East policy and the force behind their recent success in the negotiations. Kissinger described himself during his trip as "in daily touch with the President—often several times a day . . . Foreign leaders wanted the President to continue because they knew and respected him."

Nixon outdid Kissinger in trying to convince people that he remained the chief executive. On January 24, he met with the NSC, ostensibly to discuss ongoing SALT negotiations. It was "obvious" to Admiral Zumwalt "that, among other things, the meeting was a staged opportunity for Mr. Nixon to show that he was still in control. The demonstration was a mixed success. Some of the things Mr. Nixon said made perfect sense. At other times he rambled, or even indulged in non sequiturs. If it was not an alarming performance, neither was it a reassuring one."

Nixon himself told Republican congressmen that "he could not resign under any circumstances because it would overturn the election result." He said he anticipated "a real gut fight over impeachment, but" he intended "to fight like hell, even if only one Senator stands with him." Ironically, for someone accused of covering-up involvement in an illegal break-in aimed at manipulating the outcome of an election, Nixon seemed to be saying that he was determined to preserve America's democratic tradition of honoring the results of a free election.

Nixon continued to believe that the best way for him to serve the country and himself was by easing the energy crisis. On January 23, he sent a fifteen-page special message to Congress on a matter that "could affect the patterns of our national life for the rest of this century." Breaking with the tradition of waiting to spell out national legislative needs in the State of the Union speech, he felt compelled to advise Congress beforehand on a challenge that required urgent attention. Although he believed that it would take until at least 1980 to ensure American independence of foreign energy producers, he thought it essential to make this the country's highest priority and to initiate action at once.

Nixon remained convinced that the immediate answer to the country's energy shortage and possibly his political difficulties, which long lines at gas stations were compounding, was a lifting of the Arab oil embargo. But it was proving much more difficult to achieve than Kissinger had led Nixon to believe. On January 24, in messages to Sadat, Nixon and Kissinger objected to Arab insistence on maintaining the embargo until Israel made a disengagement agreement with Syria.

Sadat and the Saudis sent assurances that the president could announce in his State of the Union message that Arab oil producers were meeting to discuss an end to the embargo. Nixon and Kissinger then agreed that the president could stretch this to mean that he had "assur-

ances that the embargo will in the very near future be lifted." Nixon wanted to tell the country "with full confidence" that "there will be no rationing." His objective was "to get the damned embargo lifted . . . You know the point," he told Henry, "to make it appear like a helluva foreign policy achievement of this administration . . . That will be the good news of this speech—just that—that's all we need."

On the morning of January 30, with Nixon set to give his speech that evening, the Saudis backed away from suggestions that the embargo would be lifted. Kissinger called their back-down "a revolting performance. If I was the President," he told Scowcroft, "I would tell the Arabs to shove their oil and tell the Congress we will have rationing rather than submit and you would get the embargo lifted in three days." Henry feared that if Nixon went beyond what the Saudis "authorized us to say . . . the President will be blamed for playing cheap politics, which God forbid he would not do."

In his speech, Nixon limited himself to the observation that "through my personal contacts with friendly leaders in the Middle Eastern area, an urgent meeting will be called in the immediate future to discuss the lifting of the oil embargo. This is an encouraging sign. However, it should be clearly understood by our friends in the Middle East that the United States will not be coerced on this issue." Later that night, Nixon told Kissinger, "I coppered down that Arab part. The coercion part bothers me, but Al said you thought it was important. It's a shot across the bow. We gotta let them know we don't have to have them."

Because Nixon now understood that foreign policy was not going to insulate him from an impeachment inquiry and that his fate rested on access to the tapes, which he knew were damning, he considered destroying them and announcing it in the State of the Union address. It would be his way of saying "enough is enough . . . I was persuaded against it," he recalled, "by the argument that using the State of the Union to draw lines and force confrontations would not only heighten the impeachment issue but completely overshadow the important national policy issues in the speech."

Instead of destroying the tapes, Nixon ended his speech with a defiant extemporaneous declaration that he had provided the special prosecutor with all the material he needed to conclude his investigation and "to prosecute the guilty and to clear the innocent." He believed it was

time to end the investigation: "One year of Watergate is enough." The Democrats responded with hisses and boos. It was an almost unheard of reaction to a State of the Union address—an occasion when opposing party members deferred to presidential authority with demonstrations of polite applause or muted opposition by sitting on their hands.

LINGERING HOPES that foreign policy could somehow rescue Nixon from his domestic troubles further receded during the first week of February. Saudi King Faisal sent word that the Arab states had ruled out a lifting of the oil embargo without a Syrian-Israeli disengagement agreement that put some distance between their respective forces in the Golan Heights and reduced the chances of additional fighting. Although Kissinger urged Sadat to understand that a failure to end the embargo jeopardized a further role for the United States in Egyptian-Israeli negotiations, the Egyptian president lacked the power to force the oil-producing states to meet Washington's demand.

At the same time, Middle East difficulties threatened to impede new advances in Soviet-American relations. On January 17, after Nixon announced the disengagement agreement in the Sinai, Brezhnev complained to the president that the Geneva commitment to a Soviet part in Egyptian-Israeli negotiations was not being implemented. He asked that Gromyko and Kissinger meet to discuss renewed cooperation to eliminate the "dangerous hotbed of tension" in the Mideast before Nixon came to Moscow in the spring for another Summit meeting.

In a discussion with Kissinger on February 1, Dobrynin was more direct. He described "a bitter debate" in Moscow over what many saw as a "setback" to the Soviet Union from Henry's unilateral diplomacy in the Middle East. He warned that "an interval of bad feelings could do serious harm to our relationship." Kissinger promised to be "very circumspect" and agreed to "periodic meetings of the [Geneva] Co-Chairmen" to "symbolize our common commitment."

With Gromyko scheduled to arrive in Washington for meetings on February 4–5, Kissinger advised Nixon that reducing Soviet influence in the Middle East was placing "a certain strain on our relations." Henry wanted the president to give a rhetorical bow to U.S.-Soviet cooperation in the peace effort. It could discourage Moscow from a "spoiling effort, while at the same time retaining freedom to keep the United States in the central role."

During a two-hour meeting in the Oval Office on the afternoon of February 4, Nixon assured Gromyko that the administration was committed to the spirit and the letter of détente. Gromyko was as effusive in his expressions of eagerness to continue the trend toward accommodation, but on the Middle East he was scathing about American indifference to a Soviet role in current negotiations. Nixon tried to blunt Gromyko's concerns by declaring, "The Middle East is not pleasant for anyone." And Kissinger joked: "I would like to make a deal with our Soviet friends to turn over the Israelis to them." Gromyko was not amused. He complained that after seeming to commit itself to shared diplomatic action in the region, the United States was acting without the Soviet Union. The Geneva accord "was an empty and meaningless gesture."

Nixon reassured Gromyko that permanent peace could occur only if it was the result of joint Soviet-American efforts. They had seized the opportunity to bring about Egyptian-Israeli disengagement, but Moscow should not take this to mean that the U.S. saw negotiations in the region as "a one-man show." Henry declared: "We have no interest in proceeding unilaterally."

But of course, this is exactly what Nixon and Kissinger intended. On the night of February 5, Henry cabled a confidential report to Sadat and Fahmy on the Gromyko conversations. Gromyko demanded that all Middle East negotiations should be conducted jointly. But Kissinger promised to honor an agreement with Cairo to keep Moscow at arm's length. "Each of us will only tell the Soviets what we jointly agree to tell them."

In freezing Moscow out of Middle East talks, Kissinger saw himself as on a tightrope. Détente was too important to jeopardize for U.S. diplomatic dominance in Mideast talks. "We are not going to humiliate the Soviets by playing up the lone U.S. role in the Middle East," Henry told *Time* editors and writers in an off-the-record background discussion on February 5.

Yet he described himself as without illusion about Moscow. "The Soviet leaders are brutal, shortsighted, [and] unpleasant," he said. "But we must bring about a qualitative change in our relationship. There is a real danger if the Soviet leaders should feel humiliated and this generation should become soured about the capitalists . . . The Soviets are not whole-hearted believers in détente. They are keeping up a big mili-

tary effort." But it was essential to understand that "the Soviets and the United States can destroy humanity." It had created "the inevitable need for détente."

At the same time, however, limiting Soviet influence in the Middle East was seen as an effective means to blunt attacks on détente from domestic critics. Henry belittled the criticism of détente as an offshoot of "hatred for the President," which "is so great that people feel that no monument must be left to him, so they find flaws in détente."

But this was hardly the principal source of opposition. Senator Henry Jackson of Washington and defense secretary Jim Schlesinger led an outcry against ties to a repressive dictatorship determined to defeat the United States in the Cold War. They saw Soviet professions of support for peaceful coexistence as a ruse to lull the West into arms limitations favoring Soviet power. U.S. labor leaders opposed to trade agreements buoying the Soviet economy and supporters of Israel critical of Soviet limitations on Jewish emigration also voiced intense doubts about détente. It was a measure of how widespread these misgiving were that Schlesinger, a sitting cabinet member, would feel free to make his dissent known. By reducing Moscow's influence in the Middle East, Kissinger hoped to quiet détente's most outspoken critics.

Nixon continued to hope that a Syrian-Israeli disengagement agreement and an end to the oil embargo could improve his chances of political survival. He believed it would forcefully demonstrate White House effectiveness, raise his approval ratings, and discourage House Democrats from ousting him.

But managing Middle East tensions and coordinating an effective response to the Arab assault on Western economies remained daunting challenges. On February 9, on the eve of the Washington energy conference, Nixon and Kissinger agreed that "the Europeans, especially the French, are playing a lousy game." They feared that their "allies" would desert the United States for separate agreements with the Arab oil producers. "The Foreign Ministers are idiots," Henry said. Regardless of what the talks produced, Nixon, ever mindful of massaging his public image, instructed the White House to "give the press something after each session so we get something positive on TV."

Kissinger shared Nixon's eagerness to push oil consumers into a common front. But he worried that the president might overreach himself in

his effort to achieve unity. "I hope he [the president] doesn't dribble over them too much tonight," Henry told Haig. "Tell him to stay steady. Be conciliatory, but not groveling, but not to believe the bullshit about the great cooperation they are extending."

Although the French Foreign Minister Jobert gave what Kissinger described as "a really vicious speech," he and Nixon agreed to ignore "the bastard" and to have the president strike a conciliatory pose. In extemporaneous remarks to the conference that were anything but groveling, Nixon cautioned the foreign ministers against isolating their countries from the United States in pursuit of national advantages. Stable, affordable oil prices could only be achieved through a common policy.

Controlling allies at the conference proved easier than forcing the Saudis and Syrians to follow Washington's lead. Reports out of the Middle East on February 11 indicated that the Egyptians were "deeply concerned that the Soviets are playing a spoiling role in Syria" by "exerting heavy pressure on Assad not to be flexible on disengagement terms."

In remarks the following day at the Lincoln Memorial during a 165th-birthday celebration, a discouraged Nixon declared that the Civil War president "was very deeply hurt by what was said about him and drawn about him. But on the other hand, Lincoln had had that great strength of character never to display it, always to stand tall and strong and firm no matter how harsh or unfair the criticism might be." Lincoln had become Nixon's role model.

Nixon being Nixon, he talked himself into the belief that he and Kissinger could still blunt attacks on him with some spectacular foreign policy successes. "The main thing," he told Henry on February 13, as the conference was winding up, is to remain "upbeat and things are going to work out; we are working on the embargo and all that." Playing cheerleader, Kissinger said, "I am confident that it will be lifted in a week."

After Kissinger managed to paper over differences with other oil-consuming countries at the conference with a bland public pronouncement, Nixon depicted it as a great victory. "It was an historic breakthrough, people will see it later, Henry," he said in a phone conversation on February 14, "and by God, it was a hell of a thing." Kissinger credited the president's remarks at the conference as "terribly important . . . You made the connection between the economic and the military." It "convinced them that we meant business." Henry characterized Nixon's talk

and the outcome of the conference as "a major success." As soothing to Nixon, Henry reported that the foreign ministers would tell their governments that the president was "in marvelous shape."

Kissinger then came back to his expectation that the Saudis would lift the embargo by the end of the following week and that would be "a huge success." Nixon planned to hold a press conference on February 25 to bask in the glow of their achievement.

In the meantime, the Saudi and Egyptian foreign ministers asked to see the president in Washington. They wanted Nixon to send Kissinger back to the Middle East for another round of shuttle diplomacy between Damascus and Tel Aviv. They described an Israeli-Syrian disengagement agreement as essential to lift the embargo. Henry favored a meeting at the White House. Nixon was more skeptical. "We've been around that track before," he told Henry about another trip to the region, "and it hasn't helped on the embargo. That's the only thing the country is interested in. They don't give a damn what happens to Syria." With long lines still at gas stations, Nixon was right about public interest in increased oil supplies. Henry, however, convinced him to see the ministers by predicting that if an end to the embargo followed a meeting, the president could link it to their discussion.

Understanding how closely Nixon was tying the survival of his presidency to solving the oil crunch, Kissinger urged Haig to ensure that Nixon was "totally disciplined and aloof in the meeting . . . I don't want him to salivate." If he didn't see the ministers, however, it would encourage fresh stories that Henry was preempting presidential authority. Henry shared Nixon's belief that getting the embargo lifted would help save his presidency. But they also needed to guard against public recognition of the reality that the president wasn't entirely in command, or that Kissinger was intermittently behaving as a surrogate president.

At his news conference on February 25, Nixon had nothing to say about prospects for lifting the oil embargo. And although he acknowledged long waiting lines at gas stations, he expressed satisfaction that there was no home heating fuel crisis and that gas rationing was unlikely as long as the public continued to conserve energy. He predicted national self-sufficiency if the Congress would enact his recommended energy program.

The reporters were not convinced. They responded with a series of questions about when the embargo might be lifted, the gas lines might

shorten, and gas prices might fall. "Were you misled by the Arab leaders" when you assured the country that the embargo would end soon? one asked. Others wanted to know whether the administration could bring inflation under control and whether the president could avoid a recession in 1974. Nixon predicted a short life for the embargo and a robust economy. But his answers did nothing to bolster trust in his leadership.

If gas shortages were the public's principal concern, the media remained focused on Nixon's possible impeachment. "To heal the divisions in this country," UPI's Helen Thomas asked, "would you be willing to waive executive privilege . . . to end any question of your involvement in Watergate?" Nixon repeated earlier promises of cooperation that did not weaken the presidency. "I do not expect to be impeached" was Nixon's mantra. Would he consider resigning if it appeared that his party would suffer a severe defeat in the 1974 elections? He had no intention of resigning and peace and prosperity would carry Republicans to victory in November. Reporters had other embarrassing questions about the president's income taxes and Agnew's resignation. On balance, the televised news conference did nothing to boost the president's poor public standing.

Between February 25 and March 4, Kissinger resumed his shuttle diplomacy, traveling between Damascus, Tel Aviv, Cairo, Amman, Riyadh, and Bonn, before his return to the United States. Kissinger did not see the trip as doing more than starting preliminary disengagement negotiations between Syria and Israel. On his arrival in Damascus on February 25, Henry met with Assad from midnight to almost four in the morning. "What we have to do is to start a negotiation," he told Assad. "And this negotiation will not in my judgment make very much progress. But during that period I can begin organizing public opinion in Israel and America. And at the right moment . . . I will come back and do my best to conclude it as I did with Egypt."

Following through on his PR plan, which was aimed more at helping Nixon with domestic disputes than with building support for a disengagement agreement, he cabled Nixon on February 27 that if he were successful in selling the Israelis on discussions with Damascus, he would provide Scowcroft with a press release, which Ziegler could issue from the White House.

Nixon was delighted with Kissinger's progress in mediating Syrian-Israeli differences. Nixon was even more pleased with the press cover-

age of Henry's trip, which was making the front pages of all major U.S. newspapers. The *Washington Post* congratulated the administration on progress in the Middle East, and the *Washington Star* praised "détente with Cairo" as opening the way to peace in the region. Henry's growing reputation as a miracle peacemaker also served Nixon's purposes. A cartoon of Kissinger "perched on a dove with a briefcase flying over the Arabian Desert" was a welcome change from the numerous negative cartoons about the president. Articles in *Time* on "The Return of the Magician" to the Middle East and in *Newsweek* on "A Dove Named Henry" were also a relief from the hostile Watergate stories.

Nixon now laid plans to visit the Middle East as a follow-up to Henry's restoration of relations with Egypt and potential disengagement agreement between Israel and Syria. Sadat welcomed the prospect of a Nixon visit and predicted that "you will receive a tumultuous reception" in Egypt.

The advances for U.S. diplomacy in the Middle East, however, carried the continuing concern that it would undermine détente. With Walter Stoessel, the new U.S. ambassador to Moscow, slated to present his credentials on February 28, Kissinger instructed him not to discuss the Middle East unless Gromyko raised it. If he did, Stoessel was to say that the secretary's trip was in response to an Arab request, that he expected to do no more than launch negotiations between Syria and Israel, and that he intended to "keep [the] Soviets informed of progress so we can together . . . consider when and how best to proceed to [the] next phase in [the] Geneva framework."

During his stop in Bonn, Kissinger assured Willy Brandt that "we have no desire to humiliate the Soviet Union," though he had every intention of consigning it to a minor role in the region. "We can't brag about pushing the Soviet Union out of the Middle East," Kissinger told Nixon's cabinet on March 8. "We not only don't need the Soviet Union, but their style is bad for the Middle East." The goal was to hold them at arm's length but also to keep them in line.

Yet the good news from Kissinger's shuttle diplomacy could not mute the new Watergate stories that emerged on March 2. A grand jury announcement of seven indictments, including Mitchell, Haldeman, Ehrlichman, and Colson, "for forty-five overt acts of conspiracy" to cover up payoffs to the Watergate burglars and for perjury "resulted in a new

Watergate orgy in the press," Scowcroft wired Kissinger. "The *Washington Post* has indicated strongly that the 'secret report' of the grand jury, which it has passed to Judge Sirica, specifically ties the President to the Watergate cover-up." The White House tried to put the best possible face on Nixon's predicament by telling Henry that "the indictments have not really set the country on fire and that they had already been substantially discounted." Yet they had to admit "that there were some on the Hill who felt that they [the indictments] brought impeachment closer."

Nixon responded to the indictments and additional talk of impeachment by holding another nationally televised news conference on March 6. Ostensibly, he was meeting the press so soon again to explain a veto of an emergency energy bill passed by Congress and to urge adoption of an alternative White House program. But he knew that the questions would mainly focus on the scandal threatening his presidency. He responded to them with denials of wrongdoing and injunctions to assume that people are innocent until proven guilty, as was accepted practice in American jurisprudence.

The press conference "last night was a disaster," syndicated columnist Rowland Evans told Kissinger on March 7. When Henry put him off by saying that he had to see the vice president in five minutes, Evans joked, "You want to be sure he will reemploy you." Kissinger sprang to Nixon's defense: "There will not be an impeachment," he said. Evans disagreed: "I think there will be." Kissinger replied: "It won't succeed." Evans took Henry to mean that Nixon "won't be convicted"; he agreed.

Defending Nixon had become part of Kissinger's routine. At a Nixon-Kissinger briefing of GOP congressional leaders on March 8, Henry described Nixon as indispensable to world peace. He suggested to Nixon that he summarize his basic world strategy. Nixon replied: In the Middle East, the administration had saved Israel in the recent war, but in a way that "enhanced our role with the Arabs and did not posture us as anti-Soviet." Henry interjected, The president's détente policy was a deterrent to a nuclear conflict. Nixon elaborated on the point. Détente had allowed the United States to end the Vietnam War with "peace and honor. We got our way in Vietnam, solved Berlin, prevented war in Cuba, and got the Soviets moderated in the Middle East. If détente breaks down, we will have an arms race, no trade . . . confrontation in the Middle East and elsewhere, and they [the Soviets] will go right on repressing their

people." The briefing was an argument against those in Congress who opposed détente or favored impeachment.

The positive talk about détente, the Middle East, and foreign policy in general could not counter unsettling foreign and domestic realities. Prospects for new gains in the Middle East were held hostage to a Syrian-Israeli impasse over Israel's occupation of the Golan Heights. "I must tell you in all frankness," Kissinger advised Sadat on March 16, "that reconciling differences between Syria and Israel is likely to be a protracted process." He anticipated a period of "deadlock before decisive progress can be made."

An announcement by Arab oil ministers on March 18 of an end to the oil embargo gave the White House little to celebrate. The fact that the ministers might renew the embargo on June 1 unless there was progress in Syrian-Israeli negotiations made the development less than a satisfying victory. More discouraging was the little likelihood that oil prices would come down any time soon. Although Nixon was eager to score points for himself by describing it as an administration achievement, Kissinger warned against giving "the impression of enormous significance." It would encourage the Arabs to "blackmail us by putting it back on . . . Let's not put it on the level of the China breakthrough," he told Haig. The White House took no special notice of the Arab action.

Nixon's frustration with Middle East problems boiled over in remarks to Kissinger that he would publicly strike out at the Israelis for dragging their feet on a Syrian disengagement agreement. "He was in a rather sour mood again," Henry told Haig on the morning of March 16. "If he goes publicly after the Israelis, he might as well start a war." Haig urged Kissinger not to "be concerned about that. He is just unwinding." Haig had concerns of his own: "Listen, I was told to get the football," he told Henry. "What do you mean?" Kissinger asked. "His black nuclear bag," Haig replied. "For what?" Henry wanted to know. "He is going to drop it on the Hill. What I am saying is don't take him too seriously." Kissinger understood that Nixon was just venting his anger at the limits of their influence in the Middle East and domestic opponents eager to bring him down. Nevertheless, he begged Haig to restrain the president from saying anything publicly about Israel. "I tell you, it would be a disaster," Henry said.

A few days later, Kissinger asked Haig, "How's our leader doing?" Haig replied, "He's fine. He's dead tired. I just went over there, he was crawling." When Haig added that "the creepiest fellow I've ever seen" was in asking questions about you for a *New York Post* story, Henry was sure that the reporter was out "to screw" him. "My God, the questions he asked," Haig said. "You were using devious methods in the bureaucracy. You were paranoiac. Whether you had scars of your youth? He just went on and on . . . I told him you once told me acute paranoia in Washington would be diagnosed as excess complacency . . . He wanted me to say you are an organizational disaster." Haig denied it: "After all . . . we've kept the foreign policy and defense policy going for five years in a disastrous situation."

Nixon remained restrained in public when questioners hammered him about Watergate and détente during an appearance at the Executives' Club of Chicago. Couldn't he clarify why he thought greater cooperation with the special prosecutor and the Congress in the Watergate investigations would weaken the presidency? Given how the Watergate battles were demoralizing the country and making young people cynical about ethics, wouldn't it be better if the president resigned? Nixon's answers were a restatement of what he had been saying for months: Allowing investigators unlimited access to executive records would produce lasting injury to the presidency and resignation of a president because he was low in the polls would permanently change our form of government.

As for détente, a member of the audience saw the policy not as advancing the world toward a more stable peace but eroding America's power. Nixon's compelling response that it was better to talk than to enter into a costly arms race and an eventual nuclear war could not convince skeptics that peaceful coexistence was anything but a Communist ploy to defeat the United States.

Conservative New York Republican Senator James Buckley publicly argued with Nixon about what was undermining the presidency. A Nixon resignation, he announced, would do more to preserve the presidency than the president's continuation in office. The collapse of Nixon's "credibility and moral authority" was causing an "agonizing inch by inch . . . attrition" of presidential power. Only a prompt resignation could save executive authority from long-term damage. Opposition to Nixon's détente policy was also part of Buckley's interest in seeing an end to his presidency.

More convinced than ever that détente was essential to international stability and his political survival, Nixon instructed Kissinger to visit Moscow beginning on March 25 to lay the groundwork for another Summit in June. But problems over Vietnam, SALT, Europe, and the Middle East, made it what Kissinger described as a difficult period in Soviet-American relations.

Although it was not at the top of the Summit agenda, Nixon and Kissinger worried that Vietnam might explode in renewed violence. They hoped they could use Moscow to discourage Hanoi from fresh acts of aggression. Complaints from the North Vietnamese that the United States was systematically violating the Paris agreement by secretly maintaining military personnel in Saigon, supplying the South Vietnamese with jet fighters, and encouraging Saigon to hold on to fifteen thousand POWs, who were being tortured and maltreated at detention centers, was seen by U.S. analysts as an excuse for continuing acts of aggression. Because North Vietnam Prime Minister Pham Van Dong was visiting Moscow in March, it suggested that Hanoi might be seeking Soviet approval for a new round of attacks. Any such development would be a blow to Nixon's assertions about peace with honor. Although the state department drafted a reply to Hanoi, the more effective response to the North Vietnamese seemed through Moscow.

If a third Summit with Brezhnev was to be of any significance, Nixon and Kissinger believed that it would need to show progress on SALT II, with a focus on restraining Soviet MIRV deployments. The United States would also need to meet Soviet insistence on holding a European security conference aimed at reducing forces in central Europe and recognizing existing post-1945 borders. A third problem was Soviet sensitivity to being reduced to a minor role in the Middle East. Expanded trade was also part of the U.S. agenda. Agreements on these issues, Nixon wrote Brezhnev, "would be ample proof that the relaxation of tensions between the two strongest nuclear powers is not a passing episode but a continuing process leading to a fundamental change in the character of our relations."

Nixon hoped that further advances in Soviet-American relations would force the president's domestic critics to consider what ousting him might mean for world peace. Several of Jaworski's Texas friends urged him to weigh the president's removal from office for Watergate, admit-

tedly a "most stupid thing," against his mastery of foreign affairs and international stability. Jaworski responded that his legal obligation was to view Watergate as "not stupid, but serious offenses" that required investigation and prosecution.

As Kissinger prepared to leave for Russia, Nixon impressed him as "very preoccupied." At the end of March, Nixon believed that the impeachment fight had turned "stormy and survival seemed unlikely." The White House was under assault from a mountain of legal challenges. A staff of fifteen lawyers under James St. Clair, a Boston attorney Nixon had appointed at the beginning of 1974 to head his defense team, had to deal with a tangle of legal questions. Specifically, Jaworski and the House committee were asking for over forty more tapes, and Nixon saw "no practical choice but to comply . . . If I refused, they would vote me in contempt of Congress," he said. "I made a note on March 22, 1974, at 2 A.M.: Lowest day. Contempt equals impeachment."

The undiminished possibility of being driven from office, coupled with the likelihood that Henry might face a cool reception in Moscow, signaling limited prospects for significant agreements in June, added to Nixon's distress. Ford told a reporter at this time that Nixon was driving him "close to distraction." Ford thought it "indicates that the President has undergone a change of personality in the past year or so."

In a well-meaning attempt to boost the president, Kissinger told a press conference on March 21 that a "conceptual breakthrough" in SALT negotiations had opened the way to a second SALT agreement. Henry offered no details of what this meant. And even if he had something specific in mind, he acknowledged later that it was an ill-advised prediction. This talk of a "conceptual breakthrough," he says, was to take its place alongside his remarks about "peace is at hand" as an unrealistic assessment of what would emerge from current negotiations.

Press and public skepticism on SALT partly revolved around the fear that Nixon and Kissinger were playing what Senator Javits called "impeachment politics." Conservative Republicans believed that any arms control agreement coming out of the next Summit would be aimed less at serving the nation's security than at saving Nixon's presidency. AFL-CIO president George Meany said, "I pray every night that Henry Kissinger won't give the Russians the Washington Monument—he's given them every goddamn thing else."

Admiral Zumwalt believed that Nixon "felt compelled to seek for foreign policy 'successes' to distract the country from his domestic misbehavior." Zumwalt feared that Kissinger, whom he saw preempting a weakened president's authority, was convinced that the American people lacked the "stamina" and the "will" to compete with Moscow, and consequently hoped "to make the best possible deal with the Soviet Union while there is still time to make a deal." (The extensive documentary record of Kissinger's discussions with Nixon and numerous other officials about Soviet relations, including Kissinger's telephone transcripts, are a refutation of Zumwalt's assumption.)

"I was not in Moscow for long before I realized that things were not destined to go swimmingly," Kissinger later recalled. "Each of the subjects on the agenda bred controversy." In a contemporary report to Nixon, Kissinger described "a largely inconclusive seven hours" with Brezhnev during opening talks. "Brezhnev and Gromyko bitterly and at length, though calmly, gave vent to their resentment at Soviet exclusion from Middle East diplomacy. The discussion was one of the most acid I have had with Brezhnev." The Middle East consumed three of the seven hours.

The Soviets wanted to conclude a European security conference before Nixon came to Moscow in June. But Henry held them off. "I think such timing would be undesirable from your standpoint and would also deny you leverage during the Soviet visit." Not only were there no results to speak of from the discussion of major issues, there was a "somewhat desultory quality to the rest of the Soviet performance." At the same time, however, Kissinger reported Brezhnev's statement that the Soviet leaders had "recently decided to continue on course with us."

Kissinger's report spared Nixon Brezhnev's comments on the president's domestic problems over Watergate. Brezhnev did not want to get into "the various details of what is taking place in the United States—and we hear and read a lot about it," he said. But he applauded the president's "firmness and resolve to move ahead on the course we have charted." Nevertheless, Brezhnev felt compelled to add "that in order to move further ahead we have to overcome a few difficulties and obstacles which are integrally linked to improving relations with us . . . And that fact [Nixon's impeachment] may well come to be one of the difficulties we face." Brezhnev worried that someone less sympathetic to détente might

replace Nixon. "If we slipped back," he said, "that would be a bad sign for our two peoples."

Kissinger assured Brezhnev that Nixon and his administration remained committed to détente no matter what happened. In short, détente would continue with or without Nixon. Brezhnev expressed the hope that the improvements in their relations were "irreversible."

Aside from an agreement that Nixon would come to Moscow for a week beginning on June 24, the differences over SALT and the Middle East made it impossible to produce any significant advances in the March talks. In a final report to the president, Kissinger put the best possible face on the conversations: The atmosphere was friendly, and Brezhnev believed they would have a successful Summit.

The U.S. press, however, saw no progress in Kissinger's Moscow discussions, especially on SALT. Henry acknowledged the difficulties to Schlesinger: "Détente is in bad shape . . . and the press is building it into a crisis." The Soviet description of the SALT exchanges made "the U.S. proposal look silly." Moreover, the newspapers ridiculed Henry's earlier comments about a breakthrough, observing that Soviet-American assertions of "progress" on arms control did not amount to a "breakthrough." Nor did claims of "progress" generate much confidence in meaningful agreements at the June Summit.

Nixon was no more optimistic. The prospect of another meeting in Moscow could not counter a mood of despondency that had settled over him by the end of March. At a White House luncheon with the Reverend Norman Vincent Peale and a few others, Nixon was joyless. He "never ate a thing, just stared at his food," one of the guests recalled. "Nixon never said a word. He was obviously too much in agony to have company, yet also too much in agony to be alone."

Nixon found temporary relief from his anguish in evenings with his wife, Pat, daughter Julie, and son-in-law David Eisenhower at their secluded home in Bethesda, where they would eat dinner and sit on a closed-in porch reminiscing about past pleasures: the early years of Dick's and Pat's courtship and marriage and car and train trips. It was as if he were transporting himself away from Washington and all his current troubles into an idealized past or a happier future. The premium was on ignoring the present, Julie Eisenhower recalls. "He steadfastly was trying to sustain a lifelong philosophy of not giving in to defeat."

THE END OF
A PRESIDENCY

*All political lives, unless they are cut off in midstream
at a happy juncture, end in failure, because that is the
nature of politics and of human affairs.*

—ENOCH POWELL, 1977

*It was a Greek tragedy. Nixon was fulfilling his own
nature. Once it started it could not end otherwise.*

—HENRY KISSINGER, *Years of Upheaval*

B y the spring of 1974, public attitudes toward Nixon and Kissinger
were heading in opposite directions. The president's political sur-
vival seemed more uncertain every day, while Kissinger's public standing
reached new heights. On April 3, the White House felt compelled to
issue a statement responding to a report from the Joint Congressional
Committee on Internal Revenue Taxation saying Nixon owed $432,787
plus interest for impermissible deductions, principally for the gift of his
vice-presidential papers to the National Archives.

Although the statement emphasized the absence of any IRS sugges-
tion of fraud, the news intensified feelings of distrust toward the presi-

dent. A Gallup survey between March 29 and April 1 gave Nixon a 65 percent disapproval rating, with only 26 percent content with his job performance. At the same time, 58 percent of college students cited distrust of government as the most important problem facing the country.

By contrast, Kissinger was lionized as the single administration official untainted by Watergate. *Time* described him as "the one figure of stature remaining amid the ruins of Richard Nixon's stricken Administration." Henry was seen as someone who could ensure continuity in foreign policy if Nixon was driven from office. By contrast with Nixon, the poor boy who made good and then ruined himself by overreaching, Kissinger was the self-made man who gave success a good name. His marriage to Nancy Maginnes on March 30, 1974, added to his standing as a celebrity whose private life excited constant press attention. Forty reporters kept watch at an Acapulco estate in Mexico, where the couple honeymooned, while twelve secret service agents provided protection. In a bizarre phone call of congratulations to the bride, Nixon warned her against poisonous snakes in Acapulco and the need to extract the venom promptly should either of them be bitten.

On April 2, France's President Pompidou died after a long struggle against cancer. Nixon seized the opportunity to escape his domestic crisis temporarily by traveling to Paris. It allowed him not only to get away from Washington, however briefly, but to project an image of a confident world statesman. Holding court at the U.S. embassy, where he met with the British, Italian, West German, French, Danish, Soviet, and Japanese heads of state, Nixon impressed the French press as "the Sovereign of the Western World," who "continued to dominate international politics." *Le Figaro*, the leading French conservative paper, carried a cartoon of Nixon seated on a throne with a crowned woman representing Europe kneeling before him.

The conversations reflected a different reality. Although Nixon's counterparts were all respectful toward him, they were less than accommodating. Suspicious that détente was diminishing U.S. willingness to defend Western Europe, angry at American unilateralist dealings with the Middle East, and seeing Nixon as a damaged leader who was discredited at home, the Europeans seemed indifferent to Nixon's warnings that alliance divisions could strengthen isolationist impulses in the United States.

Nixon offended the French by using Pompidou's funeral to bolster his public image. A government official complained that Nixon "shamelessly substituted a publicity campaign for the mourning of an entire nation"; he described it as discourteous and clumsy. The liberal *Le Monde* dismissed the president's performance as "the Nixon Festival."

The Watergate scandal was waiting for him when he returned to Washington on April 7. On April 4, the Judiciary Committee had threatened Nixon with a subpoena unless he provided tapes it had requested in March. A St. Clair response on April 9 that he would provide materials by April 22, which would allow the committee to complete its investigation, could not dissuade it from voting 33 to 3 on April 11 to subpoena forty-two tapes.

St. Clair's response to the Judiciary Committee, Scowcroft told Kissinger on his return from Mexico, "was received very badly on the Hill." At the same time, Jaworski weighed in with a request to Judge Sirica for a subpoena directing the release of sixty-four more taped conversations. Sirica issued the order on April 18.

Nixon hoped to fend off the House and special prosecutor's demands by promising to release edited transcripts of his conversations at the end of April. In the meantime, he and Kissinger made fresh efforts to use foreign affairs to keep the president in office. Henry urged Nixon to plan a Middle East trip for the end of May or the beginning of June. Nixon said it depended on whether the House "left us off the hook by that time or got us on." Henry doubted that the House could act that quickly and that a trip following a Syrian-Israeli disengagement agreement "will be a political event in the Middle East of the first magnitude."

In another conversation four days later, Kissinger reported on a speech he had given at the UN, in which he had quoted the president, and the grudging response of the *New York Times*. "It just breaks their heart to say anything positive," Henry said. Nixon recounted a conversation with Mike Mansfield about a dinner meeting with Chinese diplomats. He described them as "very supportive and friendly about the President and about you." Henry berated critics of "our China . . . Russian policy" as "idiots," who couldn't understand what we were doing.

The Nixon-Kissinger conversation became an exercise in self-deception. "Well, we are coming along," Nixon declared, "and just remember if we have been able to take the heat of this last year and ac-

complish what we have, we sure as the dickens are going to be able to take it a little while longer." Henry believed that "public opinion is on the verge of turning if we can just—if there was just one unambiguous event like a House vote in your favor." Nixon doubted that he could get anything from the House, but he saw "an undercurrent of support" on foreign policy "that is just ready to break loose. What do you think?" Nixon asked. "That is my absolute conviction—that is my firm conviction," Henry replied. "In foreign policy it never has left us," Nixon asserted.

Conversations with Gromyko during a two-day visit to Washington on April 11 and April 12 gave the lie to their happy talk about significant future foreign policy gains with Moscow. Nixon and Kissinger agreed that recent discussions with the Soviets had produced no "easy answers where our positions had diverged." Gromyko's visit reinforced the impression that Soviet-American relations were at a standstill. On April 11, when Brezhnev expressed concern to Ambassador Stoessel that Watergate might hinder Nixon's freedom to negotiate additional agreements, it deepened concerns that dealings with Moscow would not translate into a domestic political benefit. Because they could not be optimistic about new agreements on any of the largest issues, Gromyko suggested that they were like two deaf men who talked past each other. They maintained some hope for better relations by not hearing what each other said.

In the two and a half weeks after Gromyko's visit, Nixon was almost exclusively occupied with managing the demands for additional tapes, which threatened impeachment and an end to his presidency. When Kissinger tried to get five minutes with the president on the morning of April 17, Scowcroft was uncertain that Nixon would see him. "The mood over here is not very good this morning," Scowcroft reported. "He is not in the cheeriest mood."

Henry had his own problems: He complained that a conference with Latin American foreign ministers made him feel as if he were "dealing with a nut house . . . These guys are the biggest gassers you've ever seen," he said. By the afternoon, Nixon's mood was still "not real good," and Henry had to press Scowcroft to squeeze Egyptian Foreign Minister Fahmy into the president's schedule for half an hour.

Two days later, Kissinger, who was struggling to focus Nixon's attention on Middle East negotiations, told Sisco that he was trying to "get to the President who is raving around here." Press speculation that the

president and secretary were not coordinating policy provoked Henry into informing Haig that he wanted to tell a journalist "that my public position is worked out closely with you and the President and has your full approval." Haig assured Henry that, as in the past, he would continue to say this to the press.

In fact, Nixon was too preoccupied with impeachment worries to concentrate on foreign affairs. True, on April 17, at a dinner honoring Latin American ministers, Nixon trumpeted a "new dialogue" with the republics to the South, which he described as "more than a slogan."

At the same time, Nixon proposed to the cabinet that they provide him with a list of suggestions, "new initiatives, new ideas, new thrust of some kind that the President could do as President." As with his rhetoric about a "new dialogue," he was intent on some bold announcements that could distract attention from his personal crisis. "Oh, Jesus Christ," Kissinger exclaimed, when Kenneth Rush described Nixon's pronouncement to the cabinet. "I don't want anything to go to the President [on international affairs] that I don't see."

But Nixon was too absorbed by the challenge of casting the taped conversations in the best possible light to give more than passing mention to new initiatives of any kind. Between April 17 and April 29, when the White House issued a 1,200-page "Blue Book" of transcripts titled *Submission of Recorded Presidential Conversations to the Committee on the Judiciary of the House of Representatives* by President Richard Nixon, he devoted himself to sanitizing a record that could confirm the worst suspicions about his involvement in a White House cover-up of campaign wrongdoing.

When he reviewed the transcripts prepared by fifteen secretaries and vetted by two attorneys, "he eliminated words, phrases, and passages. He crossed out curse words [substituting expletive deleted], insulting references to various senators . . . and other material," Ambrose explained. Nixon also believed that the bulk of the material would mute damaging revelations in the transcripts about his skullduggery.

To win the public relations war against impeachment advocates, Nixon announced the release of the "Blue Book" in a nationally televised speech from the Oval Office on the evening of April 29. In the sort of appeal for national support reminiscent of his televised Checkers talk twenty-two years before, Nixon insisted that the transcripts would

entirely exonerate him and definitively end the speculation about a presidential part in either the Watergate break-in or the subsequent cover-up. He acknowledged his reluctance to release the tapes; it had nothing to do with the scandal. Rather, he was protecting the tradition of presidential confidentiality.

The response to his speech was much less than he hoped. The press and fellow Republicans condemned the president's involvement in a cover-up of White House wrongdoing. William Safire said that "the reaction after reading the poisonous fruit of his [Nixon's] eavesdropping tree is (expletive deleted)." An academic expert on textual criticism described the transcripts as "systematically debased and corrupt." The Judiciary Committee criticized the edited White House version of the tapes as unreliable, and on May 1, by a partisan vote of 20 to 18, declared Nixon in noncompliance with its subpoena.

Al Haig concluded that sooner or later the committee would force Nixon to release the actual tapes. "How much better it would have been," he said, "to have seen the tapes go up in smoke the previous summer." In 1981, shortly after President Ronald Reagan was wounded by an assassin, Nixon told Reagan press aide Lyn Nofziger, "Lyn, don't let the president make any decisions until he's completely well, because you don't make good decisions when you're sick. You know, I made the decision not to burn the [Watergate] tapes when I was recovering from pneumonia." However, it wasn't the only time that Nixon considered and rejected the idea; he assumed that the negative political consequences from destroying the tapes would be more harmful than preserving and controlling anything he released from them.

Two days after Nixon's speech, Gallup asked Americans if recent developments had changed their feelings about the president. Of those surveyed, 74 percent had the same or a less favorable view. Nixon's speech and action improved his standing with only 17 percent of the public. By 44 percent to 41 percent, Americans thought that Nixon should be impeached and tried by the Senate. Nixon's overall approval remained at its low of 25 percent, and 73 percent of the country believed that the president either had advance knowledge of the break-in or was involved in the cover-up. The 25 percent represented the low point for any president in a second term since the advent of scientific polling.

Although Nixon continued to hope that his foreign policy leadership

could rescue him from impeachment, he was so preoccupied with his domestic crisis that he once again relied on Kissinger to manage foreign affairs. In April, searching for a formula that could overcome Syrian-Israeli differences about Israel's occupation of the Golan Heights produced almost daily exchanges between Henry and the Egyptians, Saudis, Syrians, Israelis, and Russians, who continued to feel shoved aside.

On April 26, with Kissinger about to leave for discussions with Israeli and Arab officials, Nixon emphasized his eagerness for some sort of disengagement agreement that would allow him to travel to the Middle East. "If I do take a trip," Nixon said, "I think the sooner the quicker." Henry agreed, and Nixon suggested that anytime after May 20 would be good. Kissinger promised to make the arrangements. When Kissinger reported that he would hold a press conference after their phone conversation, Nixon told him to emphasize that they were seeking "a way to keep out of war in the M[iddle] E[ast and] to keep out of war in Vietnam," and that it was the Nixon Doctrine in both places making it possible. "Hit that hard," Nixon said.

Nixon's mention of Vietnam rested on renewed anxieties that the January 1973 peace agreement was collapsing. On April 18, Le Duc Tho had written Kissinger to complain that he had not answered earlier messages in February and March about South Vietnamese and U.S. violations of the cease-fire. Henry responded four days later that he had seen no point in repeating earlier denials of Tho's charges, especially since it was Hanoi that was responsible for treaty abuses. Henry urged Tho not to interpret his silence as any indication that he did not value their channel of communication. He hoped that their continuing exchange of views might yet advance their search for a stable peace.

As April came to a close and Kissinger set off on his trip, Thieu informed Nixon that continuing North Vietnamese acts of aggression had compelled him to suspend conversations with the Viet Cong. With neither Saigon nor the Communists genuinely interested in a settlement and the White House without the wherewithal to apply fresh pressure to Hanoi, the agreement remained in jeopardy. Should full-scale fighting resume in Vietnam, it would be a severe blow to Nixon's assertions about his indispensability as a peacemaker. Press and public attention to the Middle East, however, coupled with a desire to put the conflict in Vietnam aside, muted interest in Southeast Asia.

Although preoccupied with whether his April 29 speech and release of tape transcripts would deter impeachment, Nixon was intensely interested in Kissinger's new round of shuttle diplomacy. Henry's initial report to him on April 30 describing ten and a half hours of discussions with Gromyko in Geneva were encouraging. On the Middle East, the Soviets were showing greater flexibility. "If one gives the Soviets some face-saving formula," Henry predicted, "they will not obstruct the current effort and may even be moderately helpful." He also reported a productive SALT discussion, and was optimistic about prospects of a successful Summit in June.

Kissinger sent more good news after his preliminary talks in Jerusalem. A meeting with Meir had encouraged hopes of an early break in negotiations with Syria. He believed that the consequences to Israel of failed talks were dictating greater flexibility. He told Meir and the Israeli cabinet that any failure would be blamed on them and would reduce the likelihood of reliable U.S. support. This was what the Israelis called "Henry's Doomsday Speech." Kissinger asked Nixon to send the Israelis a letter emphasizing this point.

In Syria, the next day, Kissinger urged Assad against "provocative statements . . . We have to avoid a situation which helps Israeli propaganda and the Jewish newspapers in the United States; we have to avoid an image that you are a Soviet stooge." Assad blamed Syria's poor image in America on Zionists. "That is why it is important rapidly and visibly to have an improvement in U.S./Syrian relationships," Kissinger said. "We want to change public opinion regarding the Arabs in the United States." Henry also complained about his reception in Israel as compared to Damascus, which he described as friendlier.

As Kissinger tried to work some magic in bringing an agreement out of the Israeli-Syrian standoff, Nixon fell into deeper despair over his future. The Judiciary Committee's refusal to accept the transcripts as a substitute for the tapes, coupled with Jaworski's insistence on receiving sixty-four conversations, left Nixon with the slim hope that the Supreme Court would back his claim of executive privilege and block the release of tapes that would likely force him out of office.

On May 5, Jaworski proposed a deal to Haig. If Nixon would give him eighteen conversations he considered most important in establishing the president's guilt or innocence, Jaworski would drop his request for

the additional tapes and not reveal that the grand jury had unanimously named the president as an unindicted co-conspirator in the Watergate cover-up. The jury had wanted to indict him outright, but Jaworski advised them that this would be unconstitutional. An indictment or impeachment of a president was a power reserved to the House of Representatives.

It was a stunning disclosure. Haig believed it "would shatter what was left of the President's credibility . . . Jaworski's revelation could destroy him." But because Nixon and his lawyers saw Jaworski's proposal as "prosecutorial blackmail," they decided to resist his demand. Nixon initially agreed to Haig's suggestion that he listen to the eighteen conversations before deciding what to do. But after several hours in his hideaway office hunched over a tape recorder with earphones, Nixon called in Haig and said, tell Jaworski, "No. No more tapes . . . We're not going any further, not with Jaworski, not with the Judiciary Committee. We're going to protect the presidency." Haig "had seldom seen him so disturbed or so determined. 'No one is to listen to these tapes,' he said. 'No one—understand, Al? No one. Not the lawyers. No one. Lock 'em up.' "

As Nixon understood, these eighteen tapes could doom him by demonstrating his central part in the cover-up of Watergate crimes. He believed it better to fight the demand on grounds of high principles than block news of the grand jury's action. He instructed Ziegler to release a statement saying that Washington was swamped by false rumors, led by predictions that the president would resign. "His attitude is one of determination that he will not be driven out of office by rumor, speculation, excessive charges, or hypocrisy. He is up for the battle, he intends to fight it and he feels he has a personal and constitutional duty to do so."

Nixon had talked himself into believing that his wrongdoing was less important than defending himself and, by implication, the presidency, from an unprecedented resignation or congressional action to remove him from office. What kept him from resigning, he told Rabbi Baruch Korff in a private meeting on May 13, was his innocence and determination not to undermine an institution essential to the country's future well-being. He would not succumb to "the savagery" or "viciousness" of the "libelous" personal assault on him. If "these charges on the Watergate and the cover-up, et cetera, were true, nobody would have to ask me to resign," he declared.

For Nixon, Kissinger's Middle East negotiations now took on even greater importance. Nixon sent the threatening letter to Meir that Henry had requested and instructed him to stay in the Middle East until he worked out an Israeli-Syrian settlement. Kissinger was happy to play the go-between in the talks—not only because an agreement could reduce the chances of another war but also because it could decisively inhibit Moscow from asserting greater influence in the region.

Kissinger was also happy to be away while the Watergate battles played themselves out. Even from afar, however, Henry could not entirely escape implicit involvement. Assertions by Ehrlichman and Colson describing Kissinger as warmly disposed to the establishment of the "plumbers" to plug national security leaks led Scowcroft and Haig to advise Henry to avoid saying anything about the issue.

During thirty-three days between April 28 and May 30, while he made forty-one flights between Jerusalem, Damacus, Cairo, Riyadh, Amman, and Cyprus, where he met with Gromyko, Kissinger struggled to keep the discussions alive. "Each issue becomes the subject of intensive bargaining over every detail," he wrote Nixon. "It's the most nerve-racking negotiation I've ever been involved in," he told Joe Kraft afterward. He complained that it was undignified for a secretary of state to be traveling "around for four weeks talking about a hill here and a hill there, while not conducting any other foreign policy." He complained to the Israelis, "I am wandering around here like a rug merchant in order to bargain over one hundred to two hundred meters! Like a peddler in the market! I am trying to save you, and you think you are doing me a favor when you are kind enough to give me a few extra meters." On the plane flight home, he told reporters off the record, "The Syrians and the Israelis are the only two peoples who deserve each other."

A James Reston column in the *New York Times* criticizing Kissinger's attention to the Middle East to the exclusion of other matters agitated Henry. During a shuttle flight, he asked Marvin Kalb, who was covering the negotiations for CBS television, to join him in his cabin. Kalb describes him as "unkempt, looking like a slob with one or two buttons missing from a partly open shirt." While he nervously shoved peanuts into his mouth, he asked Kalb what he thought of Reston's article. Kalb wanted to know how close Kissinger was to a deal. When Henry said, "close," Kalb urged him to stay with the negotiations.

By May 21, when a breakthrough in the negotiations seemed imminent, Nixon cabled Kissinger. "Of all your superb accomplishments since we have worked together, the Syrian/Israeli breakthrough . . . must be considered one of the greatest diplomatic negotiations of all time . . . I believe we should follow up this development with a trip to the Middle East at the earliest possible time." Nixon also assured him that despite a *New York Times* report to the contrary, "nowhere in the transcripts or the tapes did I ever use the terms 'Jew boy' or 'Wop.' " (Kissinger knew better.) Nixon looked forward to discussing plans for a joint briefing of congressional leaders.

Judicial challenges to Nixon at the end of May made him more eager than ever to use a Middle East breakthrough for domestic political purposes. On May 20, Judge Sirica ordered him to turn over the tapes subpoenaed by Jaworski. On May 29, the Judiciary Committee issued a new subpoena, reiterating its rejection of White House transcripts as a substitute for the tapes and warned that a refusal could be grounds for impeachment. On May 31, the Supreme Court rejected a Nixon plea to delay consideration of whether the president had the right to withhold tapes from the Special Prosecutor, promising to decide the matter before its summer recess. Of the public, 48 percent now favored impeachment, with only 37 percent opposed.

On May 29, in a nationally televised statement from the White House, Nixon announced an Israeli-Syrian settlement that returned some of the Golan Heights to Damascus and provided for a wider separation of Israeli and Syrian forces. Although he praised Kissinger for his painstaking efforts, he emphasized his administration's responsibility for this major diplomatic achievement. The task before them now was to arrange a permanent peace. An announcement of a presidential visit to the region would suggest that Nixon was about to put such an arrangement in place.

Kissinger resisted tying the Israeli-Syrian settlement to a Nixon trip. He worried that the press would cynically interpret his shuttle diplomacy as principally aimed at serving the president's political needs. "I objected to the idea that all of this was being done to arrange a Presidential trip to the Middle East," he told Kraft, who had made that point in a column. "That may be the result, but that was not the intention," Henry declared. It certainly was not Kissinger's primary motive for arranging a settlement but, as Kissinger acknowledged later, insistent White House

cables urging him to continue the discussions until there was an agree-ment rested on an "obsession" with a presidential visit.

Nixon's determination to use Kissinger's achievement to counter impeachment registered clearly in a May 31 Nixon-Kissinger bipartisan congressional briefing. Henry described the arduous—"excruciating"—process required to arrange the disengagement agreements between Israel and its two principal adversaries. But these accomplishments "only open the long road toward a permanent settlement," Nixon emphasized. The president and Kissinger also described their success as partly the result of détente. Moscow avoided sabotaging the Middle East negotiations because it would jeopardize improved relations with Washington. The message was clear enough: Nixon and Kissinger were essential to inter-national peace; removing the president would risk undermining all the good things his administration had put in place around the world.

A newspaper story on June 6 that Nixon was an unindicted co-conspirator and an attack on Kissinger at a news conference the same day for involvement in wire tapping raised questions as to whether any-thing could shift attention from White House wrongdoing to foreign affairs. After reporters raised the possibility that he might face a perjury indictment, an enraged Kissinger threw a tantrum, turning red in the face, stamping his feet, and storming out of the room. Afterward, he told Nixon, "The disgusting thing is . . . the whole world applauds what is being done [abroad]. These SOBs [in the press corps] turn it [wiretap-ping] in as if I'd been engaged in a criminal activity." Nixon assured him that "all the wiretapping we did was totally legal . . . Every damn one was approved by Mitchell or Hoover. Every one. Some of them turned up some very important evidence, as you well know." Henry agreed, but neither said what that evidence was. Kissinger was not reassured. He told Ziegler, "They [the press] won't rest now until they have made me a Watergate figure."

Despite the press preoccupation with administration scandals, Nixon thought that his strategy of trumping Watergate with foreign policy was working. In diary notes he made on the evening of June 7, he wrote, "What will motivate the House members at the present time I think may be their concern that if they impeach, they run the risk of taking the responsibility for whatever goes wrong in foreign and domestic policy after that." Nixon congratulated himself for hanging on despite so many

discouraging developments. He took satisfaction at having been able to hide his distress from the press and the public.

In a series of speeches—a radio address on Memorial Day, a commencement speech at the Naval Academy on June 5, and a luncheon talk on June 9 to supporters describing themselves as "the National Citizens' Committee for Fairness to the Presidency"—Nixon emphasized how fragile international stability was and how his administration had improved chances for lasting peace. But it required the "right balance" of influences for stability to be realized. Taking anything for granted now (that someone other than the team of Nixon and Kissinger could build on recent achievements) would be a great error.

On the eve of his departure for ten days in Europe and the Middle East, Nixon told himself that "the success or failure of this trip might make the decisive difference in my being able to continue to exercise presidential leadership abroad and at home despite the merciless onslaught of the Watergate attacks." Yet he also understood that "most of the press will be more obsessed with what happens with the minuscule problems involved in Watergate than they are with the momentous stakes that are involved in what I will be doing and saying in the Mideast."

Nixon had it right. The press, the Congress, and the public continued to see Watergate as more than "minuscule problems." During the trip, however, it was Kissinger, not Nixon, who became the focus of new headlines about administration scandals. Press accounts during the few days between Henry's press conference and the start of the trip on June 10 put him in a bleak mood. *Newsweek* called allegations about his part in arranging wiretaps of suspected leakers, "An Ugly Blot on Mister Clean." *New York Times* and *Washington Post* editorials questioning Kissinger's honesty rekindled his rage at being under such scrutiny.

A syndicated article by reporter Nick Thimmesch that the state department cabled Kissinger in Salzburg added to his anger. Thimmesch described Kissinger in "a slightly faded Superman suit" as "the latest victim of the Watergate fungus." Reviewing Kissinger's earlier denials before senators of any involvement with the Plumbers, Thimmesch dubbed the legislators, who had turned a blind eye to the secretary's transgressions, "a world's championship sleeping society." Although Thimmesch saw nothing illegal in Kissinger's trying to plug national

security leaks, he joined other journalists in accusing him of lying and possible perjury.

Because a *Newsweek* cover pictured Kissinger in a Superman suit and he had reached "the highest point of public acclaim ever accorded to a Secretary of State," Henry was confident that he could effectively beat back the assault on his reputation. Against the advice of Nixon, Haig, and all his closest associates, Kissinger held a press conference in Salzburg. Nixon was convinced that it would simply give the press another Watergate story that would detract from the Middle East trip. Following an opening statement exonerating himself, an angry, uncharacteristically unsmiling Kissinger protested his innocence, reminded reporters of his contributions to peace—"perhaps some lives were saved and . . . some mothers can rest more at ease"—and threatened to resign if the matter was not cleared up by the press.

It was a bravura performance masking the truth about his role in the administration's wiretapping. Although he described himself, in William Safire's words, as "a reluctant participant in a distasteful program," he was in fact a "sycophantic and enthusiastic" supporter of the administration's efforts to "destroy" (Kissinger's word) leakers by providing the names of suspects to Hoover. "Kissinger, who takes the lion's share of credit for the Nixon foreign policy successes," Safire added, "cannot avoid at least a lamb's share of blame for some of these illegal doings . . . This tolerance of eavesdropping was the first step down the Watergate road." Kissinger "cannot escape history's judgment of the way he watered the roots of Watergate."

Nixon believed that Henry's news conference was a "mistake," especially the hyping of "his case with the threat to resign, which . . . is an empty cannon." But Kissinger, in fact, had read press, public, and congressional sentiment more accurately than Nixon. The response to his threat was all he could have wished. The White House report to Kissinger about the evening news coverage of his press conference described his "many admirers and few critics on the Hill" as "stunned" by Henry's threat. NBC television called Kissinger's threat to resign "astounding." The *New York Times* reported the "Capital [Was] Rallying Round Kissinger."

Kissinger saw the reaction to his news conference as vindication of his decision, but it also rekindled smoldering tensions with Nixon. Kis-

singer believed that if Nixon had survived Watergate, he would have fired him. It seems doubtful, however, that Nixon could ever have regained enough credibility to dispense with the one person in the administration who gave it a continuing hold on public opinion.

As THE TRIP BEGAN, Nixon had other worries. He was suffering from phlebitis in his left leg—an inflammation of a vein that was quite painful, caused him to limp, and carried the greater threat of a blood clot that could break loose and travel to the lungs, where it might cause an embolism and death. During the stop in Salzburg, Nixon consulted with his White House physician, who thought that the pronounced swelling in the leg and pain was the result of the inflammation, but that the danger of a clot and an embolism had passed. The doctor told Nixon to wrap his leg in hot towels four times a day and stay off it as much as possible.

After the doctor left, Nixon called in Haig, who found the president with "his trouser leg pulled up and his leg on an ottoman. It was blue and swollen and looked absolutely like it was just moments from amputation," Haig recalled. Nixon told Haig that his doctors had urged him not to make the trip, but he had insisted on going. "I'm not so sure he wasn't hoping for something more serious," Haig believed. "And that began to worry me a great deal . . . because everything had gone black for him." Thirty-one years later an interviewer asked Haig, "You say you observed a man who had lost the will to live, and may even have had a death wish. Is that putting it too strongly?" Haig replied, "That was my concern, of course . . . And he did mention in that discussion with me . . . he said in the army, Al, you have a solution to this. When you have a disgraced leader, you put a pistol in his desk drawer and he takes care of the rest. And so that really concerned me, because he never said things lightly."

Although three days in Egypt slowed his recovery from phlebitis, the visit buoyed Nixon as nothing had since his landslide election in 1972. On the roads and streets from the Cairo airport, perhaps as many as a million people turned out in 100-degree temperature to greet the president and Sadat, who stood in an open-top limo waving to the crowds. The next day, during a three-hour train ride to Alexandria, the two presidents repeated the performance from the back of an open coach as millions of Egyptians lined the route. Although official directives urged people to come into the streets, the demonstrators reflected a genuine enthusiasm generated by the

prospect of economic help from the world's richest nation and by the regard Nixon showed for Sadat and Egypt. As Nixon said at a state dinner, "You can turn people out, but you can't turn them on." The long periods standing in summer heat increased the pain in Nixon's leg but the shouts of "Nik-son, Nik-son" renewed his hope of weathering Watergate and advancing the peace process between Israel and the Arabs.

With an eye on U.S. congressional and public opinion, Nixon seized the numerous opportunities during the visit to issue ringing public declarations about the importance of the renewed relationship with Egypt. "We stand here at a time in history which could well prove to be not only a landmark but which could well be remembered centuries from now as one of those great turning points which affects mankind for the better," Nixon said on his arrival in Cairo.

Sadat's hyperbole was a match for Nixon's. He declared himself convinced that a "statesman of the stature of President Nixon" was essential to meet the challenges facing them in the region. At a state dinner on June 13, Sadat spoke of his "admiration for your courage in taking the initiative in making daring and decisive decisions on all levels on the international plane." Sadat was "confident" that Nixon's "vast experience and your universally acknowledged reputation as a statesman" would open the way to "a just and durable peace."

"For once on a state visit," Kissinger said, "the statements [and subsequent toasts] reflected a reality. The leaders of both countries were determined to make peace." When a journalist asked Sadat, "You are not suggesting bilateral discussions with Israel?" He answered, "No, not at all. Not yet." It opened the way to the 1978 Camp David peace accords between Egypt's Sadat and Israel's Menachem Begin.

Despite Kissinger's central part in preparing the way for Nixon's visit to Egypt, the president kept him in the background. Sadat's praise of Nixon for "his role as the key factor in the peace process," coupled with the president's coolness after the Salzburg news conference, angered Henry. "Having been spoiled as the recipient of abundant flattery and attention on previous trips," Henry wrote later, "I found it—not to my credit—somewhat disconcerting, even painful, to be relegated to what in the context of a Presidential trip was quite properly a subsidiary role. The press . . . gleefully reported both the fact that I received 'little attention' and that I seemed 'glum.' "

Although less evident to the press, Nixon's understanding that a triumphal tour of Egypt would not be enough to avert impeachment curbed his elation during the visit. Kissinger recalls that Nixon's reception in Egypt "alternatively buoyed and depressed him." Moments of "relief and elation" repeatedly gave way to "despondency . . . As the trip progressed, his face took on a waxen appearance and his eyes the glazed distant look of a man parting from his true—perhaps his only—vocation; it was excruciatingly painful to watch. In Washington he had been inundated by the sordid details and desperate struggles of Watergate, yet ironically it was on his triumphant Middle East travels that the true dimension of his personal disaster was brought home to him: He was being vouchsafed a glimpse of the Promised Land that he would never be able to enter." Golda Meir later told Kissinger: "Nixon was here but his thoughts were far away."

Nixon's reception in the four other Middle East countries he visited was more subdued. Aided by memos Kissinger prepared on what the president could expect in Saudi Arabia and Syria, Nixon effectively blunted the diplomatic pressure from King Faisal and Syria's Assad to oust Israel from occupied Arab territories, including Jerusalem, the Golan Heights, and the West Bank of the Jordan, and to assure a homeland for the Palestinians. Without revealing exactly what he had in mind, Nixon promised a step-by-step process that could eventually bring peace to the region.

Assad was the most difficult of the Arab leaders Nixon saw on his trip. Years of America- and Nixon-bashing were not easily put aside by Assad or his people. He acknowledged that hating Americans and Nixon in particular was a way of life in his country. Nevertheless, Assad's eagerness for a larger Syrian role in Middle Eastern affairs made Nixon a welcome guest in Damascus. Although nothing substantive was settled during the visit, the symbolic coming together was seen as a large advance. As Nixon said good-bye at the airport, Assad kissed him on both cheeks—"an extraordinarily important gesture" for someone who had been "the leading anti-American firebrand of the Arab world."

Conversations in Israel were also more symbolic than substantive. The Israelis were passing through a political transition when Nixon arrived on June 16. Yitzhak Rabin, a former general, chief of staff, and ambassador to the United States, was replacing Golda Meir, whose gov-

ernment was ousted after the surprise and losses in the Yom Kippur War. Nixon described his reception as "warm," but "the most restrained of the trip." Although grateful for U.S. aid that had rescued them from defeat in the recent conflict, Israelis saw Nixon's peace program as likely to serve Arab interests at Israel's expense in territory and security. As the *New York Times* reported, signs on the way in from the Tel Aviv airport confronted Nixon with the sort of hostility he had fled in the United States: "You Can't Run from Justice" and "Welcome, President Ford" two of them said with reference to Watergate; "We Are All Jew Boys," another declared with allusion to the president's alleged anti-Semitism.

Rabin, who headed a shaky coalition government, was in no mood to discuss larger political questions, except for U.S. intentions about future military and economic aid. Where Rabin and his colleagues were focused on obtaining long-term commitments that could help ensure Israel's national security and prosperity, Nixon wanted to discuss future peace talks. Defense minister Shimon Peres emphasized the current limits of Israel's capacity to defend itself: The Syrians and Egyptians had twice the number of tanks Hitler had when he attacked the Soviet Union in 1941.

Nixon expressed nothing but sympathy for Israel's problem. But he refused to make any long-term commitments. The problem was with Congress, which was averse to anything but year-to-year commitments. This was true enough, but it was also Nixon's way of pressuring the Israelis to agree to further peace talks. In line with Kissinger's earlier threats, he emphasized that if the negotiations failed, it would lead to another war, in which he doubted that Israel would be able to command the extraordinary aid provided in the past year.

Nixon returned to Washington on June 19, not to a hero's welcome but to fresh recriminations over White House scandals. A poll taken between June 21 and June 24 gave him only a 26 percent approval rating; 61 percent disapproved of his job performance. When people were asked what concerned them most, the answers were high prices and Watergate. As Gallup stated the problem, where "personal diplomacy on earlier occasions [had] boosted his standing with the American public, a similar effect is not found in the current survey."

Nixon, Ford, and the rest of the White House aggressively tried to shift public perceptions of the president as a political manipulator hiding

his role in Watergate to that of righteous peacemaker. On the afternoon of June 19, Nixon told administration faithful greeting his return on the White House south lawn that he was determined "to stay the course" in the arduous struggle for Middle Eastern and world peace. He said it would be shameful if the United States abandoned its responsibility for leading the world toward this noble goal. "Blessed is the peacemaker," Vice President Ford said in response.

"We must have gotten some lift from the trip," Nixon confided to a diary, "although it seems almost impossible to break through the polls." He blamed it on the media: "Of course, this is not surprising after the terrible banging we are taking. As I pointed out to Ziegler, when he was telling me about the five or six minutes that we were getting on each network while we were away, I said, 'Compare that with the eight or ten minutes that they have been hearing on Watergate for over a year!' " Yet Nixon was hopeful that the trip had some impact. "How great and how long lasting only time will tell."

In a bipartisan congressional briefing on the morning of June 20, Nixon made a case for himself as the architect of foreign policies that had produced profound changes in world politics. Yet no one should think that they had arrived at the Promised Land, he cautioned. They faced tough problems that required continuing attention. It was important for congressional leaders to understand that "American leadership is essential to avoid future wars," and that "We need the support of the Congress." The leaders gave no indication that the president's briefing changed any minds about full White House disclosure on Watergate.

Kissinger remained publicly supportive of Nixon, but was privately skeptical of his political survival and viewed the national well-being as principally tied to himself. After returning from the Middle East, Henry told Jacob Javits, "I couldn't let myself be bled to death one leak at a time while I was traveling . . . You know what really worries me, Jack . . . with the President facing impeachment, what's been holding things together is my moral authority abroad and to some extent at home. If that's lost, we may be really in trouble."

More than egotism was at work in Kissinger's assessment; a June Sindlinger poll showed overwhelming public support for Henry: "Eighty-four percent of those sampled gave him a positive rating and no other politician or institution in the United States rates as high." Fifty-four

percent said he was doing an excellent job compared to 5 percent for Nixon and the Congress.

In the days immediately after they returned home, events in the Middle East undermined Nixon's argument for himself as an effective peacemaker. PLO attacks on northern Israeli kibbutzim the day Nixon arrived in Washington provoked Israeli air raids on Palestinian camps in Lebanon. The violence refuted Nixon's pronouncements on U.S. progress in reducing Middle East tensions. Nixon directed Kissinger to have Scowcroft tell the Israeli embassy that the president "is disturbed beyond expression that the Israelis started retaliatory raids on Lebanon the day he left there . . . If they expect political support from us, they cannot keep doing these things."

Nixon asked Henry the next day, "How about our Israeli friends? Are they still bombing?" Kissinger replied that a "sharp protest" had helped convince them to stop. "That's good," Nixon said. "If they go too far, we'll get one hell of a reaction here." Nixon believed that people wanted further progress in détente and that highlighting the likely achievements of an upcoming Summit meeting in Moscow might give him some protection against unrelenting Watergate headlines.

He knew, however, that he would need more than another foreign policy triumph to save his presidency. In the six days between his return to the United States and his scheduled departure on June 25 for Western Europe and Russia, press stories about the differences between the taped conversations and the transcripts given to the House Judiciary Committee seemed likely to lead to his impeachment. Yet he refused to believe it: The quality of the evidence against him gathered by the committee, he told himself, "was weak; most of it had little or no direct bearing on my own activities." There was even better news from Joe Waggonner, a Louisiana House Democrat, who assured the president that there were 70 anti-impeachment votes among Southern Democrats, which when coupled with 150 Republican votes, could block a Senate trial. Waggonner warned, however, that should the Supreme Court rule against the president on access to his tapes and Nixon refused to comply, his supporters would turn against him.

Nixon confided to his diary that "what happens in the Supreme Court is going to put us to a real test." He was uncertain whether the Court would want to set "a devastating precedent" by overriding execu-

tive privilege and compelling the release of his tapes. He feared that "the poison they see in the *Washington Post* must really seep in. It is very difficult for people to read it every day and not be affected by it." In Nixon's skewed outlook, if the Court forced him into releasing tapes and the Judiciary Committee then impeached him, it would be the consequence not of evidence demonstrating wrongdoing but of press stories by reporters and editors who conspired to bring him down. It was a chilling indication of what little confidence he had in the Supreme Court's judgment and how unprepared he was to face up to his own responsibility for the crisis that had descended on his presidency.

Denial was easier than acceptance of blame for the grief he, his family, and administration insiders were suffering over Watergate. Nor could he bring himself to accept that he had inflicted a deep wound on public confidence in executive authority. It was more than he could bear to accept responsibility for the pain he had caused people closest to him and the injury he had inflicted on the country's political institutions.

He clung to hopes that his upcoming Moscow visit might help "break the momentum." Kissinger encouraged him to believe that the mood in the country was shifting. "Of course, he has said this before," Nixon told himself. Haig urged him to believe that the press was getting tired of Watergate and was ready to change the subject.

The chance that Kissinger and Haig might be right gave Nixon reason to work hard for a successful Moscow Summit. In addition, he was more single-minded than ever about serving the national well-being, which he believed was tied to détente. Events preceding the Summit, however, made clear that nothing they did in Moscow could exceed or even match earlier agreements on arms control and economic exchange.

It had less to do with the Soviets than with opposition in the United States. In late May, a Soviet delegation visiting Washington brought a message from Brezhnev saying that he remained committed to détente and that he expected good results from the third Summit meeting in June. He hoped that the upcoming talks would conclude with new arms limitations, advances toward a successful European security conference, and Middle East cooperation. During a White House meeting, Nixon echoed the optimistic rhetoric of his visitors, though he told them that Congress was being uncooperative and that "he was not a magician who could produce instant solutions."

When Dobrynin saw the president five days later, he repeated Brezhnev's hopes but candidly declared Soviet puzzlement at events in the United States. "Much of what is happening is not understandable to us," he said, "but it is clear that the forces that are up in arms against the President are not friendly" to the Soviet Union. Nixon hid his own doubts and assured Dobrynin that domestic politics would not affect relations with Moscow or his planned trip.

Soviet professions of accommodation were at odds with uncompromising positions on the Middle East and arms limitations. Moscow continued to insist on a larger and more direct role in Arab-Israeli negotiations. At the beginning of June, when Kissinger learned that Sadat would be giving him the highest Egyptian decoration, he told Scowcroft, "I don't see how we can say I can't accept it. I tell you the Russians are going to go out of their cotton picking minds."

Henry also worried that the Soviet defense ministry was resistant to an expanded nuclear test ban agreement and a second SALT treaty. "They are sabotaging everything right now," Kissinger told Nixon. "Well they are trying to, but they are not going to . . . They have tried to before," and failed to block arms agreements at the first Summit, Nixon responded optimistically. It said more about his need for a successful Summit than about Soviet intentions.

Moscow was also pressing the case for a security conference that could win Western recognition of post-1945 European borders. "My problem with the European Security Conference is if it had never been invented, my life wouldn't be unfulfilled," Kissinger told the German foreign minister in June. "Second, the substance bores me to death. I have studied none of it."

Nixon needed the support of anti-Soviet Americans if there was to be substantive achievements in Moscow. But this was out of reach. Jim Schlesinger and Senator Henry Jackson, backed by the Joint Chiefs, opposed a SALT II agreement unless it gave distinct advantages to the United States the Soviets would never accept. When Paul Nitze, the defense department's chief arms-control negotiator, resigned in June out of concern that Nixon would sign an arms-limitation treaty that did more to serve his domestic political purposes than America's defense needs, it created a serious bar to successful SALT II talks. Jackson compounded the problem by charging that Nixon and Kissinger "had made a secret deal with the Soviets enabling them to exceed the limits" of SALT I.

Schlesinger and Admiral Zumwalt were unyielding opponents of a new SALT agreement that might allow the Soviets to catch up with the United States in MIRVed missiles. After Schlesinger's opposition to SALT II had become abundantly clear to Congress and the press, Nixon tried to convince him during an Oval Office meeting to change his stance. Kissinger recalls that the president had grown so politically weak that he had to deal with his defense secretary as if he were "a sovereign equal." Nixon told him, "We need your help . . . Many of my friends are horrified at our even talking to the Soviet Union. But are we going to leave the world running away with an arms race, or will we get a handle on it?"

Schlesinger rejected Nixon's appeal. During an NSC meeting on June 20, after Nixon refused to follow his suggestion that he ask the Soviets for arms arrangements they had consistently opposed, Schlesinger, who was sitting next to him, said, "But, Mr. President, everyone knows how impressed Khrushchev was with your forensic ability in the kitchen debate. I'm sure that if you applied your skills to it you could get them to accept this proposal." Schlesinger saw it producing a "major breakthrough." Kissinger dismissed it as nonsense: "Forensic skill could not achieve it; the task would have defeated Demosthenes or Daniel Webster. It would require a downright miracle. Only a conviction that Nixon was finished could have produced so condescending a presentation by a cabinet officer to his President," Kissinger concluded. Nixon considered Schlesinger's remarks "an insult to everybody's intelligence and particularly to mine."

The infighting over SALT was as ugly as anything Nixon's administration had seen in five and a half years. "The President thinks that the JCS are all 'a bunch of shits' and that you are 'the biggest shit of all,' " Schlesinger told Zumwalt. Zumwalt said that he had gotten at cross-purposes with Kissinger when he refused to follow his lead on defense issues or be his "whore." Zumwalt also complained that Kissinger "had deceived us, lied to us, and avoided consulting me" about defense questions on which they disagreed. Schlesinger characterized Nixon, Kissinger, and Haig as "paranoid" and "very sick people" who were threatened by the JCS. On June 29, when Zumwalt retired, the White House ordered Schlesinger not to appear at the Annapolis ceremony or to give him a medal. Schlesinger defied Nixon by refusing to fire Zumwalt three days before his retirement and by ignoring the White House order about his participation in the Annapolis ceremony.

Kissinger believed that the combination of opposition from Jackson, Schlesinger, Nitze, the JCS, and conservatives leery of détente ended the likelihood of a SALT II agreement before they ever arrived in Moscow.

As Nixon prepared to leave for Russia, he was determined to make the case for the value of another Summit and a SALT agreement in particular. Nixon told his cabinet on June 20, the Summit was another part of the effort to avert a future confrontation with Moscow and a possible nuclear war. Kissinger conceded that the Summit would not produce "spectacular agreements." The same day, Kissinger echoed Nixon's point to a bipartisan congressional group about reducing mistrust and minimizing misunderstanding. It was essential to moderate the arms race if they were to avoid instability and greater tensions.

Although many in Congress, the press, and the public remained skeptical of Nixon's motives, at least fourteen senators, most of them liberal Democrats, were persuaded by his appeal. They sent him a letter expressing their confidence in "your objectives at the Summit meeting with General Secretary Brezhnev. Agreements reached with the Soviet Union that are genuinely in the interests of our two countries will receive sympathetic attention in the Senate." It was hardly a ringing endorsement; 86 senators withheld overt support of Nixon's latest journey to Moscow.

On June 25, as Nixon left for a meeting in Brussels to mark the twenty-fifth anniversary of NATO, the press revealed that he was suffering from phlebitis. The president instructed Ziegler to guard against letting anyone "build it up in a way that they think the President is crippled mentally as well as physically . . . We must make sure that people never get the idea that the President is like Eisenhower in his last year or so, or like Roosevelt, or, for that matter, even like Johnson when everybody felt that Johnson was probably ready to crack up, and was drinking too much and so forth. I think we can avoid this by proper handling."

REGARDLESS OF ENDURING DIFFERENCES with allies at Brussels and the Soviets in Moscow, the premium was on describing Nixon's trip as a personal and diplomatic triumph. A variety of domestic economic problems, including oil shortages, were troubling NATO countries. They also remained concerned that détente might erode U.S. defense commitments to Western Europe. Aside from three one-on-one meetings, Nixon spent

all of ninety minutes with NATO government heads, which did little to ease their concerns. Nevertheless, the White House described the NATO talks as producing "very positive results."

A press conference Kissinger held in Brussels before departing for Moscow with the president put the best possible face on the upcoming talks. "How inhibited will the President be in negotiating because of his domestic weakness?" one reporter asked. Kissinger denied that impeachment threats would affect Nixon's capacity to deal with the Soviets; nor would the president take account of anything but the national interest. He acknowledged that the Summit was unlikely to produce a new agreement on arms limits, but nevertheless he expected some progress on SALT II. The alternative was a continuing arms race, which, after ten years, would lead to no strategic advantage for either side."

The meetings in Russia between June 27 and July 3 were a disappointment, as Nixon freely acknowledged in his memoirs. Although they agreed to reduce the number of ABM sites from two to one in each country and to sign a Threshold Test Ban Treaty, eliminating underground nuclear tests of over 150 kilotons, they could not agree on a comprehensive test ban or a SALT II treaty that reined in the arms race and particularly nuclear arsenals.

The reasons for the deadlock were transparent to both sides. A Soviet refusal to allow on-site inspections of otherwise undetectable small underground tests put a comprehensive ban out of reach. The conviction that their respective arms control proposals would give the other side an advantage that their defense establishments would vigorously oppose eliminated any hope of an immediate SALT II agreement.

"Both sides have to convince their military establishments of the benefits of [arms control] restraint, and that is not a thought that comes naturally to military people on either side," Kissinger said candidly at a press conference as the Summit concluded. He also predicted that the failure to get the arms competition under control would produce a pointless buildup without "strategic superiority" for either side. Besides, he emotionally declared, "What in the name of God is strategic superiority? What is the significance of it, politically, militarily, operationally, at these levels of numbers?" His remarks, as he put it "were a cri de coeur." They echoed warnings that more nukes could only make the rubble bounce.

Despite disappointing results at the Summit, Brezhnev and Nixon

had too much invested in détente to acknowledge that they had reached a dead end in their dealings with each other. A communiqué at the end of the meetings declared that "the talks were held in a most businesslike and constructive atmosphere and were marked by a mutual desire of both sides to continue [to] strengthen understanding, confidence and peaceful cooperation between them." To encourage hope that they would make additional progress in the future, the communiqué ended with the announcement that Brezhnev had gladly accepted an invitation to visit the United States again in 1975.

Judging from Nixon's diary notes, he and Brezhnev had developed a genuine regard for one another. Private pronouncements on saving the world from a nuclear war punctuated their conversations. Walks "through the lush greenery surrounding Brezhnev's hillside villa" in the Crimea and a ride in his yacht on the Black Sea graphically displayed their camaraderie: While they sat talking together in the back of the boat, Brezhnev "put his arm around me and said, 'We must do something of vast historical importance. We want every Russian and every American to be friends that talk to each other as you and I are talking to each other here on this boat.' "

Nixon spoke glowingly about the Summit in a report to Congress. "As the result of our most recent round of talks . . . I believe our relations will continue to improve." The ABM and Threshold Test Ban agreements represented "considerable progress." Most important, though they weren't there yet, they were intent on signing a second treaty on strategic-arms limitations that would begin in 1975 and last for ten years. The report was more an exercise in domestic politics than a realistic assessment of new advances in détente.

A nationally televised speech from Loring Air Force base in Maine, where Nixon landed on his return from Moscow, carried the same hopeful message. The conference had advanced the cause of world peace. The twenty-five-thousand miles he had traveled during the last month were aimed at building a stable structure of peace. The cornerstone of the effort was détente—"irreversible" improvements in Soviet-American relations. The talks in Moscow were notable for preparations to achieve an arms-limitation agreement that would last a decade. When coupled with the new ABM and Threshold Test Ban treaties, the latest Summit represented a significant advance toward controlling the arms race.

Despite all the upbeat talk, Nixon could not deny that the latest Summit was something of a flop. In his memoirs, he said that Watergate was less to blame than "American domestic political fluctuations, most of which had preceded Watergate, that cast the greatest doubt on my reliability: the failure to produce M[ost] F[avored] N[ation trade] status and the agitation over Soviet Jews and emigration had made it difficult for Brezhnev to defend détente to his own conservatives. Similarly, the military establishments of both countries were bridling against the sudden reality of major and meaningful arms limitation and the real prospect of arms reduction if and as détente progressed. These problems would have existed regardless of Watergate."

Kissinger was less certain. He thought that the Soviets doubted Nixon's ability to push treaty commitments through the Senate. They viewed Nixon as unlikely to defeat the political assault on him and remain in office.

Nixon was probably closer to the truth than Kissinger about impediments at the Summit. True, Watergate was evident in Moscow: Nixon seemed preoccupied throughout the meetings. The president was so distracted by his Watergate troubles, one participant said, that he " 'often didn't know what he was talking about.' . . . One of Nixon's closest aides told me," an American journalist recorded later, "the President spent much of his time in Moscow in 1974 listening to White House tapes."

Yet Nixon's Watergate troubles were less at fault in limiting Summit gains than fundamental divisions between Moscow and Washington. Long-standing distrust or irremediable tensions in relations between two diametrically opposed systems stymied mutual accommodations. In the Middle East, as with arms-control negotiations, each jousted for advantages that could assure their national security. What eventually resolved Soviet-American differences was not rational discourse about mutual national needs on armaments and other issues but the collapse of the U.S.S.R.'s Communist rule and an end to the Cold War.

As NIXON RETURNED from Russia, he dreaded the "depressing atmosphere" of Washington. His decision to speak at an air force base in Maine before a friendly audience rather than one composed partly of hostile reporters at Andrews in Maryland reflected his anxiety about ongoing impeachment proceedings. He had a "sinking feeling in the bot-

tom of his stomach," and saw "sleepless" nights ahead. He told Ziegler and Haig on the plane that the accusations against him had left "deep scars . . . [on] the public mind and will not go away. Our only course of action," he told himself, "is to keep fighting right through to the last." In diary notes, he urged himself to hold "together through this next very difficult two-month period." He believed that if he could get "by the impeachment vote, we will then have a couple of years to do as many good things for the country as we possibly can."

Nixon had no doubt that the Judiciary Committee would vote out articles of impeachment. During the ten days after he returned from Russia, he faced an avalanche of bad news—committee releases about damaging omissions from tapes' transcripts; the Ervin investigation's final report asserting that in 1972 Nixon had destroyed "the integrity of the process by which the President of the United States is nominated and elected"; a perjury conviction of Ehrlichman; and headlines that Nixon and Kissinger were "headed toward a falling-out" over the president's refusal to renew support of Henry against charges of wiretapping. Although Kissinger angrily dismissed the rumors in private as "bullshit" and Nixon described Henry's involvement as limited to carrying out his orders, the stories further weakened public regard for the president.

Nixon took refuge in San Clemente, where Ford, along with several economic advisers, met with him on July 13 to discuss inflation, which was running at almost 15 percent and had become the public's primary concern, three times greater than government wrongdoing. "I had a growing sense of his frustration, his resentment and his lack of a calm, deliberate approach to the problems of government," Ford said. "He complained bitterly how he was being mistreated by Congress and the press."

While Nixon was brooding in San Clemente, a crisis erupted between Greece and Turkey over Cyprus. Although Nixon was nominally involved in day-to-day efforts to stave off a war, Kissinger largely set and implemented U.S. policy. But the crisis gave Nixon renewed hope that the House would not move against him. It "brought home the fact," he noted in his diary, "that with the world in the situation it is, with the peace as fragile as it is in various parts of the world, a shake-up in the American presidency and a change would have a traumatic effect abroad and . . . at home."

As Nixon's diary shows, he was understandably obsessed with Judiciary Committee proceedings that were scheduled to culminate on July 24 in public hearings on impeachment. Nixon described this as his "Seventh Crisis in spades. Because the next month will be as hard a month as we will ever go through." As he told a gathering of friends in Los Angeles on July 21, "the Office of the Presidency must never be weakened, because a strong America and a strong American President is something which is absolutely indispensable if we are to build that peaceful world that we all want." Nixon hoped that the presidency and public eagerness not to undermine the institution might give him a bye for wrongdoing, allowing him to remain in power.

Kissinger was also agitated about the state of public affairs. "I'm beginning to get to the view that I cannot live any longer in this town," he told a journalist friend. "Every time you move some @#*! is putting out some story." His friend urged him "not to worry about this crap . . . People like to criticize about foreign policy but they're not really making any passes at you." Henry was not appeased. "All the animals are out of the cages," he said. "And here we've got a war cooking and the goddamnest leaking is going on—inaccurate. You go to meetings . . . and you don't worry anymore about the country, you worry how what you say will read when you see it in the *Times* or *Post*."

Not the least of Kissinger's concerns was ongoing recriminations over Vietnam. Replying to messages dating back two months to May and June, Kissinger told Le Duc Tho that negotiations in the Middle East and Moscow had delayed his response. He complained that Tho was simply repeating to him in private what he was saying publicly; it was destroying the utility of their back-channel communications. Henry reiterated earlier warnings that continuing attacks and infiltration were jeopardizing their Paris agreement. He also took issue with an article by the American journalist Tad Szulc saying that "the Vietnam problem will . . . not go away." Say what he might, it was a reality over which Kissinger had no control.

Nixon was too preoccupied with possible impeachment to pay attention to Kissinger's ongoing worries about Vietnam. On the morning of July 23, as the Judiciary Committee was about to launch its public hearings the next day, Lawrence Hogan, a conservative Maryland Republican on the committee, announced his intention to vote for impeachment.

He said that the evidence demonstrated a pattern of lying about Watergate and a direct part in the cover-up. Only Nixon's removal from office could lift the cloud of "mistrust and suspicion" that had descended over government and politics.

Although Nixon now expected to be impeached, he was not quite ready to give up. He called Alabama Governor George Wallace that afternoon to see if he would lobby an Alabama congressman, but Wallace said no. When he hung up the phone, Nixon turned to Haig, who had been urging him to call Wallace, and said, "Well, Al, there goes the presidency."

Nixon felt that he had reached the "lowest point in the presidency, and Supreme Court still to come." He didn't have long to wait. On the morning of July 24, Haig woke him at 8:30 A.M. in California to report that the Court had come down unanimously for the release of sixty-four tapes. "There's no air in it at all," Haig said. "None at all?" Nixon asked. "Tight as a drum," Haig answered. After some discussion with advisers, Nixon concluded that he had no choice but to fully comply with the Court's decision.

It meant revealing a June 23, 1972, conversation with Haldeman, in which Nixon instructed that the CIA inhibit the FBI's investigation of the break-in. As Nixon understood, anyone hearing that discussion would conclude that political rather than national security concerns, as he had publicly asserted, motivated his decision. The tape was what his counsel Fred Buzhardt described to Haig and St. Clair as the "smoking gun" that would cost the president his office. That tape, Nixon said, was "like slow-fused dynamite waiting to explode."

At 10:30 on the morning of June 26, a half hour before the president was scheduled to meet the German foreign minister in his western White House office, Kissinger gave Nixon a three-page summary of talking points. Kissinger "was shocked by the ravages just a week had wrought on Nixon's appearance. His coloring was pallid. Though he seemed composed, it clearly took every ounce of his energy to conduct a serious conversation. He sat on the sofa in his office looking over the Pacific, his gaze and thought focused on some distant prospect eclipsing the issues we were bringing before him. He permitted himself no comment about his plight. He spoke rationally, mechanically, almost wistfully. What he said was intelligent enough and yet it was put forth as if it no longer mattered: an utterance rather than an argument."

That afternoon, a shaken Kissinger called Senator Stennis of the Armed Services Committee and urged him to help squash talk about Kissinger-Schlesinger tensions. "With our President being under attack," he told Stennis, "we cannot have foreign governments see the two senior officials who have to handle crises in disagreement . . . The country must now be preserved. I'm very worried about what's going on." A half hour later, Henry spoke directly to Schlesinger. "Whatever our personal feelings may be, within this present crisis you and I cannot leave the impression to foreign countries that we are at each other's throats." Besides, Henry added, if we battle, "it is like fighting for the captaincy of the *Titanic*."

Kissinger now also discussed the crisis with Haig. By doing so, he broke "an unspoken rule" that they avoid talking about Nixon's resignation, which would be a way of showing doubt and implicitly undermining the president. But Kissinger believed that because "the end of Nixon's presidency was now inevitable, it was in the national interest that it occur as rapidly as possible." Their goal was to find the best means of assuring "a smooth transition." Haig agreed. But he shared Henry's feeling that it was not up to presidential appointees to push in that direction; "we had a duty to sustain him in his ordeal," Kissinger asserts. Elected officials would have to urge Nixon to resign. The Kissinger-Haig refusal to discuss resignation between themselves or with Nixon was either an exercise in sensible statecraft or a rationalization for giving the president uncritical support as a way to help protect their hold on power.

On July 27, when the Judiciary Committee voted by a lopsided 27 to 11 to impeach Nixon for obstructing the Watergate investigation, Kissinger tried to comfort the president. In a conversation with him, Henry was "very mournful" and tried to ease Nixon's pain by saying that his wife, Nancy, thought "that history in four years would look back on the President as a hero." Haig predicted that history would show him "to have been an outstanding president."

That day, Nixon was focused less on history's judgment than on what his post-presidential life might be like. He worried about his family's financial future and how to manage it. Although he believed that once his associates heard the June 23 tape they would urge him to quit and that the nation would be ill-served by a six-month trial, he still hesitated to resign, arguing to himself that "this would be a very bad thing for the country."

On July 29 and 30, the Judiciary Committee issued two additional articles of impeachment for illegal use of executive agencies—the IRS and FBI—and for defying committee subpoenas. With a full House debate on impeachment not to begin until August 19, Nixon still had time to consider his options. On the afternoon of July 30 Kissinger told him in a telephone conversation: "You can count on me." Nixon responded, "The whole point is it has to go to the Senate and we just have to beat it." Kissinger said, "It is an awful experience." But Nixon assured him, "We are not going to wring our hands about it." Nevertheless, Henry considered it "a terrible thing to watch and heartbreaking. You don't have to worry about anything from me," Kissinger reiterated. Nixon said, "I know that."

Unable to sleep on the night of July 30, Nixon penned a note to himself at 3:50 A.M. The brave front he had put up was crumbling: He could resign immediately; wait to see if the House impeached him and then resign; or fight an impeachment in the Senate. His impulse was to end his career as he had begun, "as a fighter." But on July 31, after Haig and Ziegler listened to the June 23 tape, they described his situation as hopeless. The next day, Nixon told Haig that he had decided to resign.

In reaching his decision, Nixon not only thought through his family's financial future but also prospects for criminal proceedings against him. He never asked Ford for assurance that if he resigned, Ford would preempt legal action against him by issuing a pardon. But he did have Haig speak to Ford about a president's pardoning powers, telling Ford that a president could preempt charges of criminal action with a pardon.

Nixon believed that he didn't need to get a Ford commitment; he was confident that Ford would pardon him for any Watergate wrongdoing before any court action was taken against him. Nixon thought that Ford, an entirely decent man with the good of the country at heart, would understand that he could not govern effectively if criminal indictments were being mounted against an ex-president. As Ford later explained his pardon of Nixon, "No other issue could compete with the drama of a former president trying to stay out of jail . . . America needed recovery, not revenge."

On August 1, it became a question of when, not if, Nixon would announce his resignation. On August 3, however, during a weekend at Camp David, when his family urged him to keep fighting, he backed

away from the decision. He decided to release the June 23 tape before making a final judgment. "If it was as bad as I expected, then we could resume the countdown toward resignation." He hoped that if "by some miracle the reaction was not so bad," he could then consider continuing to fight. With the tape scheduled for release on Monday, August 5, Nixon told his family, "It's fight or flight by Monday night."

On August 3, he tried to focus on an Israeli arms request. Haig was uncertain that the president had the emotional resources to make the decision. But during a brief conversation with Kissinger, Nixon instructed him to announce that the president had decided what to give the Israelis. "The President has approved this thing," Henry told Scowcroft later in the afternoon. "Although I'm not quite sure he knew what he was approving."

On Sunday, August 4, Nixon again concluded that he had to resign. When he asked his staff to accompany release of the June 23 tape with an explanation that on July 6, 1972, the president had directed the FBI to go forward with its Watergate investigation, the staff rebelled. They wanted to emphasize that their defense of the president had partly rested on ignorance of the contents of the June 23 tape. In response, Nixon gave up the fight: "The hell with it," he told Haig. "It really doesn't matter. Let them put out anything they want. My decision has already been made."

On the afternoon of August 5, no one could tell from a statement Nixon released about the June 23 tape that he intended to resign. Although acknowledging that he had committed a serious act of omission in not informing his attorneys about the content of the tape, he excused it by saying that he "did not realize the extent of the implications which these conversations might now appear to have." He also conceded that the "June 23 conversations are at variance with certain of my previous statements." Nevertheless, he urged everyone to look at all the evidence. He was "firmly convinced that the record, in its entirety, does not justify the extreme step of impeachment and removal of a President."

Nixon's statement about the June 23 tape incensed Barry Goldwater. "It was the same old Nixon," Goldwater said, "confessing ambiguously, in enigmatic language, still refusing to accept accountability. It was, above all, an insincere statement, as duplicitous as the man himself." The fact that twenty-one of the president's associates were under indictment,

with fourteen already convicted, and the Republican party facing likely congressional and White House defeats in 1974 and 1976 respectively, underscored for Goldwater Nixon's ruthless indifference to everyone's suffering but his own.

Despite Nixon's explanation and self-defense, the June 23 tape touched off a firestorm of speculation that he would now have to resign or face not only impeachment but also conviction by the Senate and removal from office for high crimes and misdemeanors. The reaction to the "smoking gun" left Nixon without support. The eleven members of the Judiciary Committee who had voted against the articles of impeachment now said that they would vote with the majority on Article I charging Nixon with participation in a cover-up.

When Kissinger spoke to Scotty Reston that morning, Reston, who was scheduled to leave for Europe, said, "It's a good time to get out of town." Henry shared his feeling. He told Reston off the record that when he ran into Len Garment at the White House earlier, Garment joked that if Henry could send him on a diplomatic mission, he would be his friend for life. "There are probably a lot of other takers, too," Reston laughingly declared.

On August 6, Nixon acted as if he were still determined to fight impeachment. At a morning cabinet meeting he held to business as usual, beginning with a discussion of inflation, "the most important subject before our nation." When he turned to his crisis, he acknowledged the pressure on him to resign but invoked the familiar argument against damaging the presidency. Kissinger believed that he was asking "a vote of confidence from his cabinet."

After "an embarrassed silence" amid a shuffling of papers and "much fidgeting," Ford asked for the floor. He explained that if he had known what he had learned in the last twenty-four hours, he would never have made some of the statements he had issued as minority leader and vice president. He would no longer speak publicly about Watergate. He was sure the House would vote for impeachment but couldn't predict what the Senate would do. Ford promised to continue supporting the administration's foreign policy and fight against inflation. When Nixon responded by focusing only on the inflation problem, endorsing a Ford suggestion for a Summit of American business and labor, Attorney General Saxbe bluntly objected to a Summit, saying, "We ought to be sure

you have the ability to govern." Speaking as chairman of the Republican National Committee, George Bush described the plight of the party and declared the need for a prompt end to the Watergate crisis, implying that Nixon needed to resign.

Kissinger spoke up to urge against focusing on Nixon's Watergate troubles. "We are not here to offer excuses for what we cannot do. We are here to do the nation's business . . . Our duty is to show confidence . . . For the sake of foreign policy we must act with assurance and total unity." Although he later represented his comments as a way to preserve the president's dignity, they may be read as a defense of Nixon against proponents of a quick resignation. True, Kissinger was genuinely concerned about national solidarity in dealing with overseas adversaries, but he was also defending Nixon against pressure to quit.

Later that day, a Kissinger friend, who was a New York attorney, asked, "How was the President today?" Henry replied: "He was all right." She wanted to know if Nixon was "rational." Henry would only say, "It's pretty rough." When she predicted that Nixon "will be convicted and will go to jail," Henry said, "It's unbelievable." He added: "Some awful mistakes were made by the President but he doesn't deserve this."

Kissinger was painfully ambivalent about Nixon's predicament. On one hand, he saw the ongoing crisis as an impediment to the national security and well-being which could be ended with Nixon's ouster, and on the other, he was genuinely loyal to Nixon for opening the way to his national and international eminence. He savored his position as the administration's principal foreign policy maker and could not be sure how he would fare in a Ford presidency. Would he stay on if Nixon left? his friend asked. He intended to "give it six months and see where we stand," he replied.

A private conversation Kissinger had with Nixon after the cabinet meeting illustrated Henry's divided feelings. Nixon remembered thanking Henry for "his support," "loyal friendship," and handling of foreign policy, implicitly stating his appreciation that Henry was the only cabinet officer to speak up for him at the meeting. Nixon then recalled telling Henry of his intention to resign. Kissinger thought it was the best thing to do. It would shield him from the horrors of a Senate trial and would preserve the country from a foreign policy crisis.

By contrast, Kissinger recalled initiating the discussion of a resigna-

tion, which he promised not to repeat outside the Oval Office. Nixon responded coolly: "He said he appreciated what I said. He would take it seriously. He would be in touch." Nixon's noncommittal response masked his anger at being in the humiliating position of having to discuss his resignation with a subordinate who had displaced him as the administration's most influential figure. Nixon's anger registered clearly enough on the evening of August 6, when he called Henry to say that he was rejecting Israel's request for long-term military aid and intended to cut off all help unless they agreed to a comprehensive peace. Although nothing would ever come of Nixon's intemperate instruction, Kissinger wondered, "Was it retaliation for our conversation of a few hours ago— on Nixon's assumption that my faith made me unusually sensitive to pressures on Israel?"

On the afternoon of August 6, Nixon still resisted resigning. Goldwater, who was having lunch with other Republican senators and Ford, received a call from Haig in the Oval Office. Hearing a second click on the phone, Goldwater assumed Nixon was listening in. "Haig asked how many votes the President had in the Senate. I told him no more than a dozen. I added that it was all over. Nixon was finished." To remove any doubt about his personal view, Goldwater said, "Dick Nixon has lied to me for the very last time."

Nixon now accepted that he could not survive a Senate trial. He instructed Haig and Ziegler to prepare a resignation speech for delivery from the Oval Office on Thursday evening, August 8. Ever the loyalist, Haig said, "It would be an exit as worthy as my opponents were unworthy." Nixon, at last, privately blamed himself: "Well, I screwed it up good, real good, didn't I?" The question suggested that he still wanted reassurance that his enemies, not him, were at fault. But in his memoirs, he said, "It was not really a question."

A Nixon meeting on the afternoon of August 7 with Goldwater, Senate Republican Minority Leader Hugh Scott, and House Minority Leader John Rhodes to review congressional sentiment was an exercise in the obvious. But Nixon continued to resist unpleasant realities. Earlier in the day, Haig had told Goldwater that Nixon was still in flux. He urged Goldwater not to argue for resignation when he saw the president. Nixon, he said, was "a man dancing on the point of a pin." He "could be set off in any one of several directions . . . The best thing to do would

be to show him there was no way out except to quit or lose a long, bitter battle that would be good for no one." As the three Republicans arrived at the White House, the Nixon press office released a statement saying that the president "had no intention of resigning."

As during the Mideast trip, Haig was again worried about the president's emotional stability. "One day he was going to resign and the next day he was going to fight it out and go to prison," Haig told a TV documentary producer in 2005. During "a final period leading up to his resignation," Haig added, "I told the White House doctors to be very careful of the pills available." To be clear about Haig's statement, the interviewer responded: "You were so concerned that you were talking to the doctors about just making sure no harm comes to the President. This was a very real danger in your mind." Haig replied: "I thought so . . . Everything that he had ever dreamed of in his lifetime, every aspiration he ever held, was to be President of these United States . . . It was everything. It was his whole embodiment."

At the meeting, Nixon impressed Goldwater as intent on trying "to beat the rap until it was absolutely clear that the situation was hopeless." Goldwater told him that he had at most ten Senate votes, but only four were firm. The other six, including himself, were undecided. Nixon's discomfort was palpable: "His voice dripped with sarcasm. His jaw automatically jutted out as his eyes narrowed . . . I could see that Nixon's blood pressure was rising." Although Nixon remained uncommitted, the three Republicans left the White House convinced that he would resign.

At two minutes before six, shortly after the congressional leaders had departed, Haig called Kissinger, who was in a meeting at the state department, to come immediately to the White House. Kissinger found Nixon in the Oval Office staring out at the Rose Garden. Although he "seemed very composed, almost at ease," Henry sensed his "torment" and "solitary pain." Nixon told him that he had decided to resign and expected Henry to stay on to ensure continuity in foreign policy. His effort in reporting his decision "seemed to drain him," and Henry feared that he would lose his composure. Kissinger tried to comfort him by saying that "history will treat you more kindly than your contemporaries have." In an uncharacteristic gesture, Henry remembered putting his arm around the president's shoulder. He felt toward him "a great tenderness—for the tremendous struggle he had fought within his complex personality, for

his anguish, his vulnerability, and for his great aspirations defeated in the end by weaknesses of character."

Kissinger's response echoed the ancient Greek observation that fate is character. "It was like one of those Greek things where a man is told his fate," Henry told Hugh Sidey, "and fulfills it anyway, knowing exactly what is going to happen to him."

At 9 P.M., while Kissinger was having dinner at home with his wife, children, who were visiting from Boston, and Joe Alsop, Nixon called, asking Henry to come to the White House living quarters for a talk. When Henry arrived at the Lincoln Sitting Room, the president's earlier composure had dissolved, and, as Kissinger described it later, he was "almost a basket case." The president wanted Kissinger to review with him the foreign policy triumphs of their administration, which Henry did with great emphasis on Nixon's courageous leadership. Henry reiterated assurances about history's favorable judgment on Nixon's foreign policy initiatives. But ever convinced that political bias trumped historical reality or that anyone could be objective about a president's actions, Nixon predicted that it would depend on who wrote the histories.

After some unhappy reflections from Nixon on the possibility that he would face criminal prosecutions, Kissinger promised to resign "if they harass you." Henry became so emotional at the thought of Nixon in the dock or perhaps himself forced to leave office to rescue the president and the country from a public nightmare, he began to cry. Nixon broke down as well and between sobs insisted that Henry not resign.

After an hour and a half of this emotional roller coaster, Henry started to leave. But on their way to the elevator that would liberate Henry from Nixon's embarrassing display of self-pity, the president asked him to kneel with him in prayer. As they prayed, Nixon began sobbing again amid cries of anguish at the misery his enemies had inflicted on him.

Shortly after returning to the state department, where a shaken Kissinger described the encounter to Eagleburger and Scowcroft, Nixon called on Henry's private line. He begged him not to recount their meeting to anyone. Kissinger promised that "if he ever spoke of the evening, he would do it with respect." Henry honored his promise up to a point. The events of this encounter with Nixon became public knowledge through him, but, unlike his other conversations, he allowed Scowcroft to destroy the recording and transcript of the President's late-night call.

August 8 was the worst day in Nixon's twenty-eight-year political career, exceeding the misery he had suffered after the 1960 and 1962 defeats. On those occasions, he could still imagine resuming the fight for political preferment, but not now. His resignation meant not only a decisive end to his reach for validation through politics but also his humiliation as a failed president—the only chief executive in the country's history to be forced into resignation by the threat of impeachment and conviction.

The pain was almost too much for him to bear. Having stayed up the previous night working on a resignation speech, he was exhausted. When he spoke with Ford about the succession, he urged him to keep Kissinger as secretary of state. He was the "only man who would be absolutely indispensable to him. . . . His wisdom, his tenacity, and his experience in foreign affairs" were essential to keeping foreign policy from falling into disarray. Yet he also warned Ford against letting Henry "have a totally free hand." Nixon said to someone else: "Ford has just got to realize there are times when Henry has to be kicked in the nuts. Because sometimes Henry starts to think he's president. But at other times you have to pet Henry and treat him like a child." It echoed Nixon's complaints to Scowcroft about Kissinger's efforts to act as president. (By one year into his presidency, Ford thought Kissinger "had the thinnest skin of any public figure I ever knew." Henry could not accept that he ever made a mistake. "Press criticism drove him crazy," and Ford "would literally hold his hand" to keep him from resigning. But Henry had no intention of leaving and stayed to the end of Ford's term, despite a Ford decision to replace him with Scowcroft as national security adviser.) As the Nixon-Ford meeting ended, their eyes filled with tears.

During a half-hour meeting in the cabinet room with forty-six friends and colleagues shortly before he went to the Oval Office for his 9 P.M. speech, "the emotional level in the room was almost unbearable." One witness to the meeting recorded that the president "was under great emotional stress" and spoke "in a rambling fashion . . . Several times he stopped and was so choked up and there were just those moments of absolute silence."

Nixon recalled that when he spoke of "the great moments we had shared together," many in the room began to cry. When he heard Congressman Les Arends of Illinois, "one of my closest and dearest friends, sobbing with grief, I could no longer control my own emotions, and I

broke into tears." Haig was worried that the president would crack up during his broadcast, but Nixon, who took special satisfaction in surmounting any personal crisis, assured him that he'd be all right.

He was, at least, to give his speech. He spoke to an audience of perhaps 150 million people. He announced that he was resigning as of noon the next day. He had been eager to complete his term: quitting was "abhorrent to every instinct in my body." But he felt he was acting in the best interests of the country. He regretted "any injuries that may have been done in the course of events that led to this decision." He acknowledged that some of his judgments were wrong, but "they were made in what I believed at the time to be the best interest of the nation."

So why then was he resigning? There was no mention of any personal wrongdoing on his part, no indication that he had engaged in impeachable actions that made him vulnerable to removal from office. His decision, he said, rested on his understanding that he no longer had "a strong enough political base in the Congress . . . Because of the Watergate matter, I might not have the support of the Congress that I would consider necessary to back the very difficult decisions and to carry out the duties of this office in the way the interests of the nation will require." The bulk of the speech was more an act of self-justification than contrition.

It was also at odds with earlier explanations of why he wouldn't resign. He had warned against turning the presidency into a prime minister's post such as in Britain, where a vote of no-confidence drives the chief executive from office. But that's exactly what Nixon did by saying that he had lost his political base in Congress. If this were the real reason for his resignation, he could have left office several months earlier and spared the country additional Watergate stress and the loss of presidential influence over foreign affairs.

It was vintage Nixon: a use of language to evoke sympathy and admiration for himself and his family, all of whom were suffering and sacrificing for the good of the country. Never mind the self-evident truths: that his corruption had turned the courts, the Congress, and the nation against him and that a majority of Americans eager to preserve the rule of law supported his removal from office.

At his swearing-in, Gerald Ford famously assured the nation that "Our long national nightmare is over." But it was not just the nation that was relieved to see Nixon leave; Kissinger also felt as if he were throwing

off a burden. The day before Ford became president, Kissinger discussed foreign policy with him. Henry recalled that "for the first time in years after a Presidential meeting I was free of tension. It was impossible to talk to Nixon without wondering afterward what other game he might be engaged in at the moment. Of one thing you could be sure: No single conversation with Nixon ever encapsulated the totality of his purposes. It was exciting but also draining, even slightly menacing. With Ford, one knew that there were no hidden designs, no morbid suspicions, no complexes."

One final moment of unpleasantness was played out on the morning of August 9, as Nixon prepared to leave the White House and fly to California. He gave a "rambling" final statement to his cabinet and staff, crammed into the East Room. It was part reflection on past triumphs and defeats, part self-pity, part reassurance to supporters and himself that he would continue to battle for his beliefs in "the arena." It was also notable for the absence of anything about Pat, who had consistently supported him and silently endured his ordeal.

Kissinger remembered the talk as "too much. It was as if having kept himself in check all these years he had to put on display all the demons and dreams that had driven him to this point . . . It was horrifying and heartbreaking . . . I was at the same time moved to tears and outraged at being put through the wringer once again, so that even in his last public act Nixon managed to project his ambivalence onto those around him."

It was a painful end to a tumultuous five and a half years, marked by mood swings in the White House and the country that would make the Nixon presidency one of the most memorable in American history.

EPILOGUE

History is the best antidote to illusions of omnipotence and omniscience.

—ARTHUR SCHLESINGER, JR.

Although Nixon suffered terrible health problems—phlebitis and depression—that almost took his life in the year after he resigned, he lived nearly twenty more years in relatively good physical and emotional condition. When he died at the age of 81 in 1994, only five other presidents to that point had had longer postpresidential careers—John Adams, Martin Van Buren, Millard Fillmore, Herbert Hoover, and Harry Truman.

Like Adams and Hoover, Nixon made the most of his postpresidential years. Although he said in 1990 that "No one who has been in the Presidency with the capacity and power to affect the course of events can ever be satisfied with not being there," he used his standing as an ex-president—however much shadowed by the unprecedented disgrace of a forced resignation—to travel and write in support of his historical reputation.

Liberated from continuing judicial fights by Gerald Ford's pardon, Nixon was free to devote himself to a nineteen-year political campaign

for himself as a world statesman. He traveled extensively in Europe and Asia, revisiting China and the Soviet Union, where he was lauded as an innovative foreign policy leader and a peacemaker. He published seven books, including a self-serving volume of memoirs and reflections on political leadership and international relations that he hoped would serve not only his standing as a wise leader but also the country's search for lasting peace.

In retrospect, Nixon's sustained postpresidential fight to overcome the stain of Watergate is not surprising. A drive for eminence—to be the best, to outshine the competition—had stood at the center of everything he did throughout his life. Long before Bill Clinton gained a reputation as the comeback kid, Richard Nixon had established a compelling claim to the label. Loss or defeat was not part of Nixon's vocabulary; his resignation was an inducement to strive harder to become a memorable president with achievements that propelled him into the first rank of chief executives during and after their time in office.

Kissinger was not much different. His dominant role in the Nixon administration as secretary of state carried over into the Ford presidency, where, if anything, he was even more in control of foreign policy. His drive to stand out as the best secretary of state in the country's history matched Nixon's reach for historical greatness.

Similarly, after he left government service in January 1977 at the end of Ford's term, Kissinger devoted himself to securing his reputation by publishing nine books, including three massive volumes of memoirs totaling nearly four thousand pages. Newspaper columns, public addresses, and appearances on television contributed to his status as America's most prominent foreign policy expert.

Yet whatever the merits of the case he made for himself as the country's foremost judge of what best served the national interest and world peace, no one could doubt that Kissinger's strivings were also the product of a personal reach for power, as he himself acknowledged in his memoirs.

In 1974, after the journalists Bernard and Marvin Kalb published a well-regarded biography, Marvin asked Henry how he liked the book. "I have not read it," Kissinger replied, "but I love the title," *Kissinger*. In 1992, after Walter Isaacson's notable Kissinger biography had appeared, the journalist Daniel Schorr had breakfast with Henry in Frankfurt, Germany, where they were attending a conference. During their hour or

so together, Kissinger complained nonstop about Isaacson's book, wondering why he had been so tough on him despite his cooperation with Isaacson. As Schorr was leaving, Kissinger said, "Dan, however much I hate this book, it is better than no book." Nixon and his closest aides, as is evident in several of the White House tapes, understood and resented Henry's need to hold center stage.

Nixon and Kissinger shared other traits. To advance themselves and their policies, they had few qualms about making bargains with the devil—Nixon deceiving himself, the Congress, the courts, the press, and the public; Kissinger endorsing or acquiescing in many presidential acts of deception and engaging in many of his own. William Safire said that both men were "convinced that consistent lying can be the right thing for the country." It was partly the product of arrogance—they believed they knew better than anyone else what best served the nation—and partly an aversion to criticism that any open debate was sure to bring.

Neither man could stand to be told that he was wrong: With occasional exceptions, both hid their resentment of critics from public view—Nixon with false pronouncements on regard for the American tradition of civic dissent, and Kissinger with self-deprecating humor. Behind the facade, however, Nixon railed constantly against opponents with pronouncements on schemes to punish them—some of which White House aides foolishly acted on, to Nixon's and their discredit. Kissinger's anger generally took a more benign form—ugly comments about antagonists he snidely dismissed as "maniacs."

It is not surprising then that their relationship also partly rested on deception and hostility toward one another. Nixon was simultaneously happy to rely on Kissinger's diplomatic and policy making skills while secretly resenting his emergence as someone who put the president in his shadow. Henry's insistent need for attention and control of foreign policy incensed Nixon and moved him to entertain thoughts of firing him. But Kissinger's skill at public relations and his effectiveness in dealings with the Chinese, Russians, Vietnamese, and Arabs joined to make this difficult. Watergate made it impossible: Nixon's need to use Henry and foreign policy to counter threats of impeachment made Kissinger an indispensable figure in a collapsing administration.

Kissinger reciprocated Nixon's regard and hostility. He was less than enchanted with Nixon and his White House operators, as his comments

captured in cables and telephone transcripts illustrate. Yet Henry felt beholden to a president whose faith in his talents gave him the opportunity for greatness as a foreign policy adviser. At the same time, however, he was full of disdain for someone he considered his intellectual inferior. Henry also despised Nixon's insistent demands for ostentatious displays of deference, which Kissinger readily provided as the best way to ensure his influence with the president. Kissinger's constant stroking of Nixon, again so abundantly clear in their recorded conversations, left Henry feeling compromised and sullied.

The tensions between them carried over into the post-Nixon presidency. A little after Nixon left office, Kissinger said some negative things about the president that were inadvertently caught on an open microphone. Nixon, he told Canadian dignitaries hosting a dinner for him, was an "odd," "unpleasant," "nervous," and "artificial" man, who disliked people and lacked spontaneity. Kissinger's private apologies to the president did not appease him. "You as mean as ever?" Nixon asked Henry when they were thrown together at Hubert Humphrey's funeral in 1977. "Yes," Kissinger replied, "but I don't have as much opportunity as before." In April 1994, Kissinger spoke feelingly about Nixon's "astonishing life" and achievements at the president's funeral in Yorba Linda, California. Kissinger described him as one of the country's "seminal presidents," who "laid the basis for victory in the Cold War."

Nixon's and Kissinger's personal flaws had an impact on their making of foreign policy. Nixon's drive to win reelection, which he equated with his reach for presidential greatness, and Kissinger's ambition to become the most effective and memorable national security adviser and secretary of state in history skewed their judgments and produced terrible decisions in dealings with Vietnam, India-Pakistan, and Chile. Nixon's unwise impulse, with Kissinger's complicity, to use foreign affairs to counter Watergate was another negative consequence of their mutual inclination to put themselves first. A president free of a debilitating scandal that colored his judgment about international relations could have thought more clearly about the national interest.

Nixon's and Kissinger's reach for distinction also had its virtues. Self-serving motives as well as national security considerations spurred the opening to China, détente with the Soviet Union, arms control, and an end to the Vietnam War. The last of course was hardly an unquali-

fied triumph, but a decisive conclusion to U.S. military involvement in Southeast Asia was essential to the long-term national well-being.

The foreign policy record of Nixon and Kissinger is as ambiguous as the men themselves. Private and public documents make abundantly clear that domestic politics played a consistent and central role in their foreign policy decisions: Ensuring Nixon's reelection was never excluded from considerations of how to meet overseas challenges.

The first twenty-seven months of the administration were a time of stumbling efforts in almost all its foreign dealings, especially with Vietnam. Only in the spring of 1971 did the Nixon-Kissinger reach for substantial changes in overseas relations begin to show significant results.

China led the list of gains. There is almost universal agreement that the opening to China was a wise act of statesmanship. Recognizing the achievement as a landmark moment in modern U.S. diplomatic history, Nixon and Kissinger vied for credit as the policy innovator. And although Nixon was the principal architect of the rapprochement, Kissinger was a highly effective instrument of his design. Regardless of their respective roles, however, the policy itself deserves acclaim as not only a step away from more than two decades of tensions that risked world peace but also a device for pressuring the Soviet Union into more accommodating relations with the West.

The Nixon-Kissinger reach for Soviet-American détente has spurred much greater controversy. Conservatives convinced that Moscow was an unreliable partner in the search for peace or that Soviet interest in peaceful coexistence was nothing more than a ruse to weaken Western determination to defeat communism were consistently antagonistic to the Nixon-Kissinger policy. In the 1980s, neocons, as they were dubbed, took much satisfaction in Ronald Reagan's characterization of the Soviet Union as an "Evil Empire," and even greater pleasure in the collapse of Communist rule across Eastern Europe and in Moscow. "Reagan won the Cold War" is more than a celebration of Reagan's presidency; it is an argument against the wisdom of détente.

No doubt, Reagan deserves credit for overseeing the collapse of Soviet power, but to say he won the Cold War is to overlook the larger contributions of containment and détente in bringing the forty-three-year contest with communism to a successful conclusion. Ultimately it was the profound flaws in the Communist system that brought it down: its

disregard for individual freedoms and its inability to build a consumer economy in a society devoting so much of its resources to a warfare state. Soviet Russia developed a much deserved reputation as a behemoth that fell short of its promises and ultimately alienated peoples everywhere. The Harry Truman–George Kennan strategy of deterring and containing communism until internal contradictions destroyed it was the long-term U.S. policy that facilitated Soviet collapse.

Détente was the natural outgrowth of containment, the development of Soviet nuclear parity with the West, and the growth of a Chinese threat to Moscow's national security. After Kennedy's successful resistance between 1961 and 1963 to expanded Soviet military power in Europe and the Western Hemisphere drew Moscow into a Test Ban Treaty, the logic of additional accommodations with Soviet Russia to avoid a nuclear holocaust made eminent good sense. However enduring Nixon's and Kissinger's visceral antagonism to Soviet Russia was, they understood, as Khrushchev and Brezhnev did, that a Soviet-American nuclear conflict was impermissible. It would mean the annihilation of civilization as the world knew it.

As important, the opening of Russia to Western influence through détente eroded communism's hold on its peoples at home and abroad. Economic and cultural exchanges with the United States penetrated the Iron Curtain and made continuing Soviet insularity impossible. Détente did not end the Cold War, but in conjunction with containment and deterrence, which were central to America's Soviet policy from Truman through Reagan, it set a process in motion that came to fruition under Mikhail Gorbachev at the end of the 1980s.

The Nixon-Kissinger policy in the Middle East, like everything else they did, was never linear. It was a mixture of failure and success. Between 1969 and 1973, the administration had little hope of mediating Arab-Israeli differences. True, it did step in to help preserve King Hussein's regime in Jordan in September 1970, continued to supply Israel with the military wherewithal to defend itself against Arab attacks, and discouraged an expanded Soviet presence in the Middle East, but for four and a half years the region commanded less White House attention than Vietnam, Asia, or Europe.

The Yom Kippur War in October 1973 forced the Middle East to the center of the administration's attention. With Nixon increasingly

distracted by Watergate, the burden of ending the war without a Soviet-American confrontation and finding ways to head off future conflicts fell to Kissinger. His effectiveness in bringing the conflict to a close and relying on shuttle diplomacy to reduce Israeli-Egyptian and Israeli-Syrian tensions were the greatest achievements of his tenure as national security adviser and secretary of state. The Camp David accords between Cairo and Tel Aviv under President Jimmy Carter in 1978 could not have occurred without Kissinger's diplomacy in 1973–1974.

Kissinger was more deserving of a Nobel Peace Prize for his Middle East negotiations than for anything he did in Vietnam, which netted him the reward. He described Vietnam to me as the Nixon administration's greatest disappointment. But it was worse than a disappointment; it was a cynical failure. From the start of their administration, Nixon and Kissinger placed the highest priority on ending the war before the conclusion of the president's first term. They understood that if any considerable part of the 545,000 troops remained in Vietnam by 1972, with the continuing loss of American lives, it would jeopardize Nixon's reelection.

Their solution—Vietnamization—was a fig leaf for American defeat. Determined to withdraw U.S. ground forces without conceding the likelihood of a South Vietnamese collapse, the White House alternated between expanded military action—the Cambodian "incursion" and massive air raids on North Vietnam—and slow withdrawal.

The entire policy was a disaster. Administration actions destabilized Cambodia, expended thousands of American, Vietnamese, and Cambodian lives, gained no real advantage, and divided the country. The Paris peace agreements of January 1973 neither ensured South Vietnam's autonomy nor ended the fighting, which continued in muted form until a North Vietnamese offensive in 1975 brought the South under Hanoi's control.

Similarly, a 1975 Communist offensive in Cambodia brought the Khmer Rouge to power and led to the annihilation of some two million people under their rule. California Republican congressman Pete McCloskey may have had it right when he said that America had inflicted on Cambodia "a greater evil than we have done to any country in the world." No one, however, should leave Sihanouk and the Lon Nol regime out of the equation; events in that country were also the consequence of their doing.

Nixon's and Kissinger's concern that a premature withdrawal followed by South Vietnam's collapse would seriously injure America's international credibility was a flawed judgment. The torturous four years Nixon took to end the war at the cost of more than twenty thousand American lives was a heavy price to pay for a goal that likely could have been accomplished much sooner without significant consequence for America's international influence. Hanoi's conquest of the South proved to be no more than a ripple in the Cold War. It did nothing to discredit the United States with its allies or to embolden the Soviets or the Chinese. To the contrary, nations on both sides of the line saw America's withdrawal from an unwinnable war as sensible realism allowing the United States to focus its energies on more compelling foreign policy challenges.

If one could say that the Nixon-Kissinger failure in dealing with Vietnam was the result of misjudgments, the four-year-fight-and-negotiate strategy might stand as simply a miscalculation by otherwise astute foreign policy leaders. But the failure is more deserving of condemnation. Both men knew from the first that the chances for South Vietnamese survival without continuing American military support were slim at best and that congressional and public weariness of Vietnam made such long-term backing unlikely.

Their determination "to stay the course" until Saigon could allegedly stand alone, was also the product of political cynicism. The domestic political consequences of a collapse were a primary consideration. They hung back from leaving Vietnam until the 1972 elections were behind them. As Kissinger had warned Haldeman when Nixon considered ending U.S. involvement by the close of 1971, turmoil in South Vietnam in 1972 might play havoc with Nixon's return to the White House. To ensure against subsequent complaints of failure in Vietnam, which seemed certain to follow a quick Saigon collapse after a U.S. departure, Nixon and Kissinger hoped Hanoi would allow a "decent interval" before it toppled Thieu's government.

Chile is another ugly stain on the Nixon-Kissinger foreign policy record. Their efforts, first, to bar Allende from claiming his legitimate control of Chile's presidency and then the use of economic and political means for toppling him is at odds with traditional U.S. claims to the right of national self-determination for all peoples. True, national security is a reputable excuse for undermining a hostile government capable

of injuring fundamental U.S. interests. But exaggerated fears of Allende's capacity to undermine U.S. security in the hemisphere speaks poorly of the Nixon-Kissinger judgment on what served America's national well-being. And even if they were right about Allende's threat to U.S. national security, a realistic assessment of his leadership would have led to the conclusion that his policies were creating more Chilean domestic problems than they solved and were likely to bring him down without direct U.S. pressure.

The tilt toward Pakistan in the Indo-Pakistan war was yet another foreign policy blunder. Seeing the conflict as more an extension of the Cold War, with Pakistan and China pitted against India and Russia, than a regional conflict, the White House lined up with the Pakistanis and Chinese as a means to foster the opening to China and inhibit Moscow's reach for hegemony in Asia. Yet neither Peking nor Moscow was as invested in the conflict as Washington believed. As the record shows, the contradictions between White House public statements and private actions, which became obvious at the time, undermined the administration's credibility and weakened its capacity to persuade the press, Congress, and the public to take its pronouncements at face value.

Worse, as conversations between Nixon and Kissinger now show, their overreaction to the conflict led them into reckless discussion of a possible war with the Soviet Union. With the opening to China not yet consummated in December 1971 and U.S. withdrawal from Indochina in tow, the White House was eager to establish its bona fides as a meaningful counterweight to Soviet power in Asia. "We can't allow a friend of ours and China to get screwed in a conflict with a friend of Russia's," Kissinger told the president. But William Bundy persuasively describes this as "balance-of-power diplomacy at its most naked and extreme . . . No national interest remotely warranted the risks he and Nixon ran, not to mention the intense domestic controversy that surely would have ensued if there had been a direct confrontation with the Soviet Union."

Genuine neutrality in the South Asian war would have better served American interests than the "tilt" toward Pakistan that largely ignored Karachi's terrible repression of the Bengalis, angered India and Russia, antagonized a majority of attentive Americans, who principally blamed Pakistan for the fighting, and scored few points with Peking, which saw the emergence of Bangladesh as demonstrating U.S. ineffectiveness.

The administration's greatest failure, of course, was Watergate. Although Nixon dismissed it as "a third-rate burglary," it was the visible expression of Nixon's affinity for the secret manipulation of presidential power with small regard for legal and constitutional niceties. It was also the occasion for a striking irony—as a response to the scandal, Nixon, the staunch anti-Communist, looked to better relations with the U.S.S.R. as a way to save his presidency.

The scandal justifiably compelled an end to the president's political career. Nixon would never acknowledge wrongdoing. He attributed his resignation to errors that cost him his political support, but he refused to admit any legal misdeeds. The historical record, however, makes clear that he was guilty of obstruction of justice. History also refutes his assertion that resigning would injure the office of the presidency. To the contrary, Nixon's departure from office has strengthened American institutions by demonstrating that even a president, however effective his policy making skills, cannot escape the rule of law.

This is not to suggest, however, that Nixon's imperial rule hasn't had negative consequences: His abuse of power has created a degree of distrust about executive authority that has made it more difficult for his successors to govern effectively.

Kissinger emerged from the Nixon presidency with his reputation largely intact. Clearly, he had no direct connection to the scandal. His telephone transcripts, however, underscore Kissinger's uncritical pandering to the president. His expressions of optimism that the Congress would not dare oust the president will add nothing to Kissinger's standing as a political prognosticator.

Nor can his readiness to help Nixon use foreign policy to counter Watergate be seen as honorable. His blind loyalty to Nixon was a disservice to the country. Because Nixon was so clearly impaired by Watergate in managing the Middle East crisis in 1973 and the peace negotiations in 1974, Kissinger would have done well to at least consult with other cabinet members about suspending the president's authority under the Constitution's Twenty-fifth Amendment. While any such discussion would probably have produced no action, and might have undermined Kissinger's relationship with Nixon, at least it would have signaled Kissinger's greater concern with the national well-being than with Nixon's survival. As the inner workings of Nixon's presidency amply demonstrate, Kis-

singer was as much the partisan supporter of a highly imperfect administration as he was its foreign policy expert serving the national security.

In the end, the Nixon-Kissinger relationship was one of or possibly the most significant White House collaboration in U.S. history. Their mutual interest in and knowledge of the world translated into some impressive achievements. But their shared affinity for exclusive control of foreign policy combined with their misjudgments on Vietnam, Cambodia, Chile, and South Asia also produced notable failures. Their association was a demonstration that talent, knowledge, and experience do not guarantee successful outcomes in foreign affairs. Surely, it is better to have leaders with those attributes than not. But it also suggests that no one has a monopoly on wisdom.

As Thomas Jefferson counseled, eternal vigilance is an essential element of a democratic system. A citizenry that takes the good judgment of its leaders for granted is a society that leaves itself vulnerable to disappointment and failure. The Nixon-Kissinger administration provides some constructive lessons for the present and the future on the making of foreign policy. But it also stands as a cautionary tale that the country forgets at its peril.

ACKNOWLEDGMENTS

I am grateful to a number of people for their help with the research and editing of the book.

At Archives II in College Park, Maryland, where the Richard Nixon presidential materials are housed, the archivists John Powers and Samuel Rushay were indispensable in helping me find my way through the millions of pages available to researchers studying the Nixon presidency. Michael Hamilton was especially helpful in dealing with the 2,800 hours of tapes currently available for study. Allen Rice greatly facilitated the search for photographs.

On the selection and deciphering of Nixon's taped conversations, no one was more helpful to me than Dr. Erin Mahan of the Historical Office of the Department of State. Her familiarity with the materials and willingness to share her expertise spared me from hours of tedious labor and allowed me to finish the book more quickly.

Adina Rosenbaum and Brian Wolfman at Public Citizen helped me file Freedom of Information requests for Nixon's medical records. Greg Cummings at the Richard Nixon Library in Yorba Linda, California, and Robert Nedelkopf at the Maryland Archives also provided wise counsel on locating medical information. Andre Sobicinski at the Office of the Historian, Bureau of Medicine and Surgery, U.S. Navy Department was an eager supporter of my efforts to gain access to relevant records. Dr. Seymour Perlin greatly facilitated my understanding of Nixon's psychology.

Three University of Maryland undergraduates, Robert Minford, Elizabeth Shields, and Staci Thompson, spent dozens of hours making

copies of documents and tapes that I had identified as essential for my reconstruction of the Nixon and Kissinger collaboration and actions.

William C. Gibbons kindly gave me a copy of his manuscript covering Part V, 1968–1974, of his monumental study of the U.S. government and the Vietnam War.

David Taylor lent me a transcript of his interview with Alexander Haig for his documentary on the Nixon presidency.

I am grateful to Anna Kelman for helping identify and copy photographs of Nixon and Kissinger for use as illustrations.

I am indebted to a number of people who agreed to share their knowledge of Richard Nixon and Henry Kissinger with me: Richard Allen, Professor Larry Berman, Dr. D. Earl Brown, John Dean, Dr. Justin Frank, Professor Stephen Graubard, General Alexander Haig, Walter Isaacson, Marvin Kalb, Dr. Henry Kissinger, Dr. Dale Rogers Marshall, David Oberdorfer, Ray Price, Henry Raymont, Daniel Schorr, Brent Scowcroft, Dr. Richard Solomon, Helmut Sonnenfeldt, Dr. John Tkach, and Arnold Weiss.

Matthew Dallek, Stanley I. Kutler, Erin Mahan, Stephen Solarz, and John W. Wright read and commented on the manuscript. Each of them made excellent suggestions for revisions that have greatly improved the book. Their help reminded me that every work of historical reconstruction is a joint effort dependent on the judgment of thoughtful critics.

No one provided more constructive suggestions for revisions than Fritz R. Stern. His close reading of the manuscript and support of my work over the years have been acts of generosity for which I am deeply grateful.

John Wright, my agent, has worked with me on the book from its inception and provided his usual constructive guidance that has served me so well for over a decade. I cannot imagine doing a book without him.

Like other readers of the manuscript, Tim Duggan, my editor at HarperCollins, was a splendid collaborator in bringing the book to life. He provided encouragement and penetrating criticism that was indispensable in making this a better book. He is a model of what a first-rate editor should be.

Estelle Laurence, the copyeditor, saved me from a number of errors. Allison Lorentzen, Tim Duggan's assistant, and Lydia Weaver, the production editor, cheerfully steered the manuscript through to publication. They were a pleasure to work with. Mark Jackson, a HarperCollins attorney, provided wise counsel on several points in the manuscript.

Matthew Dallek, Rebecca Dallek, and Michael Bender gave constructive advice on my descriptions of how I was organizing and making sense of the mass of material I had gathered for the book. They were particularly helpful in advising me on what a younger generation without clear memories of Nixon and Kissinger in power might want to learn about them.

No one was more helpful in supporting my decision to write the book and criticizing the manuscript than Geraldine R. Dallek. Over four years, she patiently listened to my monologues about Nixon and Kissinger, the latest historical intruders in our daily lives, and offered wise counsel on assessing their motives and actions. She made numerous suggestions that I incorporated into the manuscript. She also effectively applied her keen feel for visual materials to the selection of the book's illustrations. She has been an unnamed co-author in all of my eight books, and each one has been the better for her sensible advice.

Needless to say, but I will say it anyway, any errors in the book are strictly my responsibility.

SOURCES

The endnotes to the book cite the sources for the quotes and facts on which my narrative account is based. Most of the book rests on a large body of material drawn from the Richard Nixon Presidential Materials Staff, which is the title given to the Nixon presidential papers and tapes at National Archives II in College Park, Maryland. The various categories of presidential papers in this collection, including principally memoranda of conversations in national security files, are identified in the notes. Taped conversations are cited by numbers assigned to them by the Archives. These citations should lead any interested reader to the specific documents available to everyone in the Archives.

The most important collateral collections are Henry Kissinger's office memos, memoranda of conversations, and transcripts of telephone conversations made by aides listening in on a "dead key or undetectable extension." The transcripts were opened to researchers in May 2004. H. R. Haldeman's diaries and the files of Alexander Haig in the National Security Files and the White House Special Files (WHSF) are also indispensable collections for reconstructing the history of the Nixon-Kissinger relationship and the making of foreign policy.

A variety of interviews, conversations, newspaper, and magazine articles enriched my ability to reconstruct an accurate account of Nixon's presidential actions. The various secondary studies used in the book are listed in the bibliography, but specific materials drawn from those books are cited by page numbers in the endnotes with an eye to ensuring that proper credit is given to the pioneering research of earlier Nixon-Kissinger biographers and historians.

Abbreviations

AHCHF	Alexander Haig Chron Files
AH, WHSF	Alexander Haig, White House Special Files
ANS	Annotated News Summaries
CF	Confidential Files
DDE	Dwight David Eisenhower
FIAB	Foreign Intelligence Advisory Board
FOIA	Freedom of Information Act
FRUS	Foreign Relations of the United States
GVN	Government of South Vietnam
HK	Henry Kissinger
HKOF	Henry Kissinger Office Files
JFK	John F. Kennedy
LBJ	Lyndon B. Johnson
LC	Library of Congress
Memcon	Memorandum of Conversation
MFN	Most Favored Nation
n.d.	No Date
NLF	National Liberation Front
NPMS	Nixon Presidential Materials Staff
NSC	National Security Council
NSDM	National Security Decision Memorandum
NSSM	National Security Study Memorandum
NVA	North Vietnamese Army
NVN	North Vietnam
PDB	President's Daily Briefings
POF	President's Office Files
PPF	President's Personal Files
PPP: RN	Public Papers of the Presidents: Richard Nixon
RN	Richard Nixon
SAG	Special Action Group
SALT	Strategic Arms Limitation Talks
SF	Subject File
SRG	Senior Review Group
SVN	South Vietnam
TC(s)	Telephone Conversation(s)
USG	United States Government
VSSG	Vietnam Special Study Group
WHSF	White House Special Files
WHY	*White House Years*
WSAG	Washington Special Actions Group
YOU	*Years of Upheaval*

NOTES

CHAPTER 1 NIXON

PAGE 3 **In the nearly twenty years:** Quotes are all from M. Crowley, 50, 59, 70, 110, 150, 172, 216, 175.

PAGE 4 **Nixon's postpresidential:** RN, *Memoirs*, 3–4.

PAGE 5 **When Richard was nine:** Ibid., 12–13; Wicker, 16.

PAGE 5 **But in fact:** Ibid.; quotes about Frank Nixon are on 15–16. See also Wills, 179. Frank Nixon's impact on Richard are my conclusions partly based on Richard's lifelong strivings for distinction.

PAGE 6 **Richard felt much:** Quotes are in Wicker, 29–30.

PAGE 6 **And Hannah was:** For quotes and material about Hannah, see Morris, *Nixon*, 55, 61, 72–73.

PAGE 6 **As a boy:** Ibid. Quotes are on 102, 140–41, 143.

PAGE 7 **During his three years:** Ibid., 174–76.

PAGE 7 **When Tom Wicker:** Wicker, xii. Stevenson quote is on 21; Wills quote is on 33; RN quote is on 32.

PAGE 8 **Like Nixon:** Morris, *Nixon*, 98–99.

PAGE 8 **More was in play:** Ibid. For RN's high school career, 102–3, 107–9, 118–21; at Whittier, see chap. 5; for Duke, 164–65; quote is from RN, *Six Crises*, 295.

PAGE 9 **Although intelligence:** Hofstadter, 66, 77, 83–84, 87–88.

PAGE 9 **Dick Nixon's early life:** Quoted in Wicker, 10.

PAGE 10 **In college:** Best discussion of Orthogonians is in Morris, *Nixon*, 118–21.

PAGE 10 **Nixon later:** Quoted in Wicker, 9; Garry Wills interview is in Wills, 17–18.

PAGE 11 **A winning campaign:** Morris, *Nixon*, 148–56. Quotes are on 155–56.

PAGE 11 **When Richard began:** Ibid., 162, 179–84; Wicker, 8.

PAGE 11 **During his first two years:** See Morris, *Nixon*, chaps. 8–10; RN, *Memoirs*, 23–34.

PAGE 12 **Nixon's campaign:** Morris, *Nixon*, 307–11, 324–25. Quote is on 328.

PAGE 13 **Yet neither the money:** Greenberg, 14.

PAGE 13 **Instead, the objective:** Wills, 80–83; Wicker, 34–46. Quote is on 35.

PAGE 14 **Nixon's speeches:** The best-detailed discussion of the campaign is in Morris, *Nixon*, chap. 11. Quotes are on 288, 314, 317, 320, 325, 326, 327, 333. Greenberg, 27.

PAGE 15 **Because Nixon:** Ibid., 5.

PAGE 15 **For the ambitious:** "Of course I knew," quoted in Chafe, 241. Greenberg asserts that "the record of his [Nixon's] first campaign shows little doubt among southern Californians that he embodied their values," 20.

PAGE 16 **Nevertheless, his eagerness:** Morris, *Nixon*, 362–66.

PAGE 16 **At the same time:** Ibid., 343.

PAGE 16 **But it was his role:** RN, *Six Crises*, 11–14.

PAGE 17 **Aside from:** Quotes are in Wicker, 57.

PAGE 17 **Political ambition:** Ibid., 54–56, 62.

PAGE 18 **The more Nixon:** "Conclusive proof" and "Oh, my God," quoted in Morris, *Nixon*, 473, 475; see also Wicker, 65–66. Quote is on 63.

PAGE 18 **Nixon's success:** First quote is in Wicker, 71; second is in Morris, *Nixon*, 523–24, 531.

PAGE 18 **Douglas impressed:** On Douglas, see Morris, *Nixon*, 538–42.

PAGE 19 **But what made:** Ibid., 541–42.

PAGE 19 **Douglas was:** Quoted in Wicker, 71–72, 75–76, 78; Morris, *Nixon*, 568–69, 578, 583.

PAGE 20 **Nixon won:** For the vote and the role of interests, see Morris, *Nixon*, 568, 572–75, 585, 611, 614. Quote is on 557.

PAGE 20 **Nixon's appeal:** Quotes are in Morris, *Nixon*, 526, 535, 567, 569, 570–71, 602–3.

PAGE 21 **Nixon would later:** "I'm sorry," quoted in Wicker, 79; "the most notorious," Morris, *Nixon*, 533; "It really is true," quoted in Dallek, *Unfinished Life*, 370.

PAGE 21 **Less than two:** Wills, 93–94.

PAGE 21 **Nixon began:** Wicker, 84–85.

PAGE 22 **Nixon intended:** Quoted in ibid., 85.

PAGE 22 **But allegations:** Ibid., 80–81; Morris, *Nixon*, 812, for the Pearson charge and the quote.

PAGE 22 **Believing that:** Wicker, 80–94. Quotes are on 92–93.

PAGE 23 **On September 23:** Quotes are from Morris, *Nixon*, 826.

PAGE 23 **Nixon's speech:** Ibid., 827–32.

PAGE 24 **Nixon's performance:** "tasteless," quoted in Wills, 106. Rovere quote: Morris, *Nixon*, 856. Wicker quote is on 107.

PAGE 24 **Most of the response:** Morris, *Nixon*, 844.

PAGE 24 **Nixon's defense:** Ibid., 857–62.

PAGE 25 **Nixon's eight years:** Wicker, 200–2.

PAGE 25 **The most memorable:** RN, *Six Crises*, Section Four, esp. 216, 220, 223–24, 230–31.

PAGE 26 **Nixon's political:** Ambrose, *Nixon: Education of a Politician*, 522–26.

PAGE 26 **Nixon viewed:** For DDE's response of RN as VP, ibid., 559.

PAGE 26 **Nixon understood:** On RN's vice presidency, see Wicker, 176–206; see also 178 for travel.

PAGE 27 **But more than a strategy:** Quote is from ibid., 205–6.

PAGE 27 **Between 1960 and 1964:** On RN's hard work, the adviser's comment, and the car incident, see Ambrose, *Nixon: Education of a Politician*, 557, 560, 568; on the debate and the Daley quote, see Dallek, *Unfinished Life*, 284–86.

PAGE 28 **Nixon hoped:** Ambrose, 568–69, 582.

PAGE 28 **Unlike the campaigns:** Ibid., 584–87, for comparisons between RN and JFK.

PAGE 28 **Nixon's defeat:** Ibid., 643–45.

PAGE 29 **Nevertheless, Nixon:** Wicker is quoted in ibid., 653.

PAGE 29 **He might:** Ibid., 650–52, 666.

PAGE 29 **Angered and:** Quoted in ibid., 671.

PAGE 30 **But of course:** RN, *Memoirs*, 265.

PAGE 30 **During his time:** *New York Times* obituary of Dr. A. Hutschnecker, January 3, 2001; Interview, confidential source, March 15, 2005; Summers, Brodie provide the fullest discussions of Nixon's psychology.

PAGE 30 **Within hours:** Ambrose, *Nixon: Triumph of a Politician*, 11–13.

PAGE 31 **And so he spent:** The journalist is quoted in ibid., 52.

PAGE 31 **But preparing:** For the trips, see ibid., 22–23, 27–28, 43–44, 51–52, 64–65, 68–69, 107–10, 112–13. The quote is on 22.

PAGE 32 **Nixon did not:** Ibid., 131–32.

CHAPTER 2 KISSINGER

PAGE 33 **Like Nixon's:** "It is fashionable," quoted in the Kalbs, 35; "people understand him," Isaacson, 15. For a discussion of HK's psychohistory, including quote "is not always sure," see Dana Ward, "Kissinger" in Caldwell, ed., *Kissinger*, chap. 2. Quote is on 33.

PAGE 34 **As a boy:** See the Kalbs on the rise of Furth, 31; for the rest, see Isaacson, 17–22.

PAGE 34 **The rise to power:** Ibid., 26; "any lasting impressions," quoted in the Kalbs, 35.

PAGE 35 **But one longtime:** "Imagine," Landau, 14–15.

PAGE 35 **In August 1938:** For the decision to leave Germany: Isaacson, 26–28. HK's remark is on 13.

PAGE 35 **In America:** "For a refugee," quoted in the Kalbs, 37. For HK's tensions between assimilation and his German identity, see Isaacson, 33–38; Landau, 16–17; also see the Kalbs, 36.

PAGE 36 **Yet whatever Heinz's:** "The greening," the Kalbs, 37. Also see Isaacson, 39–40.

PAGE 36 **Ironically, Kissinger's:** For this phase of HK's army service, see the Kalbs, 38, and Isaacson, 41–43.

PAGE 36 **During his time:** On Kraemer and his relations with HK, see the Kalbs, 38–39; see also Isaacson, 43–47; on HK's German identity, see also Ward, "Kissinger" in Caldwell, ed., *Kissinger,* 36.

PAGE 37 **It was the beginning:** For HK's service in Europe, see the Kalbs, 39–42; see also Isaacson, 47–55.

PAGE 38 **In May 1946:** Isaacson, 55–58; Blumenfeld, 77–79.

PAGE 38 **He hoped that:** Isaacson, 48.

PAGE 39 **The survivors:** HK's letter is quoted in ibid., 52.

PAGE 39 **Kissinger learned:** Ibid., 52–54, 56–57.

PAGE 39 **In September 1947:** Blumenfeld, 80–86; quotes "he sat," "thin, bony," "the same clothes," and "already playing" are on 82–83; Ward, in Caldwell, ed., *Kissinger,* 45 for the quote "a discussion that was not," and Isaacson, 59–61; the quotes "I thought it was a strange" and "I got the impression," are on 60.

PAGE 40 **Henry's intelligence:** "I am interested," quoted in Blumenfeld, 86–87; Isaacson, 62–63; and Landau, 42.

PAGE 41 **Henry had:** On HK and Elliott, see Blumenfeld, 86–89, for all quotes, except "I have not had . . ." in Isaacson, 63.

PAGE 42 **As with everything:** Blumenfeld, 91–92.

PAGE 42 **Despite its flaws:** Graubard, 5–9. "Is man doomed," quoted on 8; see also Isaacson, 64–67.

PAGE 42 **What had partly:** Ward, "Kissinger," 41–42. For the quotes "fat dumpy-ish," "a Lana Turner," "she dutifully," "miserable," and "blackmail," see Isaacson, 37, 87, 101–3, 365, 368.

PAGE 43 **As he completed:** See Blumenfeld, 92–108; Graubard, 55–59; Isaacson, 69–72.

PAGE 44 **The seminar gave:** "Henry collected" and "He is obviously," quoted in Blumenfeld, 95.

PAGE 45 **If the seminar:** Interview, confidential source, March 15, 2005.

PAGE 45 **However useful:** Graubard, 13–18.

PAGE 45 **Kissinger saw parallels:** Ibid., 18–53; see also Isaacson, 74–77. Quotes are on 76.

PAGE 46 **Among several lessons:** Graubard. The quotes are on 41, 49, and 52.

PAGE 46 **The originality:** "A certain Germanic," quoted in the Kellers, 226. For the rest, see Isaacson, 77–81.

PAGE 47 **In 1955:** HK, "Military Policy . . .", *Foreign Affairs,* April 1955, 416–28.

PAGE 47 **Kissinger's article:** Graubard, 59–64, and Isaacson, 82–86.

PAGE 48 **Kissinger tried:** HK, *Nuclear Weapons.* "I don't know," quoted in Blumenfeld, 133; see also 111. "I am sure," quoted in Isaacson, 88. For the government committee, see Dallek, *Unfinished Life,* 223–24.

PAGE 48 **Kissinger's book:** The best overall discussion of Kissinger's book is in Graubard, chap. 3.

PAGE 49 **Critics of:** "If the limitations," quoted in Isaacson, 89.

PAGE 49 **Kissinger's ascent:** On the Rockefeller connection and the project, see Blumenfeld, 109–11, 114–17.

PAGE 50 **Between 1955 and 1957:** For the strains on HK, see ibid., 117–20. Ruebhausen quote is on 118; Isaacson quote is on 92.

PAGE 50 **Eventually, Kissinger:** Blumenfeld, 113–14.

PAGE 50 **Kissinger's temper:** See Graubard, 112–15; Isaacson, 94–95.

PAGE 51 **The unwelcome:** Graubard, 115, with the quote "always . . . running"; Blumenfeld, 141–42; Isaacson, 95–97; quote "malicious maniac" is on 97.

PAGE 52 **Kissinger's teaching:** Blumenfeld, 122–23; Graubard, 114, which includes the quote.

PAGE 52 **Initially, Kissinger's:** Blumenfeld, 122–25; quote "Instead of" is on 123. "Is quite a sight," quoted in Isaacson, 98.

PAGE 53 **Although he was:** Ambrose, *Nixon: Education of a Politician*, 503–4.

PAGE 53 **As a prelude:** Ibid., 536; "would be called," 540; HK, *WHY*, 3–7. The quotes are on 6, 7.

PAGE 53 **Nixon's victory:** For a listing of the articles, see Graubard, 279–80.

PAGE 54 **The articles:** Kissinger, *Necessity for Choice*, 1–4, ix, chaps. 3 and 8.

PAGE 54 **Although he did:** "We need someone," quoted in Dallek, 279; "or at least," HK, *WHY*, 8–9, 13–14; "did not commend," quoted in Graubard, 171.

PAGE 55 **Although Bundy:** "Pompous," quoted in Isaacson, 113. "With little understanding," HK, *WHY*, 9, 39–40.

PAGE 55 **But Kissinger's differences:** See Dallek, 418–25.

PAGE 56 **In August:** HK, *WHY*, 847; Isaacson, 113–14; Schulzinger, 14.

PAGE 56 **Although "he left . . .":** "He left," quoted in the Kalbs, 64. For Kissinger's critique of JFK's European policy, see Graubard, 179–88, 203–22.

PAGE 57 **His criticisms:** "My God," quoted in Blumenfeld, 148–49; see also Isaacson, 116–17.

PAGE 57 **Ironically, Kissinger's:** "We had involved," HK, *WHY*, 231–33. "You are engaged," quoted in Gibbons, 81, n.12, 83, n.19, 100.

PAGE 58 **A press report:** See Clifford, 429–32. See also Isaacson, 118–19. For Rusk's view of HK, see *FRUS: Vietnam*, 1967, 782.

PAGE 58 **In 1966:** HK to H. Lodge, quoted in Gibbons, 383–85; *Look*, August 9, 1966.

PAGE 58 **In 1967:** On the Pennsylvania negotiations, see Dallek, *Flawed Giant*, 476–85. McNamara's quote: *FRUS, Vietnam, 1967*, 859. LBJ quoted in Isaacson, 122.

CHAPTER 3 1968

PAGE 60 **When Nixon decided:** For Johnson's political decline and his specific problems over the poverty war and civil rights, see Dallek, *Flawed Giant*, chap. 10, and 221–26, 322–34.

PAGE 61 **Nixon believed that:** For RN's eagerness to run against LBJ, see Ambrose, *Nixon: Triumph of a Politician*, 90–99, 102–4, 127–28. See also Dallek, *Flawed Giant*, 524, for the *U.S. News* report.

PAGE 62 **Johnson's withdrawal:** On LBJ, see ibid., chap. 10, and 569–73 in particular; Connally quote is on 572.

PAGE 62 **During the first half of 1968:** On Rockefeller and Reagan, see Ambrose, *Nixon: Triumph of a Politician*, 104, 118–21, 127.

PAGE 63 **Percy and Romney:** "My biggest problem," ibid., 104; for the county chairmen, see also 120. For *Newsweek*, Percy's lack of party support, and quote: Wills, 196–200.

PAGE 63 **Romney was apparently:** "God and country," Dallek, *Unfinished Life*, 690. For Romney's gaffe: Tom Wicker, 296–97.

PAGE 63 **When Romney dropped out:** Ambrose, *Nixon: Triumph of a Politician*, 135, 141, 145–46, 153, 155, 160, 162, 164–65.

PAGE 64 **But Nixon's relatively:** Ibid., 145, 156.

PAGE 64 **In June:** Ibid., 157, 183; Dallek, *Flawed Giant*, 569–75.

PAGE 64 **Yet Nixon took:** Ambrose, *Nixon: Triumph of a Politician*, 141, 163–64.

PAGE 65 **Nixon's strategy:** Ibid., 163–65, 177–78, 191–92, 220.

PAGE 65 **Knowing that:** Ibid., 185–86.

PAGE 65 **Nixon was particularly:** Donald Oberdorfer interview, May 28, 2004.

PAGE 66 **Nixon and Johnson:** Dallek, *Flawed Giant*, 577–78.

PAGE 66 **Nixon followed:** Ibid., 578.

PAGE 66 **In a memo about:** Ibid.

PAGE 67 **Nixon's initiative:** Ibid., 579–81.

PAGE 67 **It was clear:** Ambrose, *Nixon: Triumph of a Politician*, 126–27, 137; Wicker, 340–41; Dallek, *Flawed Giant*, 573–75; Clifford, 562–66; quote is on 565.

PAGE 68 **But Humphrey's Vietnam:** Ambrose, *Nixon: Triumph of a Politician*, 142–44, 167–68.

PAGE 69 **And of course:** *Gallup, 1959–1971*, 2162, 2164, 2167–68.

PAGE 69 **Nixon found:** *FRUS: Vietnam, 1967*, 893; Isaacson, 125–26; Dallek, *Flawed Giant*, 544–45; *FRUS: Vietnam, January–August 1968*, 778, 895.

PAGE 70 **Kissinger's ties:** HK's ties to the Nixon and Humphrey camps and his comments about Nixon are from Richard Allen interview, May 17, 2006; Isaacson, 126–34.

PAGE 70 **In his eagerness:** The quotes are in ibid., 131, 133–34.

PAGE 70 **Nonetheless, he was:** For HK's confidence in being offered a job, see Isaacson, 131, in *FRUS: Foundations of Foreign Policy*, 21–48.

PAGE 72 **For all his expectations:** Bundy, 39; *FRUS: Vietnam, September 1968–January 1969*, 725.

PAGE 72 **None of the Johnson:** Bundy, 39. *RN, Memoirs*, 323.

PAGE 72 **During the next five:** RN, *Memoirs*, 324–27; Dallek, *Flawed Giant*, 581–84.

PAGE 73 **Was Kissinger guilty:** Bundy, 39–40, n. 81, 550. For a different assessment of HK's behavior, see Hersh.

PAGE 74 **How did Nixon:** Dallek, *Flawed Giant*, 584–87; Bundy, 40–41.

PAGE 75 **When Thieu continued:** Dallek, *Flawed Giant*, 585–86.

PAGE 75 **Because he believed:** Ibid., 586.

PAGE 75 **The intercepts:** *FRUS: Vietnam, September 1968–January 1969*, 615–16.

PAGE 75 **With only four days:** Ibid., 687; Dallek, *Flawed Giant*, 588, 591–92.

PAGE 76 **Nixon knew:** Ibid., 590–91; Bundy, 43.

PAGE 76 **Did Nixon's pressure:** For the vote and RN's appeal, see Ambrose, *Nixon: Triumph of a Politician*, 220–22. The quote about "the Silent Majority" is on 222.

PAGE 77 **Nixon's pressure on Thieu's:** Bundy, 47.

Page 78 **But it was not:** White, 445.
Page 78 **The greatest actual:** Bundy, 48, and Ambrose, *Nixon: Triumph of a Politician*, 222.
Page 78 **Nixon's victory:** HK, *WHY*, 9; Isaacson, 134–35.
Page 79 **Intrigued but:** Ibid., 135; Hersh, 23.
Page 79 **Kissinger could not:** HK, *WHY*, 10–12.
Page 80 **The conversation ended:** Ibid., 12.
Page 80 **The following day:** Ibid., 13–16.
Page 81 **In recounting:** Ibid., 12, 15.
Page 82 **Nixon was determined:** *FRUS: Vietnam, September 1968–January 1969*, 609–15; HK, *WHY*, 13.
Page 82 **Yet nothing demonstrated:** Conversation 520–8, June 15, 1971, which is part of the 3,700 hours of taped conversations in the Nixon Presidential Materials Staff (NPMS) at Archives II, College Park, Maryland. (Additional conversations are cited by number and date.)
Page 83 **Nixon chose:** HK, *WHY*, 26–28; Ambrose, *Nixon: Triumph of a Politician*, 243; Bundy, 52–53.
Page 83 **Nixon saw:** RN, *Memoirs*, 289.
Page 84 **With the formalities:** Morris, *Uncertain Greatness*, 63–64.
Page 84 **There was more:** HK, *WHY*, 39; Morris, *Uncertain Greatness*, 54–56.
Page 85 **Kissinger, with the help:** On the bureaucratic reforms, see HK to RN, n.d., but clearly January 1969, HKOF, NSC Papers, Box 2, Nixon Presidential Materials Staff, National Archives II, College Park, Maryland. All manuscripts cited in the notes are from NPMS unless otherwise indicated. Morris, 77–93; see also Kissinger, *WHY*, 38–48; and Isaacson, 151–56.

Chapter 4 The Nixon-Kissinger White House

Page 89 **By 1969:** "Political man," Safire, 599.
Page 89 **The inner workings:** The psychologists are cited in Reeves, 123.
Page 90 **Nixon is a study:** The president "is not," J. Osborne, quoted in ANS, July 1969, POF, Box 30; "Behind the façade," P. Lisagor, quoted in memo for Ehrlichman and R. Ziegler, July 16, 1969, CF, Box 65.
Page 90 **Nixon speechwriter:** Safire, 97–98, 600.
Page 90 **The placid, positive:** "Popular opinion," quoted in ibid., 103.
Page 91 **Kissinger, who saw:** "Would hole up," Isaacson's paraphrase of what HK told him, in Isaacson, 145; "Isolation," HK, *WHY*, 1408; "a very odd man," *Time*, October 27, 1975; "Goal beyond," HK, *YOU*, 1183–86.
Page 91 **So tormented:** J. Freeman to Sir D. Greenhill, June 5, 1970, FCO 73/131, British National Archives, London, England.
Page 91 **Kissinger might:** RN, *Memoirs*, 341, 433; Ehrlichman, 279–80; Eagleburger quoted in Isaacson, 139–40.
Page 92 **Nixon and Kissinger:** "It would be," quoted in E. R. Mahan, "The SALT Mindset: Détente through the Nixon Tapes," unpublished paper; RN, *Memoirs*, 715; Isaacson, 140–41.

PAGE 92 **Shared personality:** Isaacson, 141–49; see also 560–61 on RN's use of "Jew Boy." Marvin Kalb interview, May 31, 2006.

PAGE 93 **At the start of the Nixon:** An "introvert," Reeves, 11–12. "The expression" and "like a little kid," Haldeman, *Diaries*, 18, 25. The meetings and the desk: PPP:RN, 1969, 4–11; on the desk, see also W. W. Vaughan to RN, January 29, 1969; R. C. Odle, Jr. to R. M. Woods, October 30, 1969, PPF, Box 7.

PAGE 94 **At the same time:** PPP:RN, 1969, 1–4; for the protests, see Ambrose, *Nixon: Triumph of a Politician*, 245; for the news summary, see ANS, January 21, 1969, POF, Box 30; see also Handwriting, POF, Box 1.

PAGE 95 **But no one outside:** Don Oberdorfer interview, May 28, 2004; *Washington Post*, May 9, 1971.

PAGE 96 **As with every president:** Haldeman, *Diaries*, 19–20; Reeves, 29–30, 40; D. Chapin to RN, November 10, 1969, PPF, Box 14; G. Conger to RN, July 14, 1970, Box 139, Haldeman Papers, NPMS; R. C. Odle, Jr. to R. M. Woods, October 30, 1969, PPF, Box 7; RN to P. Nixon, January 25, 1969, PPF, Box 1.

PAGE 97 **As was characteristic:** RN to Haldeman, March 31, 1971, PPF, Box 3; Haldeman, *Diaries*, 26; on RN's drinking, see Reeves, 30.

PAGE 98 **A devoted staff:** Ibid., 29–30, 35, 44; Ambrose's introduction to Haldeman, *Diaries*, 7–8; Wicker, 399–400, 414–15; Ambrose, *Nixon: Triumph of a Politician*, 84, 172.

PAGE 99 **Because of his primary:** Reeves, 33.

PAGE 99 **His limited concern:** J. C. Whitaker to RN, February 11, 1969, Memoranda for the President, POF, Box 77; Haldeman, *Diaries*, 19; see also RN's concern that his administration not be seen as "a government by committee . . . Of course . . . nothing could be further from the truth," he told Ehrlichman: RN–Ehrlichman, February 4, 1969, PPF, Box 1. On the State of the Union, see R. Price to J. Keogh, January 24, 1969, and J. Keogh to RN, January 25, 1969, Handwriting, POF, Box 1.

PAGE 100 **To give foreign affairs:** RN, "Weekly Abstract," PPF, Box 13.

PAGE 100 **On the administration's third:** HK and R. Helms, January 22, 1969; HK and R. Pederson, January 27, 1969, TC, HK Papers, NPMS.

PAGE 100 **Unlike Nixon:** See Eagleburger's bio in HKOF, NSC, Box 2.

PAGE 101 **The forty-four-year-old:** A. Haig bio in ibid., Isaacson, 186–87.

PAGE 101 **Halperin was:** Ibid., 184.

PAGE 101 **Hal Sonnenfeldt:** See H. Sonnenfeldt's bio in HKOF, NSC, Box 2; Isaacson, 185–86.

PAGE 102 **The staff quickly:** Isaacson, 185, Haig, 195, 200–1.

PAGE 102 **Ten of the twenty-eight:** Haig, 201.

PAGE 102 **Haig soldiered:** Ibid., 196–97; Isaacson, 187–95.

CHAPTER 5 HOPE AND ILLUSION

PAGE 105 **Vietnam and advances:** RN, Notes, n.d., but probably January 20–21, 1969, Handwriting, POF, Box 1; Haldeman to RN's File, January 30, 1969,

Memoranda for the President, POF, Box 77; RN to HK, February 1, 1969, NSC, Box 341; NSSM 14, February 5, 1969, HKOF, NSC Box 86; PPP: RN, 1969, 15–18.

PAGE 105 **Achieving an "honorable":** HK, "Vietnam Negotiations," *Foreign Affairs* (January 1969).

PAGE 105 **Although Nixon:** On Nixon's campaign ploy, see Gibbons, manuscript, 361. *U.S. Govt. and the Vietnam War*, Part V, 1968–1976 (cited hereafter as Gibbons ms). For the rest, see HK to RN, December 20, 1968, January 2, 1969, HKOF, NSC, Box 2; HK to RN, January 4, 1969, Box 66; "Briefing: V. Nam (RN notes)," n.d., PPF, Box 16; RN, Handwriting, n.d., but probably January 20–21, POF, Box 1; see also handwritten notes headed "Bundy," n.d., in PPF, Box 12; PPP:RN, 1969, 15, 18, 23; "Progress toward a Vietnam Solution," n.d., NSC, Box 1008.

PAGE 106 **But the stalemate:** RN to HK, February 1, 1969, NSC, Box 341; RN and HK, March 4, 1969, TC; HK to RN, February 13, 1969, PDB; Haldeman, *Diaries*, 42; Haldeman, *Ends of Power*, 182; Dallek, *Flawed Giant*, 260–61.

PAGE 106 **Nixon, like Johnson:** "List of Specific Actions Agreed to at January 30, 1969, Meeting"; RN to HK, February 1, 1969; AH to HK, February 12, 1969, AHCHF, NSC Box 955; "Digest of Recent News Analyses," March 21–22, 1969, POF, Box 30; HK to K. Cole, February 10, 1969, CF, Box 1; HK, *WHY*, 239; Gibbons ms., 362–63.

PAGE 107 **On February 22:** HK to M. Laird, February 22, 1969, AHCHF, NSC, Box 955; "The Cambodian Bombing Decision," n.d., and "Secrecy of the Bombing After 1970," n.d., HKOF, NSC, Box 11.

PAGE 108 **Reluctance to:** HK and Haldeman, March 8, 1969, TC; RN, *Memoirs*, 380.

PAGE 108 **With little reason:** "Bribery": HK and R. Helms, February 12, 1969, TC; *FRUS: Vietnam, January 1969–July 1970*, 126–27; HK, *WHY*, 250, 463; RN, *Memoirs*, 125.

PAGE 109 **Before expanding:** HK to RN, January 4, 1969, HKOF, NSC, Box 66; Handwriting, n.d., but probably January 20–21, 1969, POF, Box 1; RN to W. Rogers and M. Laird, February 4, 1969, Price Speech File, PPF, Box 96; RN and A. Dobrynin, Memcon, February 17, 1969, NSC, Box 489; see also HK and R. Ellsworth, January 22, 1969, HK and M. Kalb, January 27, 1969, TCs.

PAGE 109 **Dobrynin's receptivity:** HK to RN, February 18, 1969, NSC, Box 489; M. Toon to HK, n.d., but clearly after February 17, 1969, NSC, Box 340; Gibbons ms., 387.

PAGE 110 **Toon's cautionary:** HK, *WHY*, 113–14, 140–41; Haldeman, *Diaries*, 30.

PAGE 111 **Nixon and Kissinger:** The best discussion of the Nixon-Kissinger personality defects in making policy is in Isaacson, 146–51, 205–9; quotes are on 209; for the Morris quote, see Morris, *Uncertain Greatness*, 93.

PAGE 112 **Because neither Vietnam:** For initial limits on RN's foreign policies, see his news conference, February 6, 1969, PPP:RN, 1969, 66ff., 76–77 for the announcement of his trip; 127 for "no formal communiqués"; and P. Buchanan to RN, February 19, 1969, POF, Box 77, for "under no illusions"; Haldeman, *Diaries*, 34.

PAGE 112 **The most telling:** RN, *Memoirs*, 248.

Page 112 **During the February:** HK, *WHY*, 104; RN and de Gaulle, Memcon, February 28, 1969, NSC, Box 447; See also Bundy, 59.

Page 113 **What would de Gaulle:** RN, *Memoirs*, 343.

Page 113 **De Gaulle had:** RN to de Gaulle, February 28, 1969, NSC, Box 447.

Page 113 **Nixon assured de Gaulle:** Ibid.; RN to W. Rogers and HK, February 22, 1969, PPF, Box 1; HK to RN, February 3, 1969, memos in NSC, Box 644, Box 654; NSDM, February 5, 1969; "NSC Meeting," Box H-020; A. Haig to H. Saunders, February 7, 1969, AHCHF, NSC, Box 955; HK to RN, February 13, 1969, NSC, Box 604.

Page 114 **Not surprisingly:** RN and de Gaulle, Memcon, March 1, 1969, NSC, Box 447.

Page 114 **Vietnam, by contrast:** RN and de Gaulle, March 2, 1969, ibid.; HK, *WHY*, 109–10.

Page 115 **The European trip:** H. Klein to RN, March 4, 1969; B. Harlow to Haldeman, March 10, 1969, Handwriting, POF, Box 1; two memos from P. Buchanan to RN, March 4, 1969, POF, Box 77; HK to RN, March 5, 1969, NSC, Box 446.

Page 116 **Kissinger was less:** RN and de Gaulle, March 2, 1969, MemCon, NSC, Box 447; "Terrible effect," quoted in Isaacson, 170, 169–71; "Henry swings," quoted in Haldeman, *Diaries*, 36–37.

Page 116 **After they returned:** HK to RN, March 10, 1969, NSC, Box 725; HK conversation with A. Dobrynin, March 11, 1969, described in HK to RN, March 19, 1969; HK and RN, March 11, 1969, TC, NSC, Box 489; HK and RN, March 8, 1969, two TCs; Haldeman, *Diaries*, 38.

Page 117 **During the first two weeks:** Hersh, 58–59, and RN and HK, March 8, 1969, TC.

Page 117 **Nixon now spent:** RN, *Memoirs*, 382; PPP:RN, 1969, 209–11, 215.

Page 117 **In fact, Nixon:** M. Laird and HK, March 13, 1969, TC.

Page 118 **As for bombing:** HK, *WHY*, 242–44; Hersh, 58–61.

Page 118 **For two weeks:** Hersh, 61; two RN and HK, TCs, March 8, 1969.

Page 119 **A Viet Cong:** HK and W. Rogers, March 14, 1969, TC; RN and HK, March 15, 1969, three TCs; HK, *WHY*, 245–46.

Page 119 **The air raid:** Ibid., 247; HK and General E. Wheeler, March 18, 1969, TC.

Page 119 **Although they had:** ANS, "TV Analysis," n.d., POF, Box 30; RN and HK, March 17, 1969, TC; RN and HK, March 20, 1969, two TCs.

Page 120 **It was all wishful:** HK to RN, March 25, 1969, NSC, Box 1006; NSDM 9, NSC, Box H-209; RN and HK, March 31, 1969, two TCs.

Page 120 **Despite a nonresponse:** HK to RN, April 3, 1969, NSC, Box 1008; RN to HK, April 12, 1969, NSC, Box 709; HK to RN, April 15, 1969, NSC, Box 489.

Page 120 **The Nixon-Kissinger:** Haldeman, *Diaries*, 50.

Page 121 **Nevertheless, Nixon and Kissinger:** See HK and General E. Wheeler, April 22, 1969, April 23, 1969; HK and W. Rogers, April 24, 1969, April 25, 1969, TCs; see also HK, *WHY*, 247–49, HK's defense of the bombings is on 253–54; on the controversy beginning in 1973, see Hersh, 64–65; Isaacson, 176–79.

PAGE 121 **Although the administration:** *New York Times*, May 9, 1969. "You Son of a Bitch," quoted in Isaacson, 213; HK and RN, February 14, 1969, February 21, 1969, TCs. RN to Ehrlichman, February 5, 1969, March 11, 1969, PPF, Box 1; "What is this," quoted in Isaacson, 217; See also RN to Haldeman, February 13, 1969; RN to Ehrlichman, February 17, 1969, April 10, 1969; RN to W. Rogers, M. Laird, and HK, April 14, 1969, PPF, Box 1.

PAGE 122 **Henry initially:** HK, *WHY*, 21; HK and R. Evans, January 22, 1969; HK and S. Fentriss, January 24, 1969; HK and W. Rogers, January 24, 1969; HK and J. Alsop, February 5, 1969, TCs; A. Butterfield to HK, April 28, 1969, Haldeman Papers, Box 50; Haldeman to HK, May 16, 1969, NSC, Box 817.

PAGE 122 **In April:** HK and W. Rogers, April 18, 1969; HK and J. Alsop, April 21, 1969, TCs; HK's comment to Hoover, quoted in Isaacson, 215. RN, *Memoirs*, 387–88.

PAGE 123 **When Nixon and Kissinger:** On the taps, see Gibbons ms., 397–98.

PAGE 123 **"From early 1969:** RN, *Memoirs*, 389. On J. Kraft, see Isaacson, 228–29. RN and J. Dean, February 28, 1973, conversation is in Isaacson, 225.

PAGE 124 **Partisan politics:** Haldeman, *Diaries*, 53; A. Haig to HK, May 16, 1969, AHCHF, NSC, Box 956.

PAGE 124 **Although Nixon justified:** RN, *Memoirs*, 388.

PAGE 124 **The principal motives:** "Memo of RN Meeting," March 11, 1969, NSC, Box 337; Bundy, 63; Harris poll, News Summary, March, 1969, or April 1969, POF, Box 30; B. Graham to RN, April 15, 1969, CF, Box 42.

PAGE 125 **But Nixon believed:** Quote is in Whalen, 26; RN to secretary of state, etc., April 14, 1969, NSC, Box 341; "HK and R. Ziegler, Background Briefing," May 2, 1969, NSC, Box 337.

PAGE 126 **Nixon's design:** HK to RN, May 6, 1969, NSC, Box 1008; on the requirement that Hanoi withdraw its troops from the South, see HK and R. Semple of the *New York Times*, May 2, 1969, TC; RN and HK, May 12, 1969, TC.

PAGE 126 **Nixon and Kissinger faced:** L. Garment to Haldeman, May 13, 1969, Handwriting, POF, Box 2, with RN to HK on the memo.

PAGE 127 **Nixon's sensitivity:** PPP:RN, 1969, 365–69.

PAGE 127 **The nation's growing:** On the ten points, see "Status of Paris Talks," May 28, 1969, NSC, Box 175; on HK's assurances, see "HK Background Briefing," May 14, 1969, NSC, Box 337; HK and C. Roberts, May 13, 1969, TC; on the speech, see RN and HK, May 12, 1969, May 13, 1969, two TCs, May 14, 1969; HK and E. Richardson, May 14, 1969, two TCs.

PAGE 128 **The Communists' ten points:** PPP:RN, 1969, 369–75.

PAGE 128 **Some in the United States:** "Bitter disappointment," quoted in Gibbons ms., 416; and Hanoi's response: quoted in Berman, 51.

PAGE 128 **Despite Hanoi's response:** Haldeman, *Diaries*, 58–59; RN and HK, May 14, 1969; HK and Senator C. Percy, May 14, 1969; HK and M. Laird, May 22, 1969; HK and C. Roberts, May 26, 1969; HK and B. Angelo, May 28, 1969; HK and RN, May 29, 1969; HK and W. Rogers, May 30, 1969; HK and R. Smith, May 30, 1969, TCs; P. Buchanan to HK, May 20, 1969, Subject File, Box 1; Reeves, 87–88.

PAGE 129 **Despite the tough talk:** *Washington Post*, June 3, 1969, quoted in News Digest, POF, Box 30; "Cabinet Meeting," June 3, 1969, POF, Box 78; HK to RN, June 4, 1969, NSC, Box 189; HK, *WHY*, 272.

PAGE 130 **However reluctant:** Bundy, 64; Berman, 52; Fulbright quotes are in Gibbons, 404, 418—see also chap. 9 for the pressure on Nixon to de-escalate; M. Laird quoted in Isaacson, 237; Memcon, June 8, 1969, NSC, Box 1026; Notes, Midway, June 8, 1969, PPF, Box 49.

PAGE 131 **Kissinger recalls:** HK, *WHY*, 274; ANS, June 1969, POF, Box 30; HK to W. Rogers and M. Laird, June 11, 1969, AHCHRON, NSC, Box 957; HK and E. Richardson, June 11, 1969; HK and RN, June 11, 1969, two TCs; HK to A. Dobrynin, June 11, 1969, NSC, Box 489.

PAGE 131 **On June 19:** HK and D. Rusk, June 18, 1969, TC; PPP:RN, 1969, 471–72, 476–77.

PAGE 131 **Nixon's promise:** Haldeman, *Diaries*, 65; HK, *WHY*, 274–75.

PAGE 132 **At the time:** HK and C. Roberts, June 19, 1969; RN and HK, June 19, 1969, June 20, 1969, TCs.

PAGE 132 **Kissinger understood:** RN to Haldeman and Ehrlichman, June 16, 1969, PPF, Box 1; to Ehrlichman, June 16, 1969, Handwriting, POF, Box 2.

PAGE 133 **His response to:** ANS, March 10, 1969, POF, Box 30; PPP:RN, 1969, 235–37; A. Burns to RN, May 26, 1969; Ehrlichman to RN, June 5, 1969; T. Huston to RN, June 18, 1969, Handwriting, POF; Box 2; A. Butterfield to Ehrlichman, June 2, 1969, CF, Box 36.

PAGE 133 **Why was Nixon:** Gibbons ms., 321–34.

CHAPTER 6 THE POLITICS OF FOREIGN POLICY

PAGE 135 **Arms control:** PPP:RN, 1969, 17, 62.

PAGE 136 **Nixon's commitment to:** NSDM 6, February 5, 1969, NSC, Box H-209. For Senate opinion, see P. Buchanan to RN, March 6, 1969, POF, Box 77.

PAGE 136 **By contrast:** For an excellent discussion of these developments, see Bundy, 83–88.

PAGE 136 **At a National Security:** "NSC Meeting Minutes," NSC, Meeting Minutes, Box H-109.

PAGE 137 **Nixon viewed:** RN, *Memoirs*, 416–17; PPP:RN, 1969, 208–209, 211–14, 216–19.

PAGE 137 **The contest:** HK and D. Packard, March 11, 1969; HK and Haldeman, March 11, 1969; HK and M. Bundy, March 14, 1969; RN and HK, March 14, 1969; HK and F. Lindsay, March 17, 1969, TCs.

PAGE 137 **Because it was:** ANS: "Television Analysis," March 1969, and April 6, 1969, POF, Box 30; RN to Ehrlichman and H. Klein, March 13, 1969, PPF, Box 1.

PAGE 138 **As the Senate:** Haldeman, *Diaries*, 62; June 5, 1969, entry in the CD version of the diaries; ANS, June 5, 1969, POF, Box 30; PPP:RN, 1969, 432–37, 480; K. BeLieu to RN, June 10, 1969; A. Butterfield to RN, June 11, 1969; P. Flanigan to Haldeman, June 30, 1969, Handwriting, POF,

Box 2; RN and HK, June 12, 1969, June 20, 1969; HK and B. Harlow, June 16, 1969; HK and R. Helms, June 18, 1969, TCs.

PAGE 138 **Yet all Nixon's:** Haldeman, *Diaries*, 69; A. Butterfield to R. Ziegler, July 2, 1969, CF, Box 12; ANS, July 11, 1969, POF, Box 30.

PAGE 139 **In response:** RN and HK, July 18, 1969, TC; "Telephone Call," filed August 1969, Handwriting, POF, Box 2; RN to Haldeman, Ehrlichman, and HK, August 7, 1969, NSC, Box 341.

PAGE 139 **Nixon won:** RN to Haldeman et al., ibid.

PAGE 139 **Nixon's attitude:** See E. R. Mahan, unpublished paper, "The SALT Mindset: Détente through the Nixon Tapes"; "NSC Meeting Notes," June 25, 1969, NSC, Box H-109; RN to Haldeman, June 30, 1969, Handwriting, POF, Box 2; ANS, August 3, 1969, POF, Box 30.

PAGE 139 **Nixon was especially:** RN to G. Smith, March 12, 1969, NSC, Box 319; Bundy, 90, 556, n. 48.

PAGE 140 **During the spring:** "HK Background Briefing," May 2, 1969, NSC, Box 337.

PAGE 140 **Nixon and Kissinger:** On the debate, see Bundy, 89 and 91; HK and R. Helms, June 12, 1969; RN and HK, June 12, 1969, June 19, 1969; HK and J. Mitchell, June 18, 1969, TCs; HK and M. Laird, June 23, 1969, two TCs; HK and Senator C. Percy, July 10, 1969, TC. On intelligence, see RN and HK, June 23, 1969, TC. For the RN and HK warnings about Soviet missile development, see P. Buchanan to RN, September 30, 1969, POF, Box 79. For British opposition, HK to RN, August 2, 1969, NSC. Box 452.

PAGE 141 **Settling on:** Bundy, 90–92; HK and G. Smith, June 30, 1969; HK and M. Laird, July 8, 1969, TCs; HK to RN, June 10, 1969, Meeting with A. Dobrynin, NSC, Box 340; HK to RN, June 24, 1969, CF, Box 14; "NSC Meeting Minutes," June 25, 1969, NSC, Box H-109; RN to W. Rogers, September 17, 1969, NSC, Box 711; H. Sonnenfeldt to HK, September 22, 1969; M. Laird to RN, October 7, 1969, NSC, Box 710; A. Haig to HK, October 14, 1969, AHCHF, Box 958; RN, HK, and A. Dobrynin, Memcon, October 20, 1969, NSC, Box 667; NSDM 33 demonstrates the vagueness of the U.S. position in the talks, November 12, 1969, NSC, Box H-212.

PAGE 141 **Poor prospects:** A. Haig to HK, October 29, 1969, AHCHF, NSC, Box 959; HK to W. Rogers with letters from R. Osgood and H. Okun attached, October 17, 1969, AH Special Files, NSC, Box H-1006; Haldeman to HK, September 25, 1969, Alpha Name File, Box 53, Haldeman Papers; RN to HK and HK's reply, November 12, 1969, NSC, Box 341.

PAGE 142 **Since none of Nixon's:** Haldeman, *Diaries*, 73–78. PPP:RN, 1969, 530, 541–43; S. Agnew to RN, September 15, 1969; P. Flanigan, Memo to the President's File, September 17, 1969, CF, Box 44.

PAGE 143 **Nixon's overriding:** PPP:RN, 1969, 544.

PAGE 143 **With the instincts:** Ibid., 544–49, 551–52, 555.

PAGE 144 **The press immediately:** HK, *WHY*, 224; Haldeman, *Diaries*, 78; Diary Notes, August 5, 1969, Box 40, Haldeman Papers; RN to Haldeman, Ehrlichman, and HK, August 7, 1969, NSC, Box 341.

PAGE 144 **There was little:** ANS, July 1969, POF, Box 30; Haldeman, *Diaries*, 76–77; HK to RN, July 29, 1969, NSC, Box 452; RN and Thieu, Memcon, July 30, 1969, NSC, HKOF, Box 106.

PAGE 145 **Nixon's private:** HK to RN, July n.d. 1969, NSC, Box 454.

PAGE 146 **Nixon took special:** Ibid.; Haldeman, *Diaries*, 77–78.

PAGE 146 **Nixon hoped:** "U.S. China Policy 1969–72," NSC, HKOF, Box 86; Senator M. Mansfield to Chou En-lai, June 1969; B. Harlow to RN, June 23, 1969, Handwriting, POF, Box 2; A. Haig to HK, June 24, 1969, NSC, Box 710; A. Butterfield to HK, June 26, 1969, CF, Box 6; NSDM 17, June 26, 1969, NSC, Box H-210; HK to RN, June 26, 1969, NSC, Box 392; see also Bundy, 100–5.

PAGE 147 **They also worried:** "U.S. China Policy," n.d. but clearly after June 1969, "NSC Meetings," NSC, Box H-023.

PAGE 147 **The visit to:** HK and RN, "Your Visit to Romania," n.d., NSC, Box 454; RN, HK, and Ceausescu, Memcon, August 2, 1969, August 3, 1969, NSC, Box 1023; ANS, July 14, 1969, POF, Box 30; HK to undersecretary of state, September 24, 1969, NSC, Box 710; see also Bundy, 106–7.

PAGE 147 **Since Nixon and Kissinger:** HK to W. Rogers, December 12, 1969, NSC, AHCHF, Box 960; J. W. Davis to HK, November 25, 1969, NSC: "SRG Meeting," Box H-111.

PAGE 148 **Six months into:** Haldeman, *Diaries*, 65–66, 69–70; A. Butterfield to Ehrlichman, June 24, 1969; J. R. Brown to HK, July 14, 1969, CF, Box 42; HK to RN, July 11, 1969, NSC, Box 183.

PAGE 148 **Nixon believed:** PPP:RN, 1969, 507–9; HK and Senator G. Aiken, July 14, 1969, TC.

PAGE 149 **To persuade Americans:** RN to Ho Chi Minh, July 15, 1969, NSC, HKOF, Box 106; RN, *Memoirs*, 393–94; HK, *WHY*, 277.

PAGE 149 **Simultaneous with:** ANS, July 6, 1969, POF, Box 30; A. Butterfield to HK, Ehrlichman, and H. Klein, July 15, 1969, CF, Box 42; RN and HK, July 16, 1969, TC.

PAGE 149 **In mid-July:** HK to RN, July 1969, an assessment of the July 18 meeting; T. L. Hughes to acting secretary, July 1969, NSC, Paris Talks, Box 181; RN and HK, July 18, 1969, TC; HK, *WHY*, 277–79.

PAGE 149 **Opinion polls:** Polling data is in Gibbons ms., 439–42.

PAGE 150 **Because Hanoi refused:** HK, *WHY*, 278–79. On T. Lake and General V. Walters, see Isaacson, 242–45. HK's conversation with the journalist is dated April 7, 1973, NSC, HKOF, Box 15.

PAGE 151 **Although Kissinger:** HK to RN, August 6, 1969, NSC, Box 1039; HK to E. Bunker, August 15, 1969, NSC, HKOF, Box 106; A. Haig to HK, NSC, Box 334; HK and Xuan Thuy, Memcon, August 4, 1969, ibid., Box 121; P. Buchanan and RN, August 5, 1969, "Legislative Leadership Meeting," August 5, 1969, POF, Box 79; HK and M. Schumann, Memcon, August 4, 1969, NSC, Box 675; HK, *WHY*, 278–82.

PAGE 152 **Hopes that Hanoi:** Ibid., 282; HK to RN, August 22, 1969, PDB; Ho Chi Minh to RN, August 30, 1969, NSC, HKOF, Box 106.

PAGE 152 **Nixon now found:** HK, *WHY*, 282–83; ANS, August n.d. 1969, POF, Box 30.

PAGE 153 **The administration now:** HK to RN, September 5, 1969, NSC, Box H-001, Box H-211.

PAGE 153 **Although Nixon approved:** ANS, September 8, 1969, September 10, 1969, POF, Box 30; A. Haig to HK, September 10, 1969, NSC, AHCHF, Box 958.

PAGE 153 **Because Kissinger now:** HK to RN, September 10, 1969, "NSC Meetings," NSC, Box 024.

PAGE 154 **Was there a way:** HK to RN, September 11, 1969, ibid.

PAGE 154 **Nixon found:** For the description of Duck Hook and the quotes, see Isaacson, 246, and Berman, 54–56. On the bomb, see also Hersh, 128–29.

PAGE 155 **Nixon had no:** See Burr and Kimball, "Nixon's Secret Nuclear Alert: Vietnam War Diplomacy and the Joint Chiefs of Staff Readiness Test, October 1969," *Cold War History* 3 (January 2003), 113–49, esp. 113–18.

PAGE 155 **Duck Hook was:** Isaacson, 200–2; Haldeman, *Diaries*, 86.

PAGE 155 **At an NSC meeting:** "NSC Meeting Minutes," NSC, Box H-109.

PAGE 156 **However dearly:** HK, *WHY*, 283–84.

PAGE 156 **In September, resignations from:** K. Cole to HK, September 19, 1969; HK to RN, September 22, 1969, CF, Box 14. Also HK and M. Halperin, and HK and S. Loory, September 11, TCs.

PAGE 156 **In September:** "Talking Points for HK Meeting with Vietnam Special Study Group" September 1969, NSC (VSSG), Box H-001; "HK Press Briefing," September 16, 1969, NSC, Box 339; RN and HK, September 15, 1969, September 24, 1969, September 27, 1969, TCs; HK to RN, September 24, 1969, NSC: HKOF, Box 106; RN, Notes of Meeting, September 27, 1969, POF, Box 79; RN and HK, September 27, 1969, TC; PPP:RN, 1969, 756–57.

PAGE 157 **Since domestic divisions:** ANS, September 17, 1969, POF, Box 30; A. Haig to HK, September 17, 1969, NSC: AHCHRON, Box 958; RN to Haldeman, September 27, 1969, Subject Files, Box 164, Haldeman Papers; PPP:RN, 1969, 752–53, 757–58.

PAGE 157 **At the same time:** RN to W. Rogers, September 17, 1969; H. Sonnenfeldt to HK, September 22, 1969, NSC, Box 711; HK and A. Dobrynin, Memcon, September 27, 1969, NSC, Box 489; RN and HK, September 27, 1969, TC.

PAGE 158 **Yet Nixon and Kissinger:** RN and HK, September 27, 1969, TC; ANS, October 1, 1969, POF, Box 31.

PAGE 158 **Nevertheless, Nixon:** Ibid., October 2, 1969; Haldeman to HK, October 1, 1969; Haldeman to B. Harlow, HK, and Ehrlichman, October 1, 1969, Alpha Name Files, Box 53, Haldeman Papers; RN to HK, October 1, 1969, PPF, Box 1; B. Harlow to RN, October 6, 1969, Handwriting, POF. Box 3.

PAGE 159 **As the Moratorium:** HK to Haldeman, October 9, 1969, CF, Box 36; RN and HK, September 24, 1969; HK and J. Shepley, September 25, 1969, TCs; HK to Haldeman, October 10, 1969, NSC, Box 821; HK to RN, October 14, 1969, NSC: Paris Talks, Box 175; J. Caulfield to Ehrlichman, October 10, 1969; A. Butterfield to RN, October 17, 1969, Handwriting, POF, Box 3.

PAGE 159 **Nixon and Kissinger deceived:** HK and J. Alsop, October 3, 1969; RN and HK, October 10, 1969, TCs.

PAGE 160 **Much of the Nixon-Kissinger:** All these quotes, except for the P. Buchanan one, are in ANS for October 1969, POF, Box 31; A. Haig to HK, October 8, 1969, NSC: AHCHF, Box 958, recounts the Nixon-Buchanan exchange; "So it looks like," Haldeman, *Diaries*, September 27, 1969, CD Rom version.

PAGE 161 **On October 15:** HK and A. Walinsky, October 9, 1969; HK and J. Mitchell, October 10, 1969, TCs.

PAGE 161 **Despite the growing:** Ibid.; RN and HK, October 8, 1969, TC; B. Harlow to staff secretary, October 24, 1969, POF, Box 79; Haldeman to HK, October 31, 1969, NSC, Box 817.

PAGE 161 **After October 15:** A. Haig to HK, October 13, 1969, October 17, 1969, NSC, Box 334; HK and M. Laird, October 23, 1969, TC; RN, HK, and Sir R. Thompson, Memcon, October 17, 1969, NSC, Box 1023; RN and HK, October 20, 1969, TC; RN, HK, and A. Dobrynin, Memcon, October 20, 1969, NSC, Box 667; B. Harlow, Memo to staff secretary, October 24, 1969, POF, Box 79; on Agnew, see Ambrose, *Nixon: Triumph of a Politician*, 307.

PAGE 162 **For all his rhetoric:** Haldeman, *Diaries*, 95; Haldeman to W. Rogers, October 16, 1969, CF, Box 36; RN, HK, and Sir R. Thompson, Memcon, October 17, 1969, NSC, Box 1023; Senator M. Mansfield to RN, October 31, 1969, PPF, Box 11; P. Buchanan to RN, October 27, 1969, Alpha Subject Files, Box 138, Haldeman Papers; RN and HK, October 8, 1969, TC. See also RN, *Memoirs*, 407–8; Bundy, 80–82; Isaacson, 246–48; Berman, 56–57. June 1971 conversation with Haldeman is quoted in Berman, 58.

PAGE 163 **Nixon remembered:** RN, *Memoirs*, 408; HK, *WHY*, 288.

PAGE 163 **Years later:** Nixon quoted in Isaacson, 248; Kissinger quoted in Berman, 57.

PAGE 164 **Nixon's speech:** RN to Haldeman, October 26, 1969, PPF, Box 1; RN and HK, November 3, 1969, two TCs.

PAGE 164 **Nixon's evening speech:** Ambrose, *Nixon: Triumph of a Politician*, 309.

PAGE 164 **He wanted people:** PPP:RN, 1969, 901–9. The formulation about speaking one way and acting another is from Ambrose, *Nixon: Triumph of a Politician*, 320.

PAGE 165 **Nixon said later:** RN, *Memoirs*, 410–11; Haldeman, *Diaries*, 105–6.

PAGE 165 **Behind the scenes:** RN and HK, November 4, 1969, three TCs; HK and J. Alsop, November 4, 1969, TC.

PAGE 166 **Haldeman was kept:** Haldeman, *Diaries*, 104–5.

PAGE 166 **After months of:** A. Haig to HK, November 6, 1969, AHCHF, NSC, Box 959; HK and A. Dobrynin, Memcon, November 6, 1969, NSC, Box 489.

CHAPTER 7 TROUBLES GALORE

PAGE 169 **Finding solutions:** HK, *WHY*, 341.

PAGE 169 **Nixon entered:** HK, *YOU*, 202–3.

PAGE 170 Nixon took some: Hersh, 84–86; Isaacson, 148–49, 560–62; "An increase," ANS, March n.d. 1969, POF, Box 31.

PAGE 171 Nixon began: HK, *WHY*, 348, 559; Kissinger quoted in Isaacson, 562.

PAGE 171 Because the Middle East: HK, *WHY*, 348.

PAGE 171 For Nixon and Kissinger: Ibid., 341–49; Bundy, 123–25.

PAGE 172 Two considerations: Quandt, 77; HK, *WHY*, 349–51.

PAGE 172 The different outlooks: HK, *WHY*, 351–52; HK and J. Sisco, February 3, 1969, TC.

PAGE 173 Kissinger saw: HK, *WHY*, 352–54; HK and Eisenhower, February 18, 1969; RN and HK, February 14, 1969; HK and J. Sisco, February 17, 1969, TCs.

PAGE 173 Initially, Nixon slowed: HK and J. Sisco, March 5, 1969; HK and M. Fischer, March 8, 1969, TCs; HK, *WHY*, 355–57.

PAGE 173 With Israel's Foreign Minister: HK to RN, March 8, 1969, NSC, Box 651; HK, *WHY*, 357–58.

PAGE 173 Middle East realities: Ibid. 358–63. The impasse is clearly demonstrated in the memoranda of these talks between March 13, 1969, and March 17, 1969, in NSC, Box 604, and in HK and W. Rogers, March 13, 1969; HK and L. Garment, March 14, 1969; HK and J. Sisco, March 15, 1969, and March 19, 1969, TCs. See also RN, HK, and M. Fawzi, Memcon, April 15, 1969, NSC, Box 634.

PAGE 174 Even King Hussein: HK, *WHY*, 362; Memcons, April 8, 1969, April 10, 1969, POF, Box 77; Memcon, April 11, 1969, NSC, Box 616; state department telegram, April 11, 1969, NSC, Box 613.

PAGE 174 Middle East difficulties: RN and HK, March 31, 1969, TC.

PAGE 174 At the end of April: HK to RN, April 24, 1969, NSC Meeting, Box H-022.

PAGE 174 During the meeting: "NSC Meeting Minutes," April 25, 1969, NSC, Box H-109.

PAGE 174 The discussion: NSDM, April 25, 1969, NSC, Box 651.

PAGE 175 The Israelis: HK and M. Bitan and Y. Rabin, Memcon, May 13, 1969, HKOF, NSC, Box 134; H. Saunders to HK, May 15, 1969, NSC, Box 756; HK, *WHY*, 366; Bundy describes Meir, 127.

PAGE 175 In the meantime: RN to G. Meir, June 18, 1969, NSC, Box 604; HK to RN, June 10, 1969, NSC, Box 651.

PAGE 175 Nixon sent Sisco: PPP:RN, 1969, 478–79, for the news conference, and L. Garment to Haldeman, June 21, 1969, CF, Box 42, for the reaction to it; see also PPP:RN, 1969 for the UN speech.

PAGE 175 Neither discussions in Moscow: H. Saunders to HK, July 22, 1969, NSC, Box 644; H. Sonnenfeldt to HK, August 19, 1969, NSC, Box 604; ANS, September n.d. 1969, POF, Box 30. On nuclear weapons, see Memorandum for the President, August 1, 1969; HK to RN, November 6, 1969, NSC, Box 605. The best discussion of the issue is by Cohen and Burr, "Israel Crosses the Threshold," *Bulletin of the Atomic Scientists*, May/June 2006. On J. Mitchell and domestic politics, HK, *WHY*, 369; HK to RN, September 10, 1969, NSC, Box 644; RN to HK, September 22, 1969, PPF, Box 1.

PAGE 176 **Nixon's White House:** HK, *WHY*, 370–71; RN and HK, September 27, 1969, TC.

PAGE 177 **Meir's shrewd dealings:** HK, *WHY*, 370.

PAGE 177 **Meir's stroking:** RN and HK, September 27, 1969, TC.

PAGE 177 **By the beginning of October:** RN and HK, October 7, 1969, TC; HK to RN, October 2, 1969, NSC, Box 644; HK to RN, October 15, 1969, NSC, Box 384, on the impasse.

PAGE 178 **With his attention riveted:** RN and HK, October 25, 1969, TC.

PAGE 178 **With Nixon's speech:** HK to RN, November 12, 1969, NSC, Box 341; HK, *WHY*, 373–77.

PAGE 178 **At a December 10:** "NSC Meeting Minutes," December 10, 1969, NSC, Box H-109.

PAGE 179 **Reluctant to go forward:** HK to RN, December 17, 1969, NSC, Box 650; HK and A. Eban, Memcon, December 16, 1969, NSC, Box 605; HK to RN, December 18, 1969, December 27, 1969, December 29, 1969, NSC, Box 605; HK, *WHY*, 376–77; "I still can't," handwritten note on HK to RN, December 30, 1969, NSC, Box 757; RN to Haldeman, March 2, 1970, PPF, Box 2; Haldeman, *Diaries*, 132.

PAGE 179 **Nonexistent foreign policy:** ANS, February 1970, POF, Box 31; Hersh, 205.

PAGE 180 **Beginning in the fall:** HK to RN, "Your Report on Foreign Policy," n.d. but clearly February 1970, AHCHF, NSC, Box 962; Haldeman to Mollenhoff, September 2, 1969, NSC, Box 817; RN to Haldeman, November 24, 1969, PPF, Box 1.

PAGE 180 **Reports at the beginning:** Memo to RN, December 4, 1969, Handwriting, POF, Box 4; P. Buchanan to RN, November 30, 1969, Handwriting, POF, Box 3.

PAGE 180 **Nixon, who never:** J. R. Brown to HK, December 17, 1969, CF, Box 29; also in ANS, December 7, 1969, POF, Box 31; Haldeman MS Diary, December 15, 1969, Haldeman Notes, Box 40; HK to RN, December 17, 1969, on *Newsweek*, NSC, Box 341.

PAGE 181 **Nixon was convinced:** RN to Haldeman, January 6, 1970, PPF, Box 2.

PAGE 181 **All the same:** "HK Background Briefing," December 18, 1969, NSC, Box 339.

PAGE 181 **The White House:** HK and M. Frankel, February 9, 1970, TC; "HK Talking Points, President's Foreign Policy Report," February 15, 1970, HKOF, NSC, Box 13; PPP:RN, 1970, 114–90; HK to RN, February 7, 1970, AHCHF, NSC, Box 961.

PAGE 182 **Nixon worried:** RN to HK, February 10, 1970, PPF, Box 2.

PAGE 182 **The Nixon report:** On RN's post-November 3 speech support, see ANS, December 4, 1969, POF, Box 31, and Gallup, 2236–37, 2244.

PAGE 183 **It was increasingly:** Haig, 231; Gallup, *1959–1971*, 2240; D. P. Moynihan to RN, November 25, 1969, Handwriting, POF, Box 3.

PAGE 183 **The erosion of:** RN to HK, November 24, 1969, PPF, Box 1. On the "standstill," see HK's conversation with C. Lucet, the French ambassador, November 13, 1969, NSC, Box 676; also A. Haig, Memo for the Record,

November 26, 1969, NSC, Box 183. "A definite plan" and "We simply cannot," RN to W. Rogers, November 17, 1969, Handwriting, POF, Box 3.

PAGE 184 **Kissinger advised Nixon:** HK to RN, December 1, 1969, NSC, Box 1000; HK and A. Fontaine, Memcon, December 18, 1969, NSC, Box 676; HK to W. Rogers, etc., December 22, 1969, NSC, WSAG, Box H-071; "The Impact of the U.S. Actions Upon U.S. Casualties," n.d., NSC: HKOF, Box 11; HK to RN, December 24, 1969, NSC, Box 489. On RN's fascination with Patton, see also Ambrose, *Nixon: Triumph of a Politician*, 322–23, Haldeman, *Diaries*, 58, 106, 147.

PAGE 184 **Nixon still hoped:** HK to RN, November 28, 1969, AHCHF, NSC, Box 960; ANS, December 2, 1969, December 7, 1969, December 11, 1969, POF, Box 31; Haldeman, For the President's File, December 4, 1969, POF, Box 79; Haldeman, Diary Notes, December 31, 1969, Box 40.

PAGE 185 **Nixon's antipress:** PPP:RN, 1969, 970–71, and Gallup, 2180.

PAGE 185 **In November:** Ambrose, *Nixon: Triumph of a Politician*, 312–13; PPP: RN, 1969, 1003–5; see also "MyLai," Handwriting, POF, Box 4 for his condemnation. Anti-Semitic remark quoted in Hersh, 135; HK to RN, December 3, 1969, December 6, 1969, AHCHF, NSC, Box 960; Haldeman, *Diaries*, December 1, 1969 (see both the CD version and the Haldeman Notes), Box 40; on Hersh, J. R. Brown III to A. Butterfield, December 19, 1969, CF, Box 41. HK and General E. Wheeler, March 20, 1970, TC.

PAGE 186 **Yet none of these:** HK, *WHY*, 436; RN and HK, January 16, 1970, TC.

PAGE 186 **Because Hanoi:** RN and HK, January 27, 1970, TC.

PAGE 187 **In mid-January:** HK to RN, January 26, 1970, NSC, Box 183; February 2, 1969, AHCHF, NSC, Box 961; J. R. Brown III to HK, February 5, 1970, NSC, Box 1008; see also Hersh, 168–71.

PAGE 187 **On February 16:** HK, *WHY*, 438; Berman, 62.

PAGE 187 **To hide the meeting:** RN, *Memoirs*, 396; HK, *WHY*, 436–39; Berman, 61–63; Haldeman, *Diaries*, 128.

PAGE 188 **Henry began:** HK to RN, memo on February 21, 1970, meeting, HKOF, NSC, Box 106; HK, *WHY*, 441–45.

PAGE 188 **At another meeting:** HK to RN, memo on March 16, 1970, meeting, NSC, Box 1039.

PAGE 189 **On April 4:** HK to RN, April 6, 1970, NSC, Box 1039; HK, *WHY*, 440, 445–46; Haldeman, *Diaries*, 149.

PAGE 189 **Kissinger, however:** HK to RN, April 6, 1970, NSC, Box 1039; Memcon, March 10, 1970, NSC, Box 489; HK, *WHY*, 446–48.

PAGE 190 **The failure:** J. R. Brown to HK, March 16, 1970, with J. Alsop to RN, March 9, 1970, attached, NSC, Box 807.

PAGE 190 **The eruption:** HK, *WHY*, 448–56; Bundy, 145–47; PPP:RN, 1970, 244–49.

PAGE 190 **The controversy:** Bundy, 146–47; HK, *WHY*, 456–57.

PAGE 190 **Nixon and Kissinger:** HK and M. Laird, March 11, 1970, TC; HK to RN, March 18, 1970, March 25, 1970; A. Haig to HK, March 11, 1970, AHCHF, NSC, Box 963; A. Haig to Haldeman, March 24, 1970, *ibid.*, Box 964; ANS, March 11, 1970, March 13, 1970, POF, Box 31.

PAGE 191 **But the stories:** Bundy, 148; HK to RN, February 7, 1970, NSC, Box 1008; ANS, February 8, 1970, POF, Box 31.

PAGE 191 **The Cambodian coup:** Bundy, 149–51.

PAGE 191 **Although Nixon:** PPP:RN, 1970, 291–92; HK and D. Acheson, March 20, 1970, TC.

PAGE 192 **A pro-Communist:** HK to RN, March 20, 1970, AHCHF, NSC, Box 963; HK, *WHY*, 470; RN and HK, March 20, 1970, TC.

PAGE 192 **Events in Southeast:** A. Haig to HK, April 4, 1970, NSC, Box 1009; A. Haig to HK, April 8, 1970; W. Lord to HK, April 15, 1970, AHCHF, NSC, Box 964; ANS, March 27, 1970, POF, Box 31.

PAGE 192 **The domestic pressures:** HK, *WHY*, 479.

PAGE 192 **On April 20:** PPP:RN, 1970, 373–77.

PAGE 193 **At the same time:** Bundy, 151; RN and HK, April 9, 1970, TC.

PAGE 193 **To get things moving:** HK and Haldeman, April 15, 1970; HK and Geyelin, April 17, 1970, TCs; Bundy, 152.

PAGE 193 **William Bundy:** Bundy, 152–53; Shawcross, 136.

PAGE 194 **The briefing decided:** Haldeman, *Diaries*, 152; Shawcross, 137; HK and U. A. Johnson; HK and W. Rogers, April 20, 1970; HK and W. Westmoreland, April 21, 1970, TCs; Bundy, 153.

PAGE 194 **Nixon now struggled:** RN to HK, April 22, 1970, three memos, NSC, Box 341.

PAGE 195 **A highly agitated:** NSC Cambodia—April 22, 1970, PPF, Box 57; NSDM 56, NSC, Box H-216.

PAGE 195 **Nevertheless, Nixon:** RN and HK, April 22, 1970; HK and W. Westmoreland, April 22, 1970, TCs.

PAGE 196 **Matters crystallized:** HK and W. Rogers, April 23, 1970, April 24, 1970; HK and M. Laird, April 24, 1970; HK and General E. Wheeler, April 24, 1970, TCs; Haldeman, *Diaries*, 154.

PAGE 196 **Nixon believed:** Ibid., 153–54. On the polls, see Haldeman to HK, April 25, 1970, NSC, Box 817.

PAGE 196 **Laird and Rogers:** HK to RN, April 26, 1990, April 27, 1970, PPF, Box 58; NSDM 57, April 26, 1970, and NSDM, April 28, 1970, NSC, Box H-216; Haldeman, *Diaries*, 154–56; RN and HK, April 27, 1970, TC.

PAGE 197 **Nixon wanted:** Haldeman, *Diaries*, CD Rom version, April 27, 1970; D. Chapin to Haldeman, April 27, 1970, CF, Box 12.

PAGE 197 **Kissinger was torn:** HK, *WHY*, 483; HK and Haldeman, April 27, 1970, TC.

PAGE 198 **Henry was frustrated:** "Leaning against," memo of meeting, April 28, 1970, POF, Box 80; HK, *WHY*, 502.

PAGE 198 **He gained ground:** Haldeman, *Diaries*, CD Rom version, April 29, 1970; HK and Haldeman, April 29, 1970, TC.

PAGE 198 **But it wasn't:** Haldeman, *Diaries*, 156–58; Shawcross, 141–46.

PAGE 199 **The speech was:** PPP:RN, 1970, 404–410; Shawcross, 146–49.

PAGE 200 **Nixon's popularity:** *Gallup, 1959–1971*, 2248–49.

PAGE 200 **Despite the public's:** This material, including the quotes, is in Wells, 422–23; Shawcross, chap. 10 and 163–64; the sixteen RN and HK conversations are in

TCs, including the conversation of May 8, 1970; for the schedule of the seventeen other meetings, see President's Weekly Abstract, May 1–9, 1970, PPF, Box 13; for HK's defense of RN's Cambodian policy, see "Remarks by HK to Senators and Representatives," May 12, 1970, NSC, Box 585; for the "strict instructions," see RN to Haldeman, May 11, 1970, Alpha Subject Files, Box 140, Haldeman Papers; for Kissinger's humorous conversation with A. Dobrynin, see HK and A. Dobrynin, April 6, 1970, TC; for the attempt to punish dissenting diplomats, see A. Haig to J. Brown, May 13, 1970, AHCHF, NSC, Box 966; Haldeman to HK, May 14, 1970, Box 967; see also Reeves, 216.

PAGE 201 **After visiting the Pentagon:** J. V. Brennan memo, May 4, 1970, PPF, Box 11; Reeves, 209–10; Haldeman, *Diaries*, 158–59.

PAGE 202 **The invasion quickly:** Bundy, 157–64; quote is on 164.

PAGE 202 **Although he would:** Haldeman, *Diaries*, 159–63.

PAGE 203 **To assuage his guilt:** Wells, 425.

PAGE 203 **Haldeman described:** RN to Haldeman, May 13, 1970, PPF, Box 2; Ambrose, *Nixon: Triumph of a Politician*, 354–57.

PAGE 203 **The scene:** Feeney, 192–93.

PAGE 204 **Kissinger's response:** The meetings and quotes are all from Isaacson, 278–84.

CHAPTER 8 CRISIS MANAGERS

PAGE 205 **During the Cambodian crisis:** HK, *WHY*, 514; HK and W. Rogers, May 11, 1970, TC; Klein, 125–28. HK, *Years of Upheaval*, 73–74.

PAGE 206 **Nixon also took:** HK to RN, February 6, 1970, NSC, Box 711.

PAGE 206 **Unlike Nixon:** HK, *WHY*, 514; on the pickets, see HK TCs with Haldeman and Erlichman; and with Agnew, all May 8, 1970; also HK and Erlichman, May 5, 1970; HK and W. Rogers, May 7, 1970; HK and M. Laird, May 13, 1970; on Watts, see also Hersh, 103, 190–91.

PAGE 207 **Kissinger's response:** HK, *WHY*, 505–9, 515; for an excellent summary of the negative consequences of the Cambodian invasion, see Gibbons ms., 707–12. Quote is in Bundy, 493.

PAGE 207 **Nixon's highest priority:** HK and R. McNamara, May 10, 1970; HK and E. Richardson, May 18, 1970; HK and Haldeman, May 5, 1970, TCs.

PAGE 207 **He was particularly angry:** HK and W. Rogers, May 7, 1970, TC.

PAGE 208 **Like Kissinger, Nixon:** RN and HK, May 30, 1970, July 12, 1970; HK and F. Shakespeare, June 2, 1970, TCs; "Campus Chaos," May 1970, PPF, Box 6; "Internal Security and Domestic Intelligence," June 4, 1970, CF, Box 41; Haldeman, *Diaries*, 172, 191; Reeves, 229–30, 235–37.

PAGE 209 **But none of this:** HK and W. Rogers, June 3, 1970, TC.

PAGE 209 **Nixon tried:** PPP:RN, 1970, 413–23; RN to Haldeman, May 11, 1970, Haldeman Files, Box 164.

PAGE 209 **Because violent:** PPP:RN, 1970, 476–80; Alsop conversation is quoted in Reeves, 203; RN and HK, June 3, 1970, TC.

PAGE 210 **Nixon's message:** HK and Senator H. Jackson, June 11, 1970; RN and HK, June 13, 1970, TCs; for the history of the amendment, see Bundy, 160–61. The fullest discussion of the congressional response to the Vietnam War in 1970 is in Gibbons ms., chaps. 15–17.

PAGE 210 **To put domestic:** "Report on the Cambodian Operation," PPP:RN, 1970, 529–41; interview is on 543–59, quote is on 550. HK and J. Alsop, June 29, 1970; RN and HK, June 27, 1970, TCs.

PAGE 211 **In the spring:** R. Price to Haldeman, May 25, 1970, CF, Box 15.

PAGE 211 **Nixon faced:** Safire, 406; Haldeman, June 17, 1970, Ms Diary, CD Rom; Haldeman, *Diaries*, 176, 181–82, 189.

PAGE 212 **Kissinger's complaint:** Isaacson, 359–70.

PAGE 212 **In 1970:** Safire, 384–85; PPP:RN, 1970, 825–28.

PAGE 213 **Nixon had no better:** J. Freeman to Sir D. Greenhill, May 15, 1970, FCO 73/131, National Archives, London.

PAGE 213 **To head off:** Ibid., June 5, 1970.

PAGE 214 **German-American relations:** Bundy, 110–18, 173–75.

PAGE 214 **Nixon and Kissinger tried:** HK to RN, June 18, 1970, NSC, Box 683.

PAGE 214 **Nixon, Kissinger, and Rogers:** HK to RN, July 15, 1970, CF, Box 6; July 18, 1970, POF, Box 81; HK and F. Strauss, July 15, 1970; HK and W. Rogers, July 16, 1970, TCs.

PAGE 215 **Of course, none of this:** Bundy, 175–79; *Gallup, 1959–1971*, 2305; HK to RN, August n.d. 1970; W. Lord to HK, August 27, 1970; HK to RN, August 29, 1970; RN to W. Brandt, September 1, 1970, NSC, Box 753; HK to RN, October 14, 1970, POF, Box 82; NSC Meeting, October 14, 1970, NSC, Box H-109; HK and R. Pauls, August 18, 1970, TC.

PAGE 216 **Nixon's hopes:** For RN's tough line toward Moscow, see D. Young to B. Watts, January 13, 1970, NSC, Box 711; on CIA subversion, see HK to RN, April 9, 1970, AHCHF, Box 956, with RN's handwritten comments.

PAGE 216 **In April:** HK, *WHY*, 551–53; for the more relaxed Soviet tone, see H. Saunders to HK, March 31, 1970, NSC, Box 666.

PAGE 216 **Although Kissinger believed:** HK, *WHY*, 552–53; HK and A. Dobrynin, March 11, 1970, TC; HK to RN, April 7, 1970, April 9, 1970, NSC, Box 489.

PAGE 217 **During June:** Memcon, July 9, 1970; HK and A. Dobrynin, July 28, 1970, TC, NSC, Box 489; HK, *WHY*, 554–57.

PAGE 217 **But even without:** Relevant documents here are: RN and SALT delegation, Memcon, April 11, 1970, POF, Box 80; HK to RN, June 15, 1970; HK and A. Dobrynin conversations, July 7, 1970, July 20, 1970, NSC, 489; NSDM 73, July 22, 1970, NSC, Box H-217; SALT, August 19, 1970, PPF, Box 15; ANS, August 22, 1970, POF, Box 32. HK, *WHY*, 541–42. RN's comment to Smith is in Hersh, 161–62. For a summary of the proposals and problems, see Garthoff, 133ff.

PAGE 218 **The only so-called:** "Kissinger's struggle" and "arms controllers," quoted in Hersh, 147; "made the mistake," Haldeman, *Diaries*, 177; "swayed by," HK, *WHY*, 543; see also his overall discussion, 538–51; "absolutely no strategic," Isaacson, 318; see also 316–22.

Page 219 **Perhaps the greatest:** HK and A. Dobrynin, March 11, 1970, June 30, 1970, July 27, 1970, July 28, 1970, TCs.

Page 219 **With no apparent:** Memo of H. Sonnenfeldt and Argov conversation, January 13, 1970, NSC, Box 605; HK to RN, February 1, 1970; RN to A. Kosygin, February 4, 1970, NSC, Box 340. H. Saunders to HK, March 31, 1970, NSC, Box 666; ANS, February 2, 1970, POF, Box 31.

Page 220 **The apparent Soviet:** See HK to RN, February 6, 1970, NSC, Box 650; February 18, 1970, Box 711; Status of the Four-Power Talks, February 19, 1970, NSC, Box 654; RN to HK, March 17, 1970, PPF, Box 2; Memo for the President, March 18, 1970, POF, Box 80.

Page 220 **Strategic and domestic:** Meir to RN, April 27, 1970; HK to RN, May 15, 1970, NSC, Box 756; HK to RN, May 21, 1970, AHCHF, NSC, Box 967; HK and J. Sisco, May 11, 1970; RN and HK, May 22, 1970; HK and E. Richardson, May 22, 1970, TCs; Haldeman Diary Notes, May 16, 1970, Box 41.

Page 221 **With the aid:** Bundy, 180.

Page 221 **The proposal incensed:** HK and Y. Rabin, Memcon, June 22, 1970, HKOF, NSC, Box 134.

Page 221 **Kissinger weighed in:** HK to RN, June 16, 1970, NSC, Box 645.

Page 221 **Henry's opposition:** HK to Rogers, July 9, 1970, AHCHF, NSC, Box 968; HK to RN, July 15, 1970, NSC, Box 646. Haldeman material is from the CD Rom version of the *Diaries*, July 15, 1970, July 16, 1970.

Page 222 **In August:** HK and W. Rogers, August 7, 1970, TC.

Page 222 **To Roger's satisfaction:** HK and A. Dobrynin conversations, July 7, 1970, July 9, 1970; HK to RN, July 23, 1970, NSC, Box 489; G. E. Millard to Sir D. Greenhill, July 20, 1970, FCOB 73/132, British National Archives.

Page 222 **The Israelis:** HK to RN, August 4, 1970, HKOF, NSC, Box 134; HK, *WHY*, 568, 582–85.

Page 223 **On August 7:** "President's Saturday Briefing," August 7, 1970, NSC, Box 654; Haldeman, *Diaries*, 189.

Page 223 **Neither Israel:** Bundy, 181–82. Haig to HK, September 7, 1970, AHCHF, NSC, Box 971.

Page 223 **A crisis in Jordan:** Bundy, 182–84.

Page 224 **The United States:** HK, *WHY*, 595–97.

Page 224 **Hussein managed:** Bundy, 184.

Page 224 **The crisis triggered:** RN and N. Thacher, Memcon, September 8, 1970, POF, Box 82; HK to RN, n.d., but clearly September 1970, NSC, Box 615; HK to Undersecretary of Defense, etc., September 11, 1970, AHCHF, NSC, Box 971; HK, *WHY*, 601–3; HK and M. Kalb, September 16, 1970, TC.

Page 225 **Nixon and Rogers:** HK and W. Rogers, September 12, 1970; HK and M. Laird, September 17, 1970; HK and J. Freeman, September 17, 1970, TCs; A. Haig to HK, September 17, 1970, AHCHF, NSC, Box 971; on the CIA's involvement, see Douglas Little, "Mission Impossible: The CIA and the Cult of Covert Action in the Middle East," *Diplomatic History*, November 2004, 685.

PAGE 225 **Kissinger believed:** HK and Haldeman, September 17, 1970; HK and J. Sisco, September 17, 1970; HK and Sir D. Greenhill, September 17, 1970; HK and W. Rogers, September 17, 1970; RN and HK, September 17, 1970, three conversations, TCs.

PAGE 225 **Nixon was jubilant:** RN and HK, September 17, 1970, TC; see also H. Sonnenfeldt to HK, September 18, 1970, NSC, Box 615, confirming that the Soviets could not be happy about the presence of U.S. military power in the area.

PAGE 226 **Nixon had been:** HK to RN, September 20, 1970, AHCHF, NSC, Box 972; A. Haig, Memo for the Record, September 20, 1970, NSC, Box 615; HK and W. Rogers, September 18, 1970, TC.

PAGE 226 **Although Nixon sided:** Haldeman *Diaries*, September 20, 1970, September 21, 1970, 195–96.

PAGE 226 **The latest crisis:** "Elaboration on Israeli Response," September 21, 1970; HK and Y. Rabin, Memcon, September 21, 1970, HKOF, NSC, Box 134; HK and Alsop; HK and J. Sisco; HK and Y. Rabin, September 22, 1970, TCs; HK, *WHY*, 63.

PAGE 227 **The White House:** Haldeman to HK, September 22, 1970; Alpha Name Files, Box 66, Haldeman Papers; P. Rodman to HK, September 23, 1970; and HK to Haldeman, September 26, 1970, NSC, Box 817.

PAGE 227 **Latin America:** Ambrose, *Nixon: Triumph of a Politician*, 110–12.

PAGE 228 **Despite his doubts:** K. Cole to HK, September 25, 1969, AHCHF, NSC, Box 958; PPP:RN, 1969, 893–901; HK to RN, May 19, 1970, NSC, Box H-211.

PAGE 228 **Nixon and Kissinger shared:** "Told the Chilean Foreign Minister," Bundy, 203–4; for the more detailed account with the quotes, Hersh, 263; "a dagger pointing," Hanhimaki, 101; Arnold Weiss interview, February 20, 2005.

PAGE 229 **In September 1970:** Isaacson, 295–96; HK, *WHY*, 639–52; Haig, 254–55; J. Freeman to Sir A. D. Home, October 29, 1970; J. A. N. Graham to J. Freeman, November 17, 1970; J. Freeman to Sir D. Greenhill, November 20, 1970, FCO 73/144, British National Archives.

PAGE 230 **Events in Chile:** Arthur Schlesinger, Jr., is quoted in Kornbluh, 3.

PAGE 231 **Chile, a country:** Ibid., 3–5; D. Rusk is quoted on 5. A detailed description of the CIA's activities can be found in the Hinchey Report, 2–5, which is available through the U.S. Department of State Electronic Reading Room.

PAGE 231 **Despite continuing U.S.:** Bundy, 198.

PAGE 231 **In January 1970:** U.S. embassy to W. Rogers, January 2, 1970, HKOF, NSC, Box 128; V. Vaky to HK, June 26, 1970, NSC, Box 778; NSSM 97, July 24, 1970, "NSC Meetings," Box H-029. Kornbluh, 6–11, provides the options in NSSM 97.

PAGE 232 **On the eve of:** V. Vaky quote, ibid., 11.

PAGE 232 **Winston Lord:** W. Lord to HK, September 16, 1970, NSC, Box 824; Hersh, 265.

PAGE 233 **The warnings:** Bundy, 198–201; Davis, 6; HK, *WHY*, 653–54; ANS, September 7, 1970, POF, Box 32.

PAGE 233 **Nevertheless, Nixon and:** The September 8, 1970, September 12, 1970,

and September 15, 1970, documents are in Kornbluh, 36, 45–46, 47, 49; see also Hinchey Report, 5–6, Department of State. A. Haig to HK, September 15, 1970, AHCHF, NSC, Box 971; R. Helm's recollections are quoted in Hersh, 274.

PAGE 234 **The following day:** September 16, 1970, and September 17, 1970, documents are in Kornbluh, 37–44.

PAGE 235 **Kissinger became:** HK and J. Mitchell, September 16, 1970; HK and J. Freeman, September 24, 1970, TCs. U. A. Johnson to HK, September 22, 1970, NSC, Box 778. E. Korry to state department, September 5, 1970, National Security Archives, George Washington University, available at their web site. A. Haig to HK, September 24, 1970, AHCHF, NSC, Box 972, Box 778.

PAGE 235 **By the end of September:** See documents for September 27, 1970, October 7, 1970, and October 10, 1970, in Kornbluh, 50, 57–59; see also E. Korry to HK, September 28, 1970; and 40 Committee Meeting, September 29, 1970, NSC, Box 778.

PAGE 235 **By October 15:** Kornbluh, 62–67.

PAGE 236 **A principal impediment:** Ibid., 22–29, 68–72.

PAGE 236 **Nixon and Kissinger denied:** HK, *WHY*, 676; RN and HK, October 15, 1970, TC; E. Korry to HK, October 9, 1970, NSC, Box 778; see also Kornbluh, 25–26, 64; October 18 memo is quoted on 27; October 23 cable is on 73.

PAGE 237 **Schneider's death:** HK to U. A. Johnson, October 22, 1970, AHCHF, NSC, Box 972; see also Kornbluh, 77–78.

PAGE 238 **The conciliatory statements:** A. Haig to HK, November 7, 1970, with General V. Walters's memo of November 3 attached, AHCHF, NSC, Box 973.

PAGE 238 **Walters's warnings:** D. Chapin to Haldeman, November 4, 1970, CF, Box 14.

PAGE 239 **Kissinger followed up:** HK to RN, NSC Meetings, November 5, 1970, NSC, Box H-029.

PAGE 239 **For such staunch:** HK, *WHY*, 982.

PAGE 240 **Once Nixon and:** HK to RN, NSC Meetings, November 5, 1970, NSC, Box H-029.

PAGE 240 **Henry was preaching:** NSC Meeting Minutes, November 6, 1970, NSC, Box H-109; see also NSDM 93, November 9, 1970, NSC, Box H-220; RN and HK, November 9, 1970, TC.

PAGE 240 **In fact, in November:** A. Nachmanoff to HK, November 25, 1970, with HK to RN, n.d., attached; M. Laird to RN, November 30, 1970; see also HK to undersec. of state, etc., November 27, 1970; and "Chile—Status Report on Implementation of NSDM 93," n.d., all are in NSC, Box H-220.

PAGE 241 **On November 25:** HK to RN, November 25, 1970, in Kornbluh, 133; on the warning to Moscow, see A. Haig to HK, November 25, 1970, with the note "Soviet Presence in Chile" attached, AHCHF, NSC, Box 974.

PAGE 242 **Whenever political difficulties:** See PPP:RN, 1970, 772; Haldeman Diaries, CD Rom version, Sept. 9, 1970, September 27, 1970; Haldeman Diary Notes, September 9, 1970.

PAGE 242 **The trip met:** PPP:RN, 1970, 782, 804–9.

PAGE 243 **Only a month away:** ANS, September 1, 1970, POF, Box 32; Ambrose, *Nixon: Triumph of a Politician*, 394; PPP:RN, 1970, 831–1070, for the campaign speeches; Haldeman, *Diaries*, 192.

PAGE 243 **Their strategy failed:** Ambrose, *Nixon: Triumph of a Politician*, 387–97. *Gallup, 1959–1971*, 2264, 2266–68, 2271.

PAGE 244 **The results of:** For the vote and the quote, see Ambrose, *Nixon: Triumph of a Politician*, 221, 396–97; A. Haig to HK, November 7, 1970, with the General V. Walters's memo of November 3 attached, AHCHF, NSC, Box 973.

CHAPTER 9 WINTER OF DISCONTENT

PAGE 245 **In the winter:** RN, *Memoirs*, 497.

PAGE 245 **There was little:** ANS, January 20, 1971, POF, Box 32. Buchanan quoted in Reeves, 294.

PAGE 246 **Public opinion polls:** RN's approval ratings for 1970–1971 and the match-up with Muskie are in *Gallup, 1959–1971*. The student survey is in Ambrose, *Nixon: Triumph of a Politician*, 414. The TV interview is in PPP: RN, 1971, 21.

PAGE 246 **Nixon's diminished:** Haldeman to HK, November 25, 1970, with A. Haig to HK, December 2, 1970, attached, NSC, Box 817.

PAGE 246 **In November:** See three RN to Haldeman memos, November 30, 1970, Subject Files, Box 164, Haldeman Papers; RN to Haldeman, December 18, 1970, March 8, 1971, Subject Files, Box 164, Haldeman Papers; ANS, January 6, 1971, March 17, 1971, POF, Box 32.

PAGE 247 **Nixon also thought:** Erin Mahan, unpublished paper, January 2005. Conversation 450–10, February 16, 1971; John Dean interview, November 18, 2004, and Larry Berman interview, January 13, 2005, explained the origins of the taping system to me. Berman's information rested on a conversation he had with A. Butterfield; Nixon's comment to Haldeman is in Reeves, 639, n. 305; see also "The Nixon Tapes," whitehousetapes.org, produced by the Miller Center, University of Virginia, with the Comments of Alexander Butterfield.

PAGE 247 **Nixon believed:** Haldeman, Diaries, CD ROM version, December 7, 1970; A. Haig to Haldeman, December 7, 1970, AHCHF, NSC, Box 726; A. Haig to RN, December 7, 1970, Box 974. RN to Kissinger et al., February 8, 1971, PPF, Box 3. Haldeman, *Diaries*, 236–37, 273; Conversation 462–05, March 5, 1971. HK and W. Safire, October 6, 1970, TC; William C. Selover, "Senate Skepticism Aimed at Rogers," *Christian Science Monitor*, December 16, 1970.

PAGE 249 **Nixon didn't anticipate:** Haldeman, *Diaries*, 218–19, 232; CD Rom version, January 19, 1971.

PAGE 250 **Nixon's recorded:** Conversation 456-05, Conversation 456-22, both February 23, 1971.

PAGE 250 **The next day:** Haldeman, *Diaries*, 250.

PAGE 251 **Two weeks later:** Conversation 464-25, March 9, 1971; see also 456-22, February 23, 1971.

PAGE 252 **No doubt, Nixon:** Arnold Weiss interview, February 20, 2005.

PAGE 252 **Vietnam still came:** Quoted in Gibbons ms., 720.

PAGE 252 **Throughout the second half:** HK to U. A. Johnson et al., June 17, 1970, HKOF, NSC, Box 13; J. R. Brown to HK, September 4, 1970, CF, Box 42.

PAGE 253 **Worse, by 1970–1971:** Ambrose, *Nixon, Triumph of a Politician*, 417–19; ANS, May 28, 1971, POF, Box 32. PPP:RN, 1971, 686; on the Army's drug problem, see also HK to Senator H. Scott, December 26, 1970, AHCHF, NSC, Box 975.

PAGE 253 **Nixon understood:** HK, *WHY*, 969, 974–75.

PAGE 254 **Kissinger was prepared:** HK to RN, September 7, 1970, NSC, Box 1039.

PAGE 254 **Kissinger's skepticism:** HK to RN, September 22, 1970, NSC, Box 189; September 28, 1970, NSC, Box 1039.

PAGE 254 **To advance the talks:** HK and J. Alsop, October 7, 1970, TC; Safire, 385.

PAGE 254 **In making his proposal:** HK to RN, September 26, 1970; October 22, 1970, NSC, Box 189; PPP:RN, 1970, 826, 830.

PAGE 255 **With the peace talks:** PPP:RN, 1970, 836.

PAGE 255 **A conversation Nixon:** RN and S. Phouma, Memcon, October 21, 1970, AHCHF, NSC, Box 972; HK to RN, October 23, 1970, NSC, Box 219.

PAGE 255 **In December:** HK to RN, December 20, 1970, CF, Box 10.

PAGE 255 **Reports from the field:** HK to RN, December 9, 1970, AHCHF, NSC, Box 975; RN and HK, November 30, 1970, December 9, 1970, December 19, 1970; HK and J. Alsop, December 15, 1970, 1970, TCs; Haig to Thieu, Memcon, December 17, 1970; HK to RN, December 18, 1970, NSC, Box 1011.

PAGE 256 **Despite all the:** RN's comment is written on HK to RN, October 22, 1970, NSC, Box 189; J. Holdridge to HK, with HK to RN attached, November 18, 1970, AHCHF, NSC, Box 973.

PAGE 256 **On December 10:** PPP:RN, 1970, 1101–2. HK and W. Sullivan, November 30, 1970, TC.

PAGE 256 **Kissinger also had:** HK and R. Ziegler, November 24, 1970, TC; Someone told Henry: Memcon, December 2, 1970, Averell Harriman Papers, Library of Congress (this document was given to me by historian Kai Bird); Haldeman, *Diaries*, 221, 223.

PAGE 257 **Kissinger's greater:** HK and A. Dobrynin, Memcon, January 1971, in Kimball, 138–39.

PAGE 257 **With the peace talks:** W. Lord to HK, November 25, 1970, NSC, Box 824. For RN's interest in an offensive, see RN and HK, December 9, 1970, and December 12, 1970, TC. A. Haig and Thieu, Memcon, December 17, 1970, NSC, Box 1011.

PAGE 258 **Nixon was enthusiastic:** RN et al., Memcon, January 18, 1971, POF, Box 83; Bundy, 225–26.

PAGE 258 **U. Alexis Johnson:** Haldeman, Diaries, CD Rom version, January 21, 1971, January 26, 1971; HK and Packard, January 21, 1971, TC; WSAG

Meetings, January 21, 1971, January 26, 1971, NSC, Box H-115; RN, Memcon, January 26, 1971, POF, Box 84.

PAGE 259 **Rogers also refused:** RN, Memcon, January 27, 1971, POF, Box 84; HK and W. Rogers, January 27, 1971, TC.

PAGE 259 **Nixon and Kissinger still:** HK, *WHY*, 992, 994; W. Safire to Haldeman, February 2, 1971, POF, Box 84.

PAGE 259 **The "chief drawback":** HK, *WHY*, 992.

PAGE 259 **"Lam Son 719":** Bundy, 226–27.

PAGE 260 **Nixon later called:** RN, *Memoirs*, 498–99; Conversation 459-02, February 27, 1971; Conversation 471-2, March 19, 1971, quoted in Kimball, 146; HK to RN, March 19, 1971, AHCHF, NSC, Box 977; Haldeman, *Diaries*, 260–61; Conversation 462-05, March 5, 1971.

PAGE 261 **From the start:** RN to Haldeman, February 8, 1971, PPF, Box 3; Haldeman, *Diaries*, 244–45; Conversation 468-05, March 16, 1971.

PAGE 261 **As the military situation:** HK, *WHY*, 1002; NSC Meeting, February 26, 1971, NSC, Box H-110; HK to RN, February 26, 1971, NSC, Box H-030; ANS, February 26, 1971, POF, Box 32; Conversations 456-05, February 23, 1971; 459-02, February 27, 1971; 468-05, March 16, 1971.

PAGE 261 **A majority of:** *Gallup, 1959–1971*, 2285, 2290–91; ANS, March 8, 1971, POF, Box 32; Haldeman, Diaries, CD Rom version, March 30, 1971. Conversations 466-2, 466-12, March 11, 1971; Conversation 472-08, March 23, 1971.

PAGE 262 **Nixon and Kissinger devised:** Conversation 465-08, March 10, 1971; RN and HK, March 30, 1971, TC; PPP:RN, 1971, 448–54, 522–27; Conversation 472-23, March 23, 1971; see also A. Haig to HK, April 6, 1971, describing the Kissinger campaign to influence a list of journalists, AHCHF, NSC, Box 978; *Gallup, 1959–1971*, 2307–9.

PAGE 263 **Nixon also used:** RN and HK, March 27, 1971, TC; Conversation 468-05, March 16, 1971.

PAGE 263 **Hanoi did not:** ANS, April 1971, POF, Box 33; W. R. Smyser to HK, April 15, 1971, with HK to RN attached, NSC, Box 190; Haldeman, *Diaries*, 281.

PAGE 263 **With mastery:** RN to Haldeman, March 8, 1971, Haldeman Papers, Box 140; Haldeman, Diaries, CD ROM version, March 21, 1971; Conversation 471-2, March 19, 1971.

PAGE 264 **Approaches to the Chinese:** E. Richardson to L. Meeker, November 19, 1969, HKOF, NSC, Box 86.

PAGE 264 **In January 1970:** "U.S. China Policy, 1969–72," HKOF, NSC, Box 86; HK to RN, December 10, 1970, AHCHF, NSC, Box 974; HK, *WHY*, 684–90; Bundy, 107–8.

PAGE 264 **Developments in the spring:** HK, *WHY*, 692–93.

PAGE 265 **During the summer:** "U.S. China Policy, 1969–72," HKOF, NSC, Box 86; HK to RN, October 31, 1970, NSC, Box 1024; Bundy, 166.

PAGE 265 **After a sharp:** Ibid.; NSSM, November 19, 1970, HKOF, NSC, Box 86; RN to HK, November 22, 1970, PPF, Box 2.

PAGE 265 **On December 8:** HK to RN, December 10, 1970, AHCHF, NSC, Box

974; "Record of a Discussion with Henry Kissinger," December 16, 1970, NSC, Box 1031; HK, *WHY*, 700–3.

PAGE 266 **Nixon and Kissinger shared:** PPP:RN, 1970, 1110; Bundy, 167.

PAGE 266 **In December:** HK and S. Davis, December 19, 1970, TC.

PAGE 266 **Nixon wanted no:** HK Backgrounder, December 24, 1970, HKOF, NSC, Box 86.

PAGE 266 **On January 11:** HK to RN, January 12, 1971, with RN's handwritten note, NSC, Box 1031; HK, *WHY*, 703–4.

PAGE 267 **The Chinese were:** Bundy, 231–32; PPP:RN, 1971, 160, 276–78, 390, 393–94; "U.S. China Policy, 1969–72," HKOF, NSC, Box 86; Haldeman, *Diaries*, 273–74; Conversation 1-101, April 15, 1971.

PAGE 267 **In March:** NSC Meeting, March 25, 1971, NSC, Box H-110; Conversation 051-CAB, March 25, 1971; Conversation 1-81, April 14, 1971.

PAGE 268 **Nixon was reluctant:** Haldeman, *Diaries*, 274. HK and H. Klein, April 16, 1971, TC.

PAGE 268 **During a session:** PPP:RN, 1971, 542–44.

PAGE 268 **And if the Chinese:** Haldeman, *Diaries*, 270–71; A. Haig to Haldeman, April 22, 1971, Off. Files, Box 77, Haldeman Papers; Conversation 481-7, April 17, 1971.

PAGE 269 **Kissinger was right:** P. Buchanan to RN, August 21, 1970, September 8, 1970, PPF, Box 7.

PAGE 269 **Buchanan did not:** HK and A. Akalovsky, Memcon, October 1, 1970, NSC, Box 467; HK and A. Dobrynin, Memcon, October 9, 1970, NSC, Box 1000; and October 17, 1970, NSC, Box 490.

PAGE 270 **Nevertheless, Kissinger:** HK to RN, October 27, 1970, CF, Box 29; HK and A. Dobrynin, Memcon; November 16, 1970, NSC, Box 490.

PAGE 270 **By the end of November:** RN to HK, November 30, 1970, Box 164, Haldeman Papers.

PAGE 270 **As the year:** HK and A. Dobrynin, Memcon, December 22, 1970, NSC, Box 1000; HK to RN, December 22, 1970, NSC, Box 490.

PAGE 271 **In the last ten weeks:** HK to RN, October 14, 1970, NSC, Box 490; HK and A. Dobrynin, October 14, 1970, TC; "Summit," 1969–1971, HKOF, NSC, Box 73.

PAGE 271 **SALT also:** ANS, October 17, 1970, POF, Box 32.

PAGE 271 **The Helsinki talks:** HK and A. Dobrynin, December 2, 1970, TC; Bundy, 173.

PAGE 272 **In the fall:** RN and G. Saragat, Memcon, September 27, 1970; RN and J. Tito, Memcons, September 30, 1970, October 1, 1970, NSC, Box 467.

PAGE 272 **The Soviets had no intention:** HK and A. Dobrynin, Memcon, October 6, 1970, NSC, Box 1000; HK to RN, October 7, 1970, NSC, Box 616.

PAGE 272 **Kissinger was less:** HK and A. Dobrynin, Memcon, October 9, 1970, NSC, Box 1000; HK to RN, October 9, 1970, AHCHF, NSC, Box 972.

PAGE 273 **Yet Moscow:** ANS, October 17, 1970, POF, Box 32; HK and A. Dobrynin, Memcon, October 17, 1970, NSC, Box 490.

PAGE 273 **By the beginning:** HK to RN, November 3, 1970, AHCHF, NSC, Box 973.

PAGE 273 **Because no one:** Conversation 464-25, March 9, 1971.

PAGE 274 **The extent of:** "US–U.S.S.R. Relationship in the Middle East," 1969–1971; G. Meir to RN, November 29, 1970; RN to G. Meir, December 3, 1970, NSC, Box 756; U.S. embassy, Tel Aviv, to state department, December 4, 1970; Memo for Dr. Kissinger, December 8, 1970, NSC, Box 342.

PAGE 274 **A discussion on:** RN and Hussein, Memcon, December 8, 1970, NSC, Box 616.

PAGE 274 **Nixon and Rogers:** HK to RN, December 10, 1970; HK and Y. Rabin, Memcon, December 22, 1970, NSC, Box 608; U.S. embassy, Tel Aviv to state department, December 17, 1970, NSC, Box 342; D. Kennedy to HK, December 17, 1970, AHCHF, NSC, Box 974.

PAGE 275 **Although Kissinger hoped:** HK to RN, describing his conversation with A. Dobrynin, December 22, 1970, NSC, Box 490.

PAGE 275 **In a year-end:** HK to RN, December 26, 1970, AHCHF, NSC, Box 975.

PAGE 275 **At the start of:** HK and D. Kendall, December 31, 1970, TC; SRG Meeting, January 11, 1971, NSC, Box H-112. Memcon, "NSC Meeting," February 26, 1971, NSC, Box H-110.

PAGE 276 **As Kendall:** SRG Meeting, January 11, 1971, NSC, Box H-112; HK to RN, January 27, 1971, February 8, 1971, February 27, 1971, NSC, Box 490.

PAGE 276 **Although Kissinger was:** Haldeman, Diaries, CD Rom version, February 26, 1971.

PAGE 277 **The acrimony:** HK to RN, Background on Middle East Negotiations, n.d., but clearly October 1971, NSC, Box 658.

PAGE 277 **In March:** HK to RN, March 2, 1971, HKOF, NSC, Box 134; HK to RN, March 6, 197, AHCHF, NSC, Box 977; President's Saturday Briefing, March 19, 1971, with cable of March 17, 1971, attached, NSC, Box 656; HK to RN, March 31, 1971, NSC, Box 714.

PAGE 277 **Israel was:** RN and Z. Shazar, Memcon, March 8, 1971, POF, Box 84; HK and A. Eban, Memcon, March 22, 1971, HKOF, NSC, Box 134; H. Saunders to HK, March 24, 1971, NSC, Box 656; A. Haig memo for RN's Files, March 26, 1971, AHCHF, NSC, Box 978.

PAGE 278 **Nixon also said:** For the ongoing HK-Rogers battle, see Haldeman, Diaries, CD Rom version, March 8, 1971; HK to RN, March 10, 1971, HKOF, NSC, Box 129; A. Haig to HK, March 11, 1971, AHCHF, NSC, Box 977.

PAGE 278 **April brought:** H. Saunders to HK, April 12, 1971, April 13, 1971, NSC, Box 656; "SRG Meeting," April 14, 1971, NSC, Box H-112; Haldeman to RN, April 22, 1971, Haldeman Papers, Box 163; A. Haig to HK, April 23, 1971, AHCHF, NSC, Box 979; Haldeman, Diaries, CD Rom version, April 25, 1971.

PAGE 278 **In the first months:** HK to RN, January 25, 1971, January 28, 1971, NSC, Box 490.

PAGE 279 **Under pressure:** PPP:RN, 1971, 320–25; Conversation 456-05, February 23, 1971.

PAGE 279 **At the same time:** HK to RN, February 8, 22, 1971, NSC, Box 490; RN and HK, February 22, 1971, TC; HK and A. Dobrynin, Memcon, March 5, 1971, NSC, Box 490.

PAGE 280 **Kissinger was too:** HK to RN, March 21, 1971; RN to L. Brezhnev, March 16, 1971, NSC, Box 490; HK and A. Dobrynin, Memcon, March 18, 1971; HK to RN, March 30, 1971, NSC, Box 491.

PAGE 280 **Nixon and Kissinger were determined:** HK to RN, March 6, 1971, NSC, Box H-031; NSC Meeting, March 8, 1971, NSC, Box H-110; Conversation 465-08, March 10, 1971.

PAGE 280 **But so were:** Conversation 468-05, March 16, 1971; Conversation 481-7, April 17, 1971; Haldeman, *Diaries*, 274.

PAGE 281 **The Soviet military:** Haldeman, Diaries, CD Rom version, March 31, 1971, April 27, 1971; HK to RN, April 26, 1971, April 27, 1971, summarizing the meetings with A. Dobrynin, NSC, Box 491.

PAGE 281 **Kissinger's distress:** "Summit," 1971, HKOF, NSC, Box 73; HK to RN, January 28, 1971; HK and A. Dobrynin, Memcon, February 16, 1971, Box 128; HK and A. Dobrynin, January 6, 1971, TC.

PAGE 281 **By April:** Haldeman, *Diaries*, 271; HK and A. Dobrynin, Memcon, April 23, 1971, HKOF, NSC, Box 73; Conversation 487-21, April 23, 1971; Conversation 489-17, April 26, 1971.

PAGE 281 **Nixon directed:** HK to RN, April 26, 1971, NSC, Box 491; see also HK and A. Dobrynin, Memcon, April 27, 1971, which includes more detail, HKOF, NSC, Box 73.

PAGE 282 **At the end of April:** PPP:RN, 1971, 592–602.

CHAPTER 10 THE ROAD TO DÉTENTE

PAGE 285 **They had no:** A. Drury, 389–400, for his interview with RN.

PAGE 286 **The international stability:** Haldeman, CD Rom Diaries, June 2, 1971.

PAGE 286 **In May:** HK and A. Dobrynin, May 13, 1971; HK and W. Bundy, May 14, 1971, TC; HK to RN, May 19, 1971; "Anticipated Questions to SALT Announcement," May 20, 1971, POF, Box 85; RN to A. Kosygin, May 20, 1971, NSC, Box 491.

PAGE 287 **Mutual self-interest:** Haldeman, *Diaries*, 286, 288; CD Rom version, May 18, 1971, May 21, 1971; HK and RN, May 13, 1971; HK and M. Bundy, May 14, 1971, TCs; RN with congressional leaders, Memcon, May 20, 1971, POF, Box 85.

PAGE 287 **The Soviets echoed:** Conversation 483-13, April 20, 1971; Conversation 496-09, May 10, 1971; HK and A. Dobrynin, Memcon, May 13, 1971; HK to RN, May 28, 1971, NSC, Box 491; Bundy, 252–59.

PAGE 288 **Nixon and Kissinger believed:** Message from Chou En-lai, April 21, 1971, handed to HK, April 27, 1971, National Security Archive, George Washington University on their web site; Conversation 252-20, April 28, 1971.

PAGE 288 **The evening after:** RN to HK, April 14, 1971, but probably April 16,

according to the National Security Archive, where I found the document online.

PAGE 288 **They now went:** RN to HK, April 28, 1971, NSC, Box 1031.

PAGE 289 **When Kissinger discussed:** Conversation 252-20, April 28, 1971. Haldeman, *Diaries*, 282.

PAGE 289 **On May 10:** Note handed by HK to A. Hilaly, May 10, 1971, NSC, Box 1031.

PAGE 290 **At the end of May:** Conversation 3-178, May 28, 1971.

PAGE 290 **On June 2:** Chou En-lai to RN, May 29, 1971, NSC, Box 1031.

PAGE 290 **Kissinger was "ecstatic":** Haldeman, *Diaries*, 295. RN, *Memoirs*, 551–52. HK, *WHY*, 726–27.

PAGE 290 **To give resonance:** HK and Congman. Gerald Ford, June 4, 1971, TC; A. Haig to HK, June 7, 1971, AHCHF, NSC, Box 981; "U.S. China Policy, 1969–1972," June 10, 1971, HKOF, NSC, Box 86; Bundy, 254–55.

PAGE 291 **Throughout June:** HK, *WHY*, 729.

PAGE 291 **Since this was Henry's:** Ibid., 728–29; Haldeman, Diaries, CD Rom version, June 21, 1971, June 22, 1971, June 25, 1971, June 26, 1971; Haldeman, *Diaries*, 307; HK and W. Rogers, June 28, 1971, TC.

PAGE 292 **On the morning of July 1:** Conversations 534-2, 534-3, July 1, 1971, in Kimball, 175–86.

PAGE 293 **With Kissinger cabling:** Haldeman, *Diaries*, 315–16, 318–19.

PAGE 293 **Kissinger's meetings:** A. Haig to HK, July 11, 1971, AHCHF, NSC, Box 983; HK, *WHY*, 742; HK to RN, Report on His Trip to China, July 1971, NSC, Box 846.

PAGE 293 **Yet Henry was:** HK to RN, China Trip, July 1971, NSC, Box 846.

PAGE 294 **As the records:** HK, *WHY*, 741; RN and A. Haig, July 9, 1971, TC, AHCHF, NSC, Box 998.

PAGE 294 **The almost five-hour:** HK, *WHY*, 742.

PAGE 294 **A senior member:** "Briefing of the White House Staff," July 19, 1971, POF, Box 85; HK, *WHY*, 743–46.

PAGE 295 **"Reliability is:** Ibid., 746–49; HK to RN, China Trip, July 1971, NSC, Box 846.

PAGE 296 **The tone changed:** PPP:RN, 1971, 805–6; HK to RN, China Trip, July 1971, NSC, Box 846; HK, *WHY*, 749–51.

PAGE 298 **A final evening:** HK to RN, China Trip, ibid.; HK, *WHY*, 751–54.

PAGE 298 **After Kissinger sent:** A. Haig to HK, July 11, 1971, AHCHF, NSC, Box 983; RN and A. Haig, July 11, 1971, TC, Box 998; HK, *WHY*, 755–63.

PAGE 298 **Nixon had to:** Haldeman, Diaries, CD Rom version, July 14, 1971; HK, Briefing, July 16, 1971, NSC, Box 499; RN to HK, July 19, 1971, Haldeman Papers, Box 140; HK, *WHY*, 761.

PAGE 299 **After Nixon "shocked":** HK, Briefing, July 16, 1971, NSC, Box 499; HK, *WHY*, 762–63; for justifications of the secrecy, see also HK to RN, July 17, 1971, NSC, Box 499; and Briefing of the White House Staff, July 19, 1971, POF, Box 85; in this briefing, HK falsely reported that "The Chinese wanted it [the meeting] secret."

PAGE 300 **In his brief:** PPP:RN, 1971, 820; HK, *WHY*, 763–65.

PAGE 300 **The White House:** Ibid., 763; see also RN and J. Beam, Memcon, June 10, 1971, POF, Box 85, for Nixon's view of "triangulation."

PAGE 300 **Difficulties between:** Haldeman to HK, June 8, 1971, Haldeman Papers, Box 81.

PAGE 301 **During a meeting at Camp David:** HK and A. Dobrynin, Memcon, June 8, 1971; "Summit," July 5, 1971, entry, HKOF, NSC, Box 73.

PAGE 301 **It did:** HK and A. Dobrynin, Memcon, July 19, 1971, HKOF, NSC, Box 73; RN and HK, July 19, 1971, TC.

PAGE 301 **At the end of July:** "Summit," July 29, 1971, HKOF, NSC, Box 73; HK to RN, August 9, 1971, NSC, Box 492.

PAGE 301 **On August 5:** RN to L. Brezhnev, August 5, 1971, NSC, Box 492.

PAGE 302 **Although the Soviets:** HK and A. Dobrynin, Memcon, August 5, 1971, HKOF, NSC, Box 73; "Summit," see the entries for Aug. 10, 1971– October 12, 1971, HKOF, NSC, Box 73.

PAGE 302 **With the promise:** HK, A. Gromyko and A. Dobrynin, Memcon, September 30, 1971, NSC, Box 492.

PAGE 303 **Moreover, they now:** H. Salvatori to Haldeman, July 21, 1971, attached to A. Haig to Kehrli, August 6, 1971, OF, Haldeman Papers, Box 83; Haldeman, *Diaries*, 321; HK to RN, July 22, 1971, NSC, Box 499.

PAGE 303 **In August:** HK and conservatives, Memcon, August 12, 1971, NSC, Box 1025.

PAGE 305 **Vietnam remained:** RN, *Memoirs*, 499–500; PPP:RN, 1971, 596, 599–600, 612–13.

PAGE 305 **A series of antiwar:** HK, *WHY*, 1013; for a detailed description of the spring 1971 antiwar protests, see Wells, chap. 9; the Kerry quote is on 495.

PAGE 306 **The White House:** Conversation E487-1, April 23, 1971, on Miller Center, University of Virginia, Web site. Wells, 493–94.

PAGE 306 **To disarm:** Unnumbered Conversation, March 25, 1971, on Miller Center Web site.

PAGE 306 **Nixon thought:** HK, *WHY*, 1010–16.

PAGE 306 **By the spring of 1971:** Conversation 252-30, April 28, 1971; Haldeman, Diaries, CD Rom version, May 6, 1971.

PAGE 307 **Prospects brightened:** Haldeman, *Diaries*, 286; A. Haig to HK, May 22, 1971, AHCHF, NSC, Box 980; HK to D. Kraslow, May 20, 1971; RN and HK, May 21, 1971, May 26, 1971, TCs.

PAGE 307 **The hopeful notes:** *Gallup, 1959–1971*, 2305, 2309, 2314–16; ANS, June 6, 1971, POF, Box 33; HK to RN, May 31, 1971, NSC, Box 861.

PAGE 307 **Kissinger carried:** HK to RN, May 31, 1971, ibid; HK, *WHY*, 1017–20.

PAGE 308 **Hanoi's unbending:** Haig to HK, May 31, 1971, AHCHF, NSC, Box 980; Conversation 508-13, June 2, 1971; Kimball, 161–66; see also Haldeman, Diaries, CD ROM version June 2, 1971.

PAGE 308 **With Xuan Thuy:** Haldeman, *Diaries*, 295; RN to HK, June 8, 1971; HK and A. Dobrynin, June 3, 1971, June 7, 1971, June 21, 1971, TCs.

PAGE 308 **On June 13:** Haldeman and A. Haig, June 13, 1971, TC, AHCHF, NSC, Box 998.

PAGE 309 **The initial impulse:** RN and A. Haig, June 13, 1971, TC, ibid.; RN to Haldeman, June 15, 1971, PPF, Box 3; Haldeman, *Diaries*, 299–300; RN to Ehrlichman, June 14, 1971, at the NSA Web site under "The Pentagon Papers: Secrets, Lies and Audiotapes."

PAGE 309 **After further consideration:** RN to J. Mitchell, June 14, 197, ibid; HK and W. Rogers, June 14, 1971; HK and W. Rostow, June 14, 1971; RN and HK, June 14, 1971, TCs.

PAGE 309 **On June 15:** Haldeman, *Diaries*, 300–1; Haldeman, *Ends of Power*, 154–55; "NSC Meeting Minutes," June 17, 1971, NSC, Box H-110.

PAGE 310 **The Internal discussion:** HK and W. Rogers, June 14, 1971, TC.

PAGE 310 **The search for:** HK and M. Laird; HK and S. Agnew; RN and HK, June 15, 1971, TCs.

PAGE 310 **On June 16:** Hersh, 386; HK and H. Rowen, June 16, 1971, TC.

PAGE 311 **If Kissinger was:** HK and H. Hubbard, June 17, 1971, TC.

PAGE 311 **The ties to:** Conversation 525-01, June 17, 1971; Haldeman, *Ends of Power*, 155; Hersh, 384–85.

PAGE 312 **"By the end of:** Haldeman, *Ends of Power*, 155; Haldeman, *Diaries*, 303; Conversation 525-01, June 17, 1971; Conversation 534-02, July 1, 1971.

PAGE 312 **Kissinger makes no:** HK, *WHY*, 1021.

PAGE 312 **Later in June:** On Senator M. Mansfield, see Bundy, 297; Conversation 500-10, May 18, 1971; Conversation 527-16, June 23, 1971; Haldeman, *Diaries*, 304; HK and Senator R. Dole, June 22, 1971, TC; on HK's second thoughts about secrecy, see HK, *WHY*, 1020–21.

PAGE 313 **Nixon now considered:** Haldeman, *Diaries*, 304–5; RN and HK, June 22, 1971, TC.

PAGE 314 **Nixon and Kissinger were:** RN and A. Haig, June 26, 1971, TC, AHCHF, NSC, Box 998; Conversation 529-14, June 27, 1971; HK, *WHY*, 1021–24.

PAGE 314 **With Kissinger set:** S. Kraemer to A. Haig and HK, July 1, 1971, NSC, Box 190; RN and HK and A. Haig, Memcon, July 1, 1971; A. Haig to D. Bruce, July 2, 1971, AHCHF, NSC, Box 982; Conversation 534-2, July 1, 1971; Conversation 534-3, July 1, 1971, in Kimball, 176–77, 182–86.

PAGE 315 **At the same time:** Haldeman, *Diaries*, 307–12; Reeves, 337–39.

PAGE 315 **But they did:** The Ellsberg material and quotes are in Reeves, 353, 368–69.

PAGE 316 **As Kissinger traveled:** HK, *WHY*, 1025–26.

PAGE 316 **It is difficult:** Ibid., 1026–27.

PAGE 316 **The pluses:** HK to RN, July 14, 1971, NSC, Box 861.

PAGE 317 **The meeting on July 26:** HK to RN, July 26, 1971, ibid.; see also, HK to RN, August 9, 1971, NSC, Box 492.

PAGE 317 **As they waited:** PPP:RN, 1971, 853.

PAGE 317 **Public statements:** RN and HK, August 14, 1971, TC; HK to RN, August 16, 1971, NSC, Box 861; HK, *WHY*, 1035–36.

PAGE 318 **Kissinger's memo:** RN and HK, August 16, 1971, TC; the "dead" comment is in Conversation 500-10, May 18, 1971; quote, "delusions of grandeur," in Haldeman, *Diaries*, 351.

PAGE 319 **Nixon, however:** For U.S. government distress at political developments in Saigon, see R. T. Kennedy to A. Haig, August 18, 1971, with attached cable from the U.S. embassy; R. T. Kennedy and W. Rogers, August 18, 1971, TC; two HK cables to E. Bunker, August 20, 1971, AHCHF, NSC, Box 986; see also W. Rogers to E. Bunker, August 30, 1971, August 31, 1971, HKOF, NSC, Box 103.

PAGE 319 **But the president:** RN, HK and W. J. Porter, Memcon, August 24, 1971, POF, Box 86; HK to E. Bunker, September 11, 1971, HKOF, NSC, Box 103; "Report on Scali Meeting with Ambassador Diem," September 9, 1971, AHCHF, NSC, Box 986; PPP:RN, 1971, 952–55.

PAGE 320 **When Henry met:** HK, *WHY*, 1036.

PAGE 320 **The stalemate provoked:** RN and HK, September 14, 1971; HK and Admiral T. Moorer, September 14, 1971, TCs.

PAGE 320 **On September 18:** HK, *WHY*, 1038–41.

PAGE 321 **The North Vietnamese:** Haldeman, *Diaries*, 349.

PAGE 321 **Although the Middle East:** Conversations 2-4, April 19, 1971; 483–84; April 20, 1971.

PAGE 321 **In September:** RN and A. Gromyko, Memcon, in HK to RN, September 29, 1971, NSC, Box 492.

PAGE 322 **Like the Middle East:** See summary of Ad Hoc Working Group on Chile, December 4, 1970, in "Chile and the United States, Declassified Documents relating to the Military Coup, 1970–1976"; HK, J. Place and W. Quigley, Memcon, August 17, 1971, in NSA, online documents; see also Church Committee 1975 report on "Covert Action in Chile, 1963–1973"; and the Hinchey Report, "CIA Activities in Chile," September 18, 2000, both U.S. Department of State, and both also on the Internet.

PAGE 322 **In public:** A. Haig and RN, Memcon, December 30, 1970, AHCHF, NSC, Box 975.

PAGE 322 **The covert efforts:** RN and HK, TC, November 30, 1970. On expropriation, W. T. Buchanan, April 8, 1971; A. Hewitt to HK, April 23, 1971, CF, Box 8.

PAGE 323 **Korry:** H. Raymont related his encounter with Korry to me, on May 4, 2005, but Raymont remembers the meeting as notable for Korry's agitated state rather than for anything he had to say. HK and E. Korry, December 19, 1970, TC; A. Haig to HK, February 13, 1971, AHCHF, NSC, Box 975; A. Haig to HK, March 10, 1971, Box 977; A. Haig to T. Eliot, May 10, 1971, Box 980; Haig to RN, July 12, 1971, Box 983; HK and W. Rogers, March 11, 1971; May 12, 1971, TCs; A. Haig to L. Higby, January 24, 1972, AHCHF, NSC, Box 991.

CHAPTER 11 DÉTENTE IN ASIA: GAINS AND LOSSES

PAGE 325 **Nixon entered:** Colson quote is in Ambrose, *Nixon: Triumph of a Politician*, 478. PPP:RN, 1971, 1121.

PAGE 326 **Vietnam remained:** Ibid., 949–50.

PAGE 326 **He and Kissinger remained:** HK and A. Gromyko, Memcon, September 30, 1971, NSC, Box 492.

PAGE 326 **More than ever:** ANS, October 13, 1971, POF, Box 34; and for October 1971 n.d. in Box 35.

PAGE 326 **In public, the president:** PPP:RN, 1971, 994–95, 1091–92, 1101–5, 1149.

PAGE 327 **In private, Nixon:** HK and RN, November 14, 1971; HK and Congman. G. Mahon, November 15, 1971, TCs.

PAGE 327 **The Middle East:** HK and A. Gromyko, Memcon, September 30, 1971, NSC, Box 492.

PAGE 328 **It was all a form:** H. Saunders to HK, October 5, 1971, NSC, Box 658; HK and J. Mitchell, October 7, 1971, TC.

PAGE 328 **Divisions between:** HK to RN, "Background on Middle East Negotiations," December 1971; H. Saunders to HK, October 12, 1971, NSC, Box 658; HK and J. Mitchell, October 9, 1971, TC.

PAGE 328 **Alongside developments:** Conversation 628-2, December 2, 1971.

PAGE 328 **By contrast with:** Haldeman, Diaries, CD Rom version July 20, 1971, July 21, 1971, July 22, 1971; HK, *WHY*, 769; ANS, October 15, 1971, POF, Box 34.

PAGE 329 **Although, unlike Nixon:** Haldeman, *Diaries*, 329–30.

PAGE 329 **Kissinger's real battle:** Ibid., 359–60, 362; Haldeman, Diaries, CD Rom version, October 3, 1971.

PAGE 329 **Insistence that:** J. Scali to Haldeman, September 11, 1971, September 13, 1971; D. Chapin to Haldeman, September 18, 1971, Haldeman Papers, Box 192; Haldeman, *Diaries*, 363; HK, *WHY*, 769.

PAGE 330 **As Kissinger was landing:** Haldeman, *Diaries*, 366–67.

PAGE 330 **The message was:** HK, *WHY*, 779–80.

PAGE 331 **Putting the American:** HK and Chou, Memcon, October 20, 1971, NSC, Box 846.

PAGE 331 **Technical arrangements:** Ibid.

PAGE 332 **Kissinger's and Chou's:** HK, *WHY*, 781–84; Bundy, 243.

PAGE 333 **The PRC's admission:** The struggle over Chinese representation in the UN is extensively covered in *FRUS: United Nations, 1969–1972*, 558–895, see esp., 838–58. Conversation 11-103, October 17, 1971, Conversation 11-105, October 17, 1971; for quote, "Kick the cannibals," see also Haldeman, Diaries, CD Rom version, October 30, 1971.

PAGE 334 **Nixon instructed:** HK, *WHY*, 785–86; Haldeman, Diaries, CD Rom version, October 26, 1971.

PAGE 334 **Yet it was not:** Haldeman, Diaries, CD Rom version, November 2, 1971; HK briefing of *Newsweek* group, Memcon, November 9, 1971, NSC, Box 1025; ANS, n.d, but clearly early November 1971, POF, Box 37.

PAGE 335 **In the fall of 1971:** Events described in Bundy, 269–71.

PAGE 336 **Nixon and Kissinger initially:** *FRUS: South Asia, 1971*, 13–16.

PAGE 336 **Nixon agreed that:** HK, *WHY*, 850–58; *FRUS: South Asia, 1971*, 45–48, 65, 104, 113, 123–24; "WSAG Meeting," May 26, 1971, NSC, WSAG, Box H-115.

PAGE 336 **At the end of May:** *FRUS: South Asia, 1971*, 140, 149, 167.

PAGE 337 **In July:** Ibid., *1971*, 209–11.

PAGE 337 **Kissinger's meetings:** HK to RN, June 16, 1971, CF, Box 6; *FRUS: South Asia*, 1971, 182–84; A. Haig to RN, July 8, 1971, July 9, 1971, July 10, 1971; HK cable from New Delhi, n.d., but clearly July 1971, AHCHF, NSC, Box 983; see also HK and A. Hilaly, Memcon, July 24, 1971, NSC, Box 643.

PAGE 337 **Kissinger recalls returning:** HK, *WHY*, 862–64.

PAGE 338 **Nixon described the Indians:** "NSC Meeting," July 16, 1971, NSC, Box H-110.

PAGE 338 **An Indo-Russian:** HK, *WHY*, 866–69, 767; HK and W. Rogers, August 10, 1971, TC.

PAGE 338 **Former assistant secretary:** Bundy, 273. For the argument that U.S. China policy was a cause of the Soviet treaty, see HK and L. Jha, Memcon, August 25, 1971, NSC, Box 643.

PAGE 338 **In the late summer:** HK and L. Jha, Memcon, September 11, 1971, October 8, 1971, NSC, Box 643; RN and A. Gromyko, Memcon, September 29, 1971; HK and A. Dobrynin, Memcon, October 9, 1971, NSC, Box 492.

PAGE 339 **To make the case:** RN and I. Gandhi, Memcon, November 4, 1971, NSC, Box 643.

PAGE 340 **Nixon took her:** Hersh, 456; HK, *WHY*, 848; *FRUS: South Asia, 1971*, 499–500; ANS, November 1971, POF, Box 37; RN and I. Gandhi, Memcon, November 4, 1971, November 5, 1971, NSC, Box 643.

PAGE 340 **More convinced than ever:** *FRUS: South Asia, 1971*, 592–97, 608.

PAGE 341 **Nixon saw at least:** Ibid., 611–14, 627–29; on the Security Council veto, see Bundy, 277.

PAGE 342 **The Soviet veto:** *FRUS: South Asia*, 637–39, 641, 644–45, 648–49.

PAGE 342 **With India defeating:** Ibid., 674–76, 683.

PAGE 343 **A CIA cable:** Ibid., 686–87, 701–5.

PAGE 344 **On December 9:** Ibid., 724–25; Isaacson, 376.

PAGE 344 **The same day:** *FRUS: South Asia*, 721–24, 741, 745–46.

PAGE 345 **On the afternoon:** ANS, December 7, 1971, December 9, 1971, POF, Box 37; "Talking Points," December 8, 1971, HKOF, NSC, Box 134; Bundy, 277–78.

PAGE 345 **On the evening:** *FRUS: South Asia*, 751–63.

PAGE 346 **On Sunday morning:** Ibid., 779–83, 787; Brent Scowcroft told me Nixon was preoccupied with doubts about his masculinity, interview with B. Scowcroft, January 5, 2007; RN and G. Pompidou, Memcon, December 13, 1971, POF, Box 87; in an interview on June 13, 2005, Kissinger told me that on becoming national security adviser, he had promised himself never to join in a decision for a nuclear war.

PAGE 348 **A message from:** *FRUS: South Asia*, 787–89, 792.

PAGE 348 **To their surprise:** Ibid., 783.

PAGE 348 **The crisis now:** RN and HK, December 16, 1971, December 17, 1971; HK to Haldeman, December 16, 1971; HK and H. Hubbard, December 16, 1971, TCs; Bundy, 281–82.

PAGE 348 **William Bundy's:** Ibid., 284–92.

PAGE 349 **Casualties of:** See Haldeman, Diaries, CD Rom version, December 7–14,

1971, which provides a more complete description of HK's erratic behavior than in the published *Diaries*, 380–84.

PAGE 350 **Two developments:** The Kalbs, 261–62; HK and H. Hubbard, December 16, 1971, TC.

PAGE 350 **He suffered:** Isaacson, 380; Bundy, 282.

PAGE 350 **A White House investigation:** Isaacson, 380–85; Haldeman, *Diaries*, 385–86.

PAGE 351 **Nixon was angry:** Conversation 641-10, December 23, 1971.

PAGE 351 **On December 24:** "I am out of favor," HK and H. Hubbard, December 16, 1971, TC; Ehrlichman, 278–79; "Beside myself," quoted in Isaacson, 384; Haldeman, Diaries, CD Rom version, December 22, 1971, December 23, 1971. The December 23, 1971, material about Scali is in the published *Diaries*, 387.

PAGE 352 **Kissinger seemed:** HK and H. Hubbard, December 16, 1971, TC; Ehrlichman, 279–80; Isaacson, 391–96; see also Haldeman, Diaries, CD Rom version, December 24, 1971.

PAGE 353 **As the year came:** Haldeman, *Diaries*, 388.

PAGE 353 **Robert McNamara:** HK and R. McNamara, December 22, 1971, TC.

PAGE 353 **However stressed:** RN and HK, January 3, 1972, January 4, 1972, TCs.

PAGE 353 **When Kissinger spoke:** HK, "Address to Washington Press Club," January 26, 1972, PPF, Box 30.

PAGE 354 **As 1972 began:** HK address, Memcon, January 5, 1972, NSC, Box 1026.

PAGE 354 **Yet Nixon understood:** RN statement to Soviets, "handed by K to Vorontsov," December 3, 1971, NSC, Box 492; PPP:RN, 1972, 2–5, 30, 101; ANS, January 7, 1972, POF, Box 37; see also RN's remarks to Chancellor W. Brandt, Memcon, December 29, 1971, POF, Box 87. On the possible offensive, see RN and HK, January 11, 1972, February 5, 1972, TCs; Conversation 647-97, RN, M. Laird, and A. Haig, January 13, 1972; Conversation 652-17, RN and HK, January 20, 1972; Conversation 655-3, RN, HK, and Haldeman, January 25, 1972; Conversation 318-23, RN and HK, February 2, 1972; Haldeman, *Diaries*, 401–2; HK to RN, describing "situation in Vietnam," "NSC meeting," February 2, 1972, and "President's Talking Points," February 2, 1972, NSC, Box H-032.

PAGE 355 **When Rather asked:** PPP:RN, 1972 6–8; Haldeman, *Diaries*, 391–93; see also the CD Rom version for January 1, 1972, which includes some of the quoted material not in the book.

PAGE 356 **Because Nixon refused:** P. Odeen to HK, January 6, 1972, NSC. Box 320.

PAGE 356 **If he were going:** Haldeman, Diaries, CD Rom January 13, 1972, January 14, 1972, January 18, 1972; February 3, 1972, February 11, 1972. RN to W. Rogers and HK, January 18, 1972, PPF, Box 3.

PAGE 357 **In the meantime:** Haldeman, *Diaries*, 400–1; and the CD Rom version for January 17, 1972; see also HK and J. Mitchell, January 8, 1972; HK and Y. Rabin; HK and Haldeman, January 10, 1972, TCs.

PAGE 357 **The greater political:** RN and HK, January 11, 1972, two TCs.

PAGE 357 **The speech was:** PPP:RN, 1972, 100–6; RN to L. Brezhnev, January 25, 1972, NSC, Box 862.

PAGE 358 **Nixon had small:** "Talking Points," January 22, 1972, AHCHF, NSC, Box 991. RN and HK, January 12, 1972, TC.

PAGE 358 **The White House hoped:** Haldeman, *Diaries*, 401–3; Memcon, January 26, 1972, POF, Box 87.

PAGE 359 **Reverting to campaign:** Haldeman, Diaries, CD Rom version, January 27, 1972; RN to C. Colson and Haldeman, January 28, 1972; and RN to Haldeman and P. Buchanan, February 2, 1972, PPF, Box 3.

PAGE 359 **Kissinger believed:** Haldeman, *Diaries*, 410; Conversation 670-13; RN to HK, February 14, 1972; HK, *WHY*, 1046.

PAGE 360 **Nixon prepared:** "Advance Trip to China," January 1972, NSC, Box 502; Haldeman, Diaries, CD Rom version, January 17, 1972; RN and HK, February 4, 1972, February 5, 1972, TCs.

PAGE 360 **Before going:** RN and A. Malraux, Memcon, February 14, 1972, POF, Box 87.

PAGE 360 **In contrast to:** HK to RN, February 5, 1972, HKOF, NSC, Box 91; RN and HK, February 14, 1972, TC.

PAGE 361 **Although they were:** Haldeman, Diaries, CD Rom version, February 17, 1972; Haldeman, *Diaries*, 412–13, 420; HK, *WHY*, 1053–56.

PAGE 362 **A tone of:** The Mao-RN meeting on February 21, 1972, is in Burr, 59–66. Also see HK, *WHY*, 1057–66; and RN, *Memoirs*, 560–64.

PAGE 365 **Meetings over the next:** Burr, 62; HK, *WHY*, 1066–74; See the RN and Chou, Memcons, dated between February 21, 1972, and February 28, 1972, NSC, Box 848.

PAGE 366 **Because the conversations:** HK, *WHY*, 1074–87, 1490–92.

PAGE 367 **With the conference:** Haldeman, *Diaries*, 422; HK, *WHY*, 1086.

PAGE 367 **But Kissinger's positive outlook:** Haldeman, Diaries, CD Rom version, February 28, 1972; RN to W. Rogers, M. Laird, and HK, n.d., but clearly February 29, 1972, or March 1, 1972, PPF, Box 3; "Meeting with Bipartisan Leadership," February 29, 1972; "Meeting of the Cabinet," February 29, 1972, POF, Box 88.

CHAPTER 12 THE WARRIORS AS PEACEMAKERS

PAGE 369 **In the weeks after:** C. Colson to RN, March 2, 1972, with H. K. Smith's comments attached, PPF, Box 16.

PAGE 369 **Kissinger was also:** "HK Briefing," March 7, 1972, NSC, Box 1026.

PAGE 370 **Because it was:** Haldeman, *Diaries*, 431; CD Rom, March 8, 1972, March 22, 1972; Haldeman for RN's files, March 8, 1972, Haldeman Papers, Box 163; cartoon, *Los Angeles Times*, July 8, 1972; RN and A. Haig, March 27, 1972, TC, AHCHF, NSC, Box 999; RN to Haldeman, March 13, 1972, March 27, 1972, PPF, Box 3.

PAGE 371 **In March:** Conversation 678-4, RN to HK, March 6, 1972; A. Haig to

HK, March 10, 1972, AHCHF, NSC, Box 992; RN to HK, March 11, 1972, PPF, Box 3; Conversation 685-2, RN and HK, March 14, 1972; ANS, March 21, 1972, POF, Box 39.

PAGE 371 **On March 30:** "Current Facts Regarding the Situation in South Vietnam," n.d., AHCHF, NSC, Box 992; HK, *WHY*, 1109; "GOP Leadership Meeting," April 12, 1972, POF, Box 88.

PAGE 371 **With the press:** ANS, April 3, 1972, April 4, 1972, POF, Box 40; Conversation 700-2, April 3, 1972; Conversation 701-14, April 4, 1972; HK to E. Bunker, April 4, 1972, AHCHF, NSC, Box 999; Conversation 713-1, April 19, 1972; see also Haldeman, *Diaries*, 435.

PAGE 372 **The real issue:** Conversation 685-2, March 14, 1972; A. Haig to HK, n.d., but clearly early April 1972, AHCHF, NSC, Box 992; RN, *Memoirs*, 587; HK, *WHY*, 1109.

PAGE 372 **It is understandable:** See Ambrose, *Nixon: Triumph of a Politician*, 528, on this point.

PAGE 373 **Nixon and Kissinger now:** RN, *Memoirs*, 589.

PAGE 373 **Yet for all Nixon's:** RN and HK, April 3, 1972, TC; HK and A. Dobrynin, Memcon, April 6, 1972, April 9, 1972, April 12, 1972, NSC, Box 493; HK to RN, April 14, 1972, CF, Box 9.

PAGE 374 **On April 15:** RN, *Memoirs*, 590–91; HK, *WHY*, 1120.

PAGE 374 **On the evening of:** HK and A. Dobrynin, Memcon, April 15, 1972, NSC, Box 493; convictions about success in the fighting and with the public are reflected in conversations between RN and HK on April 3, 1972, April 8, 1972, April 9, 1972, April 11, 1972, and April 17, 1972, TCs. Also in Conversation 713-1, April 19, 1972. RN, *Memoirs*, 590–91; HK, *WHY*, 1120–21.

PAGE 375 **Nixon now signed:** See RN's verbal instructions to HK on the eve of his departure for Moscow, Conversation 713-1, April 19, 1972.

PAGE 375 **A Nixon conversation:** RN and G. Pompidou, Memcon, December 13, 1971, POF, Box 87.

PAGE 375 **Nixon thought Pompidou's:** RN to HK, April 20, 1972, NSC, Box 341.

PAGE 376 **On Henry's arrival:** HK and H. Sidey—HK described his arrival in Moscow and his quarters, April 25, 1972, TC; A. Haig to RN, April 20, 1972, AHCHF, NSC. Box 992.

PAGE 376 **Kissinger now found:** RN and A. Haig, April 20, 1972, April 21, 1972, April 22, 1972, TCs, AHCHF, NSC, Box 999; Haldeman, Diaries, CD Rom version, April 22, 1972.

PAGE 376 **On April 21:** RN and A. Haig, April 21, 1972, TC, AHCHF, NSC, Box 999.

PAGE 377 **Plagued by poor:** RN and A. Haig, April 22, 1972, ibid.; HK to A. Haig, April 22, 1972, HKOF, NSC, Box 21.

PAGE 378 **Kissinger was much:** HK, *WHY*, 1155.

PAGE 378 **As Kissinger understood:** RN and A. Haig, April 22, 1972, TC, AHCHF, NSC, Box 999; A. Haig to HK, April 22, 1972, two cables, HKOF, NSC, Box 21.

PAGE 379 **Convinced that the wisest:** The cables are HK to A. Haig, 012 and 014, April 22, 1972, NSC, Box 21; on "idiocies," see Isaacson, 412.

PAGE 379 **Because Nixon was:** RN to HK, April 23, 1972; A. Haig to HK, and HK
to A. Haig, April 24, 1972, NSC, Box 21; RN and Haig, April 23, 1972,
TC, AHCHF, NSC, Box 999; Haldeman, *Diaries*, 445–46.

PAGE 380 **Kissinger objected:** HK to A. Haig, April 24, 1972, HKOF, NSC, Box 21.

PAGE 380 **When Henry arrived:** Haldeman, *Diaries*, 446–47.

PAGE 380 **But their differences:** A. Haig to HK, April 23, 1972; HK to RN, April 24,
1972, HKOF, NSC, Box 21; HK and Y. Vorontsov, April 25, 1972, for
RN's message to L. Brezhnev, TC; L. Brezhnev to RN, May 1, 1972, NSC,
Box 494.

PAGE 381 **On April 26:** PPP:RN, 1972, 550–54; Haldeman, Diaries, CD Rom ver-
sion, April 25, 1972; Haldeman, *Diaries*, 443, 448; RN to Haldeman,
April 29, 30, 1972, PPF, Box 3; RN and HK, April 29, 1972, TC.

PAGE 381 **In late April:** RN and HK, April 29, 1972, TC; HK, *WHY*, 1168–69.

PAGE 382 **The run-up to:** "Statement by the Government of the United States,"
April 27, 1972, AHCHF, NSC, Box 992; HK to RN, n.d., reporting on
the April 27 meeting; HK to RN, "Le Duc Tho April 30 Arrival State-
ment," NSC, Box 191.

PAGE 382 **Although Nixon reluctantly:** RN to HK, April 30, 1972, PPF, Box 3; RN
and HK, May 1, 1972, TC.

PAGE 382 **Nixon wanted:** RN and A. Haig, May 1, 1972, TC, AHCHF, NSC, Box
999.

PAGE 383 **With the South Vietnamese:** Conversation 716-4, May 1, 1972; A. Haig
to HK, May 1, 1972, NSC, Box 993.

PAGE 383 **Mindful of:** Haldeman, *Diaries*, 450. RN and HK, May 1, 1972, TC.

PAGE 383 **It was an unrealistic:** HK to RN, May 2, 1972, NSC, Box 862.

PAGE 384 **Nixon and Kissinger:** HK to RN, May 2, 1972, HKOF, NSC, Box 74;
Haig to HK, May 2, 1972, ibid., Box 22.

PAGE 384 **When Henry arrived:** Haldeman, *Diaries*, 451–55; RN and HK, May 2,
1972, May 3, 1972, TCs; A. Haig to HK, May 4, 1972, AHCHF, NSC,
Box 993; Isaacson, 417–19.

PAGE 386 **In an Oval Office:** L. Brezhnev to RN, May 6, 1972, NSC, Box 494.

PAGE 386 **Nixon used his:** PPP:RN, 1972, 583–87; see also pre-speech RN and HK
conversations, May 8, 1972, two TCs.

PAGE 386 **Like Nixon and Kissinger:** RN to HK, May 9, 1972, PPF, Box 4; HK and
A. Dobrynin, May 9, 1972, TC.

PAGE 387 **On May 11:** HK and A. Dobrynin, Memcon, May 11, 1972, NSC, Box
494; HK and A. Dobrynin, May 12, 1972, TC; Bundy, 319; Isaacson,
421–23; Haldeman, *Diaries*, 459; RN, *Memoirs*, 607.

PAGE 387 **Moscow's decision:** RN to Haldeman, May 13, 1972, May 15, 1972; RN
to Colson, May 15, 1972, PPF, Box 4.

PAGE 387 **The administration's attacks:** RN and A. Haig, May 16, 1972, May 17, 1972,
TCs, AHCHF, NSC, Box 999; RN to A. Haig, May 18, 1972, PPF, Box 4.

PAGE 388 **As he was about to:** RN to HK and A. Haig, May 20, 1972, ibid.

PAGE 388 **Two days before:** HK to RN, May 18, 1972, NSC, Box 494; Haldeman,
Diaries, CD Rom version, May 20, 1972.

PAGE 389 **The bigger challenge:** HK to RN, n.d., but clearly May 1972, NSC, Box
474.

P<small>AGE</small> 390 **The day before:** RN and congressional leaders, Memcon, May 19, 1972, POF, Box 88.

P<small>AGE</small> 391 **As he traveled:** HK, *WHY*, 1202–4.

P<small>AGE</small> 391 **The domestic political:** RN to HK and A. Haig, May 20, 1972, PPF, Box 4; Haldeman, Diaries, CD Rom version May 20, 1972.

P<small>AGE</small> 391 **The president's arrival:** HK, *WHY*, 1206–7.

P<small>AGE</small> 392 **As in China:** Quoted in Isaacson, 425–26.

P<small>AGE</small> 392 **Kissinger need not:** RN and L. Brezhnev, Memcon, May 22, 1972, NSC, Box 487; Haldeman, *Diaries*, 462.

P<small>AGE</small> 393 **Three meetings:** "First Plenary Session," Memcon, May 23, 1972, NSC, Box 487.

P<small>AGE</small> 393 **At the two additional:** Memcon, May 23, 1972, ibid.

P<small>AGE</small> 394 **The first day's:** Haldeman, Diaries, CD Rom version May 23, 1972, May 24, 1972; also the published Haldeman, *Diaries*, 462–63; A. Haig to HK, May 24, 1972, AHCHF, NSC, Box 993; on Rogers, see not only the Haldeman diary entries, but also the Memcons, May 24, 1972, NSC, Box 487.

P<small>AGE</small> 394 **The two-hour:** Memcon, May 24, 1972, ibid; for RN's concern about Soviet interest in weakening or dismantling NATO, see Conversation 595-7, RN and R. Ellsworth, October 18, 1971.

P<small>AGE</small> 395 **A three-hour:** Haldeman, *Diaries*, 463; HK, *WHY*, 1222–25; Isaacson, 426.

P<small>AGE</small> 395 **When shortly:** Memcons, April 24, 1972, 7:50–11:00 p.m.; May 29, 1972, NSC, Box 487.

P<small>AGE</small> 396 **Although one Soviet:** Haldeman, *Diaries*, 464; HK, *WHY*, 1227–29; Memcon, May 29, 1972, ibid.

P<small>AGE</small> 397 **Although the Summit:** Memcon, May 25, 1972, May 26, 1972, NSC, Box 487.

P<small>AGE</small> 397 **On the evening:** RN and L. Brezhnev, Memcon, May 26, 1972, ibid.

P<small>AGE</small> 398 **At eleven:** Haldeman, *Diaries*, 464–45; see also CD Rom version, May 26, 1972, which has a little more detail; HK, *WHY*, 1242–44.

P<small>AGE</small> 398 **The SALT agreement:** Isaacson, 429–38, provides a balanced analysis of Kissinger's role in the negotiations.

P<small>AGE</small> 398 **The rest of:** Mcmcons, May 29, 1972, NSC, Box 487.

P<small>AGE</small> 399 **Nixon's public:** PPP:RN, 1972, 633–42.

P<small>AGE</small> 399 **Characteristically, Nixon:** Haldeman, Diaries, CD Rom version, May 28, 1972, May 29, 1972.

P<small>AGE</small> 400 **In the midst:** PPP:RN, 1972, 660–66.

P<small>AGE</small> 400 **Despite the hyperbole:** *Gallup, 1935–1997,* CD Rom edition—polls for January 31, 1972, February 17, 1972, March 9, 1972, June 4, 1972, June 11, 1972; "Ceased being," quoted in Isaacson, 437; Marvin Kalb made the same point about HK's celebrity on CBS television, HK and M. Kalb, June 24, 1972, TC.

P<small>AGE</small> 400 **But Nixon being:** HK and K. Clawson, June 2, 1972, TC.

P<small>AGE</small> 401 **Having begun:** HK and K. Clawson, July 3, 1972, TC.

P<small>AGE</small> 401 **No one could:** HK and R. Evans, July 21, 1972, July 24, 1972; HK and P. Lisagor; HK and H. Sidey, July 27, 1972, TCs.

PAGE 402 **Behind the scenes:** RN and HK, June 24, 29, July 7, 1972; HK and A. Dobrynin, June 30, 1972, TCs.

PAGE 402 **In June:** "South Vietnam may lose," quoted in Solomon, "From Watergate to Downing Street—Lying for War," June 10, 2005, History News Network, HNN; quotes are from RN and HK, June 24, 1972, June 29, 1972, July 7, 1972, TCs.

PAGE 403 **Hanoi acknowledged:** For Hanoi's acknowledgment, see *Gallup, 1935–1997*, CD Rom edition, June 5, 1972. HK's memo quoted in HK, *WHY*, 1301–2. For the rest, see J. D. Negroponte to HK, June 6, 1972, HKOF, NSC, Box 74; A. Haig to HK, June 13, 1972, AHCHF, NSC, Box 993; L. Brezhnev to RN, June 21, 1972, NSC, Box 494; see also Bundy, 351–53; Berman, 135.

PAGE 403 **During June:** ANS, n.d., but clearly shortly before June 19, 1972, POF, Box 40; ANS, June 26, 1972, POF, Box 41.

PAGE 404 **Reports from:** ANS, July 1, 1972, July 19, 1972, July 25, 1972, POF, Box 41.

PAGE 404 **In fact, in June:** RN and HK, June 2, 1972, TC; also HK and G. Smith, June 2, 1972, ibid.

PAGE 404 **On July 12:** A. Haig to HK, June 8, 1972, AHCHF, NSC, Box 993; ANS, July 19, 1972, POF, Box 41; *Gallup, 1935–1997*, CD Rom Version, August 18, 1972.

PAGE 405 **In general, foreign:** RN and HK, June 3, 1972, TC.

PAGE 405 **The improved relations:** HK, *WHY*, 1304; HK to E. Bunker, June 24, 1972, HKOF, NSC, Box 107; HK to RN, June 27, 1972, NSC, Box 85. RN and HK, June 29, 1972, TC.

PAGE 405 **Kissinger emphasized:** HK to Chou, Memcon, June 20, 1972, in NSA online documents.

PAGE 405 **Détente with:** Brezhnev to RN, June 21, 1972; HK and A. Dobrynin, Memcon, June 26, 1972, NSC, Box 494.

PAGE 406 **In July:** HK to RN, July 12, 1972; RN to Brezhnev, July 18, 1972; HK and A. Dobrynin, Memcon, July 20, 1972; L. Brezhnev to RN, July 20, 1972, NSC, Box 494; ANS, July n.d. but after July 18, 1972, POF, Box 41; HK, *WHY*, 1297.

PAGE 406 **For Nixon and Kissinger:** PPP:RN, 1972, 705–11, 714, 716; RN and HK, June 14, 1972, TC; HK to RN, July 14, 1972, AHCHF, NSC, Box 994—all reflect RN's positive assessment of military developments; see also Isaacson, 440–41, for a persuasive description of RN's strategy; ANS, July 21, 1972, POF, Box 41; HK to E. Bunker, June 24, 1972, HKOF, NSC, Box 107.

PAGE 407 **By contrast with:** HK and J. Alsop, June 2, 1972, TC; Isaacson, 440.

PAGE 407 **Kissinger also believed:** HK and J. Mitchell, June 4, 1972, TC; HK to A. Haig, July 15, 1972, HKOF, NSC, Box 23; HK, *WHY*, 1306.

PAGE 408 **Kissinger took additional:** HK to RN, July 20, 1972, NSC, Box 1040; HK and A. Dobrynin, Memcon, July 20, 1972, NSC, Box 494; Berman, 137–38; RN and HK, July 29, 1972, TC.

PAGE 408 **Nixon found himself:** See trial heats for May 1972, June 1972, and July 1972 in *Gallup, 1935–1997*, CD Rom edition.

PAGE 409 **By any rational:** "Assault Book," June 8, 1972, Off. Files, Box 201; RN and HK, June 24, 1972, TC; A. Haig to Haldeman, July 6, 1972, Off. Files, Box 106, Haldeman Papers. Ehrlichman, 299.

PAGE 409 **Rational assessments:** RN, *Memoirs*, 637. Haldeman, *Diaries*, 480.

PAGE 410 **By 1972:** For RN's instructions on A. Dobrynin, see Ambrose, *Nixon: Triumph of a Politician*, 552–53; on Rabin, K. Clawson to Haldeman, June 14, 1972, NSC, Box 609. H. Saunders to HK, July 29, 1972, NSC. Box 658.

CHAPTER 13 TAINTED VICTORIES

PAGE 412 **In August 1972:** Conversation 697-2, March 30, 1972; Haldeman, Diaries, CD Rom version August 17, 1972; PPP:RN, 1972, 795.

PAGE 413 **Because Nixon actually:** Conversation 697-2, March 30, 1972; 329–32, April 13, 1972; RN to Haldeman, August 9, 1972, PPF, Box 9.

PAGE 413 **Where trolling for:** H. Saunders to HK, August 8, 1972, NSC, Box 609; L. Brezhnev to RN, August 8, 1972, NSC, Box 495; ANS, August 1, 1972, POF, Box 41; A. Haig to HK, August 18, 1972, AHCHF, NSC, Box 995; HK and Garment, September 6, 1972, TC.

PAGE 413 **No foreign policy:** Conversation 717-19, May 2, 1972; RN, *Memoirs*, 700–1; HK, *WHY*, 1308.

PAGE 414 **Because Nixon believed:** HK to RN, August 3, 1972, NSC, Box 862; ANS, August 3, 1972, POF, Box 42.

PAGE 414 **At the August 14:** A. Haig to RN, August 14, 1972, AHCHF, NSC, Box 995; HK to RN, August 19, 1972, NSC, Box 862; HK, *WHY*, 1319.

PAGE 414 **Despite Henry's optimism:** A. Haig to RN, August 14, 1972, AHCHF, NSC, Box 995; Haldeman, CD Rom Diaries, August 17, 1972.

PAGE 415 **Nixon saw the Paris:** RN and A. Haig, August 16, 1972, TC, AHCHF, NSC, Box 998; A. Haig to HK, August 19, 1972, HKOF, NSC, Box 22.

PAGE 415 **In his opposition:** Isaacson, 443–44; HK, *WHY*, 1319–27.

PAGE 415 **Kissinger remembered:** Ibid., 1326. RN's letter is quoted in Hung and Schecter, 68.

PAGE 416 **Despite his determination:** Polls of August 20, 1972; September 3, 1972; *Gallup, 1935–1997*, CD Rom edition.

PAGE 416 **To woo voters:** PPP:RN, 1972, 829–32.

PAGE 416 **During the first week:** "NSC Meeting Minutes," September 6, 1972, NSC, POF, Box 89; ANS, September 8, 1972, POF, Box 43.

PAGE 417 **If the White House:** PPP:RN, 1972, 828–29; Dean, 129.

PAGE 417 **In the first half of September:** Ambrose, *Nixon: Triumph of a Politician*, 606–12, 621–23; Reeves, 517–18, 526–27; Polls of August 6, 1972; October 8, 1972, *Gallup, 1935–1997*, CD Rom edition,

PAGE 418 **Because he knew:** RN, *Memoirs*, 686.

PAGE 418 **Clearly, he had:** HK and J. Chancellor, August 21, 1972; HK and J. Alsop,

October 2, 1972, TCs; Poll, December 28, 1972, *Gallup, 1935–1997*, CD Rom edition.

PAGE 418 **With Watergate:** HK to A. Haig for RN, September 13, 1972, HKOF, NSC, Box 24.

PAGE 419 **Haig informed:** A. Haig to HK, September 14, 1972, AHCHF, NSC, Box 996.

PAGE 419 **Kissinger saw the September:** HK to RN, September 19, 1972, NSC, Box 862; Haldeman, *Diaries*, 504–5.

PAGE 419 **News accounts:** Dan Rather, "First Line Report," September 15, 1972; two reports of D. R. Young to Haldeman, September 16, 1972, September 18, 1972, Off. Files, Box 191, Haldeman Papers; ANS, September 18, 1972, September 21, 1972, POF, Box 43; Haldeman, *Diaries*, 504.

PAGE 419 **At a September 20:** "President's Talking Points," September 20, 1972, NSC, Box H-032.

PAGE 419 **Kissinger's return to Paris:** A. Haig to RN, September 27, 1972, HKOF, NSC, Box 23; HK, *WHY*, 1335–38.

PAGE 420 **Kissinger understood:** Ibid., 1338; Haldeman, *Diaries*, 510; HK and H. Sidey and HK and Haldeman, September 22, 1972, TCs.

PAGE 420 **Nixon wanted Thieu:** Conversation 788-18, both September 29, 1972; HK, *WHY*, 1338–39; Hung and Schecter, 71–72; best account of Haig discussions in Saigon between October 2, 1972, and October 4, 1972, is in Berman, 149–53.

PAGE 420 **Nixon and Kissinger were:** Conversation 788-1, September 29, 1972.

PAGE 421 **Nixon offered Thieu:** Berman, 152–53; Hung and Schecter, 376.

PAGE 421 **Kissinger remained at odds:** Haldeman, *Diaries*, 512–13.

PAGE 421 **When Kissinger resumed:** "I had Haig," quoted in Isaacson, 447; HK to RN, October 9, 1972, NSC, Box 862.

PAGE 421 **Kissinger's distrust:** Material on A. Haig is drawn from Isaacson, 385–90; Lynn quote is on 389.

PAGE 422 **Nixon agreed that:** Haldeman, CD Rom Diaries, October 9, 1972.

PAGE 422 **In response to:** HK to RN, October 10, 1972, NSC, Box 862.

PAGE 422 **Nixon did not:** HK, *WHY*, 1352.

PAGE 422 **Kissinger believed that:** HK, *WHY*, 1345–46. Interview with HK, June 13, 2005.

PAGE 423 **Henry and Haig:** Haldeman, *Diaries*, 515–16.

PAGE 423 **Despite an outward:** Ibid., 516–17.

PAGE 423 **Nixon and Haig:** Ibid., 519–22.

PAGE 424 **After Kissinger returned:** HK to RN, October 17, 1972; A. Haig to HK, October 17, 1972, HKOF, NSC, Box 25.

PAGE 424 **On October 19:** RN to HK, October 19, 1972, ibid., Box 104; ANS, October 20, 1972, POF, Box 44.

PAGE 424 **Kissinger ran into:** Berman, 161–63; A. Haig to RN, October 19, 1972, AHCHF, NSC, Box 996.

PAGE 425 **In fact, Thieu:** Berman, 163–66; Isaacson, 453; HK, *WHY*, 1320; A. Haig to RN, October 20, 1972, AHCHF, NSC, Box 996.

PAGE 425 **Seizing on Thieu's:** Haig to RN, ibid., Haig to HK, Oct. 20, 1972, HKOF, NSC, Box 25.

PAGE 425 **Nixon wanted Kissinger:** A. Haig to HK, October 21, 1972, ibid.; see also RN and A. Haig, October 21, 1972, two TCs, AHCHF, NSC, Box 998.

PAGE 425 **Because Nixon feared:** Haldeman, CD Rom Diaries, October 22, 1972; RN to A. Haig, October 21, 1972, ibid.; A. Haig to HK, October 22, 1972, HKOF, NSC, Box 25.

PAGE 426 **Nixon's inattentiveness:** Cable quoted in Reeves, 537–38. HK and N. Rockefeller, October 25, 1972; HK and D. Kraslow, October 25, 1972; HK and W. Buckley, October 25, 1972; HK and W. Rogers, October 26, 1972, TCs.

PAGE 426 **Thieu's resistance:** Quoted in Isaacson, 456; see also the sanitized version of the meeting E. Bunker sent to the White House: Haig to RN, October 23, 1972, AHCHF, NSC, Box 996.

PAGE 426 **Kissinger also:** Quoted in Isaacson, 458.

PAGE 426 **The object now:** Quoted in Reeves, 538.

PAGE 427 **As he headed home:** A. Haig to HK, October 23, 1972, AHCHF, NSC, Box 996; ANS, October 23, 1972, POF, Box 45.

PAGE 427 **Within hours:** HK and M. Kalb, Oct. 23, 1972; HK and B. Toth, October 23, 1972; HK and J. Kraft Oct. 24, 1972; HK and R. Ziegler, October 24, 1972; RN and HK; HK and D. Kraslow; HK and W. Buckley, October 25, 1972, TCs.

PAGE 427 **Kissinger gave an:** Isaacson, 458.

PAGE 427 **On October 24 and 25:** Berman, 171–75; Isaacson, 458–60; RN and HK; HK and C. Colson; HK and Scali, all October 26, 1972; RN and HK, October 27, 1972, TCs; Haldeman, *Diaries*, 524.

PAGE 429 **While Nixon didn't:** Isaacson, 459.

PAGE 429 **Yet not everyone:** Reeves, 540.

PAGE 429 **Haldeman recorded:** Haldeman, *Diaries*, 525.

PAGE 429 **To keep Saigon:** Berman, 174–75.

PAGE 430 **Hanoi was more:** Haldeman, *Diaries*, 527–28; A. Haig to HK, November 4, 1972, HKOF, NSC, Box 25.

PAGE 430 **Because they had:** HK and C. Colson; RN and HK; HK and R. Valeriani, November 1, 1972; HK and W. Rogers, November 4, 1972; RN and HK, November 6, 1972, TCs; PPP:RN, 1972, 1138–39.

PAGE 430 **On November 3:** HK and Foreign Correspondents, Memcon, November 4, 1972, NSC, Box 379.

PAGE 431 **On November 7:** HK to RN, November 7, 1972, PPF, Box 10.

PAGE 432 **The note was:** Isaacson, 494, 600–1.

PAGE 432 **Yet Kissinger also:** HK, *YOU*, 121; see also Isaacson, 600.

PAGE 432 **Henry complained:** Reeves, 501–7, 519, 531–32, 539; Memcon: HK and Foreign Correspondents Meeting, November 4, 1972, NSC, Box 379; Isaacson, 502–3.

PAGE 433 **On November 7:** Ambrose, *Nixon: Triumph of a Politician*, 651–52; Reeves, 541–42; ANS, November 8, 1972, POF, Box 46.

PAGE 433 **After all his years:** Haldeman, *Diaries*, 530–33. "Make sure," quoted in Reeves, 542.

PAGE 434 **Specifically, he gave:** Haldeman, CD Rom Diaries, November 14, 1972; Reeves, 546–47.

PAGE 434 **The restaffing:** HK and K. Graham, December 16, 1972, TC.

PAGE 435 **In the weeks:** HK to A. Haig, November 10, 1972; HK to E. Bunker, November 13, 1972, AHCHF, NSC, Box 996; Berman, 181–82.

PAGE 435 **Nixon's letter:** RN to Thieu, November 9, 1972, NSC, Box 862.

PAGE 435 **Thieu was unyielding:** Berman, 185–86. RN to Thieu, November 14, 1972, NSC, Box 862.

PAGE 436 **Kissinger's return:** First two quotes are in Berman, 188–91, for the rest, see HK and Pham Dang Lam, Memcon, November 20, 1972, NSC, Box 858; Colonel R. Kennedy to Haldeman, November 21, 1972; HK to RN, November 23, 1972, HKOF, NSC, Box 26.

PAGE 436 **With Hanoi proving:** HK and D. L. Lam, Memcons, November 22, 1972, November 23, 1972, NSC, Box 858.

PAGE 436 **On November 24:** Colonel R. Kennedy to A. Haig, from RN to HK, November 24, 1972, HKOF, NSC, Box 26; Berman, 193–94, for the quotes.

PAGE 436 **Nixon repeated:** RN to HK, November 24, 1972, HKOF, NSC, Box 26; HK and N. P. Duc and D. L. Lam, Memcon, November 25, 1972, NSC, Box 858.

PAGE 437 **The North:** Colonel R. Kennedy to A. Haig, from RN to HK, November 24, 1972, HKOF, NSC, Box 26.

PAGE 437 **The deadlock:** Isaacson, 474–75; Haldeman, *Diaries*, 540–41, 544.

PAGE 437 **Nixon, in fact:** Haldeman, CD Rom Diaries, November 29, 1972.

PAGE 438 **As much as anything:** ANS, October 24, 1972, POF, Box 45; Isaacson, 479–80; Haldeman, *Diaries*, 540–41; HK, *WHY*, 1409; HK and J. Schecter, December 1, 1972, TC.

PAGE 438 **In November:** Isaacson, 476–78; Richard Solomon interview, May 5, 2006; HK and J. Schecter, December 1, 1972, December 14, 1972, TCs.

PAGE 439 **Nixon didn't mind:** Haldeman, CD Rom Diaries, November 18, 1972, November 19, 1972, November 20, 1972.

PAGE 439 **Kissinger's return from:** Haldeman, *Diaries*, 543–44; HK, *WHY*, 1320; RN and HK, November 27, 1972; for HK's hopes, HK and M. Laird; HK and M. Berger, November 27, 1972; HK and R. Ziegler; HK and Haldeman, November 28, 1972, TCs.

PAGE 440 **Nixon was more realistic:** HK to E. Bunker, November 29, 1972, describing the November 29 meeting, AHCHF, NSC, Box 997; best account of the November 29 exchanges is in Berman, 197–202.

PAGE 440 **Nixon saw the meeting:** Haldeman, *Diaries*, 546; Berman, 204–5. RN and HK, December 1, 1972, TC.

PAGE 440 **In response:** HK to RN, November 30, 1972, NSC, Box 862; HK to E. Bunker, November 30, 1972, AHCHF, NSC, Box 997. RN and Joint Chiefs, Memcon, November 30, 1972, ibid., Box 998.

PAGE 441 **If he had read:** Polls of September 3, 1972, and November 26, 1972; *Gallup, 1935–1997*, CD Rom edition; RN and HK, December 1, 1972, TC; Haldeman, CD Rom Diaries, December 6, 1972.

PAGE 442 **As Kissinger prepared:** RN and HK, December 1, 1972, TC.

PAGE 442 **Kissinger arrived in Paris:** Haldeman, CD Rom Diaries, December 2, 1972, December 5, December 6, 1972, which give additional detail to what is in Haldeman, *Diaries*, 547–50; Colonel R. Kennedy to A. Haig (RN to HK), December 4, 1972, December 5, 1972, HKOF, NSC, Box 27.

PAGE 442 **Nixon resisted:** RN and Colonel R. Kennedy, December 6, 1972, TC, AHCHF, NSC, Box 998; Haldeman, CD Rom Diaries, December 7, 1972.

PAGE 443 **Yet Nixon believed:** Haldeman, CD Rom Diaries, December 10, 1972; RN and A. Haig, December 10, 1972, TC, AHCHF, NSC, Box 998; HK to VP, December 11, 1972, HKOF, NSC, Box 27; Haldeman, *Diaries*, 553.

PAGE 443 **Before Agnew:** A. Haig to HK, December 12, 1972; A. Haig to RN, December 13, 1972, HKOF, NSC, Box 27; RN and A. Haig, December 12, 1972, TC, AHCHF, NSC, Box 998; Berman, 212–13.

PAGE 443 **The collapse:** Quoted in Isaacson, 466.

PAGE 443 **Nixon and his two aides:** Ibid.; Haldeman, CD Rom Diaries, December 8, 1972, December 13, 1972; on RN's bombing plans see also, A. Haig to HK, December 13, 1972, AHCHF, NSC, Box 997; on HK's rationality and need for rest, RN and A. Haig, December 13, 1972, TC, ibid., Box 998.

PAGE 444 **Kissinger was frustrated:** Isaacson, 467; HK and M. Berger, December 14, 1972; RN and HK, December 17, 1972, December 19, 1972, TCs.

PAGE 444 **Nixon's concerns:** Haldeman, *Diaries*, 555; see Haldeman, CD Rom version, December 14, 1972, for more detail; see also the December 19, 1972 entry.

PAGE 445 **Nixon's objective:** RN to HK, December 15, 1972, December 16, 1972, PPF, Box 4.

PAGE 445 **The news conference:** RN and HK, December 17, 1972, TC; RN and A. Haig, December 13, 1972, TCs, AHCHF, NSC, Box 998; Berman, 215–20, for additional quotes.

PAGE 446 **By contrast:** ANS, December 15, 1972, POF, Box 46; E. Bunker, A. Haig and Thieu, Memcon, December 19, 1972, NSC, Box 860.

PAGE 446 **Thieu signaled:** December 20, 1972, Memcon, with N. Thieu to RN attached, ibid.

PAGE 446 **Kissinger advised Nixon:** HKto RN, December 20, 1972, NSC, Box 862; Haldeman, CD Rom Diaries, December 20, 1972; Alexander Haig interview, September 29, 2006.

CHAPTER 14 NEW MISERIES

PAGE 451 **At the start:** Haldeman, *Diaries*, 561–62.

PAGE 451 **In January:** *Gallup, 1935–1997*, CD Rom edition, January 26, 1973. Berman, 221.

PAGE 452 **When Kissinger met:** RN, *Memoirs*, 743.

PAGE 452 **Nixon's prediction:** HK to RN, January 8, 1973, HKOF, NSC, Box 28;

"It was not," quoted in Isaacson, 480; HK and Tho, Memcon, January 8, 1973, NSC, Box 860.

PAGE 452 **Thieu's government:** RN to Thieu, January 5, 1973, NSC, Box 766; HK and Do, D. Diem, Phuong, Memcon, January 5, 1973, NSC, Box 862.

PAGE 453 **Nixon was especially:** HK to E. Bunker, January 12, 1973, HKOF, NSC, Box 28; RN to N. Thieu, January 14, 1973, NSC, Box 860.

PAGE 453 **Although Thieu finally:** Berman, 227, 233; HK and K. Hart, January 19, 1973, TC; N. Thieu to RN, January 20, 1972, NSC, Box 860; Thieu to RN, January 21, 1973, NSC, Box 1020.

PAGE 453 **To give the appearance:** RN and HK, January 20, 1972, TC.

PAGE 453 **Although he said nothing:** RN and HK, January 18, 1973, TC; Berman, 228–331.

PAGE 454 **In a speech:** PPP:RN, 1973, 18–20; "HK Press Briefing," January 24, 1973, Handwriting, POF, Box 20.

PAGE 454 **Nixon and Kissinger ignored:** HK and D. Marron, January 24, 1973; HK and R. Evans, January 24, 1973; HK and M. Kalb, January 25, 1973, TCs; Ehrlichman, 316.

PAGE 455 **The ink was:** W. Sullivan to HK, January 24, 1973, HKOF, NSC, Box 125; U.S. embassy Saigon to secretary of state, January 25, 1973, NSC, Box 192; ANS, January 30, 1973, POF, Box 46; "HK News Conference," Memcon, January 31, 1973, NSC, Box 1026.

PAGE 455 **Relief in America:** ANS, January 27, 1973, Handwriting, POF, Box 20; Haldeman, *Diaries*, 565, 568–69; RN and HK, January 18, 1973, TC; "Action Memo," January 19, 1973, Staff and Off. Files, Box 112, Haldeman Papers.

PAGE 455 **Although Kissinger told:** RN and HK, January 18, 1973; HK and B. Walters, January 31, 1973; HK conversations with M. Kalb, January 23, 1973; J. Alsop, January 24, 1973; B. Gwertzman and M. Wallace, January 25, 1973; HK and W. Porter, January 31, 1973, TCs. B. Kehrli to Haldeman, January 30, 1973, Staff and Off. Files, Box 108, Haldeman Papers.

PAGE 456 **Kissinger's celebrity:** ANS, February 2, 1973, POF, Box 46; Haldeman, *Diaries*, 573–74.

PAGE 456 **A James Reston:** Ibid., 562; Reston, "Nixon and Kissinger," *New York Times*, December 31, 1972.

PAGE 456 **In January:** Haldeman, *Diaries*, 563. The Goldwater-Buckley conversation was related to me by Professor J. Hart of Dartmouth College, a Buckley colleague at the *National Review*.

PAGE 457 **Nixon wanted:** Haldeman, *Diaries*, 565, 567. Notes, January 1973, Box 47, Haldeman Papers; Dallek, *Flawed Giant*, 618–19.

PAGE 457 **An alternative proposal:** RN to Haldeman, March 12, 1973, PPF, Box 4.

PAGE 458 **Because he believed:** ANS, February 2, 1973, POF, Box 46.

PAGE 458 **Nixon instructed:** Haldeman to C. Colson, January 22, 1973, Staff and Off. Files, Box 179, Haldeman Papers; RN to Haldeman, January 25, 1973, PPF, Box 4.

PAGE 458 **The counterpoint Nixon:** "RN and Bipartisan Leadership," Memcon, January 5, 1973, POF, Box 90; ANS, February 3, 1973, POF, Box 47.

PAGE 458 **In reality:** Buchanan, 122.

PAGE 459 **Nixon's reluctance:** HK to RN, January 20, 1972; RN to secretary of state, January 26, 1972, HKOF, NSC, Box 134; HK to RN, February 11, 1972, NSC, Box 658; RN to HK, March 23, 1972, PPF, Box 3.

PAGE 459 **Sadat's expulsion:** H. Saunders to HK, November 9, 1972, with HK to RN attached, NSC, Box 610; Haldeman, CD Rom Diaries, November 17, 1972.

PAGE 459 **Nixon shared Henry's:** HK to L. Brezhnev, December 18, 1972, NSC, Box 495; RN and Y. Rabin, Memcon, January 25, 1973, POF, Box 90.

PAGE 460 **Nixon and Kissinger agreed:** H. Saunders to HK, February 21, 1973, HKOF, NSC, Box 130; HK to RN, February 28, 1973, NSC, Box 922.

PAGE 460 **Kissinger also suggested:** HK, *YOU*, 211.

PAGE 460 **In their meeting:** RN and HK and G. Meir and Y. Rabin, Memcon, March 1, 1973, NSC, Box 1026; HK and W. Rogers and M. Laird, Memcon, March 2, 1973, HKOF, NSC, Box 8; HK, *YOU*, 220–22.

PAGE 461 **The meeting pleased:** Ibid., 221; "A war?" quoted in Ambrose, *Nixon: Triumph of a Politician*, 167.

PAGE 461 **The Middle East:** January 27, 1973, *Gallup, 1937–1997*, CD Rom edition; ANS, February 2, 1973, POF, Box 46.

PAGE 462 **The polling data:** For the Admiral E. Zumwalt and consulate general comments and the offensive against Tay Ninh, see Berman, 261, 251–52, 241–42; Bundy, 367.

PAGE 462 **Nixon and Kissinger worried:** RN and HK, February 5, 1973; HK and Admiral T. Moorer, February 6, 1973, TCs.

PAGE 463 **Cambodia and Laos:** HK and W. Rogers, February 20, 1973, TC; Bundy, 366, 374–75; HK and Admiral T. Moorer, February 20, 1973, TC; HK, *YOU*, 35–36.

PAGE 463 **Kissinger set out:** HK itinerary, February 7–19, 1973, HKOF, NSC, Box 29; HK to RN, February 27, 1973, PPF, Box 6; HK, *YOU*, 9–23.

PAGE 464 **Kissinger's three days:** HK to RN, February 27, 1973, PPF, Box 6; HK, *YOU*, 23–28; B. Scowcroft to RN, February 11, 1973, HKOF, NSC, Box 29.

PAGE 464 **The conversations:** B. Scowcroft to RN, February 14, 1973, ibid.; HK to RN, February 27, 1973, PPF, Box 6; HK, *YOU*, 34–37.

PAGE 464 **The final joint:** HK to B. Scowcroft, February 13, 1973, HKOF, NSC, Box 29; HK to secretary of defense and D.C.I., February 24, 1973, Box 8; HK to Le Duc Tho, February 20, 1973, Box 125.

PAGE 465 **Nixon also did:** ANS, February 26, 1973, POF, Box 48.

PAGE 465 **A UPI:** Ibid., February 21, 1973, POF, Box 47.

PAGE 465 **Nixon's image-making:** R. Ziegler to RN, March 6, 1973, POF, Box 91.

PAGE 466 **In January 1973:** PPP:RN, 1973, 57–58; Bundy, 415–16; RN to General A. Goodpaster, Memcon, February 15, 1973; also RN to C. Soames, Memcon, February 16, 1973, POF, Box 91; RN and E. Richardson, Memcon, and Joint Chiefs of Staff, February 15, 1973, NSC, Box 1026.

PAGE 466 **During his visit:** HK, Mao, and Chou, Memcon, February 17, 1973; HK to RN, February 24, 1973, March 2, 1973, PPF, Box 6.

PAGE 466 **In March:** RN to HK, March 10, 1973; RN to Haldeman, March 4, 1973, PPF, Box 4; Haldeman, *Diaries*, 587.

PAGE 467 **Kissinger's China visit:** HK, Mao, and Chou, Memcon, February 17, 1973; HK to RN, February 24, 1973, March 2, 1973, PPF, Box 6.

PAGE 467 **Kissinger's enthusiasm:** ANS, February 23, 1973, POF, Box 49.

PAGE 467 **However much:** Le Duc Tho to HK, March 1, 1973, March 2, 1973; B. Scowcroft to Tho, March 6, 1973, HKOF, NSC, Box 125; HK to RN, March 8, 1973, NSC, Box 495.

PAGE 468 **South Vietnam's actions:** HK and T. Phuong, Memcon, March 6, 1973, NSC, Box 943.

PAGE 468 **Yet however much:** HK and Bundy, March 2, 1973, TC; RN and Senators, Memcon, March 8, 1973; "Cabinet Meeting," March 9, 1973, POF, Box 91.

PAGE 468 **Kissinger reported to:** HK to RN, March 9, 1973, HKOF, NSC, Box 125; *Los Angeles Times* clipping, April 4, 1973, in Off. Files, Box 110, Haldeman Papers.

PAGE 469 **By the middle of March:** HK to E. Bunker, March 15, 1973, HKOF, NSC, Box 126; HK and E. Richardson, Memcon, March 16, 1973; "Cabinet Meeting," Memcon, March 18, 1973, NSC, Box 1026; Berman, 254–58.

PAGE 469 **The press began:** ANS, March 14, 1973, POF, Box 49.

PAGE 469 **Despite growing doubts:** ANS, March 5, 1973, POF, Box 49.

PAGE 469 **The White House:** HK to RN, March 30, 1973, NSC, Box 113; RN and HK, March 28, 1973, TC.

PAGE 469 **To maintain the fiction:** RN, HK, and N. Thieu, Memcon, April 2, 1973, April 3, 1973, HKOF, NSC, Box 126; HK, *YOU*, 309–15; Berman, 256–57; also the memo of a conversation N. Sheehan had with J. Negroponte, December 11, 1983, in Neil Sheehan Papers, LC. L. Berman gave me the memo.

PAGE 470 **Thieu's visit:** Bundy, 383–84.

PAGE 470 **Despite Thieu's assertions:** HK to Haig, April 9, 1973; HK, "Meeting with General Haig," April 14, 1973, AH Subject File, NSC, Box 1020; A. Haig to HK, April 11, 1973, Box 1021.

PAGE 471 **By the middle of April:** A. Dobrynin note handed to HK for RN, April 10, 1973; Memcon, HK to A. Dobrynin, April 10, 1973, NSC, Box 496; see also W. Sullivan to HK, April 15, 1973; DRV message, April 20, 1973, HKOF, NSC, Box 126; for HK's verbal sallies against the North Vietnamese, see HK and O. Passman, April 13, 1973; and HK and E. Richardson, April 14, 1973, TCs.

PAGE 471 **Kissinger's threat:** Quoted in Berman, 258–59.

PAGE 471 **Watergate was more:** RN, *Memoirs*, 815.

PAGE 471 **Renewed bombing:** RN and HK, April 21, 1973, TC.

PAGE 472 **But it wasn't:** *Gallup, 1935–1977*, CD Rom edition, January 26, 1973, March 11, 1973, July 1–20, 1973.

PAGE 472 **"By the end of April 1973":** HK, *YOU*, 324, 326–27; ANS, March 26, 1973, POF, Box 50.

PAGE 473 **During the last days:** HK and Garment, April 21, 1973, April 22, 1973, TCs; HK, *YOU*, 102–4.

PAGE 473 **Kissinger later claimed:** RN made only one other reference to the Year of Europe after his January news conference: PPP:RN, 1973, 103–4; HK, *YOU*, 100, 103; the Kalbs, 426–27; Haldeman, *Diaries*, 588–89; HK and A. Haig, May 1, 1973, TC; HK and A. Hestenes, Memcon, April 7, 1973, HKOF, NSC, Box 15.

PAGE 474 **Because Henry understood:** The Kalbs, 427–28.

PAGE 474 **The response to the speech:** Ibid., 428–29; HK, *YOU*, 101–2.

PAGE 475 **Although, as he later acknowledged:** Ibid., 79–80.

PAGE 475 **The negative response:** HK and J. Alsop, April 24, 1973; HK and P. Geyelin, April 25, 1973, TCs.

PAGE 475 **With talk of:** HK to RN, May 11, 1973, PPF, Box 14; RN and HK et al., Memcon, May 25, 1973, NSC, Box 1027; RN and G. Pompidou, Memcon, May 31, 1973, POF, Box 91.

PAGE 476 **Kissinger saw the domestic:** HK, *YOU*, 122–24.

PAGE 476 **The Soviet Summit:** RN to L. Brezhnev, February 2, 1973, NSC, Box 495; L. Brezhnev to RN, February 22, 1973, NSC, Box 72.

PAGE 476 **Nixon and Kissinger saw:** RN to cabinet, March 18, 1973, NSC, Box 1026; see also HK to RN, HK's meetings of March 6, 1973, and March 8, 1973, with A. Dobrynin; HK to RN, March 7, 1973; RN meeting with A. Dobrynin, March 8, 1973, NSC, Box 495.

PAGE 476 **Democratic Senate:** W. Timmons to RN, April 19, 1973, CF, Box 9; RN quoted in Ambrose, *Nixon: Ruin and Recovery*, 172.

PAGE 477 **Nixon hoped:** "Meeting with Senators," March 8, 1973, POF, Box 91.

PAGE 477 **At the beginning of May:** PPP:RN, 1973, 349, 352, 368–76.

PAGE 477 **Billy Graham:** L. M. Higby to RN, May 2, 1973, POF, Box 22.

PAGE 477 **Harris relayed:** W. R. Howard to RN, May 15, 1973, POF, Box 22—RN's comment is handwritten on the memo.

PAGE 478 **And in the spring:** RN to L. Brezhnev, May 1, 1973, NSC, Box 68; HK and J. Reston, May 3, 1973, TC.

PAGE 478 **Kissinger's trip:** HK to B. Scowcroft, May 8, 1973, HKOF, NSC, Box 32; HK to RN, May 11, 1973, PPF, Box 14; HK and J. Oakes, May 11, 1973, TC.

PAGE 478 **The rosy picture:** HK and RN, May 11, 1973, TC; HK to B. Scowcroft, two cables of May 5, 1973, HKOF, NSC, Boxes 32 and 33; B. Scowcroft to HK, May 8, 1973; B. Scowcroft to RN, May 9, 1973, Box 32; Isaacson, 495–97.

PAGE 480 **Brezhnev remained:** L. Brezhnev to RN, May 13, 1973, NSC, Box 72; RN to L. Brezhnev, May 16, 1973, PPF, Box 6.

PAGE 480 **If foreign policy:** HK and E. Severeid, April 26, 1973; HK and J. Reston, May 3, 1973, TCs.

PAGE 481 **As Kissinger was preparing:** Isaacson, 497–98. HK and J. Kraft, May 12, 1973, TC.

PAGE 481 **When officials:** HK and J. Kraft, May 12, 1973, May 15, 1973; HK and F. Boyd, May 14, 1973; HK and P. Lisagor, May 14, 1973; HK and J. Reston, May 15, 1973; HK and S. Hersh, May 15, 1973, TCs; Isaacson, 498–500.

PAGE 482 **As Kissinger was about:** RN and HK, May 15, 1973; HK and J. Ander-

son, June 1, 1973, TCs; see Isaacson, 500–2, for the material on HK's celebrity and party.

PAGE 483 **The negotiations in Paris:** Memo, May 6, 1973; C. Whitehouse to HK, May 12, 1973; HK to C. Whitehouse, May 12, 1973, HKOF, NSC, Box 126; HK to C. Whitehouse, May 17, 1973, Box 35.

PAGE 483 **At the opening meeting:** "Opening Statement," May 17, 1973, NSC, Box 114; HK to RN, May 17, 1973, May 18, 1973, HKOF, NSC, Box 35.

PAGE 483 **By the next day:** HK to RN, May 18, 1973, ibid.

PAGE 483 **As Kissinger would acknowledge:** HK to RN, May 24, 1973, NSC, Box 114; HK, *YOU*, 327–30.

PAGE 484 **Wishful thinking:** HK to RN, May 24, 1973, NSC, Box 114; RN, HK, and cabinet, Memcon, May 25, 1973, NSC, Box 1027.

PAGE 484 **Increasingly, the administration's:** RN and HK, June 1, 1973, TC.

PAGE 484 **The return of:** Memo for RN's File, May 24, 1973, POF, Box 91.

CHAPTER 15 IN THE SHADOW OF WATERGATE

PAGE 486 **By the beginning of June:** RN, *Memoirs*, 873–74; Ambrose, *Nixon: Ruin and Recovery*, 161, 163; HK and R. Evans, June 4, 1973; HK and S. Alsop, June 2, 1973, TCs.

PAGE 487 **Despite his distress:** RN and HK, June 10, 1973, TC.

PAGE 487 **Kissinger's hyperbole:** Coolidge quote was posted on History News Network, March 6, 2005.

PAGE 488 **They remained hopeful:** HK and Lord Cromer, June 2, 1973, TC.

PAGE 488 **Within hours of:** HK to B. Scowcroft, June 6, 1973, HKOF, NSC, Box 37; HK to B. Scowcroft, handwritten message, June 6, 1973, NSC, Box 105.

PAGE 488 **Nixon was "outraged":** B. Scowcroft to HK, June 8, 1973, two messages; HK to A. Haig, June 8, 1973; HK to B. Scowcroft, June 9, 1973, HKOF, NSC, Box 37; HK to C. Whitehouse, June 11, 1973, NSC, Box 105; HK to RN, June 11, 1973, NSC, Box 115.

PAGE 489 **Although Nixon and Kissinger:** HK and H. Sonnenfeldt, June 10, 1973; RN and HK, June 11, 1973; HK and C. Whitehouse, June 11, 1973, TCs; Thieu to RN, June 11, 1973, NSC, Box 126; RN to Thieu, June 12, 1973; Whitehouse to HK, June 13, 1973, NSC, Box 105.

PAGE 489 **Extracting Thieu's:** RN to Brezhnev, June 7, 1973, NSC, Box 68.

PAGE 489 **In private:** HK, *YOU*, 122–23, 287–88.

PAGE 490 **Although Kissinger would:** RN and HK, June 10, 1973, June 11, 1973, TCs.

PAGE 490 **The Summit was:** Summit Schedule, June 18–23, 1973, NSC, Box 939.

PAGE 490 **Whatever Soviet doubts:** RN and L. Brezhnev, Memcon, June 18, 1973, NSC, Box 75.

PAGE 491 **The afternoon exchanges:** Ibid.; HK, *YOU*, 291–93. R. Ziegler to RN, June 20, 1973, POF, Box 92.

PAGE 492 **Mindful of extensive:** RN and L. Brezhnev, Memcon, June 20, 1973; "Brezhnev Departure Remarks," June 23, 1973, POF, Box 92.

PAGE 492 **Yet the effort:** "Signing of Agreements during Brezhnev Visit," June 15, 1973, NSC, Box 939; RN and HK, June 19, 1973, TC; RN to HK, June 21, 1973, PPF, Box 10; Bundy, 409–10.

PAGE 492 **The inability to complete:** RN and L. Brezhnev, Memcon, June 20, 1973, NSC, Box 75.

PAGE 493 **China's absence:** RN and L. Brezhnev, Memcon, June 23, 1973; HK and A. Gromyko, Memcon, June 23, 1973, ibid; Bundy, 411–12.

PAGE 493 **A general statement:** HK and A. Gromyko, Memcon, June 23, 1973, NSC, Box 75; HK, *YOU*, 295–96.

PAGE 493 **On the last night:** RN and L. Brezhnev, Memcon, June 23, 1973, NSC, Box 75; HK, *YOU*, 296–99.

PAGE 494 **With Watergate pushed:** HK and R. Evans, June 22, 1973; RN and HK, June 24, 1973, TCs.

PAGE 494 **Kissinger was less:** HK, *YOU*, 300–1. HK and A. Dobrynin, Memcon, July 26, 1973, NSC, Box 68.

PAGE 494 **In the days following:** HK and RN, July 16, 1973; HK and A. Dobrynin, Memcon, July 26, 1973, NSC, Box 68.

PAGE 495 **The Summit provoked:** RN and Congressional Delegation, Memcon, June 30, 1973, NSC, Box 127; Memo "Shown to 'D' by HAK," July 10, 1973, NSC, Box 68; HK and B. Scowcroft et al., Memcon, July 19, 1973, NSC, Box 1027; R. Solomon to HK, July 24, 1973, HKOF, NSC, Box 98.

PAGE 495 **On June 25:** HK and M. Laird, June 28, 1973; HK and J. Javits, June 28, 1973; HK and W. Buckley, June 29, 1973, TCs.

PAGE 496 **At the beginning of July:** Haldeman, *Diaries*, 555; Reeves, 552–53.

PAGE 496 **For eighteen days:** RN, *Memoirs*, 896–99; Ambrose, *Nixon: Ruin and Recovery*, 179–91; see also, "Statement by Ronald Ziegler and Dr. Walter Tkach," July 12, 1973, with RN's Daily Diary attached, Press Briefings File.

PAGE 497 **As news of the president's:** Confidential source. September 23, 2005; Dale Rogers Marshall, William Rogers's daughter, says her father described such calls to him.

PAGE 497 **Nixon's paranoia:** ANS, July 23, 1973, POF, Box 50; J. Hart, a Nixon speechwriter and later distinguished professor of English at Dartmouth, to author, August 9, 2005.

PAGE 497 **During Nixon's hospitalization:** R. Ziegler and Dr. W. Tkach, July 12, 1973, Press Briefings File.

PAGE 498 **Although subsequent briefings:** R. Ziegler, Dr. W. Tkach, Dr. R. C. Elliott, and Dr. S. Katz, July 13, 1973, ibid.

PAGE 498 **On the third day:** R. Ziegler, Dr. W. Tkach, July 14, 1973, ibid.

PAGE 499 **On the fourth day:** Ibid., July 16, 1973, July 17, 1973. RN, *Memoirs*, 899–900.

PAGE 499 **Dr. D. Earl Brown:** Andre Sobocinski, Office of the Historian, Bureau of Medicine and Surgery, to author, December 12, 2005; Dr. D. Earl Brown interview, December 27, 2005.

Page 499 **Nixon's conversations:** RN and HK, July 13, 1973, July 14, 1973, July 18, 1973, TCs.

Page 500 **Eager to refute:** "Remarks of the President," and Daily Diary, July 20, 1973, Briefing Files.

Page 501 **But the public:** ANS, July 23, 1973, POF, Box 50; PPP:RN, 1973, 657–58, 660–66, 671–80; Ambrose, *Nixon: Ruin and Recovery*, 201; RN and HK, July 29, 31, 1973, TCs; P. Buchanan to A. Haig, July 31, 1973, AH, WHSF, Box 1.

Page 501 **Nixon concluded:** HK, *YOU*, 114; HK to A. Haig, August 1973, AH, WHSF, Box 3; HK and A. Haig, August 9, 1973, TC.

Page 502 **Nixon began a:** RN and HK, August 12, 1973, TC.

Page 502 **By uncritically:** HK, *YOU*, 125, 424.

Page 503 **No analysis:** HK and A. Hestenes, Memcon, April 7, 1973, HKOF, NSC, Box 15.

Page 503 **In a nationally:** PPP:RN, 1973, 698–703.

Page 503 **The initial response:** A. Haig to RN, August 18, 1973, AH, WHSF, Box 40.

Page 503 **But Watergate:** W. R. Howard to RN, September 5, 1973, CF, Box 12.

Page 504 **Nevertheless, Nixon:** Ambrose, *Nixon: Ruin and Recovery*, 210–11.

Page 504 **His speech to:** PPP:RN, 1973, 703–10.

Page 504 **Two days later:** Ambrose, *Nixon: Ruin and Recovery*, 211.

Page 505 **Nixon hoped:** PPP:RN, 1973, 710–25.

Page 505 **In his memoirs:** RN, Memoirs, 907; HK, *YOU*, 414–23; Isaacson, 502–3.

Page 506 **Nixon's characteristic:** Isaacson, 502–3; Haig, 344–45.

Page 506 **Nixon asked Haig:** Isaacson, 503.

Page 506 **On August 21:** Ibid., 503–4; HK, *YOU*, 3–4; PPP:RN, 1973, 710–11.

Page 507 **"I had achieved:** HK, *YOU*, 5.

Page 507 **In assuming:** Ibid., 122–26.

Page 507 **No doubt, portraying:** PPP:RN, 1973, 815–17.

Page 508 **Kissinger was mindful:** HK, *YOU*, 434.

Page 508 **Yet Kissinger's intellectual:** Isaacson, 509–10.

Page 508 **Whatever the limitations:** PPP:RN, 1973, 817.

Page 508 **His personal life:** Isaacson, 587–90.

Page 509 **Events in the autumn:** Ibid., 504–5. RN and HK, September 9, 1973, September 17, 1973, TCs.

Page 509 **Events in the autumn:** J. N. Irwin to HK, December 22, 1971, NSC, Box H-220; J. Connally to RN, January 15, 1972, CF, Box 6.

Page 510 **A column by:** U.S. Department of State, FOIA, Church Report (Covert Action in Chile, 1963–1973), 14–15, 27–28, 53–55; Department of State, Hinchey Report, September 18, 2000, 8, available at the department's website; Kornbluh, 97–105, 146–48.

Page 510 **Over the next five months:** Ibid., 105–9, 149–51.

Page 511 **While Nixon and Kissinger:** Ibid., 109–15, 152–60.

Page 511 **The White House at once:** HK and K. Rush, September 13, 1973; RN and HK, September 16, 1973, TCs.

Page 512 **Administration actions:** Kornbluh, 242–44.

Page 512 **Reports of severe:** Ibid., 161–62, 182–88.

PAGE 513 **Although the U.S.:** HK and F. Mankiewicz, September 20, 1973, TC.

PAGE 513 **On September 28:** "Secretary of State Staff Meeting," September 28, 1973, HK Papers; Kornbluh, 231.

PAGE 513 **U.S. officials:** "Secretary of State Staff Meetings," October 1, 1973, December 3, 1974, HK Papers; Kornbluh, 189–92, 233–36.

PAGE 515 **Few issues:** HK, *YOU*, 374.

PAGE 515 **By contrast:** Ibid., 369–73.

PAGE 516 **In September:** Ambrose, *Nixon: Ruin and Recovery*, 205–8, 222–25, 231–32.

PAGE 517 **Nixon saw Agnew's:** RN and HK, September 23, 1973, TC; PPP:RN, 1973, 867–69; HK, *YOU*, 514; Ambrose, *Nixon: Ruin and Recovery*, 237–38; Herbert S. Parmet, "Gerald R. Ford," in Graff, ed., *The Presidents* 535–50.

PAGE 517 **The eruption:** Kutler, 329–32, 400–11; Ambrose, *Nixon: Ruin and Recovery*, 200, 239, 241–44, 247–50; PPP:RN, 1973, 887–91.

PAGE 518 **Similarly, Nixon's:** Kutler, 438–39, 601–3; Ambrose, *Nixon: Ruin and Recovery*, 239, 254; PPP:RN, 1973, 893–95.

PAGE 519 **Nixon fought back:** PPP:RN, 1973, 896–906.

PAGE 519 **On November 7:** Kutler, 439.

PAGE 520 **Not even a war:** HK to RN, n.d., summarizing HK meeting with Ismail, May 20, 1973, HKOF, NSC, Box 130.

PAGE 520 **Washington and Moscow:** For a fine discussion of the American failure to foresee the 1973 war, see Bundy, 428–34; HK and A. Dobrynin, Memcon, August 16, 1973, NSC, Box 68.

PAGE 521 **Sadat believed:** My analysis of RN and HK goals in the war largely rests on W. B. Quandt and HK, October 16, 1973, October 17, 1973; HK to RN, October 17, 1973; RN, HK, and Arab foreign ministers, Memcon, October 17, 1973, NSC, Box 664; "Cabinet Meeting," October 18, 1973, POF, Box 92; see also Bundy's analysis of U.S. goals in the war: 442–44.

PAGE 521 **While Kissinger:** HK and A. Haig, October 6, 1973, TC.

PAGE 522 **Forty-five minutes:** HK and A. Dobrynin; RN and HK, ibid.

PAGE 522 **At 9:35 A.M.:** HK and A. Haig, ibid; HK to RN, October 6, 1973, NSC, Box 664; "Walter Mitty" comment quoted in Isaacson, 514.

PAGE 522 **Over the next three:** HK and Israeli Chargé; Memcon, October 7, 1973, NSC, Box 664; L. Brezhnev to RN, October 7, 1973; HK to E. Amman, October 9, 1973, NSC, Box 68; W. B. Quandt, October 9, 1973, NSC, Box 318.

PAGE 522 **Between October 6:** See the conversations on October 7, 1973 and October 8, 1973, between HK and the president, Schlesinger, and Ziegler, TCs. Also, Isaacson, 517–18, for developments on October 9, 1973.

PAGE 523 **On October 10:** H. Sonnenfeldt to HK, October 10, 1973, NSC, Box 68.

PAGE 523 **On the same day:** HK and A. Haig; HK and R. Ziegler, October 10, 1973, TCs.

PAGE 524 **Nixon's inattentiveness:** RN and HK, October 11, 1973, TC.

PAGE 524 **At seven fifty-five that:** HK and B. Scowcroft, October 11, 1973, TC.

PAGE 524 **Although Nixon would:** PPP:RN, 1973, 871; RN, HK, and Arab foreign

ministers, Memcon, October 17, 1973, NSC, Box 664; "Cabinet Meeting," October 18, 1973, POF, Box 92; HK to B. Scowcroft, October 15, 1973, TC; A. Haig to HK, October 13, 1973, AH, WHSF, Box 8.

PAGE 525 **Between October 6:** See the exchanges between L. Brezhnev and RN between October 12, 1973, and October 19, 1973 in NSC, Box 69.

PAGE 525 **On October 19:** HK to B. Scowcroft, October 21, 1973, HKOF, NSC, Box 39; HK to A. Haig, AH, WHSF, Box 40.

PAGE 526 **Nixon lodged:** B. Scowcroft to HK, October 20, 1973, and two cables on October 21, 1973; HK to B. Scowcroft, October 21, 1973, HKOF, NSC, Box 39. Interview with B. Scowcroft, January 5, 2007.

PAGE 526 **With Kissinger and:** A. Haig to HK, October 22, 1973, ibid.

PAGE 527 **Kissinger shared:** HK, *YOU*, 535, 596, 598–99; for HK's calls to congressmen, see RN and HK, October 23, 1973, TC. On the Twenty-fifth Amendment, Alexander Haig interview, September 29, 2006; on HK's reluctance to tie foreign policy too closely to Watergate, see HK and A. Haig, October 19, 1973, TC.

PAGE 528 **Yet he was:** HK, *YOU*, 593; PPP:RN, 1973, 904.

PAGE 529 **As developments:** "State Department Staff Meeting," October 23, 1973, HK Papers.

PAGE 529 **His euphoria:** Messages are all in NSC, Box 69; see also HK, *YOU*, 575–81.

PAGE 529 **In the midst:** Ibid., 581–82; RN and HK, October 24, 1973, TC.

PAGE 530 **After receiving Brezhnev's:** HK, *YOU*, 585–88; HK and A. Haig, October 24, 1973, TCs; unsigned message to Brezhnev, October 25, 1973, NSC, Box 69.

PAGE 530 **The message:** L. Brezhnev to RN, October 26, 1973; RN to L. Brezhnev, two messages, October 27, 1973, HKOF, NSC, Box 10; RN to L. Brezhnev, October 26, 1973, October 27, 1973, NSC, Box 69; H. Sonnenfeldt to HK, October 26, 1973, NSC, Box 723; Bundy, 441–42.

PAGE 531 **Throughout the Middle East:** "The Decision to Alert U.S. Forces, October 24–25," NSC, Box 664; "Was this [alert]," quoted in HK, *Crisis*, 363; this book of transcripts omits materials I quote in my narrative. HK and A. Haig, October 24, 1973; October 25, 1973; RN and HK, October 25, 1973, TCs.

PAGE 531 **Although Kissinger was willing:** HK and A. Haig, Oct. 26, 1973, 7:55 P.M.; 8:13 P.M., TCs.

PAGE 532 **Nixon and his aides:** HK and A. Haig, October 24, 1973; HK and J. Reston, October 25, 1973, TCs.

PAGE 532 **But the way:** RN and HK, October 24, 1973, 7:10 P.M., TC.

CHAPTER 16 THE NIXON-KISSINGER PRESIDENCY

PAGE 534 **On October 30:** PPP:RN, 1973, 912–13; Ambrose, *Nixon: Ruin and Recovery*, 261.

PAGE 535 **For Kissinger and Haig:** HK and A. Haig, October 27, 1973, TC.

PAGE 535 **Nixon pressed:** RN and HK, October 29, 1973, TC.

PAGE 535 **Arranging:** HK and A. Haig, October 29, 1973; RN and HK, October 30, 1973, November 3, 1973; HK and B. Scowcroft, November 1, 1973, TCs.

PAGE 536 **Nixon, Kissinger:** RN and HK, November 4, 1973, TC.

PAGE 536 **Kissinger's strategy:** Isaacson, 538–39; Bundy, 444–45.

PAGE 536 **On November 7:** HK, *YOU*, 632–46. B. Scowcroft to RN, November 7, 1973, NSC, Box 1027.

PAGE 537 **Nixon tried:** PPP:RN, 1973, 916–22.

PAGE 537 **As a follow-up:** A. Haig to HK, November 8, 1973, NSC, Box 41.

PAGE 537 **Kissinger replied:** A. Haig to HK; HK to A. Haig, both November 8, 1973, NSC, Box 41; A. Haig to HK, November 8, 1973, AH, WHSF, Box 40.

PAGE 538 **For another week:** B. Scowcroft to RN, November 9, 1973, NSC, Box 139.

PAGE 538 **In China:** HK to B. Scowcroft, November 10, 1973, November 12, 1973, November 13, 1973 (two cables), NSC, Box 41; HK and Mao and Chou, Memcon, November 12, 1973, HKOF, NSC, Box 100.

PAGE 538 **Haig cabled:** B. Scowcroft to HK, November 14, 1973, ibid.; A. Haig to HK, November 13, 1973, AH, WHSF, Box 40.

PAGE 539 **Yet the harder:** PPP:RN, 1973, 946–64; Ambrose, *Nixon: Ruin and Recovery*, 271–72.

PAGE 539 **His performance:** For Nixon's public comments, see PPP:RN, 1973, 934–82; HK, "State Department Staff Meetings," November 19, 1973, HK Papers.

PAGE 540 **Henry had his hands:** On Vietnam, see HK to Le Duc Tho, November 5, 1973, NSC, Box 568; Tho to HK, November 15, 1973, NSC, Box 41; and Tho to HK, November 24, 1973, HKOF, NSC, Box 127; for the rest, see HK's staff meetings at the state department and his TCs between November 20, 1973 and November 30, 1973, HK Papers; see also the record of the RN and HK meeting with the bipartisan leadership, November 27, 1973, NSC, Box 1027, in which Kissinger briefed congressional leaders about Middle East policy. Nixon had very little to say.

PAGE 540 **Managing the president:** HK and A. Haig, November 17, 1973, TC.

PAGE 540 **Renewed press:** HK and A. Haig, November 24, 1973, TC.

PAGE 540 **Given Kissinger's affinity:** HK and R. McNamara, November 29, 1973, TC.

PAGE 541 **Kissinger's dominant:** RN to HK, "Meeting with Bi-Partisan Leaders," November 27, 1973, NSC, Box 1027; on the 18½-minute gap, see Ambrose, *Nixon: Ruin and Recovery*, 227–28, 268, 276–77; on administration oil policy and congressional response, see Bundy, 452–58.

PAGE 541 **Kissinger's continuing:** HK to H. Eilts, November 30, 1973, NSC, Box 639; HK and A. Ghorbal, Memcon, December 7, 1973, NSC, Box 1027; HK and G. Ford, December 7, 1973, TC.

PAGE 542 **Because Nixon's denial:** PPP:RN, 1973, 1005–9.

PAGE 542 **Between December 10:** Reports are in NSC, Box 42, Box 43. On the difficulties with Israel and HK's response to Tel Aviv and the attacks on

him, see B. Scowcroft to HK, December 12, 1973; HK to B. Scowcroft, December 13, 1973; HK to B. Scowcroft, December 15, 1973, NSC, Box 42.

PAGE 543 **Despite Henry's denials:** A. Haig to HK, December 18, 1973, AH, WHSF, Box 40. Interview with B. Scowcroft, January 5, 2007.

PAGE 543 **After ten hours:** HK to B. Scowcroft, December 17, 1973, NSC, Box 42; B. Scowcroft to RN, December 18, 1973, NSC, Box 43; Bundy, 448–49.

PAGE 543 **Nixon was delighted:** B. Scowcroft to HK, December 20, 1973, AH, WHSF, Box 12; HK to B. Scowcroft, December 19, 1973, NSC, Box 42.

PAGE 543 **If Kissinger had:** "Talking Points for the President on the Middle East," December 22, 1973, NSC, Box 43.

PAGE 544 **At the same time:** "Viet-Nam: The Setting in 1973," NSSM, NSC, Box H-201.

PAGE 544 **On December 7:** HK and V. Bac, Memcon, December 7, 1973, NSC, Box 1027.

PAGE 544 **Kissinger saw his:** B. Scowcroft to RN, December 21, 1973, HKOF, NSC, Box 127.

PAGE 544 **Yet Henry's success:** PPP:RN, 1973, 1016–18; Ambrose, *Nixon: Ruin and Recovery*, 283–84.

PAGE 544 **On December 20:** Goldwater, 339–44.

PAGE 545 **Admiral Elmo Zumwalt:** 459–60.

PAGE 546 **The two episodes:** Nixon's medical and psychological history is amply developed in Summers, *The Arrogance of Power*; see the numerous references in the book's index to Nixon's health, depression, drinking, and relations with Dr. Arnold Hutschnecker; "short circuits" quote is on 95; see also V. D. Volkan, N. Itzkowitz, and A. W. Dod's book, listed in the bibliography. Dr. J. R. Tkach to author, December 12, 2005; and author to Dr. Tkach, December 23, 2005.

PAGE 547 **Yet for all Nixon's:** Summers, 94.

PAGE 547 **Nixon matched:** PPP:RN, 1973, 1022–23.

PAGE 547 **Because Kissinger:** RN and HK, December 26, 1973, December 27, 1973, December 29, 1973, TCs. HK to RN, December 31, 1973, NSC, Box 69.

PAGE 548 **Nixon ended the year:** On the plane trip, see HK and A. Haig, December 26, 1973; RN and HK, December 27, 1973, TCs; for the rest, Ambrose, *Nixon: Ruin and Recovery*, 286–87; RN, *Memoirs*, 969–71.

PAGE 548 **Although Nixon remained:** PPP:RN, 1974, 5–6. *Gallup, 1935–1997*, CD-Rom edition; Ambrose, *Nixon: Ruin and Recovery*, 289.

PAGE 549 **Kissinger, who was:** HK and R. Pierpoint, M. Kalb et al., Memcon, January 2, 1974, NSC, Box 1028; *New York Times*, January 4, 1974.

PAGE 549 **The reporter's questions:** RN and HK, January 4, 1974, TC.

PAGE 549 **Kissinger's assurances:** B. Scowcroft to HK, n.d., but clearly January 1974, NSC, Box 43.

PAGE 550 **Kissinger was preoccupied:** HK to I. Fahmy, January 5, 1974, NSC, Box 639.

PAGE 550 **Nixon was reluctant:** RN, *Memoirs*, 984–85; HK, *YOU*, 885; Ambrose, *Nixon: Ruin and Recovery*, 292; PPP:RN, 1974, 8–10.

PAGE 550 **Nixon worried:** HK and L. Garment, January 23, 1974, TC.

PAGE 550 **Kissinger tried:** HK and A. Haig, January 8, 1974, TC.

PAGE 551 **In the afternoon:** HK and B. Scowcroft, January 8, 1974, TC.

PAGE 551 **The planned release:** HK and A. Haig, January 8, 1974, TC.

PAGE 551 **Kissinger flew:** HK and A. Sadat, Memcon, January 14, 1974, NSC, Box 1028.

PAGE 552 **Fahmy was:** Quoted in Isaacson, 552–53, 549; for HK's understanding of his role, see H. Saunders to HK, February 13, 1974, NSC, Box 318.

PAGE 552 **The extent to:** For the setting, see HK, *YOU*, 809–10; the cables are not in HK's memoirs. HK to B. Scowcroft, January 13, 1974, NSC, Box 453; B. Scowcroft to RN, January 13, 1974, HKOF, NSC, Box 140.

PAGE 553 **To squeeze every:** HK to B. Scowcroft, January 14, 1974, NSC, Box 43; PPP:RN, 1974, 11–12; Isaacson, 548–49.

PAGE 553 **To Nixon's dismay:** The poll is in Isaacson, 549–50.

PAGE 553 **On January 19:** PPP:RN, 1974, 12–16.

PAGE 553 **Although he said:** HK to B. Scowcroft, January 19, 1974, NSC, Box 43.

PAGE 553 **After a largely:** For the meeting in Syria, see HK to B. Scowcroft, January 20, 1974, NSC, Box 43; HK and H. Assad, Memcon, January 20, 1974, NSC, Box 1028, HK's rebuke to B. Scowcroft, January 20, 1974, NSC, Box 43; HK, *YOU*, 892–93.

PAGE 554 **The climate:** B. Scowcroft to HK, January 18, 1974, NSC, Box 43.

PAGE 554 **Press accounts:** B. Scowcroft to HK, January 13, 1974, January 14, 1974; HK to B. Scowcroft, January 13, 1974, January 14, 1974, NSC, Box 43; HK and H. Sidey, January 21, 1974, TC.

PAGE 555 **Kissinger's complaint:** HK and R. Ziegler, January 23, 1974; RN and HK, January 24, 1974, TCs.

PAGE 555 **Publicly, Nixon:** Zumwalt, 479.

PAGE 556 **Nixon himself:** HK and *Washington Star*, Memcon, January 28, 1974, NSC, Box 1028; RN meeting with GOP congressmen, January 28, 1974, POF, Box 93.

PAGE 556 **Nixon continued:** PPP:RN, 1974, 17–32.

PAGE 556 **Nixon remained:** RN and HK, January 23, 1974; January 28, 1974, January 29, 1974, TCs; HK to A. Sadat, January 24, 1974, NSC, Box 639.

PAGE 557 **On the morning:** HK and B. Scowcroft, January 30, 1974, TC.

PAGE 557 **In his speech:** PPP:RN, 1974, 49; RN and HK, January 30, 1974, TC.

PAGE 557 **Because Nixon:** RN, *Memoirs*, 975.

PAGE 557 **Instead of destroying:** PPP:RN, 1974, 54–55; Haig, 444–45.

PAGE 558 **Lingering hopes:** HK to A. Sadat, February 4, 1974, NSC, Box 639.

PAGE 558 **At the same time:** L. Brezhnev to RN, January 17, 1974, NSC, Box 43.

PAGE 558 **In a discussion:** Memcon: HK and A. Dobrynin, February 1, 1974, NSC, Box 69.

PAGE 558 **With Gromyko:** HK to RN, February 4, 1974, NSC, Box 71.

PAGE 559 **During a two-hour:** RN, HK and A. Gromyko, Memcon, February 4, 1974; HK and A. Gromyko, February 5, 1974, ibid.

PAGE 559 **But of course:** HK to N. Fahmy, February 5, 1974, NSC, Box 639.

PAGE 559 **In freezing Moscow:** HK and *Time* eds., Memcon, February 5, 1974, NSC, Box 1028.

PAGE 560 **But this was hardly:** On opposition to détente, see Bundy, 343–44, 347, 407–409, 423, 425.

PAGE 560 **Nixon continued to hope:** RN and HK et al., Memcon, February 9, 1974, NSC, Box 1028.

PAGE 560 **Kissinger shared Nixon's:** HK to I. Fahmy, February 10, 1974, NSC, Box 639; HK and A. Haig, February 11, 1974, TC.

PAGE 561 **Although the French:** RN and HK, February 11, 1974, TC; PPP:RN, 1974, 150–56.

PAGE 561 **Controlling allies:** U.S. mission, Cairo to HK, February 11, 1974, NSC, Box 639. PPP:RN, 1974, 157.

PAGE 561 **Nixon being Nixon:** RN and HK, February 13, 1974, TC.

PAGE 561 **After Kissinger managed:** RN and HK, February 14, 1974, TC.

PAGE 562 **In the meantime:** RN and HK, February 18, 1974, TC.

PAGE 562 **Understanding how:** HK and A. Haig, February 17, 1974, TC.

PAGE 562 **At his news conference:** PPP:RN, 1974, 199–209.

PAGE 563 **Between February 25:** HK and H. Assad, Memcon, February 25, 1974, February 26, 1974, NSC, Box 1028; HK to RN, February 27, 1974, NSC, Box 44.

PAGE 563 **Nixon was delighted:** HK to B. Scowcroft, February 28, 1974, ibid.; HK to A. Sadat, March 4, 1974, NSC, Box 640.

PAGE 564 **The advances for:** HK to W. Stoessel, February 28, 1974, NSC, Box 639; HK and W. Brandt, Memcon, March 4, 1974; RN, HK and Cabinet, Memcon, March 8, 1974, NSC, Box 1028.

PAGE 564 **Yet the good news:** Kutler, 465. B. Scowcroft to HK, March 3, 1974, March 4, 1974, NSC, Box 44.

PAGE 565 **Nixon responded:** PPP:RN, 1974, 222, 226–40.

PAGE 565 **The press conference:** HK and R. Evans, March 7, 1974, TC.

PAGE 565 **Defending Nixon:** RN, HK, and GOP Congressional Leadership, Memcon, March 8, 1974, NSC, Box 1028.

PAGE 566 **The positive talk:** HK to A. Sadat, March 16, 1974, NSC, Box 640; HK to RN, n.d., but clearly March 18, 1974, or March 19, 1974, AH, WHSF, Box 21; HK and A. Haig, March 18, 1974, TC; RN's public comments about the lifting of the embargo were very guarded: see PPP:RN, 1974, 267–68.

PAGE 566 **Nixon's frustration:** HK and A. Haig, March 16, 1974, TC.

PAGE 567 **A few days:** HK and A. Haig, March 20, 1974, TC.

PAGE 567 **Nixon remained restrained:** PPP:RN, 1974, 261–77.

PAGE 567 **Conservative New York:** Kutler, 451.

PAGE 568 **More convinced:** HK and D. Rockefeller, March 22, 1974, TC.

PAGE 568 **Although it was not:** Le Duc Tho to HK, March 20, 1974, HKOF, NSC, Box 116; W. Stearman to HK, March 22, 1974, NSC., Box 569; W. Stearman to HK, March 29, 1974, NSC, Box 1028.

PAGE 568 **If a third Summit:** "Talking Points for Secretary Kissinger's Pre-NSC Discussion with the President," March 21, 1974; "NSC Meeting," March 21, 1974, NSC, Box H-033; RN to L. Brezhnev, March 21, 1974; A. D. Clift to HK, March 22, 1974, NSC, Box 69; Jaworski's friends, see Kutler, 465.

PAGE 569 **As Kissinger prepared:** HK and B. Scowcroft, March 22, 1974, TC; Kutler, 445–46; RN, *Memoirs*, 991–93; *New Republic*, April 13, 1974.

PAGE 569 **In a well-meaning:** "Conceptual breakthrough": HK, *YOU*, 1020–21; J. Javits and G. Meany quotes are in Ambrose, *Nixon: Ruin and Recovery*, 319–20; see also Zumwalt, xiv–xv.

PAGE 570 **"I was not:** HK, *YOU*, 1021–22; HK to RN, March 26, 1974, NSC, Box 76.

PAGE 570 **Kissinger's report:** HK and Brezhnev, Memcon, March 25, 1974, ibid.

PAGE 571 **Aside from an agreement:** "Empowered," quoted in ibid; B. Scowcroft to RN, March 27, 1974, NSC, Box 76.

PAGE 571 **The U.S. press:** HK and J. Schlesinger, March 29, 1974; HK and Senator A. Stevenson, March 29, 1974; HK and A. Haig, March 30, 1974, TCs.

PAGE 571 **Nixon was no more:** Summers, 469. Ambrose, *Nixon: Ruin and Recovery*, 312.

CHAPTER 17 THE END OF A PRESIDENCY

PAGE 572 **By the spring of 1974:** PPP:RN, 1974, 335; surveys, April 14, 1974, May 2, 1974, *Gallup, 1935–1997*, CD Rom edition.

PAGE 573 **By contrast:** Isaacson, 590–93.

PAGE 573 **On April 2:** PPP:RN, 1974, 332, 336–37; Ambrose, *Nixon: Ruin and Recovery*, 324.

PAGE 573 **The conversations reflected:** HK, *YOU*, 193–94, 715–21, 733–34; RN and W. Brandt, Memcon, April 6, 1974; RN to N. Podgorny, April 7, 1974, NSC, Box 1028; Ambrose, *Nixon: Ruin and Recovery*, 324–25.

PAGE 574 **The Watergate scandal:** Kutler, 451.

PAGE 574 **St. Clair's response:** HK and B. Scowcroft, April 10, 1974, TC; Kutler, 451–52.

PAGE 574 **Nixon hoped to:** RN and HK, April 12, 1974, TC.

PAGE 574 **In another conversation:** Ibid., April 16, 1974.

PAGE 575 **Conversations with Gromyko:** HK and A. Gromyko, Memcon, April 12, 1974, NSC, Box 69.

PAGE 575 **In the two and a half:** See HK and B. Scowcroft conversations on April 17, 1974, three TCs.

PAGE 575 **Two days later:** HK and J. Sisco, April 19, 1974; HK and A. Haig, April 22, 1974, TCs.

PAGE 576 **In fact, Nixon:** PPP:RN, 1974, 358–59; HK and K. Rush, April 26, 1974, TC.

PAGE 576 **But Nixon was:** PPP:RN, 1974, 994; Ambrose, *Nixon: Ruin and Recovery*, 326–29.

PAGE 576 **To win the public:** PPP:RN, 1974, 389–97.

PAGE 577 **The response:** Kutler, 452–55; Ambrose, *Nixon: Ruin and Recovery*, 327, 334.

PAGE 577 **Al Haig:** Haig, 453; Thomas, 94.

PAGE 577 **Two days after:** Opinion surveys, April 12–15, 1974, May 5, 1974, May 23, 1974, May 26, 1974, *Gallup, 1935–1997*, CD Rom edition.

PAGE 577 **Although Nixon continued:** Discussions are in HK to RN: "Discussion with Fahmy," April 18, 1974, NSC, Box 640; RN and HK, April 26, 1974, TC; see also J. Sisco to U.S. Ambassador, April 4, 1974; H. Saunders to HK, April 12, 1974; HK to A. Sadat, April 23, 1974; HK to U.S. Ambassador, April 25, 1974, NSC, Box 640; HK and al-H. Shihabi, Memcon, April 13, 1974, NSC, Box 1028; HK and Bipartisan Leadership Meeting, April 24, 1974, NSC, Box 318; HK and N. Fahmy, April 18, 1974; HK and B. Scowcroft, April 23, 1974; HK and S. Dinitz, April 27, 1974, TCs.

PAGE 578 **Nixon's mention:** Tho to HK, April 18, 1974, NSC, Box 116; HK to Tho, April 22, 1974, NSC, Box 127; R. Kennedy to HK, April 23, 1974; U.S. embassy to HK, April 27, 1974, NSC, Box 569; Thieu to RN, April 25, 1974, NSC, Box 766.

PAGE 579 **Although preoccupied:** HK and A. Gromyko, Memcon, April 28, 1974, April 29, 1974, NSC, Box 1028; quotes are from B. Scowcroft to RN, April 30, 1974, NSC, Box 71.

PAGE 579 **Kissinger sent more:** B. Scowcroft to RN, May 2, 1974, NSC, Box 45; Isaacson, 567–68.

PAGE 579 **In Syria:** HK and H. Assad, Memcon, May 3, 1974, NSC, Box 1028.

PAGE 579 **As Kissinger tried:** Haig, 453–56; PPP:RN, 1974, 997–98.

PAGE 580 **Nixon had talked:** "Meeting with Rabbi Korff," May 13, 1974, POF, Box 94.

PAGE 581 **For Nixon, Kissinger's:** PPP:RN, 1974, 1000; Isaacson, 572; B. Scowcroft to HK, May 2, 1974, NSC, Box 46; B. Scowcroft to RN, May 23, 1974, NSC, Box 45.

PAGE 581 **During thirty-three days:** B. Scowcroft to RN, May 10, 1974, May 14, 1974; HK to B. Scowcroft, May 23, 1974, NSC, Box 45; HK and G. Meir, Memcon: May 20–21, 1974, NSC, Box 1029; HK and J. Kraft, May 31, 1974, TC; last two quotes in paragraph are in Isaacson, 570–72.

PAGE 581 **A James Reston:** Marvin Kalb interview, May 31, 2006.

PAGE 582 **By May 21:** B. Scowcroft to HK, May 21, 1974, NSC, Box 47.

PAGE 582 **Judicial challenges:** Ambrose, *Nixon: Ruin and Recovery*, 343–44; Opinion survey, May 27, 1974, *Gallup, 1935–1997*, CD Rom edition.

PAGE 582 **On May 29:** G. Meir to RN, May 30, 1974; "Draft Talking Points for Presidential Announcement," May 29, 1974, NSC, Box 45; PPP:RN, 1974, 463–64.

PAGE 582 **Kissinger resisted:** B. Scowcroft to HK, n.d., but probably May 30, 1974, NSC, Box 47; HK and J. Kraft, May 31, 1974, TC; HK, *YOU*, 1092.

PAGE 583 **Nixon's determination:** RN, HK, and Bipartisan Congressional Leadership, Memcon, May 31, 1974, NSC, Box 1029.

PAGE 583 **A newspaper story:** Isaacson, 584; RN and HK, June 6, 1974; HK and R. Ziegler, June 7, 1974, TCs.

PAGE 583 **Despite the press:** RN, *Memoirs*, 1002–4.

PAGE 584 **In a series of speeches:** PPP:RN, 1974, 457–60, 467–73, 475–77.

PAGE 584 **On the eve:** RN, *Memoirs*, 1008–9.

PAGE 584 **Nixon had it right:** Isaacson, 584–85; Ambrose, *Nixon: Ruin and Recovery*, 352; state department cable to HK, June 11, 1974, HKOF, NSC, Box 143.

PAGE 585 **Because a *Newsweek*:** HK, *YOU*, 1111, 1118–20; RN, *Memoirs*, 1009.

PAGE 585 **It was a bravura:** Safire, 165–69.

PAGE 585 **Nixon believed:** K. Troia to L. Janka and P. Rodman, June 11, 1974, HKOF, NSC, Box 143; RN, *Memoirs*, 1009–10; Isaacson, 585–86; Ambrose, *Nixon: Ruin and Recovery*, 353.

PAGE 585 **Kissinger saw:** HK, *YOU*, 1121–23.

PAGE 586 **As the trip began:** RN, *Memoirs*, 1010.

PAGE 586 **After the doctor left:** Interview with Haig in 2005 by D. Taylor for a television documentary, which Taylor kindly shared with me.

PAGE 586 **Although three days:** RN, *Memoirs*, 1010–11.

PAGE 587 **With an eye:** PPP:RN, 1974, 485–94, 496–99.

PAGE 587 **"For once:** HK, *YOU*, 1126; PPP:RN, 1974, 494.

PAGE 587 **Despite Kissinger's central:** HK, *YOU*, 1125.

PAGE 588 **Although less evident:** Kissinger's role in preparing Nixon for the trip included, HK to RN, "Your Talks in Egypt," June 12–14, 1974, HKOF, NSC, Box 140; for quotes, see HK, *YOU*, 1125.

PAGE 588 **Nixon's reception:** HK to RN, "Your Talks in Saudia Arabia," June 14–15, 1974; "Your Talks in Syria," June 15–16, 1974, HKOF, NSC, Box 141; PPP:RN, 1974, 506–11; RN, *Memoirs*, 1012–13.

PAGE 588 **Assad was:** Ibid., 1013–15; HK, *YOU*, 1131–36.

PAGE 588 **Conversations in Israel:** RN, *Memoirs*, 1015–16; *New York Times*, June 17, 1974.

PAGE 589 **Rabin:** See Memcons of two June 17, 1974, meetings among RN, HK, Y. Rabin et al., in HKOF, NSC, Box 135, Box 1029; see also, HK to RN, "Your Talks in Israel," June 16–17, 1974, HKOF, NSC, Box 141; PPP: RN, 1974, 518–25.

PAGE 589 **Nixon returned:** Opinion survey, July 4, 1974, *Gallup, 1935–1997*, CD Rom edition.

PAGE 589 **Nixon, Ford:** PPP:RN, 1974, 539–41.

PAGE 590 **"We must:** RN, *Memoirs*, 1017–18.

PAGE 590 **In a bipartisan:** Ibid., 1018; Memcon, June 20, 1974, NSC, Box 1029.

PAGE 590 **Kissinger remained:** HK and J. Javits, June 20, 1974, TC. R. Kennedy to B. Scowcroft, July 2, 1974, NSC, Box 950.

PAGE 591 **In the days:** HK and M. Peretz, June 20, 1974; HK and B. Scowcroft, June 21, 1974; RN and HK, June 21, 1974, TCs.

PAGE 591 **He knew:** RN, *Memoirs*, 1018–21.

PAGE 592 **The chance that:** Memcons: RN and Soviet Parliamentarians, May 23, 1974; RN and A. Dobrynin, May 28, 1974, NSC, Box 1029.

PAGE 593 **Soviet professions:** On the Middle East, L. Brezhnev to RN, May 15, 1974, NSC, Box 69; HK and B. Scowcroft, June 5, 1974, TC; on the Soviet defense ministry, RN to HK, June 2, 1974, NSC, Box 69; on the European security conference, L. Brezhnev to RN, June 8, 1974, NSC, Box 72; HK and H. D. Genscher, Memcon, June 11, 1974, NSC, Box 1029.

PAGE 593 **Nixon needed:** Bundy, 465–67; RN, *Memoirs*, 1023–26; HK, *YOU*, 1143–44, 1150–51, 1156–58; Zumwalt, 499–511.

PAGE 595 **As Nixon prepared:** "Talking Points for Pres. Nixon Congressional and Cabinet Briefings," apparently June 20, 1974, PPF, Box 105; "Notes on Cabinet Meeting," June 20, 1974, POF, Box 94; Memcon, June 20, 1974, NSC, Box 1029.

PAGE 595 **Although many:** E. Muskie, E. Kennedy et al. to RN, June 24, 1974, NSC, Box 950.

PAGE 595 **On June 25:** RN, *Memoirs*, 1027.

PAGE 595 **Regardless of:** "Meeting with NATO Heads of Government," June 26, 1974, NSC, Box 950; "Talking Points: NATO Heads of Government Meeting," n.d., but clearly July 1974, POF, Box 94.

PAGE 596 **A press conference:** HK press conference, June 26, 1974; "Pool Report," June 27, 1974, PPF, Box 106.

PAGE 596 **The meetings in Russia:** RN, *Memoirs*, 1026–39; HK, *YOU*, 1173–75; for an excellent summary of the Summit, see Garthoff, 425–31.

PAGE 596 **Despite disappointing:** PPP:RN, 1974, 567–77.

PAGE 597 **Judging from Nixon's:** See transcripts of conversations for June 28–30, 1974, July 2, 1974, July 3, 1974, all in HK's Trip Files, NSC, Box 77; quote is in RN, *Memoirs*, 1032–33.

PAGE 597 **Nixon spoke:** "Talking Points," n.d., but clearly July 1974, POF, Box 94.

PAGE 597 **A nationally televised:** PPP:RN, 1974, 578–82.

PAGE 598 **Despite all the upbeat:** RN, *Memoirs*, 1036: HK, *YOU*, 1163–64.

PAGE 598 **Kissinger was less:** Ibid., 1164; Valeriani, 141–42.

PAGE 598 **As Nixon returned:** *RN*, Memoirs, 1040–42.

PAGE 599 **Nixon had no:** Ambrose, *Nixon: Ruin and Recovery*, 385–86; HK and B. Kalb, July 12, 1974; HK and R. Ziegler, 1974, TCs; PPP:RN, 1974, 589–90.

PAGE 599 **Nixon took refuge:** Ambrose, *Nixon: Ruin and Recovery*, 385; Ford, 123.

PAGE 599 **While Nixon:** See HK's TCs, including several with RN, about the crisis, July 15–21, 1974; quote is in RN, *Memoirs*, 1047.

PAGE 600 **As Nixon's diary:** Ibid., 1047–48. PPP:RN, 1974, 603–4.

PAGE 600 **Kissinger was also:** HK and T. Braden, July 21, 1974, TC.

PAGE 600 **Not the least:** HK to Tho, July 22, 1974, HKOF, NSC, Box 127.

PAGE 600 **Nixon was too:** *New York Times*, July 24, 1974; RN, *Memoirs*, 1049–51.

PAGE 601 **Nixon felt:** Ibid., 1051–52; PPP:RN, 1974, 606.

PAGE 601 **It meant revealing:** RN, *Memoirs*, 1052–53.

PAGE 601 **At 10:30:** HK, *YOU*, 1095–97; HK and J. Stennis, July 26, 1974; HK and J. Schlesinger, July 26, 1974, TCs.

PAGE 602 **On July 27:** RN, *Memoirs*, 1054–55.

PAGE 603 **On July 29:** Ibid., 1055–57; RN and HK, July 30, 1974, TC.

PAGE 603 **In reaching his:** Kutler, 555, 570–73; Haig, 513–14, 518; Ambrose, *Nixon: Ruin and Recovery*, 406–9.

PAGE 603 **On August 1:** RN, *Memoirs*, 1058–63; HK and A. Haig, RN and HK, HK and B. Scowcroft, all August 3, 1974, TCs; Ambrose, *Nixon: Ruin and Recovery*, 412–14.

PAGE 604 **On the afternoon:** PPP:RN, 1974, 621–23.

Page 604 **Nixon's statement:** Goldwater, 350.

Page 605 **Despite Nixon's explanation:** RN, *Memoirs*, 1063–64; Ambrose, *Nixon: Ruin and Recovery*, 416–17; HK and J. Reston, August 5, 1974, TC.

Page 605 **On August 6:** HK, *YOU*, 1202–4; HK and R. Hauser, August 6, 1974, TC.

Page 606 **A private conversation:** RN, *Memoirs*, 1066; HK, *YOU*, 1205.

Page 607 **On the afternoon:** Goldwater, 350–51.

Page 607 **Nixon now accepted:** RN, *Memoirs*, 1067–68.

Page 607 **A Nixon meeting:** D. Taylor, interview with Alexander Haig, 2005.

Page 608 **At the meeting:** Goldwater, 352–55.

Page 608 **At two minutes:** HK, *YOU*, 1206–7; HK and H. Sidey, August 9, 1974, TC.

Page 609 **At 9 p.m.:** Isaacson, 597–600.

Page 610 **August 8:** RN, *Memoirs*, 1077–82; Ford, 28–29; Isaacson, 601–2, quotes RN's remarks to someone else; for the Ford view of Kissinger, see David Broder's article, *Washington Post*, December 28, 2006; witness's account is in Ambrose, *Nixon: Ruin and Recovery*, 433–34. See interview with B. Scowcroft, January 5, 2007, on Nixon's complaints.

Page 611 **He was, at least:** PPP:RN, 1974, 626–30; Ambrose, *Nixon: Ruin and Recovery*, 437; opinion surveys, August 7, 1974, August 11, 1974, and August 15, 1974, *Gallup, 1935–1997*, CD Rom edition.

Page 611 **At his swearing-in:** Ambrose, *Nixon: Ruin and Recovery*, 438–45; HK, *YOU*, 1211–13.

Epilogue

Page 613 **Like Adams:** Quote is in Ambrose, *Nixon: Ruin and Recovery*, 452.

Page 614 **In 1974:** Marvin Kalb interview, May 21, 2006. Daniel Schorr interview, April 8, 2006.

Page 615 **Nixon and Kissinger shared:** Safire, 168.

Page 616 **The tensions:** Ambrose, *Nixon: Ruin and Recovery*, 488–89, 515; HK's eulogy is available on Google.com under Richard Nixon's funeral.

Page 619 **Similarly, a 1975:** Quoted in Isaacson, 638.

Page 621 **The tilt:** Bundy, 290–91.

BIBLIOGRAPHY

Ambrose, Stephen. *Nixon: The Education of a Politician, 1913–1962.* New York: Simon & Schuster, 1987.

———. *Nixon: Ruin and Recovery, 1973–1990.* New York: Simon & Schuster, 1991.

———. *Nixon: The Triumph of a Politician, 1962–1972.* New York: Simon & Schuster, 1989.

Berman, Larry. *No Peace, No Honor: Nixon, Kissinger and Betrayal in Vietnam.* New York: Free Press, 2001.

Blumenfeld, Ralph. *Henry Kissinger: The Private and Public Story.* New York: New American Library, 1974.

Brodie, Fawn. *Richard Nixon: The Shaping of His Character.* New York: Norton, 1981.

Buchanan, Patrick J. *The Death of the West.* New York: St. Martin's Press, 2002.

Bundy, William. *A Tangled Web: The Making of Foreign Policy in the Nixon Presidency.* New York: Hill and Wang, 1998.

Burr, William, ed. *The Kissinger Transcripts.* New York: The New Press, 1998.

Caldwell, Dan, ed. *Henry Kissinger: His Personality and Policies.* Durham, N.C.: Duke University Press, 1983.

Chafe, William H. *Private Lives/Public Consequences.* Cambridge, Mass.: Harvard University Press, 2005.

Clifford, Clark. *Counsel to the President.* New York: Random House, 1991.

Crowley, Monica. *Nixon Off the Record: His Candid Commentary on People and Politics.* New York: Random House, 1996.

Dallek, Robert. *Flawed Giant: Lyndon Johnson and His Times, 1961–1973.* New York: Oxford University Press, 1998.

———. *An Unfinished Life: John F. Kennedy, 1917–1963.* Boston: Little, Brown, 2003.

Davis, Nathaniel. *The Last Two Years of Salvador Allende.* Ithaca, N.Y.: Cornell University Press, 1985.

Dean, John W. III. *Blind Ambition.* New York: Simon & Schuster, 1976.

Drury, Allen. *Courage and Hesitation: Notes and Photographs of the Nixon Administration.* New York: Doubleday, 1971.

Ehrlichman, John. *Witness to Power: The Nixon Years.* New York: Simon & Schuster, 1982.

Feeney, Mark. *Nixon at the Movies.* Chicago: University of Chicago Press, 2004.

Ford, Gerald. *A Time to Heal.* New York: Harper & Row, 1979.

Gallup, George. *The Gallup Poll, Public Opinion, 1935–1997.* CD Rom edition. Wilmington, Del.: Scholarly Resources, 1998.

———. *The Gallup Poll: Public Opinion, 1959–1971.* New York: Random House, 1972.

Garthoff, Raymond L. *Détente and Confrontation: American-Soviet Relations from Nixon to Reagan.* Washington, D.C.: The Brookings Institution, 1985.

Gibbons, William C. *The U.S. Government and the Vietnam War, Part IV: July 1965–January 1968.* Washington, D.C.: U.S. Government Printing Office, 1994.

Goldwater, Barry. *Goldwater.* New York: St. Martin's Press, 1988.

Graff, Henry F., ed. *The Presidents: A Reference History.* New York: Simon & Schuster Macmillan, 1997.

Graubard, Stephen R. *Kissinger: Portrait of a Mind.* New York: Norton, 1973.

Greenberg, David. *Nixon's Shadow: The History of an Image.* New York: Norton, 2003.

Haig, Alexander M. Jr. *Inner Circles: How America Changed the World: A Memoir.* New York: Warner Books, 1992.

Haldeman, H. R. *The Ends of Power.* New York: Times Books, 1978.

———. *The Haldeman Diaries: Inside the Nixon White House.* New York: Putnam, 1994.

Hanhimaki, Jussi. *The Flawed Architect: Henry Kissinger and American Foreign Policy.* New York: Oxford University Press, 2004.

Hersh, Seymour M. *The Price of Power: Kissinger in the Nixon White House.* New York: Summit Books, 1983.

Hitchens, Christopher. *The Trial of Henry Kissinger.* London: Verso, 2001.

Hofstadter, Richard. "Pseudo-Conservatism Revisited—1965," in *The Paranoid Style in American Politics and Other Essays.* New York: Vintage Books, 1967.

Hung, Nguyen Tien, and Jerrold L. Schecter. *The Palace File.* New York: Harper & Row, 1986.

Isaacson, Walter. *Kissinger.* New York: Simon & Schuster, 1996.

Kalb, Marvin, and Bernard Kalb. *Kissinger.* Boston: Little, Brown, 1974.

Karnow, Stanley. *Vietnam: A History.* New York: Viking Press, 1983.

Keller, Morton, and Phyllis Keller. *Making Harvard Modern.* New York: Oxford University Press, 2001.

Kimball, Jeffrey. *The Vietnam War Files.* Lawrence, Kans.: University Press of Kansas, 2004.

Kissinger, Henry. *Crisis: The Anatomy of Two Major Foreign Policy Crises.* New York: Simon & Schuster, 2003.

———. *Necessity for Choice.* New York: Harper & Row, 1961.

———. *Nuclear Weapons and Foreign Policy.* New York: Harper and Row, 1957.

———. *The Troubled Partnership: A Reappraisal of the Atlantic Alliance.* New York: McGraw-Hill, 1965.

———. *White House Years.* Boston: Little, Brown, 1979.

———. *Years of Upheaval.* Boston: Little, Brown, 1982.

Klein, Herbert G. *Making It Perfectly Clear.* New York: Doubleday, 1980.

Kornbluh, Peter. *The Pinochet File: A Declassified Dossier on Atrocity and Accountability.* New York: New Press, 2004.

Kutler, Stanley I. *Wars of Watergate, The Last Crisis of Richard Nixon.* New York: Alfred A. Knopf, 1990.

Landau, David. *Kissinger.* New York: Crowell, 1972.

Morris, Roger. *Richard Milhous Nixon: The Rise of an American Politician.* New York: Holt, 1990.

———. *Uncertain Greatness: Henry Kissinger and American Foreign Policy.* New York: Harper & Row, 1977.

Nixon, Richard M. *RN: The Memoirs of Richard Nixon.* New York: Grosset & Dunlap, 1978.

———. *Six Crises.* New York: Doubleday, 1962.

Public Papers of the Presidents: Richard Nixon, 1969–1974, 6 vols. Washington, D.C.: U.S. Government Printing Office, 1971–1975.

Quandt, William B. *Decade of Decisions: American Policy Toward the Arab-Israeli Conflict, 1967–1976.* Berkeley, Calif.: University of California Press, 1977.

Reeves, Richard. *President Nixon: Alone in the White House.* New York: Simon & Schuster, 2001.

Safire, William. *Before the Fall: An Inside View of the Pre-Watergate White House.* New York: Da Capo Press, 1975.

Schulzinger, Robert. *Henry Kissinger: Doctor of Diplomacy.* New York: Columbia University Press, 1989.

Shawcross, William. *Sideshow: Kissinger, Nixon and the Destruction of Cambodia.* New York: Simon & Schuster, 1987.

Summers, Anthony. *The Arrogance of Power: The Secret World of Richard Nixon.* New York: Viking, 2000.

Thomas, Helen. *Thanks for the Memories, Mr. President.* New York: Scribner, 2002.

U.S. Department of State. *Foreign Relations of the United States: Foundations of Foreign Policy, 1969–1972.* Washington, D.C.: U.S. Government Printing Office, 2003.

———. *Foreign Relations of the United States, 1969–1976: South Asia Crisis, 1971.* Washington, D.C.: U.S. Government Printing Office, 2005.

———. *Foreign Relations of the United States, 1969–1976: United Nations, 1969–1972.* Washington, D.C.: U.S. Government Printing Office, 2004.

———. *Foreign Relations of the United States, 1964–1968: Vietnam, 1967.* Washington, D.C.: U.S. Government Printing Office, 2002.

———. *Foreign Relations of the United States, 1964–1968: Vietnam, January–August 1968.* Washington, D.C.: U.S. Government Printing Office, 2002.

———. *Foreign Relations of the United States, 1964–1968: Vietnam, September 1968–January 1969.* Washington, D.C.: U.S. Government Printing Office, 2003.

———. *Foreign Relations of the United States, 1969–1976: Vietnam, January 1969–July 1970.* Washington, D.C.: U.S. Government Printing Office, 2006.

Valeriani, Richard. *Travels with Henry.* Boston: Houghton Mifflin, 1979.

Volkan, Vamik D., Norman Itzkowitz, and Andrew W. Dod. *Richard Nixon: A Psychobiography.* New York: Columbia University Press, 1997.

Wells, Tom. *The War Within: America's Battle over Vietnam.* New York: Henry Holt, 1996.

Whalen, Richard. *Catch the Falling Flag*. Boston: Houghton Mifflin, 1972.

White, Theodore H. *The Making of the President, 1968*. New York: Atheneum, 1969.

Wicker, Tom. *One of Us: Richard Nixon and the American Dream*. New York: Random House, 1991.

Wills, Garry. *Nixon Agonistes: The Crisis of the Self-Made Man*. Boston: Houghton Mifflin, 2002.

Zumwalt, Elmo R. Jr. *On Watch*. New York: Quadrangle, 1976.

PHOTO CREDITS

INDEX

India *(cont.)*
 Soviet treaty with (1971), 338, 339; U.S. economic aid to, 336, 339, 340, 345. *See also* Indo-Pakistan war
Indonesia, 145
Indo-Pakistan war (1971), xi, 325, 332, 335–49, 621; American liberals and, 341–42; author's assessment of Nixon-Kissinger policy on, 616, 621, 623; W. Bundy's assessment of Nixon-Kissinger policy on, 348–49; cease-fire negotiations in, 348; circumstances leading to, 335–36; danger of widened conflict in, 337, 338, 339, 343, 344, 345, 347, 350; diplomatic efforts to avert war, 336–41; eruption of full-scale hostilities in, 341; HK's reputation for honesty and his ties to Nixon as casualties of, 349–53; Nixon administration's reluctance to intervene in, 336–37; nuclear option and, 347, 350; RN's and HK's personalization of, 346; "tilt" policy revelations and, 350–51, 352, 621; UN and, 342, 348, 350; U.S. warship and troop movements and, 344, 345
inflation, 243, 477, 599, 605
Inter-American Development Bank (IDB), 229, 322
Inter-American Press Association, 228
intercontinental ballistic missiles (ICBMs), 136, 137; SALT and, 217, 218, 271, 280, 398; SS-9s, 136, 139, 140, 219
Internal Revenue Service (IRS), 133, 411, 457–58, 496, 572, 603
International Telephone and Telegraph (ITT), 510
Iran, 538
Iraq, xii, 224, 225

Ireland, 242, 334
Isaacson, Walter, 50, 111, 415, 439, 614–15
Ismail, Hafiz, 520
Israel, xii, 56, 113–14, 158, 169–79, 252, 321–22, 334, 402, 413, 555, 560, 618–19; American Jewish community's support for, 169–70, 175, 176, 178, 220–21, 275–76, 278, 328, 357, 410, 579; Arab recognition of, 169, 171, 173, 328, 479; assassination of athletes from, at Munich Olympics, 416–17; bilateral talks of Egypt and, 587; deadlock in Egyptian tensions with, 220–23, 224, 273–78, 327–28, 406, 458–61, 479, 490–91, 493–94, 520–33; difficulties in U.S. relations with, 174–79, 274–75, 277–78, 328, 357; HK suspected of bias toward, 171, 273–74; HK's views on creation of state, 40; Jordanian crisis and, 224, 225, 226–27, 272; Lebanon attacked by, 591; nuclear weapons of, 176; occupied territories and, 169, 171, 274, 277, 328, 459, 460, 461, 479, 494, 521, 523, 543, 588; RN's reelection bid and, 410; RN's trip to (1974), 588–89; Six-Day War and, 84, 113, 169, 172, 460; U.S. aid to, 172, 176, 177, 179, 220–21, 222, 225, 274, 275, 276, 277, 357, 461, 522, 523, 524, 525, 536, 543, 589, 604, 607, 618; Yom Kippur War and ensuing peace negotiations and, 520–26, 529, 531, 533, 535, 536, 537, 542, 543, 549–54, 556, 558, 559, 560, 562, 563–64, 565, 566, 574, 578, 579, 581–83, 588–89, 619. *See also* Middle East; Yom Kippur War